The

Subcultures

Reader

Edited, with introductions
by

Ken Gelder

and

Sarah Thornton

London and New York

In Memoriam

Cicely Yalden

1965–1990

First published 1997
by Routledge
11 New Fetter Lane, London EC4P 4EE

Simultaneously published in the USA
and Canada by Routledge
29 West 35th Street, New York,
NY 10001

Typeset in Perpetua by
Florencetype Ltd, Stoodleigh, Devon

Printed and bound in Great Britain by
TJ Press (Padstow) Cornwall

British Library Cataloguing in Publication Data
A catalogue record for this book is available from the British Library

Library of Congress Cataloguing in Publication Data
The subcultures reader/edited by Ken Gelder and Sarah Thornton.
p. cm.
Includes bibliographical references and index.
1. Subculture. 2. Social psychology. 3. Group identity.
I. Gelder, Ken, 1955– . II. Thornton, Sarah.
HM291.S853 1996
306'.1-dc20 96-11488
CIP

ISBN 0-415-12727-0 (hbk)
 0-415-12728-9 (pbk)

The Subcultures Reader

The Subcultures Reader together the most valuable and stimulating writings on subcultures from the Chicago School to the present day. Subcultures come in many, varied and disputed forms, and, although there is no consensus about the definition of a 'subculture' amongst the contributors to the *Reader*, most would agree that subcultures can be broadly defined as social groups organized around shared interests and practices. However, individual authors and schools of thought use the term 'subculture' in more detailed and rigorous ways, shedding light on social worlds generally perceived as mysterious, esoteric and arcane.

While some subcultures are secretive, others are spectacularly public in their clothes, music and behaviour. Subcultures often distinguish themselves against *others* – workers, achievers, 'squares' or the 'mainstream'. They also differentiate amongst themselves and in so doing create hierarchies of participation, knowledge and taste. Subcultures may carve out their own territories in the street, school or asylum, but they also inhabit commercial spaces provided especially for them in football grounds, dance clubs and rock venues.

The identification of subcultures has its seeds in eighteenth- and nineteenth-century reportage which satisfied a prurient interest in the hidden underworld of the 'vulgar classes'. In the early twentieth century, scholars – particularly the sociologists of the Chicago School – began to subject subcultures to systematic research. After 1945, criminologists entered the field, aligning subcultures with felons, delinquents and other 'outsiders'. In the 1970s, researchers in the Centre for Contemporary Cultural Studies at the University of Birmingham redefined subcultures in relation to class, ethnicity and gender. Since then, subcultures have been explored from a range of disciplinary perspectives including social history, anthropology, and literary, cultural and media studies.

The Subcultures Reader provides an essential guide to subcultural studies, enabling students and teachers to understand how the field developed, the range of work it encompasses, and future directions of study.

Editors: Ken Gelder is Senior Lecturer in English at the University of Melbourne and the author of *Reading the Vampire*. Sarah Thornton is Lecturer in Media Studies at Sussex University and the author of *Club Cultures: Music, Media and Subcultural Capital*.

Contents

PART FOUR
Ethics and ethnography

PART FIVE
Historical subcultures

PART SIX
Place, identity, territory

PART SEVEN
Sounds, styles and embodied politics

PART EIGHT
Mediated and virtual subcultures

List of illustrations

Figures

Tables

Plates

Acknowledgements

We would like to thank Rebecca Barden, Christopher Cudmore, Vivien Antwi, Susan Dunsmore and Lisa O'Connell at Routledge for their work towards the publication of this book. Thanks also to all the authors we contacted who kindly gave their permission to reprint edited extracts of their writing.

Caroline Bassett, 'Virtually gendered: life in an on-line world'.

Howard Becker, 'The culture of a deviant group: the dance musician', from *Outsiders* (Chicago: The Free Press 1963).

Marcos Becquer and José Gatti, 'Elements of vogue', from *Third Text*, 16/17 (1991).

Gary Clarke, 'Defending ski-jumpers: a critique of theories of youth subcultures', from *On Record*, eds Simon Frith and Andrew Goodwin (London: Routledge 1990). First published by University of Birmingham, Centre for Contemporary Cultural Studies (1981).

John Clarke, *et al.*, 'Subcultures, cultures and class', from *Resistance Through Rituals*, eds Stuart Hall and Tony Jefferson (1975; London: Routledge 1993).

Albert Cohen, 'A general theory of subcultures', from *Delinquent Boys* (New York: The Free Press 1955).

Phil Cohen, 'Subcultural conflict and working-class community', from *Working Papers in Cultural Studies*, 1 (1972) (University of Birmingham, Centre for Contemporary Cultural Studies).

Stanley Cohen, 'Symbols of trouble', from *Folk Devils and Moral Panics* (1972; Oxford: Martin Robertson 1980).

Paul G. Cressey, 'The life-cycle of the taxi-dancer', from *The Taxi-Dance Hall* (New York: Greenwood Press 1932).

Douglas Crimp with Adam Rolston, 'AIDS activist graphics: a demonstration', from *AIDS DemoGraphics* (Seattle: Bay Press 1990).

Barbara Ehrenreich, Elizabeth Hess and Gloria Jacobs, 'Beatlemania: sexually defiant consumer subculture', from *The Adoring Audience*, ed. Lisa A. Lewis (London: Routledge 1992).

Wendy Fonarow, 'The spatial dynamics of indie music gigs', extract from PhD (University of California, Los Angeles).

Simon Frith, 'Formalism, realism and leisure: the case of punk' (original title: 'Music for Pleasure'), from *Screen Education*, 34 (1980).

T. R. Fyvel, 'Fashion and revolt', from *The Insecure Offenders: Rebellious Youth in the Welfare State* (revised edition) (1961; Harmondsworth: Penguin 1963).

Marjorie Garber, 'Sign, co-sign, tangent', from *Vested Interests: Cross-Dressing and Cultural Anxiety* (London: Routledge 1992).

Paul Gilroy, 'Diaspora, utopia and the critique of capitalism', from *There Ain't No Black in the Union Jack* (London: Unwin Hyman 1987).

Erving Goffman, 'Hospital underlife: places', from *Asylums* (New York: Anchor Books, Doubleday & Co. 1961).

Milton Gordon, 'The concept of the sub-culture and its application', from *Social Forces*, 26 (October 1947).

Lawrence Grossberg, 'Another boring day in paradise: rock and roll and the empowerment of everyday life', from *Popular Music*, 4 (1984).

Dick Hebdige, extract from *Subculture: The Meaning of Style* (London: Methuen 1979).

Dick Hebdige, 'Posing . . . threats, striking . . . poses: youth, surveillance and display', from *SubStance*, 37/38 (1983).

Laud Humphreys, 'The sociologist as voyeur', from *Tearoom Trade: Impersonal Sex in Public Places* (Chicago: Aldine 1970).

John Irwin, 'Notes on the status of the concept subculture', from *Subcultures*, ed. David O. Arnold (New York: The Glendessary Press 1970).

Henry Jenkins, 'Television fans, poachers, nomads', from *Textual Poachers* (London: Routledge 1992).

Dave Laing, 'Listening to punk', from *One Chord Wonders* (Milton Keynes: Open University Press 1985).

George Lipsitz, 'Cruising around the historical bloc: postmodernism and popular music in East Los Angeles', from *Time Passages: Collective Memory and American Culture* (Minneapolis: University of Minnesota Press 1990).

Peter Marsh, Elizabeth Rosser and Rom Harré, 'Life on the terraces', from *The Rules of Disorder* (London: Routledge and Kegan Paul 1978).

Angela McRobbie and Jenny Garber, 'Girls and subcultures', from *Resistance Through Rituals*, eds Stuart Hall and Tony Jefferson (1975; London: Routledge 1993).

Angela McRobbie, 'Second-hand dresses and the role of the ragmarket', from *Postmodernism and Popular Culture* (London: Routledge 1994). First published in *Zoot Suits and Second-Hand Dresses*, ed. Angela McRobbie (London: Macmillan 1989).

Kobena Mercer, 'Black hair/style politics', from *Welcome to the Jungle: New Positions in Black Cultural Studies* (London: Routledge 1994). First published in *New Formations*, 3 (Winter 1987).

Robert E. Park, 'The city: suggestions for the investigation of human behavior in the urban environment', from *The City*, ed. R.E. Park (London: University of Chicago Press 1925).

Geoffrey Pearson, 'Victorian boys, we are here!' from *Hooligans: A History of Respectable Fears* (London: Macmillan 1983).

Ned Polsky, 'Research method, morality and criminology', from *Hustlers, Beats and Others* (Harmondsworth: Penguin 1967).

Peter Stallybrass and Allon White, 'From carnival to transgression', from *The Politics and Poetics of Transgression* (London: Methuen 1986).

Jon Stratton, 'On the importance of subcultural origins', extract from 'Youth subcultures and their cultural contexts', *Australian and New Zealand Journal of Sociology*, 21, 2 (1985).

Will Straw, 'Systems of articulation, logics of change', from *Cultural Studies*, 5, 3 (1991).

Sarah Thornton, extracted from *Club Cultures: Music, Media and Subcultural Capital* (Cambridge: Polity/Wesleyan University Press 1995).

Andrew Tolson, 'Social surveillance and subjectification: the emergence of "subculture" in the work of Henry Mayhew', from *Cultural Studies*, 4, 2 (1990).

Ralph Turner and Samuel Surace, 'Zoot-suiters and Mexicans: symbols of crowd behavior', from *The American Journal of Sociology*, 57, 1 (1956).

Stephen A. Tyler, 'Post-modern ethnography: from document of the occult to occult document', from *Writing Culture*, eds James Clifford and George Marcus (Berkeley: University of California Press 1986).

Robert Walser, 'Eruptions: heavy metal appropriations of classical virtuosity', from *Running with the Devil: Power, Gender and Madness in Heavy Metal Music* (Hanover: Wesleyan University Press 1993).

Jeffrey Weeks, 'Inverts, perverts and Mary-Annes' (original title: 'Inverts, perverts and Mary-Annes: male prostitution and the regulation of homosexuality in England in the nineteenth and early twentieth century'), from *Journal of Homosexuality*, 6, 1/2 (1981).

ACKNOWLEDGEMENTS

William Foote Whyte, 'The problem of Cornerville', from *Street Corner Society* (Chicago: University of Chicago Press 1943).

Paul Willis, extract from *Learning to Labour* (Aldershot: Saxon House 1977).

Paul Willis, 'Theoretical confessions and reflexive method' (original title: 'Notes on method'), from *Culture, Media, Language*, eds Stuart Hall *et al.* (London: Hutchinson & Co. 1980).

Jock Young, 'The subterranean world of play', from *The Drugtakers: The Social Meaning of Drug Use* (London: Paladin 1971).

General introduction

■ Sarah Thornton

W HAT IS A 'SUBCULTURE'? What distinguishes it from a
'community'? And what differentiates these two social forma-
tions from the 'masses', the 'public', 'society', 'culture'? These are
obstinate questions to which there is no agreed answer, but rather
a debate – the problem at the root of which is about how scholars
imagine and make sense of people, not as individuals, but as
members of discrete populations or social groups. Studies of subcul-
tures are attempts to map the social world and, as such, they are
exercises in representation. In attempting to depict the social world
or translate it into sociology (or cultural studies or any of the other
disciplines that are active in this field), we are unavoidably involved
in a process of construction.

Definitions of 'subcultures' have shifted dramatically since the
term was coined in the 1940s, to the degree that only the broadest
and most basic of definitions would accommodate the rich range
of theory and research included in this Reader. All of our contrib-
utors would probably agree that subcultures are groups of people
that have something in common with each other (i.e. they share a
problem, an interest, a practice) which distinguishes them in a
significant way from the members of other social groups. But this
description holds true equally for many other kinds of groups, like

1

'communities' or 'societies' or even 'cultures'. What is unique about 'subcultures'? Why devote a book to them? To answer these questions, it is more productive to explore the connotations the various terms have accrued through use, rather than to be distracted by strict differences of lexical meaning. For, while definitions are regularly contested, there is a notable continuity in the kinds of social network and activity that scholars have labelled or looked at in terms of 'subculture'.

'Community' is perhaps the label whose referent is closest to subculture, to the degree that several contributors use the terms interchangeably. Nevertheless, there are subtle disparities between the two concepts, which affect when and why one or the other is applied in any given case. 'Community' tends to suggest a more permanent population, often aligned to a neighbourhood, of which the family is the key constituent part. Kinship would seem to be one of the main building blocks of community. By contrast, those groups identified as 'subcultures' have tended to be studied apart from their families and in states of relative transience. It is also often assumed that there is something innately oppositional in the word 'subculture'. While struggles over territory, place and space are core issues, subcultures would appear to bring a little disorder to the security of neighbourhood. Subcultures are more often characterized as appropriating parts of the city for their street (rather than domestic) culture. These are some of the reasons why one hears frequently of 'youth subcultures', but seldom of 'youth communities'. Youth attempt to define their culture against the parental home. 'Subcultures' (as they have been written about over the past three-quarters of a century) have come to designate social groups which are perceived to deviate from the normative ideals of adult communities.

The 'public' and the 'masses', while antithetical to each other, are also both opposed to subcultures. The public has been conceived as a body of rational individuals, responsible citizens who are able to form their own opinion and express it through officially recognized democratic channels. By contrast, subcultures have tended to be envisaged as disenfranchised, disaffected and unofficial. Their shadowy, subterranean activities contrast dramatically with the 'enlightened' civil decencies of the 'public'.

In contrast to the public, the 'mass' has often been portrayed as undifferentiated, irrational and politically manipulated. It has been imagined as the passive product of the homogenization and standardization of mass media and mass production processes. Studies of subcultures, however, picture common people not only as highly differentiated, but as active and creative. The Chicago School of sociology, in which the tradition of subcultural studies has its roots, was interested in exploring the extraordinary diversity of human behaviour in the American city. The notion of a mass society, on the other hand, was developed by critical theorists working in an entirely different scholarly tradition at the Frankfurt School (which was displaced to Columbia University in New York during the Second World War). The two academic legacies are to some extent fused in the subcultural studies in the Birmingham tradition of the 1970s (and, also, in the transitional work of Jock Young), one of whose main concerns was the relation of subcultures to media, commerce and mass culture. Influenced by both the Frankfurt School's Marxist vision of a mass society and the Chicago School's liberal–pluralist studies of subcultures, this work was ambivalent about the politics of subcultures, alternately seeing them as resistant and subordinate, politically hopeful and spectacularly impotent.

'Society' is another key term used to frame and make sense of populations. It is a macro-sociological abstraction which offers at best only an indirect sense of belonging. The identification of a subculture, by contrast, tends to be the tangible and immediate result of qualitative micro-sociological research. Subcultures are known to their members and often investigated through their eyes, to the extent that the distinction between subcultural insider and non-subcultural outsider is often a matter of collective perception rather than any legal, physical or geographical divide. With 'society', however, the borders of identification tend to be remote, drawn alongside those of the nation-state and investigated in statistical terms. Internal boundaries are understood more often than not as 'stratifications' and it is within these strata or as a consequence of them that we might discover a subculture. Subcultural studies can be seen as part of an anatomizing logic by which scholars dissect and analyse ever smaller segments of the social world.

Expressed in the plural, however, the term 'societies' is closer to most uses of 'subcultures' in so far as both terms assume a small-scale association of people united by a common interest. Yet, one of the connotations of 'societies' is that they have formal membership processes that may involve bureaucratic recruitment, written constitutions, official badges and uniforms. Subcultures have generally been seen to be informal and organic, whether participants congregate by choice or through the forced fraternities of the prison or the asylum. Nonetheless, these implications have been successfully undermined by the addition of the prefix 'sub' to the degree that the term 'sub-societies' was, for a time, used interchangeably with 'subcultures'.

In fact, the prefix 'sub', which ascribes a lower or secondary rank to the entity it modifies, gives us a clue to one of the main assumptions of this tradition of scholarship – namely, that the social groups investigated in the name of 'subcultures' are subordinate, subaltern or subterranean. There are two main, often overlapping, ways in which subcultures have been considered beneath, but within, 'society' or 'culture', both of which relate to the social status of their participants. First, the groups studied as subcultures are often positioned by themselves and/or others as deviant or debased. Criminal 'undergrounds', for instance, are partly defined from above by the law and partly from below by their participants. Gay and lesbian subcultures, as another example, are subjected to compulsory heterosexual norms, except where they can carve out spaces for their own rules and practices. Both re-negotiate their subordinate position within their subculture, jockeying for self-esteem and alternative forms of status. Second, social groups labelled as subcultures have often been perceived as lower down the social ladder due to social differences of class, race, ethnicity and age. Subcultural studies have paid attention to cultures that have been dismissed as insignificant by most disciplines in the humanities – like the cultures of black, hispanic, working-class, poor and young people. Researchers have paid particular attention to the way members of subcultures collectively work through, contest or resolve issues related to their social station. (Chapters in the Reader that explore the subcultures of racial minorities, for example, include those by Cressey, Gilroy, Lipsitz, Turner and Surace, Mercer, and Becquer

and Gatti. Questions of class, ethnicity and age seem to creep into most of the analyses to varying degrees.)

One of the strengths of subcultural studies and one of its many values for the social sciences and humanities is its systematic investigation of the cultural. Sociologists have too often attempted to segregate culture as some subsidiary or derivative matter from their analysis of society, while literary and artistic traditions have too willingly relegated society as a peripheral issue of 'context'. The tradition of subcultural studies, by contrast, effectively conflates society and culture. In other words, culture, as a pattern of beliefs and values or even ideologies, cannot be separated from action and social organization. Culture and society are both 'ways of life'. The defining attribute of 'subcultures', then, lies with the way the accent is put on the distinction between a particular cultural/social group and the larger culture/society. The emphasis is on variance from a larger collectivity who are invariably, but not unproblematically, positioned as normal, average and dominant. Subcultures, in other words, are condemned to and/or enjoy a consciousness of 'otherness' or difference.

This summary of the contrasting characteristics generally associated with subcultures and other social formations is not meant to define subcultures. Although this outline simplifies the subcultural tradition, I hope it will clarify two important issues. First, in the process of portraying social groups, scholars inevitably construct them. As mentioned in my opening paragraph, 'subcultures', like 'communities' or 'masses', do not just exist out there, waiting for their patterns to be perceived by the diligent researcher. To label a social formation is in part to frame, shape and delineate it. Second, the qualities of subcultures listed above are meant to reveal the biases of the tradition of subcultural studies towards the counter-cultural, the deviant, the young – and the masculine. 'Subcultures' are typically populated by 'outsiders', 'perverts' and/or 'radicals'. These biases are the limitations but also the strengths of this tradition, which has arguably contributed more than any other to our understanding of the social groups labelled in these ways.

This is not to say that the biases – the nexus of problems and types of people researched as 'subcultures' – have not been contested. Feminists, in particular, have queried the male bias of

definitions of subcultures, and as a result have even pushed back the boundaries of what we might define as subcultural. Although Paul Cressey studied the social world of women 'taxi-dancers' in the 1930s, he was an exception to a general rule in which sub- cultures were inevitably and rather unquestioningly male. In the 1970s, the work of Angela McRobbie was particularly important in thinking through the position of girls within youth subcultures. Since then, some feminists, such as Ehrenreich *et al.* and Thornton, have interrogated the female activities usually relegated to the realm of a passive and feminized 'mainstream' (a colloquial term against which scholars have all too often defined their subcultures), while others – Fonarow and Bassett, for example – have seen gender as, quite simply, a central issue within the male dominated worlds which they research. Interestingly, gay men have long been given a home within subcultural studies as 'sexual deviants'; the contributions of Humphreys, Weeks, Crimp, Becquer and Gatti concentrate on issues of homosexuality.

One of the main themes of the work collected in the first three Parts of this Reader is the search for a general definition of subcul- tures. These Parts are, in the main, devoted to defining, redefining and contesting the subcultural terrain. Arranged in chronological order, they include some of the most important work from three distinct stages of research activity. The first Part includes a broad range of essays by sociologists researching in the tradition of the Chicago School between the 1920s and late 1960s. The second Part comprises material from scholars working in or around the Centre for Contemporary Cultural Studies at University of Birmingham during the 1970s, while the third Part chronicles various reactions to the Birmingham work – some of which harks back to Chicago-School-style lines of inquiry.

Between these three Parts, and indeed throughout the collection, one finds a productive tension between sociological/ anthropological approaches and textual/semiotic approaches to subcultures. The distinction is both methodological and theoretical. At the sociological end of the continuum, research has tended to be done through participant observation and written up as ethno- graphies, whereas at the cultural studies end of the spectrum, scholars have tended to submit subcultural forms (like clothes or

music) to varieties of textual analysis. At one end, more attention has been paid to issues of organization and interaction; at the other, writers have concentrated on symbols and meanings.

The remaining five Parts are organized along themes to which subcultural studies has devoted considerable research and development. The first two, 'Ethics and ethnography' and 'Historical subcultures', are methodologically defined. 'Ethics and ethnography' looks at a main method of subcultural studies, investigating the complex relations of power between researcher and researched. 'Historical subcultures' comprises interdisciplinary chapters which remind us that although subcultural studies are a twentieth-century field of inquiry, a retrospective application of its key concepts can yield illuminating results. The final three Parts – 'Place, identity, territory', 'Sounds, styles and embodied politics' and 'Mediated and virtual subcultures' – cover issues of long-standing significance to the field as well as ones recently put on the subcultural studies agenda. Generally, they highlight the most important ways in which subcultural groups both differentiate themselves from others and identify amongst themselves, that is, through the appropriation of space, through modes of visual and aural self-representation and through selective mediated symbolic interaction. All of the Parts are preceded by an introduction which details the key questions and considerations which have accompanied each subject area.

The Subcultures Reader is designed to bring together the most influential and inspiring articles in order to historicize and focus debate on subcultures. 'Subcultures' have given rise to some of the most stimulating work in cultural studies, criminology, sociologies of youth and minorities, anthropologies of music and theories of culture and consumption. Given this, it is astonishing that this field of inquiry, which spans much of the twentieth century, has not been subject to definitive collection. Our book aims to give form and coherence to this relatively unexcavated discipline. We hope that students will use the Reader as a starting-point for further exploration of their own and other subcultural worlds.

The 'Chicago School' and the sociological tradition

Introduction to part one

■ Sarah Thornton

T HE 'CHICAGO SCHOOL' IS USED informally to refer to
several generations of sociologists who shared certain concerns
and perspectives about society and culture, many of whom either
taught or were trained in the sociology department of the University
of Chicago. Formed in 1892 as the Department of Sociology and
Anthropology, Chicago's was the first sociology department to be
established anywhere in the world and, until the late 1920s, some
would argue, 'Chicago sociology was, in effect, American sociology'
(Smith 1988). With the growth of competing departments around
the United States, Chicago came to be seen as an advocate of qual-
itative empirical research, distinguishing it from the pure theoretical
tendencies of Harvard's sociology department or the statistical
investigations of Columbia's. The Chicago School also came to be
associated with a specific kind of urban micro-sociology which gave
particular attention to the interaction of people's perceptions of
themselves with others' views of them.

The above is not meant as a comprehensive account of all the
work done in the department between the end of the First World
War and the 1960s, but merely a description of what the 'Chicago
School' became best known for. Amongst the authors contributing
to this Part, Robert E. Park was one of the leading forces of the

department, Paul E. Cressey and Howard Becker were students in the department, while John Irwin was part of a later group called the 'Chicago Irregulars' who founded the journal *Urban Life* in 1969. Authors included in other Parts of the Reader who studied sociology at the University of Chicago include Erving Goffman, Ned Polsky, Ralph Turner and William Foote Whyte.

One of the principal publications which heralded the establishment of the distinctive agenda of Chicago sociology was Robert E. Park's 1915 essay on 'The city' which we have abridged and re-published as the first chapter. Here, Park outlines a project to map the social groups of the city in a way which includes their modes of conflict and control, network and segregation, vocation and lifestyle. One of his many influential suggestions is that participant observation might be the most valuable method for exploring 'the customs, beliefs, social practices and general conceptions of life and manners' of urban inhabitants. Park's chapter provides a fitting beginning to the Reader because subcultural studies have responded repeatedly and productively to his call to observe and investigate 'human behaviour in an urban environment'.

This first Part of the Reader includes a broad range of material. The earlier chapters, like that of Park and Paul Cressey, seed some of the main concerns of the tradition before the term 'subculture' was even coined, while the later work bears witness to the gestation and maturation of a distinct set of questions and concepts associated with subcultural studies. Some of the contributions offer case studies, others propose general theories, but collectively they should give a clear idea of the contribution of this body of work. Although they have both substantially advanced subcultural theory, Paul Cressey's and Howard Becker's chapters are intricately analysed empirical studies. Short chapters by Milton Gordon and John Irwin define, in their very different ways, the meaning and uses of the term, 'subculture'. In his chapter, 'A general theory of subcultures', Albert Cohen overviews and gives definitive explication to some of the main tenets of the Chicago tradition. Finally, the last chapter in this Part signals transition: Jock Young's 'The subterranean world of play' bears witness to the importation of subcultural studies to Britain, the embracing of critical theorists and the transformation of subcultural studies into something

substantively different which gestures towards later Birmingham elaborations.

Paul Cressey's chapter examines the life-cycle of women who dance with men for money. These 'taxi-dancers' generally lost status as their youth or novelty value wore thin. Their careers, argues Cressey, can be seen in terms of a series of degenerative cycles which often ended in prostitution. As the taxi-dancer's status declines within a given social group, she then moves into a new but subordinate group where she temporarily recovers a higher rank. Significantly, the hierarchical divisions between these groups are racial: the taxi-dancer 'descends' through white, then 'Oriental', then 'Negro' worlds. With this case, Cressey explores in rich detail a social process that had never been subject to the same kind of exacting empirical scrutiny. Although there have never been a shortage of theories about 'fallen women', Cressey transforms what would have conventionally been viewed as a 'moral decline' into a form of downward mobility.

Drawing on his research into the delinquent members of male gangs in the 1950s, Albert Cohen outlines a series of questions whose exploration is necessary to the development of a general theory of subcultures. Cohen argues that subcultures emerge when a number of actors with similar problems of social adjustment interact with one another and innovate new frames of reference. Problems, of course, are not equally distributed throughout the society. Moreover, the social structure and the immediate social milieu help determine 'the creation and selection of solutions'. Cohen's argument very much set the agenda for subsequent research; the idea of collective problem-solving became one of the cornerstones of subcultural theory.

Howard Becker's contribution to the Reader combines concerns for the dynamics of status and self-esteem with one for 'deviant' symbolic solutions. Extracted from his classic book, *The Outsiders*, his chapter on 'The culture of a deviant group' is a subtle analysis of the cultural values of a loose association of musicians who make their living performing popular dance standards in the late 1940s, but aspire to playing jazz for an audience of like-minded peers. Central to the 'jazz' musicians' view of their social world is an antithesis between the 'hip' and the 'square'. To be 'hip' is to be

SARAH THORNTON

'in the know', to possess a mysterious attitude which could not be acquired through education, and to disdain conventional social norms, whereas to be 'square' is to be 'the opposite of all the musicians were'. Becker's beautifully observed, intricate explanation of the symbolic interactions entailed in the operations of 'hipness' is a model of subcultural analysis which, by analogy, illuminates many different kinds of music and youth culture today. Most importantly, his interpretation of the musicians' culture is grounded in the socio-economic relations of occupation, ethnicity and class, as well as exceptionally lucid definitions of deviance and culture.

The short chapters by Milton Gordon and John Irwin work through the definition and considerably clarify the circulation of 'subcultures'. Gordon is the first scholar to reflect self-consciously upon the hyphenated term 'sub-culture' and his elaboration both corresponds with and diverges in a few interesting ways from later uses of the term. One of the key improvements that 'sub-culture' made over previous formulations was, as Gordon writes, that it enabled scholars 'to discern closed and relatively cohesive systems of social organization' which had formerly been analysed separately with sociological tools like 'class' or 'ethnic group'. Rather than dissecting or segmenting the population along a single demographic line of inquiry, the concept of a sub-culture enabled a more holistic, integrated appreciation of a 'world within a world'.

In his chapter which gestures back to and evaluates Gordon's, John Irwin explores the changing meanings and uses of both the term and the fact of 'subculture' in the context of a more pluralistic and relativistic America. He examines how the term has come to refer to lifestyles, action systems and social worlds which are not fixed to any specific social group. Crucially, he also addresses the important (and heretofore ignored) issue of the cognitive status of the concept 'subculture' in the minds of members of subcultures and argues that the appearance in the late 1960s of colloquial terms like 'scenes' and 'bags' (which identify parallel social formations) suggest that subcultural phenomena have changed in some fundamental ways.

Although British sociologists and criminologists had been looking into deviancy and delinquency in the manner of the American studies for some thirty years (most inportant in this

regard is the work of Paul Rock and David Downes; see also Cohen in Part Three and Fyvel in Part Seven), Jock Young's work acts as a bridge between the distinct theoretical and political agendas of the work associated with the Chicago School and those of the later Birmingham tradition (which are the subject of Part Two). 'The subterranean world of play', which is an excerpt from his book, *The Drugtakers*, departs from the liberal or democratic politics of the Chicago School and embraces a critical Marxist perspective. Young's use of the Freudian and Marxist theories of Herbert Marcuse ultimately integrates late Frankfurt School paradigms into Chicago School concerns. This productive synthesis enables a dramatic re-thinking of subcultural theory – one which integrates capitalism (and not just class) into the model. Following this logic, Young characterizes his subcultures as 'groups that exist beyond the ethos of productivity', contrasting 'formal work values' like deferred gratification and conformity to bureaucratic rules with 'subterranean values' like short-term hedonism and disdain for work.

Through the writing gathered within it, Part One attempts to create a gestural history of a paradigm, from its theoretical and terminological origins, through its elaboration and refinement, to work which is heavily indebted to, but ultimately departs from, this first model of subcultures. A selection of seven articles cannot possibly do justice to the wealth and diversity of research done in the name or spirit of the Chicago School. Students should see the work re-published here as only the tip of an intellectual iceberg, the bulk of which is unfortunately out-of-print, but gratefully still available in many university libraries.

Robert E. Park

THE CITY
Suggestions for the investigation of human behaviour [1915]

THE CITY IS SOMETHING MORE than congeries of individual men and social conveniences – the streets, buildings, electric lights, tramways, and telephones etc.; something more, also, than a mere constellation of institutions and administrative devices – courts, hospitals, schools, police, and civil functionaries of various sorts. The city is, rather, a state of mind, a body of customs and traditions, and of the organized attitudes and sentiments that inhere in these customs and are transmitted with this tradition. The city is not, in other words, merely a physical mechanism and an artificial construction. It is involved in the vital processes of the people who compose it; it is a product of nature, and particularly of human nature. . . .

Anthropology, the science of man, has been mainly concerned up to the present with the study of 'primitive' peoples. But 'civilized' man is quite as interesting an object of investigation, and at the same time his life is more open to observation and study. . . . The same patient methods of observation which anthropologists like Boas and Lowie have expended on the study of the life and manners of the North American Indian might be even more fruitfully employed in the investigation of the customs, beliefs, social practices, and general conceptions of life prevalent in Little Italy on the lower North Side in Chicago, or in recording the more sophisticated folkways of the inhabitants of Greenwich Village and the neighborhood of Washington Square, New York.

We are mainly indebted to writers of fiction for our more intimate knowledge of contemporary urban life. But the life of our cities demands a more searching and disinterested study than even Emile Zola has given us in his 'experimental.'

We need such studies, if for no other reason than to enable us to read the newspapers intelligently. The reason that the daily chronical of the newspaper is so shocking, and at the same time so fascinating, to the average reader is because the average reader knows so little about the life of which the newspaper is the record.

The observations which follow are intended to define a point of view and to indicate a program for the study of urban life: its physical organization, its occupations, and its cultures. . . .

I. The city plan and local organization

Physical geography, natural advantages and disadvantages, including means of transportation, determine in advance the general outlines of the urban plan. As the city increases in population, the subtler influences of sympathy, rivalry, and economic necessity tend to control the distribution of population. Business and industry seek advantageous locations and draw around them certain portions of the population. There spring up fashionable residence quarters from which the poorer classes are excluded because of the increased value of the land. Then there grow up slums which are inhabited by great numbers of the poorer classes who are unable to defend themselves from association with the derelict and vicious.

In the course of time every section and quarter of the city takes on something of the character and qualities of its inhabitants. Each separate part of the city is inevitably stained with the peculiar sentiments of its population. The effect of this is to convert what was at first a mere geographical expression into a neighborhood, that is to say, a locality with sentiments, traditions, and a history of its own. Within this neighborhood the continuity of the historical processes is somehow maintained. The past imposes itself upon the present, and the life of every locality moves on with a certain momentum of its own, more or less independent of the larger circle of life and interests about it.

Proximity and neighborly contact are the basis for the simplest and most elementary form of association with which we have to do in the organization of city life. Local interests and associations breed local sentiment, and, under a system which makes residence the basis for participation in the government, the neighborhood becomes the basis of political control. In the social and political organization of the city it is the smallest local unit. . . .

In the city environment the neighborhood tends to lose much of the significance which it possessed in simpler . . . forms of society. The easy means of communication and of transportation, which enable individuals to distribute their attention and to live at the same time in several different worlds, tend to destroy the permanency and intimacy of the neighborhood. On the other hand, the isolation of the immigrant and racial colonies of the so-called ghettos and areas of population segregation tend to preserve and,

where there is racial prejudice, to intensify the intimacies and solidarity of the local and neighborhood groups. Where individuals of the same race or of the same vocation live together in segregated groups, neighborhood sentiment tends to fuse together with racial antagonisms and class interests.

Physical and sentimental distances reinforce each other, and the influences of local distribution of the population participate with the influences of class and race in the evolution of the social organization. Every great city has its racial colonies, like the Chinatown of San Francisco and . . . the Little Sicily of Chicago, and various other less pronounced types. In addition to these, most cities have their segregated vice districts, like that which until recently existed in Chicago, their rendezvous for criminals of various sorts. Every large city has its occupational suburbs . . . and its residential enclaves, each of which has the size and the character of a complete separate town, village, or city, except that its population is a selected one. Undoubtedly the most remarkable of these cities within cities, of which the most interesting characteristic is that they are composed of persons of the same race, or of persons of different races but of the same social class, is East London, within a population of 2,000,000 laborers . . .

> [East London] is . . . full of churches and places of worship, yet there are no cathedrals, either Anglican or Roman; it has a sufficient supply of elementary schools, but is has not public or high school, and it has no colleges for the higher education and no university; the people all read newspapers, yet there is no East London paper except of the smaller and local kind. . . . People, shops, houses, conveyances – all together are stamped with the unmistakable seal of the working class.
>
> Perhaps the strangest thing of all is this: in a city of two millions of people there are no hotels! That means, of course, that there are no visitors.
>
> [Besant, 1912]

. . . East London is a city of a single class, but within the limits of that city the population is segregated again and again by racial, cultural, and vocational interests. . . .

What we want to know of these neighborhoods, racial communities, and segregated city areas, existing within or on the outer rims of great cities, is what we want to know of all other social groups:

> What are the elements of which they are composed?
> To what extent are they the product of a selective process?
> How do people get in and out of the group thus formed?
> What are the relative permanence and stability of their populations?
> What about the age, sex, and social condition of the people?
> What about the children? How many of them are born, and how many of them remain?

What is the history of the neighborhood? What is there in the subconsciousness — in the forgotten or dimly remembered experiences — of this neighborhood which determines its sentiments and attitudes?

What is there in clear consciousness, i.e. what are its avowed sentiments, doctrines, etc?

What does it regard as matter of fact? What is news? What is the general run of attention? What models does it imitate and are these within or without the group?

What is the social ritual, i.e., what things must one do in the neighborhood in order to escape being regarded with suspicion or looked upon as peculiar?

Who are the leaders? What interests of the neighborhood do they incorporate in themselves and what is the technique by which they exercise control?

II. Industrial organization and the moral order

The ancient city was primarily a fortress, a place of refuge in time of war. The modern city, on the contrary, is primarily a convenience of commerce, and owes its existence to the market place around which it sprang up. Industrial competition and the division of labour, which have probably done most to develop the latent powers of mankind, are possible only upon condition of the existence of markets, of money, and other devices for the facilitation of trade and commerce.

An old German adage declares that 'city air makes men free' (*Stadt Luft macht frei*). This is doubtless a reference to the days when the free cities of Germany enjoyed the patronage of the emperor, and laws made the fugitive serf a free man if he succeeded for a year and a day in breathing city air. Law, of itself, could not, however, have made the craftsman free. An open market in which he might sell the products of his labour was a necessary incident of his freedom, and it was the application of the money economy to the relations of master and man that completed the emancipation of the serf. . . .

The old adage which describes the city as the natural environment of the free man still holds so far as the individual man finds in the chances, the diversity of interests and tasks, and in the vast subconscious co-operation of city life the opportunity to choose his own vocation and develop his peculiar individual talents. The city offers a market for the special talents of individual men. Personal competition tends to select for each special task the individual who is best suited to perform it. . . .

The effect of the vocations and the division of labor is to produce, in the first instance, not social groups, but vocational types: the actor, the plumber, and the lumber-jack. The organizations, like the trade and labor unions which men of the same trade or profession form, are based on common

interests. In this respect they differ from forms of association like the neigh-borhood, which are based on contiguity, personal association, and the common ties of humanity. The different trades and professions seem disposed to group themselves in classes, that is to say, the artisan, business, and profes-sional classes. But in the modern democratic state the classes have as yet attained no effective organization. Socialism, founded on an effort to create an organization based on 'class consciousness,' has never succeeded, except, perhaps, in Russia, in creating more than a political party.

The effects of the division of labor as a discipline, i.e., as means of molding character, may therefore be best studied in the vocational types it has produced. Among the types which it would be interesting to study are: the shop [assistant], the policeman, the peddler, the cabman, . . . the clairvoyant, the performer, the strike-breaker, the labor agitator, the school teacher, the reporter, the stockbroker; all of these are characteristic products of the conditions of city life; each, with its special experience, insight, and point of view determines for each vocational group and for the city as a whole its individuality. . . .

> What prestige and what prejudices attach to different trades and professions and why?
>
> In what occupations do men, in what occupations do women, succeed better, and why?
>
> How far is occupation, rather than association, responsible for the mental attitude and moral predilections? Do men in the same profes-sion or trade, but representing different nationalities and different cultural groups, hold characteristic and identical opinions?
>
> To what extent is the social or political creed, that is, socialism, anar-chism, syndicalism, etc., determined by occupation? by temperament?
>
> To what extent have social doctrine and social idealism superseded and taken the place of religious faith in the different occupations, and why?
>
> Do social classes tend to assume the character of cultural groups? That is to say, do the classes tend to acquire the exclusiveness and inde-pendence of a caste or nationality; or is each class always dependent upon the existence of a corresponding class?
>
> To what extent do children follow the vocations of their parents and why?
>
> To what extent do individuals move from one class to another, and how does this fact modify the character of class relationships?

The division of labor, in making individual success dependent upon concen-tration upon a special task, has had the effect of increasing the interdependence of the different vocations. A social organization is thus created in which the individual becomes increasingly dependent upon the community of which he is an integral part. The effect, under conditions of personal competition, of

this increasing interdependence of the parts is to create in the industrial organization as a whole a certain sort of social solidarity, but a solidarity based, not on sentiment and habit, but on community of interests.

In the sense in which the terms are here used, sentiment is the more concrete, interest the more abstract, term. We may cherish a sentiment for a person, a place, or any object whatsoever. It may be a sentiment of aversion, or a sentiment of possession. But to possess or to be possessed by a sentiment for, or in regard to, anything means that we are incapable of acting towards it in a thoroughly rational way. It means that the object of our sentiments corresponds in some special way to some inherited or acquired disposition.

The existence of a sentimental attitude indicates that there are motives for action of which the individual who is moved by them is not wholly conscious; motives over which he has only a partial control. Every sentiment has a history, either in the experience of the individual, or in the experience of the race, but the person who acts on that sentiment may not be aware of this history.

. . . Our sentiments are related to our prejudices, and prejudices may attach to anything – persons, races, as well as inanimate things. Prejudices are related also to taboos, and so tend to maintain 'social distances' and the existing social organization. Sentiment and prejudice are elementary forms of conservatism. Our interests are rational and mobile, and make for change.

Money is the cardinal device by which values have become rationalized and sentiments have been replaced by interests. It is just because we feel no personal and no sentimental attitude towards our money, such as we do towards, for example, our home, that money becomes a valuable means of exchange. . . .

The extension of industrial organization, which is based on the impersonal relations defined by money, has gone forward hand in hand with an increasing mobility of the population. . . . However, mobility in an individual or in a population is measured, not merely by change of location, but rather by the number and variety of the stimulations to which the individual or the population responds. Mobility depends, not merely upon transportation, but upon communication. Education and the ability to read, the extension of the money economy to an ever increasing number of the interests of life, in so far as it has tended to depersonalize social relations, has at the same time vastly increased the mobility of modern peoples. . . .

It is a commonplace that decisive factors in the movements of crowds are psychologic. This means that among the individuals who make up the crowd, or who compose the public which participates in the movements reflected in the market, a condition of instability exists which corresponds to what has been defined elsewhere as crisis. It is true of the exchanges, as it is of crowds, that the situation they represent is always critical, that is to say, the tensions are such that a slight cause may precipitate an enormous

effort. The current euphemism, 'the psychological moment,' defines such a critical condition.

Psychological moments may arise in any social situation, but they occur more frequently in a society which has acquired a high state of mobility. They occur more frequently in a society where education is general, where railways, telegraph, and the printing press have become an indispensable part of the social economy. They occur more frequently in cities than in smaller communities. In the crowd and the public every moment may be said to be 'psychological.' . . .

Under the title of collective psychology much has been written in recent years in regard to crowds and kindred phenomena of social life. Most that has been written thus far has been based upon general observation and almost no systematic methods exist for the study of this type of social organization. The practical methods which practical men like the political boss, the labor agitator, the stock-exchange speculator, and others have worked out for the control and manipulation of the public and the crowd furnish a body of materials from which it is possible to make a more detailed, a more intimate study of what may be called, in order to distinguish it from that of more highly organized groups, collective behavior.

The city, and particularly the great city, in which more than elsewhere human relations are likely to be impersonal and rational, defined in terms of interest and in terms of cash, is in a very real sense a laboratory for the investigation of collective behavior. Strikes and minor revolutionary movements are endemic in the urban environment. Cities, and particularly the great cities, are in unstable equilibrium. The result is that the vast casual and mobile aggregations which constitute our urban populations are in a state of perpetual agitation, swept by every new wind of doctrine, subject to constant alarms, and in consequence the community is in a chronic condition of crisis.

What has been said suggests first of all the importance of a more detailed and fundamental study of collective behavior. The questions which follow will perhaps suggest lines of investigation that could be followed profitably by students of urban life.

What is the psychology of crisis? What is the cycle of events involved in the evolution of a crisis, political or economic? . . .

To what extent are mob violence, strikes, and radical political movements the results of the same general conditions that provoke financial panics, real estate booms, and mass movements in the population generally?

To what extent are the existing unstable equilibrium and social ferment due to the extent and speed of economic changes as reflected in the stock exchange?

What are the effects of the extension of communication and of news upon fluctuations in the stock market and economic changes generally? . . .

Do the reports in the newspapers, so far as they represent the facts, tend to speed up social changes, or to stabilize a movement already in progress?

What is the effect of propaganda and rumor, in cases where the sources of accurate information are cut off? . . .

III. Secondary relations and social control

Modern methods of urban transportation and communication – the electric railway, the automobile, the telephone, and the radio – have silently and rapidly changed . . . the social and industrial organization of the modern city. They have been the means of concentrating traffic in the business districts, have changed the whole character of retail trade, multiplying the residence suburbs and making the department store possible. These changes in the industrial organization and in the distribution of population have been accompanied by corresponding changes in the habits, sentiments, and character of the urban population.

The general nature of these changes is indicated by the fact that the growth of cities has been accompanied by the substitution of indirect, 'secondary,' for direct, face-to-face, 'primary,' relations in the associations of individuals in the community. . . . Touch and sight, physical contact, are the basis for the first and most elementary human relationships. [Parent] and child, husband and wife, . . . master and servant, . . . minister, physician, and teacher – these are the most intimate and 'real' relationships of life, and in the small community they are practically inclusive.

The interactions which take place among the members of a community so constituted are immediate and unreflecting. Intercourse is carried on largely within the region of instinct and feeling. Social control arises, for the most part spontaneously, in direct response to personal influences and public sentiment. It is the result of a personal accommodation, rather than the formulation of a rational and abstract principle. . . .

In a great city, where the population is unstable, where parents and children are employed out of the house and often in distant parts of the city, where thousands of people live side by side for years without so much as a bowing acquaintance, these intimate relationships of the primary group are weakened and the moral order which rested upon them is gradually dissolved.

Under the disintegrating influences of city life most of our traditional institutions, the church, the school, and the family, have been greatly modified. The school, for example, has taken over some of the functions of the family. It is around the public school and its solicitude for the moral and physical welfare of the children that something like a new neighborhood and community spirit tends to get itself organized. The church, on the other hand, which has lost much of its influence since the printed page has so

largely taken the place of the pulpit in the interpretation of life, seems at present to be in process of readjustment to the new conditions. . . .

It is probably the breaking down of local attachments and the weakening of the restraints and inhibitions of the primary group, under the influence of the urban environment, which are largely responsible for the increase of vice and crime in great cities. It would be interesting in this connection to determine by investigation how far the increase in crime keeps pace with the increasing mobility of the population. . . . It is from this point of view that we should seek to interpret all those statistics which register the disintegration of the moral order, for example, the statistics of divorce, or truancy, and of crime.

What is the effect of ownership of property, particularly of the home, on truancy, on divorce, and on crime?

In what regions and classes are certain kinds of crime endemic?

In what classes does divorce occur most frequently? What is the difference in this respect between farmers and, say, actors?

To what extent in any given racial group, for example, the Italians in New York or the Poles in Chicago, do parents and children live in the same world, speak the same language, and share the same ideas, and how far do the conditions found account for juvenile delinquency in that particular group?

How far are the home mores responsible for criminal manifestations of an immigrant group? . . .

It is one of the characteristic phenomena of city life and of society founded on secondary relationships that advertising should have come to occupy so important a place in its economy.

In recent years every individual and organization which has had to deal with the public, that is to say the public outside the smaller and more intimate communities of the village and small town, has come to have its press agent, who is often less an advertising man than a diplomatic man accredited to the newspapers, and through them to the world at large. . . .

As a source of social control public opinion becomes important in societies founded on secondary relationships, of which great cities are a type. In the city every social group tends to create its own milieu and, as these conditions become fixed, the mores tend to accommodate themselves to the conditions thus created. In secondary groups and in the city fashion tends to take the place of custom, and public opinion, rather than mores, becomes the dominant force in social control.

In any attempt to understand the nature of public opinion and its relation to social control it is important to investigate first of all the agencies and devices which have come into practical use in the effort to control, enlighten, and exploit it.

The first and the most important of these is the press, that is, the daily newspaper and other forms of current literature, including books classed as current.

After the newspaper, the bureaus of research which are now springing up in all the large cities are the most interesting and the most promising devices for using publicity as a means of control. . . .

In addition to these there are the educational campaigns in the interest of better health conditions, the child-welfare exhibits, and the numerous 'social advertising' devices which are now employed, sometimes upon the initiative of private societies, sometimes upon that of popular magazines or newspapers, in order to educate the public and enlist the masses of the people in the movement for the improvement of conditions of community life.

The newspaper is the great medium of communication within the city, and it is on the basis of the information which it supplies that public opinion rests. The first function which a newspaper supplies is that which formerly was performed by the village gossip.

In spite, however, of the industry with which newspapers pursue facts of personal intelligence and human interest, they cannot compete with the village gossips as a means of social control. For one thing, the newspaper maintains some reservations not recognized by gossip, in the matters of personal intelligence. For example, until they run for office or commit some other overt act that brings them before the public conspicuously, the private life of individual men or women is a subject that is, for the newspaper, taboo. It is not so with gossip, partly because in a small community no individual is so obscure that his private affairs escape observation and discussion; partly because the field is smaller. In small communities there is a perfectly amazing amount of personal information afloat among the individuals who compose them.

The absence of this in the city is what, in large part, makes the city what it is. . . .

IV. Temperament and the urban environment

Great cities have always been the melting-pots of races and of cultures. Out of the vivid and subtle interactions of which they have been the centers, there have come the newer breeds and the newer social types. The great cities of the United States, for example, have drawn from the isolation of their native villages great masses of the rural populations of Europe and America. . . .

Transportation and communication have effected, among many other silent but far-reaching changes, what I have called the 'mobilization of the individual man.' They have multiplied the opportunities of the individual man for contact and for association with his fellows, but they have made these contacts and associations more transitory and less stable. A very large part of the populations of great cities, including those who make their homes in tenements and apartment houses, live much as people do in some great hotel, meeting but not knowing one another. The effect of this is to substitute

fortuitous and casual relationships for the more intimate and permanent associations of the smaller community.

Under these circumstances the individual's status is determined to a considerable degree by conventional signs – by fashion and 'front' – and the art of life is largely reduced to skating on thin surfaces and a scrupulous study of style and manners.

Not only transportation and communication, but the segregation of the urban population tends to facilitate the mobility of the individual man. The processes of segregation establish moral distances which make the city a mosaic of little worlds which touch but do not interpenetrate. This makes it possible for individuals to pass quickly and easily from one moral milieu to another, and encourages the fascinating but dangerous experiment of living at the same time in several different contiguous, but otherwise widely separated, worlds. All this tends to give city life a superficial and adventitious character; it tends to complicate social relationships and to produce new and divergent individual types. It introduces, at the same time, an element of chance and adventure which adds to the stimulus of city life and gives it, for young and fresh nerves, a peculiar attractiveness. . . .

The attraction of the metropolis is due in part, however, to the fact that in the long run every individual finds somewhere among the varied manifestations of city life the sort of environment in which he expands and feels at ease; finds, in short, the moral climate in which his peculiar nature obtains the stimulations that bring his . . . dispositions to full and free expression. It is, I suspect, motives of this kind which . . . draw many, if not most, of the young men and young women from the security of their homes in the country into the big, booming confusion and excitement of city life. In a small community it is the normal man, the man without eccentricity or genius, who seems most likely to succeed. The small community . . . tolerates eccentricity. The city, on the contrary, rewards it. Neither the criminal, the defective, nor the genius has the same opportunity to develop his . . . disposition in a small town that he invariable finds in a great city.

Fifty years ago every village had one or two eccentric characters who were treated ordinarily with a benevolent toleration, but who were regarded meanwhile as impracticable and queer. These exceptional individuals lived an isolated existence, cut off by their very eccentricities, whether of genius or of defect, from genuinely intimate intercourse with their fellows. . . . In the city many of these divergent types now find a milieu [or 'moral region'] in which, for good or for ill, their dispositions and talents parturiate and bear fruit. . . .

> Investigation of the problems involved might well begin by a study and comparison of the characteristic types of social organization which exist in these regions.
>
> What are the external facts in regard to the life in Bohemia, the half-world, the red-light district, and other 'moral regions' less pronounced in character?

What is the nature of the vocations which connect themselves with the ordinary life of these regions? What are the characteristic mental types which are attracted by the freedom which they offer?

How do individuals find their way into these regions? How do they escape from them?

To what extent are the regions referred to the product of the license; to what extent are they due to the restrictions imposed by city life on the natural man?

. . . Association with others of their own ilk provides also not merely a stimulus, but a moral support for the traits they have in common which they would not find in a less select society. . . . We must then accept these 'moral regions' and the more or less eccentric and exceptional people who inhabit them, in a sense, at least, as part of the natural, if not the normal, life of a city. It is not necessary to understand by the expression 'moral region' a place or a society that is either necessarily criminal or abnormal. It is intended rather to apply to regions in which a divergent moral code prevails, because it is a region in which the people who inhabit it are dominated, as people are ordinarily not dominated, by a taste or by a passion or by some interest which has its roots . . . [in] moral, rather than intellectual, isolation.

Because of the opportunity it offers, particularly to the exceptional and abnormal types of man, a great city tends to spread out and lay bare to the public view in a massive manner all the human characters and traits which are ordinarily obscured and suppressed in smaller communities. The city, in short, shows the good and evil in human nature in excess. It is this fact, perhaps, more than any other, which justifies the view that would make of the city a laboratory or a clinic in which human nature and social processes may be conveniently and profitably studied.

Paul G. Cressey

THE LIFE-CYCLE OF THE TAXI-DANCER [1932]

Taxi-dance halls are relatively unknown to the general public. Yet for thousands of men throughout the United States who frequent them they are familiar establishments. Located inconspicuously in buildings near the business centers of many cities, these taxi-dance halls are readily accessible. They are a recent development and yet already are to be found in most of the larger cities of the country and are increasing steadily in number. . . . [U]nder one guise or another, they can be discovered in cities as different as New Orleans and Chicago, and as far apart as New York, Kansas City, Seattle, and Los Angeles.

In these halls young women and girls are paid to dance with all-comers, usually on a fifty-fifty commission basis. Half of the money spent by the patrons goes to the proprietors who pay for the hall, the orchestra, and the other operating expenses while the other half is paid to the young women themselves. The girl employed in these halls is expected to dance with any man who may choose her and to remain with him on the dance floor for as long a time as he is willing to pay the charges. Hence the significance of the apt name 'taxi-dancer' which has been given her. Like the taxi-driver with his cab, she is for public hire and is paid in proportion to the time spent and the services rendered. . . .

A generation ago the young girl who broke with her home and neighborhood and set out alone upon the high roads of adventure had little opportunity to do other than sink, almost immediately, into some form of prostitution. But today many legitimate avenues are open to her and, if she adopts an unconventional mode of life, many intermediate stages precede actual prostitution. The girl may organize her life in terms of an intermediate stage and never become a prostitute. The life of the taxi-dancer is one of

these intermediate stages, and, like prostitution, it is an employment which can be of only short duration. The career of a taxi-dancer ends in her late twenties. It is a source of income only for the interim between later adolescence and marriage. Many young women use the taxi-dance hall in this way. Others use it to provide for themselves during the interlude between marital ventures. Still others – married women – use it as a source of additional funds and, not infrequently, as a diversion from monotonous married lives.

All this exists because, as never before in our mobile cities, it is possible for young people to lead dual lives, with little probability of detection. Thus the young woman may 'get in' and 'out' of prostitution with a facility and rapidity which renders ineffective the traditional forms of social control. Likewise the taxi-dancer, if she so desires, has a greater opportunity than ever before afforded to such a girl to 'come back' and again fit into conventional society.

Many girls, however, do not satisfactorily readjust themselves to conventional life. A part of the explanation may be that they are the more unstable and improvident ones, who naturally would be unable to extricate themselves from any exigency in which they might find themselves. More important, it would seem, is the fact that in this little isolated world of taxi-dance halls, the young woman may very soon come to accept without great resistance the standards of life and the activities of those with whom she is inevitably associated. . . .

In the following instance, May Ferguson, a young woman of twenty-four, cut all connections with her relatives and friends in Rogers Park and, for a time, lived intensely the life revolving around the taxi-dance hall. Her reactions to the critical question of 'dating' and marrying an Oriental reflect the effectiveness of this social world in making possible a complete change in the activities and personal standards of a young woman of middle-class American society.

> It's strange how my attitudes toward the mixing of the races has changed and then changed back again in a little over a year. Two years ago I would have shuddered at the thought of dancing with a Chinaman or a Filipino and hated them just about as much as I did a 'nigger.' Then I learned that Dick had been unfaithful to me, and I wanted to get away from everything, everybody. For a while I didn't care what happened.
>
> When I first started in the dance hall on the West Side everything was exciting and thrilling. The only thing that bothered me was to have to dance with the Filipinos and the Chinamen. The first time one danced with me it almost made me sick. But after I'd been dancing there two months I even came to think it was all right to go out with Filipinos. You see, everybody else was doing it, and it seemed all right. But I never got so I would go out with a Chinaman.
>
> I didn't really think of marrying a Filipino until I met Mariano. He

seemed different. I thought he was really going to school. He always treated me in a perfectly gentlemanly way, and I thought he was better than other Filipinos. For a time I let myself think seriously of marrying him, but down deep I knew I could never marry a Filipino. One thing I could never get straightened out was the question of the children. . . .

Soon after, Mariano and I broke up, and I never was serious with any other Filipino. . . . Then I quit the dance hall, and went back to live my old life on the North Side.

Just a few weeks ago, after I'd been away from the West Side for nearly a year, I was talking with some friends. They were telling about a chop-suey proprietor who had married a white woman. For some reasons that made me mad, and I started in telling what I thought of anyone who would marry a 'Chink.' Then all of a sudden I stopped and bit my lip I had just realized that only the year before I was seriously considering marrying a Filipino, who was even darker than a Chinaman. And now, just a few months later, I had all the hatred toward them that I had before I went out on the West Side.

The taxi-dancer's life-cycle fundamentally retrogressive

For those young women who do not 'get out' of the dance-hall life while still relatively new to it there appear to be rather definite and regular stages of regression which eventually lead to some form of prostitution. It may be noted also that the 'lower' the level reached by the girl, the more difficult is her re-entrance into conventional society. These stages in their life-cycle appear, on careful inspection, to be so regular and almost inevitable for those who persist in taxi-dancing that in its generalized aspects this life-cycle may be considered valuable for prediction.

The hypothesis is here suggested, with a view toward further verification, that the taxi-dancer, starting with an initial dissatisfaction in her home situation, tends to go through a series of cycles of a regressive character, i.e., the latter part of each cycle involving a continual loss of status in a given group, and the initial part of a succeeding cycle indicating a regaining of status in a new but usually lower group than the preceding ones. This cyclical theory of the taxi-dancer's life is simply a graphic way of conceiving of the difficulties of maintaining status over any span of years in a social world of the type found in the taxi-dance hall.

A very important aspect of the hypothesis has to do with the higher status granted the girl by each group during the initial period in each cycle. Finding herself losing favor in one social world, the taxi-dancer 'moves on' to the group with which, in the natural course of her life, she has recently been brought most vitally in contact. This may involve a movement from one taxi-dance hall to another, perhaps one of lower standing; and again, it

may in the later stages mean a trend toward other social worlds to which the life in the taxi-dance hall is frequently but a threshold. As a 'new girl' in a new group, she is accorded a satisfactory status, and in the novelty of the situation she finds new excitement. Thus begins a new cycle in the girl's life. After a time, however, she is no longer a 'new girl' and finds herself losing caste in favor of younger and still newer girls. Her decline in any particular social world may be rapid or slow, depending upon the personality, ingenuity, and character of the individual girl, but in any case a gradual decline in status in any such dance hall seems almost inevitable. . . .

The initial position of status accorded the 'new girl' in the taxi-dance hall and the later struggle to maintain that status is indicated in the following case of Wanda, a young girl of Polish parentage, who subsequently married a Filipino youth whom she had met in the dance hall. This case also reveals the way in which the girl's scheme of life may be completely altered through a brief sojourn in the world of the taxi-dance hall.

> Wanda, American-born but of Polish parents, at fifteen . . . secured work in a cigar factory, telling her employer that she was eighteen. Shortly after, she left home and no trace of her was found until four months later, when she was found married to a young Filipino. He said his wife told him that she was nineteen and that he had no reason to doubt her. Wanda met him in the taxi-dance hall in which she had been employed. They had known each other only a month before their marriage.
>
> According to Wanda's story, she left the cigar factory because the work was monotonous. All day long she wrapped cigars until after a month she could endure it no longer. Through a friend in the factory she secured employment in the dance hall, dignified by the name of a 'dancing school for men.' . . . Wanda was rather embarrassed at first at the prospect of dancing with so many strange men, but before the end of the first evening she found herself thoroughly enjoying it and turned in more tickets than any other girl on the floor. She began to look forward to the evenings in the dance hall; she 'got a thrill' from meeting so many new people.
>
> Her popularity continued for several evenings, much to the annoyance of the other girl employees. But one night one of her steady partners tried to 'get fresh.' Wanda left him in the middle of the floor. Her partner complained to the management, and that evening Wanda got a 'terrible bawling out.' She was made to understand that she was hired for the purpose of entertaining, not insulting the patrons. If she didn't like it, she could leave. But she didn't want to leave. She had been having too good a time, and so she agreed to be more compliant.
>
> But her clientèle began to fall off. She learned that several of the other girls, jealous of her success, were circulating tales that she was

a 'bad sport' and a prude. To rectify this Wanda resorted to the wiles of the other girls; she rouged heavily, darkened her eyes, and shortened her skirts. Again she achieved popularity, also the other girls grew more tolerant of her.

One evening she danced with Louis, a Filipino. His peculiar accent intrigued her, and she accepted an invitation to supper. Their friendship grew. He told her of his childhood on his native islands, and she confided her growing dislike for the dance hall. They agreed that they would like to 'settle down,' and so one evening Wanda 'resigned' and they drove to Indiana and were married.

[Reported by a Chicago social worker]

In the whole gamut of cycles through which the taxi-dancer tends to go, at least four may be suggested. The first cycle involves the girl's dissatisfaction with the type of life associated with the home and neighborhood. This may come about largely through a growing consciousness of economic lack in the family, through a thwarting of the desire of a type of masculine contacts which the home or the neighborhood fails to offer, through a sense of insufficient prestige in the home and the community, or through a loss of status due to the girl's supposed transgression of the established moral code. At all events, the girl, finding her way sooner or later to the taxi-dance hall, secures therein a satisfaction of certain wishes previously unfulfilled.

Here she at first finds an enhanced prestige accorded her – even though by a world which her family and her neighborhood would adjudge as lower than their own. Thus begins a second cycle for the girl. As a novice in the taxi-dance hall she is at first 'rushed,' and enjoys the thrill of being very popular. But after a time she ceases to be a novitiate and must make a deliberate effort to maintain her status. If she fails and is no longer able to secure sufficient patronage exclusively from the white group, she comes eventually to accept the romantic attentions of Filipinos and other Orientals.

Thus begins a third cycle for the girl, at the beginning of which she experiences a new prestige accorded her by the Oriental group. Here, again, a girl may continue to 'get by' with the group with which she has become associated, being consistently accorded a degree of status which to her is satisfying. But such are the hazards of maintaining standing in this social world that if she accepts the attentions of too many Orientals she is adjudged 'common' by them, and thus again loses caste.

A failure to make satisfactory adjustment in the world of Orientals may bring the girl to a fourth cycle, which is begun when she centers her interests upon the social world which in Chicago has been associated with the 'black and tan' cabarets. She usually comes into contact with these groups through her associations with Orientals. With the Negroes she again achieves temporarily the prestige accorded the novitiate. But here, too, she is doomed to a decline in status, and this seems very frequently to lead to prostitution in the Black Belt.

As has been said, the evidence to support this theory of retrogressive cycles is not conclusive, and the suggestion is offered merely as a hypothesis for further study. Yet the data which are at hand seem to be suggestive. . . .

The following case is one in which the girl ran through the whole gamut of experiences until she reached a low level of prostitution. . . .

> Tina was a Polish girl whose parents lived on the Northwest Side. When she was about sixteen she married a young man from the same neighborhood. She later left him, claiming non-support and entered a taxi-dance hall, where she was for a time quite popular. At first she would not dance with Filipinos if she could avoid it. Sometime later, however, when she had come to regard them as a lucrative source for income she became very interested in several. They frequently escorted her to 'black and tan' cabarets and in this way she made contacts with young Negroes.
>
> The Filipinos, very conscious of their anomalous racial position in this country, would tolerate no such conduct on the part of any girls with whom they associated. They immediately deserted her, leaving her in the cabaret. In this way began her activities in the South Side Black Belt, where she subsequently became known as an independent prostitute, carrying on her business chiefly with Negroes and Chinese. Occasionally she seeks to return to the taxi-dance halls and to other Filipino activities, but there are always those who remember her and warn the others that she has already 'gone African.'
>
> [Compiled from information supplied by two persons
> well acquainted with the young woman]

The theory of the retrogressive life-cycles, while only a hypothesis, can perhaps be seen best through a reference to the typical experiences of taxi-dancers before and after entering these resorts. These experiences seem so frequently to have common elements in them and to follow such a regular sequence of typical experiences that they can be conceived as a 'behavior sequence.' In any event it is clear that a better perspective can be gained by classifying these experiences and arranging them chronologically. Some of the characteristic experiences, fortunate and unfortunate, which befall the taxi-dancer can be seen in the following.

Distracting and disorganizing experiences before entering the taxi-dance hall

It is clear that the typical taxi-dancer, even though young in years, is not inexperienced. Most taxi-dancers have had varied experiences, both occupationally and sexually. They have engaged in a variety of occupations, usually of the unskilled type, such as waitress, factory operative, or salesgirl. Their

experiences often include at least one marriage, usually unsuccessful and characterized by considerable infidelity on both sides, resulting in separation or divorce. In most cases there seems to be, in addition, a background of intense family conflict.

When the girl enters the taxi-dance hall she usually has already broken with many of the stable community groups, such as her family and church. Usually, she also has failed to find conventional ways of satisfying certain dominant interests, such as her need for friendship and affection, for status, and for excitement. Nor does she have a well-defined standard of conduct or a goal in life towards which she may work. The taxi-dancer enters her vocation already somewhat disorganized, often feeling herself in conflict with conventional society.

The initial period of uncertainty and distrust

The initial experiences of the taxi-dancer are so similar that it is possible to perceive a fundamental sequence in the girl's affiliation with the establishment and its personnel. With few exceptions, the primary factor attracting the girl to the establishment is the possibility of making money in an easier way than she otherwise could. A young taxi-dancer without training of any kind frequently earns as much as thirty-five or forty dollars a week. But the economic interest is paralleled by an interest in the 'thrill' and excitement of the dance hall. Yet the strangeness and uncertainty of the situation, compelled with an antagonism or disgust for the conduct of certain taxi-dancers, may cause many new taxi-dancers to remain aloof. . . .

[About half] of the young girls who attempt a career in the taxi-dance hall drop out during the first few weeks. Either they are not able to attract sufficient patronage or they are antagonized by the practices seen about the establishment. Likewise, to many taxi-dancers their work in the dance hall is purely a segmental activity, engaged in primarily to supplement an insufficient income earned as clerical office-workers, clerks in department stores, or at light industry and in laundries.

Thrills of early success: the romantic period

The successful novices among the taxi-dancers, however, very soon overcome any hesitancy they may have and throw themselves whole-heartedly into the life revolving about the establishment. Courted intensively and sought after in a manner seldom experienced in more conventional life, the 'new girl' comes to enjoy immensely these new thrills and satisfactions. A host of new men, many of them attractive, some of them strange and fascinating, present themselves and bid for her favor. She is escorted to expensive night clubs where she is served in a manner which, according to her conception, befits only the socially elect.

Out of it she very quickly gains an enhanced conception of herself. The Polish girl from 'back of the yards' is metamorphosed into a 'dancing instructress,' and frequently acquires a new name comparable to her new station in life. The following list, while disguised, nevertheless distinguishes in a true manner the characteristic original and 'professional' names, respectively, of certain Chicago taxi-dancers. These new names reveal the girl's conception of herself and suggest the ideals and aspirations by which her life is ordered.

Real Name	*'Professional' Name*
Christina Stranski	DeLoris Glenn
Louise Lorenz	Bobby LeMann
Sophie Zelinski	Gwendolyn Llewellen
Alma Heisler	Helene de Valle
Pearl Babcock	Melba DeMay
Eleanor Hedman	Gloria Garden
Anna Prasenski	Althea LeMar
Mary Bulonowski	LaBelle Shelley
Alice Borden	Wanda Wang
Mary Maranowski	Jean Jouette

With this new conception of herself the girl enters a series of romantic experiences, in which every consideration is sacrificed for the free play of the romantic impulse.

> I don't know what there is about the dance hall, but I never had so many serious 'cases' in such a short time as I had those few months I was on the West Side. I was always getting a flame over this fellow or that one. If it wasn't a Filipino it was a good-looking young Italian or even a Greek. I never have been able to understand what got into me. There was always someone I was crazy about. . . .

'Getting the dances' – the veteran taxi-dancer's problem

As the taxi-dancer becomes an accepted member of the dance-hall personnel and, unconsciously, has come to acquire in it a certain rôle, the problem of 'getting the dances' becomes a more pressing one. While she may remain a popular girl with a certain group of patrons, many others have abandoned her for other new and more interesting taxi-dancers. As her pay check dwindles, she begins deliberately to use certain techniques to attract dance partners. At the same time the girl has become more aware of her standing with her co-workers. They, in turn, demand certain standards of performance from her. In response to their ridicule, jeers, and laughter, she complies with their expectations, changes her mode of dressing, of acting,

and of thinking, and gradually becomes accepted into the little group of women who set the mode in the world of the taxi-dance hall. Through these contacts the novitiate gradually learns the techniques for being a successful taxi-dancer.

Learning the taxi-dancer's techniques

These techniques are often very simple in character. One of the first considerations is the question of the type of dressing and 'make-up' most advantageous in the dance hall.

> 'Say,' Lila said to me, 'why don't you blondine your hair? You know, all the Filipinos go for blondes. . . .
> 'You come over to my house tomorrow and I'll fix you up before we go to the dance. . . . [W]e'll put a hem in your dress and make it tighter. You aren't such a bad looker. Your shape ain't bad, but you don't know how to show it.'
> [*Chicago Daily Times* 1 February 1930]

. . . There is also the ruse by which the girl, who believes that a patron does not recognize her, represents herself to him as a novice with the hope that she will thereby secure more dances with him. The pretended promise of a late night engagement is also used to induce patrons to continue dancing. In this way the patron is kept in a mood for spending money until the dénouement, at the close of the evening's dancing, when the girl informs him that she has made 'other arrangements.'

A somewhat more complex technique involves the playing of the racial prejudices against each other. Especially with such incompatible groups as Filipinos and race-conscious white Americans, the shrewder taxi-dancer may devise a play by which she utilizes the racial attitudes of both groups for her own financial advantage.

> I noticed a rather attractive young woman . . . standing on the side lines beside a Filipino. As she saw me looking at her, her eyes glanced down obliquely toward him in a manner which seemed to indicate that she at least despised the rather dark-skinned youth with whom she had just been conversing. This seemed a new and interesting affection. As she moved away from the Filipino I approached her and began conversation.
> 'Apparently you don't like your sun-browned friend,' I commented. 'Well, no!' she replied, hesitatingly. 'You see he's a Filipino.' 'But you should worry about that,' I countered. 'The Flips [Filipinos] treat a girl better and will spend more money on her than the other fellows.' She hesitated a moment and then said in mock concern, 'But they're not white!'

Late in the evening, after she had seen me in friendly conversation with several Filipinos, this same girl approached and offered the following explanation of her conduct:

'I don't know whether you know, but I'm engaged to marry the Filipino you saw me talking to. I just acted the way I did about him to get you to dance with me. When I saw you looking at us, I decided I'd have to pretend I didn't like him, so that you would give me some tickets. . . . Most of the white fellows won't dance with me if they learn I go out all the time with Flips. So I say something against them when I'm with white fellows just so they'll give me more dances. . . .

'Even if I do go out with Filipinos, it doesn't pay to dance all the time with them. If I dance all the time with Filipinos I've got to dance with many different ones. If a girl dances with too many Flips they think she's common, so they won't keep on coming to her for dances. . . . I've got to dance with some good-looking white fellows once in a while so the Filipinos will keep on dancing with me.'

[Report of an investigation]

Discovering a profitable dance-hall personality: types among the taxi-dancers

Out of the commercial rivalry among the taxi-dancers, certain rather definitely understood 'roles' develop, by which different girls have discovered they can commercialize most efficiently their personal charm. Each of these roles has its own activities, its own patterns of behavior, its own individual techniques, its own standards, and its own scheme of life.

The highest type among these dance-hall roles is that of the so-called 'nice girl.' The 'nice girl' is the one who possesses sufficient charm, physical attractiveness, and vivacity to secure dances without transgressing the conventional standards of propriety. She may never accept dates from patrons, or may not even frequent a hall where she is expected to dance with Filipinos and other Orientals. She plays the part of the entirely virtuous girl.

Gwendolyn Costello, as she styles herself, is the 'belle' of one of the taxi-dance halls in the Loop, where she has danced for over three years. She is a vivacious girl with a coquettish – almost roguish – manner. She is a graceful dancer, and can follow successfully any kind of dancing. In addition, she has what is called a 'good line.' Although she looks as though she were eighteen she is probably every bit of twenty-four. She is very popular with the patrons, especially with the men between twenty-five and forty. On busy nights at the establishment she is never inactive except on her own volition. Most of the men – new and old patrons – appear to like her, but she is known never to accept dates from anyone met in the hall. For most of the men who dance with her

she remains as much of a mystery at the end of a year's contract as she was the first evening.

[Records of an investigator]

While the motive toward exploitation may be found in the case of the 'nice girl,' it is more prominent in the case of the 'smart girl.' The girl of this type accepts exploitation as the order of the day and frankly sets out to utilize her attractiveness for all the material gain which can be realized therefrom. 'Fishing' and the 'sex game' become for these girls the accepted ways of earning a living; and prestige is accorded to the one who is cleverest in gaining the most (see Cressey 1932).

Among the more immoral young women can be distinguished a third type, the 'never-miss girl.' She is the type who is known by the more initiated patrons to be quite affectionate. Sometimes to other taxi-dancers she may represent herself as successfully 'fishing' her men friends. But to her masculine acquaintances she presents an entirely different picture. The girl of this type may occasionally have a little retinue of men who have special 'roles' or functions in her life. Towards each she has a certain romantic interest, though even with her it is sometimes coupled with a unique sense of objectivity and detachment. . . .

Always fearful lest she become notorious and thus no longer able to secure dance patronage, yet desirous of having what she chooses to consider a 'good time,' the taxi-dancer of this type is torn between the double dilemma of respectability with decreasing income and the greater hazard of becoming notorious and thus unemployable at legitimate dancing in the taxi-dance halls.

For the young woman whose character is held in question, or who for some reason cannot measure up to the requirements for the other types, there is yet one opportunity to continue in some taxi-dance halls, if she will but join the fourth class of taxi-dancers – those who engage in sensual dancing. The older, more sophisticated women, the more homely girls, and others not especially superior in beauty, ability in dancing, and who, for one reason or another, do not wish to date patrons, constitute this fourth class.

For the girl who adopts this way of 'getting along,' financial hazards are considerably reduced. In the other roles the girl is insecure, always exposed to the vicissitudes of dance-hall popularity, always uncertain of her income. But after once adapting herself to sensual dancing her income becomes more regular and more secure. . . . It is also unnecessary for her to engage in coquetry and cajolery to secure patronage. . . .

The contact of the patrons with the taxi-dancer who practices sensual dancing is almost invariably impersonal and utilitarian. Romance, even of the type found among other taxi-dancers, seldom develops between patron and girl meeting on the basis of sensuality. A cold, impersonal bargaining interest identical with prostitution characterizes these contacts. In the dance hall this type of taxi-dancer functions as a utility for her patrons.

While these roles are rather distinct at any given time, competition among the dancers, as well as the arrival of new girls, makes for continual readjustment among them. The taxi-dancer who formerly was the belle of the dance hall is forced either to work harder for her laurels or to engage in less desirable practices, i.e., accept a new and lower role for herself.

'Moving on': seeing the United States via taxi-dancing

When life and activities in the taxi-dance halls of a certain city begin to pall, the taxi-dancer may travel to another city where she can secure similar employment. She will find in almost every large city taxi-dance halls, all essentially alike. Once adjusted to the life, she can easily make her way in any taxi-dance hall. Another stimulus toward movement from city to city is her constant association with people who are in the habit of moving about frequently. She catches the spirit and also wants to 'see the country.' Among veteran taxi-dancers it is not uncommon to find girls who have been to both the Pacific and the Atlantic coasts, making their way about the country through their earnings in the taxi-dance halls. Such a story as the following is not at all uncommon.

> I've been all over the country because of these halls. My home's Chicago, but I've been in New York, New Orleans, Kansas City, Seattle, and Los Angeles. . . .
> Everywhere I went, though, I'd meet somebody I'd known somewhere else. In New York I saw some Flips [Filipinos] I used to know here in Chicago. When I was in Los Angeles I met a girl that used to be out on the West Side. The other night I met a Flip here I used to know out in Seattle. It's a small world, after all.

At present there is a tendency for taxi-dancers of the Middle West to migrate eastward toward New York. . . .

The future of this new type of feminine migration is uncertain. These young taxi-dancers, with their good incomes and the relative ease with which they can quickly secure employment in taxi-dance halls in other cities, have become a mobile group of a new variety. They have gained a freedom of movement and a ready source for a legitimate income beyond the conception of any previous generation of girls.

Milton M. Gordon

THE CONCEPT OF THE SUB-CULTURE AND ITS APPLICATION [1947]

ONE OF THE FUNCTIONS of any science, 'natural' or 'social,' is admittedly to discover and isolate increasingly smaller units of its subject matter. This process leads to more extensive control of variables in experiment and analysis. There are times, however, when the scientist must put some of these blocks back together again in an integrated pattern. This is especially true where the patterning reveals itself as a logical necessity, with intrinsic connections which create something more, so to speak, than the mere sum of the parts. Specifically, in the social sciences, this patterning is necessary where the impact of the nexus on the human being is that of a unit, and not a series of disconnected social situations. This chapter represents an attempt to delineate such a nexus by a logical extension of the concept of culture.

American sociologists, on the whole, have seemed reluctant to extend the concept of culture beyond the point where is has already been developed and more or less handed to us by the anthropologists. We hear an occasional reference to 'urban culture,' or 'rural culture,' or 'the culture of the middle class,' but these references have seemed to represent sporadic resting-places of semantic convenience rather than any systematic application of the term to well-defined social situations. Broadly speaking, we have been content to stop the concept of culture at national boundaries, and engage in our intra-national analyses in terms of the discrete units of ethnic background, social class, regional residence, religious affiliation, and so on. It is the thesis of this [chapter] that a great deal could be gained by a more extensive use of the concept of the *sub-culture* — a concept used here to refer to a

sub-division of a national culture, composed of a combination of factorable social situations such as class status, ethnic background, regional and rural or urban residence, and religious affiliation, but *forming in their combination a functioning unity which has an integrated impact on the participating individual.* No claim is made here for origination of the term. Although its use has apparently not been extensive enough to merit it a place in the *Dictionary of Sociology*[1] . . . a recent and perceptive use of the term has been made in a paper by Green, where he speaks incidentally of 'highly organized subcultures,' and, in connection with the question of neuroses, phrases a query in the following manner: 'Since in modern society no individual participates in the total cultural complex totally but primarily in a series of population segments grouped according to sex, age, class, occupation, region, religion, and ethnic group – all with somewhat differing norms and expectations of conduct – how do these combine in different ways to form varying backgrounds for individual etiologies of neurotic trends?' [Green 1946: 354]

Green, by implication, uses the term 'sub-culture' and 'population segment' interchangeably. Nomenclature is relative unimportant so long as it is consistent, but we prefer the former term since it seems to emphasize more directly the dynamic character of the framework within which the child is socialized. It is a world within a world, so to speak, but *is* a world. The emphasis in this [chapter], then, is simply on the unifying and transmuting implications of the term 'sub-culture' for such combinations of factors as ethnic group, social class, region, occupation, religion, and urban or rural residence, and on the need for its wider application.

A primary and major implication of this position is that the child growing up in a particular sub-culture feels its impact as a unit. For instance, the son of lower-class Italian immigrants, growing up in New York's upper East Side, is not a person who is simultaneously affected by separable items consisting of ethnic background, low-economic status, and a highly urbanized residential situation. He is a person whose environmental background is an interwoven and variegated combination of all these factors. Each of the elements has been somewhat transformed by virtue of its combination with the others. This fact must be taken into consideration in research procedures dealing with environmental backgrounds and their effects. A corollary of this position is that identically named factors in different sub-cultures are not interchangeable. Thus being a middle-class Jew is not the same thing as being a middle-class Gentile except for the additional factor of being Jewish.

A wider use of the concept of the *sub-culture* would, in the opinion of this writer, give us a keen and incisive tool which would, on the one hand, prevent us from making too broad groupings where such inclusiveness is not warranted (we would, for instance, refer not so much to 'the Negro,' as to 'Southern, rural, lower-class Negroes,' or 'North, urban, middle-class Negroes,' etc.), and, on the other hand, enable us to discern relatively closed and cohesive systems of social organization which currently we tend to analyze separately with our more conventional tools of 'class' and 'ethnic group.'

The writer, for instance, has been interested to observe in the city of Phila-delphia a not entirely cohesive, but unmistakably present, sub-culture composed of members of the Society of Friends (Quakers), and ranging in class position from upper-middle to upper-upper. More conventional objects of sociological attention, second and third generation Jews, would seem, for the most part, to be neither 'marginal men' in the Park and Stonequist phrase, nor competitors in the social class system with white Gentiles, but rather members of highly integrated 'marginal sub-cultures' (called marginal here because, like the 'marginal man,' these sub-cultures composed of the descen-dants of immigrant Jews lie somewhere between the immigrant culture and the native Gentile culture and contain cultural contributions from both) whose variable elements are size of community, of residence and social class.

A distinction must, of course, be made between separate sub-cultures and separate units of the same sub-culture. Thus lower-class white Protestants in one medium-sized New England city would presumably belong to the same sub-culture as lower-class white Protestants in another medium-sized New England community hundreds of miles away, though each group would constitute a separate unit. Whether lower-class white Protestants in a medium-sized community in the Middle-West would form a different sub-culture is a more difficult point. The question of whether variation of one factor is sufficient to set up a separate sub-culture would have to be answered empirically by a field study of the community situations in question.

A comprehensive application of the sub-cultural concept to the American scene would, in time, lead to the delineation of a fairly large number of sub-cultures of varying degrees of cohesiveness and with varying patterns of interaction with each other. Among the many further research problems which such an analysis would pose, six of particular interest to the writer are mentioned here:

1 How do the various sub-cultures rank on a scale of differential access to the rewards of the broader American culture, including both material rewards and status?

2 How is the experience of growing up in a particular sub-culture reflected in the personality structure of the individual? Is there a portion of the personality which is roughly equivalent to a similar portion of the personality of every other individual who has matured in the same sub-culture, and which might, then, be referred to as the 'sub-cultural personality'? . . .

3 In what way are identical elements of the national culture refracted dif-ferentially in the sub-culture? We have been prone, perhaps, to assume uniformities which do not entirely exist. Football, to male adolescents of one sub-culture may mean the chance to hawk programs and peanuts and make some money, to those of another, enthusiastic attendance at the High School game on Saturday afternoon, and to those of still a third, inviting girls up to the campus for a houseparty week-end.

4　What are the most indicative indices of participation in a particular sub-culture? If any one had to be singled out, the writer would offer speech patterns (particularly pronunciation and inflection) as at once the easiest to 'observe' and the most revealing. Clothes would probably rank next in indicativeness and ease of discernability – contrary to casual opinion, for men as well as women.

5　What explains the 'deviant,' that is, the person who does not develop the sub-cultural or social personality characteristic of the particular sub-culture in which he was born and nurtured? An interesting question here is whether there are particular combinations of biological charac-teristics which would adjust more or less easily to the sub-cultural personalities specifically demanded. What about the above-average in intelligence and sensitive boy, for instance, born into a sub-culture of low-status and rather rough behavior patterns? or, conversely, the son of professional parents who cannot make the grade at college but would much rather be out tinkering with the motor of his automobile?

6　In upward social mobility, does a change of 'sub-cultural personality' invariable accompany acquisition of some of the more objective indices of higher status, such as wealth or more highly valued occupation? If not, what stresses and strains result? This last question . . . is a most interesting one, and, in the growing literature on social mobility, [it] has barely been touched.

Note

1　Henry Pratt Fairchild, ed., *Dictionary of Sociology*, New York, 1944; the nearest concept in the *Dictionary* is that of the 'culture-sub-area,' which is defined as 'a sub-division of a larger culture area, distinguished by the comparative completeness of the development of a particular culture trait, or the comparative readiness with which such a trait will be diffused' (p. 83). The emphasis here is obviously on *area* – physical contiguity, which factor may, or may not, or may only partially be present in the *sub-culture*. Thus groups of lower-class white Protestants may live in different sections of the same city. Or middle-class Jews may be scattered over a medium-sized city and still form a [society entity.] . . .

Albert K. Cohen

A GENERAL THEORY OF SUBCULTURES
[1955]

Action is problem-solving

THIS IS A CHAPTER ON SUBCULTURES IN GENERAL, how they get started and what keeps them going. . . . Our point of departure is the 'psychogenic' assumption that all human action – not delinquency alone – is an ongoing series of efforts to solve problems. By 'problems' we do not only mean the worries and dilemmas that bring people to the psychiatrist and the psychological clinic. Whether or not to accept a proffered drink, which of two ties to buy, what to do about the unexpected guest or the 'F' in algebra are problems too. They all involve, until they are resolved, a certain tension, a disequilibrium and a challenge. We hover between doing and not doing, doing this or doing that, doing it one way or doing it another. Each choice is an act, each act is a choice. Not every act is a *successful* solution, for our choice may leave us with unresolved tensions or generate new and unanticipated consequences which pose new problems, but it is at least an attempt at a solution. On the other hand, not every problem need imply distress, anxiety, bedevilment. Most problems are familiar and recurrent and we have at hand for them ready solutions, habitual modes of action which we have found efficacious and acceptable both to ourselves and to our neighbors. Other problems, however, are not so readily resolved. They persist, they nag, and they press for novel solutions.

What people do depends upon the problems they contend with. If we want to explain what people do, then we want to be clear about the nature of human problems and what produces them. As a first step, it is important to recognize that all multifarious factors and circumstances that conspire to

produce a problem come from one or the other of two sources, the actor's 'frame of reference' and the 'situation' he confronts. All problems arise and all problems are solved through changes in one or both of these classes of determinants.

First, the situation. This is the world we live in and where we are located in that world. It includes the physical setting within which we must operate, a finite supply of time and energy with which to accomplish our ends, and above all the habits, the expectations, the demands and the social organization of the people around us. Always our problems are what they are because the situation limits the things we can do and have and the conditions under which they are possible. It will not permit us to satisfy equally potent aspirations, e.g., to enjoy the blessings of marriage and bachelorhood at the same time. The resources it offers may not be enough to 'go around,' e.g., to send the children to college, to pay off the mortgage and to satisfy a thousand other longings. To some of us it may categorically deny the possibility of success, as we define success. To others, it may extend the possibility of success, but the only means which it provides may be morally repugnant; e.g., cheating, chicanery and bootlicking may be the only road open to the coveted promotion.

But the niggardliness, the crabbiness, the inflexibility of the situation and the problems they imply are always relative to the actor. What the actor sees and how he feels about what he sees depend as much on his 'point of view' as on the situation which he encounters. Americans do not see grasshoppers as belonging to the same category as pork chops, orange juice and cereal; other peoples do. Different Americans, confronting a 'communist' . . . have very different ideas of what kind of person they are dealing with. The political office which one man sees as a job, another sees as an opportunity for public service and still another as something onerous and profitless to be avoided at all costs. Our beliefs about what is, what is possible and what consequences flow from what actions do not necessarily correspond to what is 'objectively' true. 'The facts' never simply stare us in the face. We see them always through a glass, and the glass consists of the interests, preconceptions, stereotypes and values we bring to the situation. This glass is our frame of reference. . . .

Our really hard problems are those for which we have no ready-at-hand solutions which will not leave us without feelings of tension, frustration, resentment, guilt, bitterness, anxiety or hopelessness. These feelings and therefore the inadequacy of the solutions are largely the result of the frame of reference through which we contemplate these solutions. It follows that an effective, really satisfying solution *must entail some change in that frame of reference itself*. The actor may give up pursuit of some goal which seems unattainable, but it is not a 'solution' unless he can first persuade himself that the goal is, after all, not worth pursuing; in short, his values must change. He may resolve a problem of conflicting loyalties by persuading himself that the greater obligation attaches to one rather than to the other, but this too

involves a change in his frame of reference: a commitment to some standard for adjudicating the claims of different loyalties. 'Failure' can be transformed into something less humiliating by imputing to others fraud, malevolence or corruption, but this means adopting new perspectives for looking at others and oneself. He may continue to strive for goals hitherto unattainable by adopting more efficacious but 'illicit' means; but, again, the solution is satisfying only to the degree that guilt is obviated by a change in moral standards. All these and other devices are familiar to us as the psychologist's and the psychoanalyst's 'mechanisms of adjustment' – projection, rationalization, substitution, etc. – and they are all ways of coping with problems by a change within the actor's frame of reference.

A second factor we must recognize in building up a theory of subcultures is that human problems are not distributed in a random way among the roles that make up a social system. Each age, sex, racial and ethnic category, each occupation, economic stratum and social class consists of people who have been equipped by their society with frames of reference and confronted by their society with situations which are not equally characteristic of other roles. If the ingredients of which problems are compounded are likened to a deck of cards, your chances and mine of getting a certain hand are not the same but are strongly affected by where we happen to sit. The problems and preoccupations of men and women are different because they judge themselves and others judge them by different standards and because the means available to them for realizing their aspirations are different. It is obvious that opportunities for the achievement of power and prestige are not the same for people who start out at different positions in the class system; it is perhaps a bit less obvious that their levels of aspiration in these respects and therefore what it will take to satisfy them are likely also to differ. All of us must come to terms with the problems of growing old, but these problems are not the same for all of us. To consider but one facet, the decline of physical vigor may have very different meaning for a steel worker and a physician. There is a large and increasing scholarly literature, psychiatric and sociological, on the ways in which the structure of society generates, at each position within the system, characteristic combinations of personality and situation and therefore characteristic problems of adjustment.

Neither sociologists nor psychiatrists, however, have been sufficiently diligent in exploring the role of the social structure and the immediate social milieu in determining *the creation and selection of solutions*. A way of acting is never completely explained by describing, however convincingly, the problems of adjustment to which it is a response, *as long as there are conceivable alternative responses*. Different individuals *do* deal differently with the same or similar problems and these differences must likewise be accounted for. One man responds to a barrier on the route to his goal by redoubling his efforts. Another seeks for a more devious route to the same objective. Another succeeds in convincing himself that the game is not worth the candle. Still another accepts, but with ill grace and an abiding feeling of bitterness and

frustration, the inevitability of failure. Here we shall explore some of the ways in which the fact that we are participants in a system of social inter-action affects the ways in which we deal with our problems.

Pressures towards conformity

In a general way it is obvious that any solution that runs counter to the strong interests or moral sentiments of those around us invites punishment or the forfeiture of satisfactions which may be more distressing than the problem with which it was designed to cope. We seek, if possible, solutions which will settle old problems and not create new ones. A first requirement, then, of a wholly acceptable solution is that it be acceptable to those on whose cooperation and good will we are dependent. This immediately imposes sharp limits on the range of creativity and innovation. Our dependence upon our social milieu provides us with a strong incentive to select our solutions from among those already established and known to be congenial to our fellows.

More specifically, the consistency of our own conduct and of the frame of reference on which it is based with those of our fellows is a criterion of status and a badge of membership. Every one of us wants to be a member in good standing of some groups and roles. We all want to be recognized and respected as a full-fledged member of some age and sex category, as an American, perhaps also as a Catholic, a Democrat, a Southerner, a Yale man, a doctor, a man-of-the world, a good citizen of West Burlap. For every such role there are certain kinds of action and belief which function, as truly and effectively as do uniforms, insignia and membership cards, as signs of member-ship. To the degree that we covet such membership, we are motivated to assume those signs, to incorporate them into our behavior and frame of refer-ence. Many of our religious beliefs, aesthetic standards, norms of speech, political doctrines, and canons of taste and etiquette are so motivated.

Not only recognition as members of some social category but also the respect in which others hold us are contingent upon the agreement of the beliefs we profess and the norms we observe with their norms and beliefs. However much we may speak of tolerance of diversity and respect for differ-ences, we cannot help but evaluate others in terms of the measure of their agreement with ourselves. With people who think and feel as we do we are relaxed. We do not have to defend ourselves to them. We welcome them to our company and like to have them around. But in dissent there is neces-sarily implied criticism, and he who dissents, in matters the group considers important, inevitably alienates himself to some extent from the group and from satisfying social relationships.

Not only is consensus rewarded by acceptance, recognition and respect; it is probably the most important criterion of the *validity* of the frame of reference which motivates and justifies our conduct. The man who stands

alone in holding something dear or in despising some good that others cherish, whether it be a style of art, a political belief, a vocational aspiration, or a way of making money not only suffers a loss of status; he is not likely to hold to his beliefs with much conviction. His beliefs will be uncertain, vacillating, unstable. If others do not question us, on the other hand, we are not likely to question ourselves. For any given individual, of course, some groups are more effective than others as authorities for defining the validity or plausibility of his beliefs. These are his 'reference groups.' For all of us, however, faith and reason alike are curiously prone to lead to conclusions already current in our reference groups. It is hard to convince ourselves that in cheating, joining the Christian Science Church, voting Republican or falsifying our age to buy beer we are doing the right thing if our reference groups are agreed that these things are wrong, stupid or ridiculous.

We see then why, both on the levels of overt action and of the supporting frame of reference, there are powerful incentives not to deviate from the ways established in our groups. Should our problems be not capable of solution in ways acceptable to our groups and should they be sufficiently pressing, we are not so likely to strike out on our own as we are to shop around for a group with a different subculture, with a frame of reference we find more congenial. One fascinating aspect of the social process is the continual realignment of groups, the migration of individuals from one group to another in the unconscious quest for a social milieu favorable to the resolution of their problems of adjustment.

How subcultural solutions arise

Now we confront a dilemma and a paradox. We have seen how difficult it is for the individual to cut loose from the culture models in his milieu, how his dependence upon his fellows compels him to seek conformity and to avoid innovation. But these models and precedents which we call the surrounding culture are ways in which other people think and other people act, and these other people are likewise constrained by models in *their* milieux. *These models themselves, however, continually change.* How is it possible for cultural innovations to emerge while each of the participants in the culture is so powerfully motivated to conform to what is already established? . . .

The crucial condition for the emergence of new cultural forms is the existence, *in effective interaction with one another, of a number of actors with similar problems of adjustment*. These may be the entire membership of a group or only certain members, similarly circumstanced, within the group. Among the conceivable solutions to their problems may be one which is not yet embodied in action and which does not therefore exist as a cultural model. This solution, except for the fact that it does not already carry the social criteria of validity and promise the social rewards of consensus, might well answer more neatly to the problems of this group and appeal to its members

more effectively than any of the solutions already institutionalized. For each participant, this solution would be adjustive and adequately motivated provided that he could anticipate a simultaneous and corresponding transformation in the frames of reference of his fellows. Each would welcome a sign from the others that a new departure in this direction would receive approval and support. But how does one *know* whether a gesture toward innovation will strike a responsive and sympathetic chord in others or whether it will elicit hostility, ridicule and punishment? *Potential* concurrence is always problematical and innovation or the impulse to innovate a stimulus for anxiety.

The paradox is resolved when the innovation is broached in such a manner as to elicit from others reactions suggesting their receptivity; and when, at the same time, the innovation occurs by increments so small, tentative and ambiguous as to permit the actor to retreat, if the signs be unfavorable, without having become identified with an unpopular position. Perhaps all social actions have, in addition to their instrumental, communicative and expressive functions, this quality of being *exploratory gestures*. For the actor with problems of adjustment which cannot be resolved within the frame of reference of the established culture, each response of the other to what the actor says and does is a clue to the directions in which change may proceed further in a way congenial to the other and to the direction in which change will lack social support. And if the probing gesture is motivated by tensions common to other participants it is likely to initiate a process of *mutual* exploration and *joint* elaboration of a new solution. My exploratory gesture functions as a cue to you; your exploratory gesture as a cue to me. By a casual, semi-serious, non-committal or tangential remark I may stick my neck out just a little way, but I will quickly withdraw it unless you, by some sign of affirmation, stick *yours* out. I will permit myself to become progressively committed but only as others, by some visible sign, become likewise committed. The final product, to which we are jointly committed, is likely to be a compromise formation of all the participants to what we may call a cultural process, a formation perhaps unanticipated by any of them. Each actor may contribute something directly to the growing product, but he may also contribute indirectly by encouraging others to advance, inducing them to retreat, and suggesting new avenues to be explored. The product cannot be ascribed to any one of the participants; it is a real 'emergent' on a group level.

We may think of this process as one of mutual conversion. The important thing to remember is that we do not first convert ourselves and then others. The acceptability of an idea to oneself depends upon its acceptability to others. Converting the other is part of the process of converting oneself.

A simple but dramatic illustration may help. We all know that soldiers sometimes develop physical complaints with no underlying organic pathology. We know that these complaints, which the soldier himself is convinced are real, are solutions to problems. They enable the soldier to escape from

a hazardous situation without feeling guilty or to displace his anxiety, whose true cause he is reluctant to acknowledge even to himself [see Strecker 1940]. . . . This route [of] escape [is] available only because hundreds of other soldiers [are] 'in the same boat' and in continual communicative interaction before, during and after the shelling. One soldier might be ripe for this delusion but if his buddies are not similarly ripe he will have a hard time persuading them he has been gassed, and if they persist in not being gassed he will have a hard time persuading himself. If all are ripe, they may, in a relatively short time, collectively fabricate a false but unshakeable belief that all have been gassed. It is most unlikely that these 500 soldiers would have been able to 'describe all the details with convincing earnestness and generally some dramatic quality of expression' if they had not been able to communicate with one another and develop a common vocabulary for interpreting whatever subjective states they did experience.

The literature on crowd behavior is another source of evidence of the ability of a propitious interaction situation to generate, in a short time, collective although necessarily ephemeral and unstable solutions to like problems. Students are agreed that the groundwork for violent and destructive mob behavior includes the prior existence of unresolved tensions and a period of 'milling' during which a set of common sentiments is elaborated and reinforced. It is incorrect to assume, however, that a certain magic in numbers simply serves to lift the moral inhibitions to the expression of already established destructive urges. Kimball Young observes:

> Almost all commentators have noted that individuals engaged in mass action, be it attack or panic flight, show an amazing lack of what are, under calmer conditions, considered proper morals. There is a release of moral inhibitions, social taboos are off, and the crowd enjoys a sense of freedom and unrestraint.

He goes on to add, however:

> Certainly those engaged in a pogrom, a lynching or a race riot have a great upsurge of moral feelings, the sense of righting some wrong . . . Though the acts performed may be viewed in retrospect as immoral, and may later induce a sense of shame, remorse and guilt, at the time they seem completely justified.
>
> [Young 1946: 398–399]

It is true that ordinary moral restraints often cease to operate under mob conditions. These conditions do not, however, produce a suspension of all morality, a blind and amoral outburst of primitive passions. The action of each member of the mob is in accordance with a collective solution which has been worked out during the brief history of the mob itself. This solution includes not only something to do but a positive morality to justify conduct at such gross variance with the mob members' ordinary conceptions

of decency and humanity. In short, what occurs under conditions of mob interaction is not the annihilation of morality but a rapid transformation of the moral frame of reference.

Here we have talked about bizarre and short-lived examples of group problem-solving. But the line between this sort of thing and large-scale social movements, with their elaborate and often respectable ideologies and programs, is tenuous. No fundamentally new principles have to be invoked to explain them. . . .

The emergence of these 'group standards' of this shared frame of reference, is the emergence of a new subculture. It is cultural because each actor's participation in this system or norms is influenced by his perception of the same norms in other actors. It is *sub*cultural because the norms are shared only among those actors who stand somehow to profit from them and who find in one another a sympathetic moral climate within which these norms may come to fruition and persist. In this fashion culture is continually being created, re-created and modified wherever individuals sense in one another like needs, generated by like circumstances, not shared generally in the larger social system. Once established, such a subcultural system may persist, but not by sheer inertia. It may achieve a life which outlasts that of the individuals who participated in its creation, but only so long as it continues to serve the needs of those who succeed its creators.

Subcultural solutions to status problems

One variant of this cultural process interests us especially because it provides the model for our explanation of the delinquent subculture. Status problems are problems of achieving respect in the eyes of one's fellows. Our ability to achieve status depends upon the criteria of status applied by our fellows, that is, the standards or norms they go by in evaluating people. These criteria are an aspect of their cultural frames of reference. If we lack the characteristics or capacities which give status in terms of these criteria, we are beset by one of the most typical and yet distressing of human problems of adjustment. One solution is for individuals who share such problems to gravitate towards one another and jointly to establish new norms, new criteria of status which define as meritorious the characteristics they *do* possess, the kinds of conduct of which they *are* capable. It is clearly necessary for each participant, if the innovation is to solve his status problem, that these new criteria be shared with others, that the solution be a group and not a private solution. If he 'goes it alone' he succeeds only in further estranging himself from his fellows. Such new status criteria would represent new subcultural values different from or even antithetical to those of the larger social system.

In general conformity with this pattern, social scientists have accounted for religious cults and sects such as the Oxford Group and Father Divine's Kingdom as attempts on the part of people who feel their status and self-

respect threatened to create little societies whose criteria of personal good-ness are such that those who participate can find surcease from certain kinds of status anxiety. They have explained such social movements as the Nazi Party as coalitions of groups whose status is unsatisfactory or precarious within the framework of the existing order and who find, in the ideology of the movement, reassurance of their importance and worth or the promise of a new society in which their importance and worth will be recognized. They have explained messianic and revivalistic religious movements among some American Indian and other non-literate groups as collective reactions to status problems which arise during the process of assimilation into a culture and social system dominated by white people. In this new social system native [Americans] find themselves relegated to the lowest social strata. They respond by drawing closer to one another and elaborating ideologies which emphasize the glories of the tribal past, the merit of member-ship in the tribe and an early millennium in which the ancient glory and dignity of the tribe will be reestablished. All these movements may seem to have little in common with a gang of kids bent on theft and vandalism. It is true that they have little in common on the level of the concrete content of ideologies and value systems. . . [H]owever, . . . the general principles of explanation which we have outlined here are applicable also to the culture of the delinquent gang.

Some accompaniments of the cultural process

The continued serviceability and therefore the viability of a subcultural solu-tion entails the emergence of a certain amount of group solidarity and heightened interaction among the participants in the subculture. It is only in interaction with those who share his values that the actor finds social vali-dation for his beliefs and social rewards for his way of life, and the continued existence of the group and friendly intercourse with its members becomes values for [the] actor. Furthermore, to the extent that the new subculture invites the hostility of outsiders – one of the costs of subcultural solutions – the members of the subcultural group are motivated to look to one another for those goods and services, those relationships of cooperation and exchange which they once enjoyed with the world outside the group and which have now been withdrawn. This accentuates still further the separateness of the group, the dependence of the members on the group and the richness and individuality of its subculture. No group, of course, can live entirely unto itself. To some extend the group may be compelled to improvise new arrange-ments for obtaining services from the outside world. 'The fix,' for example, arises to provide for the underworld that protection which is afforded to legitimate business by the formal legal system and insurance companies.

Insofar as the new subculture represents a new status system by sanctioning behavior tabooed or frowned upon by the larger society, the

acquisition of status within the new group is accompanied by a loss of status outside the group. To the extent that the esteem of outsiders is a value to the members of the group, a new problem is engendered. To this problem the typical solution is to devalue the good will and respect of those whose good will and respect are forfeit anyway. The new subculture of the community of innovators comes to include hostile and contemptuous images of those groups whose enmity they have earned. Indeed, this repudiation of outsiders, necessary in order to protect oneself from feeling concerned about what they may think, may go so far as to make nonconformity with the expectations of the outsiders a positive criterion of status within the group. Certain kinds of conduct, that is, become reputable precisely because they are disreputable in the eyes of the 'out-group.'

One curious but not uncommon accompaniment of this process is what Fritz Redl has called 'protective provocation.' Certain kinds of behavior to which we are strongly inclined may encounter strong resistances because this behavior would do injury to the interests or feelings of people we care about. These same kinds of behavior would, however, be unequivocally motivated without complicating guilt feelings if those people stood to us in the relation of enemies rather than friends. In such a situation we may be unconsciously motivated to act precisely in those ways calculated to stimulate others to expressions of anger and hostility, which we may then seize upon as evidences of their essential enmity and ill will. We are then absolved of our moral obligations towards those persons and freer to act without ambivalence. The hostility of the 'out-group,' thus engendered or aggravated, may serve to protect the 'in-group' from mixed feelings about its way of life.

Conclusion

. . . It is to be emphasized that the existence of problems of adjustment, even of like problems of adjustment among a plurality of actors, is not sufficient to insure the emergence of a subcultural solution. The existence of the necessary conditions for effective social interaction prerequisite to such a solution cannot be taken for granted. Who associates with whom is partly a matter of 'shopping around' and finding kindred souls. But circumstances may limit this process of mutual gravitation of people with like problems and free and spontaneous communication among them. People with like problems may be so separated by barriers of physical space or social convention that the probability of mutual exploration and discovery is small. Free choice of associates may be regulated by persons in power, as parents may regulate the associates of their children. Where status differences among people with like problems are great, the probability of spontaneous communication relating to private, intimate, emotionally involved matters is small. Where the problems themselves are of a peculiarly delicate, guilt-laden nature, like

many problems arising in the area of sex, inhibitions on communication may be so powerful that persons with like problems may never reveal themselves to one another, although circumstances are otherwise favorable for mutual exploration. Or the problems themselves may be so infrequent and atypical that the probability of running into someone else whose interests would be served by a common solution is negligible.

Because of all these restraints and barriers to communication, as well as the costs of participation in subcultural groups, which may sometimes be counted excessive, subcultural solutions may not emerge, or particular individuals may not participate in them. Nonetheless, the problems of adjustment may be sufficiently intense and persistent that they still press for some kind of change that will mitigate or resolve the problem. Since group solutions are precluded, the problem-solving may well take a 'private,' 'personal-social' or 'neurotic' direction and be capable of satisfactory description in primarily psycho[logical] terms.

A complete theory of subcultural differentiation would state more precisely the conditions under which subcultures emerge and fail to emerge, and would state operations for predicting the content of subcultural solutions. Such a task is beyond the scope of this chapter, and, in any case, the completion of this theory must await a great deal more of hard thinking and research. In this chapter we have tried to put on record, in a highly general and schematic way, the basic theoretical assumptions [of our model of subcultures].

Howard Becker

THE CULTURE OF A DEVIANT GROUP
The 'jazz' musician[1] [1963]

ALTHOUGH DEVIANT BEHAVIOR is often proscribed by law – labeled criminal if engaged in by adults or delinquent if engaged in by youths – this need not be the case. Dance musicians . . . are a case in point. Though their activities are formally within the law, their culture and way of life are sufficiently bizarre and unconventional for them to be labeled as outsiders by more conventional members of the community.

Many deviant groups, among them dance musicians, are stable and long-lasting. Like all stable groups, they develop a distinctive way of life. To understand the behavior of someone who is a member of such a group it is necessary to understand that way of life.

Robert Redfield expressed the anthropologist's view of culture this way:

> In speaking of 'culture' we have reference to the conventional under-standings, manifest in act and artifact, that characterize societies. The 'understandings' are the meanings attached to acts and objects. The meanings are conventional, and therefore cultural in so far as they have become typical for the members of that society by reason of inter-communication among the members. A culture is, then, an abstraction: it is the type toward which the meanings that the same act or object has for the different members of the society tend to conform. The meanings are expressed in action and in the results of action, from which we infer them; so we may as well identify 'culture' with the extent to which the conventionalized behavior of members of the society is for all the same.
>
> [Redfield 1941: 132]

Hughes has noted that the anthropological view of culture seems best suited to the homogeneous society, the primitive society on which the anthropologist works. But the term, in the sense of an organization of common understandings held by a group, is equally applicable to the smaller groups that make up a complex modern society. Ethnic groups, religious groups, regional groups, occupational groups – each of these can be shown to have certain kinds of common understandings and thus a culture.

> Wherever some group of people have a bit of common life with a modicum of isolation from other people, a common corner in society, common problems and perhaps a couple of common enemies, there culture grows. It may be the fantastic culture of the unfortunates who, having become addicted to the use of heroin, share a forbidden pleasure, a tragedy and a battle against the conventional world. . . . It may be the culture of a group of students who, ambitious to become physicians, find themselves faced with the same cadavers, quizzes, puzzling patients, instructors and deans.
>
> [Hughes 1961: 28–9]

Many people have suggested that culture arises essentially in response to a problem faced in common by a group of people, insofar as they are able to interact and communicate with one another effectively [see Cohen 1955, Cloward and Ohlin 1960, Becker *et al.* 1961]. People who engage in activities regarded as deviant typically have the problem that their view of what they do is not shared by other members of the society. The homosexual feels his kind of sex life is proper, but others do not. The thief feels it is appropriate for him to steal, but no one else does. Where people who engage in deviant activities have the opportunity interact with one another they are likely to develop a culture built around the problems arising out of the differences between their definition of what they do and the definition held by other members of the society. They develop perspectives on themselves and their deviant activities and on their relations with other members of the society. (Some deviant acts, of course, are committed in isolation and the people who commit them have no opportunity to develop a culture. Examples of this might be the compulsive pyromaniac or the kleptomaniac, Cressey 1962). Since these cultures operate within, and in distinction to, the culture of the larger society, they are often called subcultures.

The dance musician, to whose culture or subculture this [chapter] is devoted, may be defined simply as someone who plays popular music for money. He is a member of a service occupation and the culture he participates in gets its character from the problems common to service occupations. The service occupations are, in general, distinguished by the fact that the worker in them comes into more or less direct and personal contact with the ultimate consumer of the product of his work, the client is able to direct or attempt to direct the worker at his task and to apply sanctions of various kinds, ranging from

informal pressure to the withdrawal of his patronage and the conferring of it on some others of the many people who perform the service.

Service occupations bring together a person whose full-time activity is centered around the occupation and whose self is to some degree deeply involved in it, and another person whose relation to it is much more casual. It may be inevitable that the two should have widely varying pictures of the way the occupational service should be performed. Members of service occupations characteristically consider the client unable to judge the proper worth of the service and bitterly resent attempts on his part to exercise control over the work. Conflict and hostility arise as a result, methods of defense against outside interference become a preoccupation of the members, and a subculture grows around this set of problems.

Musicians feel that the only music worth playing is what they call 'jazz,' a term which can be partially defined as that music which is produced without reference to the demands of outsiders. Yet they must endure unceasing interference with their playing by employers and audience. The most distressing problem in the career of the average musician, as we shall see later, is the necessity of choosing between conventional success and his artistic standards. In order to achieve success he finds it necessary to 'go commercial,' that is, to play in accord with the wishes of the non-musicians for whom he works; in doing so he sacrifices the respect of other musicians and thus, in most cases, his self-respect. If he remains true to his standards, he is usually doomed to failure in the larger society. Musicians classify themselves according to the degree to which they give in to outsiders; the continuum ranges from the extreme 'jazz' musician to the 'commercial' musician.

Below I will focus on the following points: (1) the conceptions that musicians have of themselves and of the non-musicians for whom they work and the conflict they feel to be inherent in this relation; (2) the basic consensus underlying the reactions of both commercial and jazz musicians to this conflict; and (3) the feelings of isolation musicians have from the larger society and the way they segregate themselves from audience and community. The problems arising out of the difference between the musician's definition of his work and those of the people he works for may be taken as a prototype of the problems deviants have in dealing with outsiders who take a different view of their deviant activities. [For other studies of the Jazz musician, see Lastrucci 1941, Cameron 1954, Merriam and Mack 1960] . . .

Musician and 'square'

The system of beliefs about what musicians are and what audiences are is summed up in a word used by musicians to refer to outsiders – 'square.' It is used as a noun and as an adjective, denoting both a kind of person and a quality of behavior and objects. The term refers to the kind of person who is the opposite of all the musician is, or should be, and a way of thinking,

feeling, and behaving (with its expression in material objects) which is the opposite of that valued by musicians.

The musician is conceived of as an artist who possesses a mysterious artistic gift setting him apart from all other people. Possessing this gift, he should be free from control by outsiders who lack it. The gift is something which cannot be acquired through education; the outsider, therefore, can never become a member of the group. A trombone player said, 'you can't teach a guy to have a beat. Either he's got one or he hasn't. If he hasn't got it, you can't teach it to him.'

The musician feels that under no circumstances should any outsider be allowed to tell him what to play or how to play it. In fact, the strongest element in the colleague code is the prohibition against criticizing or in any other way trying to put pressure on another musician in the actual playing situation 'on the job.' Where not even a colleague is permitted to influence the work, it is unthinkable that an outsider should be allowed to do so.

The attitude is generalized into a feeling that musicians are different from and better than other kinds of people and accordingly ought not to be subject to the control of outsiders in any branch of life, particularly in their artistic activity. The feeling of being a different kind of person who leads a different kind of life is deep-seated, as the following remarks indicate:

> I'm telling you, musicians are different than other people. They talk different, they act different, they look different. They're just not like other people, that's all. . . . You know it's hard to get out of the music business because you feel so different from others.
>
> Musicians live an exotic life, like in a jungle or something. They start out, they're just ordinary kids from small towns – but once they get into that life they change. It's like a jungle, except that their jungle is a hot, crowded bus. You live that kind of life long enough, you just get to be completely different.
>
> Being a musician was great, I'll never regret it. I'll understand things that squares never will.

An extreme of this view is the belief that only musicians are sensitive and unconventional enough to be able to give real sexual satisfaction to a woman.

Feeling their difference strongly, musicians likewise believe they are under no obligation to imitate the conventional behavior of squares. From the idea that no one can tell a musician how to play it follows logically that no one can tell a musician how to do anything. Accordingly, behavior which flouts conventional social norms is greatly admired. Stories reveal this admiration for highly individual, spontaneous, devil-may-care activities; many of the most noted jazzmen are renowned as 'characters,' and their exploits are widely recounted. For example, one well-known jazzman is noted for having jumped on a policeman's horse standing in front of the night club in which

he worked and ridden it away. The ordinary musician likes to tell stories of unconventional things he has done:

> We played the dance and after the job was over we packed up to get back in this old bus and make it back to Detroit. A little way out of town the car just refused to go. There was plenty of gas; it just wouldn't run. These guys all climbed out and stood around griping. All of a sudden, somebody said, 'Let's set it on fire!' So someone got some gas out of the tanks and sprinkled it around, touching a match to it and whoosh, it just went up in smoke. What an experience! The car burning up and all these guys standing around hollering and clapping their hands. It was really something.

This is more than idiosyncrasy; it is a primary occupational value, as indicated by the following observation of a young musician: 'You know, the biggest heroes in the music business are the biggest characters. The crazier a guy acts, the greater he is, the more everyone likes him.'

As they do not wish to be forced to live in terms of social conventions, so musicians do not attempt to force these conventions on others. For example, a musician declared that ethnic discrimination is wrong, since every person is entitled to act and believe as he wants to:

> Shit, I don't believe in any discrimination like that. People are people, whether they're Dagos or Jews or Irishmen or Polacks or what. Only big squares care what religion they are. It don't mean a fucking thing to me. Every person's entitled to believe his own way, that's the way I feel about it. Of course, I never go to church myself, but I don't hold it against anybody who does. It's all right if you like that sort of thing.

The same musician classified a friend's sex behavior as wrong, yet defended the individual's right to decide what is right and wrong for himself: 'Eddie fucks around too much; he's gonna kill himself or else get killed by some broad. And he's got a nice wife too. He shouldn't treat her like that. But what the fuck, that's his business. If that's the way he wants to live, if he's happy that way, then that's the way he oughta do.' Musicians will tolerate extraordinary behavior in a fellow-musician without making any attempt to punish or restrain him. . . .

The musician thus views himself and his colleagues as people with a special gift which makes them different from non-musicians and not subject to their control, either in musical performance or in ordinary social behavior.

The square, on the other hand, lacks this special gift and any understanding of the music or the way of life of those who possess it. The square is thought of as an ignorant, intolerant person who is to be feared, since he produces the pressures forcing the musician to play inartistically.

The musician's difficulty lies in the fact that the square is in a position to get his way: if he does not like the kind of music played, he does not pay to hear it a second time.

Not understanding music, the square judges music by standards foreign to musicians and not respected by them. . . . The following conversation illustrates the . . . attitude:

> JOE: You'd get off the stand and walk down the aisle, somebody'd say, 'Young man, I like your orchestra very much.' Just because you played soft and the tenorman doubled fiddle or something like that, the squares liked it. . . .
>
> DICK: It was like that when I worked at the M—— Club. All the kids that I went to high school with used to come out and dig the band. . . . That was one of the worst bands I ever worked on and they all thought it was wonderful.
>
> JOE: Oh, well, they're just a bunch of squares anyhow.

'Squareness' is felt to penetrate every aspect of the square's behavior just as its opposite, 'hipness,' is evident in everything the musician does. The square seems to do everything wrong and is laughable and ludicrous. Musicians derive a good deal of amusement from sitting and watching squares. Everyone has stories to tell about the laughable antics of squares. . . . Every item of dress, speech, and behavior which differs from that of the musician is taken as new evidence of the inherent insensitivity and ignorance of the square. Since musicians have an esoteric culture these evidences are many and serve only to fortify their conviction that musicians and squares are two different kinds of people.

But the square is feared as well, since he is thought of as the ultimate source of commercial pressure. It is the square's ignorance of music that compels the musician to play what he considers bad music in order to be successful.

> BECKER: How do you feel about the people you play for, the audience?
>
> DAVE: They're a drag.
>
> BECKER: Why do you say that?
>
> DAVE: Well, if you're working on a commercial band, they like it and so you have to play more corn. If you're working on a good band, then they don't like it, and that's a drag. If you're working on a good band and they like it, then that's a drag, too. You hate them anyway, because you know that they don't know what it's all about. . . .

This last statement reveals that even those who attempt to avoid being square are still considered so, because they still lack the proper understanding, which only a musician can have – 'they don't know what it's all about.' The jazz

fan is thus respected no more than other squares. His liking for jazz is without understanding and he acts just like the other squares; he will request songs and try to influence the musician's playing, just as other squares do.

The musician thus sees himself as a creative artist who should be free from outside control, a person different from and better than those outsiders he calls squares who understand neither his music nor his way of life and yet because of whom he must perform in a manner contrary to his professional ideals.

Reactions to the conflict

Jazz and commercial musicians agree in essentials on their attitude towards the audience, although they vary in the way they phrase this basic consensus. Two conflicting themes constitute the basis of agreement: (1) the desire for free self-expression in accord with the beliefs of the musician group, and (2) the recognition that outside pressures may force the musician to forego satisfying that desire. The jazzman tends to emphasize the first, the commercial musician the second; but both recognize and feel the force of each of these guiding influences. Common to the attitudes of both kinds of musician is an intense contempt for and dislike of the square audience whose fault it is that musicians must 'go commercial' in order to succeed.

The commercial musician, though he conceives of the audience as square, chooses to sacrifice self-respect and the respect of other musicians (the rewards of artistic behavior) for the more substantial rewards of steady work, higher income, and the prestige enjoyed by the man who goes commercial. One commercial musician commented:

> They've got a nice class of people out here, too. Of course, they're squares, I'm not trying to deny that. Sure, they're a bunch of fucking squares, but who the fuck pays the bills? They pay 'em, so you gotta play what they want. I mean, what the shit, you can't make a living if you don't play for the squares. How many fucking people you think aren't squares? Out of a hundred people you'd be lucky if 15 per cent weren't squares. I mean, maybe professional people – doctors, lawyers, like that – they might not be square, but the average person is just a big fucking square. Of course, show people aren't like that. But outside of show people and professional people, everybody's a fucking square. They don't know anything. . . .

The jazzman feels the need to satisfy the audience just as strongly, although maintaining that one should not give in to it. Jazzmen, like others, appreciate steady jobs and good jobs and know they must satisfy the audience to get them, as the following conversation between two young jazzmen illustrates:

CHARLIE: There aren't any jobs where you can blow jazz. You have to play rumbas and pops [popular songs] and everything. You can't get anywhere blowing jazz. Man. I don't want to scuffle all my life.

EDDIE: Well, you want to enjoy yourself, don't you? You won't be happy playing commercial. You know that.

CHARLIE: I guess there's just no way for a cat to be happy. 'Cause it sure is a drag blowing commercial, but it's an awful drag not ever doing anything and playing jazz.

EDDIE: Jesus, why can't you be successful playing jazz? . . . you could have a sexy little bitch to stand up in front and sing and shake her ass at the bears [squares]. Then you could get a job. And you could still play great when she wasn't singing.

CHARLIE: Well, wasn't that what Q——'s band was like? Did you enjoy that? Did you like the way she sang?

EDDIE: No, man, but we played jazz, you know. . . .

Somewhat inconsistently, the musician wants to feel that he is reaching the audience and that they are getting some enjoyment from his work, and this also leads him to give in to audience demands. One man said:

I enjoy playing more when there's someone to play for. You kind of feel like there isn't much purpose in playing if there's nobody there to hear you. I mean, after all, that's what music's for – for people to hear and get enjoyment from. That's why I don't mind playing corny too much. If anyone enjoys it, then I kind of get a kick out of it. I guess I'm kind of a ham. But I like to make people happy that way.

This statement is somewhat extreme; but most musicians feel it strongly enough to want to avoid the active dislike of the audience: 'That's why I like to work with Tommy. At least when you get off the stand, everybody in the place doesn't hate you. It's a drag to work under conditions like that, where everybody in the place just hates the whole band.'

Isolation and self-segregation

Musicians are hostile to their audiences, afraid that they must sacrifice their artistic standards to the squares. They exhibit certain patterns of behavior and belief which may be viewed as adjustments to this situation. These patterns of isolation and self-segregation are expressed in the actual playing situation and in participation in the social intercourse of the larger community. The primary function of this behavior is to protect the musician from the interference of the square audience and, by extension, of the conventional society. Its primary consequence is to intensify the musician's status

as an outsider, through the operation of a cycle of increasing deviance. Difficulties with squares lead to increasing isolation which in turn increases the possibility of further difficulties.

As a rule, the musician is spatially isolated from the audience. He works on a platform, which provides a physical barrier that prevents direction inter- action. This isolation is welcomed because . . . [t]he musicians fear that direct contact with the audience can lead only to interference with the musical performance. Therefore, it is safer to be isolated and have nothing to do with them. . . .

Musicians, lacking the usually provided physical barriers, often improvise their own and effectively segregate themselves from their audience.

> I had a Jewish wedding job for Sunday night. . . . We decided, after I had conferred with the groom, to play during dinner. We set up in a far corner of the hall. Jerry pulled the piano around so that it blocked off a small space, which was thus separated from the rest of the people. . . . I wanted to move the piano so that the boys could stand out in front of it and be next to the audience, but Jerry said, half-jokingly, 'No, man. I have to have some protection from the squares.' So we left things as they were. . . .

Many musicians almost reflexively avoid establishing contact with members of the audience. When walking among them, they habitually avoid meeting the eyes of squares for fear this will establish some relationship on the basis of which the square will then request songs or in some other way attempt to influence the musical performance. Some extend the behavior to their ordinary social activity, outside of professional situations. A certain amount of this is inevitable, since the conditions of work – late hours, great geographic mobility, and so on – make social participation outside of the professional group difficult. If one works while others sleep, it is difficult to have ordi- nary social intercourse with them. This was cited by a musician who had left the profession, in partial explanation of his action: 'And it's great to work regular hours, too, where you can see people instead of having to go to work every night.' Some younger musicians complain that the hours of work make it hard for them to establish contracts with 'nice' girls, since they preclude the conventional date.

But much self-segregation develops out of the hostility towards squares. The attitude is seen in its extreme among the 'X—— Avenue Boys,' a clique of extreme jazzmen who reject the American culture *in toto*. The quality of their feeling toward the outside world is indicated by one man's private title for his theme song: 'If You Don't Like My Queer Way You Can Kiss My Fucking Ass.' The ethnic makeup of the group indicated further that their adoption of extreme artistic and social attitudes was part of a total rejection of conventional American society. With few exceptions the men came from older, more fully assimilated national groups: Irish, Scandinavian, German,

63

and English. Further, many of them were reputed to come from wealthy families and the higher social classes. In short, their rejection of commercialism in music and squares in social life was part of the casting aside of the total American culture by men who enjoyed a privileged position, but were unable to achieve a satisfactory personal adjustment within it.

Every interest of this group emphasized their isolation from the standards and interests of conventional society. They associated almost exclusively with other musicians and girls who sang or danced in night clubs . . . and had little or no contact with the conventional world. They were described politically thus: 'They hate this form of government anyway and think it's real bad.' They were unremittingly critical of both business and labor, disillusioned with the economic structure, and cynical about the political process and contemporary political parties. Religion and marriage were rejected completely, as were American popular and serious culture, and their reading was confined solely to the more esoteric *avant garde* writers and philosophers. In art and symphonic music they were interested in only the most esoteric developments. In every case they were quick to point out that their interests were not those of the conventional society and that they were thereby differentiated from it. It is reasonable to assume that the primary function of these interests was to make this differentiation unmistakably clear.

Although isolation and self-segregation found their most extreme development among the 'X—— Avenue Boys,' they were manifested by less deviant musicians as well. The feeling of being isolated from the rest of society was often quite strong; the following conversation, which took place between two young jazzmen, illustrates two reactions to the sense of isolation.

> EDDIE: You know, man, I hate people. I can't stand to be around squares. They drag me so much I just can't stand them.
> CHARLIE: You shouldn't be like that, man. Don't let them drag you. Just laugh at them. That's what I do. Just laugh at everything they do. That's the only way you'll be able to stand it.

A young Jewish musician, who definitely identified himself with the Jewish community, nevertheless felt this professional isolation strongly enough to make the following statements.

> You know, a little knowledge is a dangerous thing. That's what happened to me when I first started playing. I just felt like I knew too much. I sort of saw, or felt, that all my friends from the neighborhood were real square and stupid. . . .
>
> You know, it's funny. When you sit on that stand up there, you feel so different from others. Like I can even understand how Gentiles feel toward Jews. You see these people come up and they look Jewish, or they have a little bit of an accent or something, and they ask for a rumba or some damn thing like that, and I just feel, 'What damn

squares, these Jews,' just like I was a *goy* myself. That's what I mean when I say you learn too much being a musician. I mean, you see so many things and get such a broad outlook on life that the average person just doesn't have. . . .

The process of self-segregation is evident in certain symbolic expressions, particularly in the use of an occupational slang which readily identifies the man who can use it properly as someone who is not square and as quickly reveals as an outsider the person who uses it incorrectly or not at all. Some words have grown up to refer to unique professional problems and attitudes of musicians, typical of them being the term 'square.' Such words enable musicians to discuss problems and activities for which ordinary language provides no adequate terminology. There are, however, many words which are merely substitutes for the more common expressions without adding any new meaning. For example, the following are synonyms for money: 'loot,' 'gold,' 'geetz,' and 'bread.' Jobs are referred to as 'gigs.' There are innumerable synonyms for marijuana, the most common being 'gage,' 'pot,' 'charge,' 'tea,' and 'shit.'

The function of such behavior is pointed out by a young musician who was quitting the business:

> I'm glad I'm getting out of the business, though. I'm getting sick of being around musicians. There's so much ritual and ceremony junk. They have to talk a special language, dress different, and wear a different kind of glasses. And it just doesn't mean a damn thing except 'we're different.'

Note

1 This essay was originally subtitled 'The dance musician'. The musicians in this study did not work as professional jazz musicians but dreamed of doing so as they earned their living playing weddings, bar mitzvahs and dances. This aspiration was a central determinant in the shape of their culture and so is foregrounded, but qualified, by quotation marks. [Eds]

John Irwin

NOTES ON THE STATUS OF THE CONCEPT SUBCULTURE [1970]

T**HE RECENT EMERGENCE** of various folk concepts should entice us to re-examine our notion of subculture. I am speaking of such concepts as 'scene,' 'bag,' and 'thing.' The popular use of these indicates that there have been significant shifts in the phenomenon to which subculture refers. Generally, in sociology, subculture has referred to a subset of patterns recognized by social scientists. The use of the metaphors above indicates that it is presently becoming a subset of patterns that the ordinary man recognizes and responds to. This changes the phenomenon in many essential ways, some of which will be discussed in the following paragraphs.[1]

Before turning to the contemporary phenomenon, let me briefly analyze the cognitive status of subculture in its two major uses. In the first systematic definitional treatment of subculture, Milton Gordon defines subculture as a subset of cultural patterns carried by a population *segment* [see Chapter 5]. He argues that it would be useful to divide the American society by ethnic, economic, regional and religious variables into segments with unique subcultures. The division into cultural units is somewhat arbitrary, however, since the variables applied do not necessarily relate to other subsystems. These are not necessarily subcultures which are attached to particular social structures or are recognized by anyone except the social scientist applying these variables.[2]

In another of its major uses – subculture as a small group or the patterns carried by a small group – the question of the cognitive status of the concept in the minds of its carriers is likewise ignored. In this version, which traces back to the Chicago deviance studies [see Anderson 1923, Thrasher 1927, Shaw 1930, Shaw 1931, Sutherland 1937, Shaw *et al.,* 1938], but which received its major developments in the 1950s (see Cohen 1955, Cloward

and Ohlin 1960, Becker 1963), the problem of whether or not the group which is carrying the subculture or whether a larger group who comes into contact with it recognized the distinct set of patterns is never considered. In fact, in his milestone treatment in *Delinquent Boys*, Cohen seems to assume that the distinct set of patterns does not extend very far. He feels obliged to explain the emergence of each new set of patterns [see Chapter 6].

Subculture as a social world

In an early treatment of concepts related to subculture, Tamatsu Shibutani actually supplied a conception of subculture which is highly adaptable to the contemporary phenomenon. He did not, however, use the label. He suggested that *reference groups* should be viewed as *reference worlds*, or *social worlds* which are not tied to any particular collectivity or territory [Shibutani 1955]. He also pointed out that persons could simultaneously or alternately identify with more than one social world. Though Shibutani did not call social worlds or reference worlds subcultures, this is one of the ways in which subculture has been viewed. Subculture, rather than the subset of behavior patterns of a segment, or the patterns of a small group, is often thought of as a social world, a shared perspective, which is not attached firmly to any definite group or segment. It is this version which we will adopt here to make sense of contemporary subcultural phenomena in the United States. One dimension of social world as a subculture which Shibutani did not make explicit must be emphasized: the social world can be and often is an explicit category in the minds of a broader population than social scientists and the group carrying the subculture.

Subculture as an explicit life style

People today are becoming more aware of the existence of subcultures, variant life styles or social worlds, and are more often structuring their own behavior, making decisions and planning future courses of action according to their conception of these explicitly subcultural entities. Concrete evidence of this emerging trend is the appearance of several folk metaphors which refer to styles of life as things. The most current of these is the 'scene.' This metaphor in its present folk usage – such as, in the phrases: 'make the scene' and 'that's not my scene' – refers mainly to a style of life which is well known among insiders and outsiders to the scene. In the first phrase 'make the scene,' the scene usually has a definite location and is transitory. It is something which is occurring at a particular time and place. In the second phrase, it refers to a more permanent life style. The usages share three connotations: (1) The style of life is recognized as an explicit and shared category. In other words a particular scene is well known among some relatively large segment. It must be to be a scene, since the term connotes popularity.

(2) There are various styles of life available to a particular person, since there is always more than one scene. (3) Finally, one's commitment to a particular scene is potentially tentative and variable.

Two other metaphors which reflect the explicitness of life styles are 'bag' and 'thing.' The phrases 'that's not my bag' and 'do your own thing,' for instance, both reflect that the life styles are being seen as entities.

American subcultural pluralism and relativism

Of course, these metaphors are only used in the daily speech of a small minority. But a larger segment, perhaps a majority, hears them, at least in the mass media, and recognizes their meaning. This is just one indicator that we are generally aware of the 'subcultural' pluralism of the American society. Perhaps twenty years ago most people took American culture for granted and assumed that it was the same for everyone (with a few obvious exceptions, of course, such as Indians, foreigners, and 'deviants').[3] Presently, however, because of the mass media, behavioral scientists' exposés of deviant subcultures, geographical mobility, and higher education, a larger segment of American people have recognized the extent of cultural variation in the country. Accompanying this realization is a shift in one's conception of his own values and beliefs. One may no longer take the 'goodness' or the 'rightness' of his own culture or subculture for granted. In effect, he is beginning to experience *subcultural relativism*.

Subculture as an action system

Increased subcultural pluralism and relativism have effected two important changes in the nature of interaction of the ordinary man. First, one's beliefs, values and cultural meaning have become explicit categories of action. Furthermore, the ordinary man tends to conceive of these categories as a set making up a whole – a life style or cohesive social world. So in a sense persons in interaction are involved in comparing, sharing, negotiating and imparting cultural patterns. While they are doing this they attempt, because of a general human concern for order, to bring the cultural components into a consistent relationship and to maintain boundaries around the system. It may be stated, therefore, that the subculture has become a concrete action system.[4]

Being on

The second manner in which interaction is changing is that persons are more often 'on.' All action categories are becoming more explicit and the person is more often a self conscious *actor*. In an article on the dramaturgic model

Sheldon Messinger and others suggested that life is not like a theater (Messinger 1962). They stated that natural interaction is unselfconscious and the actors did not conceive of themselves as actors in a role. The dramaturgic model is useful, they argue, as an analytical tool, but we must remember that it is seldom a concrete model. They did point out, however, that in some life contexts it approaches concreteness. For instance, the [black man] is 'on' when he is in the company of whites and the mental patient, who is constantly under the surveillance of judges, is 'on' most of the time.

I would like to suggest that with the growing recognition of subcultural pluralism, the increase in subcultural relativism and the emergence of cultural categories as explicit action categories and as a cohesive system, more persons are finding themselves judged by outsiders and finding themselves marginal. They are increasingly 'on.' They more often see themselves as performers in various 'scenes' and are becoming more aware of the dimensions of their various performances. Life is becoming more like a theater.

Summary

In former treatment of the concept subculture the cognitive status of the concept in the minds of the folk was not addressed. This is now highly important because subculture is becoming a conscious category at the folk level. The widespread use of the metaphor 'scene' reflects this trend. American people are becoming aware of the subcultural variation in their society and are experiencing subcultural relativism.

This subcultural pluralism and relativism is having two important effects on everyday interaction. One's values, beliefs, and cultural meanings are no longer taken for granted. More often one is involved in consciously comparing, negotiating and sharing these with others. Furthermore one tends to bring these components into some logically consistent relationship, and therefore, the subculture is becoming an explicit and important action system.

Secondly, action categories in general are becoming more explicit. One is more often conscious of himself as an actor in scenes. Life is becoming more like a theater.

Notes

1 Viewing culture or subculture as explicit categories or as an explicit entity in the minds of the folk sidesteps a particularly troublesome dilemma. This is the problem of circular reasoning in employing culture as an independent variable or explanatory concept. For instance, Edwin Lemert has remarked that 'inescapable circularity lies in the use of culture as a summary to describe modal tendencies in the behavior of human beings and, at the same time, as a term of designating the causes of the modal tendencies.

The empirically more tenable alternative is that only human beings define, regulate, and control behavior of other human beings' (Lemert 1967: 5). But if the folk are making the cultural summary and then defining, regulating and controling behavior of other human beings on the basis of their cultural summary, the concept takes on independence or explanatory weight.

2 In a later treatment of subculture in his book *Assimilation in American Life*, Milton Gordon relates this use of subculture to 'subsociety' which contains 'both sexes, all ages, and family groups, and which parallels the larger society in that it provides for a network of groups and institutions extending throughout the individual's entire life cycle' (1964: 39). I find these subsocieties to be rather vague entities, however. Some communities and some ethnic segments may take on the dimensions of a subsociety, but many segments which he has designated as carriers of subcultures by his variables do not seem to.

3 The belief in the consensus of American values and beliefs was reflected in R. K. Merton's theory of *anomie* introduced in 1938. Merton suggested at that time that Americans generally shared the same 'culturally defined goals, purposes and interests.' (Merton 1938: 673). It is also revealing that in the 1950s and 1960s this assumption in his theory is one which has been most often questioned. For instance, see Lemert 1964: 64–71).

4 In a collective statement as an introduction to *Toward A General Theory of Action*, Talcott Parsons, Edward A. Shils, Gordon W. Allport, Clyde Kluckhohn, Henry A. Murray, Robert R. Sears, Richard C. Sheldon, Samuel A. Stouffer, and Edward C. Tolman write that 'the cultural tradition in its significance both as an *object* of orientation and as an *element* in the orientation of action must be articulated both conceptually and empirically with personalities and social systems. Apart from embodiment in the orientation systems of concrete actors, culture, though existing as a body of artifacts and as systems of symbols, is not in itself organized as a system of action' [Parsons *et al.* 1951: 7].

Jock Young

THE SUBTERRANEAN WORLD OF PLAY
[1971]

IT IS NECESSARY, in order to explain the phenomenon of drugtaking, to relate it to factors existing in the wider society. It is simply not sufficient to state that drug use is a behaviour associated with certain disturbed personalities – to talk as the absolutist does of a monolithic body of 'normal' people contrasted with a few deviants condemned to the fringes of society because of their abnormal psyches or genetic make-ups. For this does not cast any light on why whole categories of people – ghetto blacks, middle-class youth, merchant seamen, Puerto Ricans and doctors for instance – have peculiarly high propensities to take drugs. Rather, one must explain such behaviour in terms of the particular subcultures to which each of these groups belong. The *meaning* of drugtaking has to be sought in the context of the group's values and world view. For an item of behaviour cannot be understood in isolation from its social milieu: man is the only animal that gives meaning to his actions and it is his system of values which provides these meanings.

Furthermore, we must relate subcultures to the total society: for they do not exist in a vacuum, they are a product of or a reaction to social forces existing in the world outside. Drugtaking is almost ubiquitous in our society – the totally temperate individual is statistically the deviant; it is only the type and quantity of psychotropic drugs used which varies. There must be fundamental connections between drugtaking and the configuration of values, ways of life and world views prevalent throughout our society. It is with this in mind that I wish to examine the nature of work and leisure in advanced industrial societies and the position that drugs play in the modern world.

The theory of subterranean values

In 1961 Matza and Sykes evolved a critique of a central part of absolutist theory. First they noted that it was preposterous to assume that everyone within society adhered to middle-class standards of behaviour and attitudes. But this was, by that time, a commonplace criticism of sociological theory. More significantly, they went on to argue that this revised picture of society as being composed of a heterogeneous collection of strata each with different values did not go far enough. If the divisions between social groups were important, so also were the inconsistencies within the values of specific groups themselves. Society was not only split horizontally into strata, it was divided vertically within each group. For there was, they suggested, a fundamental contradiction running through the value systems of all members of society. Coexisting alongside the overt or official values of society are a series of *subterranean* values. One of these, for example, is the search for excitement: for new 'kicks'. Society, they argue, tends to provide institutionalized periods in which these subterranean values are allowed to emerge and take precedence. Thus we have the world of leisure: of holidays, festivals and sport in which subterranean values are expressed rather than the rules of workaday existence. A particularly apposite value is the saturnalia of the ancient world, which involved behaviour the very opposite of that allowed normally. The West Indian carnival is a modern illustration of this. Thus they write: 'the search for adventure, excitement and thrill is the subterranean value that . . . often exists side by side with the values of security, routinization and the rest. It is not a deviant value, in any full sense, but must be held in abeyance until the proper moment and circumstances for its expression arrive' [Matza and Sykes 1961: 716]. The juvenile delinquent then, in this light, is seen as: 'not an alien in the body of society but representing instead a disturbing reflection or caricature'. He takes up the subterranean values of society: hedonism, disdain for work, aggressive and violent notions of masculinity, and accentuates them to the exclusion of the formal or official values. Moreover, he is encouraged in this process by the fictional portrayals in the mass media (for example, Westerns, crime stories, war adventures) of heroes who epitomize precisely these values.

All members of society hold these subterranean values; certain groups, however, accentuate these values and disdain the workaday norms of formal society.

What is the precise nature of the subterranean values? This is perhaps best brought out by constructing a table in which one can contrast subterranean values with the formal, official values of the workaday world [see Table 9.1].

Now the formal values are consistent with the structure of modern industry. They are concomitant with the emergence of large-scale bureaucracies embodying a system of economic rationality, high division of labour, and finely woven, formalized rules of behaviour. These values are functional for the maintenance of diligent, consistent work and the realization of long-term productive goals. They are not, however, identical with the Protestant ethic.

Table 9.1 Formal and subterranean values contrasted

Formal work values	Subterranean values
1. deferred gratification	short-term hedonism
2. planning future action	spontaneity
3. confirmity to bureaucratic rules	ego-expressivity
4. fatalism, high control over detail, little over direction	autonomy, control of behaviour in detail and direction
5. routine, predictability	new experience, excitement
6. instrumental attitudes to work	activities performed as an end-in-themselves
7. hard productive work seen as a virtue	disdain for work

For whilst the latter dictated that a man realized his true nature and position in the world through hard work and painstaking application to duty, the formal values insist that work is merely instrumental. You work hard in order to earn money, which you spend in the pursuit of leisure, and it is in his 'free' time that a man really develops his sense of identity and purpose.

The Protestant ethic has, outside the liberal professions, entered into a remarkable decline. Berger and Luckmann have argued that the growth of bureaucracies in almost every sphere of social life have enmeshed the workaday world in a system of rules which have precluded to a large extent the possibility for the individual to express his identity through his job [Berger and Luckmann 1964: 331]. The high division of labour and rationalization of occupational roles have made them inadequate as vehicles of personal desires and expressivity. Work has come to be regarded instrumentally by nearly all sections of society, middle class as much as working class [Dublin 1962]. Thus Bennett Berger writes: 'whether it is the relatively simple alienation so characteristic of assembly-line work in factories, or the highly sophisticated kind of alienation we find in the folk ways of higher occupations, one thing is clear: the disengagement of self from occupational role not only is more common than it once was but is also increasingly regarded as "*proper*" ' [Berger 1963: 34]. It is during leisure and through the expression of subterranean values that modern man seeks his identity, whether it is in a 'home-centred' family or an adolescent peer group. For leisure is, at least, purportedly non-alienated activity.

It must not be thought, however, that contemporary man's work and leisure form watertight compartments. The factory-belt worker experiencing boredom and alienation does not come home in the evening to a life of undiluted hedonism and expressivity! The world of leisure and of work are

intimately related. The money earned by work is spent in one's leisure time. It is through the various life styles which are evolved that men confirm their occupational status. Leisure is concerned with consumption and work with production; a keynote of our bifurcated society, therefore, is that individuals within it must constantly consume in order to keep pace with the productive capacity of the economy. They must produce in order to consume, and consume in order to produce. The interrelationship between formal and subterranean values is therefore seen in a new light: hedonism, for instance, is closely tied to productivity. Matza and Sykes have oversimplified our picture of the value systems of modern industrial societies: true, there is a bifurcation between formal and subterranean values, but they are not isolated moral regions; subterranean values are subsumed under the ethos of productivity. This states that a man is justified in expressing subterranean values if, and only if, he has earned the right to do so by working hard and being productive. Pleasure can only be legitimately purchased by the credit card of work. For example, unlike the 'leisure classes' depicted by Veblen, modern captains of industry feel duty bound to explain how the richness of their leisure is a legitimate reward for the dedication of their labour.

The ethos of productivity, then, attempts to legitimize and encompass the world of subterranean values. But there are cracks and strains in this moral code. People doubt both the sanity of alienated work and the validity of their leisure. For they cannot compartmentalize their life in a satisfactory manner: their socialization for work inhibits their leisure, and their utopias of leisure belittle their work. . . .

Both the values of work and those of leisure are . . . viewed ambivalently. For the socialization necessary to ensure incessant consumption conflicts with that necessary to maintain efficient production. The hedonistic goals conjured up in the media are sufficient as a carrot but contain no mention of the stick. 'Through television we are encouraging, on the consumption side, things which are entirely inconsistent with the disciplines necessary for our production side. Look at what television advertising encourages: immediate gratification, do it now, buy it now, pay later, leisure time, hedonism' [Antony Downs, quoted in *Newsweek* 6 October 1969: 31–2].

Play and subterranean values

The subterranean values of expressivity, hedonism, excitement, new experience and non-alienated activity are identical with the customary definition of *play*. Thus A. Giddens defines play as the aspect of leisure which is:

(i) Self-contained, non-instrumental: it is an end-in-itself.
(ii) Cathartic.
(iii) Ego-expressive.

[Giddens 1964: 73]

Similarly, Huizinga in *Homo Ludens* defines play as:

(i) Voluntary activity.
(ii) It is not ordinary or real life, 'It is rather a stepping out of "real" life into a temporary sphere of activity with a disposition all of its own'.
(iii) Play is distinct from ordinary life both as to locality and duration and it contains its own course and meaning.

[Huizinga 1969]

Now as to the status of play, various authorities vary in their assessment of its importance. For some it is a mere recreation from work, whilst for others, 'man only plays when in the full meaning of the word he is a man, and he is only completely a man when he plays' [Schiller 1793]. It is such a world of play that Marx envisages in his future utopia where it will 'be possible for me to do this today and that tomorrow, to hunt in the morning, to fish in the afternoon, to raise cattle in the evening, to be a critic after dinner, just as I feel at the moment: without ever being a hunter, fisherman, herdsman, or critic' [Marx 1938]. This is a world without alienation, a world where work itself is synonymous with leisure.

Play, the demesne of subterranean values, occurs when man steps out of the workaday world, beyond the limitations of economic reality as we know it. The bifurcation between formal and subterranean values has a Freudian parallel in the distinction between pleasure and reality principles. Herbert Marcuse summed this up well when he wrote:

The change in the governing value system may be tentatively defined as follows:

from	*to*
immediate satisfaction	delayed satisfaction
pleasure	restraint of pleasure
joy (play)	toil (work)
receptiveness	productiveness
absence of repression	security

[Marcuse 1956: 12]

The socialization of a child involves a transition from the pleasure principle to the reality principle, from a world of free expression and hedonism to one of deferred gratification and productivity. Every man having tasted the paradise of play in his own childhood holds in his mind as an implicit utopia a world where economic necessity does not hold sway and where he is capable of free expression of his desires. This is the psychological basis of the subterranean values, and it is in one's leisure time that a watered-down expression of 'free time' and play holds sway. Marcuse would go on from this point and argue that the increased productivity of advanced technological societies has created the potentiality for the abolition of scarcity, of harsh economic necessity. Thus he writes:

> No matter how justly and rationally the material production may be organized it can never be a realm of freedom and gratification; but it can release time and energy for the free play of human faculties *outside* the realm of alienated labor, the greater the potential of freedom: total automation would be the optimum.
>
> [Marcuse 1956: 156]

Modern industrial society creates, then, the productivity for the development of a leisure which would give full rein to the expression of subterranean values. But such a development would threaten vested interests. For:

> The closer the real possibility of liberating the individual from the constraints once justified by scarcity and immaturity, the greater the need for maintaining and streamlining these constraints lest the established order of domination dissolve. Civilization has to defend itself against the specter of a world which could be free. If society cannot use its growing productivity for reducing repression (because such usage would upset the hierarchy of the *status quo*), productivity must be turned *against* the individuals, it becomes itself an instrument of universal control.
>
> [Marcuse 1956: 93]

Thus Marcuse, unlike Marx, sees the bifurcation between work and leisure as ineradicable. What is necessary is that productivity should be harnessed in order to provide a material basis for the realization of subterranean values. The ethos of hedonism must hold sway over the world of productivity: the present order must be reversed.

The Age of Leisure, often heralded as an imminent possibility by social commentators throughout the last decade, has instead involved Western man in an increasing spiral of consumption and production. Formal values – the ethos of productivity – still rule the roost over the subterranean values of freedom. Consumption has become, according to Marcuse, a sophisticated form of social control. Thus, in *One-Dimensional Man*, he writes:

> We may distinguish both true and false needs. 'False' are those which are superimposed upon the individual by particular social interests in his repression: the needs which perpetuate toil, aggressiveness, misery and injustice. . . . Most of the prevailing needs to relax, to have fun, to behave and consume in accordance with the advertisements to love and hate what others love and hate, belong to this category of false needs.
>
> The people recognize themselves in their commodities; they find their soul in their automobile, hi-fi set, split-level home, kitchen equipment. The very mechanism which ties the individual to his society has changed; and social control is anchored in the new needs which it has produced.
>
> [Marcuse 1956: 93]

Consumer needs, as Galbraith . . . argued, do not spring directly out of some mysterious 'urge to consume' implicit in man's nature. They are created by the ethos of production, rather than the latter emerging to meet an innate demand. Advertising stimulates and creates desires in order to ensure a secure market for future production. And the ethos itself creates a calculus in which men are judged by their ability to possess:

> Because the society sets great store by ability to produce a high living standard, it evaluates people by the products they possess. The urge to consume is fathered by the value system which emphasizes the ability of the society to produce. The more that is produced the more that must be owned in order to maintain the appropriate prestige.
>
> [Galbraith 1962: 133]

Our leisure, then, is closely geared to our work, it is not 'play' in the sense of a sharply contrasting realm of meaning to the workaday world. It is merely the arena where just rewards for conscientious labour are enacted, where occupational status is confirmed by appropriate consumption, and where the appetites which spur on productivity and aid social control are generated. Children from the age of about five are socialized by school and family to embrace the work ethic. For the young child play is possible, for the adolescent it is viewed ambivalently, but for the adult play metamorphoses into leisure. This process of socialization engenders in the adult a feeling of guilt concerning the uninhibited expression of subterranean values. He is unable to let himself go fully, release himself from the bondage of the performance ethic and enter unambivalently into the world of 'play'. . . .

In short, our socialization is only appropriate for leisure commensurate with the work ethic: it is inappropriate to a world of 'play'. . . .

Drugs and subterranean values

In [my book *The Drugtakers*] I analysed the factors which determined the social valuation of a particular form of drugtaking. I concluded that it was not the drug *per se*, but the reason why the drug was taken that determined whether there would be an adverse social reaction to its consumption. The crucial yardstick in this respect is the ethos of productivity. If a drug either stepped up work efficiency or aided relaxation after work it was approved of; if it was used for purely hedonistic ends it was condemned [see Table 9.2].

For a moment let us focus on the legitimate psychotropic drugs, remembering that over 12p in the pound of British consumer spending is devoted to the purchase of alcohol and tobacco alone, not counting coffee, tea and prescribed barbiturates, amphetamines and tranquillizers.

Kessel and Walton see the function of drinking as a means of relieving the tensions created by the need in advanced industrial societies for

Table 9.2 Perceived motivation for use of drug

Perceived motivation for use of drug	Drugs
1. to aid productivity	caffeine (coffee and tea) cigarettes (nicotine) amphetamine use by soldiers, students, astronauts etc.
2. to relax after work	'social' drinking prescribed barbiturates cigarettes (nicotine)
3. purely hedonistic ends	'problem' drinking marihuana heroin non-prescribed amphetamines

conforming to an externally conceived system of rules [Kessel and Walton 1965] . . . I would agree with the[m] . . . up to a point. It is true that alcohol is used to break down the inhibitions inculcated by modern society, but it is does not result in an asocial response consisting of indiscriminate aggressive and sexual urges. Rather, it leads to a social area where hedonistic and expressive *values* come to the fore, replacing the bureaucratic rules of the workplace. Alcohol, in short, is used as a *vehicle* which enhances the ease of transition from the world of formal values to the world of subterranean values. And the same is true for many of the myriad other psychotropic drugs used by humanity. As Aldous Huxley put it:

> That humanity at large will ever be able to dispense with Artificial Paradises seems very unlikely. Most men and women lead lives at the worst so painful, at the best so monotonous, poor, and limited that the urge to escape, the longing to transcend themselves if only for a few moments, is and has always been one of the principal appetites of the soul. Art and religion, carnivals and saturnalia, dancing and listening to oratory – all these have served, in H. G. Wells's phrase, as Doors in the Wall. And for private, for everyday use, there have always been chemical intoxicants. All the vegetable sedatives and narcotics, all the euphorics that grow on trees, the hallucinogens that ripen in berries or can be squeezed from roots – all, without exception, have been known and systematically used by human beings from time immemorial. And to these natural modifiers of consciousness modern science has added its quota of synthetics – chloral, for example, and benzedrine, the bromides, and the barbiturates.
>
> Most of these modifiers of consciousness cannot now be taken except under doctor's orders, or else illegally and at considerable risk.

For unrestricted use the West has permitted only alcohol and tobacco. All the other chemical Doors in the Wall are labelled Dope, and their unauthorized takers are Fiends.

[Huxley 1959: 51–2]

These Doors in the Wall open into the world of subterranean values. They allow us to step out into a world free of the norms of workaday life; not, let me repeat, to an asocial world. For there are norms of appropriate behaviour when drunk or 'stoned', just as there are norms of appropriate behaviour when sober. For . . . the effects of drugs, although physiologically induced, are socially shared. We have definite expectations or roles as to appropriate and reprehensible behaviour whilst 'under the influence'. It may be that some individuals imbibe so much that they completely lose control, but this merely underlines my argument in that loss of control is defined precisely in terms of deviation from the appropriate norms of drug-induced behaviour.

It is fallacious to think of these episodes as escapes from reality; rather we must view them as escapes into *alternative* forms of reality. For social reality is socially defined and constructed and the world of subterranean values, however ambivalently it is viewed by 'official' society, is as real as the world of factories, workbenches and conveyor-belts. In fact, many authors such as Huxley would argue that the world behind the Doors in the Wall is more substantial and realistic than that of the formal world.

Alcohol, then, is a common vehicle for undermining the inhibitions built up by our socialization into the work ethic. It is the key to an area of subterranean values which are, however, in our society tightly interrelated and subsumed by the work ethic. It is as if the Door in the Wall merely led on to an antechamber of the World of Work, a place to relax and refresh oneself before the inevitable return to 'reality'. But other drugs, in the hands of groups who disdain the ethic of productivity, are utilized as vehicles to more radical accentuations of subterranean reality. It is drug use of this kind that is most actively repressed by the forces of social order. For it is not drugtaking *per se* but the culture of drugtakers which is reacted against: not the notion of changing consciousness but the type of consciousness that is socially generated.

Groups that exist beyond the ethos of productivity

Socialization into the work ethic is accomplished by inculcating into individuals the desirability of the various material rewards which the system offers, and the efficacy of work as a means of achieving them. There are two possible ways in which this process can break down and prove unsuccessful:

1 If the means of obtaining these goals are unobtainable: if work suitable to realize the material aspirations of certain groups is not forthcoming.

> 2 If the material rewards or goals are not valued by the individuals, sections of the community which are beyond the work ethos.

Two sections of the community are prominent examples of groups which are beyond the strict dictates of the work ethos: the ghetto black community and the bohemian young. The former lack the means of achieving society's rewards, the latter disdain the rewards themselves. For different reasons, therefore, they share similar values and both are – very revealingly – particularly prone to illicit drug use. [Here, we need] to examine, first, the *general* factors which precipitate the emergence of subcultures of youth in advanced industrial societies, and then analyse the different styles of life which specific youth cultures have evolved as a solution to their problems. In particular [we should] focus on the various roles drugs play in the formulation of such solutions.

The Birmingham tradition and cultural studies

Introduction to part two

■ Ken Gelder

THE CENTRE FOR CONTEMPORARY Cultural Studies at Birmingham University (CCCS) – established in 1964 – profoundly shaped the interests and methods of subcultural analysis for the next two decades. Researchers turned their attention in particular to the category of 'youth'. Their analyses were influenced by the work of a number of British Marxist critics – Raymond Williams, E. P. Thompson and Richard Hoggart, who was the Centre's first Director – but also by Continental theorists such as Louis Althusser, Antonio Gramsci and the early Roland Barthes. What developed was an ambitious and interdisciplinary kind of analysis – although it is worth noting that this focus on youth, if seen in the context of the Chicago School's engagement with so many different kinds of 'deviant' behaviours, resulted in a substantial narrowing of the range of subcultural activity under discussion.

CCCS researchers were preoccupied with the relations between ideologies (or 'ideological dimensions') and form, particularly the spectacular forms adopted by youth subcultures, mods, Teds, skinheads, punks, and so on. Their work thus turned to the distinctive 'look' of these subcultures; but the primary aim was to locate them in relation to three broader cultural structures, the working class

or the 'parent culture', the 'dominant' culture, and mass culture. Youth subcultures were always *working-class* youth subcultures, thus further narrowing the field of activity under analysis, and their subcultural status was linked to their class subordination. But they were also located ambivalently in relation to this category and to the family/parental structures it had upheld, not least because of the influence of leisure and commercialism on youth which fostered a 'generational consciousness' that could unhinge one's class- and family-based identity.

Youth thus seemed to embody the instability of 'class' as a workable category. The emphasis was on youth as a transitional moment, a somewhat fragile point of mediation between the class-located identity of the 'parent culture' and the increasingly attractive commercialized world of mass culture – between what Hoggart, in his seminal study *The Uses of Literacy* (1957), had called the ' "older" order' and 'the newer mass arts'. Accordingly, rather than seeing it as aimless, delinquent, and so on, the CCCS constructed youth as symptomatic of the central contradictions of the time. Yet youth was by no means seen as alienated. Analysts at the CCCS emphasized its 'cultural' aspects, drawing on a Marxian notion of (cultural) production: one's identity is created through the use one makes of, and the meanings one ascribes to, the 'raw materials' of existence. In this context, youth became expressive, meaningful, significant. Much like the various items of popular culture for Roland Barthes in his classic study *Mythologies* (1972), youth subcultures could thus be read as a kind of text or sign. Far from being inexplicable or difficult to comprehend, they were understood by the Birmingham Centre's analysts only too well.

Phil Cohen's chapter shares the spatial, sociological interests of the Chicago School through its focus on life in East End London. This short piece set the agenda for the CCCS with its argument that youth subcultures are a kind of symptom of class-in-decline. When working-class communities are undergoing change and displacement – when the 'parent culture' is no longer cohesive – youth (and the focus here is always on working-class youth) responds by becoming subcultural. Subcultures thus become a

means of expressing and, for Cohen, also 'resolving' the crisis of class. Cohen suggests that subcultural youth exists in an 'imaginary' or 'symbolic' relationship to class – where one is no longer iden-tifiable as 'working class', even as that conceptual category is being recovered through, for example, one's 'look' (e.g. as a skinhead). Subcultural youth may also replace a lost sense of working-class 'community' with subcultural 'territory' – a shift which is sympto-matic of the relocation of youthful expression to the field of leisure rather than work. In this sense, youth subcultures seem to be a means of recreating the condition of the parent culture at one remove. Although they may 'win space' for themselves, subcultures thus play an essentially conservative role. Moreover, because subcul-tural identity formulates itself in the field of leisure, one has 'no career prospects as such'. When one is in a subculture, in other words, one quite literally has no future.

John Clarke, Stuart Hall, Tony Jefferson and Brian Roberts, in their long theoretical introduction to *Resistance Through Rituals* (1975, 1993), also return youth to the category of class – giving the latter a kind of residual function in the sense that it stubbornly continues to shape experience. This is so even in the apparently 'classless' realm of mass culture. These authors are accordingly less hostile to mass cultural forms than the Marxist critical theo-rists from the Frankfurt School, refusing to subscribe to the view (also put forward by Hoggart) that youth is manipulated or hom-ogenized under their influence. Rather, they developed a more dynamic relation between the two, acknowledging the increasing role of 'affluence' and leisure in youth activity while insisting on youth's continuing location in class-based categories. To give this dynamic a theoretical expression they turned to Antonio Gramsci, drawing on his notion of 'hegemony' – a term which describes the means by which the ruling classes secure their authority over sub-ordinate classes, not by coercion but by obtaining the latter's 'consent'. This is done through on-going processes of negotiation and regulation. In turn, however, the subordinate classes (subcul-tures are seen in this way, as a subset of the working class) operate by 'winning space' back, by issuing challenges. Clarke *et al.* thus emphasize 'resistance' more than Cohen, giving subcultures a more

creative kind of agency. Subcultures do not have political solutions, however. Their 'resistances' are worked out in the less constrained but otherwise 'limited' field of leisure, rather than in the workplace, which leads these authors to reproduce Cohen's narrative of failure in a wider context.

Angela McRobbie has offered a very different perspective on youth subcultures, looking at the way subcultural analysis had tended more or less to equate subcultural youth with boys – ignoring the role of girls altogether. Her chapter, co-written with Jenny Garber, looks at the subcultural spaces available for girls, concluding with some remarks on 'pre-teen' girls or 'teenyboppers'. The interest here is not so much in class alignments, but in one's gendered relations to mass cultural images: pop idols, in this case. Of course, the criticism that male accounts of subcultures present girls as subordinate to boys is not entirely overcome in an analysis which focuses on girl fans' adoration of male singers and male groups. The teenybopper culture is represented here as vulnerable, impressionable, centred in the home; in the light of this, McRobbie and Garber work hard to claim subcultural status for these girls. Certainly a less constrained kind of femininity is also available for female fans, through its public manifestation at a concert, for example (see Barbara Ehrenreich *et al.*'s contribution in Part Eight). McRobbie and Garber's early contribution may be regarded ambivalently in this context; they rightly seek an alternative to the CCCS's generally masculinist emphasis on 'resistance' and 'struggle', but the choice of the teenybopper at the same time poses a challenge to the tendency to locate more 'progressive' modes of femininity in subcultures. In her later work, however, McRobbie turns to different, more productive concepts of femininity, such as pleasure, tastes and 'enterprise culture', which enable her to develop a more dynamic account of subcultural girls' relations to commercial processes. We have included an example of this work in Part Three.

In contrast to most of the researchers at the CCCS, Paul Willis worked ethnographically, spending time with subcultural groups at particular sites, talking with them, and presenting them 'in their own words'. His classic study, *Learning to Labour*, looks at a group

of 'lads' at a school in the West Midlands, returning to the question of class in an institutional setting. The 'lads' do not conform, unlike the 'ear 'oles', the nickname for boys who are more integrated and conformist. Willis looks at how resistance at the school – where less constrained leisure activities are brought into the workplace – produces distinction and empowerment. Yet it also produces 'self-damnation': the 'lads' actively assist in their own incorporation into capitalist structures of inequality by ending up with working-class or 'menial' (rather than 'mental') jobs. This is because of what Willis calls *differentiation*, the way in which being 'working class' already shapes one's relationship to the school one attends. This is a compelling account, although it tends to reproduce a familiar narrative at the Birmingham Centre, that subcultural empowerment is empowerment without a future. Stanley Cohen has criticized Willis in Part Three along these lines; while McRobbie (1980) has noted Willis's failure to question the sexism and misogyny of the 'lads'. More attuned to the variability of 'everyday life', McRobbie has also noted how the language and behaviour of the 'lads' are tied to the school in which Willis sets his study. There is no attempt, for example, to inquire into relationships, behaviours and so on outside of this institutional setting. One final criticism can be made, involving Willis's tendency to foreground the 'lads' – even, to identify with them – at the expense of the more conformist 'ear 'oles' who barely get a word in edgeways. The non-conformist boy – a minority – is more attractive, more 'spectacular', even in his failure; the ordinariness of the 'ear 'ole', on the other hand, makes him as invisible as the girls.

Dick Hebdige's influential study of subcultural style takes spectacularity as a given condition for subcultures, which mass cultural forms then attempt to tame or control. In this excerpt Hebdige looks primarily at punks in Britain in the late 1970s and offers a genealogy which is less bound up with class than Cohen, Willis and others. Indeed, the privileged referent in his book is ethnicity rather than class; the kind of immigration patterns which Cohen had seen as dislocating class structures in East End London are here regarded as central to the development of subcultural style.

Subcultural style, in other words, is always culturally syncretic – punk borrows from reggae traditions from the Caribbean, for example. To give this process expression, Hebdige himself borrowed John Clarke's (1975) borrowing of the anthropologist Claude Levi-Strauss's concept of *bricolage*. *Bricolage* is a mode of adaptation, where things are put to uses in ways for which they were not intended, ways which dislocate them from their 'normal' context. Hebdige saw punks as *bricoleurs par excellence*, using dislocation as a form of 'refusal' (rather than, say, 'resistance'). The problem is that once an item in culture has been so dislocated, how can it be read as a sign? Hebdige moves excitedly into the methodology of semiotics, and yet a certain mystification of punk arises in his account. The concept of *bricolage* may be partly responsible for this: the emphasis it places on a general practice of dislocation for its own sake prevents the analyst from looking at particular uses of items in particular sites at particular moments.

The five chapters here attempt to represent the best work from the CCCS during the 1970s – work usually taken as foundational for the broader discipline of Cultural Studies. These authors attempted to read contemporary youth culture in its various 'new formations', framing it in the broader structures of class, mass culture, gender (McRobbie and Garber) and ethnicity and immigration (Hebdige). The emphasis on style, fashion and the 'look' of subcultures has proved extraordinarily influential, and we devote Part Seven of this Reader to these topics. This emphasis was often attached to a narrative which saw subcultures as inevitably 'incorporated' or diffused, however – an attachment which is problematic, as several chapters in Part Three will demonstrate. Also, the focus on style comes at the expense of other subcultural features: modes of pleasure and fun, for example; or particular uses of space; or the various kinds of self-positionings one might adopt within a subculture (many of which may not prioritize style at all); or subcultural relations to forms of commercial exchange and to various kinds of media. Overall, the CCCS adopted a primarily synchronic approach to subcultures, eschewing an analysis of specific developments in what Paul G. Cressey had called the 'life cycle' in favour of attaching subcultural identities to their 'final signifying products'

(McRobbie 1994: 160). Finally, the CCCS insisted on the representational aspects of youth, that they always symbolized something larger than themselves. As Stanley Cohen notes in the next Part, under this particular burden one can be a 'mere' delinquent no longer; the emphasis on determining structures such as class and the commercialism of 'late capitalism' gives youth an epic quality that can obscure the more 'ordinary' but equally compelling accounts of everyday life.

Phil Cohen

SUBCULTURAL CONFLICT AND WORKING-CLASS COMMUNITY [1972]

T HE 1950s SAW the development of new towns and large estates on the outskirts of east London (Dagenham, Greenleigh and so on), and a large number of families from the worst slums of the East End were rehoused in this way. The East End, one of the highest-density areas in London, underwent a gradual depopulation. . . .

As the worst effects of this . . . both on those who moved and on those who stayed behind, became apparent, the planning authorities decided to reverse their policy. Everything was now concentrated on building new estates on slum sites within the East End. But far from counteracting the social disorganization of the area, this merely accelerated the process. . . . No one is denying that redevelopment brought an improvement in material conditions for those fortunate enough to be rehoused (there are still thousands on the housing list). But while this removed the tangible evidence of poverty, it did nothing to improve the real economic situation of many families, and those with low incomes may, despite rent-rebate schemes, be worse off.

The first effect of the high-density, high-rise schemes was to destroy the function of the street, the local pub, the corner shop as articulations of communal space. Instead there was only the privatized space of family units, stacked one on top of each other, in total isolation, juxtaposed with the totally public space which surrounded them and which lacked any of the informal social controls generated by the neighbourhood. The streets which serviced the new estates became thoroughfares, their users 'pedestrians' and, by analogy, so many bits of human traffic — and this irrespective of whether or not they were separated from motorized traffic. . . .

The second effect of redevelopment was to destroy what we have called 'matrilocal residence'. Not only was the new housing designed on the model of the nuclear family, with little provision for large low-income families (usually designated 'problem families'!) and none at all for groups of young single people, but the actual pattern of distribution of the new housing tended to disperse the kinship network; families of marriage were separated from their families of origin, especially during the first phase of the redevelopment. The isolated family unit could no longer call on the resources of wider kinship networks or of the neighbourhood, and the family itself became the sole focus of solidarity. This meant that any problems were bottled up within the immediate interpersonal context which produced them; and at the same time family relationships were invested with a new intensity to compensate for the diversity of relationships previously generated through neighbours and wider kin. The trouble was that although the traditional kinship system which corresponded to it had broken down, the traditional patterns of socialization (of communication and control) continued to reproduce themselves in the interior of the family. The working-class family was thus not only isolated from the outside but also undermined from within. There is no better example of what we are talking about than the plight of the so-called 'housebound mother'. The street or turning was no longer available as a safe playspace, under neighbourly supervision. Mum or Auntie was no longer just around the corner to look after the kids for the odd morning. Instead, the task of keeping an eye on the kids fell exclusively to the young wife, and the only safe playspace was the 'safety of the home'. Feeling herself cooped up with the kids and cut off from the outside world, it wasn't surprising if she occasionally took out her frustration on those nearest and dearest! Only market research and advertising executives imagine that the housebound mother sublimates everything in her G-plan furniture, her washing machine or her non-stick frying pans. Underlying all this, however, there was a more basic process of change going on in the community, a change in the whole economic infrastructure of the East End.

In the late 1950s the British economy began to recover from the effect of the war and to apply the advanced technology developed during this period to the more backward sectors of the economy. Craft industries and small-scale production in general were the first to suffer; automated techniques replaced the traditional handskills and their simple division of labour. Similarly, the economies of scale provided for by the concentration of capital resources meant that the small-scale family business was no longer a viable unit. Despite a long rearguard action, many of the traditional industries – tailoring, furniture making, many of the service and distributive trades linked to the docks – rapidly declined or were bought out. Symbolic of this was the disappearance of the corner shop; where these were not demolished by redevelopment they were replaced by larger supermarkets, often owned by large combines. . . . The local economy as a whole contracted, became less diverse. The only section of the community which was unaffected by this

was dockland, which retained its position in the labour market and, with it, its traditions of militancy. It did not, though, remain unaffected by the breakdown of the pattern of integration in the East End as a whole *vis-à-vis* its sub-community structure. Perhaps this goes some way to explaining the paradoxical fact that within the space of twelve months the dockers could march in support of Enoch Powell and take direct action for community control in the Isle of Dogs!

If someone should ask why the plan to 'modernize' the pattern of East End life should have been such a disaster, perhaps the only honest answer is that given the macro-social forces acting on it, given the political, ideological and economic framework within which it operated, the result was inevitable. For example, many local people wonder why the new environment should be the way it is. The reasons are complex. They are political in so far as the system does not allow for any effective participation by a local working-class community in the decision-making process at any stage or level of planning. The clients of the planners are simply the local authority or the commercial developer who employs them. They are ideological in so far as the plans are unconsciously modelled on the structure of the middle-class environment, which is based on the concept of *property* and private *ownership*, on individual differences of status, wealth and so on, whereas the structure of the working-class environment is based on the concept of community or collective identity, common lack of ownership, wealth, etc. Similarly, needs were assessed on the norms of the middle-class nuclear family rather than on those of the extended working-class family. But underpinning both these sets of reasons lie the basic economic factors involved in comprehensive redevelopment. Quite simply, faced with the task of financing a large housing programme, local authorities are forced to borrow large amounts of capital and also to design schemes which would attract capital investment to the area. This means that they have to borrow at the going interest rates, which in this country are very high, and that to subsidize housing certain of the best sites have to be earmarked for commercial developers.

All this means that planners have to reduce the cost of production to a minimum through the use of capital-intensive techniques – prefabricated and standardized components which allow for semi-automated processes in construction. The attraction of high-rise developments ('tower blocks', outside the trade) is that they not only meet these requirements but they also allow for certain economies of scale, such as the input costs of essential services, which can be grouped around a central core. As for 'non-essential' services, that is, ones that don't pay, such as playspace, community centres, youth clubs and recreational facilities, these often have to be sacrificed to the needs of commercial developers – who, of course, have quite different priorities.

The situation facing East Enders at present is not new. When the first tenements went up in the nineteenth century they provoked the same objections from local people, and for the same very good reasons, as their modern

counterparts, the tower blocks. What *is* new is that in the nineteenth century the voice of the community was vigorous and articulate on these issues, whereas today, just when it needs it most, the community is faced with a crisis of indigenous leadership.

The reasons for this are already implicit in the analysis above. The labour aristocracy, the traditional source of leadership, has virtually disappeared, along with the artisan mode of production. At the same time there has been a split in consciousness between the spheres of production and consumption. More and more East Enders are forced to work outside the area; young people especially are less likely to follow family traditions in this respect. As a result, the issues of the workplace are no longer experienced as directly linked to community issues. Of course, there has always been a 'brain drain' of the most articulate, due to social mobility. But not only has this been intensified as a result of the introduction of comprehensive schools, but the recruitment of fresh talent from the stratum below – from the ranks of the respectable working class, that is – has also dried up. For this stratum, traditionally the social cement of the community, is also in a state of crisis.

The economic changes which we have already described also affected its position and, as it were, *destabilized* it. The 'respectables' found themselves caught and pulled apart by two opposed pressures of social mobility – downwards, and upwards into the ranks of the new suburban working-class elite. And, more than any other section of the working class, they were caught in the middle of the two dominant but contradictory ideologies of the day: the ideology of spectacular consumption, promoted by the mass media, and the traditional ideology of production, the so-called work ethic, which centred on the idea that a man's dignity, his manhood even, was measured by the quantity or quality of his effort in production. If this stratum began to split apart, it was because its existing position had become untenable. Its bargaining power in the labour market was threatened by the introduction of new automated techniques, which eliminated many middle-range, semi-skilled jobs. Its economic position excluded its members from entering the artificial paradise of the new consumer society; at the same time changes in the production process itself have made the traditional work ethic, pride in the job, impossible to uphold. They had the worst of all possible worlds.

Once again, this predicament was registered most deeply in and on the young. But here an additional complicating factor intervenes. We have already described the peculiar strains imposed on the 'nucleated' working-class family. And their most critical impact was in the area of parent/child relationships. What had previously been a source of support and security for both now became something of a battleground, a major focus of all the anxieties created by the disintegration of community structures around them. One result of this was to produce an increase in early marriage. For one way of escaping from the claustrophobic tensions of family life was to start a family of your own! And given the total lack of accommodation for young, single people in the new developments, as well as the conversion of cheap

rented accommodation into middle-class, owner-occupied housing, the only practicable way to leave home was to get married. The second outcome of generational conflict (which may appear to go against the trend of early marriage, but in fact reinforced it) was the emergence of specific youth subcultures in opposition to the parent culture. And one effect of this was to weaken the links of historical and cultural continuity, mediated through the family, which had been such a strong force for solidarity in the working-class community. It is, perhaps, not surprising that the parent culture of the respectable working class, already in crisis, was the most 'productive' vis-à-vis subcultures; the internal conflicts of the parent culture came to be worked out in terms of generational conflict. What I think is that one of the functions of generational conflict is to decant the kinds of tensions which appear face-to-face in the family and to replace them by a generational-specific symbolic system, so that the tension is taken out of the interpersonal context, placed in a collective context and mediated through various stereotypes which have the function of defusing the anxiety that interpersonal tension generates.

It seems to me that the latent function of subculture is this: to express and resolve, albeit 'magically', the contradictions which remain hidden or unresolved in the parent culture. The succession of subcultures which this parent culture generated can thus all be considered so many variations on a central theme – the contradiction, at an ideological level, between traditional working-class puritanism and the new hedonism of consumption; at an economic level, between a future as part of the socially mobile elite or as part of the new lumpen proletariat. Mods, parkas, skinheads, crombies all represent, in their different ways, an attempt to retrieve some of the socially cohesive elements destroyed in their parent culture, and to combine these with elements selected from other class fractions, symbolizing one or other of the options confronting it.

It is easy enough to see this working in practice if we remember, first, that subcultures are symbolic structures and must not be confused with the actual kids who are their bearers and supports. Secondly, a given life-style is actually made up of a number of symbolic subsystems, and it is the way in which these are articulated in the total life-style that constitutes its distinctiveness. There are basically four subsystems, which can be divided into two basic types of forms. There are the relatively 'plastic' forms – dress and music – which are not directly produced by the subculture but which are selected and invested with subcultural value in so far as they express its underlying thematic. Then there are the more 'infrastructural' forms – argot and ritual – which are most resistant to innovation but, of course, reflect changes in the more plastic forms. I'm suggesting here that mods, parkas, skinheads, crombies are a succession of subcultures which all correspond to the same parent culture and which attempt to work out, through a system of transformations, the basic problematic or contradiction which is inserted in the subculture by the parent culture. So one can distinguish three levels in the analysis of subcultures; one is historical analysis, which isolates the

specific problematic of a particular class fraction – in this case, the respectable working class; the second is a structural or semiotic analysis of the subsystems, the way in which they are articulated and the actual transformations which those subsystems undergo from one structural moment to another; and the third is the phenomenological analysis of the way the subculture is actually 'lived out' by those who are the bearers and supports of the subculture. No real analysis of subculture is complete without all those levels being in place.

To go back to the diachronic string we are discussing, the original mod life-style could be interpreted as an attempt to realize, *but in an imaginary relation*, the conditions of existence of the socially mobile white-collar worker. While the argot and ritual forms of mods stressed many of the traditional values of their parent culture, their dress and music reflected the hedonistic image of the affluent consumer. The life-style crystallized in opposition to that of the rockers (the famous riots in the early sixties testified to this), and it seems to be a law of subcultural evolution that its dynamic comes not only from the relations to its own parent culture, but also from the relation to subcultures belonging to *other class factions*, in this case the manual working class.

The next members of our string – the parkas or scooter boys – were in some senses a transitional form between the mods and the skinheads. The alien elements introduced into music and dress by the mods were progressively de-stressed and the indigenous components of argot and ritual reasserted as the matrix of subcultural identity. The skinheads themselves carried the process to completion. Their life-style, in fact, represents a systematic inversion of the mods – whereas the mods explored the upwardly mobile option, the skinheads explored the lumpen. Music and dress again became the central focus of the life-style; the introduction of reggae (the protest music of the West Indian poor) and the 'uniform' (of which more in a moment) signified a reaction against the contamination of the parent culture by middle-class values and a reassertion of the integral values of working-class culture through its most recessive traits – its puritanism and chauvinism. This double movement gave rise to a phenomenon sometimes called 'machismo' – the unconscious dynamics of the work ethic translated into the out-of-work situation; the most dramatic example of this was the epidemic of 'queer-bashing' around the country in 1969–70. The skinhead uniform itself could be interpreted as a kind of caricature of the model worker – the self-image of the working class as distorted through middle-class perceptions, a metastatement about the whole process of social mobility. Finally, the skinhead life-style crystallized in opposition both to the greasers (successors to the rockers) and the hippies – both subcultures representing a species of hedonism which the skinheads rejected.

Following the skinheads there emerged another transitional form, variously known as crombies, casuals, suedes and so on (the proliferation of names being a mark of transitional phases). They represent a movement back

towards the original mod position, although this time it is a question of incorporating certain elements drawn from a middle-class subculture – the hippies – which the skinheads had previously ignored. But even though the crombies have adopted some of the external mannerisms of the hippy life-style (dress, soft drug use), they still conserve many of the distinctive features of earlier versions of the subculture.

If the whole process, as we have described it, seems to be circular, forming a closed system, then this is because subculture, by definition, cannot break out of the contradiction derived from the parent culture; it merely transcribes its terms at a microsocial level and inscribes them in an imaginary set of relations.

But there is another reason. Apart from its particular, thematic contradiction, all subcultures share a general contradiction which is inherent in their very conditions of existence. Subculture invests the weak points in the chain of socialization between the family/school nexus and integration into the work process which marks the resumption of the patterns of the parent culture for the next generation. But subculture is also a compromise solution to two contradictory needs: the need to create and express *autonomy and difference* from parents and, by extension, their culture and the need to maintain the security of existing ego defences and the *parental identifications* which support them. For the initiates the subculture provides a means of 'rebirth' without having to undergo the pain of symbolic death. The autonomy it offers is thus both real (but partial) and illusory as a total 'way of liberation'. And far from constituting an improvised *rite de passage* into adult society, as some anthropologists have claimed, it is a collective and highly ritualized defence against just such a transition. And because defensive functions predominate, ego boundaries become cemented into subcultural boundaries. In a real sense, subcultural conflict (greasers *versus* skinheads, mods *versus* rockers) serves as a displacement of generational conflict, both at a cultural level and at an interpersonal level within the family. One consequence of this is to foreclose artificially the natural trajectory of adolescent revolt. For the kids who are caught up in the internal contradictions of a subculture, what begins as a break in the continuum of social control can easily become a permanent hiatus in their lives. Although there is a certain amount of subcultural mobility (kids evolving from mods to parkas or even switching subcultural affiliations, greasers 'becoming' skinheads), there are no career prospects! There are two possible solutions: one leads out of subculture into early marriage, and, as we've said, for working-class kids this is the normal solution; alternatively, subcultural affiliation can provide a way into membership of one of the deviant groups which exist in the margins of subculture and often adopt its protective coloration, but which nevertheless are not structurally dependent on it (such groups as pushers, petty criminals, junkies, even homosexuals).

This leads us into another contradiction inherent in subculture. Although as a symbolic structure it *does* provide a diffuse sense of affinity in terms of

a common life-style, it does not in itself prescribe any crystallized group structure. It is through the function of *territoriality* that subculture becomes anchored in the collective reality of the kids who are its bearers, and who in this way become not just its passive support but its conscious agents. Territoriality is simply the process through which environmental boundaries (and foci) are used to signify group boundaries (and foci) and become invested with a subcultural value. This is the function of football teams for the skin-heads, for example. Territoriality is thus not only a way in which kids 'live' subculture as a collective behaviour, but also the way in which the subcultural group becomes rooted in the situation of its community. In the context of the East End, it is a way of retrieving the solidarities of the traditional neighbourhood destroyed by development. The existence of communal space is reasserted as the common pledge of group unity – you belong to the Mile End mob in so far as Mile End belongs to you. Territoriality appears as a magical way of expressing ownership; for Mile End is not owned by the people but by the property developers. Territorial division therefore appears within the subculture and, in the East End, mirrors many of the traditional divisions of sub-communities: Bethnal Green, Hoxton, Mile End, Whitechapel, Balls Pond Road and so on. Thus, in addition to conflict between subcultures, there also exists conflict within them, on a territorial basis. Both these forms of conflict can be seen as displacing or weakening the dynamics of generational conflict, which is in turn a displaced form of the traditional parameters of class conflict.

A distinction must be made between subcultures and delinquency. Many criminologists talk of delinquent subcultures. In fact, they talk about anything that is not middle-class culture as subculture. From my point of view, I do not think the middle class produces subcultures, for subcultures are produced by a dominated culture, not by a dominant culture. I am trying to work out the way that subcultures have altered the pattern of working-class delin-quency. But now I want to look at the delinquent aspect.

For during this whole period there was a spectacular rise in the delin-quency rates in the area, even compared with similar areas in other parts of the country. The highest increase was in offences involving attacks on prop-erty – vandalism, hooliganism of various kinds, the taking and driving away of cars. At the simplest level this can be interpreted as some kind of protest against the general dehumanization of the environment, an effect of the loss of the informal social controls generated by the old neighbourhoods. The delinquency rate also, of course, reflected the level of police activity in the area and the progressively worsening relations between young people and the forces of law and order. Today, in fact, the traditional enmity has become something more like a scenario of urban guerrilla warfare!

There are many ways of looking at delinquency. One way is to see it as the expression of a system of transactions between young people and various agencies of social control, in the subcultural context of territoriality. One advantage of this definition is that it allows us to make a conceptual distinction

between delinquency and deviancy, and to reserve this last term for groups (for example, prostitutes, professional criminals, revolutionaries) which crystallize around a specific counter-ideology, and even career structure, which cuts across age grades and often community or class boundaries. While there is an obvious relation between the two, delinquency often serving as a means of recruitment into deviant groups, the distinction is still worth making.

Delinquency can be seen as a form of communication about a situation of contradiction in which the 'delinquent' is trapped but whose complexity is excommunicated from his perceptions by virtue of the restricted linguistic code which working-class culture makes available to him. Such a code, despite its richness and concreteness of expression, does not allow the speaker to make verbally explicit the rules of relationship and implicit value systems which regulate interpersonal situations, since this operation involves the use of complex syntactical structures and a certain degree of conceptual abstraction not available through this code. This is especially critical when the situations are institutional ones, in which the rules of relationship are often contradictory, denied or disguised but nevertheless binding on the speaker. For the working-class kid this applies to his family, where the positional rules of extended kinship reverberate against the personalized rules of its new nuclear structure; in the school, where middle-class teachers operate a whole series of linguistic and cultural controls which are 'dissonant' with those of his family and peers, but whose mastery is implicitly defined as the index of intelligence and achievement; at work, where the mechanism of exploitation (extraction of surplus value, capital accumulation) are screened off from perception by the apparently free exchange of so much labour time for so much money wage. In the absence of a working-class ideology which is both accessible and capable of providing a concrete interpretation of such contradictions, what can a poor boy do? Delinquency is one way he can communicate, can represent by analogy and through non-verbal channels the dynamics of some of the social configurations he is locked into. And if the content of this communication remains largely 'unconscious', then that is because, as Freud would say, it is 'over-determined'. For what is being communicated is not one but *two different* systems of rules: one belonging to the sphere of object relations and the laws of symbolic production (more specifically, the parameters of Oedipal conflict), the second belonging to property relations, the laws of material production (more specifically, the parameters of class conflict).

Without going into this too deeply, I would suggest that where there is an extended family system the Oedipal conflict is displaced from the triadic situation to sibling relations, which then develops into the gang outside the family. When this begins to break down the reverse process sets in. In the study of the structural relations for the emergence of subcultures the implications of this are twofold: first, changes in the parameters of class conflict are brought about by advanced technology where there is some class consensus

between certain parent cultures, and that level of conflict appears to be invisible or acted on in various dissociated ways; second, the parameters of Oedipal conflict are becoming replaced in the family context but are refracted through the peer-group situation. It is a kind of double inversion that needs to be looked at not only in terms of a Marxist theory, which would analyse it simply by reference to class conflict and the development of antagonistic class fractions simply syphoning down vertically into another generational situation, but also in psychoanalytic terms, through the dynamics of Oedipal conflict in adolescence. We need to look at the historical ways in which class conflict and the dynamics of Oedipal conflict have undergone transformation and have interlocked, reverberating against each other.

John Clarke, Stuart Hall, Tony Jefferson and Brian Roberts

SUBCULTURES, CULTURES AND CLASS [1975]

Sᴜʙᴄᴜʟᴛᴜʀᴇs ᴍᴜsᴛ ᴇxʜɪʙɪᴛ a distinctive enough shape and struc-
ture to make them identifiably different from their 'parent' culture. They
must be focussed around certain activities, values, certain uses of material
artefacts, territorial spaces etc. which significantly differentiate them from
the wider culture. But, since they are sub-sets, there must also be signifi-
cant things which bind and articulate them with the 'parent' culture. The
famous Kray twins, for example, belonged both to a highly differentiated
'criminal subculture' in East London and to the 'normal' life and culture of
the East End working class (of which indeed, the 'criminal subculture' has
always been a clearly identifiable part). The behaviour of the Krays in terms
of the criminal fraternity marks the differentiating axis of that subculture:
the relation of the Krays to their mother, family, home and local pub is the
binding, the articulating axis. . . .

Subcultures, therefore, take shape around the distinctive activities and
'focal concerns' of groups. They can be loosely or tightly bounded. Some
subcultures are merely loosely-defined strands or 'milieux' within the parent
culture: they possess no distinctive 'world' of their own. Others develop a
clear, coherent identity and structure. . . . When these tightly-defined groups
are also distinguished by age and generation, we call them 'youth sub-
cultures'.

'Youth subcultures' form up on the terrain of social and cultural life. Some
youth subcultures are regular and persistent features of the 'parent' class-
culture: the ill-famed 'culture of delinquency' of the working-class adolescent
male, for example. But some subcultures appear only at particular historical
moments: they become visible, are identified and labelled (either by themselves

or by others): they command the stage of public attention for a time: then they fade, disappear or are so widely diffused that they lose their distinctiveness. It is the *latter* kind of subcultural formation which primarily concerns us here. The peculiar dress, style, focal concerns, milieux, etc. of the Teddy Boy, the Mod, the Rocker or the Skinhead set them off, as distinctive groupings, both from the broad patterns of working-class culture as a whole, and also from the more diffused patterns exhibited by 'ordinary' working-class boys (and, to a more limited extent, girls). Yet, despite these differences, it is important to stress that, as subcultures, they continue to exist within, and coexist with, the more inclusive culture of the class from which they spring. Members of a subculture may walk, talk, act, look 'different' from their parents and from some of their peers: but they belong to the same families, go to the same schools, work at much the same jobs, live down the same 'mean streets' as their peers and parents. In certain crucial respects, they share the same position (*vis-à-vis* the dominant culture), the same fundamental and determining life-experiences, as the 'parent' culture from which they derive. Through dress, activities, leisure pursuits and life-style, they may project a different cultural response or 'solution' to the problems posed for them by their material and social class position and experience. But the membership of a subculture cannot protect them from the determining matrix of experiences and conditions which shape the life of their class as a whole. They experience and respond to the *same basic problematic* as other members of their class who are not so differentiated and distinctive in a 'subcultural' sense. Especially in relation to the *dominant* culture, their subculture remains like other elements in their class culture – subordinate and subordinated.

In what follows, we shall try to show why this *double articulation* of youth subcultures – first, to their 'parent' culture (e.g. working-class culture), second, to the dominant culture – is a necessary way of staging the analysis. For our purposes, subcultures represent a necessary, 'relatively autonomous', but *inter-mediary* level of analysis. Any attempt to relate subcultures to the 'socio-cultural formation as a whole' must grasp its complex unity by way of these necessary differentiations. . . .

To locate youth subculture in this kind of analysis, we must first situate youth in the dialectic between a 'hegemonic' dominant culture and the subordinate working-class 'parent' culture, of which youth is a fraction. These terms – hegemonic/corporate, dominant/subordinate – are crucial for the analysis, but need further elaboration before the subcultural dimension can be introduced. Gramsci used the term 'hegemony' to refer to the moment when a ruling class is able, not only to *coerce* a subordinate class to conform to its interests, but to exert a 'hegemony' or 'total social authority' over subordinate classes. This involves the exercise of a special kind of power – the power to frame alternatives and contain opportunities, *to win and shape consent*, so that the granting of legitimacy to the dominant classes appears not only 'spontaneous' but natural and normal. Lukes has recently defined this as the power to define the agenda, to shape preferences, to 'prevent conflict

from arising in the first place', or to contain conflict when it does arise by defining what sorts of resolution are 'reasonable' and 'realistic' – i.e. within the existing framework (Lukes 1974: 23–4). The terrain on which this hegemony is won or lost is the terrain of the superstructures; the institutions of civil society and the state – what Althusser (1971) and Poulantzas (1973), somewhat misleadingly, call 'ideological state apparatuses'. Conflicts of interest arise, fundamentally, from the difference in the structural position of the classes in the productive realm: but they 'have their effect' in social and political life. Politics, in the widest sense, frames the passage from the first level to the second. The terrain of civil and state institutions thus becomes essentially 'the stake, but also the site of class struggle' (Althusser 1971). In part, these apparatuses work 'by ideology'. That is, the definitions of reality institutionalised within these apparatuses come to constitute a lived 'reality as such' for the subordinate classes – that, at least, is what hegemony attempts and secures. . . .

Hegemony works through ideology, but it does not consist of false ideas, perceptions, definitions. It works *primarily* by inserting the subordinate class into the key institutions and structures which support the power and social authority of the dominant order. It is, above all, in these structures and relations that a subordinate class *lives its subordination*. Often, this subordination is secured only because the dominant order succeeds in weakening, destroying, displacing or incorporating alternative institutions of defence and resistance thrown up by the subordinate class. Gramsci insists, quite correctly, that 'the thesis which asserts that men become conscious of fundamental conflicts on the level of ideology is not psychological or moralistic in character but *structural and epistemological*' (our italics; Gramsci 1971: 164).

Hegemony can rarely be sustained by one, single class stratum. Almost always it requires an *alliance* of ruling-class fractions – a 'historical bloc'. The content of hegemony will be determined, in part, by precisely which class fractions compose such a 'hegemonic bloc', and thus what interests have to be taken into account within it. Hegemony is not simple 'class rule'. It requires to some degree the 'consent' of the subordinate class, which has, in turn, to be won and secured; thus, an ascendancy of social authority, not only in the state but in civil society as well, in culture and ideology. Hegemony prevails when ruling classes not only rule or 'direct' but *lead*. The state is a major educative force in this process. It educates through its regulation of the life of the subordinate classes. These apparatuses reproduce class relations, and thus class subordination (the family, the school, the church and cultural institutions, as well as the law, the police and the army, the courts).

The struggle against class hegemony also takes place within these institutions, as well as outside them – they become the 'site' of class struggle. But the apparatuses also depend on the operation of 'a set of predominant values, beliefs, rituals and institutional procedures ("rules of the game") that operate systematically and consistently to the benefit of certain persons and groups' (Bacrach and Baratz 1962). . . .

In relation to the hegemony of a ruling class, the working class is, by definition, a *subordinate* social and cultural formation. Capitalist production, Marx suggested, reproduces capital and labour in their ever-antagonistic forms. The role of hegemony is to ensure that, in the social relations between the classes, each class is continually *reproduced* in its existing dominant-or-subordinate form. Hegemony can never wholly and absolutely absorb the working-class *into* the dominant order. Society may seem to be, but cannot actually ever be, in the capitalist mode of production, 'one-dimensional'. Of course, at times, hegemony is strong and cohesive, and the subordinate class is weak, vulnerable and exposed. But it cannot, by definition, disappear. It remains, as a subordinate structure, often separate and impermeable, yet still contained by the overall rule and domination of the ruling class. The subordinate class has developed its own corporate culture, its own forms of social relationship, its characteristic institutions, values, modes of life. . . .

Working-class culture has consistently 'won space' from the dominant culture. Many working-class institutions represent the different outcomes of this intense kind of 'negotiation' over long periods. At times, these institutions are adaptive; at other times, combative. Their class identity and position are never finally 'settled': the balance of forces within them remains open. They form the basis of what Parkin has called a '"negotiated version" of the dominant system . . . dominant values are not so much rejected or opposed as modified by the subordinate class as a result of circumstances and restricted opportunities' (Parkin 1971: 92). Often, such 'negotiated solutions' prevail, not because the class is passive and deferential to ruling class ideas, but because its perspectives are bounded and contained by immediate practical concerns or limited to concrete situations. . . .

Negotiation, resistance, struggle: the relations between a subordinate and a dominant culture, wherever they fall within this spectrum, are always intensely active, always oppositional, in a structural sense (even when this opposition is latent, or experienced simply as the normal state of affairs). Their outcome is not given but *made*. The subordinate class brings to this 'theatre of struggle' a repertoire of strategies and responses — ways of coping as well as of resisting. Each strategy in the repertoire mobilises certain real material and social elements: it constructs these into the supports for the different ways the class lives and resists its continuing subordination. . . .

We can return, now, to the question of 'subcultures'. Working-class subcultures, we suggested, take shape on the level of the social and cultural class-relations of the subordinate classes. In themselves, they are not simply 'ideological' constructs. They, too, *win space* for the young: cultural space in the neighbourhood and institutions, real time for leisure and recreation, actual room on the street or street-corner. They serve to mark out and appropriate 'territory' in the localities. They focus around key occasions of social interaction: the weekend, the disco, the bank-holiday trip, the night out in the 'centre', the 'standing-about-doing-nothing' of the weekday evening, the Saturday match. They cluster around particular locations. They develop

specific rhythms of interchange, structured relations between members: younger to older, experienced to novice, stylish to square. They explore 'focal concerns' central to the inner life of the group: things always 'done' or 'never done', a set of social rituals which underpin their collective identity and define them as a 'group' instead of a mere collection of individuals. They adopt and adapt material objects – goods and possessions – and reorganise them into distinctive 'styles' which express the collectivity of their being-as-a-group. These concerns, activities, relationships, materials become embodied in rituals of relationship and occasion and movement. Sometimes, the world is marked out, linguistically, by names or an *argot* which classifies the social world exterior to them in terms meaningful only within their group perspective, and maintains its boundaries. This also helps them to develop ahead of immediate activities a perspective on the immediate future – plans, projects, things to do to fill out time, exploits . . . They too are concrete, identifiable social formations constructed as a collective response to the material and situated experience of their class.

Though not 'ideological', subcultures have an ideological dimension: and, in the problematic situation of the post-war period, this ideological component became more prominent. In addressing the 'class problematic' of the particular strata from which they were drawn, the different subcultures provided for a section of working-class youth (mainly boys) *one* strategy for negotiating their collective existence. But their highly ritualised and stylised form suggests that they were also *attempts at a solution* to that problematic experience: a resolution which, because pitched largely at the symbolic level, was fated to fail. The problematic of a subordinate class experience can be 'lived through', negotiated or resisted; but it cannot be *resolved* at that level or by those means. There is no 'subcultural career' for the working-class lad, no 'solution' in the subcultural milieu, for problems posed by the key structuring experiences of the class.

There is no 'subcultural solution' to working-class youth unemployment, educational disadvantage, compulsory miseducation, dead-end jobs, the routinisation and specialisation of labour, low pay and the loss of skills. Subcultural strategies cannot match, meet or answer the structuring dimensions emerging in this period for the class as a whole. So, when the post-war subcultures address the problematics of their class experience, they often do so in ways which reproduce the gaps and discrepancies between real negotiations and symbolically displaced 'resolutions'. They 'solve', but in an imaginary way, problems which at the concrete material level remain unresolved. Thus the 'Teddy Boy' expropriation of an upper-class style of dress 'covers' the gap between largely manual, unskilled, near-lumpen real careers and life-chances, and the 'all-dressed-up-and-nowhere-to-go' experience of Saturday evening. Thus, in the expropriation and fetishisation of consumption and style itself, the 'Mods' cover for the gap between the never-ending-weekend and Monday's resumption of boring, dead-end work. Thus, in the resurrection of an archetypal and 'symbolic' (but, in fact,

anachronistic) form of working-class dress, in the displaced focusing on the football match and the 'occupation' of the football 'ends', Skinheads reassert, but 'imaginarily', the values of a class, the essence of a style, a kind of 'fan-ship' to which few working-class adults any longer subscribe: they 're-present' a sense of territory and locality which the planners and speculators are rapidly destroying: they 'declare' as alive and well a game which is being commer-cialised, professionalised and spectacularised. 'Skins Rule, OK'. OK? But

> in ideology, men do indeed express, not the real relation between them and their conditions of existence, but *the way* they live the relation between them and the conditions of their existence; this presupposes both a real and an '*imaginary*', '*lived*' relation. Ideology then, is . . . the (over determined) unity of the real relation and the imaginary relation . . . that expresses a will . . . a hope, or a nostalgia, rather than describing a reality.
>
> (Althusser 1969: 233–4)

Working-class subcultures are a response to a problematic which youth shares with other members of the 'parent' class culture. . . . But, over and above these shared class situations, there remains something privileged about the specifically *generational experience* of the young. Fundamentally, this is due to the fact that youth encounters the problematic of its class culture in *different sets of institutions and experiences* from those of its parents; and when youth encounters the same structures, it encounters them at *crucially different points* in its biographical careers.

We can identify these aspects of 'generational specificity' in relation to the three main life areas we pointed to earlier: education, work and leisure. Between the ages of five and sixteen, education is the institutional sphere which has the most sustained and intensive impact on the lives of the young. It is the 'paramount reality' imposing itself on experience, not least through the fact that it cannot (easily) be avoided. By contrast, the older members of the class encounter education in various *indirect* and distanced ways: through remembered experiences ('things have changed' nowadays); through special mediating occasions – parents' evenings, etc.; and through the interpreta-tions the young give of their school experiences.

In the area of work, the difference is perhaps less obvious, in that both young and old alike are facing similar institutional arrangements, organisa-tions and occupational situations. But within this crucial differences remain. The young face the problem of choosing and entering jobs, of learning both the formal and informal cultures of work – the whole difficult transition from school to work. . . .

In the broader context, the young are likely to be more vulnerable to the consequence of increasing unemployment than are older workers: in the unemployment statistics of the late [1960s], unskilled school leavers were twice as likely to be unemployed as were older, unskilled workers. In addition,

the fact of unemployment is likely to be differentially *experienced* at different stages in the occupational 'career'.

Finally, leisure must be seen as a significant life-area for the class. As Marx observed,

> The worker therefore only feels himself outside his work, and in his work feels outside himself. He is at home when he is not working, and when he is working he is not at home. His labour is therefore not voluntary but coerced; it is forced labour. It is therefore not the satisfaction of a need; it is merely the means to satisfy needs external to it.
>
> [Marx 1964: 110–11]

In working-class leisure, we see many of the results of that 'warrenning' of society by the working-class discussed above. Leisure and recreation seem to have provided a more negotiable space than the tightly-disciplined and controlled work situation. The working-class has imprinted itself indelibly on many areas of mass leisure and recreation. These form an important part of the corporate culture and are central to the experience and cultural identity of the whole class. Nevertheless, there are major differences in the ways working-class adults and young people experience and regard leisure. This difference became intensified in the 1950s and 1960s, with the growth of the 'teenage consumer' and the reorganisation of consumption and leisure provision (both commercial and non-commercial) in favour of a range of goods and services specifically designed to attract a youthful clientele. This widespread availability and high visibility of Youth Culture structured the leisure sphere in crucially different ways for the young. The equation of youth with consumption and leisure rearranged and *intensified* certain long-standing parent culture orientations; for example, towards the special and privileged meaning of 'freetime', and towards 'youth' as a period for 'having a good time while you can' – the 'last fling'. This reshaping of attitudes from within the class, in conjunction with pressures to rearrange and redistribute the patterns of leisure for the young from outside, served to highlight – indeed to *fetishise* – the meaning of leisure for the young. Thus, not only did youth encounter leisure in different characteristic institutions from their parents (caffs, discos, youth clubs, 'all nighters', etc.): these institutions powerfully presented themselves to the young as different from the past, partly because they were so uncompromisingly youthful.

Here we begin to see how forces, working right across a class, but differentially experienced as between the generations, may have formed the basis for generating an outlook – a kind of consciousness – specific to age position: a *generational consciousness*. We can also see exactly why this 'consciousness', though formed by class situation and the forces working in it, may nevertheless have taken the form of a consciousness apparently separate from, unrelated to, indeed, able to be set over against, its class content and context.

. . . A 'generational consciousness' is likely to be strong among those sectors of youth which are upwardly and outwardly mobile from the workings-class – e.g. Hoggart's 'scholarship boy'. Occupational and educational change in this period led to an increase in these paths of limited mobility. The upward path, through education, leads to a special focusing on *the school and the education system* as the main mechanism of advancement: it is this which 'makes the difference' between parents who stay where they were and children who move on and up. It involves the young person valuing the dominant culture positively, and sacrificing the 'parent' culture – even where this is accompanied by a distinct sense of cultural disorientation. His experience and self-identity will be based around mobility – something specific to his generation, rather than to the over-determining power of class. One of the things which supports this taking-over of a 'generational consciousness' by the scholarship boy is, precisely, his cultural isolation – the fact that his career is different from the majority of his peers. The peer group is, of course, one of the real and continuing bases for collective identities organised around the focus of 'generation'. But a sense of generational distinctness may also flow from an individual's isolation from the typical involvement in kinds of peer-group activities which, though specific to youth, are clearly understood as forming a sort of cultural apprenticeship to the 'parent' class culture. This kind of isolation may be the result of biographical factors – e.g. inability to enter the local football game where football is the primary activity of the peer group; or being a member of a relatively 'closed' and tight family situation. A young person, who for whatever reasons, fails to go through this class–culture apprenticeship, may be more vulnerable to the vicarious peer-group experience provided by the highly visible and widely accessible commercially provided Youth Culture, where the audience as a whole substitutes for the real peer group as one, vast, symbolic 'peer group': 'Our Generation'.

'Generational consciousness' thus has roots in the real experience of working-class youth as a whole. But it took a peculiarly intense form in the post-war subcultures which were sharply demarcated – amongst other factors – by age and generation. Youth felt and experienced itself as 'different', especially when this difference was inscribed in activities and interests to which 'age', principally, provided the passport. This does not necessarily mean that a 'sense of class' was thereby obliterated. Skinheads, for example, are clearly both 'generationally' and 'class' conscious. As Phil Cohen suggested, 'subculture is . . . a compromise solution, between two contradictory needs: the need to create and express *autonomy and difference* from parents . . . and the need to maintain . . . the *parental identifications* which support them' (Cohen 1972: 26). It is to the formation of these generationally distinct working-class subcultures that we next turn. . . .

It is at the intersection between the located parent culture and the mediating institutions of the dominant culture that youth subcultures arise. Many forms of adaptation, negotiation and resistance, elaborated by the 'parent'

culture in its encounter with the dominant culture, are borrowed and adapted by the young in *their* encounter with the mediating institutions of provision and control. In organising their response to these experiences, working-class youth subcultures take some things principally from the located 'parent' culture: but they apply and transform them to the situations and experiences characteristic of their own distinctive group-life and generational experience. Even where youth subcultures have seemed most distinctive, different, stylistically marked out from adults and other peer-group members of their 'parent' culture, they develop certain distinctive outlooks which have been, clearly, structured by the parent culture. We might think here of the recurrent organisation around collective activities ('group mindedness'); or the stress on 'territoriality' (to be seen in both the Teddy Boys and Skinheads); or the particular conceptions of masculinity and of male dominance (reproduced in all the post-war youth subcultures). The 'parent' culture helps to define these broad, historically located 'focal concerns'. Certain themes which are key to the 'parent culture' are reproduced at this level again and again in the subcultures, even when they set out to be, or are seen as, 'different'.

But there are also 'focal concerns' more immediate, conjunctural, specific to 'youth' and its situation and activities. On the whole, the literature on post-war subculture has neglected the first aspect (what is shared with the 'parent' culture) and over-emphasised what is distinct (the 'focal concerns' of the youth groups). But, this second element – which is, again, generationally very specific – must be taken seriously in any account. It consists both of the materials available to the group for the construction of subcultural identities (dress, music, talk), and of their contexts (activities, exploits, places, caffs, dance halls, day-trips, evenings-out, football games, etc.). Journalistic treatments, especially, have tended to isolate *things*, at the expense of their use, how they are borrowed and transformed, the activities and spaces through which they are 'set in motion', the group identities and outlooks which imprint a style *on* things and objects. While taking seriously the significance of objects and things for a subculture, it must be part of our analysis to *de*-fetishise them.

The various youth subcultures have been identified by their possessions and objects: the boot-lace tie and velvet-collared drape jacket of the Ted, the close crop, parka coats and scooter of the Mod, the stained jeans, swastikas and ornamented motorcycles of the bike-boys, the bovver boots and skinnedhead of the Skinhead, the Chicago suits or glitter costumes of the Bowieites, etc. Yet, despite their visibility, things simply appropriated and worn (or listened to) do not make a style. What makes a style is the activity of stylisation – the active organisation of objects with activities and outlooks, which produce an organised group-identity in the form and shape of a coherent and distinctive way of 'being-in-the-world'. Phil Cohen, for example, has tried to shift the emphasis away from things to the *modes* of symbolic construction through which style is generated in the subcultures. He identified four modes for the generation of the subcultural style: dress, music, ritual and *argot*.

Whilst not wanting to limit the 'symbolic systems' to these particular four, and finding it difficult to accept the distinction (between less and more 'plastic') which he makes, we find this emphasis on group generation far preferable to the instant stereotyped association between commodity-objects and groups common in journalistic usage.

Working-class subcultures could not have existed without a real economic base: the growth in money wages in the 'affluent' period, but, more important, the fact that incomes grew more rapidly for teenagers than for adults in the working-class, and that much of this was 'disposable income' (income available for leisure and non-compulsory spending). But income, alone, does not make a style either. The subcultures could not have existed without the growth of a consumer market specifically geared to youth. The new youth industries provided the raw materials, the goods: but they did not, and when they tried failed to, produce many very authentic or sustained 'styles' in the deeper sense. The objects were there, available, but were *used* by the groups in the construction of distinctive styles. But this meant, not simply picking them up, but actively constructing a specific selection of things and goods *into* a style. And this frequently involved . . . subverting and transforming these things, from their given meaning and use, to other meanings and uses. All commodities have a social use and thus a cultural meaning. We have only to look at the language of commodities – advertising – where, as Barthes observes, there is no such thing as a simple 'sweater': there is only a 'sweater for autumnal walks in the wood' or a sweater for 'relaxing at home on Sundays', or a sweater for 'casual wear', and so on (Barthes, 1971). Commodities are, also, cultural *signs*. They have already been invested, by the dominant culture, with meanings, associations, social connotations. Many of these meanings seem fixed and 'natural'. But this is only because the dominant culture has so fully appropriated them to its use, that the meanings which it attributes to the commodities have come to appear as the only meaning which they can express. In fact, in cultural systems, there is no 'natural' meaning as such. Objects and commodities do not mean any one thing. They 'mean' only because they have already been arranged, according to social use, into cultural codes of meaning, which *assign meanings to them*. The bowler hat, pin-stripe suit and rolled umbrella do not, in themselves, mean 'sobriety', 'respectability', bourgeois-man-at-work. But so powerful is the social code which surrounds these commodities that it would be difficult for a working-class lad to turn up for work dressed like that without, either, aspiring to a 'bourgeois' image or clearly seeming to take the piss out of the image. This trivial example shows that it is possible to expropriate, as well as to appropriate, the social meanings which they seem 'naturally' to have: or, by combining them with something else (the pin-stripe suit with brilliant red socks or white running shoes, for example), to change or inflect their meaning. . . .

Working-class youth needed money to spend on expressive goods, objects and activities – the post-war consumer market had a clear economic infra-

structure. But neither money nor the market could fully dictate what groups used these things to *say* or *signify* about themselves. This re-signification was achieved by many different means. One way was to inflect 'given' meanings by combining things borrowed from one system of meanings into a different code, generated by the subculture itself, and through subcultural use. Another way was to modify, by addition, things which had been produced or used by a different social group (e.g. the Teddy Boy modifications of Edwardian dress). . . . Another was to intensify or exaggerate or isolate a given meaning and so change it (the 'fetishising' of consumption and appearance by the Mods . . .; or the elongation of the pointed winkle-picker shoes of the Italian style; or the current 'massification' of the wedge-shapes borrowed from the 1940's). Yet another way was to combine forms according to a 'secret' language or code, to which only members of the group possessed the key (e.g. the *argot* of many subcultural and deviant groups; the 'Rasta' language of black 'Rudies'). These are only *some* of the many ways in which the subcultures used the materials and commodities of the 'youth market' to construct meaningful styles and appearances for themselves.

Far more important were the aspects of group life which these appropriated objects and things were made to reflect, express and resonate. It is this reciprocal effect, between the things a group uses and the outlooks and activities which structure and define their use, which is the generative principle of stylistic creation in a subculture. This involves members of a group in the appropriation of particular objects which are, or can be made, 'homologous' with their focal concerns, activities, group structure and collective self-image – objects in which they can see their central values held and reflected. . . . The adoption by Skinheads of boots and short jeans and shaved hair was 'meaningful' in terms of the subculture only because these external manifestations resonated with and articulated Skinhead conceptions of masculinity, 'hardness' and 'working-classness'. This meant overcoming or negotiating or, even, taking over in a positive way many of the negative meanings which, in the dominant cultural code, attached to these things: the 'prison-crop' image of the shaved head, the work-image, the so-called 'outdated cloth-cap image', and so on. The new meanings emerge because the 'bits' which had been borrowed or revived were brought together into a new and distinctive stylistic *ensemble*: but also because the symbolic objects – dress, appearance, language, ritual occasions, styles of interaction, music – were made to form *a unity* with the group's relations, situation, experiences: the crystallisation in an expressive form, which then defines the group's public identity. The symbolic aspects cannot, then, be separated from the structure, experiences, activities and outlook of the groups as social formations. Subcultural style is based on the infra-structure of group relations activities and contexts.

This registering of group identity, situation and trajectory in a visible style both consolidates the group from a loosely focused to a tightly bounded entity: and sets the group off, distinctively, from other similar and dissim-

ilar groups. Indeed, like all other kinds of cultural construction, the symbolic use of things to consolidate and express an internal coherence was, in the same moment, a kind of implied opposition to (where it was not an active and conscious contradiction of) *other* groups *against* which its identity was defined. This process led, in our period, to the distinctive visibility of those groups which pressed the 'subcultural solution' to its limits along this stylistic path. It also had profound negative consequences for the labelling, stereotyping and stigmatisation, in turn, of those groups by society's guardians, moral entrepreneurs, public definers and the social control culture in general.

It is important to stress again that subcultures are only *one* of the many different responses which the young can make to the situations in which they find themselves. In addition to indicating the range and variation in the options open to youth, we might add a tentative scheme which helps to make clear the distinction we are drawing between youth's *position* and the cultural options through which particular responses are organised.

We can distinguish, broadly, between three aspects: structures, cultures and biographies. . . . By *structures* we mean the set of socially organised positions and experiences of the class in relation to the major institutions and structures. These positions generate a set of common relations and experiences from which meaningful actions – individual and collective – are constructed. *Cultures* are the range of socially organised and patterned responses to these basic material and social conditions. Though cultures form, for each group, a set of traditions – lines of action inherited from the past – they must always be collectively constructed anew in each generation. Finally, *biographies* are the 'careers' of particular individuals through these structures and cultures – the means by which individual identities and life-histories are constructed out of collective experiences. Biographies recognise the element of individuation in the paths which individual lives take through collective structures and cultures, but they must not be conceived as either wholly individual or free-floating. Biographies cut paths in and through the determined spaces of the structures and cultures in which individuals are located. Though we have not been able, here, to deal at all adequately with the level of biography, we insist that biographies only make sense in terms of the structures and cultures through which the individual constructs himself or herself.

Angela McRobbie and
Jenny Garber

GIRLS AND SUBCULTURES [1975]

VERY LITTLE SEEMS to have been written about the role of girls in youth cultural groupings. They are absent from the classic subcultural ethnographic studies, the pop histories, the personal accounts and the journalistic surveys of the field. When girls do appear, it is either in ways which uncritically reinforce the stereotypical image of women with which we are now so familiar . . . for example, Fyvel's reference, in his study of teddy boys [Fyvel 1961], to 'dumb, passive teenage girls, crudely painted' . . . or else they are fleetingly and marginally presented:

> It is as if everything that relates only to us comes out in footnotes to the main text, as worthy of the odd reference. We come on the agenda somewhere between 'Youth' and 'Any Other Business'. We encounter ourselves in men's cultures as 'by the way' and peripheral. According to all the reflections we are not really there.
>
> [Rowbotham 1973: 35]

How do we make sense of this invisibility? Are girls really not present in youth subcultures? Or is it something in the way this kind of research is carried out that renders them invisible? When girls are acknowledged in the literature, it tends to be in terms of their sexual attractiveness. But this, too, is difficult to interpret. For example, Paul Willis comments on the unattached girls who hung around with the motor-bike boys he was studying, as follows: 'What seemed to unite them was a common desire for an attachment to a male and a common inability to attract a man to a long-term relationship. They tended to be scruffier and less attractive than the attached girls' [Willis 1978].

Is this simply a typically dismissive treatment of girls reflecting the natural rapport between a masculine researcher and his male respondents? Or is it that the researcher who is, after all, studying the motor-bike boys, finds it difficult not to take the boys' attitudes to and evaluation of the girls, seriously? He therefore reflects this in his descriptive language and he unconsciously adopts it in the context of the research situation. Willis later comments on the girls' responses to his questions. They are unforthcoming, unwilling to talk and they retreat, in giggles, into the background . . . Are these responses to the man as a researcher or are they the result of the girls' recognition that 'he' identifies primarily with 'them'? Is this characteristic of the way in which girls customarily negotiate the spaces provided for them in a male-dominated and male-defined culture? And does this predispose them to retreat, especially when it is also a situation in which they are being assessed and labelled according to their sexual attributes?

It is certainly the case that girls do not behave in this way in all mixed-sex situations. In the classroom, for example, girls will often display a great show of feminine strength from which men and boys will retreat. It may well be that in Willis's case the girls simply felt awkward and self-conscious about being asked questions in a situation where they did not feel particularly powerful or important, especially if they were not the steady girlfriends of the boys in question.

What follows is a tentative attempt to sketch some of the ways we might think about and research the relationship between girls and subcultures. Many of the concepts utilised in the study of male subcultures are retained: for example, the centrality of class, the importance of school, work, leisure and the family: the general social context within which the subcultures have emerged, and the structural changes in post-war British society which partially define the different subcultures. Added to these issues are the important questions of sex and gender. The crucial question is: How does this dimension reshape the field of youth cultural studies as it has come to be defined?

It has been argued recently for example that class is a critical variable in defining the different subcultural options available to middle-class and working-class boys. Middle-class subcultures offer more full-time careers, whereas working-class subcultures tend to be restricted to the leisure sphere. This structuring of needs and options must also work at some level for girls. It might be easier for middle-class hippie girls, for example, to find an 'alternative' career in the counter-culture than it would be for working-class skinhead girls to find a job in that culture. Some subcultural patterns are therefore true for both boys and girls, while others are much more gender-divergent.

It might even be the case that girls are not just marginal to the post-war youth cultures but located structurally in an altogether different position. If women are marginal to the male cultures of work, it is because they are central and pivotal to a subordinate sphere. They are marginal to work because they are central to the family. The marginality of girls in these 'spectacular'

male-focused subcultures might redirect our attention away from this arena towards more immediately recognisable teenage and pre-teenage female spheres like those forming around teenybop stars and the pop-music industry. . . . Girls' subcultures may have become invisible because the very term 'subculture' has acquired such strong masculine overtones.

Are girls really absent from subcultures?

The most obvious factor which makes this question difficult to answer is the domination of sociological work (as is true of most areas of scholarship) by men. Paradoxically, the exclusion of women was as characteristic of the new radical theories of deviance and delinquency as it had been of traditional criminology. The editors of *Critical Criminology* argue that the new deviancy theory often amounted to a 'celebration rather than an analysis of the deviant form with which the deviant theorist could vicariously identify – an identification by powerless intellectuals with deviants who appeared more successful in controlling events' [Taylor, Walton and Young 1975]. With the possible exception of sexual deviance, women constituted an uncelebrated social category, for radical and critical theorists. This general invisibility was of course cemented by the social reaction to the more extreme manifestations of youth subcultures. The popular press and media concentrated on the sensational incidents associated with each subculture (for example, the teddy-boy killings, the Margate clashes between mods and rockers). One direct consequence of the fact that it is always the violent aspects of a phenomenon which qualify as newsworthy is that these are precisely the areas of subcultural activity from which women have tended to be excluded. . . .

Are girls present but invisible?

. . . Texts and images suggest . . . that girls were involved with and considered themselves as part of the teddy-boy subculture. Girls can be seen in footage from the 1950s dancing with teddy-boys at the Elephant and Castle; they can also be seen in the background in the news pictures taken during the Notting Hill race riots of 1958. There are, however, many reasons why, to working-class girls in the late 1950s, this was not a particularly attractive option.

Though girls participated in the general rise in the disposable income available to youth in the 1950s, girls' wages were not as high as those of boys. Patterns of spending were also structured in a different direction. Girls' magazines emphasised a particularly feminine mode of consumption and the working-class girl, though actively participating in the world of work, remained more focused on home and marriage than her male counterpart. Teddy-boy culture was an escape from the claustrophobia of the family, into the street and 'caff'. While many girls might adopt an appropriate way of

dressing, complementary to the teds, they would be much less likely to spend the same amount of time hanging about on the streets. Girls had to be careful not to 'get into trouble' and excessive loitering on street corners might be taken as a sexual invitation to the boys. The double standard was probably more rigidly maintained in the 1950s than in any other time since then. The difficulty in obtaining effective contraception, the few opportunities to spend time unsupervised with members of the opposite sex, the financial dependency of the working-class woman on her husband, meant that a good reputation mattered above everything else. As countless novels of the moment record, neighbourhoods flourished on rumours and gossip and girls who spent too much time on the street were assumed to be promiscuous.

At the same time the expanding leisure industries were directing their attention to *both* boys and girls. Girls were as much the subject of attention as their male peers when it came to pin-up pictures, records and magazines. Girls could use these items and activities in a different context from those in which boys used them. Cosmetics of course were to be worn outside the home, at work and on the street, as well as in the dance-hall. But the rituals of trying on clothes, and experimenting with hair-styles and make-up were home-based activities. It might be suggested that girls' culture of the time operated within the vicinity of the home, or the friends' home. There was room for a great deal of the new teenage consumer culture within the confines of the girls' bedrooms. Teenage girls did participate in the new public sphere afforded by the growth of the leisure industries, but they could also consume at home, upstairs in their bedrooms.

The involvement of girls in the teddy-boy subculture was sustained therefore by a complementary but different pattern. What girls who considered themselves 'teddy-girls', did, and how they acted, was possibly exactly the same as their more conventional non-subcultural friends. It is gender therefore which structures differences rather than subcultural attachment. The same process can be seen at work in the emergence of rock and pop music. Girls and boys, in or out of subcultures, responded differently to this phenomenon. Boys tended to have a more participative and a more technically-informed relationship with pop, where girls in contrast became fans and readers of pop-influenced love comics. . . .

What broad factors might have created a situation where girls could find subcultural involvement an attractive possibility? The emergence of a softer more feminised subculture in the 1960s, might well have opened the doors to female participation. There were certainly thousands of 'mod' girls who made their appearance in the nightclubs, on the streets, at work and even on the fringes of the clashes between the mods and rockers during the various Bank-holiday weekends throughout the mid-1960s (and remembered in the film, *Quadrophenia*). It may well be that the mod preoccupation with style and the emergence of the unisex look and the 'effeminate' mod man, gave girls a more legitimate place in the subculture than had previously been the case.

This trend was confirmed and extended as mod moved towards the consumerist mainstream, and as it began to give way simultaneously to the hippy underground and psychedelia. In this space, inhabited largely though not exclusively by middle-class youth, we also find women taking on a much higher profile. . . .

Where girls are visible, what are their roles and do these reflect the general subordination of women in culture?

Three selected images – the motor-bike girl, the 'mod' girl, and the hippy – will have to do here: where girls are present, but where the way they are present suggests that their cultural subordination is retained and reproduced.

Motor-bike girl

The motor-bike girl, leather-clad, a sort of subcultural pin-up heralding – as it appeared in the press – a new and threatening sort of sexuality. This image was often used as a symbol of the new permissive sexuality of the 1960s and was encapsulated in the figure of Brigitte Bardot astride a motor-bike with her tousled hair flying behind her. More mundanely this image encoded female sexuality in a modern, bold and abrasive way. With matte pan-stick lips, an insolent expression in her eyelined eyes and an unzipped jacket, the model looked sexual, numbed and unfeeling, almost expressionless. This was an image therefore at odds with conventional femininity and suggestive of sexual deviance. At the same time this very image was utilised in advertising and in soft pornography, an example of how – within the repertoire of subcultural representations – girls and women have always been located nearer to the point of consumerism than to the 'ritual of resistance'.

In rocker or motor-bike culture this sexualised image of a girl riding a bike remained a fantasy rather than a reality. Girls were rarely if ever seen at the handles and instead were ritualistically installed on the back seat. If Paul Willis is right, few girls ever penetrated to the symbolic heart of the culture – to the detailed knowledge of the machine, to the camaraderie and competition between the riders [Willis 1978]. A girl's membership seemed to depend entirely on whose girlfriend she was. In the Hell's Angels groups, where the dynamics of the subculture were even more strenuously masculine, girls occupied particular institutionalised roles. Hunter Thompson suggests that the Angels treated their women primarily as sexual objects. If they were not objects of the 'gang-bang' the only other role open to them was that of a 'Mama' [Thompson 1966].

The mod girl

Mod culture offers a more complex subcultural opportunity for girls, if for no other reason than that it was located in and sprang from the mainstream of working-class teenage consumerism. In the mid- to late 1960s there were more teenage girls at work and there were new occupations in the distribution and service sector, particularly in the urban centres. Jobs in the new boutiques, in the beauty business and in clothing as well as in the white-collar sector all involved some degree of dressing up. It was from the mid-1960s onwards that the girls behind the counter in the new boutiques were expected to reflect the image of the shop and thus provide a kind of model or prototype for the young consumer. Glamour and status in these fields often compensated for long hours and low wages. Full employment and freedom to 'look the part' at work, encouraged greater freedom in domestic life. Tom Wolfe's accurate and vivid account of mod girls in London describes how many of these girls were living in flats and bedsits, a pattern hitherto unknown for working-class girls [Wolfe 1968b]. These factors made it more likely that girls got involved in mod culture than might otherwise have been the case.

Because mod style was in a sense quietly imperceptible to those unaware of its fine nuances, involvement was more easily accommodated into the normal routines of home, school and work. There was less likelihood of provoking an angry parental reaction since the dominant look was neat, tidy and apparently unthreatening. Parents and teachers knew that girls looked 'rather odd these days, with their white drawn faces and cropped hair', but as Dave Laing noted, 'there was something in the way they moved which adults couldn't make out' [Laing 1969]. The fluidity and ambiguity of the subculture meant that a girl could be around, could be a 'face' without necessarily being attached to a boy. Participation was almost wholly reliant on wearing the right clothes, having the right hair-style and going to the right clubs. With this combination right, the girl was a mod. Like her male counterpart, the mod girl demonstrated the same fussiness for detail in clothes, the same over-attention to appearance. Facial styles emphasised huge, darkened eyes and body-style demanded thinness.

It may be that mod girls came to the attention of the commentators and journalists because of the general 'unisex' connotations of the subculture. The much mentioned effeminacy of the boys drew attention to the boyish femininity of the girls, best exemplified in the early fashion shots of Twiggy. An absence of exaggerated masculinity like that displayed in the rocker subculture or by Willis's motor-bike boys, made the mod subculture both exciting and accessible to girls. Like their female counterparts, these boys were more likely to be employed in white-collar office work than in unskilled manual jobs. This greater visibility of girls in the subculture, single or attached, has also got to be seen in terms of the increasing visibility and confidence of teenage girls in the 1960s, working-class and middle-class. Mod culture

tippled easily into 'Swinging London' whose favourite image was the 'liberated' dolly-bird. The Brooke clinics opened in 1964 making the pill available to single girls and this facility also affected the sexual confidence not just of the middle-class girls in the universities but also of the working-class girls living in London's bedsitter-land.

However, this new prominence and confidence should not be interpreted too loosely. The presence of 'girls' in the urban panoramas of trendy fashion photography, the new-found autonomy and sexual freedom, have got to be set alongside the other material factors which still shaped and determined their lives. This independence reflected short-term rather than long-term affluence. The jobs which provided the extra cash afforded immediate access to consumer goods, but few opportunities for promotion or further training. There is nothing to suggest that participation in the mod subculture changed the social expectations of girls, or loosened the bonds between mothers and daughters, even if they were temporarily living in flats. These girls had been educated under the shadow of the Newsom Report and had therefore been encouraged to consider marriage their real careers.

The hippy

The term 'hippy' is of course an umbrella term, covering a variety of diverse groupings and tendencies. However, it is most likely that girls would have entered this subculture through the social life afforded by the universities in the late 1960s and early 1970s. Access to prolonged higher education gives the middle-class girl the space, by right, which her working-class counterpart is denied or else gains only through following a more illegitimate route. The flat or the room in the hall of residence provides the female student with space to experiment, time of her own, and relatively unsupervised leisure. She also has three or four years during which marriage is pushed into the background. The lack of strict demarcation between work and leisure also allows for – indeed encourages – the development of a more uniquely personal style. The middle-class girl can express herself in dress without having to take into account the restrictions of work.

None the less, traditional sex roles prevailed in the hippy subculture as numerous feminist authors have described. Femininity moved imperceptibly between the 'earth-mother', the pre-Raphaelite mystic, the kind of 'goddess' serenaded by Bob Dylan, and the dreamy fragility of Marianne Faithful. Media representations and especially visual images, of course, have to be read and interpreted with care. Moral panics around 'dirty hippies' frequently drew attention to the presence of girls and to the sexual immorality of commune-living. The images which linger tend also to suggest excessive femininity and 'quiet restraint' as demonstrated in the figure of Joni Mitchell. A still more dramatic rejection of the feminine image in the early 1970s carried a self-destructive element in it, as the addiction and eventual death of Janis Joplin shows. Although the range of available and acceptable images of femininity

tended to confirm already-existing stereotypes, none the less the hippy under-ground, set against a background of widespread social protest and youthful revolt, also represented an empowering space for women. Within its confines and even on the pages of the underground press, the first murmurings of feminism were heard.

Do girls have alternative ways of organising their cultural life?

The important question may not be the absence or presence of girls in male subcultures, but the complementary ways in which young girls interact among themselves and with each other to form a distinctive culture of their own, one which is recognised by and catered to in the girls' weekly comics and magazines. For example 'teenybopper' culture, based round an endless flow of young male pop stars, is a long-standing feature of post-war girls' culture. Where this kind of cultural form is markedly different from the male sub-cultures, is in its commercial origins. It is an almost totally packaged cultural commodity. It emerges from within the heart of the pop-music business and relies on the magazines, on radio and TV for its wide appeal. As a result it seems to carry less of the creative elements associated with the working-class youth subcultures considered by male sociologists like those mentioned above. However, teenybopper stars carry socially exclusive connotations and oppor-tunities for their fans. . . . Even in so manufactured a form of pop culture we can locate a variety of negotiative processes at work:

1. Young pre-teen girls have access to less freedom than their brothers. Because they are deemed to be more at risk on the streets from attack, assault, or even abduction, parents tend to be more protective of their daughters than they are of their sons (who after all have to learn to defend themselves at some point, as men). Teenybopper culture takes these restrictions into account. Participation is not reliant on being able to spend time outside the home on the streets. Instead teenybopper styles can quite easily be accommodated into school-time or leisure-time spent in the home. . . .
2. There are few restrictions in relation to joining this mainstream and commercially-based subculture. It carries no strict rules and requires no special commitment to internally generated ideas of 'cool'. Nor does it rely on a lot of money. Its uniforms are cheap, its magazines are well within the pocket-money weekly budget, its records are afford-able and its concerts are sufficiently rare to be regarded as treats.
3. Membership carries relatively few personal risks. For girls of this age real boys remain a threatening and unknown quantity. Sexual experi-ence is something most girls of all social classes want to hold off for some time in the future. They know, however, that going out with

boys invariably carries the possibility of being expected to kiss, or 'pet'. The fantasy boys of pop make no such demands. They 'love' their fans without asking anything in return. . . .

4. The kind of fantasies which girls construct around these figures play the same kind of role as ordinary daydreams. Narrative fantasies about bumping into David Cassidy in the supermarket, or being chosen out by him from the front row of a concert, both carry a strongly sexual element, and are also means of being distracted from the demands of work or school or other aspects of experience which might be perceived as boring or unrewarding.

5. Girls who define themselves actively within these teenybopper subcultures are indeed being *active*, even though the familiar iconography seems to reproduce traditional gender stereotypes with the girl as the passive fan, and the star as the active male. These girls are making statements about themselves as consumers of music, for example. . . . Teenybopper culture offers girls a chance to define themselves as different from and apart from both their younger and their older counterparts. They are no longer little girls and not yet teenage girls. Yet this potentially awkward and anonymous space can be, and is transformed into a site of active feminine identity.

Conclusion

Female participation in youth cultures can best be understood by moving away from the 'classic' subcultural terrain marked out as oppositional and creative by numerous sociologists. Girls negotiate a different leisure space and different personal spaces from those inhabited by boys. These in turn offer them different possibilities for 'resistance', if indeed that is the right word to use. Some of the cultural forms associated with pre-teenage girls, for example, can be viewed as responses to their perceived status as girls and to their anxieties about moving into the world of teenage sexual interaction. One aspect of this can be seen in the extremely tight-knit friendship groups formed by girls. A function of the social exclusiveness of such groupings is to gain private, inaccessible space. This in turn allows pre-pubetal girls to remain seemingly inscrutable to the outside world of parents, teachers, youth workers and boys as well. Teenybopper subcultures could be interpreted as ways of buying time, within the commercial mainstream, from the real world of sexual encounters while at the same time imagining these encounters, with the help of the images and commodities supplied by the commercial mainstream, from the safe space of the all-female friendship group.

Paul E. Willis

CULTURE, INSTITUTION, DIFFERENTIATION [1977]

NO MATTER HOW HARD the creation, self-making and winning of counter-school culture, it must . . . be placed within a larger pattern of working-class culture. This should not lead us, however, to think that this culture is all of a piece, undifferentiated or composed of standard clonal culture modules spontaneously reproducing themselves in an inevitable pattern.

Class cultures are created specifically, concretely in determinate conditions, and in particular oppositions. They arise through definite struggles over time with other groups, institutions and tendencies. Particular manifestations of the culture arise in particular circumstances with their own form of marshalling and developing of familiar themes. The themes are *shared* between particular manifestations because all locations at the same level in a class society share similar basic structural properties, and the working-class people there face similar problems and are subject to similar ideological constructions. In addition, the class culture is supported by massive webs of informal groupings and countless overlappings of experience, so that central themes and ideas can develop and be influential in practical situations where their direct logic may not be the most appropriate. A pool of styles, meanings and possibilities are continuously reproduced and always available for those who turn in some way from the formalised and official accounts of their position and look for more realistic interpretations of, or relationships to, their domination. As these themes are taken up and recreated in concrete settings, they are reproduced and strengthened and made further available as resources for others in similar structural situations.

However, these processes of borrowing, regeneration and return in particular social regions are not often recognised by those concerned as class processes. Neither the institutionalised, customary and habitual forms in which domination is mediated from basic structural inequality, nor the regional forms in which they are broken out of, opposed and transformed, are recognised for what they are. This is partly because social regions and their institutional supports and relationships really do have a degree of autonomy and separateness from each other and the rest of the social system. They have their own procedures, rules and characteristic ideological balances. They have their own legitimising beliefs, their own particular circles of inversion and informality.

Despite their similarity, it is a mistake, therefore, to reduce particular social forms and regions too quickly to the obvious central class dynamics of domination and resistance. They have simultaneously both a local, or institutional, logic and a larger class logic. The larger class logic could not develop and be articulated without these regional instances of struggle, nor could, however, these instances be differentiated internally and structured systematically in relation to other instances and the reproduction of the whole without the larger logic.

The state school in advanced capitalism, and the most obvious manifestations of oppositional working-class culture within it, provide us with a central case of mediated class conflict and of class reproduction in the capitalist order. It is especially significant in showing us a circle of unintended consequences which act finally to reproduce not only a regional culture but the class culture and also the structure of society itself.

Emergence of opposition

Even if there is some form of social division in the junior school, in the first years of the secondary school everyone, it seems, is an 'ear'ole'. Even the few who come to the school with a developed delinquent eye for the social landscape behave in a conformist way because of the lack of any visible support group:

[In a group discussion]
> SPIKE In the first year . . . I could spot the ear'oles. I knew who the fucking high boys was, just looking at 'em walking around the playground – first day I was there . . . I was just quiet for the first two weeks, I just kept meself to meself like, not knowing anybody, it took me two years to get in with a few mates. But, er . . . after that, the third year was a right fucking year, fights, having to go to teachers a lot . . .

In the second to fourth years, however, some individuals break from this pattern. From the point of view of the student this break is the outstanding

landmark of his school life, and is remembered with clarity and zest. 'Coming out' as a 'lad' is a personal accomplishment:

[In an individual interview]

> JOEY And in the second year, I thought, 'This is a fucking dead loss', 'cos I'd got no real mates, I saw all the kids palling up with each other, and I thought, 'It's a fucking dead loss, you've got to have someone to knock about with'. So I cracked eyes on Noah and Benson, two kids who weren't in the group, fucking Benson, summat's happened to Benson, summat terrible, he's really turned fucking ear'ole now, but I still like him, he still makes me laff. He can't say his r's properly . . . but I clocked . . . I seen these two, 'cos our mum used to be at work then, and our dad used to go out at night, so I grabbed them and I said, 'Do you want to come down to our fucking house tonight?', and skin-heads just starting up then, and I think Benson and them had the first fucking levis and monkey boots. And I started knocking about with them, they came down the first night, and we drank a lot of whisky, and I pretended to be fucking drunk like, which we warn't, and it was from there on. We parted off from the rest . . . we always used to sit together, we used to start playing up wild, like, 'cos playing up in them days was fucking hitting each other with rulers, and talking, and it just stemmed from there. And Bill started to come with us, Fred and then Spike . . . And from then on it just escalated, just came more and more separated. We used to go out of nights, and carrying on from hitting each other with rulers we used to fucking chuck bottles at each other, so the major occupation was roaming around the streets, looking for bottles to lam at each other. And from that came a bit of vandalism, here and there like. . . .

Staff too notice these dramatic changes and are not short of explanations. Kids start 'lording it about' and develop 'wrong attitudes' because they become exposed to 'bad influences'. The 'bad influences' arise from behaviour attributed, in the first place, to individual pathology: 'He's made of rubber, there's nothing to him at all', 'If you want the truth, you just take the opposite of what he says', 'He's a mixed up lad, no idea where he's going', 'He worries me stiff, his personality is deficient'. The counter-school culture arises from permutations of these character deficiencies in relation to 'the impressionable'. We have the classic model of a minority of 'trouble-makers' being followed by the misguided majority:

> DEPUTY HEAD Joey is the outstanding one as far as follow my leader is concerned . . . Spike being the barrack room lawyer would support him, and those two did the stirring . . . and Will is easily led.

It is interesting generally to note just how much teachers personalise, and base observations about kids – themselves lost in social and class processes – on what are taken to be concrete individual characteristics. Verbal comments start with 'I like' or 'I haven't much time for', and accounts are interrupted – in a way which is presented as illuminating – with '. . . a bloody good lad too', or '. . . a bad lot altogether, have you seen his dad?' Written school leaving and other reports clearly demonstrate notions of pathology in relation to a basic social model of the leaders and the led:

> [Joey] proved himself to be a young man of intelligence and ability who could have done well at most subjects, but decided that he did not want to work to develop this talent to the full and allowed not only his standard of work to deteriorate, except for English, but also attendance and behaviour . . . too often his qualities of leadership were misplaced and not used on behalf of the school.

> [Spansky] in the first three years was a most co-operative and active member of school. He took part in the school council, school play and school choir in this period and represented the school at cricket, football and cross-country events.
> Unfortunately, this good start did not last and his whole manner and attitude changed. He did not try to develop his ability in either academic or practical skills . . . his early pleasant and cheerful manner deteriorated and he became a most unco-operative member of the school . . . hindered by negative attitudes.

> [Eddie's] conduct and behaviour was very inconsistent and on occasions totally unacceptable to the school. A lack of self-discipline was apparent and a tendency to be swayed by group behaviour revealed itself.

Explanations involving random causality or pathology may or may not hold elements of truth. Certainly they are necessary explanations-in-use for teachers trying to run a school and make decisions in the contemporary situation; they will not do, however, as proper social explanations for the development of an anti-school culture.

Differentiation and the teaching paradigm

The particular process by which working-class culture creatively manifests itself as a concrete form within, and separates itself from even as it is influenced by, the particular institution I shall call *differentiation*. *Differentiation* is the process whereby the typical exchanges expected in the formal institutional paradigm are reinterpreted, separated and discriminated with respect

to working-class interests, feelings and meanings. Its dynamic is opposition to the institution which is taken up and reverberated and given a form of reference to the larger themes and issues of the class culture. *Integration* is the opposite of *differentiation* and is the process whereby class oppositions and intentions are redefined, truncated and deposited within sets of apparently legitimate institutional relationships and exchanges. Where *differentiation* is the instrusion of the informal into the formal, *integration* is the progressive constitution of the informal into the formal or official paradigm. It may be suggested that all institutions hold a balance between *differentiation* and *integration*, and that *differentiation* is by no means synonymous with breakdown or failure in function. Indeed, as I will go on to argue, it is the aspects of *differentiation* in the make up of an institution, and its effects upon particular social regions, which allow it to play a successful, if mystifying, role in social reproduction. *Differentiation* is experienced by those concerned as, on the one hand, a collective process of learning whereby the self and its future are critically separated from the pre-given institutional definitions and, on the other hand, by institutional agents, as inexplicable breakdown, resistance and opposition. What is produced, on the one side, are working-class themes and activities reworked and reproduced into particular institutional forms and, on the other, retrenchment, hardening, or softening – all variants of a response to loss of legitimacy – of the formal institutional paradigm. Within the institution of the school the essential official paradigm concerns a particular view of teaching and its *differentiation* produces forms of the counter-school culture.

There are a number of possible relationships between teacher and taught. . . . I want to outline the basic teaching paradigm which I suggest locates all others – even as they attempt to go beyond it – and which, I would argue, remains massively dominant in our schools. Whether modified or not, near to the surface or not, its structure is common to all the varied main forms of classroom teaching.

Teachers know quite well that teaching is essentially a relationship between potential contenders for supremacy. It makes sense to speak of, and it does feel like, 'winning and losing':

> DEPUTY HEAD It's a funny thing . . . you get a situation where you've got a class or a boy and you think, 'God, he's beaten me', but the dividing line is so close, push a bit harder and you're over, and you're there . . . this is surprising about kids who are supposed to be dull. They will find a teacher's weakness as quickly as any lad.

Yet the teacher's actual power of direct coercion in modern society is very limited. The kids heavily outnumber the teachers and sanctions can be run through with frightening rapidity. The young teacher often wants a show of force to back him up; the experienced teacher knows that the big guns can only fire once:

> DEPUTY HEAD You see we have very few sanctions and punishments we can apply. Very few indeed. So it's a question of spacing them out and according them as much gravity as you can. And we've got a reporting system with the staff now, whereby eventually they get through as far as me, the head's the ultimate, the next ultimate in the range . . . You can't go throwing suspensions around all the time. Like the football referees today, I mean they're failing because they're reduced to the ultimate so quickly somehow . . . the yellow card comes out first of all, and once they've done that, they've either got to send the player off or ignore everything else he does in the game . . .

> HEAD If enough people set out in defiance of anything . . . if all my boys tomorrow in school decide to do something wrong, what chance have I got?

The teacher's authority must therefore be won and maintained on moral not coercive grounds. There must be consent from the taught. However, the permanent battle to assert and legitimate a personal moral supremacy, especially with limited personal power, is tiring and not really a viable strategy for the long term. Sleight of hand is involved. It is this which marks off the 'experienced' teacher. It is the learning of the relative autonomy of the teaching paradigm: the recognition that the ideal of teaching is related only variably to particular individuals. It is the *idea* of the teacher, not the individual, which is legitimized and commands obedience.

This idea concerns teaching as a fair exchange – most basically of knowledge for respect, of guidance for control. Since knowledge is the rarer commodity this gives the teacher his moral superiority. This is the dominant educational paradigm which stands outside particular teachers but enables them to exert control legitimately upon the children. It is legitimated in general because it provides equivalents which can enter into other successive exchanges which are to the advantage of the individual. The most important chain of exchanges is, of course, that of knowledge for qualifications, qualified activity for high pay, and pay for goods and services. The educational is, therefore, the key to many other exchanges.

All of these exchanges are supported in structures which hold and help to define, as well as being themselves to some extent created and maintained by, the particular transaction. The educational exchange is held in a defining framework which establishes an axis of the superiority of the teacher in a particular way. Whilst the exchange and its 'fairness' is open to view and is the basis for consent, the framework which holds and defines the terms is both less explicit and in some ways more powerful. It must be considered as an integral part of our basic view of the teaching paradigm. The exchange spins, as it were, like a giro in this framework which it thus helps to stabilise and orientate. But the framework must be secured and ensured by other

means as well. It must be capable both of enforcing definitions to some degree where the exchange itself cannot generate them (which is, of course, the case for such as 'the lads'), and to reinforce the exchange, where it is successful, by guaranteeing the equivalents, the concrete referents, external signs and visible supports. . . .

It is of the utmost importance to appreciate that the exchange relationship in the educational paradigm is not primarily in terms of its own logic a relationship between social classes or in any sense at all a self-conscious attempt on the part of teachers to dominate or suppress either working-class individuals or working-class culture as such. The teachers, particularly the senior teachers of the Hammertown school, are dedicated, honest and forthright and by their own lights doing an exacting job with patience and humanity. Certainly it would be quite wrong to attribute to them any kind of sinister motive such as miseducating or oppressing working-class kids. The teacher is given formal control of his pupils by the state, but he exerts his social control through an educational, not a class, paradigm.

It is important to realise just how far the teaching paradigm and especially the axis of control and definition which makes it possible are clearly bound up, supported and underwritten in countless small and in certain large, as it were, architectural ways by the material structure, organisation and practices of the school as we know it in our society.

In a simple physical sense school students, and their possible views of the pedagogic situation, are subordinated by the constricted and inferior space they occupy. Sitting in tight ranked desks in front of the larger teacher's desk; deprived of private space themselves but outside nervously knocking on the forbidden staff room door or the headmaster's door with its foreign rolling country beyond; surrounded by locked up or out of bounds rooms, gyms and equipment cupboards; cleared out of school at break with no quarter given even in the unprivate toilets; told to walk at least two feet away from staff cars in the drive – all of these things help to determine a certain orientation to the physical environment and behind that to a certain kind of social organisation. They speak to the whole *position* of the student.

The social organisation of the school reinforces this relationship. The careful bell-rung timetable; the elaborate rituals of patience and respect outside the staff room door and in the classroom where even cheeky comments are prefaced with 'sir'; compulsory attendance and visible staff hierarchies – all these things assert the superiority of staff and of their world. And, of course, finally it is the staff who are the controllers most basically and despite the advent of 'resources centres' of what is implied to be the scarce and valuable commodity of knowledge. The value of knowledge to be exchanged in the teaching paradigm derives not only from an external definition of its worth or importance for qualifications and mobility but also from its protected institutional role: its disposition is the prerogative of the powerful. Teachers distribute text books as if they owned them and behave like outraged, vandalised householders when they are lost, destroyed

or defaced; teachers keep the keys and permissions for the cupboards, libraries and desks; they plan courses and initiate discussions, start and end the classes. . . .

Many experienced teachers in working-class schools sense a potential weakness in the hold of the basic paradigm on their 'less able', disinterested and disaffected students and seek to modify one of its terms in some way or another. Perhaps the classic move here, and one which is absolutely typical of the old secondary modern school and still widespread in working-class comprehensives, is the revision from an objective to a moral basis of what is in the teacher's gift and is to be exchanged by him for obedience, politeness and respect from the students. This is the crucial shift and mystification in many forms of cultural and social exchange between unequal territories in late capitalist society: that the objective nature of the 'equivalents' are transmuted into the fog of moral commitment, humanism and social responsibility. A real exchange becomes an ideal exchange. The importance of all this is not, of course, that the values and stances involved might be admirable or execrable, correct or incorrect, or whatever. The point is a formal one: the moral term, unlike the objective one, is capable of infinite extension and assimilation because it has no real existence except in itself. The real world cannot act as a court of appeal. Moral definitions make their own momentum. So far as the basic teaching paradigm is concerned what it is worth the student striving for becomes, not knowledge and the promise of qualification, but somehow deference and politeness themselves – those things which are associated certainly with academic and other kinds of success but are only actually their cost and precondition. The shift implies that such qualities are desirable in their own right, detachable from the particular project and negotiable for themselves in the market place of jobs and social esteem.

The pivotal notion of 'attitudes' and particularly of 'right attitudes' makes its entry here. Its presence should always warn us of a mystificatory transmutation of basic exchange relationships into illusory, ideal ones. If one approaches school and its authority, it seems, with the 'right attitude' then employers and work will also be approached with the 'right attitude' in such a way indeed that real social and economic advances can be made – all without the help of academic achievement or success. Of course this crucial move renders the basic paradigm strictly circular and tautological since the same thing is being offered on both sides without any disjunctions or transformations occurring in the circle of the relationship. What the student gets all round is deference and subordination to authority. He could learn this for himself. The objective tautology which turns on that too little examined category 'the right attitude' does not necessarily damage the basic paradigm so long as its nature remains concealed or mystified. Indeed insofar as it maintains the tempo of apparently fair exchange, reinforces the institutionally defined axis and restrains other tendencies, this modification strengthens the basic paradigm. It keeps its giro spinning. . . .

During *differentiation* the basic paradigm (no matter how modified) is to some extent delegitimised. The teacher's superiority is denied because the axis in which it is held has been partially dislodged. Because what the teacher offers is seen to be less than an equivalent the establishment of the framework which guarantees the teaching exchange is regarded with suspicion and is seen more and more obviously in its repressive mode. For 'the lads' other ways of valuing the self and other kinds of possible exchange present themselves. The teacher's authority becomes increasingly the random one of the prison guard, not the necessary one of the pedagogue. Where 'the private' was penetrated and controlled before it now becomes shared, powerful and oppositional. In a system where exchange of knowledge and the educational paradigm is used as a form of social control, denial of knowledge and refusal of its educational 'equivalent', respect, can be used as a barrier to control. 'The lads' become 'ignorant', 'awkward' and 'disobedient'. It should be noted that measured intelligence and exam results in general are much more likely to be based on the individual's position in this social configuration of knowledge than on his 'innate' abilities. Furthermore, many of an individual's 'personal characteristics' should be understood in this social sense rather than in an individual sense.

At any rate the challenge to the formal paradigm, and re-evaluation of the self and the group, comes from those 'private' areas now *shared* and made visible which were held in check before. These private areas are nothing more nor less, of course, than the class experiences of the working-class boy and derive basically from outside the school. Where the basic paradigm excludes class from the educational realm, its *differentiation* invites it in. . . .

Dick Hebdige

SUBCULTURE
The meaning of style [1979]

Subculture: the unnatural break

SUBCULTURES REPRESENT 'NOISE' (as opposed to sound): interference in the orderly sequence which leads from real events and phenomena to their representation in the media. We should therefore not underestimate the signifying power of the spectacular subculture not only as a metaphor for potential anarchy 'out there' but as an actual mechanism of semantic disorder: a kind of temporary blockage in the system of representation. . . .

Violations of the authorized codes through which the social world is organized and experienced have considerable power to provoke and disturb. They are generally condemned, in Mary Douglas' words (1967), as 'contrary to holiness' and Levi-Strauss has noted how, in certain primitive myths, the mispronunciation of words and the misuse of language are classified along with incest as horrendous aberrations capable of 'unleashing storm and tempest' (Levi-Strauss 1969). Similarly, spectacular subcultures express forbidden contents (consciousness of class, consciousness of difference) in forbidden forms (transgressions of sartorial and behavioural codes, law breaking, etc.). They are profane articulations, and they are often and signif-icantly defined as 'unnatural'. . . . no doubt, the breaking of rules is confused with the 'absence of rules' which, according to Levi-Strauss (1969), 'seems to provide the surest criteria for distinguishing a natural from a cultural process'. Certainly, the official reaction to the punk subculture, particularly to the Sex Pistols' use of 'foul language' on television and record, and to the vomiting and spitting incidents at Heathrow Airport, would seem to indi-cate that these basic taboos are no less deeply sedimented in contemporary British society.

Two forms of incorporation

> Has not this society, glutted with aestheticism, already integrated
> former romanticisms, surrealism, existentialism and even Marxism to
> a point? It has, indeed, through trade, in the form of commodities.
> That which yesterday was reviled today becomes cultural consumer-
> goods, consumption thus engulfs what was intended to give meaning
> and direction.
>
> (Lefebvre 1971)

. . . The emergence of a spectacular subculture is invariably accompanied by
a wave of hysteria in the press. This hysteria is typically ambivalent: it fluc-
tuates between dread and fascination, outrage and amusement. Shock and
horror headlines dominate the front page (e.g. 'Rotten Razored', *Daily Mirror*,
28 June 1977) while, inside, the editorials positively bristle with 'serious'
commentary and the centrespreads or supplements contain delirious accounts
of the latest fads and rituals (see, for example, *Observer* colour supplements
30 January, 10 July 1977, 12 February 1978). Style in particular provokes
a double response: it is alternately celebrated (in the fashion page) and
ridiculed or reviled (in those articles which define subcultures as social
problems). . . .

As the subculture begins to strike its own eminently marketable pose,
as its vocabulary (both visual and verbal) becomes more and more familiar,
so the referential context to which it can be most conveniently assigned is
made increasingly apparent. Eventually, the mods, the punks, the glitter
rockers can be incorporated, brought back into line, located on the preferred
'map of problematic social reality' (Geertz 1964) at the point where boys
in lipstick are 'just kids dressing up', where girls in rubber dresses are 'daugh-
ters just like yours'. . . . The media, as Stuart Hall (1977) has argued, not
only record resistance, they 'situate it within the dominant framework of
meanings' and those young people who choose to inhabit a spectacular youth
culture are simultaneously *returned*, as they are represented on TV and in
the newspapers, to the place where common sense would have them fit
(as 'animals' certainly, but also 'in the family', 'out of work', 'up to date',
etc.). It is through this continual process of recuperation that the fractured
order is repaired and the subculture incorporated as a diverting spectacle
within the dominant mythology from which it in part emanates: as 'folk
devil', as Other, as Enemy. The process of recuperation takes two charac-
teristic forms:

(1) the conversion of subcultural signs (dress, music, etc.) into mass-
 produced objects (i.e. the commodity form);
(2) the 'labelling' and re-definition of deviant behaviour by dominant groups
 – the police, the media, the judiciary (i.e. the ideological form).

The commodity form

The first has been comprehensively handled by both journalists and academics. The relationship between the spectacular subculture and the various industries which service and exploit it is notoriously ambiguous. After all, such a subculture is concerned first and foremost with consumption. It operates exclusively in the leisure sphere. . . . It communicates through commodities even if the meanings attached to those commodities are purposefully distorted or overthrown. It is therefore difficult in this case to maintain any absolute distinction between commercial exploitation on the one hand and creativity/originality on the other, even though these categories are emphatically opposed in the value systems of most subcultures. Indeed, the creation and diffusion of new styles is inextricably bound up with the process of production, publicity and packaging which must inevitably lead to the defusion of the subculture's subversive power – both mod and punk innovations fed back directly into high fashion and mainstream fashion. . . .

. . . As soon as the original innovations which signify 'subculture' are translated into commodities and made generally available, they become 'frozen'. Once removed from their private contexts by the small entrepreneurs and big fashion interests who produce them on a mass scale, they become codified, made comprehensible, rendered at once public property and profitable merchandise. In this way, the two forms of incorporation (the semantic/ideological and the 'real'/commercial) can be said to converge on the commodity form. Youth cultural styles may begin by issuing symbolic challenges, but they must inevitably end by establishing new sets of conventions; by creating new commodities, new industries or rejuvenating old ones (think of the boost punk must have given haberdashery!). This occurs irrespective of the subculture's political orientation: the macrobiotic restaurants, craft shops and 'antique markets' of the hippie era were easily converted into punk boutiques and record shops. It also happens irrespective of the startling content of the style: punk clothing and insignia could be bought mail-order by the summer of 1977, and in September of that year *Cosmopolitan* ran a review of Zandra Rhodes' latest collection of couture follies which consisted entirely of variations on the punk theme. Models smouldered beneath mountains of safety pins and plastic (the pins were jewelled, the 'plastic' wet-look satin) and the accompanying article ended with an aphorism – 'To shock is chic' – which presaged the subculture's imminent demise.

The ideological form

The second form of incorporation – the ideological – has been most adequately treated by those sociologists who operate a transactional model of deviant behaviour. For example, Stan Cohen has described in detail how one particular moral panic (surrounding the mod–rocker conflict of the

mid-60s) was launched and sustained [Cohen 1972]. Although this type of analysis can often provide an extremely sophisticated explanation of why spectacular subcultures consistently provoke such hysterical outbursts, it tends to overlook the subtler mechanisms through which potentially threatening phenomena are handled and contained. As the use of the term 'folk devil' suggests, rather too much weight tends to be given to the sensational excesses of the tabloid press at the expense of the ambiguous reactions which are, after all, more typical. As we have seen, the way in which subcultures are represented in the media makes them both more *and less* exotic than they actually are. They are seen to contain both dangerous aliens and boisterous kids, wild animals and wayward pets. Roland Barthes furnishes a key to the paradox in his description of 'identification' – one of the seven rhetorical figures which, according to Barthes, distinguish the meta-language of bour-geois mythology. He characterizes the petit-bourgeois as a person '. . . unable to imagine the Other . . . the Other is a scandal which threatens his existence' (Barthes 1972).

Two basic strategies have been evolved for dealing with this threat. First, the Other can be trivialized, naturalized, domesticated. Here, the difference is simply denied ('Otherness is reduced to sameness'). Alternatively, the Other can be transformed into meaningless exotica, a 'pure object, a spectacle, a clown' (Barthes 1972). In this case, the difference is consigned to a place beyond analysis. Spectacular subcultures are continually being defined in precisely these terms. Soccer hooligans, for example, are typically placed beyond 'the bounds of common decency' and are classified as 'animals'. . . . On the other hand, the punks tended to be resituated by the press in the family, perhaps because members of the subculture deliberately obscured their origins, refused the family and willingly played the part of folk devil, presenting themselves as pure objects, as villainous clowns. Certainly, like every other youth culture, punk was perceived as a threat to the family. Occasionally this threat was represented in literal terms. For example, the *Daily Mirror* (1 August 1977) carried a photograph of a child lying in the road after a punk–ted confrontation under the headline 'VICTIM OF THE PUNK ROCK PUNCH-UP: THE BOY WHO FELL FOUL OF THE MOB'. In this case, punk's threat to the family was made 'real' (that could be my child!) through the ideological framing of photographic evidence which is popularly regarded as unproblematic.

None the less, on other occasions, the opposite line was taken. For what-ever reason, the inevitable glut of articles gleefully denouncing the latest punk outrage was counter-balanced by an equal number of items devoted to the small details of punk family life. For instance, the 15 October 1977 issue of *Woman's Own* carried an article entitled 'Punks and Mothers' which stressed the classless, fancy dress aspects of punk. Photographs depicting punks with smiling mothers, reclining next to the family pool, playing with the family dog, were placed above a text which dwelt on the ordinariness of individual punks: 'It's not as rocky horror as it appears' . . . 'punk can be a family

affair' . . . 'punks as it happens are non-political', and, most insidiously, albeit accurately, 'Johnny Rotten is as big a household name as Hughie Green'. Throughout the summer of 1977, the *People* and the *News of the World* ran items on punk babies, punk brothers, and punk–ted weddings. All these articles served to minimize the Otherness so stridently proclaimed in punk style, and defined the subculture in precisely those terms which it sought most vehemently to resist and deny. . . .

Style as intentional communication

. . . The cycle leading from opposition to defusion, from resistance to incorporation encloses each successive subculture. We have seen how the media and the market fit into this cycle. We must now turn to the subculture itself to consider exactly how and what subcultural style communicates. Two questions must be asked which together present us with something of a paradox: how does a subculture make sense to its members? How is it made to signify disorder? To answer these questions we must define the meaning of style more precisely. . . .

Umberto Eco writes, 'not only the expressly intended communicative object . . . but every object may be viewed . . . as a sign' (Eco 1973). For instance, the conventional outfits worn by the average man and woman in the street are chosen within the constraints of finance, 'taste', preference, etc. And these choices are undoubtedly significant. Each ensemble has its place in an internal system of differences – the conventional modes of sartorial discourse – which fit a corresponding set of socially prescribed roles and options. These choices contain a whole range of messages which are transmitted through the finely graded distinctions of a number of interlocking sets – class and status, self-image and attractiveness, etc. Ultimately, if nothing else, they are expressive of 'normality' as opposed to 'deviance' (i.e. they are distinguished by their relative invisibility, their appropriateness, their 'naturalness'). However, the intentional communication is of a different order. It stands apart – a visible construction, a loaded choice. It directs attention to itself; it gives itself to be read.

This is what distinguishes the visual ensembles of spectacular subcultures from those favoured in the surrounding culture(s). They are *obviously* fabricated (even the mods, precariously placed between the worlds of the straight and the deviant, finally declared themselves different when they gathered in groups outside dance halls and on sea fronts). They *display* their own codes (e.g. the punk's ripped T-shirt) or at least demonstrate that codes are there to be used and abused (e.g. they have been thought about rather than thrown together). In this they go against the grain of a mainstream culture whose principal defining characteristic, according to Barthes, is a tendency to masquerade as nature, to substitute 'normalized' for historical forms, to translate the reality of the world into an image of the world which in turn presents

itself as if composed according to 'the evident laws of the natural order' (Barthes 1972). . . .

Style as *bricolage*

. . . The subcultures with which we have been dealing share a common feature apart from the fact that they are all predominantly working class. They are, as we have seen, cultures of conspicuous consumption – even when, as with the skinheads and the punks, certain types of consumption are conspicuously refused – and it is through the distinctive rituals of consumption, through style, that the subculture at once reveals its 'secret' identity and communicates its forbidden meanings. It is basically the way in which commodities are *used* in subculture which marks the subculture off from more orthodox cultural formations.

Discoveries made in the field of anthropology are helpful here. In particular, the concept of *bricolage* can be used to explain how subcultural styles are constructed. In *The Savage Mind* Levi-Strauss shows how the magical modes utilized by primitive peoples (superstition, sorcery, myth) can be seen as implicitly coherent, though explicitly bewildering, systems of connection between things which perfectly equip their users to 'think' their own world. These magical systems of connection have a common feature: they are capable of infinite extension because basic elements can be used in a variety of improvised combinations to generate new meanings within them. *Bricolage* has thus been described as a 'science of the concrete' in a recent definition which clarifies the original anthropological meaning of the term:

> [Bricolage] refers to the means by which the non-literate, non-technical mind of so-called 'primitive' man responds to the world around him. The process involves a 'science of the concrete' (as opposed to our 'civilised' science of the 'abstract') which far from lacking logic, in fact carefully and precisely orders, classifies and arranges into structures the *minutiae* of the physical world in all their profusion by means of a 'logic' which is not our own. The structures, 'improvised' or made up (these are rough translations of the process of *bricoler*) as *ad hoc* responses to an environment, then serve to establish homologies and analogies between the ordering of nature and that of society, and so satisfactorily 'explain' the world and make it able to be lived in.
>
> (Hawkes 1977)

The implications of the structured improvisations of *bricolage* for a theory of spectacular subculture as a system of communication have already been explored. For instance, John Clarke has stressed the way in which prominent forms of discourse (particularly fashion) are radically adapted, subverted and extended by the subcultural *bricoleur*:

> Together, object and meaning constitute a sign, and, within any one culture, such signs are assembled, repeatedly, into characteristic forms of discourse. However, when the bricoleur re-locates the significant object in a different position within that discourse, using the same overall repertoire of signs, or when that object is placed within a different total ensemble, a new discourse is constituted, a different message conveyed.
>
> (Clarke 1975)

In this way the teddy boy's theft and transformation of the Edwardian style revived in the early 1950s by Savile Row for wealthy young men about town can be construed as an act of *bricolage*. Similarly, the mods could be said to be functioning as *bricoleurs* when they appropriated another range of commodities by placing them in a symbolic ensemble which served to erase or subvert their original straight meanings. Thus pills medically prescribed for the treatment of neuroses were used as ends-in-themselves, and the motor scooter, originally an ultra-respectable means of transport, was turned into a menacing symbol of group solidarity. In the same improvisatory manner, metal combs, honed to a razor-like sharpness, turned narcissism into an offensive weapon. Union jacks were emblazoned on the backs of grubby parka anoraks or cut up and converted into smartly tailored jackets. More subtly, the conventional insignia of the business world – the suit, collar and tie, short hair, etc. – were stripped of their original connotations – efficiency, ambition, compliance with authority – and transformed into 'empty' fetishes, objects to be desired, fondled and valued in their own right.

At the risk of sounding melodramatic, we could use Umberto Eco's phrase 'semiotic guerrilla warfare' (Eco 1972) to describe these subversive practices. The war may be conducted at a level beneath the consciousness of the individual members of a spectacular subculture (though the subculture is still, at another level, an intentional communication . . .) but with the emergence of such a group, 'war – and it is Surrealism's war – is declared on a world of surfaces' (Annette Michelson, quoted Lippard 1970).

The radical aesthetic practices of Dada and Surrealism – dream work, collage, 'ready mades', etc. – are certainly relevant here. . . . The subcultural *bricoleur*, like the 'author' of a surrealist collage, typically 'juxtaposes two apparently incompatible realities [i.e. "flag": "jacket"; "hole": "teeshirt"; "comb": "weapon"] on an apparently unsuitable scale . . . and . . . it is there that the explosive junction occurs' (Ernst 1948). Punk exemplifies most clearly the subcultural uses of these anarchic modes. It too attempted through 'perturbation and deformation' to disrupt and reorganize meaning. It, too, sought the 'explosive junction'. . . . Like Duchamp's 'ready mades' – manufactured objects which qualified as art because he chose to call them such, the most unremarkable and inappropriate items – a pin, a plastic clothes peg, a television component, a razor blade, a tampon – could be brought within the province of punk (un)fashion. Anything within or without reason could

be turned into part of what Vivien Westwood called 'confrontation dressing' so long as the rupture between 'natural' and constructed context was clearly visible (i.e. the rule would seem to be: if the cap doesn't fit, wear it). . . .

Style as homology

The punk subculture . . . signified chaos at every level, but this was only possible because the style itself was so thoroughly ordered. The chaos cohered as a meaningful whole. We can now attempt to solve this paradox by referring to another concept originally employed by Levi-Strauss: homology.

Paul Willis (1978) first applied the term 'homology' to subculture in his study of hippies and motor-bike boys using it to describe the symbolic fit between the values and life-styles of a group, its subjective experience and the musical forms it uses to express or reinforce its focal concerns. In *Profane Culture*, Willis shows how, contrary to the popular myth which presents subcultures as lawless forms, the internal structure of any particular subculture is characterized by an extreme orderliness: each part is organically related to other parts and it is through the fit between them that the subcultural member makes sense of the world. For instance, it was the homology between an alternative value system ('Tune in, turn on, drop out'), hallucogenic drugs and acid rock which made the hippy culture cohere as a 'whole way of life' for individual hippies. In *Resistance Through Rituals* Clarke *et al.* crossed the concepts of homology and *bricolage* to provide a systematic explanation of why a particular subcultural style should appeal to a particular group of people. The authors asked the question: 'What specifically does a subcultural style signify to the members of the subculture themselves?'

The answer was that the appropriated objects reassembled in the distinctive subcultural ensembles were 'made to reflect, express and resonate . . . aspects of group life' (Clarke *et al.*, 1975). The objects chosen were, either intrinsically or in their adapted forms, homologous with the focal concerns, activities, group structure and collective self-image of the subculture. They were 'objects in which (the subcultural members) could see their central values held and reflected' (Clarke *et al.*, 1975). . . .

The punks would certainly seem to bear out this thesis. The subculture was nothing if not consistent. There was a homological relation between the trashy cut-up clothes and spiky hair, the pogo and amphetamines, the spitting, the vomiting, the format of the fanzines, the insurrectionary poses and the 'soulless', frantically driven music. The punks wore clothes which were the sartorial equivalent of swear words, and they swore as they dressed – with calculated effect, lacing obscenities into record notes and publicity releases, interviews and love songs. Clothed in chaos, they produced Noise in the calmly orchestrated Crisis of everyday life in the late 1970s – a noise which made (no)sense in exactly the same way and to exactly the same extent as a piece of *avant-garde* music. If we were to write an epitaph for the punk

subculture, we could do no better than repeat Poly Styrene's famous dictum: 'Oh Bondage, Up Yours!', or somewhat more concisely: the forbidden is permitted, but by the same token, nothing, not even these forbidden signifiers (bondage, safety pins, chains, hair-dye, etc.) is sacred and fixed.

This absence of permanently sacred signifiers (icons) creates problems for the semiotician. How can we discern any positive values reflected in objects which were chosen only to be discarded? For instance, we can say that the early punk ensembles gestured towards the signified's 'modernity' and 'working-classness'. The safety pins and bin liners signified a relative material poverty which was either directly experienced and exaggerated or sympathetically assumed, and which in turn was made to stand for the spiritual paucity of everyday life. In other words, the safety pins, etc. 'enacted' that transition from real to symbolic scarcity which Paul Piccone (1969) has described as the movement from 'empty stomachs' to 'empty spirits – and therefore an empty life notwithstanding the chrome and the plastic . . . of the life style of bourgeois society'.

We could go further and say that even if the poverty was being parodied, the wit was undeniably barbed; that beneath the clownish make-up there lurked the unaccepted and disfigured face of capitalism; that beyond the horror circus antics a divided and unequal society was being eloquently condemned. However, if we were to go further still and describe punk music as the 'sound of the Westway' or the pogo as the 'high-rise leap', or to talk of bondage as reflecting the narrow options of working-class youth, we would be treading on less certain ground. Such readings are both too literal and too conjectural. They are extrapolations from the subculture's own prodigious rhetoric, and rhetoric is not self-explanatory: it may say what it means but it does not necessarily 'mean' what it 'says'. In other words, it is opaque: its categories are part of its publicity. . . .

To reconstruct the true text of the punk subculture, to trace the source of its subversive practices, we must first isolate the 'generative set' responsible for the subculture's exotic displays. Certain semiotic facts are undeniable. The punk subculture, like every other youth culture, was constituted in a series of spectacular transformations of a whole range of commodities, values, common-sense attitudes, etc. It was through these adapted forms that certain sections of predominantly working-class youth were able to restate their opposition to dominant values and institutions. However, when we attempt to close in on specific items, we immediately encounter problems. What, for instance, was the swastika being used to signify?

We can see how the symbol was made available to the punks (via Bowie and Lou Reed's 'Berlin' phase). Moreover, it clearly reflected the punks' interest in a decadent and evil Germany – a Germany which had 'no future'. It evoked a period redolent with a powerful mythology. Conventionally, as far as the British were concerned, the swastika signified 'enemy'. None the less, in punk usage, the symbol lost its 'natural' meaning – fascism. The

punks were not generally sympathetic to the parties of the extreme right. On the contrary, . . . the conflict with the resurrected teddy boys and the widespread support for the anti-fascist movement (e.g. the Rock against Racism campaign) seem to indicate that the punk subculture grew up partly as an antithetical response to the re-emergence of racism in the mid-1970s. We must resort, then, to the most obvious of explanations – that the swastika was worn because it was guaranteed to shock. (A punk asked by *Time Out* (17–23 December 1977) why she wore a swastika, replied: 'Punks just like to be hated'.) This represented more than a simple inversion or inflection of the ordinary meanings attached to an object. The signifier (swastika) had been wilfully detached from the concept (Nazism) it conventionally signified, and although it had been re-positioned (as 'Berlin') within an alternative sub-cultural context, its primary value and appeal derived precisely from its lack of meaning: from its potential for deceit. It was exploited as an empty effect. We are forced to the conclusion that the central value 'held and reflected' in the swastika was the communicated absence of any such identifiable values. Ultimately, the symbol was as 'dumb' as the rage it provoked. The key to punk style remains elusive. Instead of arriving at the point where we can begin to make sense of the style, we have reached the very place where meaning itself evaporates.

Style as signifying practice

> We are surrounded by emptiness but it is an emptiness filled with signs.
> (Lefebvre 1971)

It would seem that those approaches to subculture based upon a traditional semiotics (a semiotics which begins which some notion of the 'message' – of a combination of elements referring unanimously to a fixed number of signifieds) fail to provide us with a 'way in' to the difficult and contradictory text of punk style. Any attempt at extracting a final set of meanings from the seemingly endless, often apparently random, play of signifiers in evidence here seems doomed to failure.

And yet, over the years, a branch of semiotics has emerged which deals precisely with this problem. Here the simple notion of reading as the revelation of a fixed number of concealed meanings is discarded in favour of the idea of *polysemy* whereby each text is seen to generate a potentially infinite range of meanings. Attention is consequently directed towards that point – or more precisely, that level – in any given text where the principle of meaning itself seems most in doubt. Such an approach lays less stress on the primacy of structure and system in language ('langue'), and more upon the *position* of the speaking subject in discourse ('parole'). It is concerned with the *process* of meaning–construction rather than with the final product. . . .

Julia Kristeva's work on signification seems particularly useful. In *La Révolution du Langage Poétique* [1974, trans. 1984] she explores the subversive possibilities within language through a study of French symbolist poetry, and points to 'poetic language' as the 'place where the social code is destroyed and renewed' (Kristeva 1984). She counts as 'radical' those signifying practices which negate and disturb syntax . . . and which therefore serve to erode the concept of 'actantial position' upon which the whole 'Symbolic Order' is seen to rest.[1]

Two of Kristeva's interests seem to coincide with our own: the creation of subordinate groups through *positioning in language* (Kristeva is especially interested in women), and the disruption of the process through which such positioning is habitually achieved. In addition, the general idea of signifying practice (which she defines as 'the setting in place and cutting through or traversing of a system of signs') can help us to rethink in a more subtle and complex way the relations not only between marginal and mainstream cultural formations but between the various subcultural styles themselves. For instance, we have seen how all subcultural style is based on a practice which has much in common with the 'radical' collage aesthetic of surrealism and we shall be seeing how different styles represent different signifying practices. Beyond this I shall be arguing that the signifying practices embodied in punk were 'radical' in Kristeva's sense: that they gestured towards a 'nowhere' and actively *sought* to remain silent, illegible.

We can now look more closely at the relationship between experience, expression and signification in subculture; at the whole question of style and our reading of style. To return to our example, we have seen how the punk style fitted together homologically precisely through its lack of fit (hole:tee-shirt::spitting:applause::bin-liner:garment::anarchy:order) – by its refusal to cohere round a readily identifiable set of central values. It cohered, instead, *elliptically* through a chain of conspicuous absences. It was characterized by its unlocatedness – its blankness – and in this it can be contrasted with the skinhead style.

Whereas the skinheads theorized and fetishized their class position, in order to effect a 'magical' return to an imagined past, the punks dislocated themselves from the parent culture and were positioned instead on the outside: beyond the comprehension of the average (wo)man in the street in a science fiction future. They played up their Otherness, 'happening' on the world as aliens, inscrutables. Though punk rituals, accents and objects were deliberately used to signify working-classness, the exact origins of individual punks were disguised or symbolically disfigured by the make-up, masks and aliases which seem to have been used, like Breton's art, as ploys 'to escape the principle of identity'.

This working-classness therefore tended to retain, *even in practice, even in its concretized forms*, the dimensions of an idea. It was abstract, disembodied, decontextualized. Bereft of the necessary details – a name, a home, a history – it refused to make sense, to be grounded, 'read back' to its origins. It

stood in violent contradiction to that other great punk signifier – sexual 'kinkiness'. The two forms of deviance – social and sexual – were juxta-posed to give an impression of multiple warping which was guaranteed to disconcert the most liberal of observers, to challenge the glib assertions of sociologists no matter how radical. In this way, although the punks referred continually to the realities of school, work, family and class, these references only made sense at one remove: they were passed through the fractured circuitry of punk style and re-presented as 'noise', disturbance, entropy.

In other words, although the punks self-consciously mirrored what Paul Piccone (1969) calls the 'pre-categorical realities' of bourgeois society – inequality, powerlessness, alienation – this was only possible because punk style had made a decisive break not only with the parent culture but with its own *location in experience*. This break was both inscribed and re-enacted in the signifying practices embodied in punk style. The punk ensembles, for instance, did not so much magically resolve experienced contradictions as *re-present* the experience of contradiction itself in the form of visual puns (bondage, the ripped tee-shirt, etc.). Thus while it is true that the symbolic objects in punk style (the safety pins, the pogo, the ECT hairstyles) were 'made to form a "unity" with the group's relations, situations, experience' (Clarke *et al.*, 1975), this unity was at once 'ruptural' and 'expressive', or more precisely it expressed itself through rupture.

This is not to say, of course, that all punks were equally aware of the disjunction between experience and signification upon which the whole style was ultimately based. The style no doubt made sense for the first wave of self-conscious innovators at a level which remained inaccessible to those who became punks after the subculture had surfaced and been publicized. Punk is not unique in this: the distinction between originals and hangers-on is always a significant one in subculture. Indeed, it is frequently verbalized (plastic punks or safety-pin people, burrhead rastas or rasta bandwagon, weekend hippies, etc. versus the 'authentic' people). For instance, the mods had an intricate system of classification whereby the 'faces' and 'stylists' who made up the original coterie were defined against the unimaginative majority – the pedestrian 'kids' and 'scooter boys' who were accused of trivializing and coarsening the precious mod style. What is more, different youths bring different degrees of commitment to a subculture. It can represent a major dimension in people's lives – an axis erected in the face of the family around which a secret and immaculate identity can be made to cohere – or it can be a slight distraction, a bit of light relief from the monotonous but none the less paramount realities of school, home and work. It can be used as a means of escape, of total detachment from the surrounding terrain, or as a way of fitting back in to it and settling down after a week-end or evening spent letting off steam. In most cases it is used, as Phil Cohen suggests, magically to achieve both ends. However, despite these individual differ-ences, the members of a subculture must share a common language. And if a style is really to catch on, if it is to become genuinely popular, it must

say the right things in the right way at the right time. It must anticipate or encapsulate a mood, a moment. It must embody a sensibility, and the sensibility which punk style embodied was essentially dislocated, ironic and self-aware. . . .

Note

1 The 'symbolic order' to which I have referred throughout should not be confused with Kristeva's 'Symbolic Order' which is used in a sense derived specifically from Lacanian psychoanalysis. I use the term merely to designate the apparent unity of the dominant ideological discourse in play at any one time.

Contesting the subcultural terrain

Introduction to part three

■ Ken Gelder

ANALYSTS AT THE BIRMINGHAM CENTRE for Contemporary Cultural Studies were more or less in agreement about what a subculture was, and what it does – emphasizing style, the ability to transform cultural objects or to borrow from other places and other times, the engagement in ritualistic or symbolic modes of 'resistance', and the ambivalent structural relations a subculture bears to the working-class 'parent culture' and the less class-bound realm of mass culture. Class has not been the only social referent for the CCCS's work, of course: Angela McRobbie and Jenny Garber have explored issues of gender and subcultural identification, and Hebdige has related subcultural formations to ethnicity and migration. Subsequent commentators have introduced different kinds of configurations into the subcultural mix, however, in some cases producing extensive critiques of the CCCS's methodologies and assumptions. The main criticisms made by authors in this Part involve the CCCS's over-privileging of spectacular styles, its one-dimensional view of 'resistance' and 'incorporation', and (with the exception of Willis) its refusal to engage more concretely with subcultures as distinctive arrangements of everyday life – its refusal to look at what they actually *do*. CCCS analysts had spoken of subcultures as if they were homogeneous, as if their 'style' and

their 'problems' were shared equally amongst the participants. There was little interest, in other words, in the internal stratifications of a subculture. Moreover, the emphasis on 'resistance' led to a down-playing of subcultural participation in commerce, in the processes of purchase and exchange – important in the actual formation of subcultural styles.

The chapters by Stanley Cohen and Gary Clarke each engage directly with the CCCS's work. Cohen's classic book *Folk Devils and Moral Panics* (1972; 1980) had examined the various ways in which disruptive subcultures are created by mass media and received in society – hysterically, as a form of entertainment, nostalgically, and so on. His introduction to the new edition is an appeal for the return to sociology in subcultural analysis, a discipline which is less caught up with the obfuscations of contemporary Continental theory and which stresses the importance of rigorous methods of research. Cohen turns to the ordinariness of subcultural life, rejecting the Birmingham Centre's tendency to privilege spectacularity and resistance. Indeed, for Cohen, subcultures have more to do with how one gets by in the present moment, with apathy, passivity, conformity and the more mundane 'daily round of . . . life', rather than with their relations to the broader structures of class, capitalism, and so on. Cohen's view of subcultural formations not as a single, over-determined response to particular conditions but as one kind of response amongst others certainly moves towards a much-needed demystification of the subcultural 'image'. Importantly, Cohen also calls for a method of analysis which involves actually *talking* to subcultural participants – he values Paul Willis in this context, as an ethnographer rather than a semiotician.

Gary Clarke's contribution, taken from a longer article published as a working paper at Birmingham, is a critique of Hebdige's division of spectacular subcultures – those with 'style' – from an undifferentiated 'general public'. Style is dissociated from mass culture; or, if they are brought together, it is at the expense of a certain level of contempt for the latter (more pronounced in Hebdige than in John Clarke *et al.*). In fact, mass cultural styles may also engage with processes of transformation, recontextualization and so on, processes which Hebdige had only attributed to

subcultures. Hebdige tended to treat subcultures as authentic, original and vulnerable to incorporation into mass cultural production but Clarke argues that a more developed sense of the interaction between subcultures and mass cultural forms would easily problematize this kind of trajectory.

The chapters by Jon Stratton and Simon Frith emphasize not 'resistance' but *conventionality* in subcultural identification. Stratton investigates the transferability of subcultures from one place to another. For the CCCS analysts, subcultures more or less remained in place and were often short-lived. But some subcultures – Stratton's examples are surfies and bikers – are more long-lasting, self-contained and self-generating, not least because they are less constrained by location and class. But they cannot be conceived of in terms of 'resistance' since they live out consumerist ambitions ('the American Dream' or 'a myth of leisure', for example), albeit in an 'alternative way'. It is not that these subcultures will eventually be 'incorporated' either, since they are already in a relationship with the commodificatory processes of dominant culture, which, indeed, brought them into being in the first place.

Simon Frith looks at two prevailing views of music culture: the 'realist' view, which values 'authenticity' and small-scale levels of production, locating this as 'anti-establishment', as innovatory, and so on; and the 'formalist' view, which stresses the influence of conventions, seeing music (small-scale or otherwise) as a form which unfolds within the frame of an inherited, determining set of constraints. Punk tends to be characterized in the former way, while disco, is often considered from the latter perspective. For Frith music can itself 'articulate' an audience's alignment to either of these positions – but that alignment will in turn determine music's ideological effects. All this is enacted in the field of leisure, which also unfolds under the constraints of conventions, such as 'entertainment'. This may significantly curtail a subculture's capacity to 'resist'.

The chapters by McRobbie and Thornton investigate the dynamics of subcultures – again, to produce accounts that move beyond the concept of 'resistance'. McRobbie looks at subcultural style in terms of the processes of 'buying and selling' in the marketplace – ordinary activities overlooked by Birmingham analysts. Her

relation to the Birmingham tradition is not surprisingly ambivalent (she was a graduate student at the CCCS): she returns subcultural analysis to the field of sociology and everyday life, but she also touches the kind of romantic narrative found in Hebdige involving the capacity of subcultures to precipitate change in 'contemporary consumer culture . . . from below'. In particular, her juxtaposition of the 'enterprise culture' of subcultures with the fashion 'designer' recalls Hebdige's use of the Levi-Straussian distinction between the '*bricoleur*' and the 'engineer'.

Thornton departs more radically from CCCS paradigms, replacing their politicization of youth with an account of the micropolitics of the cluster of overlapping subcultures that British youth call 'club cultures'. She develops the notion of 'subcultural capital', drawing on Pierre Bourdieu (for 'distinction') and turning back to the Chicago School (for 'status') to investigate social conflicts and cultural competition *within* subcultures. These may be built around hierarchies of taste or knowledge, or access to certain locations and events. Subcultural capital is accumulative: some people have it, others don't. It can work to disavow social categories – to produce a 'fantasy of classlessness' in the club, for example – and yet it can also reproduce them (through 'classed' images of club types). In this sense, subcultures may or may not be 'progressive', depending upon the case.

The chapters here each complicate the notion of a 'subculture' as it had been developed through the Birmingham Centre for Contemporary Cultural Studies. The ground has shifted methodologically: there is, in many of the chapters, a return to sociology and an agreement about the importance of grounding subcultural analysis in the empirical world, valuing specific, localized studies over general, theoretical pronouncements. Crucially, the notion of subcultural 'resistance' is either rejected or considerably diluted in favour of a model which sees subcultural activity as much more dependent upon and co-operative with commerce and convention. The suggestion that subcultural style might inevitably be 'incorporated' into commercial or mass culture may in fact say more about a subculture's own investment in its 'unique' identity than about the predatory nature of the marketplace.

Stanley Cohen

SYMBOLS OF TROUBLE [1980]

TRADITIONAL SUBCULTURAL THEORY of delinquency is too well known to have to expound here. The intellectual offspring of two oddly matched but conventional strands of American sociology – functionalist anomie theory and the Chicago school – and the political offspring of the end of ideology era, it has shaped sociological visions of delinquency for twenty-five years. Like all intellectual departures – particularly those influenced by political considerations and particularly those in the deviancy field – when new subcultural theory appeared in Britain at the beginning of the 1970s it was concerned to show how radically it differed from tradition. And it could hardly have *looked* more different.

It was not just the switch from functionalist to Marxist language but the sense conveyed of why this switch 'had' to take place. The context was light years away from America in the mid-1950s: a sour, post welfare state Britain which had patently not delivered the goods; the cracking of all those inter-dependent myths of classlessness, embourgeoisement, consumerism and pluralism; the early warnings of economic recession and high (particularly juvenile) unemployment; the relative weakness of recognizably political resistance.

No tortuous sociology of knowledge is needed to see how this context 'influenced' the theories; the context was explicitly woven into the theories' very substance. History and political economy became open rather than hidden; the 'problem' of the working-class adolescent was seen not in terms of adjustment, or providing more opportunities to buy a larger share of the cake, but of bitter conflict, resistance and strife. The delinquent changed

from 'frustrated social climber' to cultural innovator and critic. What was really happening on the beaches of Brighton and Clacton – as well as earlier at the Teddy Boy dance halls and later on the football terraces and punk concerts – was a drama of profound symbolic resonance. Subculture was, no less, a political battleground between the classes.

I will come back in more detail to this framework. It is worth noting, though, that for all its obvious novelty and achievement – it is now simply not possible to talk about delinquent subcultures in the same way – the new theory shares a great deal more with the old than it cared to admit. Both work with the same 'problematic' (to use the fashionable term): growing up in a class society; both identify the same vulnerable group: the urban male working-class late adolescent; both see delinquency as a collective solution to a structurally imposed problem. For example, while its tone and political agenda are distinctive enough, Willis's statement of what has to be explained is not too far away from the original theories: 'the experience and cultural processes of being male, white, working class, unqualified, disaffected and moving into manual work in contemporary capitalism' [Willis 1977: 119]. These common assumptions must be emphasized precisely because they do *not* appear in the rhetoric of moral panics or in conventional criminology or in the official control culture.

Beyond this, of course, there are the novelties and differences to which [I shall] now turn. These lie primarily in the levels of sophistication and complexity which the new theories have added, in the location of delin-quency in the whole repertoire of class-based negotiations and in the rescuing of traditional subcultural theory from its historical flatness by placing both the structural 'problem' and its subcultural 'solution' in a recognizable time and place. Of course – as I will point out again – most delinquency is numb-ingly the same and has never had much to do with those historical 'moments' and 'conjunctures' which today's students of working-class youth cultures are so ingeniously trying to find. But whatever the object of attention – 'expressive fringe delinquency' (as I originally called it) or ordinary main-stream delinquency – the new theories distinguish three general levels of analysis: *structure*, *culture* and *biography*. I will adopt (and adapt) these head-ings to organize my review.

(i) *Structure* refers to those aspects of society which appear beyond indi-vidual control, especially those deriving from the distribution of power, wealth and differential location in the labour market. These are the struc-tural 'constraints', 'conditions', 'contingencies' or 'imperatives' which the new theory identifies in general terms – and then applies to the group most vulnerable to them, that is, working-class youth. In old subcultural theory, these conditions constitute the 'problem' to which (ii) the *culture* is the solu-tion. More broadly, culture refers to the traditions, maps of meanings and ideologies which are patterned responses to structural conditions; more narrowly, *sub*culture is the specific, especially symbolic form through which the subordinate group negotiates its position. Then (iii) there is *biography*:

broadly, the pattern and sequence of personal circumstances through which the culture and structure are experienced. More narrowly: what the subculture means and how it is actually lived out by its carriers.

Much of the new work of British post-war youth cultures is a teasing out of the relationships between these three levels. And all of this work is more or less informed by the Marxist categorization of structure, culture and biography as the determinate conditions ('being born into a world not of your own choosing') to which the subculture is one of the possible working-class responses ('making your own history').

1. Structure/history/problem

In the more one-dimensional world of the original theories, working-class kids somehow hit the system – as represented variously by school, work or leisure. To use the common metaphor: the theories explained how and why kids would kick a machine that did not pay; no one asked how the machine was rigged in the first place. The new theories are very much concerned with how the machine got there. From a general analysis of post-war British capitalism, specific features – particularly the pervasiveness of class – are extracted and historicized. Their impact on the working class – and more particularly, its community and its most vulnerable members, adolescents – is then identified as a series of pressures or contradictions stemming from domination and subordination.

To determine what the old theories would classify as the 'problem' to which delinquency is the 'solution', one must 'situate youth in the dialectic between a "hegemonic" dominant culture and the subordinate working-class "parent" culture of which youth is a fraction' [Clarke et al. 1975: 38]. The conventional assumptions of the old theories are thus politically (and alas, linguistically) retranslated. In so doing, the individualistic bias of those theories (the assumption that status frustration, alienation or whatever, somehow had to be psychologically recognized) is removed. By stating the problem in historical or structural terms, there is no necessary assumption that it has to be present in a realized conscious form. Ethnographic support (in the form of statements about the 'system', the 'authorities', the 'fucking bosses') is occasionally cited but clearly the theories would not be embarrassed without this support. . . .

Let me list three representative such attempts to find the structural problem; each is a Marxist revision of the liberal or social-democratic assumptions behind the equivalent traditional theories.

Phil Cohen's influential work [Cohen 1972] is a radicalized and historically specific rendering of traditional accounts of working-class culture and community. He uses a particular delinquent youth culture, the Skinheads, and a particular place, the East End of London, to analyse the destruction of the working-class community and the erosion of its traditional culture.

Kinship network, neighbourhood ecology, local occupational structure, depopulation, the destruction of communal space, immigration, post-war redevelopment and housing, the stress on the privatized space of the family unit . . . all these vectors of life so commonly ignored in standard delinquency theory, are assembled into a model of the internal conflicts in the parent (i.e. adult) culture which come to be worked out in terms of generational conflict. These conflicts (or contradictions) register most acutely on the young and might appear at all sorts of levels: at the ideological, between the traditional working-class puritanism and the new hedonism of consumption; at the economic, between the future as part of the socially mobile élite (the future 'explored' by the Mods) and the future as part of the new lumpen (represented by the Skinhead inversion of the glossy element in Mod style). The latent function of the subculture is 'to express and resolve, albeit magically, the contradictions which remain hidden or unresolved in the parent culture' [Cohen 1972: 23]. Delinquent cultures retrieve social cohesive elements destroyed in the parent culture.

My next example is Corrigan (1979) – and this time, the target is the social democratic view of educational disadvantage. The persistent theme in his ethnography of 14–15-year-old boys in two Sunderland working-class schools, is power and subordination. Far from being a public sports track in which the earnest working-class youth's striving for status and mobility is thwarted by his deprived background, the school is a hidden political battleground, a setting in which the historical role of compulsory state education in attacking working-class culture is re-enacted each day. Bourgeois morality, values, discipline and surveillance, on the one hand; the continuous 'guerrilla warfare' of truancy, mucking about, 'dolling off' and getting into trouble, on the other. The kids simply do not *see* the world in the same way as the school; their 'problem' is how to resist and protect themselves from an alien imposition, not how to attain its values.

Then there is Willis [1977] – whose target is also liberal ideologies about education, opportunity and work (and who provides the most sophisticated theory of the interplay between structure, culture and biography). His ethnographic picture – based on two years work with boys in a Midlands comprehensive school, 'Hammertown', and then another year as they moved into work – is similar to Corrigan's, but even bleaker and darker. Again, there is the metaphor of a 'permanent guerrilla war' – and the bland sociological notion of a 'counter culture' is replaced by 'caged resentment which always stops just short of outright confrontation' [Willis 1977: 12–13]. The boys' class culture is devoted to subverting the institution's main aim: making them work. But – and here lies the subtlety and originality of Willis's thesis – this culture, with its values of chauvinism, solidarity, masculinity and toughness, contains also the seeds of the boys' defeat. The same transcendence of the school system – the refusal to collude in the elaborate pretence of qualifications, useless certificates, vocational guidance and careers advice – signals insertion into a system of exploitation through the acceptance of

manual labour. (Willis's view of culture – 'not simply layers of padding between human beings and unpleasantness' – as a creative appropriation in its own right, in fact undermines the whole solution/problem framework. The solution, ironically, is the problem: the boys eventually collude in their own domination.)

Each of these formulations – and other allied work – needs, and no doubt will receive, separate criticism. I want to mention here just one general problem: the over-facile drift to historicism. There are too many points at which the sociological enterprise of understanding the present is assumed to have been solved by an appeal to the past. No doubt it is important to see today's school in terms of the development of state education in the nineteenth century; to specify the exact historical transformations in the working-class neighbourhood; to define football hooliganism in terms of the erosion of the sport's traditions by bourgeois entertainment values, or to explain an episode of 'Paki-bashing' by Skinheads not in terms of a timeless concept of racial prejudice but by the place of migrant workers in the long historical drama of the collapse and transformation of local industry [Taylor 1971; Clarke 1978; Pearson 1976]. In each case the connections sound plausible. But in each case, a single and one-directional historical trend is picked out – commercialization, repression, bourgeoisification, destruction of community, erosion of leisure values – and then projected on to a present which (often by the same sociologist's own admission) is much more complicated, contradictory or ambiguous.

The recent enthusiasm with which criminologists have taken up the new 'history from below' derives from a common spirit [Pearson 1978]. The enterprise of bestowing meaning to certain contemporary forms of deviance was identical to the rescuing of groups like Luddites from (in E. P. Thompson's famous ringing phrase) 'the enormous condescension of posterity'. The appeal to history, though, is a hazardous business – especially in the form I will later discuss of trying to find actual continuities in resistance. I am less than convinced that any essentialist version of history – such as the dominant one of a free working class interfered with since the eighteenth century by the bourgeois state apparatus – is either necessary or sufficient to make sense of delinquency or youth culture today. It also leads to such nonsense as the assertion that *because* of this historical transformation, each working-class adolescent generation has to learn anew that its innocent actions constitute delinquency in the eyes of the state.

2. Culture/style/solution

Above all else, the new theories about British post-war youth cultures are massive exercises of decoding, reading, deciphering and interrogating. These phenomena *must* be saying something to us – if only we could know exactly *what*. So the whole assembly of cultural artefacts, down to the punks' last

safety pin, have been scrutinized, taken apart, contextualized and re-contextualized. The conceptual tools of Marxism, structuralism and semiotics, a Left-Bank pantheon of Genet, Levi-Strauss, Barthes and Althusser have all been wheeled in to aid this hunt for the hidden code. The result has been an ingenious and, more often than not, plausible reading of subcultural style as a process of generating, appropriating and re-ordering to communicate new and subversive meaning.

Whether the objects for decoding are Teddy Boys, Mods and Rockers, Skinheads or Punks, two dominant themes are suggested: first that style – whatever else it is – is essentially a type of *resistance* to subordination; secondly, that the form taken by this resistance is somehow *symbolic* or *magical*, in the sense of not being an actual, successful solution to whatever is the problem. The phrase 'resistance through ritual' clearly announces these two themes.

The notion of resistance conveys – and is usually intended to convey – something more active, radical and political than the equivalent phrases in old subcultural theory. It is not a question any more of passive adaptation or desperate lashing out in the face of frustrated aspirations, but of a collective (and, we are sometimes asked to believe) historically informed response, mediated by the class-culture of the oppressed. The following is a list of the terms actually used in the literature to convey this reaction:

> *in relationship to dominant values*:
> either: *resistance*: attack, subversion, overturning, undermining, struggle, opposition, defiance, violation, challenge, refusal, contempt
> or: *transformation*: transcendence, reworking, adaption, negotiation, resolution, realization
>
> *in relationship to traditional working-class values*:
> either: *defend*: safeguard, protect, preserve, conserve
> or: *recapture*: reappropriate, retrieve, reassert, reaffirm, reclaim, recover

Clearly, the nuances of these words convey somewhat different meanings but there are common threads particularly in the recurrent theme of *winning space*. Territoriality, solidarity, aggressive masculinity, stylistic innovation – these are all attempts by working-class youth to reclaim community and reassert traditional values.

Sociologically more opaque than this notion of resistance is the reciprocal idea that this process (whether conceived as defence, re-working, re-assertion or whatever) is somehow a symbolic one. Again it is instructive to list the actual words used to convey this meaning: ritualistic; imaginary; mythical; fantastic; metaphorical; magical; allegorical; ideological; suppressed; displaced; dislocated. There appear to be three contexts in which such concepts are invoked:

(i) When the target for attack is inappropriate, irrational or simply wrong in the sense that it is not logically or actually connected with the source of the problem. Thus Teddy Boys attacking Cypriot cafe owners, Mods and Rockers attacking each other, Skinheads beating up Pakistanis and gays, or football hooligans smashing up trains, are all really (though they might not know it) reacting to other things, for example, threats to community homogeneity or traditional stereotypes of masculinity. To quote Cohen and Robins on the Arsenal youth end, 'It's as if for these youngsters, the space they share on the North Bank is a way of magically retrieving the sense of group solidarity and identification that once went along with living in a traditional working-class neighbourhood' [Cohen and Robins 1978: 137].

(ii) The second (and allied) meaning is that the solution is 'always and only' magical in that it does not confront the real material bases of subordination and hence lacks the organization and consequences of a genuinely political response. Such attempts to deal with contradictions and subordination 'crucially do not mount their solutions on the real terrain where the contradictions themselves arise and . . . thus fail to pose an alternative, potentially counter hegemonic solution' [Clarke 1975: 189]. The gestures are as effective as sticking pins into kewpie dolls or as neurotic defence mechanisms like displacement or suppression. The bosses, educational disadvantage, unemployment, the police, remain where they were. Relations with the state are conducted at an imaginary level '. . . not in the sense that they are illusory, but in that they enfold the human beings who find themselves in confrontation in a common misrecognition of the real mechanisms which have distributed them to their respective positions' [Cohen and Robins 1978: 113]. It is a staged shadow boxing, a very bad case indeed of false consciousness.

(iii) The final (and more conventional) meaning of symbolic, is simply that the subcultural style stands for, signifies, points to or denotes something beyond its surface appearance. The Mods' scooters, the Skinheads' working boots, the Punks' facial make-up are all making oblique, coded statements about relationships – real or imaginary – to a particular past or present. Objects are borrowed from the world of consumer commodities and their meanings transferred by being reworked into a new ensemble which expresses its opposition obliquely or ironically.

Hebdige captures all these three meanings:

> These 'humble objects' can be magically appropriated; 'stolen' by subordinate groups and made to carry 'secret' meanings which express, in code, a form of resistance to the order which guarantees their continued subordination.
>
> [Hebdige 1979: 18]

Both these themes of *resistance* and *symbols* are rich and suggestive. I have only the space to mention, somewhat cryptically, a few of the problems they raise.

155

The first arises from the constant impulse to decode the style in terms *only* of opposition and resistance. This means that instances are sometimes missed when the style is conservative or supportive: in other words, not reworked or reassembled but taken over intact from dominant commercial culture. Such instances are conceded, but then brushed aside because – as we all know – the style is a *bricolage* of inconsistencies and anyway things are not what they seem and so the apparently conservative meaning really hides just the opposite.

There is also a tendency in some of this work to see the historical development of a style as being wholly internal to the group – with commercialization and co-option as something which just happens afterwards. In the understandable zeal to depict the kids as creative agents rather than manipulated dummies, this often plays down the extent to which changes in youth culture are manufactured changes, dictated by consumer society. I am not aware of much evidence, for example, that the major components in punk originated too far away from that distinctive London cultural monopoly carved up between commercial entrepreneurs and the lumpen intellectuals from art schools and rock journals. An allied problem is the often exaggerated status given to the internal circuit of English working-class history. The spell cast on the young by American cultural imperialism is sometimes downgraded. Instead of being given a sense of the interplay between borrowed and native traditions [Hebdige, of course, does just this; see also Cohen and Robins 1978: 96–103] we are directed exclusively to the experiences of nineteenth-century Lancashire cotton weavers.

This is inevitable if the subculture is taken to denote some form of cumulative historical resistance. Where we are really being directed is towards the 'profound line of historical continuity' between today's delinquents and their 'equivalents' in the past. And to find this line, we have to ask questions like 'How would "our" hooligans appear if they were afforded the same possibilities of rationality and intelligibility say as those of Edward Thompson?' [Pearson 1978: 134] . . . Historical evidence is cited [by these theorists] to prove that mass proletarian resistance to the imposition of bourgeois control did not after all die out. It lives on in certain forms of delinquency which – though more symbolic and individualistic than their progenitors – must still be read as rudimentary forms of political action, as versions of the same working-class struggle which has occurred since the defeat of Chartism. What is going on in the streets and terraces is not only not what it appears to be, but moreover is really the same as what went on before. And to justify this claim, a double leap of imagination is required. In Pearson's example, the 'proof' that something like Paki-bashing is a 'primitive form of political and economic struggle' lies not in the kids' understanding of what it is they are resisting (they would probably only say something like, 'When you get some long stick in your 'and and you are bashing some Paki's face in, you don't think about it') but in the fact that the machine smashers of 1826 would *also* not have been aware of the real political significance of their action [Pearson 1976].

This seems to me a very peculiar sort of proof indeed. If ever Tolstoy's remark applied, it might be here: 'History is like a deaf man replying to questions which nobody puts to him.'

This leads on to the vexing issue of consciousness and intent, a problem present even when the appeal is to symbols rather than history. Now it would be as absurd to demand here that every bearer of symbols walks around with structuralist theory in his head, as it would be to expect the oppressed to have a detailed knowledge of dialectical materialism. It seems to me, though, that *somewhere* along the line, symbolic language implies a knowing subject, a subject at least dimly aware of what the symbols are supposed to mean. To be really tough-minded about this, our criterion for whether or not to go along with a particular symbolic interpretation should be Beckett's famous warning to his critics: 'no symbols where none intended'.

And at times, the new theories would seem to accept such a tough criterion. Clarke, for example, insists at one point 'that the group self-consciousness is sufficiently developed for its members to be concerned to recognize themselves in the range of symbolic objects available' [Clarke 1975: 179]. More often than not, though, this tough criterion of a fit, consonance or homology between self-consciousness and symbolism is totally ignored and the theory is content to find theoretical meanings (magic, recovery of community, resistance or whatever) quite independent of intent or aware-ness. Indeed Hebdige – who is more sensitive than most to this problem – ends up by conceding 'It is highly unlikely . . . that the members of any subcultures described in this book would recognize themselves reflected here' [Hebdige 1979: 139].

Some inconsistencies arise – I think – from a too-literal application of certain strands in structuralism and semiotics. Hebdige, for example, uses Barthes' contrast between the obviously intentional signification of adver-tisements and the apparently innocent signification of news photos to suggest that subcultural style bears the same relationship to conventional culture as the advertising images bear to the less consciously constructed news photo. In other words, subcultural symbols are, obviously and conspicuously, fabri-cated and displayed. This is precisely how and why they are subversive and against the grain of mainstream culture which is unreflexive and 'natural'. But in the same breath, Hebdige repeats the semiotic article of faith that signification need not be intentional, that Eco's 'semiotic guerrilla warfare' can be conducted at a level beneath the consciousness of the individual members of a spectacular subculture – though, to confuse things further 'the subculture is still at another level an intentional communication' [Hebdige 1979: 101, 105].

This leaves me puzzled about the question of intent. I doubt whether these theories take seriously enough their own question about how the subcul-ture makes sense to its members. If indeed not all punks 'were equally aware of the disjunction between experience and signification upon which the whole style was ultimately based' or if the style made sense for the first wave of

self-conscious innovators from the art schools 'at a level which remained inaccessible to those who became punks after the subculture had surfaced and been publicized' [Hebdige 1979: 122] – and surely all this must be the case – then why proceed as if such questions were only incidental? It is hard to say which is the more sociologically incredible: a theory which postulates cultural dummies who give homologous meanings to all artefacts surrounding them or a theory which suggests that individual meanings do not matter at all.

Even if this problem of differential meaning and intent were set aside, we are left with the perennial sociological question of how to know whether one set of symbolic interpretation is better than another – or indeed if it is appropriate to invoke the notion of symbols *at all*. Here, my feeling is that the symbolic baggage the kids are being asked to carry is just too heavy, that the interrogations are just a little forced. This is especially so when appearances are, to say the least, ambiguous or (alternatively) when they are simple, but taken to point to just their opposite. The exercise of decoding can then only become as arcane, esoteric and mysterious as such terms as Hebdige's imply: 'insidious significance', 'the invisible seam', 'secret language', 'double meaning', 'second order system', 'opaque sign', 'secret identity', 'double life', 'mimes of imagined conditions', 'oblique expression', 'magical elisions', 'sleight of hand', 'present absence', 'frozen dialectic', 'fractured circuitry', 'elliptic coherence', 'coded exchanges', 'submerged possibilities', etc.

This is, to be sure, an imaginative way of reading the style; but how can be we sure that it is also not imaginary? When the code is embedded in a meaning system already rich in conscious symbolism, then there are fewer problems. For example, when Hebdige is writing about black rasta culture, the connections flow smoothly, the homology between symbols and life could hardly be closer. The conditions in the original Jamaican society, Rastafarian beliefs, the translation of reggae music to Britain . . . all these elements cohere. A transposed religion, language and style create a simultaneously marginal and magical system which provides a subtle and indirect language of rebellion. Symbols are *necessary*: if a more direct language had been chosen it would have been more easily dealt with by the group against which it was directed. Not only does the system display a high degree of internal consistency – particularly in its references to the historical experience of slavery – but it refers directly to patterns of thought which are *actually* hermetic, arcane, syncretic and associative.

If such patterns have to be forced out of the subject-matter, though, the end result is often equally forced. When any apparent inconsistencies loom up, the notion of 'bricolage' comes to the rescue: the magic ensemble is only *implicitly* coherent, the connections can be infinitely extended and improvised. And even this sort of rescue is too 'traditional' and 'simple' we are now told: instead of a reading being a revelation of a fixed number of concealed meanings, it's really a matter of 'polysemy': each text is seen to

generate a potentially infinite range of meanings. Style fits together precisely because it does not fit; it coheres 'elliptically through a chain of conspicuous absences' [Hebdige 1979: 117–20].

This is an aesthetics which may work for art, but not equally well for life. The danger is of getting lost in 'the forest of symbols' and we should take heed of the warnings given by those, like anthropologists, who have searched more carefully in these same forests than most students of youth culture. Thus in trying to interpret what he calls these 'enigmatic forma- tions', Turner is aware of certain frontiers to the anthropologist's explanatory competence [Turner 1967]. Some method or rules of guidance are needed. It would do no harm, for example, to follow his distinction between the three levels of data involved in trying to infer the structure and property of symbols and rituals: first, the actual observable external form, the 'thing'; secondly, the indigenous exegetics offered either by ritual specialists like priests (esoteric interpretations) or by laymen (exoteric interpretations); and finally the attempt by the social scientist to contextualize all this, particu- larly by reference to the field: the structure and composition of the group that handles the symbol or performs mimetic acts with reference to it.

Having made a simple enough distinction like this, it is then possible to proceed to the interesting complications: the problem of intent; of polysemy (a single symbol standing for many things); how people's interpretations of what they are doing might contradict how they actually behave; under what conditions the observer must go beyond indigenous interpretations because of what he knows of the context. All this requires great care. Much decoding of youth cultures simply does not make the effort – and often does foolish things like taking a priestly exegesis (for example, by a rock journalist) at its face value, or alternatively, offering a contextualization that is wholly gratuitous.

Let me conclude this [section] by giving an example of the dangers of searching the forest of symbols without such a method – or indeed any method. This is the example often used by Hebdige and other theorists of punk: the wearing of the swastika emblem. Time and time again, we are assured that although this symbol is 'on one level' intended to outrage and shock, it is *really* only being employed in a meta-language: the wearers are ironically distancing themselves from the very message that the symbol is usually intended to convey. Displaying a swastika (or singing lyrics like 'Belsen was a gas') shows how symbols are stripped from their natural context, exploited for empty effect, displayed through mockery, distancing, irony, parody, inversion.

But how are we to know this? We are never told much about the 'thing': when, how, where, by whom or in what context it is worn. We do not know what, if any, difference exists between indigenous and sociological explanations. We are given no clue about how these particular actors manage the complicated business of distancing and irony. In the end, there is no basis whatsoever for choosing between this particular sort of interpretation and

159

any others: say, that for many or most of the kids walking around with swastikas on their jackets, the dominant context is simple conformity, blind ignorance or knee-jerk racism.

Something more of an answer is needed to such questions than simply quoting Genet or Breton. Nor does it help much to have Hebdige's admission (about a similar equation) that such interpretations are not open to being tested by standard sociological procedures: 'Though it is undeniably there in the social structure, it is there as an immanence, as a submerged possibility, as an existential option; and one cannot verify an existential option scientifically – you either see it or you don't' [Hebdige 1979: 131].

Well, in the swastika example, I don't. And, moreover, when Hebdige does defend this particular interpretation of punk, he does it not by any existential leap but by a good old-fashioned positivist appeal to evidence: punks, we are told, 'were not generally sympathetic to the parties of the extreme right' and showed 'widespread support for the anti-Fascist movement' [116]. These statements certainly constitute evidence, not immanence – though not particularly good evidence and going right against widespread findings about the racism and support for restrictive immigration policies among substantial sections of working-class youth.

I do not want to judge one reading against the other nor to detract from the considerable interest and value of this new decoding work. We need to be more sceptical though of the exquisite aesthetics which tell us about things being fictional and real, absent and present, caricatures and re-assertions. This language might indeed help by framing a meaning to the otherwise meaningless; but this help seems limited when we are drawn to saying about Skinhead attacks on Pakistani immigrants: 'Every time the boot went in, a contradiction was concealed, glossed over or made to disappear' [58]. It seems to me – to borrow from the language of contradictions – that both a lot more and a lot less was going on. Time indeed to leave the forest of symbols; and '. . . shudder back thankfully into the light of the social day' [Turner 1967: 46].

3. Biography/phenomenology/living through

In one way or another, most of the problems in the 'resistance through rituals' framework are to be found at the theory's third level: how the subculture is actually lived out by its bearers. The nagging sense here is that these lives, selves and identities do not always coincide with what they are supposed to stand for.

What must be remembered first is that the troubles associated with stylistic and symbolic innovation are not all representative of all delinquency (let alone of all post-war British youth). Mundane day-to-day delinquency is and always has been predominantly property crime and has little to do with magic, codes or rituals. I doubt that many of the intricate preoccupations of

these theorists impinge much on the lives, say, of that large (and increasing) number of juveniles in today's custodial institutions: the 11,638 sent to detention centres, 7,067 to Borstals, 7,519 to prisons in 1978.

I fear that the obvious fascination with these spectacular subcultures will draw attention away from these more enduring numbers as well as lead to quite inappropriate criticisms of other modes of explanation. This, of course, will not be entirely the fault of the theorists themselves: the Birmingham group, for example, makes it absolutely clear that they are only concerned with subcultures which have reasonably tight boundaries, distinctive shapes and cohere around specific actions or places. As they are very careful to point out, the majority of working-class youth never enter such subcultures at all: 'individuals may in their personal life careers move into one and out of one, or indeed, several subcultures. Their relations to the existing subcultures may be fleeting or permanent, marginal or central' [Clarke *et al.* 1975: 16].

Despite these disavowals, though, the *method* used in most of this work detracts us from answering the more traditional, but surely not altogether trivial sociological questions about these different patterns of involvement. Why should some individuals exposed to the same pressures respond one way rather than another or with different degrees of commitment? As one sympathetic criticism [Murdock and McCron 1976] suggests, the problem arises from *starting* with groups who are already card-carrying members of a subculture and then working backwards to uncover their class base. If the procedure is reversed and one starts from the class base, rather than the cultural responses, it becomes obvious that an identical location generates a very wide range of responses and modes of accommodation.

Thus time and time again, studies which start in a particular biographical location – school, neighbourhood, work – come up with a much looser relationship between class and style. They show, for example, the sheer ordinariness and passivity of much working-class adolescent accommodation and its similarities to, rather than dramatic breaks with, the respectable parent culture. In the cultural repertoire of responses to subordination – learning how to get by, how to make the best of a bad job, how to make things thoroughly unpleasant for 'them' – symbolic innovation may not be very important.

Such studies are also needed to give a sense of the concrete – some feeling of time and space; when and how the styles and symbols fit into the daily round of home, work or school, friendship. Without this, it becomes difficult, for example, to meet the same standard objection levelled against traditional subcultural theory: the assumption of overcommitment and the fact that apart from the code itself, these young people may be models of conventionality elsewhere. The intellectual pyrotechnics behind many of these theories are also too cerebral, in the sense that a remote, historically derived motivational account (such as 'recapturing community') hardly conveys the immediate emotional tone and satisfaction of the actions themselves. Indeed the action (for example, fighting or vandalism) is often completely ignored

except when historicism is temporarily abandoned. A good example of this might be Corrigan's wholly believable account of the context and sequence in which trouble emerges among kids in the street corner of Sunderland: how 'doing nothing' leads to 'weird ideas' which lead to trouble. Another example would be Robins and Cohen's account of growing up on a council estate. The sense of imprisonment running through the different biographies they collect (under the heading 'We Gotta Get Out of This Place') relates closely with their theoretical explanation of what the street groups are actually doing.

Willis stands alone in showing how that (now) abused sociological task of linking history to subjective experience can be attempted. Structure is not left floating on its own – but a commitment to ethnography need not produce a series of disembodied phenomenological snapshots. He can retain the Marxist insistence that not everything is lived out at the level of practical consciousness – a level that is a poor guide to contradictions – and refuse 'to impute to the lads individually any critique or analytic motive', but still try to show what the 'giving of labour power' actually means subjectively. The struggle against subordination is lived out in the daily round of school life, in the rituals about dress, discipline, smoking, drinking, rules.

Simon Frith

FORMALISM, REALISM AND LEISURE
The case of punk [1980]

THE RECURRING PROBLEM for cultural theorists is to relate general accounts of ideology to the structures of particular media: it is difficult, for example, to find much in studies of film or television that seems directly applicable to an assessment of the cultural significance of popular music. In this [chapter] I want to suggest that the formalism versus realism debate in film studies is relevant to the analysis of pop music, but that in looking at pop in this way we come up against a neglected concept, leisure, which is, in turn, important for the analysis of other media.

The question common to studies of all media – and at the heart of the formalism/realism dispute – concerns ideology. How do different media work ideologically? What are their ideological effects and how are they achieved? At issue here is the concept of signification: how do different media organize the meanings with which and on which they work?

'Realist' theories assume that media operate with some degree of transparency: media images represent reality as if through a window or in a mirror; they are ideological to the degree that they are false. This can be measured against non-ideological representations, against experience. The argument is common in the sociology of television: news programmes are examined for bias, for false descriptions (of industrial conflict, for example); light entertainment is examined for stereotypes, for false images (of women, blacks and so forth). The political question is posed in terms of why media distort reality, and the answer is found not in media forms (which are examined only to see how distortion works) but in their controllers. Television news is bad because it is controlled by bad people, people who, for whatever reason (professionalism, political interest) have an ideological axe to grind.

There are different degrees of control – from straight censorship to the vague 'feel' that producers have for 'good television' – but all have the same ideological effect: the reproduction of a false account of how the capitalist world works. The way to change this media message is to seize the technical means of message production, to take over the machines. Ideology is a problem of content and control; the media simply communicate the knowledge that is fed into them.

'Formalist' theories concentrate, in contrast, on the formal means of signification. Their assumption is that media images don't reflect or copy reality but construct it. Media forms are structures of meaning which bind us an ideological account of the world; the very notion that we can judge such accounts against experience is 'an ideological effect of the realist discourse'. This approach is common in film studies: films are read not as distorted pictures of an independent reality, but as complex constructions of meaning which have 'a reality effect' – which makes us read them as if they were distorted pictures of an independent reality. The form has the same ideological effect whoever owns it. The political problem thus becomes not how to control a neutral process of production but how to read an ideological structure of signification; it is a question not of access, but of meaning. The ideological effect rests on the relationship between media texts and their readers.

The problem of pop

I have given a deliberately crude account of a familiar debate in order to emphasise the problems of applying its terms (routine, in more sophisticated forms, in discussions of literature, film, television, the press) to music. There are obvious difficulties, for example, in describing musical texts in semiological terms: the theories of representation that film critics have taken from literary criticism aren't immediately available to music critics unless we reduce music to songs and songs to words. What does it mean to call a piece of music a 'classic realist text'? And, precisely because the content of music is not obvious, the question of the control of music is more confused than in, say, the politics of television. The state does seek to regulate musical communication – records are banned from radio, groups are banned from town halls – but this is a limited form of control (*Anarchy in the UK* was still a best seller) and, anyway, offence is almost always taken at the words involved. The Gang of Four, for example, were told to change the word 'rubbers' (contraceptives – a traditionally sensitive product for the BBC) to 'rubbish' in order to perform *At Home He's A Tourist* on *Top of the Pops*; the programme's producer had no other way of pinning down the subversiveness of the group's music.

It is difficult, then, to say how musical texts mean or represent, and it is difficult to isolate structures of musical creation or control. (Who owns

the means of music making – the musicians? their record companies? broad-
casters?) Music critics analyse pop not in terms of form and content but in
terms of production and consumption: the argument is either that the ideo-
logical meaning of music lies in the way that it is commercially produced,
in its commodity form; or that consumers create their own meanings out of
the commodities on offer. Neither of these arguments is used in film and
television studies, but the resulting disagreements do refer back to the
aesthetic debates in Germany in the 1930s – the debates not about art and
modernism, but about the mass media, about the political significance of
cultural goods bought and sold in the market [see Bloch *et al.* 1977: 100–141].

The most convincing critique of mass culture is still that developed by
the Frankfurt School. Adorno's was the original argument that the produc-
tion of music as a commodity determines its cultural quality, that the
standardisation of music is the source of its cultural effect. This subjection
of creativity to commodity form (to 'capital discipline' in Horkheimer's
words) was made possible, according to Adorno, by the technology of mass
production, and he explained the popularity of mass music in psychological
terms: the pleasure of mass culture is the pleasure of a particular kind of
consumption – a passive, endlessly repeated confirmation of the world-as-it-
is. The pleasure of art, in contrast, is the pleasure of imagination and involves
an engagement with the world-as-it-could-be. This is a version of formalism.
Adorno argued that the way a cultural text is produced (as a commodity)
determines its significance. In particular, mass texts do their ideological work
through their construction of an illusion of reality. Consumers 'experience'
mass art as if they were grasping something for themselves but there is, in
fact, no individual way into the construction of mass meaning. Subjectivity,
in this context, means nothing more than market choice, and 'objectivity,
the ability to evaluate mass culture, means nothing more than a mass of
similar market choices.

The weakness of the argument lies in its account of consumption, its
reduction of a complex social process to a psychological effect. Walter
Benjamin's contrasting celebration of mechanical reproduction rested on the
argument that because the artistic authority of cultural goods had been broken,
their significance had become a matter of political dispute in which consumers
did have a say: in the community of mass consumption everyone is an expert.
The ideological significance of mass culture is determined, in other words,
in the process of consumption itself. The grasping of particular works by
particular audiences was, for Benjamin, a political rather than a psycholog-
ical event; how such works got to the market was of less significance.
Benjamin tended to treat the means of mass communication in technological
terms, as ideologically neutral.

Critical accounts of popular music still depend on the Adorno/Benjamin
positions. Out of Adorno have come, however crudely, analyses of the
economics of entertainment and descriptions of cultural imperialism, in which
the ideological effect of commercial music-making – the transformation of a

creative people into a passive mass — is taken for granted. Out of Benjamin, however distantly, have come subcultural theories, descriptions of the struggle for the sign. Thus youth subcultures are said to make meanings out of records, products that have no cultural significance until they are consumed, until teenagers to go work on them. These arguments are not just a matter of high theory. Adorno's analysis (mediated through Marcuse) has been important for music consumers themselves. The ideological separation of rock and pop in the 1960s rested on it. Pop was 'rubbish', 'escapist', 'vacuous' or whatever because it was 'commercial', because it was produced only for the money. Rock was superior (and potentially subversive) in as far as it was made for uncommercial reasons and remained true to the youth culture or artist's vision from which it came. The crucial struggle for 1960s rock fans was between music and money, between music as art or folk culture and music as commodity.

In retrospect, now that rock is big business, the counter-cultural critique of pop seems naïve and/or dishonest, but the point is that the terms of the critique remain dominant. . . . The problem evaded in this approach, from Adorno onwards, is that records, pop and rock, like all cultural products, embody both use and exchange value and their ideological significance can't be reduced to exchange value alone. This explains the continued confusions in rock criticism. Rock's commodity form can't be denied . . ., but the problem is to what extent its commercial function determines its cultural meaning. It is with reference to this problem that music theorists can learn from the formalist/realist debates in theoretical work on other media. The subcultural solution to the problem is, without such a reference, too vague. It asserts that meanings are created out of commodities, but does not make clear how free such creation can be — what are the limits of records not as commodities but as texts, as signification structures with rules and restrictions of their own? In answering this question, subcultural studies of youth have, unfortunately, focused more on visual than on musical signs. . . .

The case of punk

Punk is particularly important for this discussion because of its effect on cultural theorists. Before punk, popular music was rarely a matter of theoretical concern, and among organised socialists the line, in as far as there was one, tended towards folk purism. Within a few months of its public emergence in 1977, though, virtually every left paper agreed that Punk was a Good Thing. There were no doubts that it had transformed pop: it was credited with the success of Rock Against Racism [RAR] and the Anti-Nazi League carnivals and, in general terms, it was argued that popular music was now being made, heard and discussed in new ways. Punk took on this extraordinary significance because it seemed to focus three different arguments. The first was about the *audience*: punk was seen as a folk music and as a subcultural movement. The

music was thus taken to represent or symbolise class consciousness – the consciousness of working-class youth. The second concerned the problem of *commodity production*, in that punk seemed to challenge capitalist control of mass music. There was an emphasis on do-it-yourself, on seizing the technical means of music production. Finally, it raised questions about *meaning*, about how music works; punk seemed to involve new sounds, new forms, new texts. By combining these positions, punk was able to ease the doubts of at least some of rock's previous critics. It seemed to be different from previous mass music in terms of how it was made *and* how it was used *and* how it meant. Now, three years later [in 1980], it is possible to examine the implications of these assumptions in more detail.

Punk as folk

The political argument that punk represented working-class youth consciousness contained strong elements of opportunism – cultural politics often seemed to mean adopting youth styles in order to attract young people to adult issues; this was certainly an element in RAR's strategy. More important here, though, was the way that the argument drew on subcultural theory. The music was taken to articulate the values of the punk subculture and these, in turn, were read as a form of working-class consciousness – 'an oblique challenge to hegemony' in Dick Hebdige's words. In many ways the punks' music, their essentially masculine styles, were not much of a departure from rock'n'roll tradition: class consciousness here meant a new variation of the established gestures of teenage bravado (gestures originally developed by teds, mods, skins and the rest). Indeed, the punk-as-folk position had to take on board an embarrassing amount of 'spontaneous' sexism and racism. The achievement of RAR in recruiting punks to the anti-racist struggle can't be over-estimated, because this was a matter of hard ideological work – RAR did not reflect some given punk consciousness. The political contradictions of punk ideology are obvious in Julie Burchill and Tony Parsons' *The Boy Looked at Johnny*: the book contained a dedication to Menachim Begin, for example, which the publishers – symptomatically, Pluto Press – felt bound to disclaim.

The left argument was that punk was a stage in the movement from class consciousness to class political consciousness: this depended on a description of punk as rank and file music, the direct expression of the way things were – a kind of realism. But even in terms of reflection theory, punk as spontaneous expression of live experience, the argument did not make a lot of sense. The pioneering punk rockers themselves were a self-conscious, artful lot with a good understanding of both rock tradition and populist cliché; the music no more reflected directly back onto conditions in the dole queue than it emerged spontaneously from them. The musical 'realism' of punk was an effect of formal conventions, of a particular combination of sounds; more precisely, it was defined through its aural opposition to the 'unrealism' of

mainstream pop and rock. The real/unreal distinction played on a series of musical connotations – ugly versus pretty, harsh versus soothing, 'raw' (lyrics constructed around simple syllables, a three-chord lack of technique, a 'primitive' beat) versus 'cooked' (rock 'poetry', virtuosity, technical complexity). These new conventions in fact drew on well known rock'n'roll signs – often established within the original American garage band meaning of punk rock – but they now took on a rather different currency. This shift was to a large extent achieved by the punk fanzines, which themselves had their stylistic origins (or at least parallels) in Andy Warhol's *Interview* magazine – the same 'artless' reproduction of every word spoken, the same sense of slapped together necessity, the same effect of realism as sly style.

Most of the left converts simply ignored these histories and rejected any suggestion that punk reality was *constructed*. Punk for them was simply a transparent image of a real youth condition. But even in its own terms, their account was unconvincing in that it had no basis in an independent analysis of that reality. As a result, the relationship between youth culture and youth politics, between punk ideology and socialist practice, remained extremely unclear. In this it proved even less politically developed than the attempt by the Weathermen to incorporate American street youth (and its musical tastes) into a political organisation, the RYM (Revolutionary Youth Movement), during the late 1960s. Their argument had involved two assumptions; that young people, from draftees to students, were similarly *exploited* because American capital faced a crisis of overproduction, and were similarly *oppressed* by the force of the State, whether in the army, in the classroom or on the streets [see Jacobs ed. 1970]. Although the political strategy was a failure and the assumptions were wrong, the Weathermen did at least attempt to theorise youth mobilisation. The apologists of British punk a decade later made little attempt to analyse the effects of changing social conditions on youth, to tackle the political complexities of how (or whether) to organise punks or to understand the aesthetic conventions of the music. Based on unconsidered notions that punk described young people's reality and expressed their boredom and rage, their arguments involved not cultural analysis but a purely rhetorical optimism.

The problem of production

The punk argument about music production was drawn directly from debates in the 1960s. Punk opposed commercial music in two ways. First, it denounced multi-national record companies with a version of the assertion that 'small is beautiful' – punk music was, authentically, the product of small scale independent record and distribution companies. Secondly, punk demystified the production process itself – its message was that anyone can do it! The effect of this has been an astonishing expansion of local music making (for the results listen to John Peel's nightly show on Radio 1). In economic terms, then, punk is essentially petit-bourgeois. An important

strand in its development has been a cultural version of consumerism; the idea is that record buyers have a right to maximum market choice, that record buying should involve customer expression rather than producer manipulation. Just as the hippie entrepreneurial spirit had found its expression in the shop-based Virgin Records a decade ago, so the most enterprising punk company – Rough Trade – is also, symptomatically, based on a shop. This consumerism has led to the creation of an 'alternative' production system that both parallels the established industry (alternative shops sell records made by alternative record companies and featured in the Alternative Charts) and is integrated into it. 'Independent' records, made by do-it-yourself companies, remain commodities.

Independence, in this context, seems to refer primarily to the question of artistic control (as in the Clash's anti-CBS records *Remote Control* and *Complete Control*). The punks, like hippie musicians before them, assume an opposition between art and business, between honesty and bureaucracy. This involves not only the Adorno argument about commodities, but also a romantic argument about creativity. Punk did not discuss the social relations of music production. Musicians were not seen as workers, as cultural employees akin to journalists, film technicians or actors: they were artists. Their music was progressive because it involved the direct expression of the people-as-artists; the punk task was to make everyone a star. Punk messages could be distorted by the process of commercial production, but only if this process was in the wrong hands (multi-national bureaucrats, boring old farts). This was the other side of punk realism and, again, the political problem is ownership. Punk truth could get through, but the means of music making had to be kept under control – by the musicians, by the kids.

The problem of meaning

Although this was the most muddled strand in the argument, punk texts were clearly felt to challenge (by ridicule) pop and rock conventions of romance, beauty and ease: punk image (the safety pin) and sound (particularly of voices) had a shock effect. It soon became apparent, however, that punk was constricted by its realist claims, by its use of melodic structures and a rhythmic base which told-it-like-it-was *because* they followed rock'n'roll rules. The result of these limits to experiment was the emergence, after 1977, of a clear split: punk populism versus the punk avant-garde. The punk populists remain locked in their original position. They read teenage gestures and hear punk forms as the spontaneous expression of anti-hegemonic youth; they see the political problem as developing youth consciousness and preventing its symbols being commercialised. This is the standard left position: its clearest statements are in *Temporary Hoarding*, the RAR paper, where (usually adult) ideologists write in the populist punk style – not in reflection of a movement but in an attempt to sustain one. The punk avant-garde is more interested in musical meaning. These musicians (The Pop Group, Public Image Ltd, The

Gang of Four, Scritti Politti, for example) expose textual structures in famil-
iar ways (some of them have studied discourse theory) – by distancing them-
selves from their own performances and by juxtaposing terms from different
genres (musical montages of rock/reggae/funk/improvisation). They under-
mine the populist assumptions of transparency, mocking the idea of a direct
line from social experience to musical form, and expose the subjective claims
deeply embedded in all rock music.

Music is a medium in which the expression of emotion, feeling and belief
by performers can seem so direct (they talk straight at us) that powerful
conventions of 'subjective realism', or truth to feeling, have developed. These
are represented, most obviously, by the blues element in popular music –
rock, for example, drew on both blues and post-Dylan singer/songwriting
to develop its claims of authenticity, sincerity, depth of feeling and individ-
uality. These terms were important for punk too; they lurk behind its realist
claims, its subcultural theory and its struggle for artists' control. The avant-
garde punks, in contrast, exploit 'artificial' musical forms – pop disco,
synthesisers – and challenge their listeners to hear them without using the
language of rock criticism, the terms of emotion, feeling, style. Meanwhile,
the rock critics are still struggling to listen to the music of Public Image Ltd
as a reflection of Johnny Rotten's 'abrasive personality'.

It is therefore possible to see the contrast between avant-garde punk and
traditional rock in the familiar cultural terms of the formalism/realism debate.
In setting up the distinction like this, as a rock critic trying to make sense
of post-punk rock texts, I am conscious of using the terms in a rather over-
simplified and idiosyncratic way. 'Realism' is an especially difficult term here
because in the analysis of other media (cinema, television, literature, the
visual arts) it denotes both particular sets of practices within cultural produc-
tion (genres) and also a mode of analysis based on an epistemological assertion
about the relationship of 'text' to 'world'. The first sense doesn't apply in
music – there are no classic realist musical texts – and so we have to think
about the question of meaning without any of the usual critical shortcuts
created by the ambivalence of 'realism'. It is in this muddled and undevel-
oped area that the punk avant-garde is working – along with, for example,
certain schools of improvised music. Nevertheless, punk remains a commer-
cial medium and my elevation of an 'avant-garde' is misleading – the problems
of production (rock as commodity) and consumption (the rock audience)
are unresolved by even the most 'objective' or 'deconstructed' musical text.
. . . Rock politics is never just a matter of meaning. This can be illustrated
by one specific struggle, Rock Against Sexism, which involves three different
problems. The first is the fight against sexist representation and stereotypes
in rock – whether songs, images, journalism or album sleeves. This is really
a question of education and propaganda, in which 'realist' assumptions are
quite appropriate. Secondly, there is the need to encourage female musicians
by providing places to play, gigs, contacts, workshops, and so on; this is a
practical struggle in which the control of music-making institutions is a key

issue. Thirdly, at the theoretical level, musical signification needs to be explored in the attempt to explain how sexual representations work musically. Although these are different forms of intervention into different forms of struggle, they are obviously related: theories of rock meaning can only be developed through rock practice, and rock practice involves a relationship between musicians and audiences in a particular cultural institution. The ideology of rock, in short, is determined not by its texts – musical forms don't have eternal sexual meanings – but by its context. Rock music is an aspect of leisure.

The problem of leisure

The concept of leisure provides another way of relating use and exchange value in the circulation of cultural goods and this approach has the great advantage of providing a historical and material account of needs and values. But it has been surprisingly little used by cultural theorists and it is worth making a simple point: the ideology of leisure in capitalist societies is that people (i.e. men) work in order to be able to enjoy their leisure – leisure is 'free' time, when people (i.e. men) do what they want, realise their individual interests and abilities; even in Marxist accounts there is an assumption that leisure values are determined in a purely ideological struggle. But the freedom involved in this account of leisure is deceptive, and not only in ideological terms. Leisure is necessary for capital: it is the time when labour is replenished physically and culturally, re-creation time, and it is the time when workers consume, when surplus value is realised. 'Free' time is structured not only by ideas but also by material forces, by the availability of goods and resources, by the effects of the labour process on people's capacities and desires. Leisure involves a tension between choice and constraint: it is an aspect of the general relationship between production and consumption. Leisure, in other words, is an effect of capital accumulation and it is in this setting that the meaning of cultural goods has to be analysed. This argument has long been made by social historians, who have shown how the imposition of rational work discipline meant, necessarily, the imposition of a rational leisure discipline: traditional forms of release and riot became bound by the timed routines of the industrial labour process. It was these routines that constituted the meaning of modern leisure, and the issues discussed by historians of nineteenth-century leisure remain important for the analysis of contemporary mass culture: it was then that leisure was established as a particular set of ideological and cultural relationships.

The first point to make is that there is a permanent strain between the need to control leisure (hence all the licences and licensing authorities) and the ideological importance of leisure as the time when people experience themselves as 'free' labourers – cultural conflict cannot be divided along simple class lines. Leisure commodities are not necessarily conductive to good

order. Drink, for example, has been an issue of bourgeois dispute since Liberal manufacturers denounced Tory brewers, and a similar contradiction was obvious in the commercial exploitation of punk – private clubs put on the groups town halls banned, Virgin snapped up the Sex Pistols after EMI dropped them. As Marx noted, employers have quite different attitudes to their own workers, whose needs they attempt to limit, and to other people's, whose needs they attempt to extend.

Nineteenth-century leisure was organised through two sorts of bourgeois enterprise. The moral entrepreneurs saw leisure as a means to the end of self-improvement. Leisure was treated as an educational institution: rational recreation was encouraged for its useful effects. The argument is well illustrated by Sir James Kay-Shuttleworth's enthusiasm for music instruction in elementary schools. Songs, he declared, were 'an important means of forming an industrious, brave, loyal and religious working class. They might inspire cheerful views of industry and associate amusements . . . with duties' [cited in Bailey 1978: 46]. This emphasis on the moral significance of leisure remains embodied in state policy – in the use of subsidies to support particular high art forms, for example. Nineteenth-century leisure was defined along moral lines for the bourgeoisie as much as for the labourer, and the assumption that middle-class pleasures too must be functional lives on in the *Sunday Times* culture of joggers, gardeners and cooks. But the moral approach to leisure is complemented (and sometimes opposed) by commercial entrepreneurs churning out 'escapist' cultural commodities with reference not to their content but to their profitability. The logic of their production also puts a premium on order and routine, but through notions of professionalism, predictability and reduced commercial risk. Music hall proprietors weren't much interested in the morality of music, but they had their own concern for good order:

> It is one of the greatest nuisances possible to sensible people who go to places of amusement to divert their minds from politics and business alike to have the opinions of the daily papers reproduced in verse and flung at their heads by a music hall singer. Persons who go to a place of amusement to be amused, and these, we believe, form the steadily paying class, are too sensible to care to proclaim their private opinions by applauding mindless rubbish with a political meaning.
> [*The Era*, 28 November 1885; cited in Bailey 1978: 165]

This is a familiar assertion; we hear it most often these days from radio programmers, still giving people what they *really* want.

Working-class responses to the leisure provided contain their own contradictions. In working-class radical traditions, leisure was equally a time for improvement, political education and disciplined consciousness. Socialists have been as much concerned to encourage the rational use of free time as bourgeois moralists (in the temperance movement, for example) and the

socialist distinction between escapist and improving leisure, the socialist critiques of commercial play and 'light' entertainment, remain potent. They surface, for example, in the punk denunciation of disco as 'mindless' hedonism. There is a tension between leisure as an individual activity (the realm of choice) and leisure as a collective activity (the realm of solidarity). State policies have always reflected a fear of public disorder – the dangers of dancing in the streets, class conspiracy, youthful anarchy. But the mass market depends on forms of collectivity, and leisure is crucially associated with the values of conviviality and comradeship. The public/private distinction has been mediated through the family: the home, as the refuge from work, has become an essential setting for most leisure consumption. Marx suggested that in capitalist social relations the worker 'feels himself at home only during his leisure', and the relationship works the other way round too – by the end of the nineteenth century workers were collecting household goods, going on family holidays and enjoying 'family entertainment'. The equation of leisure and home puts women in a double disadvantage: it is their labour which makes the home comfortable but they are excluded from the usual work/leisure distinction – women's pleasures, even more than men's, are confined to the household but this is, in fact, their place of work. The contradictions are obvious in, say, Radio 1's daytime programming – music to clean up and wash clothes by.

I have only had space here to skim the surface of the issues raised by studies of leisure, but the point I'm trying to make is that rock records aren't just commodities, they are *leisure* commodities. This is the context of their use value. To understand how leisure goods signify we have to refer them to the general meanings of leisure, meanings which have their own processes of construction and dispute: the ideology of rock comes from a relationship between form *and* use. The pleasure of rock is not just a textual matter. It reflects those wider definitions of the leisure experience embodied in concepts like 'entertainment', 'relaxation', and 'fun', which themselves emerged from a complex cultural struggle and rest on a structure of sexual differentiation. This is the structure Rock Against Sexism has to take on. Even the simplest of rock categories – like dance music or party music – are redolent with social significance: dances and parties are historically and socially specific institutions and their ideological meanings – as breaks from work, settings for sexual contact, expressions of solidarity – are not only articulated by different types of music (disco, the Rolling Stones) but, simultaneously, determine those musics' ideological effects.

The meaning of leisure is, nevertheless, essentially contradictory. The use value of entertainment derives from its intimations of fun, irresponsibility and fulfilment – leisure is an implicit critique of work. The ideology of leisure has to strike a balance between freedom and order, and so the experience of freedom must be real (otherwise leisure goods would have no use) but not disruptive of work routines. Leisure must give pleasure, but not too much. Pleasure, in turn, is not just a psychological effect, but refers

to a set of experiences rooted in the social relations of production. It is important to stress that there cannot yet be *a* theory of pleasure, if only because the concept refers to too disparate a set of events – individual and collective, active and passive, defined against different situations of displeasure/pain/reality. I am not convinced that all these experiences can be explained in terms of sexuality. And it is also in this context that the importance of the bohemian tradition in rock (as in cultural history generally) needs explaining: bohemians articulate a particular kind of leisure critique of the work ethic. They are cultural radicals not just as the source of the formalist avant-garde, but also in institutional terms.

The problem of cultural politics, in short, is not just to organise subcultural resistance, to infiltrate the means of cultural production and to open closed texts, but to do these things with reference to the contradictions that are necessarily built into cultural consumption. It is this concept of 'consumption' that remains, in cultural analysis, the most difficult to define. It is, indeed, a term in a number of quite different discourses. It may, in each case, refer to the same activity (although even this is unclear – would it mean buying a record or listening to it?) but the concept means different things according to the analytic frameworks involved: in Marxist economic theory it refers to a moment in the circulation of value, in recent literary and film theory it refers to a kind of pleasure, in historical sociology it refers to an institutional process. Cultural theories of consumption are left in a muddle – 'passive consumption', for example, is a term used by theorists of all persuasions but as a rhetorical rather than as a theoretical device. My point is that we have to clarify the different meanings of 'consumption' before we can use the term adequately in the analysis of ideology.

Chapter 19

Gary Clarke

DEFENDING SKI-JUMPERS
A critique of theories of youth subcultures [1981][1]

SINCE ITS PUBLICATION, the 'new subcultural theory' contained in the Centre for Contemporary Cultural Studies' collection *Resistance Through Rituals* [1976] has become the new orthodoxy on youth; the collection and its spinoffs are firmly established on course reading lists at a time when youth has become a major focal concern of the state and parties across the political spectrum. To a large extent, the acceptance of the literature and its acclaim are justified: the authors realistically outlined the lived experience of postwar working-class youth subcultures in a sympathetic manner which was hitherto unknown. However, the approach has not been without its critics.

The major emphasis of the Centre for Contemporary Cultural Studies has been to explain the emergence of particular youth styles in terms of their capacity for problem solving. Phil Cohen's . . . complex analysis takes into account the full interplay of economic, ideological, and 'cultural' factors which give rise to subcultures. Subcultures are seen as 'a common solution between two contradictory needs: the need to create and express autonomy and difference from parents . . . and the need to maintain parental identifications' [Cohen 1972].

Cohen explains the development of subcultures on the basis of the re-development and reconstruction of the East End of London, which resulted in the fragmentation and disruption of the working-class family, economy, and community-based culture. Cohen suggests that the subcultures among working-class youth emerged as an attempt to resolve these experiences. Subcultures are seen as collective solutions to collectively experienced problems. Mods are seen to correspond to, and subsequently construct a

parody of, the upwardly mobile solution, while skinheads are read as an attempt to recover magically the chauvinisms of the 'traditional' working-class community.

However, Cohen (and adherents) are imprecise on the necessary extent of the connection between actual structural location and the problem-solving option. Is it possible, say, to have an upwardly mobile skinhead? Also, we are given little explanation as to how and why the class experiences of youth crystallize into a distinct subculture. The possible constituency of a new style is outlined, but where do the styles come from? Who designed the first fluorescent pink or leopardskin drape suit, for example, and how do we analytically leap from the desire for a solution to the adoption of a particular style? This is a significant problem when it seems that *both* skins and teds seek to revive and defend the 'traditional' working-class community, but through different styles. Furthermore, since any discussion of life chances is regarded as a 'Weberian deviation,' we are given no clues as to how we can explain the different degrees of commitment to a subculture other than through some neopositivist reference to the extent of the problems which stimulate the emergence of subcultures. The subcultures as discussed in *Resistance Through Rituals* are essentialist and non-contradictory. As Chris Waters [1981] has argued, the subcultures are treated as static and rigid anthropological entities when in fact such reified and pure subcultures exist only at the Centre's level of abstraction which seeks to explain subcultures in terms of their genesis. Hence there is an uncomfortable absence in the literature of any discussion as to how and with what consequences the pure subcultures are sustained, transformed, appropriated, disfigured, or destroyed. It is extremely difficult to consider the individual life trajectories of youth within the model laid down by Cohen. If each subculture is a specific problem-solving option, how are we to understand how individuals move in and out of different subcultures? . . .

The fundamental problem with Cohenite subcultural analysis is that it takes the card-carrying members of spectacular subcultures as its starting point and then teleologically works backward to uncover the class situation and detect the specific set of contradictions which produced corresponding styles. This could lead to the dangerous assumption that all those in a specific class location are members of the corresponding subculture and that all members of a subculture are in the same class location. A basic problem is that the elements of youth culture (music, dancing, clothes, etc.) which are discussed are not enjoyed *only* by the fully paid-up members of subcultures. If we reverse the methodological procedure adopted by the Centre and start with an analysis beginning with the social relations based around class, gender, and race (and age), rather than their stylistic products, we have to examine the whole range of options, modes of negotiation, or 'magical resolution' (and the limitations of access and opportunity that exist) that are open to, and used by, working-class youth. Such an approach would require a break from the Centre's paradigm of examining the 'authentic' subcultures in a

synthetic moment of frozen historical time which results in an essentialist and noncontradictory picture. Any empirical analysis would reveal that subcultures are diffuse, diluted, and mongrelized in form. For example, certain skins may assert values of 'smartness' which are considered by the authors to be restricted to the mods. The anthropological analysis of unique subcultures means that descriptions of the processes by which they are sustained, transformed, and interwoven are absent. Similarly, the elitist nature of the analysis (that is, the focus on 'originals') means that we are given no sense of how and why the styles became popular (and how and why they eventually cease to be in vogue) other than through a simplistic discussion of the corruption and incorporation of the original style.

By focusing on subcultures at their innovatory moment, the authors are able to make elaborate and generalized readings of the symbols from a few scant observations of styles and artifacts. Youth subcultures are seen not simply as 'imaginary solutions' but also as symbolic resistance, counter-hege-monic struggle, a defense of cultural space on a 'relatively autonomous' ideological level. For example, Hebdige considers the mods to have won a magical 'victory':

> The style they created therefore, constituted a parody of the consumer society in which they were situated. The mod delivered his blows by inverting and distorting the images (of neatness, of short hair) so cher-ished by his employers and parents which while being overtly close to the straight world was nonetheless incomprehensible to it.
>
> [Hebdige 1975: 93]

Similarly, the teds' 'reworking' of Edwardian dress is seen as a reasser-tion of traditional working-class values in the face of affluence, and the model-worker image of the skins is interpreted as part of a symbolic return to the 'traditional' working-class community.

The paradigm developed in *Resistance Through Rituals* [is] taken to extremes in *Subculture: The Meaning of Style* [1979], in which Dick Hebdige presents a detailed analysis of postwar subcultures. Hebdige is the theorist of style and subculture *par excellence*: wheeling in the entire left-of-field gurus of art, literature, linguistics, and semiotics 'to tease out the meanings embedded in the various post-war youth styles'. Springing from the art-school tradition himself, Hebdige prioritizes the creativity of subcultures, their 'art', 'aesthetics', the 'signs of forbidden identity' contained in the styles. This lies in the *bricolage* of subcultures, in their ability to create meaning and transform 'everyday objects' as if they were a walking Andy Warhol exhibition. Since Hebdige's problem is to witness and understand the trans-formative moment in which new meanings are created . . ., the resultant 'semiotic guerrilla warfare' is restricted to a flashpoint of rebellion. This is necessary by definition in Hebdige, since it seems that the symbolic potency of a style rests entirely upon the innovatory and unique nature of a sub-

culture's 'appearance'. Hence, for all the discussions of 'the subversive implications of style . . . the idea of style as a form of refusal . . . a gesture of defiance or contempt,' when it all boils down, the power of subcultures is a temporary 'power to disfigure.' The politics of youth is not only restricted to a consideration of the symbolic power of style, but this is also confined to the moment of innovation since . . . stylistic configurations soon lose their shock potential in Hebdige's analysis.

But what is the symbolic power of style in Hebdige's analysis? Quite simply it is a case of 'shocking the straights': the power of subcultures is their capacity to symbolize Otherness among an undifferentiated, untheorized, and contemptible 'general public.' Subcultures 'warn the straight world in advance of a similar presence – the presence of differences – and draw upon themselves vague suspicions, uneasy laughter, white and dumb rages'.

This dichotomy between subcultures and an undifferentiated 'general public' lies at the heart of subcultural theory. The readings of subcultural style are based on a necessary consideration of subcultures at a level of abstraction which fails to consider subcultural flux and the dynamic nature of styles; second, and as a result, the theory rests upon the consideration of the rest of society as being straight, incorporated in a consensus, and willing to scream undividedly loud in any moral panic. Finally, the analysis of subculture is posited upon the elevation of the vague concept of style to the status of an objective category. In *Subculture* the degree of blackness of a subculture provides the yardstick, but generally, the act of basic consideration (like the old song) is that 'you either have or you haven't got style'. . . .

Any future analysis of youth must transcend an exclusive focus on style. The Centre's subculturalists are correct to break away from a crude conception of class as an abstract relationship to the forces of production. However, subcultures are conceived as a leisure-based career, and the 'culture' within 'youth subculture' is defined in terms of the possession of particular artifacts and styles rather than as a whole 'way of life' structured by the social relations based on class, gender, race, and age. Consequently we are given little sense of what subcultures actually *do*, and we do not know whether their commitment is fulltime or just, say, a weekend phenomenon. We are given no sense of the age range, income (or source of income), and occupations of the members of a subculture, no explanation as to why some working-class youths do not join. Individual subcultural stylists are, ironically, reduced to the status of dumb, anonymous mannequins, incapable of producing their own meanings and awaiting the arrival of the code breaker.

Even if we accept that it is possible to read youth styles as a form of resistance, the Centre's claims that subcultures 'operate exclusively in the leisure sphere' mean that the institutional sites of hegemony (those of school, work, and home) are ignored. Surely these are the sites in which any resistance is located, and they need to be considered in order to examine the relationship between working-class youth and working-class culture in general. Paul Willis's *Learning to Labour* [1977] presents such an analysis,

examining boys' resistance at school to explain the reproduction of a shopfloor culture of masculinity. Unfortunately, Willis's categories of the 'lads' and the 'earoles' reproduce the dichotomy between deviant and 'normal' working-class youth which underlies the rest of the literature. The 'lads' are the focus of attention in the study, while the modes of negotiation (probably based on instrumentalism) adopted by the 'earoles' are ignored since they are presumed to be unproblematically incorporated into state schooling.

I would argue generally that the subcultural literature's focus on the stylistic deviance of a few contains (albeit implicitly) a similar treatment of the rest of the working class as unproblematically incorporated. This is evident, for example, in the distaste felt for youth deemed as outside subcultural activity – even though most 'straight' working-class youths enjoy the same music, styles, and activities as the subcultures – and in the disdain for such cults as glam, disco, and the ted revival, which lack 'authenticity.' Indeed, there seems to be an underlying contempt for 'mass culture' (which stimulates the interest in those who deviate from it) which stems from the work of the Marxism of the Frankfurt School and, within the English tradition, to the fear of mass culture expressed in *The Uses of Literacy* [Hoggart 1957]. . . .

Subcultural theory concerns itself with the original authentic members of a subculture and *their* creativity rather than how the styles dissipate and become used among working-class youth more generally. . . . Hence, we are to presume that the subcultures are brought back into line, rendered meaningless, 'incorporated' within the consensus, as their creativity is adopted by the ranks of the 'artless' working-class.

It is true that subcultures do lose their potency, but the discussions of the 'incorporation' of styles are inadequate for various reasons. First, the 'creativity' of the initial members of a subculture is overstated and the 'relative autonomy' of youth from the market is inadequately theorized. Within these accounts, the 'moment' of creative assemblage is *before* the styles become available. However, such innovations usually have a firm stake in the commodity market themselves. For example, the partnership of Malcolm McLaren and Vivienne Westwood was central in the manufacturing and selling of both punk ('cash from chaos') and the 'warrior chic' of the 1980s. If we are to speak of the creativity of working-class youth in their appropriations from the market, the journey from stylistic assemblage to mass selling must be reversed. In light of Hebdige's [1979] admission that, 'in the case of the punks, the media's sighting of punk style virtually coincided with the invention of punk deviance,' I can see little point in any analysis which worships the innovators yet condemns those youth who appropriate that style when it becomes a marketed product and splashed across the *Sun*'s center page. Surely, if we are to focus on the symbolic refusal contained in items of clothing such as bondage trousers, we ought to focus on the moment when the style becomes available – either as a commodity or as an idea to be copied (for example by attaching zips and straps to a pair of old school trousers); any future analysis of youth should take the breakthrough of a style

as its starting point. It is true that most youths do not enter into the subcultures in the elite form described in the literature, but large numbers do draw on particular elements of subcultural style and create their own meanings and uses of them. The concept of *bricolage* does not apply simply to an exclusive few – most working-class youths (and adults) combine elements of clothing to create new meanings. If anything, what makes subcultures outstanding is *not* their obvious *bricolage* (as Hebdige argues), but the lack of any fashion confusion as a style becomes a 'uniform.' An examination of male working-class youth quietly reveals that 'normal' dressing means using elements drawn from government surplus stores, sportswear (such as training shoes, track suits, rugby shirts, 'Fred Perry' tops, hunting jackets, rally jackets, flying suits, etc.), subcultural clothing appropriated from different historical eras via the secondhand clothing markets, and, finally, mass market fashion, which itself contains forms of recontextualized meaning, be it ski jumpers or work overalls. Girls are less free to experiment, but a closer examination is required here, since women's fashion cannot be simply conflated with an unchanging cult of femininity. In particular, it may be possible for our semioticians to make detailed readings of the *bricolage* which passes off as 'accessories' on the fashion pages.

If we are to consider the 'symbolic refusals' contained in items of clothing, we should not be content to read the styles of subcultural mannequins during their leisure time while dismissing other styles as if they were merely bland. Instead we should focus on the diluted 'semiotic guerilla warfare' in certain sites: in particular, those of school, home, and the workplace. This is evident, for example, in the stylistic disruptions of school uniform, the nonregulation jumper; earrings (on boys and girls); hair that is too long or too short; the trousers that are too wide, too straight, or that should be a skirt; the shirt or blouse of an unacceptable color or with a collar that is too short or long; the wearing of sneakers in class, and so forth. Similarly, a youth does not have to adopt the complete uniform of a subculture to be sent home from work or a training course, to annoy parents, to be labeled 'unmasculine' or 'unfeminine,' to be refused service in a bar or café, to be moved on by the police, and so forth. Clearly, the diffusion of styles cannot be classed as a simple defusing of the signifying practice of an elite few. . . . [Besides,] the absolute distinction between subcultures and 'straights' is increasingly difficult to maintain: the current diversity of styles makes a mockery of subcultural analysis as it stands.

Note

1 Ski-jumpers are cheap, imported, acrylic sweaters depicting a row of three skiers as a band across the chest. The origin of the style or the cult is impossible to trace, yet they are worn by a large majority of working-class youth, regardless of race or gender.

Jon Stratton

ON THE IMPORTANCE OF
SUBCULTURAL ORIGINS [1985]

I WANT TO . . . CONSIDER the problem of how subcultures originate. This problem is important because it locates a key moment of difference between spectacular and commodity oriented youth subcultures. The Birmingham Centre's Althusserian, structuralist scheme views subcultures as already constituted meaning systems providing imaginary resolutions to real contradictions. The premise of this argument is that all subcultures have the same form. Given this approach, it is understandable why the middle-class subculture of the hippies should be the only one singled out as a threat to bourgeois hegemony. The consequence of the Birmingham Centre's position is that all working-class subcultures must, in the end, be conservative because in performing ritual resolutions to contradictions which are not fundamental, the youth groups themselves provide the illusion of defensible space enabling the bourgeoisie to keep the overt forces of control, the army and the police, in low profile. If we look at the conditions under which the different forms of youth subculture emerge the importance of a socio-cultural, rather than a political, specificity will become clear. The hippies are then considered to be radical because they deconstruct bourgeois ideology from within.

Taylor and Wall [1976] in their article on skinheads and glam rock produce a grounded argument which suggests that the basic values of the skinheads were those of the British working class and they then argue that the subculture represented a real attempt to defend those values through their spectacular valorisation. The utility of this theoretical grounding is three fold. In the first place it enables us to understand an origin to the subculture in its attempt to defend working-class values not just at an ideological

181

level but at the real level of asserting: (a) the virtues of the corner pub which was being destroyed by a bourgeois capital more concerned with the economies of scale of large service clubs and discos: (b) the working-class control of football which was being eroded by the interest of the intellectual middle class; and (c) the defence of the work place in the overt celebration of racism. This specificity allows us to understand, in the second place, why skinheads remained a British movement. Whilst the style itself was readily exportable the praxis which gave the style coherence and cohesion was not; that is to say that the particular combination of real social institutions and economic and ideological threat not only did not occur in the rest of Europe but was not present in other cultures where Britain has had influence such as America and Australia. In the third place this theoretical grounding gives us a focus which enables us to locate the sign structure involved in the subculture in a larger societal context. The question which must then be posed is why spectacular subcultures articulating such specific and localised concerns should occur in Britain and not, to all intents and purposes, in other capitalist socio-cultural contexts. In order to answer this we must confront the problem of the added resonance accruing to the spectacular aspects of youth subcultures in Britain. Why is it that their spectacular formulations should be disguised symbolic iterations? The conventional answer to this . . . is that it is a consequence of the combined effects of consumerism and the mass media. . . . I think that there is a great deal that is right in this view. However, it does not solve the problem that the vast majority of spectacular youth subcultures have their origins in Britain. Of those that do not, black America provided both zootsuiters and the disco outrage fashions of the mid-1970s. It is questionable the extent to which either of these were actually subcultures however.

White America has provided – with the exception of the hippies, a subculture I have no room to discuss here – only two subcultures and both of these are commodity-oriented youth subcultures. There is first of all the upper working-class subculture of the surfies. Irwin argues for the origin of this subculture in the discontent and disillusionment felt by many Americans after the end of the Second World War. He argues that

> There were many returning veterans who were not ready to pick up civilian life, which, after the intensity of war, seemed dull and meaningless. In addition, many civilians were experiencing a freedom and a reluctance to return to the 'petty pursuits' of civilian life.
> ([Irwin] 1973: 134)

Hunter Thompson suggests the same origin for America's other commodity-oriented youth subculture, the bikies. He writes:

> Like the drifters who rode west after Appomattox, there were thousands of veterans in 1945 who flatly rejected the idea of going back to

their pre-war pattern . . . They wanted more action and one of the ways to look for it was on a big motorcycle.

([Thompson] 1966: 67)

The simple origin is significant because it allows us to compare surfies and bikies with British spectacular youth subcultures. The teddy boys were not a subculture developed by British World War Two veterans. Surfies and bikies were founded in an existential, experienced reaction not only to personal disorientation but also to the change in American society towards consumerism. Surfie and bikie subcultures arose out of individual attempts to cope with these problems. Spectacular subcultures are holistic, group phenomena. In their defining orientations we can compare the surfies and the bikies with the later British spectacular subcultural pair, the mods and the rockers. These two commodity-oriented subcultures represented two different ways of living the American Dream of consumerism from outside of the American social structure. By contrast mods and rockers presented spectacular solutions to British upper working-class aspirations. While mods signified an upward mobility, rockers acted out an assertion of working-class values and life-style which I shall discuss below.

The crucial distinction is that in spectacular youth subcultures, aspects of the culture of one or more socio-cultural groups, in the case of Britain, West Indian blacks or women, are appropriated whilst those groups are them-selves excluded from the youth subculture. Using the term in a general sense we may then suggest that spectacular subcultures are built on repression whilst commodity-oriented subcultures are the acting out of fantastic extrapo-lations of specific ideological tropes.

There had been surfing in California before the war, as there had been motorbike riders. What occurred after the war was an appropriation of the practice of surfing. Previously, surfing had simply been a leisure activity. In the post-war period it was rearticulated as the living of a myth of leisure. What made this shift possible was the development by Bob Simmons in the early 1950s of what is now known as the Malibu board. . . . This is not to say that the Malibu board caused the surfie subculture. The board was a product of a pre-existing set of attitudes and provided a focus for the elab-oration of the subculture. Unlike the older surf boards, Malibu boards were cheap, light and easily transportable. All these factors are important because they enabled the expansion of personal ownership, access to conspicuous consumption and the development of the board as an aspect of a particular subcultural style. As Irwin [1973: 143] points out, the new board also allowed a greater range of waves to be ridden. By enabling surfing to occur close to populated beaches surfing could generate a relationship between the dominant culture. One more point needs to be made about the impact of the new board and this is that it enabled a new more individualistic surfing form to develop as an effect of the increased manoeuvrability of the board. Indeed, in common with bikies, surfies emphasise a close link between the consumed

object and individualism. In this way they assert two of the fundamentals of American capitalism, consumerism and individualism.

Surfies, however, articulate the bourgeois leisure dream and emphasise individual skill and enjoyment. One of what Hunter Thompson calls the paradoxes of the Hells Angels is that, having spent a great deal of time (labour) and money personalising a Harley-Davidson, an Angel is more than likely to destroy it in a crash ([Thompson 1966:] 101–106). Bikies view themselves as outlaws and one aspect of this outlawry is spectacular destruction, a destruction which challenges the bourgeois values of caution and the sanctity of property. Surfies present to the dominant culture their leisure myth in magnified form. Bikies appear to challenge the values of the dominant culture, something which they are able to do because they, in the first place, like the surfies, accept them.

The surfie subculture in its full form was confined to those areas of the world where there is surf. It spread throughout the Pacific region and Australia and developed an outpost in South Africa. In addition imitative, and more symbolic and spectacular, formulations have had short lives in other places where there is no surf. They have not been sustainable. The introduction of this subculture to Australia is usually dated to 1956 when an American surf life saving group led by Tom Zahn toured the Australian east coast demonstrating the new boards. However, as Pearson had pointed out (Pearson 1979: 57–58) it was not the Malibu board which produced the subculture. Rather, as in America, the board allowed a pre-existing set of attitudes to be articulated in a particular way. The subculture articulates a middle-class myth; the holiday leisure time spent consuming an ideological myth of relaxation. The bleached blond, bronzed surfie lives his myth of escape for the individual trapped in his/her 48 week-a-year job. Simultaneously, the surfie is given status by his position as myth. Women's position in surfie culture, as in bikie culture, replicates visibly their position in the dominant ideology. Nevertheless, surfie women also contribute to the myth; they lie on the beach all day and get brown, the lived incarnation of the conventional female holiday fantasy, constituted within the dominant male-generated fantasy consisting of the holiday industry's well-known four S's: sun, sand, sea and sex.

The surfie and the bikie subcultures, rather than attempting through spectacle, mythically, to solve the inherent contradictions of capitalism, are both founded on the dominant post-war capitalist ideological theme of consumption. By comparison spectacular subcultures are much more culturally oriented. They are more expressive in their use of lived culture to symbolise problematic cultural areas whilst commodity oriented subcultures utilise certain ideological positions fundamental to capitalism. This makes them much more easily transferable between those cultures which share a capitalist economic structure, and also much more enduring than spectacular subcultures which tend to be much more localised both culturally and temporally. Both subcultures have had a tendency to become spectacular, however, even in America, as a consequence of their relationship with the mass media.

Irwin has described this development for the surfie subculture. The key moment in this shift was the first Hollywood surfie movie called *Gidget* which was released in 1959 (Irwin claims the year was 1957). The dominant culture's accommodation of surfies may be found in the spectacular reconstruction of the basic empathy between the dominant culture and the subculture which was further exhibited in the 1960s Hollywood trend for beach fantasies started by *Beach Party* which was released in 1963. *Gidget* and its sequels acceptably precursed a more generalised fantasy development.

The second youth subculture provided by America, then, is a working-class subculture built around the motorbike. This subculture has spread throughout the Western world. Paul Willis, in his study of British bikies, remarks: 'The motor-bike reflected and generated many of the central meanings of the bike culture. It must be understood as one of the main elements of its stylistic make-up' ([Willis] 1978: 52). It constitutes the most successful subcultural defence of working-class values and it is worth examining for a moment. In America, the first media celebration of the rocker or greaser was in the 1954 film *The Wild One*, in which Marlon Brando played a misunderstood youth leading a motor-cycle gang of leather clad kids who terrorise a small town. This film was the first attempt to spectacularise the subculture. The obviousness with which this is being done may be illustrated by noting that *The Wild One* was based on an actual incident in 1947 when a motorcycle gang known as the Booze Fighters caused a significant problem in a small California town called Hollister (Thompson 1966: 121). The first point to be made is that already in this film the working-class youth subculture is appropriated as it is spectacularised by the dominant bourgeois culture as a folk devil against which bourgeois values can be measured. This involves simultaneously valorising the gang and criticising it.

As well as the gang led by Marlon Brando there is another gang in the film led by Lee Marvin. Marvin's gang call themselves a club, which term suggests official parental/bourgeois acceptance. Brando and his group have broken away from the club. In this sense Marvin's group ought to be more acceptable, but the reverse is the case. The film becomes a vehicle for producing the Brando figure as sympathetic but also as a folk devil. At the same time it mythologises bourgeois/working-class distinctions into a generation problem. We can make a direct comparison with the surfie film *Gidget* in which a folk angel was produced. In this film the heroine is a teenager played by Sandra Dee who gets involved with some boys who are clearly sensible middle-class kids just having a bit of fun. The audience was led via Gidget herself into a sympathetic involvement with a tamed surfie culture. It is worth expanding the surfie, bikie comparison by looking at the mods and rockers. Both groups have analogous class backgrounds. Surfies were predominantly upper working class as Irwin notes (1973: 146–147) whilst bikies were mainly drawn from the lower end of the working class (Thompson 1966: 160–161). Similarly mods in Britain tended to be semi-skilled manual workers whilst rockers tended to be unskilled (Phil Cohen 1972: 35–36).

It would seem, then, that in the case of both mods and surfies, different kinds of strategies for middle-class acceptance were being mobilized. In the former case this was instituted through a mythic spectacular emulation of middle-class lifestyle whilst in the latter case the surfies presented themselves as a part of middle-class fantasy. British rockers on the other hand took over aspects of the American bikie style and reproduced them in the context of a spectacular subculture. Thus, for example, for the Hells Angels many of their adornments formed a secret code: among others the number 13 indicated a marijuana smoker whilst different coloured wings on their emblem meant the wearer had accomplished certain mostly sexual acts (Thompson 1966: 121). In Britain the 'meaning' of rocker clothing was directed outwards, the meaning construing itself in relation to the dominant ideology. American bikie culture did, and does, not have this degree of spectacularisation in spite of the media images which have been produced of it.

At a later date, the Hells Angels gained a currency and notoriety as the spectacular Other of the hippies. In this way, for a while, bikie culture in America was spectacularised into the Hells Angels, who were, in fact, simply one of a number of bikie gangs. This appropriation and spectacularisation are well illustrated in both the account of Ken Kesey's party in Hunter Thompson's *Hells Angels* (another account is to be found in Tom Wolfe's *The Electric Kool Aid Acid Test*) and in the film of the Rolling Stone's concert at Altmont. In Britain the Hells Angels performed an analogous function as is shown in the job they were given of 'policing' the legendary London squat at 144 Piccadilly. The Stones used the American Hells Angels to police Altmont. Particularly in the light of the murder at the concert this is often considered to have been a bad move by the Stones. I would argue that they misunderstood the nature of the American subculture which, being British, they would have taken to be spectacular. Instead they were dealing with a much more internalised and internally cohesive subculture. In Britain, with its tendency towards spectacularisation, bikie culture has always been less securely gang-oriented. Bourgeois ideology utilises the bikie subculture as an opposition Other to highlight and valorise bourgeois values. The bikie subculture has, from *The Wild One* on, been both accepted and glorified in terms of outlaw values characterised in angst and misunderstoodness whilst simultaneously being castigated for holding 'anarchic' values. This subculture is truly a bourgeois Folk Devil, something recognised in their institutional name. In Australia the different ideological positions held by surfies and bikies are illustrated in the confrontational attitudes to one another when, in the early 1960s, they seemed to be spectacularly acting out the roles apportioned to mods and rockers in England.

During the hippie period in the exceptionally long-lasting life of the bikie subculture – something else which separates commodity-oriented subcultures off from more transitory spectacular subcultures – a very illuminating transposition took place. In bourgeois society the rank and file of the police force is drawn from the middle and upper areas of the working class and serve to

protect the bourgeoisie from the deprecations of the lower working class – or so the myth in both Britain and America has it. In the British case mentioned above precisely this situation was reconstituted in the imaginary resolutions put forward in Britain by the hippies and the Hells Angels. In the case of Altmont this situation was re-constructed with remarkable ease under British influence. It might be argued then, against Hall *et al.* [in *Resistance Through Rituals*], that, certainly in Britain, the hippies were never a truly threatening movement because they were never able to break down the real social relations of capitalism. They simply provided a mythic solution to some of its contradictions as they presented themselves to middle-class youth. Similarly in America the hippies never really penetrated beyond the boundaries of the white middle class for whom they lived out a sometimes shocking fantasy life, and the bikie subculture has remained a bastion of working-class values.

The bikie subculture, like the surfies, is not a spectacular subculture. Indeed, as the close links between the Hells Angels and organised crime would suggest, it bears resemblance to earlier working-class gangs. In addition to being commodity-oriented it is locatable within the American working-class gang tradition and it is a culture of gangs where there exists not only the Hells Angels but Satans Slaves and Gypsy Jokers and many more. However, as I have illustrated by reference to *The Wild One*, bourgeois ideology consistently appropriates it spectacularly to generate an oppositional threat. As a consequence it often accepts the values attributed to it. At times groups have also drawn on the subculture to generate a more pure spectacular reconstruction of it. The most obvious example of this was the working-class exploitation of the image in the British rockers, of mods and rockers fame.

The bikie subculture is functionally organised around a specific consumer durable which has moved (or has been moved) downmarket, the motorbike. The conventional leather attire of the subculture is very traditional. The early automobile users wore leather as a protection. Bikies use it for the same reason, although it has now acquired an iconic importance as well. The popular Freudian equation of sexuality, power and the motorbike was finally made spectacularly explicit at the time that the hippies and the Hells Angels began their ritual dance in Marianne Faithful's performance in *Girl on a Motorcycle* (1968) – the Americans, with an equal candour but emphasising sex rather than symbol, called it *Naked under Leather*. The result of the equation is not only an assertion of sexist working-class values but a celebration of the bourgeois-originated myth of consumerism. The best bikie had the biggest/most expensive bike. He was also the bikie most unconcerned about destroying it, and possibly himself (Willis 1978). The subculture, to the extent that it is spectacular and articulates a mythically constituted artefact, exists as an uncomfortable mix consisting of the assertion of a set of working-class values and the acceptance of bourgeois hegemonic constructions. It means different things for those (predominantly working-class) who live it and those who view it often through bourgeois ideological recreations of

it in the media. Its basis, however, is not lodged in bourgeois fantasy at all. It is a commodity-oriented subculture asserting the values of a capitalist working class.

We might now suggest that, to the extent that a continuity might be discerned in this bike-oriented culture, it exists as an assertion of certain working-class values articulated in views which, unlike those of the skinheads, were transcultural. Bikies are not worried about the corner pub. They are, more fundamentally, worried about alcohol or drugs in general, both as a way of making money (cf., the pre-war razor gangs) and as a means of defensively/offensively coping with the strategies of bourgeois hegemonic ideology. They are not concerned with football or subtle changes in opportunities for meeting women but rather determinedly pursue the sexual division of labour, including the gratification of male rather than female desire, and the dominant status of the male. Given that popular music is an accepted aspect of the construction of both commodity-oriented and spectacular youth subcultures, it is significant that the music critics have always argued that the kind of music generally found acceptable by bikies, heavy metal, should be regularly criticised for its lack of musical content, its conservative lyrics and the repetitive nature of its beat. Yet, in spite of this, it is an international form stretching from the Australian AC/DC and Rose Tattoo through the American bands such as Van Halen to British bands like Judas Priest and Def Leppard. It is also a long-running genre stretching back to Deep Purple in Britain and Vanilla Fudge in America. The racist skinhead subculture, on the other hand, utilised the black West Indian music of ska thus generating one, of many, irreconcilable contradictions. One aspect of spectacular subcultures is their discussability. This is a product of their generation of meanings as a part of their spectacular formation. The frustration which tends to surround discussion of heavy metal music suggests that it does not interact with ease with the dominant ideology. It has, in this sense, a potential for self-containment which is analogous to that which exists more generally within commodity-oriented youth subcultures.

So . . . why do so many spectacular youth subcultures develop in Britain? In order to understand the answer which I have already sketched it is worth charting the teddy boy phenomenon. It was started, as Tony Jefferson [1975] documents, in 1950 by a group of Savile Row tailors who wanted to form a new style for young aristocratic men about town. By 1953, this style – importantly itself of aristocratic origin in an Edwardian fashion – had been appropriated by working-class youths. What occurred next, was a celebration of consumerism in fashion. As a tailor said to Fyvel:

> No, I wouldn't say there is a distinct style. Not like that old velvet collar business. That blew itself up and blew itself out . . . It's just a general style – all younger people are wearing brighter clothes today. Like our latest styles – Costa Brava Grey or Cha-Cha Check . . .
>
> (Fyvel 1961: 116–117)

Jefferson argues that the working-class appropriation of the style represents an attempt to 'buy status' because the style was, in the first place, that of the aristocratic dandies dressed by Savile Row. This misses the point that in origin, the style was that of the established aristocracy of the last great period for that group, the Edwardian. Britain is not a 'new society' such as America and Australia. It is not dominated by the bourgeois achievement orientation of the former or the 'working-class' self-conscious egalitarianism of the latter. . . . The historical continuity of British society has enabled a very strong residue of feudality to remain, a residue manifested in economic terms in the high percentage of capital in the hands of the aristocracy and in social terms in that obsession with the outward signs of status manifest in such things as dialect, area of residence and fashion, and finally, in the respect still shown to members of the hereditary aristocracy. The appropriation by working-class youth of the Edwardian style may be viewed, then, not merely as an attempt to buy status in the sense of appropriating the style of a higher class but in the more important sense of establishing status in the context of an aristocratic heritage with the awareness that, in a visually oriented culture, style is a singular sign of belonging. In Britain the significance of consumerism and the mass media in promoting spectacular subcultures has been reinforced by the emphasis on spectacle derived from a feudal preoccupation with status. The teddy boys, the first spectacular youth subculture, utilised the feudal resonance to reinforce the aristocratic style itself.

One reason why teddy boys did not appear in either America or Australia was that there was not the appropriate heritage to give the style its signification of upward nobility. The aristocracy either did not carry enough meaning as a group in their own right or carried the wrong meanings. There is no point appropriating the style of a social group which your society considers irrelevant, effete or ineffectual. Instead, the style which did develop in Australia – that of bodgies and widgies – was . . . derived originally from a black American style and in Australia articulated a symbolic affirmation of consumerism. In Australia it leads in a clear line to the working-class subculture bikie tradition outlined above. It started as a celebration of American consumerism and ended as an assertion of conservative working-class values. . . . In Australia the appropriation of the zootsuit style was closely tied in with the impact of American bourgeois consumerism by way of American servicemen during and after the Second World War. Whilst British Teds drew on a preoccupation with status and an aristocratic heritage to emulate their 'betters', Australians bought consumerism by a symbolic emulation whilst unable to buy the consumer goods themselves. This metamorphosed into the bikie culture which asserted traditional working-class values as working-class access to the consumer goods was permanently frustrated through the effects of income differentials. At the same time the symbolic cargo cult aspects of the subculture lost their spectacular orientation in a cultural setting which did not place an overdetermining emphasis on the spectacle as meaning. The subculture shifted towards a commodity-oriented

formulation, a logical development when its original concern with consumerism is taken into account.

In considering cultural productions such as youth subcultures, then, it is important to understand the structuration of the cultural context in which they occur. In recent accounts there has been a tendency either to emphasise the deviance of the activity at the expense of any cultural consideration, as in delinquency-oriented accounts, or to emphasise the cultural contextualisation of the subcultures at the expense of considering them as unitary phenomena. In order to develop a theory of youth subcultures applicable across a range of cultural orders it is necessary to appreciate that cultures have internal idiosyncracies which give them individuated integrities. Once we accept this we can go on to formulate a theoretical strategy for classifying youth subcultures. . . . We will then be in a position to talk about the problem of transference of youth subcultures from one cultural context to another.

Angela McRobbie

SECOND-HAND DRESSES AND
THE ROLE OF THE RAGMARKET [1989]

Introduction

SEVERAL ATTEMPTS HAVE been made recently to understand 'retro-style'. These have all taken as their starting point that accelerating tendency in the 1980s to ransack history for key items of dress, in a seemingly eclectic and haphazard manner. Some have seen this as part of the current vogue for nostalgia while others have interpreted it as a way of bringing history into an otherwise ahistorical present. This [chapter] will suggest that second-hand style or 'vintage dress' must be seen within the broader context of post-war subcultural history. It will pay particular attention to the existence of an entrepreneurial infrastructure within these youth cultures and to the opportunities which second-hand style has offered young people, at a time of recession, for participating in the fashion 'scene'.

Most of the youth subcultures of the post-war period have relied on second-hand clothes found in jumble sales and ragmarkets as the raw material for the creation of style. Although a great deal has been written about the meaning of these styles little has been said about where they have come from. In the early 1980s the magazine *iD* developed a kind of *vox pop* of street style which involved stopping young people and asking them to itemise what they were wearing, where they had got it and for how much. Since then many of the weekly and monthly fashion publications have followed suit, with the result that this has now become a familiar feature of the magazine format. However, the act of buying and the processes of looking and choosing still remain relatively unexamined in the field of cultural analysis.

One reason for this is that shopping has been considered a feminine activity. Youth sociologists have looked mainly at the activities of adolescent boys and young men and their attention has been directed to those areas of experience which have a strongly masculine image. Leisure spheres which involve the wearing and displaying of clothes have been thoroughly documented, yet the hours spent seeking them out on Saturday afternoons continue to be overlooked. Given the emphasis on street culture or on public peer-group activities, this is perhaps not surprising, but it is worth remembering that although shopping is usually regarded as a private activity, it is also simultaneously a public one and in the case of the markets and second-hand stalls it takes place in the street. This is particularly important for girls and young women because in other contexts their street activities are still curtailed in contrast to those of their male peers. This fact has been commented upon by many feminist writers but the various pleasures of shopping have not been similarly engaged with. Indeed, shopping has tended to be subsumed under the category of domestic labour with the attendant connotations of drudgery and exhaustion. Otherwise it has been absorbed into consumerism where women and girls are seen as having a particular role to play. Contemporary feminism has been slow to challenge the early 1970s orthodoxy which saw women as slaves to consumerism. Only Erica Carter's work [1979] has gone some way towards dislodging the view that to enjoy shopping is to be passively feminine and incorporated into a system of false needs.

Looking back at the literature of the late 1970s on punk, it seems strange that so little attention was paid to the selling of punk, and the extent to which shops like the *Sex* shop run by Malcolm McLaren and Vivienne Westwood functioned also as meeting places where the customers and those behind the counter got to know each other and met up later in the pubs and clubs. In fact, ragmarkets and second-hand shops have played the same role up and down the country, indicating that there is more to buying and selling subcultural style than the simple exchange of cash for goods. Sociologists of the time perhaps ignored this social dimension because to them the very idea that style could be purchased over the counter went against the grain of those analyses which saw the adoption of punk style as an act of creative defiance far removed from the mundane act of buying. The role of McLaren and Westwood was also downgraded for the similar reason that punk was seen as a kind of collective creative impulse. To focus on a designer and an art-school entrepreneur would have been to undermine the 'purity' or 'authenticity' of the subculture. The same point can be made in relation to the absence of emphasis on buying subcultural products. What is found instead is an interest in those moments where the bought goods and items are transformed to subvert their original or intended meanings. In these accounts the act of buying disappears into that process of transformation. Ranked below these magnificent gestures, the more modest practices of buying and selling have remained women's work and have been of little interest to those concerned with youth cultural resistance. . . .

The role of the ragmarket

Second-hand style owes its existence to those features of consumerism which are characteristic of contemporary society. It depends, for example, on the creation of a surplus of goods whose use value is not expended when their first owners no longer want them. They are then revived, even in their senility, and enter into another cycle of consumption. House clearances also contribute to the mountain of bric-à-brac, jewellery, clothing and furniture which are the staple of junk and second-hand shops and stalls. But not all junk is used a second time around. Patterns of taste and discrimination shape the desires of second-hand shoppers as much as they do those who prefer the high street or the fashion showroom. And those who work behind the stalls and counters are skilled in choosing their stock with a fine eye for what will sell. Thus although there seems to be an evasion of the mainstream, with its mass-produced goods and marked-up prices, the 'subversive consumerism' of the ragmarket is in practice highly selective in what is offered and what, in turn, is purchased. There is in this milieu an even more refined economy of taste at work. For every single piece rescued and restored, a thousand are consigned to oblivion. Indeed, it might also be claimed that in the midst of this there is a thinly-veiled cultural élitism in operation. The sources which are raided for 'new' second-hand ideas are frequently old films, old art photographs, 'great' novels, documentary footage and textual material. The apparent democracy of the market, from which nobody is excluded on the grounds of cost, is tempered by the very precise tastes and desires of the second-hand searchers. Second-hand style continually emphasizes its distance from second-hand clothing.

The London markets and those in other towns and cities up and down the country cater now for a much wider cross-section of the population. It is no longer a question of the *jeunesse dorée* rubbing shoulders with the poor and the down-and-outs. Unemployment has played a role in diversifying this clientele, so also have a number of other less immediately visible shifts and changes. Young single mothers, for example, who fall between the teen dreams of punk fashion and the reality of pushing a buggy through town on a wet afternoon, fit exactly with this new constituency. Markets have indeed become more socially diverse sites in the urban landscape. The Brick Lane area in London, for example, home to part of the Bangladeshi population settled in this country, attracts on a Sunday morning, young and old, black and white, middle-class and working-class shoppers as well as tourists and the merely curious browsers. It's not surprising that tourists include a market such as Brick Lane in their itinerary. In popular currency, street markets are taken to be reflective of the old and unspoilt; they are 'steeped in history' and are thus particularly expressive of the town or region.

The popularity of these urban markets also resides in their celebration of what seem to be pre-modern modes of exchange. They offer an oasis of cheapness, where every market day is a 'sale'. They point back in time to

an economy unaffected by cheque cards, credit cards and even set prices. Despite the lingering connotations of wartime austerity, the market today promotes itself in the language of natural freshness (for food and dairy produce) or else in the language of curiosity, discovery and heritage (for clothes, trinkets and household goods). There is, of course, a great deal of variety in the types of market found in different parts of the country. In London there is a distinction between those markets modelled on the genuine fleamarkets, which tend to attract the kind of young crowd who flock each weekend to Camden Lock, and those which are more integrated into a neighbourhood providing it with fruit, vegetables and household items. The history of these more traditional street markets is already well documented. They grew up within the confines of a rapidly expanding urban economy and played a vital role in dressing (in mostly second-hand clothes), and feeding the urban working classes, who did not have access to the department stores, grocers or other retail outlets which catered for the upper and middle classes. As Phil Cohen [1979] has shown, such markets came under the continual surveillance of the urban administrators and authorities who were concerned with 'policing the working class city'. The streetmarkets were perceived by them as interrupting not only the flow of traffic and therefore the speed of urban development, but also as hindering the growth of those sorts of shops which would bring in valuable revenue from rates. These were seen as dangerous places, bringing together unruly elements who were already predisposed towards crime and delinquency; a predominantly youthful population of costermongers had to be brought into line with the labour discipline which already existed on the factory floor.

The street market functioned, therefore, as much as a daytime social meeting place as it did a place for transactions of money and goods. It lacked the impersonality of the department stores and thrived instead on the values of familiarity, community and personal exchange. This remains the case today. Wherever immigrant groups have arrived and set about trying to earn a living in a largely hostile environment a local service economy in the form of a market has grown up. These offer some opportunities for those excluded from employment, and they also offer some escape from the monotony of the factory floor. A drift, in the 1970s and 1980s, into the micro-economy of the street market is one sign of the dwindling opportunities in the world of real work. There are now more of these stalls carrying a wider range of goods than before in most of the market places in the urban centres. There has also been a diversification into the world of new technology, with stalls offering cut-price digital alarms, watches, personal hi-fis, videotapes, cassettes, 'ghetto-blasters' and cameras. The hidden economy of work is also supplemented here by the provision of goods obtained illegally and sold rapidly at rock-bottom prices.

This general expansion coincides, however, with changing patterns in urban consumerism and with attempts on the part of mainstream retailers to participate in an unexpected boom. (In the inner cities the bustling markets

frequently breathe life and colour into otherwise desolate blighted areas. This, in turn, produces an incentive for the chain stores to reinvest, and in places such as Dalston Junction in Hackney, and Chapel Market in Islington, the redevelopment of shopping has taken place along these lines, with Sainsbury's, Boots the Chemist and others, updating and expanding their services. The stores flank the markets, which in turn line the pavements, and the consumer is drawn into both kinds of shopping simultaneously. In the last few years many major department stores have redesigned the way in which their stock is displayed in order to create the feel of a market place. In the 'Top Shop' basement in Oxford Street, for example, there is a year-round sale. The clothes are set out in chaotic abundance. The rails are crushed up against each other and packed with stock, which causes the customers to push and shove their way through. This intentionally hectic atmosphere is heightened by the disc jockey who cajoles the shoppers between records to buy at an even more frenzied pace.

Otherwise, in those regions where the mainstream department stores are still safely located on the other side of town, the traditional street market continues to seduce its customers with its own unique atmosphere. Many of these nowadays carry only a small stock of second-hand clothes. Instead, there are rails of 'seconds' or cheap copies of high street fashions made from starched fabric which, after a couple of washes, are ready for the dustbin. Bales of sari material lie stretched out on counters next to those displaying make-up and shampoo for black women. Reggae and funk music blare across the heads of shoppers from the record stands, and hot food smells drift far up the road. In the Ridley Road market in Hackney the hot bagel shop remains as much a sign of the originally Jewish population as the eel pie stall reflects traditional working-class taste. Unfamiliar fruits create an image of colour and profusion on stalls sagging under their weight. By midday on Fridays and at weekends the atmosphere is almost festive. Markets like these retain something of the pre-industrial gathering. For the crowd of shoppers and strollers the tempo symbolises time rescued from that of labour, and the market seems to celebrate its own pleasures. Differences of age, sex, class and ethnic background take on a more positive quality of social diversity. The mode of buying is leisurely and unharassed, in sharp contrast to the Friday afternoon tensions around the checkout till in the supermarket.

Similar features can be seen at play in markets such as Camden Lock on Saturday and Sunday afternoons. Thousands of young people block Camden's streets so that only a trickle of traffic can get through. The same groups and the streams of punk tourists can be seen each week, joined by older shoppers and those who feel like a stroll in the sun, ending with an ice cream further along Chalk Farm road. Young people go there to see and be seen if for any other reason than that fashion and style invariably look better worn than they do on the rails or in the shop windows. Here it is possible to see how items are combined with each other to create a total look. Hairstyles, shoes, skirts and 'hold-up' stockings; all of these can be taken in at a glance. In this context

shopping is like being on holiday. The whole point is to amble and look, to pick up goods and examine them before putting them back. Public-school girls mingle with doped-out punks, ex-hippies hang about behind their Persian rug stalls as though they have been there since 1967, while more youthful entrepreneurs trip over themselves to make a quick sale.

Subcultural entrepreneurs

The entrepreneurial element, crucial to an understanding of street markets and second-hand shops, has been quite missing from most subcultural analysis. The vitality of street markets today owes much to the hippy counter-culture of the late 1960s. It was this which put fleamarkets firmly back on the map. Many of those which had remained dormant for years in London, Amsterdam or Berlin, were suddenly given a new lease of life. In the years following the end of World War Two the thriving black markets gradually gave way to the fleamarkets which soon signalled only the bleakness of goods discarded. For the generation whose memories had not been blunted altogether by the dizzy rise of post-war consumerism, markets for old clothes and jumble sales in the 1960s remained a terrifying reminder of the stigma of poverty, the shame of ill-fitting clothing, and the fear of disease through infestation, rather like buying a second-hand bed.

Hippy preferences for old fur coats, crêpe dresses and army great-coats, shocked the older generation for precisely this reason. But they were not acquired merely for their shock value. Those items favoured by the hippies reflected an interest in pure, natural and authentic fabrics and a repudiation of the man-made synthetic materials found in high street fashion. The pieces of clothing sought out by hippy girls tended to be antique lace petticoats, pure silk blouses, crêpe dresses, velvet skirts and pure wool 1940s'-styled coats. In each case these conjured up a time when the old craft values still prevailed and when one person saw through his or her production from start to finish. In fact, the same items had also won the attention of the hippies' predecessors, in the 'beat culture' of the early 1950s. They too looked for ways of by-passing the world of ready-made clothing. In the rummage sales of New York, for example, 'beat' girls and women bought up the fur coats, satin dresses and silk blouses of the 1930s and 1940s middle classes. Worn in the mid 1950s, these issued a strong sexual challenge to the spick and span gingham-clad domesticity of the moment.

By the late 1960s, the hippy culture was a lot larger and much better off than the beats who had gone before them. It was also politically informed in the sense of being determined to create an alternative society. This subculture was therefore able to develop an extensive semi-entrepreneurial network which came to be known as the counter-culture. This was by no means a monolithic enterprise. It stretched in Britain from hippy businesses such as Richard Branson's Virgin Records and Harvey Goldsmith's Promotions to all

the ventures which sprang up in most cities and towns, selling books, vege-tarian food, incense, Indian smocks, sandals and so on. It even included the small art galleries, independent cinemas and the London listings magazine *Time Out*.

From the late 1960s onwards, and accompanying this explosion of 'alter-native' shops and restaurants, were the small second-hand shops whose history is less familiar. These had names like 'Serendipity', 'Cobwebs' or 'Past Caring' and they brought together, under one roof, all those items which had to be discovered separately in the jumble sales or fleamarkets. These included flying jackets, safari jackets, velvet curtains (from which were made the first 'loon' pants) and 1920s flapper dresses. These second-hand goods provided students and others drawn to the subculture, with a cheaper and much more expansive wardrobe. (The two looks for girls which came to characterise this moment were the peasant 'ethnic' look and the 'crêpey' bohemian Bloomsbury look. The former later became inextricably linked with Laura Ashley and the latter with Biba, both mainstream fashion newcomers.) Gradually hippie couples moved into this second-hand market, just as they also moved into antiques. They rapidly picked up the skills of mending and restoring items and soon learnt where the best sources for their stock were to be found. This meant scouring the country for out-of-town markets, making trips to Amsterdam to pick up the long leather coats favoured by rich hippy types, and making thrice-weekly trips to the dry cleaners. The result was loyal customers, and if the young entrepreneurs were able to anticipate new demands from an even younger clientele, there were subse-quent generations of punks, art students and others.

The presence of this entrepreneurial dynamic has rarely been acknowl-edged in most subcultural analysis. Those points at which subcultures offered the prospect of a career through the magical exchange of the commodity have warranted as little attention as the network of small-scale entrepre-neurial activities which financed the counter-culture. This was an element, of course, vociferously disavowed within the hippy culture itself. Great efforts were made to disguise the role which money played in a whole number of exchanges, including those involving drugs. Selling goods and commodities came too close to 'selling out' for those at the heart of the subculture to feel comfortable about it. This was a stance reinforced by the sociologists who also saw consumerism within the counter-culture as a fall from grace, a lack of purity. They either ignored it, or else, employing the Marcusian notion of recuperation, attributed it to the intervention of external market forces. It was the unwelcome presence of media and other commercial inter-ests which, they claimed, laundered out the politics and reduced the alternative society to an endless rail of cheesecloth shirts.

There was some dissatisfaction, however, with this dualistic model of creative action followed by commercial reaction. Dick Hebdige [1979] and others have drawn attention to the problems of positing a raw and undiluted (and usually working-class) energy, in opposition to the predatory youth

industries. Such an argument discounted the local, promotional activities needed to produce a subculture in the first place. Clothes have to be purchased, bands have to find places to play, posters publicising these concerts have to be put up . . . and so on. This all entails business and managerial skills even when these are displayed in a self-effacing manner. The fact that a spontaneous sexual division of labour seems to spring into being is only a reflection of those gender inequalities which are prevalent at a more general level in society. It is still much easier for girls to develop skills in those fields which are less contested by men than it is in those already occupied by them. Selling clothes, stage-managing at concerts, handing out publicity leaflets, or simply looking the part, are spheres in which a female presence somehow seems natural.

While hippy style had run out of steam by the mid-1970s the alternative society merely jolted itself and rose to the challenge of punk. Many of those involved in selling records, clothes and even books, cropped their hair, had their ears pierced and took to wearing tight black trousers and Doctor Marten boots. However, the conditions into which punk erupted and of which it was symptomatic for its younger participants were quite different from those which had cushioned the hippy explosion of the 1960s. Girls were certainly more visible and more vocal than they had been in the earlier subculture, although it is difficult to assess exactly how active they were in the do-it-yourself entrepreneurial practices which accompanied, and were part of, the punk phenomenon. Certainly the small independent record companies remained largely male, as did the journalists and even the musicians (though much was made of the angry femininity of Poly Styrene, The Slits, The Raincoats and others). What is less ambiguous is the connection with youth unemployment, and more concretely, within punk, with the disavowal of some of the employment which was on offer for those who were not destined for university, the professions or the conventional career structures of the middle classes.

Punk was, first and foremost, cultural. Its self-expressions existed at the level of music, graphic design, visual images, style and the written word. It was therefore engaging with and making itself heard within the terrain of the arts and the mass media. Its point of entry into this field existed within the range of small-scale youth industries which were able to put the whole thing in motion. Fan magazines (fanzines) provided a training for new wave journalists, just as designing record sleeves for unknown punk bands offered an opportunity for keen young graphic designers. In the realm of style the same do-it-yourself ethic prevailed and the obvious place to start was the jumble sale or the local fleamarket. Although punk also marked a point at which boys and young men began to participate in fashion unashamedly, girls played a central role, not just in looking for the right clothes but also in providing their peers with a cheap and easily available supply of second-hand items. These included 1960s cotton print 'shifts' like those worn by the girls in The Human League in the early 1980s (and in the summer of 1988 'high

fashion' as defined by MaxMara and others), suedette sheepskin-styled jackets like that worn by Bob Dylan on his debut album sleeve (marking a moment in the early 1960s when he too aspired to a kind of 'lonesome traveller' hobo look), and many other similarly significant pieces.

This provision of services in the form of dress and clothing for would-be punks, art students and others on the fringe, was mostly participated in by lower middle-class art and fashion graduates who rejected the job opportunities available to them designing for British Home Stores or Marks and Spencer. It was a myth then, and it is still a myth now, that fashion houses were waiting to snap up the talent which emerges from the end-of-term shows each year. Apart from going abroad, most fashion students are, and were in the mid-1970s, faced with either going it alone with the help of the Enterprise Allowance Schemes (EAS), or else with joining some major manufacturing company specialising in down-market mass-produced fashion. It is no surprise, then, that many, particularly those who wanted to retain some artistic autonomy, should choose the former. Setting up a stall and getting a licence to sell second-hand clothes, finding them and restoring them, and then using a stall as a base for displaying and selling newly-designed work, is by no means unusual. Many graduates have done this and some, like Darlajane Gilroy and Pam Hogg, have gone on to become well-known names through their appearance in the style glossies like *The Face*, *Blitz* and *iD*, where the emphasis is on creativity and on fashion-as-art.

Many others continue to work the markets for years, often in couples and sometimes moving into bigger stalls or permanent premises. Some give up, re-train or look round for other creative outlets in the media. The expansion of media goods and services which has come into being in the last ten years, producing more fashion magazines, more television from independent production companies, more reviews about other media events, more media personalities, more media items about other media phenomena, and so on, depends both on the successful and sustained manifestation of 'hype' and also on the labour power of young graduates and school leavers for whom the allure of London and metropolitan life is irresistible. For every aspiring young journalist or designer there are many thousands, however, for whom the media remains tangible only at the point of consumption. Despite the lingering do-it-yourself ethos of punk, and despite 'enterprise culture' in the 1980s, this bohemian world is as distant a phenomenon for many media-struck school-leavers as it has always been for their parents. 'Enterprise subcultures' remain small and relatively privileged metropolitan spaces.

Sarah Thornton

THE SOCIAL LOGIC OF
SUBCULTURAL CAPITAL [1995]

'CLUB CULTURE' is the colloquial expression given to the British youth cultures for whom dance clubs and their offshoot, raves, are the symbolic axis and working social hub. Club culture is not a unitary culture but a cluster of subcultures which share this territorial affiliation, but maintain their own dress codes, dance styles, music genres and catalogue of authorized and illicit rituals. Club cultures are *taste cultures*. The crowds generally congregate on the basis of their shared taste in music, their consumption of common media and, most importantly, their preference for people with similar tastes to themselves. Taking part in club cultures, in turn, builds further affinities, socializing participants into a knowledge of (and frequently a belief in) the likes and dislikes, meanings and values of the culture. Clubs and raves, therefore, house *ad hoc* communities with fluid boundaries which may come together and dissolve in a single summer or endure for several years.

Club nights continually modify their style, change their name and move their location. Club cultures are faddish, fragmented and heavily dependent on people 'being in the know' – on being 'hip', 'cool', or 'happening'. In fact, if one had to settle on one term to describe the cultural organization or social logic by which most clubs operate, it would have to be 'hipness'. But what is this willfully arcane attitude? This cultural value? How it is embodied? How is it displayed? Why is it most important to young people and something older people readily or reluctantly give up? What are its social uses, its demographics, its biases and discriminations?

Although this study is indebted to the subcultural studies associated with the Centre for Contemporary Cultural Studies, University of Birmingham,

it is nevertheless distinctly 'post-Birmingham' in several ways. First, it doesn't position youthful consumer choices as proto-artistic and/or proto-political acts, ultimately explaining the logic of their cultural consumption in terms of its 'opposition' to vague social bodies variously called the parent culture, the wider culture or the term I find most revealing (and will discuss at length below), the 'mainstream'.

Vague opposition is certainly how many members of youth subcultures characterize their *own* activities. However, we can't take youthful discourses literally; they are not a transparent window on the world. Many cultural studies have made the mistake of doing this. They have been insufficiently critical of subcultural ideologies, first, because they were diverted by the task of puncturing and contesting dominant ideologies and, second, because their biases have tended to agree with the anti-mass society discourses of the youth cultures they study. While youth have celebrated 'underground', the academics have venerated 'subcultures'; where young people have denounced the 'commercial', scholars have criticized 'hegemony'; where one has lamented 'selling out', the other has theorized 'incorporation'. In this way, the Birmingham tradition has both over-politicized youthful leisure and at the same time ignored the subtle relations of power at play within it.

Subcultural ideologies are a means by which youth imagine their own and other social groups, assert their distinctive character and affirm that they are not anonymous members of an undifferentiated mass. They are not innocent accounts of the way things really are, but ideologies which fulfill the specific cultural agendas of their beholders. In this way, I am not simply researching the beliefs of a cluster of communities, but investigating the way they make 'meaning in the service of power' – however modest these powers may be (Thompson 1989: 7). Distinctions are never just assertions of equal difference; they usually entail some claim to authority and presume the inferiority of *others*.

In pursuit of this theme, I found it productive to return to the work of Chicago School subculturalists, particularly Howard Becker and Ned Polsky. Becker offers a compelling analysis of 'distinction' under another name in his study of a 'deviant' culture of musicians in the 1940s (see Chapter 7). The aspirant jazz musicians of his study saw themselves as possessing a mysterious attitude called 'hip' and disdained other people, particularly their own audience, as ignorant 'squares'. Similarly, in 1960, Ned Polsky researched the social world of Greenwich Village Beatniks, finding that the Beats distinguished not only between being 'hip' and 'square', but added a third category of the 'hipster' who shared the Beatnik's fondness for drugs and jazz, but was said to be a 'mannered show off regarding his hipness' (Polsky 1967: 149).

In trying to make sense of the values and hierarchies of club cultures, I've also drawn extensively but critically from the work of the French sociologist, Pierre Bourdieu, particularly his book *Distinction* (1984) and related essays on the links between taste and the social structure. Bourdieu

explores what he calls *cultural capital* or knowledge that is accumulated through upbringing and education which confers social status. It is the linchpin of a system of distinction in which cultural hierarchies correspond to social ones and people's tastes are first and foremost a marker of class. For instance, in Britain accent has long been a key indicator of cultural capital and university degrees have long been cultural capital in institutionalized form. Cultural capital is different from *economic capital*. High levels of income and property often correlate with high levels of cultural capital, but the two can also conflict. Comments about the '*nouveau riche*' disclose the possible frictions between those rich in cultural capital but relatively poor in economic capital (like academics) and those rich in economic capital but less affluent in cultural capital (like professional football players).

One of the many advantages of Bourdieu's schema is that it moves away from rigidly vertical models of the social structure. Bourdieu locates social groups in a highly complex multi-dimensional space rather than on a linear scale or ladder. His theoretical framework even includes discussion of a third category – *social capital* – which stems not from *what* you own or know, but from *who* you know (and who knows you). Connections in the form of friends, relations, associates and acquaintances can all bestow status. The aristocracy has always privileged social over other forms of capital, as have many private members' clubs and 'old boy's networks'.

In addition to these three major types of capital – cultural, economic and social – Bourdieu elaborates many subcategories of capital which operate within particular fields such as 'linguistic', 'academic', 'intellectual', 'information' and 'artistic' capital. One characteristic that unifies these capitals is that they are all at play within Bourdieu's *own* field, within *his* social world of players with high volumes of institutionalized cultural capital. However, it is possible to observe sub-species of capital operating within other less privileged domains. In thinking through Bourdieu's theories in relation to the terrain of my empirical research, I've come to conceive of 'hipness' as a form of *subcultural capital*.

Although subcultural capital is a term that I've coined in relation to my own research, it is one that jibes reasonably well with Bourdieu's system of thought. In his essay, 'Did You Say Popular?', he contends that 'the deep-seated "intention" of slang vocabulary is above all the assertion of an aristocratic distinction' (Bourdieu 1991: 94). Nevertheless, Bourdieu does not talk about these popular 'distinctions' as 'capitals'. Perhaps he sees them as too paradoxical in their effects to warrant the term? In response, I would argue that clubs are refuges for the young where their rules hold sway and that, inside and even outside these spaces, subcultural distinctions have significant consequences.

Subcultural capital confers status on its owner in the eyes of the relevant beholder. It affects the standing of the young in many ways like its adult equivalent. Subcultural capital can be *objectified* or *embodied*. Just as books and paintings display cultural capital in the family home, so subcultural capital is

objectified in the form of fashionable haircuts and carefully assembled record collections (full of well-chosen, limited edition 'white label' twelve-inches and the like). Just as cultural capital is personified in 'good' manners and urbane conversation, so subcultural capital is embodied in the form of being 'in the know', using (but not over-using) current slang and looking as if you were born to perform the latest dance styles. Both cultural and subcultural capital put a premium on the 'second nature' of their knowledges. Nothing depletes capital more than the sight of someone trying too hard. For example, fledgling clubbers of 15 and 16 years old wishing to get into what they perceive as a sophisticated dance club will often reveal their inexperience by over-dressing or confusing 'coolness' with an exaggerated cold blank stare.

A critical difference between subcultural capital (as I explore it) and cultural capital (as Bourdieu develops it) is that the media are a primary factor governing the circulation of the former. Several writers have remarked upon the absence of television and radio from Bourdieu's theories of cultural hierarchy (Frow 1987; Garnham 1993). Another scholar has argued that they are absent from his schema because 'the cultural distinctions of particular taste publics collapse in the common cultural domain of broadcasting' (Scannell 1989: 155). I would argue that it is impossible to understand the distinctions of youth subcultures without some systematic investigation of their media consumption. For within the economy of subcultural capital the media is not simply another symbolic good or marker of distinction (which is the way Bourdieu describes films and newspapers *vis-à-vis* cultural capital), but a network crucial to the definition and distribution of cultural knowledge. In other words, the difference between being *in* or *out* of fashion, high or low in subcultural capital, correlates in complex ways with degrees of media coverage, creation and exposure.

It has been argued that what ultimately defines cultural capital as *capital* is its 'convertibility' into economic capital (Garnham and Williams 1986: 123). While subcultural capital may not convert into economic capital with the same ease or financial reward as cultural capital, a variety of occupations and incomes can be gained as a result of hipness. DJs, club organizers, clothes designers, music and style journalists and various record industry professionals all make a living from their subcultural capital. Moreover, within club cultures, people in these professions often enjoy a lot of respect not only because of their high volume of subcultural capital, but because of their role in defining and creating it. In knowing, owning and playing the music DJs, in particular, are sometimes positioned as the masters of the scene, although they can be overshadowed by club organisers whose job it is to know who's who and gather the right crowd.

Although it converts into economic capital, subcultural capital is not as class-bound as cultural capital. This is not to say that class is irrelevant, simply that it does not correlate in any one-to-one way with levels of youthful subcultural capital. In fact, class is willfully obfuscated by subcultural distinctions. For instance, it is not uncommon for public school educated youth to adopt

working-class accents during their clubbing years. Subcultural capitals fuel rebellion against, or rather escape from, the trappings of parental class. The assertion of subcultural distinction relies, in part, on a fantasy of classlessness. This may be one reason why music is the cultural form privileged within youth's subcultural worlds. Age is the most significant demographic when it comes to taste in music, to the extent that playing music in the family home is the most common source of generational conflict after arguments over the clothes sons and daughters choose to wear (Euromonitor 1989).

After age, the social difference along which subcultural capital is aligned most systematically is, in fact, gender. On average, girls invest more of their time and identity in doing well at school. Boys, by contrast, spend more time and money on leisure activities like going out, listening to records and reading music magazines (Mintel 1988; Euromonitor 1989). But this doesn't mean that girls do not participate in the economy of subcultural capital. On the contrary, if girls opt out of the game of 'hipness', they will often defend their tastes (particularly their taste for pop music) with expressions like 'It's crap but I like it'. In so doing, they acknowledge the subcultural hierarchy and accept their lowly position within it. If, on the other hand, they refuse this defeatism, female clubbers and ravers are usually careful to distance themselves from the degraded pop culture of 'Sharon and Tracy'; they emphatically reject and denigrate a feminized mainstream.

The 'hip' versus the 'mainstream'

Hipness is not a single unified style, nor is it captured definitively by any one scene.[1] Not all youth have it, but the majority are concerned about it. Within club worlds, there is much less consensus about what's 'hip' than what's not. Although most clubbers and ravers characterize their own crowd as mixed or impossible to classify, they are generally happy to identify a homogenous crowd to which they don't belong. And while there are many 'other' scenes, most clubbers and ravers see themselves as outside and in opposition to the 'mainstream'.

When I began research in 1988, hardcore clubbers of all kinds located the mainstream in the 'chartpop disco'. 'Chartpop' did not refer to the many different genres that make it onto the top forty singles sales chart as much as to a particular kind of dance music which included bands like Erasure and the Pet Shop Boys but was identified most strongly with the music of Stock, Aitken and Waterman (the producers of Kylie Minogue, Jason Donovan, Bananarama and other dance-oriented acts). Although one was most likely to hear this playlist at a provincial gay club, the oft-repeated, almost universally accepted stereotype of the chartpop disco was that it was a place where 'Sharon and Tracy dance around their handbags'. This crowd was considered unhip and unsophisticated. They were denigrated for having indiscriminate music tastes, lacking individuality and being amateurs in the art of clubbing.

Who else would turn up with that uncool feminine appendage, that burdensome adult baggage – the handbag?

Toward the middle of 1989, in the wake of extensive newspaper coverage of acid house culture, clubbers began to talk of a new mainstream – or rather, at first, it was described as a second-wave of media-inspired, sheeplike acid house fans. This culture was populated by 'mindless ravers' or 'Acid Teds'. Teds were understood to travel in same-sex mobs, support football teams, wear kicker boots and be 'out of their heads'. Like Sharon and Tracy, they were white, heterosexual and working class. But unlike the girls, the ravers espoused the subterranean values proper to a youth culture at least in their predilection for drugs, particularly Ecstasy or 'E'.

However, when the culture came to be positioned as *truly* 'mainstream' rather than just behind the times, it was feminized. This shift coincided with the dominance of house and techno in the compilation album top twenty throughout 1991 and 1992. By the end of this period, talk of 'Acid Teds' was superseded by disparagement of raving Sharons and 'Techno Tracys'. The genre had even come to be called 'handbag house'. As one clubber explained to me, 'The rave scene is dead and buried. There is no fun in going to a legal rave when Sharons and Tracys know where it is as soon as you buy a ticket'.

Some clubbers and ravers might want to defend these attitudes by arguing that the music of Stock/Aitken/Waterman, then acid house-come-techno respectively dominated the charts in 1987–88, and 1989–91. But there are a couple of problems with this reasoning. First, the singles sales chart is mostly a pastiche of niche sounds which reflect the buying patterns of many taste cultures, rather than a monolithic mainstream (Crane 1986). Moreover, buyers of the same records do not necessarily form a coherent social group. Their purchase of a given record may be contextualized within a very different range of consumer choices; they may never occupy the same social space; they may not even be clubgoers.

Second, whether these 'mainstreams' reflect empirical social groups or not, they exhibit the burlesque exaggerations of an imagined 'other'. *Teds* and *Tracys*, like *lager louts*, *sloanes*, *preppies* and *yuppies*, are more than euphemisms of social class and status; they demonstrate 'how we create groups with words' (Bourdieu 1990: 139). So the activities attributed to 'Sharon and Tracy' should by no means be confused with the actual dance culture of working-class girls. The distinction reveals more about the cultural values and social world of hardcore clubbers because, to quote Bourdieu again, 'nothing classifies somebody more than the way he or she classifies' (Bourdieu 1990: 132).

It is precisely because the social connotations of the mainstream are rarely examined that the term is so useful; clubbers can denigrate it without self-consciousness or guilt. However, even a cursory analysis reveals the relatively straightforward demographics of these personifications of the mainstream. First, the clichés have class connotations. Sharon and Tracy, rather than, say, Camilla and Imogen, are what sociologists have tended to call the 'respectable

working class'. Still, they are not envisaged as *beneath* the class of clubbers as much as being *classed*, full stop. In other words, they are guilty of being trapped in their class. They do not enjoy the classless autonomy of hip youth. The obfuscation of class goes some way toward explaining why straight white youth so frequently borrow tastes and fashions from gay and black cultures (Becker 1963; Hebdige 1979; Lee 1988; Polsky 1967; Savage 1988).

Age, the dependence of childhood and the accountabilities of adulthood are also signalled by these visions of the mainstream. The recurrent trope of the handbag is something associated with mature womanhood or with pretending to be grown up. It is definitely *not* a sartorial sign of youth culture, nor a form of objectified subcultural capital, but rather a symbol of the social and financial shackles of the housewife. Young people, irrespective of class, often refuse the responsibilities and identities of the work world, choosing to invest their attention, time and money in leisure. In his classic article from the 1940s, 'Age and Sex in the Social Structure of the United States', Talcott Parsons argues that young people espouse a different 'order of prestige symbols' because they cannot compete with adults for occupational status (Parsons 1964: 94). They focus less on the rewards of work and derive their self-esteem from leisure – a sphere which is more conducive to the fantasies of classlessness which are central to club and rave culture. In *Distinction*, Bourdieu identifies an analogous pattern for French middle-class youth alone: 'bourgeois adolescents who are economically privileged and (temporarily) excluded from the reality of economic power, sometimes express their distance from the bourgeois world which they cannot really appropriate by a refusal of complicity whose most refined expression is a propensity towards aesthetics and aestheticism' (Bourdieu 1984: 55).

But a 'refusal of complicity' might be said to characterize the majority of British youth. Having loosened ties with family but not settled with a partner nor established themselves in an occupation, youth are not as anchored in their social place as those younger and older than themselves. By investing in leisure, youth can further reject being fixed socially. They can procrastinate what Bourdieu calls 'social aging' or that 'slow renunciation or disinvestment' which leads people to 'adjust their aspirations to their objective chances, to espouse their condition, become what they are and make do with what they have' (Bourdieu 1984: 110–111). This is one reason why youth culture is often attractive to people well beyond their youth. It acts as a buffer against social aging – not against the dread of getting older, but of resigning oneself to one's position in a highly stratified society.

The material conditions of youth's investment in subcultural capital (which is part of the aestheticized resistance to social aging) results from the fact that youth, from many class backgrounds, enjoy a momentary reprieve from necessity. According to Bourdieu, economic power is primarily the power to keep necessity at bay. This is why it 'universally asserts itself by the destruction of riches, conspicuous consumption, squandering and every form of gratuitous luxury' (Bourdieu 1984: 55). But 'conspicuous',

'gratuitous' and 'squandering' might also describe the spending patterns of the young. Since the 1950s, the 'teenage market' has been characterized as displaying 'economic indiscipline'. Without adult overheads like mortgages, pension plans and insurance policies, youth are free to spend on goods like clothes, music, drink and drugs which form 'the nexus of adolescent gregariousness outside the home' (Abrams 1959: 1).

Freedom from necessity, therefore, does not mean that youth have wealth so much as that they are exempt from adult commitments to the accumulation of economic capital. In this way, British youth can be seen as momentarily enjoying what Bourdieu argues is reserved for the bourgeoisie, that is the 'taste of liberty'. British youth cultures exhibit that 'stylization of life' or 'systemic commitment which orients and organizes the most diverse practices' that develops as the objective distance from necessity grows (Bourdieu 1984: 55–56). This is a possibility for all but the poorest sections of the youth population, perhaps the top 75 per cent. While youth unemployment, homelessness and poverty are widespread, there is still considerable discretionary income amongst the bulk of 16–24 year olds. The 'teenage market', however, has long been dominated by the boys. In the 1950s, 55 per cent of teenagers were male because girls married earlier and 67 per cent of teenage spending was in male hands because girls earned less (Abrams 1959). In the 1990s, the differential earnings of young men and women have not changed all that much – a fact which no doubt contributes to the masculine bias of subcultural capital (Euromonitor 1990; Mintel 1988).

Although clubbers and ravers loathe to admit it, the femininity of these representations of the mainstream is hard to deny. Girls and women are, in fact, more likely to identify their taste in music with pop. Moreover, they spend less time and money on music, the music press and going out, and more on clothes and cosmetics (Mintel 1988; Euromonitor 1989). One might assume, therefore, that they are less sectarian and specialist in relation to music because they literally and symbolically invest less in their taste in music and participation in music culture.

The objectification of young women, entailed in the 'Sharon and Tracy' image, is significantly different from the 'sluts' or 'prudes', 'mother' or 'pretty waif' frameworks typically identified by feminist sociologists (Cowie and Lees 1981; McRobbie 1991). It is not primarily a vilification or veneration of girls' sexuality (although that does come into it), but a position statement made by youth of both genders about girls who are not culturally 'one of the boys'. Subcultural capital would seem to be a currency which correlates with and legitimizes unequal statuses.

Conclusions

Subcultural capital is the linchpin of an alternative hierarchy in which the axes of age, gender, sexuality and race are all employed in order to keep

the determinations of class, income and occupation at bay. Interestingly, the social logic of subcultural capital reveals itself most clearly by what it dislikes and by what it emphatically isn't. The vast majority of clubbers and ravers distinguish themselves against the mainstream which, to some degree, can be seen to stand in for the masses – the discursive distance from which is a measure of a clubber's cultural worth. Interestingly, the problem for *under-ground subcultures* is a popularization by a gushing *up* to the mainstream rather than, say, the artworld's dread of 'trickle down'. These metaphors are not arbitrary; they betray a sense of social place. Subcultural ideology implicitly gives alternative interpretations and values to young people's, particularly young men's, subordinate status; it re-interprets the social world.

These popular distinctions are a means by which young people jockey for social power; they are discriminations by which players are both assigned social statuses and strive for a sense of self-worth. This perspective envisages popular culture as a multi-dimensional social space rather than as a flat folk culture or as simply the bottom rung on some linear social ladder. Rather than characterizing cultural differences as 'resistances' to hierarchy or to the remote cultural dominations of some ruling body, it investigates the micro-structures of power entailed in the cultural competition that goes on between more closely associated social groups.

Youthful interest in distinction is not new. One could easily re-interpret the history of post-war youth cultures in terms of subcultural capital. In a contemporary context, however, dynamics of distinction are perhaps more obvious for at least two reasons. First, unlike the liberalizing 1960s and 1970s, the 1980s were 'radical' in their conservatism. Change was experienced as a move to the right, while the left was effectively positioned as reactionary in its intent to preserve the past. Unlike Jock Young's drugtaking hippies or Dick Hebdige's stylish punks (portrayed in two classic texts which capture the spirit of British youth in their respective periods and which are excerpted in Chapters 9 and 15 of this Reader), the youth of my research were, to cite the cliché, 'Thatcher's children'. Well versed in the virtues of competition, their cultural heroes came in the form of radical young entrepreneurs who had started up clubs and record labels, rather than the poets and activists of yesteryear.

The second reason that the pursuit of distinction may be more noticeable today is because sociological debates have shifted our vision of *difference*. For example, despite their many disparate opinions, both Young and Hebdige see the assertion of cultural difference as an essentially progressive gesture, a step in the right direction away from conformity and submission. Difference was cast positively as *deviance* and *dissidence*. If one believes that it is in the nature of power to homogenize – be it in the form of Young's 'consensus' or Hebdige's 'hegemony' – then difference can be seen as a good thing in itself. But if one considers the function of difference within an ever more finely graded social structure, its political tendencies become more

ambiguous. In a post-industrial world where consumers are incited to individualize themselves and where the operations of power seem to favour classification and segregation, it is hard to regard difference as *necessarily* progressive. The flexibility of new modes of commodity production and the expansion of multiple media support micro-communities and fragmented niche cultures. Today, it is easier to see each cultural difference as a potential distinction, a suggestion of superiority, an assertion of hierarchy, a possible alibi for subordination.

These two senses of difference – deviance/dissidence and discrimination/distinction – clarify the politics of the youthful will to classlessness. At one level, youth do aspire to a more egalitarian and democratic world. On the other hand, classlessness is a strategy for transcending being classed. It is a means of obfuscating the dominant structure in order to set up an alternative and, as such, is an ideological precondition for the effective operations of subcultural capital. This is the paradoxical cultural response of youth to the problem of age and the social structure.

Note

1 An interest in distinction would seem to be the norm in all kinds of club cultures. Nevertheless, the subcultural capitals I investigate are those of predominantly straight and white club and rave cultures. Similar 'underground' discourses operate in gay and lesbian clubs but, as the alternative values involved in exploring sex and sexuality complicate the situation beyond easy generalization, I concentrate on their heterosexual manifestation. Moreover, 'campness' rather than 'hipness' may be a more appropriate way to characterize the prevailing cultural values of these communities (Sontag 1966; Savage 1988). And, although I did substantial research in Afro-Caribbean and mixed-race clubs, my account more thoroughly (but not exclusively) analyses the cultural worlds of the white majority. Despite the fact that black and white youth cultures share many of the same attitudes and some of the same musics, race is still a conspicuous divider.

Ethics and ethnography

Introduction to part four

■ Sarah Thornton

ETHNOGRAPHERS INVESTIGATE CULTURES in their everyday setting through a conscientious combination of two methods: participation and observation. Although arguably an important tool for novelists and journalists, ethnography was developed as a more systematic mode of investigation by anthropologists in the nineteenth century. Used initially for studying foreign cultures, Robert E. Park led the call to apply the methodology to one's own society. Participant observation, he contended, was the only adequately qualitative and holistic means of understanding the subtleties of a community's beliefs and social practices.

Ethnography is a deceptively complex method precisely because it is how we learn generally; since infancy, we have come to accomplish smiling, walking and talking through careful observation and participation. However, the *naturalism* of the method makes it difficult to draw boundaries of emotional, moral and political involvement. Ethnographers do their research on location, often without even a tape recorder to distance themselves from their subjects of study. Moreover, unless they are researching in a work environment, the site is by definition *unprofessional*. Nothing could be further from the safe and controlled conditions of the laboratory or library. On the ethnographic site, subcultural participants

make their own rules which, in the case of subcultures, are often at odds with the law, contrary to institutional policies and/or the personal habits of the ethnographer.

Ethical dilemmas are therefore an integral part of the process of doing good ethnographic research on subcultures. If researchers have not experienced concern about their decisions and practices then it is possible that, rather than negotiating the delicate balance of the two methods that make up ethnography, they have simply opted for one or the other. If they err on the side of distant observation, then they do not get inside the perspective of the participants and there is little chance of developing a full appreciation of the subculture in question. However, if they err on the side of staunch participation, then they are in danger of what has been called 'going native', that is, of over-identifying with and being an uncritical celebrant of the subculture. Either extreme can be seen as an evasion of responsibility, by which the researcher escapes the necessary work of developing a situational ethics.

Ned Polsky and Laud Humphreys offer dramatic accounts of the moral imperatives behind striking the right balance between being an insider and an outsider and both dwell on the central quandary of how researchers should represent themselves. In his reflections on his methods of exploring the illicit underworld of New York beatniks, hustlers and junkies, Polsky argues that 'you must walk a tightrope between openness and disguise' but under no circumstances should you pretend to be 'one of them'. By contrast, in his study of sexual activities in men's toilets (called 'tearooms' in the US and 'cottages' in the UK), Humphreys maintains that the 'only way to watch highly discreditable behavior is to pretend to be in the same boat with those engaged in the activity'. Both scholars advance well developed, convincing rationales for their choice of conduct which suggests that ethnographic ethics are best left relative to the subcultural situation. Some readers, however, may be uncomfortable with this flexible morality and seek at least a few absolute strictures. Either way, these two classic essays are exemplary for thinking through the detailed decisions that accompany the *means* of ethnographic research.

The ethics of the *ends* of research is also a key issue, which is often couched as a dichotomy (usually a false one) between the

moral duty to speak the truth and an imperative to contribute to a cause. The traditional social scientific position has been that in order for researchers to be as accurate and faithful as possible, they should put all theories, convictions and causes out of their mind and let hypotheses generate from their empirical work. Both Humphreys and Polsky come from this tradition: the former warns against the 'restrictions and distortions' of theory, while the latter advises against the 'misplaced morality' involved in confounding the roles of social worker and sociologist.

Paul Willis, however, argues forcefully against this 'postponement of theory'. Since there is 'no truly untheoretical way to "see" an "object"' because researchers can never escape their socialization, education or frames of reference, written work should always be preceded by what Willis calls a 'theoretical confession'. In other words, we have an ethical responsibility to 'recognize the necessary theoretical form of what we "discover"'. This kind of open acknowledgement of position attempts to qualify the reception of his research, admitting that any ethnographic account is as much about the observer as it is about the observed.

The imbalance of power between investigators and their 'subjects' is a fundamental problem for ethnography. It is often the case that researchers enjoy a more privileged position – being better educated and of a higher social class – than their subcultural informants. Additionally, they have the responsibility and authority to write the story of the subculture and therefore control its representation to the outside world. Willis suggests that these inequities can be mitigated through reflexivity; if researchers uncover and explain their 'consciousness, culture and theoretical organisation', then it goes some way towards clearing a path for a less obstructed disclosure of the culture under analysis.

In his chapter outlining a 'postmodern' ethnography, Stephen Tyler advocates an even more radically reflexive approach – one which is characterized not just by dialogue but by polyphony, not simply a juxtaposition of insider and outsider viewpoints but a complete perspectival relativity. Tyler actually recommends abandoning science – disowning the will to power through knowledge and the control of representation. In its stead, he suggests that we should practise ethnography as if it were poetry. The researcher

would then aim to 'evoke' rather than 'describe', liberating rather than dominating the culture in question. Tyler walks the outer limits of ethnography in pursuit of high and uncompromising ethical standards. His agenda is idealistic, perhaps even impossible, but constructively thought-provoking.

Ethnographers have produced a wealth of literature both questioning and defending the validity and ethics of participant observation. Unfortunately, subcultural textual analysis and, to a lesser extent, historical studies, have not generated the same degree of methodological reflection. As a result, they tend to be less self-conscious of their methodological limitations and over-confident about the authority of their interpretations, venturing into terrains and making generalizations which they cannot properly substantiate. Whatever the method, it is hoped that this section will sensitize the reader to the fundamental significance of approaches and techniques of research.

Ned Polsky

RESEARCH METHOD, MORALITY AND CRIMINOLOGY [1969]

EXPERIENCE WITH ADULT, unreformed, 'serious' criminals in their natural environment – not only those undertaking felonies in a moonlighting way, such as pool hustlers, but career felons – has convinced me that if we are to make a major advance in our scientific understanding of criminal lifestyles, criminal subcultures, and their relation to the larger society, we must undertake genuine field research on these people. I am also convinced that this research can be done by many more sociologists, and much more easily, than the criminology textbooks lead us to suppose. . . .

Most sociologists find it too difficult or distasteful to get near adult criminals except in jails or other anti-crime settings, such as the courts and probation and parole systems. . . .

[But if . . . sociology is] the study of how society is really run as distinguished from how the society's civics textbooks say it is run, then . . . it is exactly the discrepancies between law breaking and law enforcement that constitute one of the most central topics of criminology. But we are never going to know much about that topic, or many another, until we get out of the jails and the courts and into the field. Of course our ignorance can remain blissful if . . . we use labelling theory as a form of verbal magic to convince ourselves that the only 'real' criminal is a caught criminal, one whom law enforcers have obligingly placed where it is convenient for criminologists to study him. . . .

It is all very well to draw a fuller quantitative picture of the numbers and kinds of criminals or criminal acts. But we cannot use this to dodge what is the ultimate qualitative task – particularly regarding career criminals, whose

217

importance to any theorist of human behaviour, not to mention the rest of society, is so disproportionate to their numbers: providing well-rounded, contemporary, sociological descriptions and analyses of criminal life-styles, sub-cultures, and their relation to larger social processes and structures.

That is just where criminology falls flat on its face. Especially in the study of adult career criminals, we over-depend on a skewed sample, studied in non-natural surroundings (anti-crime settings), providing mostly data recollected long after the event. . . .

This means – there is no getting away from it – the study of career criminal *au naturel*, in the field, the study of such criminals as they normally go about their work and play, the study of 'uncaught' criminals and the study of others who in the past have been caught but are not caught at the time you study them. . . .

The main obstacle to studying criminals in the field, according to Sutherland and Cressey, lies in the fact that the researcher 'must associate with them as one of them'. Few researchers 'could acquire the techniques to pass as criminals', and moreover 'it would be necessary to engage in crime with the others if they retained a position once secured' (Sutherland and Cressey 1960: 69). Where Sutherland and Cressey got this alleged fact they don't say and I can't imagine. It is just not true. On the contrary, in doing field research on criminals you damned well better *not* pretend to be 'one of them', because they will test this claim out and one of two things will happen: either you will, as Sutherland and Cressey indicate, get sucked into 'participant' observation of the sort you would rather not undertake, or you will be exposed, with still greater negative consequences. You must let the criminals know who you are; and if it is done properly . . . it does not sabotage the research.

Another mistaken Sutherland–Cressey claim about field research on career criminals is that 'few of them [criminals] would permit interrogations regarding their earlier lives or would volunteer information regarding the processes by which they became criminals' (Sutherland and Cressey 1960: 69). A few won't but most will – they will, that is, if you aren't pretending to be 'one of them'. Some examples: A syndicate criminal connected with illegal control of bars and nightclubs has described to me how he entered his line of work. (The process was in all essential respects comparable to an upper-class youth 'going into daddy's business'.) A long-time professional burglar has described to me his teenage apprenticeship to an older burglar. (The apprenticeship took place with his father's knowledge and consent, the father's chief concerns being that the older burglar not make a punk out of his son and that he teach him how to stay out of jail.) . . .

Although criminologists need not 'acquire the techniques to pass as criminals', there is another matter of individual competence that excludes, or rather should exclude, a number of potential researchers. . . . The problem inheres in that requirement of telling criminals who you are. In field investigating, before you can tell a criminal who you are and make it stick, you have to know this yourself – know, especially, just where you draw the line

between you and him. If you aren't sure, the criminal may make it his business to see that you get plenty shook up, really rack you up about it. I shall come back to this matter later. My point here is that field research on criminals . . . seems especially attractive to people who are still trying to find out who they are. I have had to learn to discourage converts who are going through various identity crises and to indicate bluntly that for them field research on criminals is a good thing to stay away from. Unfortunately, it is often the people best able to overcome moralism and achieve genuine empathy with criminals who are most vulnerable to allowing empathy to pass into identity.

But that 'screening' problem aside, most criminologists can intelligently, safely, and successfully undertake field study of adult criminals if they put their minds to it. In what follows I shall discuss problems connected with this research method; and counter some additional objections to this kind of research.

2

Most difficulties that one meets and solves in doing field research on criminals are simply the difficulties one meets and solves in doing field research. The basic problem many sociologists would face in field work on criminals, therefore, is an inability to do field work. . . .

Successful field research depends on the investigator's trained abilities to look at people, listen to them, think and feel with them, talk with them rather than at them. It does *not* depend fundamentally on some impersonal apparatus, such as a camera or tape recorder or questionnaire, that is interposed between the investigator and the investigated. Robert E. Park's concern that the sociologist become first of all a good reporter meant not that the sociologist rely on gadgets to see, hear, talk and remember for him; quite the contrary, it asked the sociologist to train such human capacities in himself to their utmost and use them to their utmost in direct observation of people he wants to learn something about. But the problem for many . . . sociologist[s] today – the result of curricula containing as much scientism as science – is that these capacities, far from being trained in [them], have been trained out of [them]. . . . [They] can't see people any more, except through punched cards and one-way mirrors. [They] can't talk with people any more, only 'survey' them. Often [they] can't even talk *about* people any more, only about 'data'. Direct field study of social life, when [they are] forced to think about it at all, is something [they] fondly label 'soft' sociology, as distinguished from [their] own confrontation of social reality at several removes, which in [their] mysterious semantics is 'hard' sociology. . . .

Perhaps the largest set of problems arises from the fact that a criminal judges the judges, puts down the people who put him down. Any representative of the square world initially encounters some covert if not overt

suspicion or hostility; it is best to assume such feelings are there (in the criminal) even if they don't show, and that you are not going to get far unless and until you overcome those feelings. This problem, although it exists in studying a criminal enmeshed with the law, is usually magnified in dealing with an uncaught criminal in his natural surroundings, for the following reasons: (1) You are more of an intruder. As far as he is often concerned, it's bad enough that he has to put up with questioning when in the hands of the law, and worse when squares won't even leave him in peace in his own tavern. (2) He is freer to put you down and you are more on your own; you have no authority (police, warden, judge, parole board) to back you up. (3) There is more of a possibility that he might be hurt by you, that is, he has more to lose than someone already in jail.

At least potentially going for you, on the other hand, is the fact that because you are not working in a law-enforcement setting you might *possibly* be all right; and the sooner you firmly establish in his mind that you are not any kind of cop or social worker, the sooner that fact begins going for you.

The following paragraphs will not solve for every researcher these and related problems, but will give some procedures – in no special order – that I have found useful to overcome such problems and often to prevent them from arising in the first place. They should be understood as a first attempt to state formally what I have arrived at on a more or less intuitive and trial-and-error basis in dealing with uncaught criminals. They might not work for every researcher, but I think they would work for most.

1. Although you can't help but contaminate the criminal's environment in some degree by your presence, such contamination can be minimized if, for one thing, you use no gadgets (no tape recorder, questionnaire form) and, for another, do not take any notes in the criminal's presence. It is quite feasible to train yourself to remember details of action and speech long enough to write them up fully and accurately after you get home at the end of the day (or night, more typically). . . .

2. Most important when hanging around criminals – what I regard as the absolute 'first rule' of field research on them – is this: initially, keep your eyes and ears open *but keep your mouth shut*. At first try to ask no questions whatsoever. Before you can ask questions, or even speak much at all other than when spoken to, you should get the 'feel' of their world by extensive and attentive listening – get some sense of what pleases them and what bugs them, some sense of their frame of reference, and some sense of *their* sense of language (not only their special argot, as is often mistakenly assumed, but also how they use ordinary language). . . .

Until the criminal's frame of reference and language have been learned, the investigator is in danger of coming on too square, or else of coming on too hip (anxiously over-using or misusing the argot). The result of failure to avert such dangers is that he will be put on or, more likely, put down, and end by provoking the hostility of his informant. . . .

3. Once you know the special language, there is a sense in which you should try to forget it. You cannot accurately assess any aspect of a deviant's lifestyle or subculture through his argot alone, although many investigators mistakenly try. . . . Such attempts result in many errors, because there is often a good deal of cultural lag between the argot and the reality. One cannot, for instance, assume that every important role in a deviant subculture is represented by a special term. An example: A distinctive role in the male homosexual sub-culture is played by that type of woman, not overtly lesbian, who likes to pal around with male homosexuals and often serves as a front for them in the heterosexual world; but although this role has, according to older homosexuals I know, existed for decades, it is only within the past several years that homosexual argot has developed special terms for such a woman (today homosexuals [on the east coast of America] often refer to her as a 'faghag' and [on the west coast] homosexuals refer to her as a 'fruit fly').

Conversely, the widespread use of a term for a deviant role is not always a good clue to the prevalence or even the existence of role incumbents. An example: In the American kinship system, the three basic types of incest are brother–sister, father–daughter, and mother–son. We have a common term, originating in black sub-cultures and now part of general American slang, to designate one partner in the third type ('motherfucker'), and no special terms for the other types. But the facts of American incest are the reverse of what the language might lead one to believe: brother–sister and father–daughter incest are frequent, whereas mother–son incest is [comparatively] rare. . . .

Thus the presence or absence of special language referring to deviance is conclusive evidence for nothing except the presence or absence of such special language. It may sensitize you as to what to look for in actual behaviour, but the degree of congruence between the language and the reality of deviance is an empirical matter to be investigated in each case.

Also, the researcher should forget about imputing beliefs, feelings, or motives (conscious or otherwise) to deviants on the basis of the origins of words in their argot. Whether the etymologies are genuine or fancied (what linguists call 'folk' or 'false' etymologies), they tell us nothing about the psychic state of the users of the words. One form of analysis, a kind of parlour version of psychoanalysis, implicitly denies this. I have seen it seriously argued, for example, that heroin addicts must unconsciously feel guilty about their habit because they refer to heroin by such terms as 'shit', 'junk', and 'garbage'. Actually, the use of any such term by a heroin addict indicates, in itself, nothing whatever about his guilt feelings or the lack thereof, but merely that he is using a term for heroin traditional in his group.

At best, deviant argot is supporting evidence for behavioural phenomena that the investigator has to pin down with other kinds of data.

4. In my experience the most feasible technique for building one's sample is 'snowballing': get an introduction to one criminal who will vouch for you with others, who in turn will vouch for you with still others. (It is of course

best to start at the top if possible, that is, with an introduction to the most prestigious person in the group you want to study.)

Getting an initial introduction or two is not nearly so difficult as it might seem. Among students whom I have had perform the experiment of asking their relatives and friends to see if any could provide an introduction to a career criminal, fully a third reported that they could get such introductions. . . . Moreover, once your research interests are publicly known you get volunteer offers of this sort. . . . from students, faculty . . . criminal lawyers and crime reporters (to say nothing of law enforcement personnel).

Be that as it may, there are times when you don't have an introduction to a particular scene you want to study, and you must start 'cold'. In such a situation it is easier, usually, to get acquainted first with criminals at their play rather than at their work. Exactly where this is depends on your individual play interests. Of course, initiating such contact means recognizing that criminals are not a species utterly different from you; it means recognizing . . . that you do have some leisure interests in common with criminals. It means recognizing the reality of a criminal's life (as distinguished from the mass-media image of that life), which is that he isn't a criminal twenty-four hours a day and behaves most of the time just like anyone else from his class and ethnic background.

In fact, one excellent way of establishing contact involves a small bit of fakery at the beginning, in that you can get to know a criminal on the basis of common leisure pursuits and *then* let him know of your research interest in him. (But this latter should be done quite soon, after the first meeting or two.) Where and how you start depends, other things being equal, on what you do best that criminals are also likely to be interested in. For example, in trying to make contact with criminals in a neighbourhood new to me, I of course find it best to start out in the local pool-room. But if you can drink most people under the table, are a convivial bar-room companion, etc., then you should start out in a tavern. If you know horses, start out at a horse parlour. If you know cards, ask around about a good poker game. If you know fighters, start out at the local fight gym.

5. If you establish acquaintance with a criminal on some basis of common interest, then, just as soon as possible, let him know of the differences between you if he hasn't guessed them already; that is, let him know what you do for a living and let him know why, apart from your interest in, say, poker, you are on his scene. This isn't as ticklish as it seems to people who haven't tried it – partly because of that common interest and partly because the criminal often sees, or can easily be made to see, that there may be something in it for him. For example, he may have some complaint about the outside world's mistaken view of him that you, as someone who has something in common with him, might sympathetically understand and correctly report. . . . Or he may want to justify what he does . . . Or he may be motivated by pride and status considerations, e.g., want to let you know that his kind of criminality is superior to other kinds. (Examples: A burglar tells me his line of work is

best because 'if you do it right, there are no witnesses.' Another, indicating his superiority to pimps, told me that among his colleagues a common saying about a girl supporting a pimp is that 'Maybe she'll get lucky and marry a thief.' . . .

These and similar motives are present not far below the surface in most criminals, and are discoverable and usable by any investigator alert for them.

6. In studying a criminal it is important to realize that he will be studying you, and to let him study you. Don't evade or shut off any questions he might have about your personal life, even if these questions are designed to 'take you down', for example, designed to force you to admit that you too have knowingly violated the law. He has got to define you satisfactorily to himself and his colleagues if you are to get anywhere, and answering his questions frankly helps this process along.

Sometimes his definitions are not what you might expect. (One that pleased but also disconcerted me: 'You mean they pay you to run with guys like me? That's a pretty good racket.') The 'satisfactory' definition, however, is usually fairly standardized – one reason being that you are not the first non-criminal he's met who didn't put him down and consequently he has one or more stereotyped exceptions to his usual definitions of squares. And with a bit of experience you can angle for this and get yourself defined as, for example, 'a square who won't blow the whistle' or 'a square who likes to play with characters' or 'a right square'.

One type of definition you should always be prepared for (though it is by no means always overtly forthcoming) is the informant's assumption that you want to be like him but don't have the nerve and/or are getting your kicks vicariously. Thus one of the better-known researchers on drug addiction has been described to me by junkies as 'a vicarious junkie', criminals often define interested outsiders as 'too lazy to work but too scared to steal', and so on. This type of definition can shake you if there is any truth in it, but it shouldn't; and indeed you can even capitalize on it by admitting it in a back-handed sort of way, that is, by not seriously disputing it.

7. You must draw the line, to yourself and to the criminal. Precisely where to draw it is a moral decision that each researcher must make for himself in each research situation. (It is also to some extent a decision about personal safety, but this element is highly exaggerated in the thinking of those who haven't done field work with criminals.) You need to decide before-hand, as much as possible, where you wish to draw the line, because it is wise to make your position on this known to informants rather early in the game. For example, although I am willing to be told about anything and everything, and to witness many kinds of illegal acts, when necessary I make it clear that there are some such acts I prefer not to witness. (With two exceptions I have had this preference respected.) To the extent that I am unwilling to witness such acts, my personal moral code of course compro-mises my scientific role – but not, I think, irreparably.

. . . There is another kind of compromise that must be made, this by way of keeping faith with informants. As the careful reader of some other parts of this book will gather, in reporting one's research it is sometimes necessary to write of certain things more vaguely and skimpily than one would prefer. But that is more of a literary than a scientific compromise; there need be no distortion of the *sociological* points involved.

. . . Letting criminals know where you draw the line of course depends on knowing this yourself. If you aren't sure, the criminal may capitalize on the fact to manoeuvre you into an accomplice role.

The possibility of such an attempt increases directly as his trust of you increases. For example, I knew I was really getting somewhere with one criminal when he hopefully explained to me why I would make a fine 'steer-horse' (which in his argot means someone who fingers a big score for a share of it). To receive such indication of 'acceptance' is of course flattering – and is meant to be – but the investigator must be prepared to resist it or the results can be far more serious than anything he anticipates at the beginning of his research. . . .

8. Although I have insisted that in studying criminals you mustn't be a 'spy', mustn't pretend to be 'one of them', it is equally important that you don't stick out like a sore thumb in the criminal's natural environment. You must blend in with the human scenery so that you don't chill the scene. One consequence is that often you must modify your usual dress as well as your usual speech. In other words, you must walk a tightrope between 'openness' on the one hand and 'disguise' on the other, whose balancing point is determined anew in each investigation. Let me illustrate this with an example.

During the summer of 1960 . . . I spent much time with people involved in heroin use and distribution, in their natural settings: on rooftops, in apartments, in tenement hallways, on stoops, in the streets, in automobiles, in parks and taverns. . . . On the one hand, I did not dress as I usually do (suit, shirt and tie), because that way of dressing in the world which I was investigating would have made it impossible for many informants to talk with me, e.g., would have made them worry about being seen with me because others might assume I represented the law. But on the other hand, I took care always to wear a short-sleeved shirt or T-shirt and an expensive wristwatch, both of which let any newcomer who walked up know immediately that I was not a junkie.

9. A final rule is to have few unbreakable rules. For example: although the field investigator can, to a large extent, plan his dress, speech and other behaviour beforehand so as to minimize contamination of the environment he is investigating, such plans should be seen as provisional and subject to instant revision according to the requirements of any particular situation. Sometimes one also must confront unanticipated and ambiguous situations for which one has no clear behavioural plan at all, and abide the maxim *On s'engage et puis on voit* [rough translation: we must wait and see].

So much for the abecedarium I have evolved in studying criminals outside jails. Obviously it is not exhaustive. But I hope it will encourage other sociologists to study adult criminals in their natural settings. A bit more needs to be said, however, about what the criminal's 'natural setting' actually means.

Studying a criminal in his natural setting means . . . studying him in *his* usual environments rather than yours, in his living quarters or streets or taverns or wherever, not in your home or your office or your laboratory. And it means you mustn't schedule him, mustn't try to influence his shifting choices among his environments or interfere with his desire either for mobility or immobility. . . . Such free-ranging study, as the animal ecologists call it, is concerned to avoid as far as possible any serious disruption of his daily routine. . . .

Sociology isn't worth much if it is not ultimately about real live people in their ordinary life-situations, yet many of the 'precise, controlled techniques of observation' introduced by the investigator produce what is for the subject anything but an ordinary life-situation. . . . [T]he 'scientific' objections to field research on criminals . . . boil down to the truism that our research methods in general fall short of perfection. The regularity with which criminologists focus on alleged scientific objections to field research, and the regularity with which they ignore or barely hint at the obvious *moral* objection to such research, suggests that the issue of morality is really what bothers them most. . . .

3

If [sociologists are] effectively to study adult criminals in their natural settings, [they] must make the moral decision that in some ways [they] will break the law [themselves]. [They] need not be a 'participant' observer and commit the criminal acts under study, yet [they have] to witness such acts or be taken into confidence about them and not blow the whistle. That is, investigators have to decide that when necessary [they] will 'obstruct justice' or have 'guilty knowledge' or be an 'accessory' before or after the fact, in the full legal sense of those terms. [They] will not be enabled to discern some vital aspects of criminal life-styles and sub-cultures unless [they] (1) make such a moral decision, (2) make . . . the criminals believe [them] and (3) convince . . . them of their ability to act in accord with [their] decision. That third point can sometimes be neglected with juvenile delinquents, for they know that professionals studying them are almost always exempt from police pressure to inform; but adult criminals have no such assurance, and hence are concerned to assess not merely the investigators' intentions but their ability to remain 'stand-up guys' under police questioning.

To my knowledge, Lewis Yablonsky is the only criminologist who has had the good sense and emotional honesty to object to such research primarily on moral grounds. He claims that the views expressed in the foregoing paragraph . . . and any similar views, go too far from a moral standpoint.

According to Yablonsky, non-moralizing on the part of the researcher, when coupled with intense interest in the criminal's life, really constitutes a romantic encouragement of the criminal (Yablonsky 1965: 72).

Not so. To be sure, the research involvement I recommend is hardly uninterested; but also obviously, it tries to be as far as humanly possible *dis*interested, a scientific undertaking concerned neither to confirm the criminal in his criminality nor to change him, but to understand him. Furthermore, if the sociologist[s themselves] have any lingering 'romantic' view of criminality, there is nothing so effective as close association with criminals to get [them] over it, because criminals themselves – at least those who are beyond the novice stage and seriously committed to crime as a career – are usually quite hard-headed and unromantic about it all. In any case, the criminal scarcely needs the sociologist to make him feel important as an object of romantic interests when, everyday, every TV set in the land blares forth such messages for those criminals interested in picking up on them.

It is possible – highly doubtful, but possible – that a few criminals might become more set in their criminality, to some minuscule degree, by the mere fact that my type of investigating is totally unconcerned to 'reform' them or 'rehabilitate' them or 'make them see the error of their ways'. But in the first place, such unconcern is qualitatively different from positive encouragement or approval. (Indeed, part of what I conceive to be proper research technique with criminals, as indicated previously, involves letting them know that your value choices are different from theirs). Secondly, the burden of proof rests upon those who claim that abstention from moralizing by the field investigator has any significantly encouraging effect on criminals' lifestyles, and they have not supplied one bit of such proof. . . .

The great majority of criminologists are social scientists only up to a point – the point usually being the start of the second, 'control of crime', half of the typical criminology course – and beyond that point they are really social workers in disguise or else correction officers *manqués*. For them a central task of criminology, often *the* central task, is to find more effective ways to reform lawbreakers and to keep other people from becoming lawbreakers.

If [people] want . . . to make that sort of thing [their] life work I have no objection; that is [their] privilege. I suggest merely that [they] not do so in the name of sociology, criminology or any social science. I suggest that [they] admit [they] are undertaking such activity not as social scientists but as technologists or moral engineers for an extra-scientific end: making [other] people obey current American criminal law. This is not to deny [their] rights as ordinary citizens to be 'engaged' and make value judgements about crime, politics, sex, religion or any other area of moral dispute. Rather, it is to deny that everything appropriate to one's role as ordinary citizen is appropriate to one's role as scientist, and to insist that making such value judgements is not only inappropriate to the latter role but highly inimical to it.

To locate such inimical effect one need look no further than Yablonsky's own admission that in his work with juvenile delinquents 'some gang boys who met with me almost daily – some over several years – never fully believed that I was not "really a cop"' (Yablonsky 1965: 56). Any student of deviance who confounds the roles of social worker and sociologist ('the dual role of practitioner–researcher', as Yablonsky puts it) is bound to elicit that sort of response and have his research flawed by it. And if failure to solve this problem is serious in the scientific study of delinquents, failure to solve it in the study of adult career criminals is catastrophic.

The failure derives from what is truly a romantic ideology, one common to 'applied sociologists': a sentimental refusal to admit that the goals of socio-logical research and the goals of social work are always distinct and often in conflict. The conflict happens to be extremely sharp in the case of adult felony crime. The criminologist who refuses fully to recognize this conflict and to resolve it in *favour of sociology* erects a major barrier to the extension of scientific knowledge about such crime and such criminals.

But what of one's duty as a citizen? Shouldn't that take precedence? Well, different types of citizens have different *primary* duties. And our very understanding of 'citizenship' itself is considerably furthered in the long run if one type of citizen, the criminologist, conceives his primary duty to be the advancement of scientific knowledge about crime even when such advancement can be made only by 'obstructing justice' with respect to particular criminals in the short run.

Many anthropologists have been able to advance the state of knowledge only by keeping faith with people who radically transgress the moral norms of their society, that is, by refusing to turn people in to colonial officials and cops, so I fail to see why criminologists shouldn't do the same. Of course, if someone really wants to behave towards the 'savages' as a missionary rather than as an anthropologist, if he really wants to be a superior sort of social worker or cop or therapist rather than a sociologist, there is no denying him this right; but at least let him own up to what he really is and stop fouling the waters of science with muck about 'the dual role of practitioner–researcher'.

I would not wish to be understood as claiming that the criminologist[s], in [their] role as criminologist[s], must ignore value judgements. On the contrary, [they] might scientifically deal with them in several ways well known to sociology. For example, [they] could study how a society came to have the particular moral norms that it has, or study the unanticipated conse-quences of these norms for the society, or study the differential distribution and varying intensity of these norms within different sub-cultures of a complex society. The sociologist or criminologist can, as a scientist, do the foregoing things and more with respect to values. But if some people claim that what-ever the law may say at the moment, it is 'right' (or 'wrong') to do this or that and they act in accord with their value judgement, one thing the soci-ologist[s] or criminologist[s] cannot do, directly or indirectly, is to gainsay

them and interfere with their lives in the name of science. Social scientist[s have] no business attempting to 'adjust' people to the moral norms of [their] society or any other.

Max Weber, in emphasizing that sociology must be value-neutral if it is to be genuinely scientific, long ago made the key distinctions between one's role as ordinary citizen and one's role as social scientist. Our allegedly sociological students of crime, however, have forgotten Weber's lesson if, indeed, they ever learned it.

It is hard to blame them when they see other social scientists directly criticize Weber's fastidiousness . . . out of a gluttonous desire to have their cake and eat it, to be moralizers and scientists at once. But the criticism levelled at Weber on this matter, whether by 'natural law' ideologues . . . or 'applied sociology' ideologues . . . comes to no more than the statement that the value-neutral ideal is impossible of full attainment and that even the great Max Weber could not always keep his personal values completely out of his scientific work. Such criticism is quite true and equally irrelevant: although the ideal is indeed not fully attainable, there are radically different degrees of approximation to it that are attainable, and these quantitative differences add up to a significant difference in quality; which is to say that if we try like hell we can come very close to the ideal and enormously improve the state of our science thereby. But the critics of Weber aren't interested in trying. They apparently believe that because we cannot be virgin pure with respect to value-neutral social science we might as well be whores.

Actually, two related modes of sociological inquiry can prod us toward objectivity. One, indicated above, consciously excludes value judgements to a degree that comes close to the Weberian ideal, so much so that it can even produce findings which go against the personal values of the investigator. (For example, [in my work on pornography, I come to] conclusions about highly erotic art that seem to be inescapable as a sociologist but that I personally regret having to report – because they give ammunition to censors, whom I detest, see Polsky 1969.) The related mode, suggested to me by Howard Becker . . . counterbalances the values of one's society – and the investigations by social workers or 'applied sociologists' of one's society – by using an 'anti-social' perspective, e.g., by viewing society as a 'problem' for the deviant rather than the other way round. Although such counterbalancing need not be restricted to criminology – one could, for example, sympathetically study the racist's 'problem' of how to check desegregation and increase racial discrimination. . . . This route to value neutrality I find adumbrated not in Max Weber's work but in Friedrich Nietzsche's *Genealogy of Morals*:

> It is no small discipline and preparation of the intellect on its road to final 'objectivity' to see things for once through the wrong end of the telescope; and 'objectivity' is not meant here to stand for 'disinterested contemplation' (which is a rank absurdity) but for the ability to have to pros and cons in one's power and to switch them on and off, so as

to get to know how to use, for the advancement of knowledge, the *difference* in the perspectives and psychological interpretations. . . . All seeing is essentially perspective, and so is all knowing. The more emotions we allow to speak on a given matter, the more different eyes we train on the same thing, the more complete will be our conception of it, the greater our 'objectivity'.

4

My complaint, however, is basically Weberian in origin: I object not that criminologists have an anti-criminal moral code but that it is misplaced morality, acted upon within the scientific role instead of being kept firmly outside it. Such misplacement is not only inappropriate to scientific endeavour but clearly detrimental to it: . . . although criminologists sometimes give lip service to the scientific ideal of dispassionately studying criminals in the open, they immediately subvert that ideal. Obviously they do so out of fear of being caught with their anti-criminal values down. Their misplaced morality leads them, in practice, to pass up the field study of criminals, to invent various rationalizations for avoiding it, to exaggerate its difficulties, and to neglect some fairly obvious techniques for avoiding these difficulties.

But if . . . criminologist[s] want to help build a real science . . . [they] might ponder the reaction of Bronislaw Malinowksi, over forty years ago, to a similar situation that then obtained in anthropology:

> We are obviously demanding a new method of collecting evidence. The anthropologist must relinquish his comfortable position in the long chair on the veranda of the missionary compound, Government station, or planter's bungalow, where, armed with pencil and notebook and at times with a whisky and soda, he has been accustomed to collect statements from informants, write down stories, and fill out sheets of paper with savage texts. He must go out into the villages, and see the natives at work in gardens, on the beach, in the jungle. . . . Information must come to him full-flavored from his own observations of native life, and not be squeezed out of reluctant informants as a trickle of talk. Field work can be done first or secondhand even among the savages, in the middle of pile dwellings, not far from actual cannibalism and head-hunting. Open-air anthropology, as opposed to hearsay note-taking, is hard work, but it is also great fun. Only such anthropology can give us the all-round vision of primitive man and primitive culture.
> (Malinowsky 1926/1954: 146–7)

Until criminologist[s] learn to suspend [their] personal distaste for the values and life-styles of 'untamed savages', until [they] go out in the field to the cannibals and head-hunters and observe . . . them without trying either to

'civilize' them or turn them over to colonial officials, [they] will be only
. . . veranda anthropologist[s]. That is, [they] will be only a jail-house or
court-house sociologist, unable to produce anything like a genuinely scientific
picture of crime.

But if one refuses to be a sociologist of the jailhouse or court system,
takes Malinowski to heart, and goes out into the field, there is risk involved.
At least I have found this so in my own experience. It is the sort of risk that
writers of criminology texts, for all their eagerness to put down field work,
surprisingly don't mention: most of the danger for the field worker comes
not from the cannibals and head-hunters but from the colonial officials. . . .
Criminologists studying uncaught criminals in the open find sooner or later
that law enforcers try to put them on the spot – because, unless they are
complete fools, they uncover information that law enforcers would like to
know, and, even if they are very skilful, they cannot always keep law enforcers
from suspecting that they have such information.

Although communication between someone and their spouse or lawyer
or doctor is legally privileged (these people cannot be required to divulge
the communication), there is no such status accorded to communication
between anyone and the criminologist. The doctrine of legally privileged
communication has so far been extended only to cover certain of those other
professionals (nurses, priests, psychotherapists) who are in a 'treatment' rela-
tionship with clients. . . . If the . . . criminologist stood fast on his obligation
to protect informants in the face of law enforcers' demands that he tell all,
the guiding judicial precedents most likely would be the cases of journalists
who have done likewise in legally unprotected situations, and he would
be held in contempt of court. . . . Should we manage . . . to get the
communication between criminal and criminologist accorded the same legal
status as that between criminal and lawyer, then field research on adult crim-
inals would really come into its own, for we would at once have provided
the necessary stiffening of criminologists' spines and have removed the biggest
single obstacle to cooperation from our research subjects.

However, I see no reason to be hopeful that we will be granted this
legal privilege, and in fact am quite pessimistic. In the foreseeable future,
field research on criminals will have to be carried out under the hazards and
handicaps that now obtain. But even under present conditions such research
can be done. And if we are serious about studying crime scientifically, it
must be done.

Laud Humphreys

THE SOCIOLOGIST AS VOYEUR [1970]

IN THE SUMMER OF 1965, I wrote a research paper on the subject of homosexuality. After reading the paper, my graduate adviser raised a question, the answer to which was not available from my data or from the literature on sexual deviance: 'But where does the average guy go just to get a blow job? That's where you should do your research.' I suspected that the answer was 'to the tearooms,' but this was little more than a hunch. We decided that this area of covert deviant behavior, tangential to the subculture, was one that needed study.

Stories of tearoom adventures and raids constantly pass along the homosexual grapevine. There is a great deal of talk (usually of a pejorative nature) about these facilities in gay circles. Most men with whom I conversed at any length during my brief research admitted to 'tricking' (engaging in one-time sexual relationships) in tearooms from time to time.

Sociologists had studied bar operations and the practice of male prostitution by teenage gang members but no one had tackled the scenes of impersonal sex where most arrests are made. Literature on the subject indicates that, up to now, the police and other law enforcement agents have been the only systematic observers of homosexual action in public restrooms. . . .

Social scientists have avoided this area of deviant behavior, perhaps due to the many emotional and methodological problems it presents – some of which are common to any study of a deviant population. Ethical and emotional problems, I suspect, provide the more serious obstacles for most prospective researchers. As Hooker points out, 'Gaining access to secret worlds of homosexuals, and maintaining rapport while conducting an ethnographic field study, requires the development of a non-evaluative attitude toward all forms

of sexual behavior' (Hooker 1965: 40). Such an attitude, involving divorce from one's socialization, is not easy to come by. No amount of intellectual exercise alone can enable the ethnographer to make such emotional adjustments, and ethical concerns . . . serve to complicate the task. . . .

This is not a study of 'homosexuals' but of participants in homosexual acts. The subjects of this study have but one thing in common: each has been observed by me in the course of a homosexual act in a public park restroom. . . .

There is probably no major city in the nation without its tearooms in current operation. These facilities constitute a major part of the free sex market for those in the homosexual subculture – and for millions who might never identify with the gay society. For the social scientist, these public toilets provide a means for direct observation of the dynamics of sexual encounters *in situ*; moreover, as will be seen, they facilitate the gathering of a representative sample of secret deviants, for most of whom association with the deviant subculture is minimal.

Neatness versus accuracy

I employed the methods described herein not because they are the most accurate in the sense of 'neatness' or 'cleanness' but because they promised the greatest accuracy in terms of faithfulness to people and actions as they live and happen. These are strategies that I judged to be the least obtrusive measures available – the least likely to distort the real world.

My biases are those that Bruyn attributes to the participant observer, who 'is interested in people as they are, not as he thinks they ought to be according to some standard of his own' (Bruyn 1966: 18). To employ, therefore, any strategies that might distort either the activity observed or the profile of those who engage in it would be foreign to my scientific philosophy and inimical to my purposes. . . .

Hypotheses should develop *out of* such ethnographic work, rather than provide restrictions and distortions from its inception. Where my data have called for a conceptual framework, I have tried to supply it, sometimes with the help of other social scientists. In those cases, where data were strong enough to generate new theoretical approaches, I have attempted to be a willing medium. The descriptive study is important, not only in obtaining objective and systematic knowledge of behavior that is either unknown or taken for granted, but in providing the groundwork for new theoretical development. If the social scientist is to move back and forth between his data and the body of social theory, the path of that movement should not be restricted to a set predestined hypotheses. (For a description of theory development at its best see Mills 1959: 73.)

The research in which I engaged, from the summer of 1965 through the winter of 1967–68, may be broken down into two distinct stages, each with its subcategories. The first was an ethnographic or participant-observation

stage. This part of the research was extended over two years on a part-time basis (I was also involved in graduate study at the time).

The second half involved six months of full-time work in administering interview schedules to more than one hundred respondents and in attempting to interview another twenty-seven. Another year has been devoted to analysis of the resulting data.

As an ethnographer, my first task was to acquaint myself with the homosexual subculture. Because of my pastoral experience, I was no total stranger to those circles. While a seminarian, I was employed for two years in a parish that was known in the homosexual world as Chicago's 'queen parish' – a place to which the homosexuals could turn up for counsel, understanding priests, good music, and worship with an aesthetic emphasis. I soon came to know the gay parishioners and to speak their language. Seminarians who worked there called on people who lived in unbelievable squalor and in houses of prostitution, so it was nothing for us to seek the flock in gay bars as well. One of the faithful churchmen was bartender and part-time entertainer in one of the more popular spots, and he always looked after the seminaries and warned us of impending raids. . . .

From 1955 to 1965, I served parishes in Oklahoma, Colorado, and Kansas, twice serving as Episcopal campus chaplain on a part-time basis. Because I was considered 'wise' and did not attempt to 'reform' them, hundred of homosexuals of all sorts and conditions came to me during those years for counselling. Having joined me in counselling parishioners over the coffee pot for many a night, my wife provided much understanding assistance in this area of my ministry.

The problem, at the beginning of my research, was threefold: to become acquainted with the sociological literature of sexual deviance; to gain entry to a deviant subculture in a strange city where I no longer had pastoral, and only part-time priestly, duties; and to begin to listen to sexual deviants with a scientist's rather than a pastor's ear.

Passing as deviant

Like any deviant group, homosexuals have developed defenses against outsiders: secrecy about their true identity, symbolic gestures and the use of the eyes for communication, unwillingness to expose the whereabouts of their meeting places, extraordinary caution with strangers, and admission to certain places only in the company of a recognized person. Shorn of pastoral contacts and unwilling to use professional credentials, I had to enter the subculture as would any newcomer and to make contact with respondents under the guise of being another gay guy.[1]

Such entry is not difficult to accomplish. Almost any taxi driver can tell a customer where to find a gay bar. A guide to such gathering places may be purchased for five dollars. The real problem is not one of making contact

with the subculture but of making the contact 'stick.' Acceptance does not come easy, and it is extremely difficult to move beyond superficial contact in public places to acceptance by the group and invitations to private and semiprivate parties. . . .

On one occasion, for instance, tickets to an after-hours party were sold to the man next to me at a bar. When I asked to buy one, I was told that they were 'full-up.' Following the tip of another customer, I showed up anyway and walked right in. No one questioned my being there. Since my purpose at this point of the field study was simply to 'get the feel' of the deviant community rather than to study methods of penetrating its boundaries, I finally tired of the long method and told a friendly potential respondent who I was and what I was doing. He then got me invited to cocktail parties before the annual 'drag ball,' and my survey of the subculture neared completion.

During those first months, I made the rounds of ten gay bars then operating in the metropolitan area, attended private gatherings and the annual ball, covered the scene where male prostitutes operated out of a coffeehouse, observed pick-up operations in the parks and streets, and had dozens of informal interviews with participants in the gay society. I also visited the locales where 'instant sex' was to be had: the local bathhouse, certain movie theatres, and the tearooms.

From the beginning, my decision was to continue the practice of field study in passing as deviant. Although this raises questions of scientific ethics, which will be dealt with later, there are good reasons for following this method of participant observation.

In the first place, I am convinced that there is only *one* way to watch highly discreditable behavior and that is to pretend to be in the same boat with those engaging in it. To wear a button that says 'I Am a Watchbird, Watching You' into a tearoom, would instantly eliminate all action except the flushing of toilets and the exiting of all present. Polsky has done excellent observation of pool hustlers because he is experienced and welcome in their game. He is accepted as one of them. He might also do well, as he suggests, in interviewing a jewel thief or a fence in his tavern hangout. But it should be noted that he does not propose watching them steal, whereas my research required observation of criminal acts [see Chapter 24].

The second reason is to prevent distortion. Hypothetically, let us assume that a few men could be found to continue their sexual activity while under observation. How 'normal' could that activity be? How could the researcher separate the 'show' and the 'cover' from the standard procedures of the encounter? Masters and Johnson might gather clinical data in a clinical setting without distortion, but a stage is a suitable research site only for those who wish to study the 'onstage' behavior of actors.

Serving as 'watchqueen'

In *Unobtrusive Measures*, the authors refer to the participant observation method as one of 'simple observation' (Webb *et al.* 1966: 149). This is something of a misnomer for the study of sexually deviant behavior. Observation of tearoom encounters – far from being simple – became, at some stages of the research, almost impossibly complex.

Observation is made doubly difficult when the observer is an object of suspicion. Any man who remains in a public washroom for more than five minutes is apt to be either a member of the vice squad or someone on the make. As yet, he is not suspected as being a social scientist. The researcher, concerned as he is in uncovering information, is unavoidably at variance with the secretive interests of the deviant population. Because his behavior is both criminal[2] and the object of much social derision, the tearoom customer is exceptionally sensitive to the intrusion of all strangers.

Bruyn points out three difficulties attendant to participant observation: 'how to become a natural part of the life of the observed,' 'how to maintain scientific integrity,' and 'problems of ethical integrity.' Each of these problems is intensified in the observation of homosexual activity. When the focus of an encounter is specifically sexual, it is very difficult for the observer to take a 'natural part' in the action without involvement of a sexual nature. Such involvement would, of course, raise serious questions of both scientific and ethical integrity on his part. His central problem, then, is one of maintaining both objectivity and participation (the old theological question of how to be *in*, but not *of*, the world). . . .

[M]y preliminary observations of tearoom encounters led to the discovery of an essential strategy – the real methodological breakthrough of this research – [which] involved mobilization of the social organization being observed. The very fear and suspicion encountered in the restrooms produces a participant role, the sexuality of which is optional. This is the role of the lookout ('watchqueen' in the argot), a man who is situated at the door or windows from which he may observe the means of access to the restroom. When someone approaches, he coughs. He nods when the coast is clear or if he recognizes an entering party as a regular.

The lookouts fall into three main types. The most common of these are the 'waiters,' men who are waiting for someone with whom they have made an appointment or whom they expect to find at this spot, for a particular type of 'trick,' or for a chance to get in on the action. The others are the masturbaters, who engage in autoerotic behavior (either overtly or beneath their clothing) while observing sexual acts, and the voyeurs, who appear to derive sexual stimulation and pleasure from watching the others. Waiters sometimes masturbate while waiting – and I have no evidence to prove that some are not also voyeurs. The point is that the primary purpose of their presence differs from that of the pure masturbater or voyeur: the waiters expect to

become players. In a sense, the masturbaters are all voyeurs, while the reverse is not true.

In terms of appearances, I assumed the role of the voyeur – a role superbly suited for sociologists and the only lookout role that is not overtly sexual. On those occasions when there was only one other man present in the room, I have taken a role that is even less sexual than that of the voyeur–lookout: the straight person who has come in for purposes of elimination. Although it avoids sexual pressure, this role is problematic for the researcher: it is short-lived and invariably disrupts the action he has set out to observe. . . .

Before being alerted to the role of lookout by a cooperating respondent, I tried first the role of the straight and then that of the waiter. As the former, I disrupted the action and frustrated my research. As the latter – glancing at my watch and pacing nervously from window to door to peer out – I could not stay long without being invited to enter the action and could only make furtive observation of the encounters. As it was, the waiter and voyeur roles are subject to blurring and I was often mistaken for the former.

By serving as a voyeur–lookout, I was able to move around the room at will, from window to window, and to observe all that went on without alarming my respondents or otherwise disturbing the action. I found this role much more amenable and profitable than the limited roles assumed in the earlier stages of research. Not only has being a watchqueen enabled me to gather data on the behavioral patterns, it has facilitated the linking of participants in homosexual acts with particular automobiles. . . .

The park restrooms first become active as sexual outlets between 7:30 and 8:30 A.M., when the park attendants arrive to unlock them. The early customers are men who meet on their way to work. After 9:00, the activity drops off sharply until lunch time. During the first two hours of the afternoon, there is another abrupt increase in activity from those who spend their lunch breaks in the park, followed by a leveling-off until about 4:00 P.M. From this time until about 7:00 in the evening, the great bulk of tearoom participants arrive. Most participants stop off in the park restrooms while driving home from work. As one respondent stated, he tries to make it to a tearoom 'nearly every evening about 5:30 for a quick job on the way home.' . . .

Sampling covert deviants

Hooker has noted that homosexuals who lead secret lives are usually available for study 'only when caught by law enforcement agents, or when seeking psychiatric help' (Hooker 1965: 169). To my knowledge, no one has yet attempted to acquire a *representative* sample of *covert* deviants for any sort of research. Polsky's efforts to secure a representative sample of 'beats,'

in order to effect a survey of drug use among them, is a possible exception to this generalization, although I question whether Village beats should be called *covert* deviants.

. . . I gathered a sample of the tearoom participants by tracing the license plates of the autos they drive to the parks. . . . Operation of one's car is a form of self-presentation that tells the observant sociologist a great deal about the operator.

For several months, I had noted fluctuations in the number of automobiles that remained more than fifteen minutes in front of the sampled tearooms. My observations had indicated that, with the sole exception of police cars, autos that parked in front of these public restrooms (which, as has been mentioned, are usually isolated from other park facilities) for a quarter of an hour or more invariably belonged to participants in the homosexual encounters. . . .

In September of 1966, then, I set about to gather a sample in as systematic a manner as possible under the circumstances. . . . Random selection cannot be claimed for this sample: because of the pressures of time and possible detection, I was able to record only a portion of the license plates of participating men I saw at any one time, the choice of which to record being determined by the volume and flow of traffic and the position in which the autos were parked.

I also noted, whenever possible, a brief description of both the car and its driver. By means of frequent sorties into the tearooms for observation, each recorded license number was verified as belonging to a man actually observed in homosexual activity inside the facilities. Sometimes the numbers were taped prior to my entrance, in anticipation of what I would find inside. In most cases, however, I observed the activity, left the tearoom, waited in my car for the participants to enter their autos – then recorded the plate numbers and brief descriptions. For each of these men but one I added to the data the role he took in the sexual encounter.

The original sample thus gained was of 134 license numbers, carefully linked to persons involved in the homosexual encounters, gathered from the environs of ten public restrooms in four different parks of a metropolitan area of two million people. With attrition and additions that will be described later, one hundred participants in the tearoom game were included in the final sample.

Systematic observation

Before leaving the account of my observation strategies to consider the archival measures employed during the first half of my research, I want to describe the techniques employed in 'tightening up' my data. Following the preliminary observations, I developed a 'Systematic Observation Sheet' on which to record my observations. This form – used by myself in describing

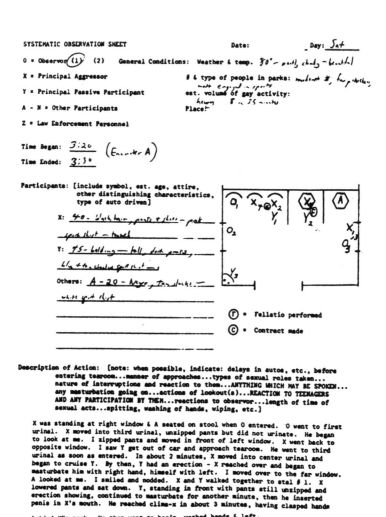

SYSTEMATIC OBSERVATION SHEET Date: _Day: *Sat*

0 = Observer (1) (2) General Conditions: Weather & temp. *80° - partly cloudy - beautiful*

X = Principal Aggressor # & type of people in parks: *moderate #, few pedestrians,*
many engaged in sports

Y = Principal Passive Participant est. volume of gay activity:
heavy *8 in 35 minutes*

A - N = Other Participants Place:

Z = Law Enforcement Personnel

Time Began: *3:20* (*Encounter A*)
Time Ended: *3:30*

Participants: [include symbol, est. age, attire,
 other distinguishing characteristics,
 type of auto driven]

X: *40 - dark hair, pants & shirt - pink*
sport shirt - tanned

Y: *45 - balding — tall, dark pants,*
blue & tan checked sport shirt —

Others: *A - 20 - blond, tan slacks —*
white sport shirt

(F) = Fellatio performed
(C) = Contract made

Description of Action: [note: when possible, indicate: delays in autos, etc., before
 entering tearoom...manner of approaches...types of sexual roles taken...
 nature of interruptions and reaction to them...ANYTHING WHICH MAY BE SPOKEN...
 any masturbation going on...actions of lookout(s)...REACTION TO TEENAGERS
 AND ANY PARTICIPATION BY THEM...reactions to observer...length of time of
 sexual acts...spitting, washing of hands, wiping, etc.]

X was standing at right window & A seated on stool when 0 entered. 0 went to first
urinal. X moved into third urinal, unzipped pants but did not urinate. He began
to look at me. I zipped pants and moved in front of left window. X went back to
opposite window. I saw Y get out of car and approach tearoom. He went to third
urinal as soon as entered. In about 2 minutes, X moved into center urinal and
began to cruise Y. By then, Y had an erection - X reached over and began to
masturbate him with right hand, himself with left. I moved over to the far window.
A looked at me. I smiled and nodded. X and Y walked together to stal # 1. X
lowered pants and sat down. Y, standing in front with pants still unzipped and
erection showing, continued to masturbate for another minute, then he inserted
penis in X's mouth. He reached clima-x in about 3 minutes, having clasped hands
behind X"s neck. He then went to basin, washed hands & left.

Figure 25.1 Systematic Observation Sheet

fifty encounters and by a cooperating participant in the recording of thirty others – helped to assure consistent and thorough recording of the observed encounters.

Figure 25.1 is a reproduction of an actual Systematic Observation Sheet, as filled out by me immediately upon return to my office one summer afternoon. Only the date, place, and description of an auto have been blanked out in order to avoid incrimination. This was the first, and briefest, of a series of three successive encounters observed in that popular restroom in the course of thirty-five minutes. . . .

As may be seen, this report sheet includes places for recording the time and place involved; a description of the participants (their age, attire, auto, and role in the encounter); a description of weather and other environmental conditions; a diagram on which movements of the participants could be plotted, along with location of the places of contact and fellatio; as well as a complete description of the progress of the encounters and reactions of the observer.

Such care was taken for several reasons. My first concern has been for objective validity – to avoid distortion of the data either by my presence or my presuppositions. I have also desired to make future replications and comparative studies possible, by being as systematic as possible in recording and gathering data.

Finally, I wanted to make the best of a rather unique opportunity for participant observation. The tearooms are challenging, not only because they present unusual problems for the researcher but because they provide an extraordinary opportunity for detailed observation. Due to the lack of verbal communication and the consistency of the physical settings, a type of laboratory is provided by these facilities – one in which human behavior may be observed with the control of a number of variables.

[My] analysis of the encounters . . . is based, primarily, on the fifty systematic observations I made between March and August 1967. The numerous informal observations I made previously – and the thirty systematic observations made by a cooperating respondent – have served mainly as checks against this systematic portion of my research. Although I can think of no way in which my earlier observations run counter to these detailed ones, their greatest value was as preparation for this stage of the participant observation. Those of the respondent were also in general agreement with mine. Perhaps because he was frequently a sexual participant in the encounters he observed, however, he tended to concentrate more on the details of the sexual acts and less on the interaction leading to them. . . .

The talk outside

A sociologist without verbal communication is like a doctor without a stethoscope. The silence of these sexual encounters confounded such research

problems as legitimation of the observer and identification of roles. As indicated above, however, it has certain advantages in limiting the number of variables that must be observed, recorded, and evaluated. When action alone is being observed and analyzed, the patterns of behavior themselves acquire meaning independent of verbalization. 'The method of participant observation,' Bruyn states, 'is a research procedure which can provide the basis for establishing adequacy at the level of meaning' (Bruyn 1966: 179). What verbal research is possible through outside interview then becomes an independent means of verifying the observations.

Despite the almost inviolate silence within the restroom setting, tearoom participants are neither mute nor particularly taciturn. Away from the scenes where their sexual deviance is exposed – outside what I shall later discuss as the 'interaction membrane' – conversation is again possible. Once my car and face had become familiar, I was able to enter into verbal relationships with twelve of the participants, whom I refer to as the 'intensive dozen.' Eight of these men are included in the final sample. Four others, although engaged in dialogue near the tearooms where I observed them, were not included in the sample. Of the eight in the sample, five (including the two 'walkers,' who had walked rather than driven to the tearooms) were contacted after leaving the scene of an encounter, and three became cooperating respondents as a result of relationships that developed from the formal interviews.

After the initial contacts with this intensive dozen, I told them of my research, disclosing my real purpose for being in the tearooms. With the help of some meals together and a number of drinks, all agreed to cooperate in subsequent interviewing sessions. A few of these interviews were taped (only two men were sufficiently unafraid to allow their voices to be recorded on tape – and I don't blame the others) but most were later reconstructed from notes. Apart from the systematic observations themselves, these conversations constitute the richest source of data in the study.

Some may ask why, if nine of these cooperating respondents were obtained without the formal interviews, I bothered with the seemingly endless task of acquiring a sample and administering questionnaires – particularly when interviews with the intensive dozen provided such depth to the data. The answer is simple: these men are not representative of the tearoom population. I could engage them in conversation only because they are more overt, less defensive, and better educated than the average participant. This suggests a problem for all research that relies on willing respondents. Their very willingness to cooperate sets them apart from those they are meant to represent. . . .

Archival evidence

The unobtrusive measures of participant observation and physical traces, combined with a limited use of open-ended interviews for purposes of correction

and validation, enabled me to describe the previously unexplored area of tearoom encounters. The preliminary description of the participant population, however, began only after the establishment of a verified sample. For this stage of the study, I turned to archival measures, 'the running record' (Webb *et al.* 1966: 53–87).

Identification of the sample was made by using the automobile license registers of the states in which my respondents lived. Fortunately, friendly policemen gave me access to the license registers, without asking to see the numbers or becoming too inquisitive about the type of 'market research' in which I was engaged. These registers provided the names and addresses of those in the sample, as well as the brand name and year of the automobiles thus registered. The make of the car, as recorded in the registers, was checked against my transcribed description of each car. In the two cases where these descriptions were contradictory, the numbers were rejected from the sample. Names and addresses were then checked in the directories of the metropolitan area, from which volumes I also acquired marital and occupational data for most of the sample. . . .

For fear of eliminating variables that might profitably be studied at a later date, I did not scrub from my sample those for whom the archives provided no marital or occupational data. These men, I felt, might represent either a transient or secretive portion of tearoom participants, the exclusion of which would have distorted the population. . . .

A view from the streets

Like archives, park restrooms, and automobiles, the streets of our cities are subject to public regulation and scrutiny. They are thus good places for non-reactive research (nonreactive in that it requires no response from the research subjects). Having gained addresses for every person in my sample, I spent a Christmas vacation on the streets and highways. By recording a description of every residence and neighborhood represented in the sample, I was able to gain further data on my research subjects.

The first purpose of this survey of homes was to acquire descriptions of the house types and dwelling areas that, when combined with occupational data gleaned from the archives, would enable me to use Warner's Index of Status Characteristics . . . for a socioeconomic profile of my population (Warner *et al.* 1949). Generally speaking, this attempt was not successful; job classifications were too vague and large city housing units too difficult to rank by Warner's criteria.

As physical evidence, however, homes provide a source of data about a population that outweighs any failure they may have as a status index. Swing sets and bicycles in the yards indicate that a family is not childless. A shrine to Saint Mary suggests that the resident is Roman Catholic in religious identification. Christmas decorations bespeak at least a nominal Christian

preference. A boat or trailer in the driveway suggests love of the outdoor life. 'For Rent' signs may indicate the size of an average apartment and, in some cases, the price. The most important sign, however, was the relative 'neatness' of the house and grounds. . . .

Obtrusive measures

Realizing that the majority of my participant sample were married – and nearly all of them quite secretive about their deviant activity – I was faced with the problem of how to interview more than the nine willing respondents. Formal interviews of the sample were part of the original research design. The little I knew about these covert deviants made me want to know a great deal more. Here was a unique population just waiting to be studied – but I had no way to approach them. Clearly, I could not knock on the door of a suburban residence and say, 'Excuse me, I saw you engaging in a homosexual act in a tearoom last year, and I wonder if I might ask you a few questions.' Having already been jailed, locked in a restroom, and attacked by a group of ruffians, I had no desire to conclude my research with a series of beatings.

Perhaps I might have had some success by contacting these men at their work, granted that I could obtain their business addresses. This strategy would have precluded the possibility of seeing their homes and meeting their wives, however, and I believed these confrontations to be important.

About this time, fortunately, I was asked to develop a questionnaire for a social health survey of men in the community, which was being conducted by a research center with which I had been a research associate. Based on such interview schedules already in use in Michigan and New York, the product would provide nearly all the information I would want on the men in my sample: family background, socioeconomic factors, personal health and social histories, religious and employment data, a few questions on social and political attitudes, a survey of friendship networks, and information on marital relationships and sex.

With the permission of the director of the research project, I added my deviant sample to the overall sample of the survey, making certain that only one trusted, mature graduate student and I made all the interviews of my respondents. Thus legitimized, we set out to interview. Using a table of random numbers, I randomized my sample, so that its representativeness would not be lost in the event that we should be unable to complete all 100 interviews.

More will be written later of the measures taken to safeguard respondents; the important thing to note here is that none of the respondents was threatened by the interviews. My master list was kept in a safe-deposit box. Each interview card, kept under lock and key, was destroyed with completion of the schedule. No names or other identifying tags were allowed to

appear on the questionnaires. Although I recognized each of the men interviewed from observation of them in the tearooms, there was no indication that they remembered me. I was careful to change my appearance, dress, and automobile from the days when I had passed as deviant. I also allowed at least a year's time to lapse between the original sampling procedure and the interviews.

This strategy was most important – both from the standpoint of research validity and ethics – because it enabled me to approach my respondents as normal people, answering normal questions, as part of a normal survey. They *are* part of a larger sample. Their being interviewed is not stigmatizing, because they comprise but a small portion of a much larger sample of the population in their area. They were not put on the spot about their deviance, because they were not interviewed as deviants.

The attrition rate for these interviews was high, but not discouragingly so. Attempts were made at securing seventy-five interviews, fifty of which were completed. Thirty-five per cent were lost by attrition, including 13 per cent who refused to cooperate in the interviews. In addition to the fifty completed schedules, three fathers of participants consented to interviews on the social health survey, as did two fathers of the control sample.

Because of the preinterview data obtained by the archival and observational research previously described, it was possible to learn a great deal even from the losses. As should be expected, the residue of men with whom interviews were completed are slightly overrepresentative of the middle and upper classes; they are suburbanites, more highly educated men. Those who were lost represent a more transient group (the most common reason for loss was that the subject had moved and left no forwarding address), employed in manual jobs. From preinterview information it was learned that the largest single occupational class in the sample was the truck driver. Only two members of this class remained among those interviewed.

The refusals also indicated some biases. These men, when pinpointed on a map, clustered around the Italian and working-class German areas of the city. Of the ten lost in this manner, three had Italian names and five bore names of distinctly German origin.

Once these interviews were completed, preparations could be made for the final step of the research design. From names appearing in the randomly selected sample of the overall social health survey, fifty men were selected, matched with the completed questionnaires on the following four categories: . . . occupation, race, area of the metropolitan region in which the party resided, and marital status. The loss here was not from refusals or lost addresses but from those who, when interviewed, failed to correspond with the expected characteristics for matching. Our procedure, in those cases, was simply to move on to another name in the larger sample.

These last fifty interviews, then, enabled me to compare characteristics of two samples – one deviant, one control – matched on the basis of certain

socioeconomic characteristics, race and marital status. Although I made a large proportion of these interviews, and nearly all of the deviant interviews, I found it necessary to hire and train two graduate students to assist with interviewing the control sample. A meeting was held with the assistant interviewers immediately following the completion of each schedule – and all coding of the questionnaires was done by us in conference.

There were a number of open-ended questions in the interview schedules, but the majority included a wide range of precoded answers, for the sake of ease in interviewing and economy in analysis. In addition, the interviewers were trained to make copious marginal notes and required to submit a postinterview questionnaire with each schedule. The median time required for administering the interview schedules did not differ greatly between the two samples: one hour for the deviants, fifty-five minutes for the 'straights.' Even the days of the week when respondents were interviewed showed little variation between the two samples: Sunday, Tuesday, and Saturday, in that order, being the more popular days.

From a methodological standpoint, the value of this research is that it has employed a variety of methods, each testing a different outcropping of the research population and their sexual encounters. It has united the systematic use of participant observation strategies with other non-reactive measures such as physical traces and archives. The exigencies of research in a socially sensitive area demanded such approaches; and the application of unobtrusive measures yielded data that call, in turn, for reactive methods.

Research strategies do not develop *ex nihilo*. In part, they are the outgrowth of the researcher's basic assumptions. Special conditions of the research problem itself also exercise a determining influence upon the methods used. This chapter has been an attempt to indicate how my ethnographic assumptions, coupled with the difficulties inhering in the study of covert deviants and their behavior, have given rise to a set of strategies.

With the help of 'oddball' measures, the outlines of the portrait of participants in the homosexual encounters of the tearooms appeared. Reactive strategies were needed to fill in the distinguishing features. They are human, socially patterned features; and it is doubtful that any one method could have given them the expressive description they deserve.

Notes

1 My reticence at admitting I was a sociologist resulted, in part, from the cautioning of a gay friend who warned me that homosexuals in the community are particularly wary of sociologists. This is supposedly the result of the failure of a graduate student at another university to disguise the names of bars and respondents in a master's thesis on this subject.

2 The Revised Statutes of the state under study, for instance, read . . . :
 . . . *The abominable and detestable crime against nature – penalty*: – Every
person who shall be convicted of the detestable and abominable crime
against nature, committed with mankind or with beast, with the sexual
organs or with the mouth, shall be punished by imprisonment in the peni-
tentiary not less than two years.

Paul E. Willis

THEORETICAL CONFESSIONS
AND REFLEXIVE METHOD [1976]

THIS [CHAPTER] AIMS to identify the really central principles of partici-
pant observation and to suggest what is worth preserving and what is
worth firmly rejecting in a preliminary attempt to outline a method genuinely
adapted to the study of human meanings. . . .

The manifest posture

The most obvious thrust of 'qualitative' methodology has been *against* tradi-
tional sociological theory and methods modelled on what are taken to be the
procedures and tests of the natural sciences. To simplify, the fear seems to
be that a theory can only, ultimately, demonstrate its own assumptions. What
lies outside these assumptions cannot be represented or even acknowledged.
So to maintain the richness and authenticity of social phenomena it is neces-
sary, certainly in the early stages of research, to receive data in the raw,
experimental and relatively untheorized manner – 'Allowing substantive
concepts and hypotheses to emerge first on their own'(Glaser and Strauss
1979: 304). It is recognized, of course, that there will have to come a time
of closure. It is hoped, however, that the selectivity and theorization of the
final work will reflect the patterning of the real world rather than the patterns
of received theory. These 'anti'-theoretical concerns generate a profound
methodological stress on contacting the subject as directly as possible. It is
as if the ideal researcher's experience can achieve a one-to-one relationship
with that of the researched (see, for example, Whyte 1969, Becker 1963,
Downes 1966, Polsky 1969).

This conviction, and the general distrust of theory, are most clearly expressed through and by the techniques and methods it is proposed to use. The researcher is to work in the environment of his/her subjects rather than in the laboratory and is to enter the field as free as possible from prior theory. S/he is to participate in the round of activities of his/her subjects but to avoid 'disturbing' the field. S/he should not question his/her subjects directly but be as open as possible to the realm of the 'taken-for-granted'. S/he must take great care to plan his/her entrance into the field, prepare a feasible role and assiduously court those who might sponsor his/her membership in selected social groups.

It is the openness and directness of this methodological approach which promises the production of a final account which, like an icon, will bear some of the marks, and recreate something of the richness, of the original.

The hidden practice

If the techniques of 'qualitative' methodology mark a decisive break from 'quantitative' ones, the way in which they are *usually applied* makes a secret compact with positivism to preserve the subject finally as an object. Indeed, what the all-embracing concern for techniques and for the reliability of the data really shows us is a belief that the object of the research exists in an external world, with knowable external characteristics which must not be disturbed.

The central insistence, for instance, on the *passivity* of the *participant observer* depends on a belief that the subject of the research is really an object. The concern is to minimize 'distortion of the field', with the underlying fear that the *object* may be *contaminated* with the subjectivity of the researcher. Too easily it becomes an assumption of different orders of reality between the researched and the researcher.

The insistent, almost neurotic, technical concern with the differentiation of PO from reportage and Art is also a reflection of the subterranean conviction that PO belongs with the 'sciences' and must, in the end, respect objectivity. There is a clear sociological fear of naked subjectivity. The novel can wallow in subjectivity – this is how it creates 'colour' and 'atmosphere' – but how do we know that the author did not make it all up? Indeed, in one obvious way he or she did make it all up! So the search must be for a unified object which might be expected to present itself as *the same* to many minds. The first principle of PO, the postponement of theory, compounds the dangers of this covert positivism. It strengthens the notion that the object can present itself directly to the observer.

On the role of theory

In fact, there is no truly untheoretical way in which to 'see' an 'object'. The 'object' is only perceived and understood through an internal organization

of data, mediated by conceptual constructs and ways of seeing the world. The final account of an object says as much about the observer as it does about the object itself. Accounts can be read 'backwards' to uncover and explicate the consciousness, culture and theoretical organization of the observer.

However, we must recognize the ambition of the PO principle in relation to theory. It has directed its followers towards a profoundly important methodological possibility – that of *being surprised*, of reaching knowledge not prefigured in one's starting paradigm. The urgent task is to chart the feasibility, scope and proper meaning of such a capacity.

If we are to recognize the ambition of the participant observation principle in relation to theory. It has directed its followers towards a profoundly important methodological possibility – that of *being surprised*, of reaching knowledge not prefigured in one's starting paradigm. The urgent task is to chart the feasibility, scope and proper meaning of such a capacity.

If we are to recognize the actual scope for the production of 'new' knowledge, we must avoid delusions. We must not be too ambitious. It is vital that we admit the most basic foundations of our research approach and accept that no 'discovery' will overthrow this most basic orientation. The theoretical organization of the starting-out position should be outlined and acknowledged in any piece of research. This inevitable organization concerns attitudes towards the social world in which the research takes place, a particular view of the social relationships within it and of its fundamental determinations and a notion of the analytic procedures which will be used to produce the final account. It would also explain why certain topics have been chosen for research in the first place.

This theoretical 'confession', however, need not specify the 'whole' of social reality in a given region; it has merely specified the kind of world in which its action is seen as taking place. Although it involves the general form of, it does not include, *specific* explanation – especially concerning the *manner*, the 'how' or the degree of external determination of a given social region – nor does it anticipate the particular meaning of the future flow of data.

It is indeed crucial that a qualitative methodology be confronted with the maximum flow of relevant data. Here resides the power of the evidence to 'surprise', to contradict, specific developing theories. And here is the only possible source for the 'authenticity', the 'qualitative feel', which is one of the method's major justifications. It is in this area – short of any challenge to one's world view – that there is the greatest possibility of 'surprise'.

This is not to allow back an unbridled, intuitive 'naturalism' on impoverished terms. Even with respect to what remains unspecified by the larger 'confession', we must recognize the necessarily theoretical form of what we 'discover'. Even the most 'naturalistic' of accounts involves deconstruction of native logic and builds upon reconstruction of compressed, select, significant moments in the original field experienced. There is an art concealing art which precisely obscures the theoretical work that has taken

place. Having recognized the inevitability of a theoretical component, it can be used more self-consciously to probe those areas about which knowledge is incomplete.

We will find in any cultural form and related form of consciousness a submerged text of contradictions, inconsistencies and divergencies. If we are tuned in to an illusory attempt to present a single-valency account without interpretative or reductive work, we shall more usually miss (or, at best, simply reproduce) this sub-text. It is necessary to add to the received notion of the 'quality' of the data an ability to watch for inconsistencies, contradictions and misunderstandings and to make theoretical interpretations of them. We must maintain the richness and atmosphere of the original while attempting to illuminate its inner connection. Certainly, the necessary and inevitable level of interpretative theorizing within the method can be used to explicate chosen topics without running greater dangers than are running conventionally in an *unrecognized* way.

On reflexivity: the politics of fieldwork

If we wish to represent the subjective meanings, feelings and cultures of others, it is not possible to extend to them less than we know of ourselves. What is so often taken as the 'object' and the researcher lie parallel in their humanity. The 'object' of our inquiry is in fact, of course, a subject and has to be understood and presented in the same mode as the researcher's own subjectivity – this is the true meaning of 'validity' in the 'qualitative zone'. The recognition of this truism is not, however, to declare against all forms of 'objectivity'. We are still in need of a method which respects evidence, seeks corroboration and minimizes distortion, *but which is without rationalist natural-science-like pretence.*

Though we can only know it through our own concepts, there is nevertheless a *real* subject for our inquiry, which is not entirely spirited away by our admission of its relativized position. If our purpose is a fuller understanding and knowledge of this subject, then we must have some concern for the reliability of the data we use. Furthermore, if our focus is not on isolated, subjective meanings but on their associated symbolic systems and cultural forms, then we are concerned also with real material elements. It is perfectly justifiable to use rigorous techniques to gain the fullest knowledge of these things. This is, therefore, to go partly down the road of traditional 'objectivity': many of the techniques used will be the same. The parting of the ways comes at the end of this process. The conventional process takes its 'objective' data-gathering as far as possible and then consigns the rest (what it cannot know, measure or understand) to . . . 'the problem of subjectivity'. Having constituted its object truly as an 'object', and having gained all possible knowledge about this 'object', the process must stop; it has come up to the 'inevitable limitations of a quantitative methodology'.

But it is precisely at this point that a reflexive, 'qualitative' methodology comes into its own. Never having constituted the subject of its study as an 'object', it is not surprised that there is a limit to factual knowledge. What finally remains is *the relationship between subjective/cultural systems*.

The rigorous stage of the analysis, the elimination of distortion, the cross-checking of evidence and so on have served to focus points of divergence and convergence between systems. Reducing the confusion of the research situation, providing a more precise orientation for analysis, allows a closer reading of separate realities. By reading moments of contact and divergence it becomes possible to delineate other worlds, demonstrating their inner symbolic qualities. And when the conventional techniques retire, when they cannot follow the subjects of subjects themselves – this is the moment of *reflexivity*. Why are these things happening? Why has the subject behaved in this way? Why do certain areas remain obscure to the researcher? What differences in orientation lie behind the failure to communicate?

It is here, in this interlocking of human meanings, of cultural codes and of forms, that there is the possibility of 'being surprised'. And in terms of the generation of 'new' knowledge, we know what it is precisely *not* because we have shared it – the usual notion of empathy – but because we have *not* shared it. It is here that the classical canons are overturned. It is time to ask and explore, to discover the differences between subjective positions, between cultural forms. It is time to initiate actions or to break expectations in order to probe different angles in different lights. Of course, this is a time of maximum disturbance to researchers, whose own meanings are being thoroughly contested. It is precisely at this point that the researcher must assume an unrestrained and hazardous *self-reflexivity*. And it is the turning away from a full commitment, at this point, which finally limits the methods of traditional sociology.

It is in these moments also that there can be a distinctive relationship with a specifically Marxist form of analysis. The terrain uncovered and explored during this reflexive stage is likely to concern contradictions and tensions, both within the field of study – contrasting moments of subjective experience, tensions between what is said and done, differences between what collective forms or materials seem to say or promise and what *actually* happens or is experienced – and between the researcher's expectations, codes and cultural forms of understanding and those which he or she is uncovering. It is likely to be a difficult field of contradictions, picked up at this point precisely because it is the notion of *contradiction* which the traditional 'naturalistic' technique is unable to register or registers only as a weakness or breakdown in its method, or as the 'limit case' to the researcher's effectivity in the field – beyond which lies only 'going native' or withdrawal. With only a notion of 'what follows' taken from the surface reality of the 'object' and picked up transparently in the universal codes of 'science', contradictory messages, conflicts or breakdowns between codes and broken communication can only be understood as 'failures', to be transcended ultimately by better technique.

However, if these moments of crisis can be seen as a creative uncertainty, entered through a structured social relationship, indicating and arising from important contradictions, then further theoretical and methodological options become available. The theoretical understanding developed through . . . a more active and reflexive method can be in the form of a reformulation . . . of what I called earlier the larger theoretical 'confession' and [a more precise articulation of the] particular relationships of determination within the regional area under study. . . . Often this must be through recognizing a necessary unevenness and complexity in the way that external forces or ideologies pattern a given area. This is a non-mechanistic, non-reductive view of the relationships . . . which leave[s] some scope for reciprocal effectivity between located cultural forms, subjective experience and larger structures or may insist on indirect or mediating processes, but which is still concerned with determination. This greater theoretical elaboration, extension and specification – especially within a theory which recognizes the play of contradiction – will then allow the better grasp and explanation of the now more complex and layered subject of study and the nature of the relationship which has uncovered it so far. It should also suggest *particular* questions and difficulties which renewed and more unconventional methods can seek to clarify. There is thus the possibility of a circular development between a progressively more specified 'theoretical confession' and the specific contradictions and tensions of fieldwork on to, in the return sweep, reconstituted forms of theory and back to the specifics of the fieldwork relation. This is the project of producing, finally, a fuller explanatory presentation of the concrete.

I am not necessarily arguing that the final account should show the several stages of this often tortuous process, or that these stages are necessarily always self-conscious: I would argue that it is something of this sort, often unconscious or even denied, which has taken place in the research work of those 'naturalistic' accounts which do have explanatory power. Nor am I denying that, as in the more classical notion of the Marxist method, this circular movement cannot occur after fieldwork is finished or upon secondary data, through the principles of search and selectivity on existing or received materials. What I am arguing, in the context of 'qualitative' methods, is that significant data are collected not through the purity of scientificism of its method, but through the status of the method as a social relationship, and specifically through the moments of crisis in that relationship and its to-be-discovered pattern of what is/what is not shared: the contradictions within and between these things. And, furthermore, that where the fieldwork is really extensive or where the researcher . . . can theorize . . . on his/her feet, for all the difficulties and disorientations, reflexivity can allow the progressive constitution of the concrete in relation to theory, not merely as an analytic protocol but as a dynamic, dialectical method. This can give a concentration and an obstinate capacity to penetrate through successive layers of 'blank' data in the pursuit of particular themes not available to other methods. Not only the quality of the data, nor even its . . . capacity to

'surprise', but this potential . . . for a cyclic control and focus of method in the rich veins of 'lived' contradiction is what can most distinguish the 'qualitative' approach.

On technicism

The notion of a reflexive methodology, then, takes us beyond a simple concern with techniques of data-gathering. It is often stated as a truism that forms of data collection and analytic procedures are profoundly interconnected. I am arguing that it is precisely a *theoretical* interest which induces the researcher to develop certain kinds of technique, to make comparative forays, to invent or invert methodological canons, to select certain 'problems' for analytical explication. Though techniques are important, and though we should be concerned with their 'validity', they can never stand in the place of a theoretical awareness and interest arising out of *the recognition of one's role in a social relationship and its variable patterning*. Without this theoretical quickening, the techniques merely record uncritically only the apparent outward face of an external 'reality'.

We should resist, therefore, the hegemonizing tendency of technique. It seeks to take command whenever there is uncertainty. It disguises the creative potential of uncertainty. In particular, we should deconstruct the portmanteau, heavily mystified notion of participant observation, whose mere invocation and taxonomical description seem to guarantee the quality of an account. We should break down and detail its parts, along with a number of other techniques, to give us a flexible range of particular techniques to be drawn upon according to our theoretical needs. Within its spectrum the following techniques can be specified: participation; observation; participation as observer; observation as participant; just 'being around'; group discussion; recorded group discussion; unfocused interview; recorded unfocused interview.

It is clearly misleading to think of these techniques as constituting one blanket methodology. Techniques lower down this list, for example, are more likely to be applied to . . . phenomen[a] from the past [to] develop . . . oral histor[ies]. A particular strength can be gained by a more self-conscious combination of methods, where different modes of data collection, used at different times, give important cross-checks, as well as indicating the particular layered configuration of important contradictions. All of these techniques are relevant to the principles of 'qualitative' methodology, and each should be rigorously thought through in its particular research context.

Conclusion

Traditional sociology, then, provides a useful starting-point. But we must submit its methods to a rigorous screening to make explicit the denied

theoretical account and to remove the hidden tendency towards positivism. We must liberate the whole notion of 'methodology' and argue, finally, for a recognition of the reflexive relationship of researchers to their subjects.

Stephen A. Tyler

POST-MODERN ETHNOGRAPHY [1986]

A POST-MODERN ETHNOGRAPHY is a cooperatively evolved text consisting of fragments of discourse intended to evoke in the minds of both reader and writer an emergent fantasy of a possible work of common-sense reality, and thus to provoke an aesthetic integration that will have a therapeutic effect. It is, in a word, poetry – not in its textual form, but in its return to the original context and function of poetry, which, by means of its performative break with everyday speech, evoked memories of the ethos of the community and thereby provoked hearers to act ethically. . . . Post-modern ethnography attempts to recreate textually this spiral of poetic and ritual performance. Like them, it defamiliarizes commonsense reality in a bracketed context of performance, evokes a fantasy whole abducted from fragments, and then returns participants to the world of common sense – transformed, renewed, and sacralized. It has the allegorical import, though not the narrative form, of a vision quest or religious parable. The break with everyday reality is a journey apart into strange lands with occult practices – into the heart of darkness – where fragments of the fantastic whirl about in the vortex of the quester's disoriented consciousness, until, arrived at the maelstrom's center, he loses consciousness at the very moment of the miraculous, restorative vision, and then, unconscious, is cast up onto the familiar, but forever transformed, shores of the commonplace world. Post-modern ethnography is not a new departure, not another rupture in the form of discourse of the sort we have come to expect as the norm of modernist esthetics' scientistic emphasis on experimental novelty, but a self-conscious return to an earlier and more powerful notion of the ethical character of all discourse, as captured in the ancient significance of the family of terms 'ethos', 'ethnos', 'ethics.'

Because post-modern ethnography privileges 'discourse' over 'text', it foregrounds dialogue as opposed to monologue, and emphasizes the cooperative and collaborative nature of the ethnographic situation in contrast to the ideology of the transcendental observer. In fact, it rejects the ideology of 'observer–observed,' there being nothing observed and no one who is observer. There is instead the mutual, dialogical production of a discourse, of a story of sorts. We better understand the ethnographic context as one of cooperative story making that, in one of its ideal forms, would result in a polyphonic text, none of whose participants would have the final word in the form of a framing story or encompassing synthesis – a discourse on the discourse. It might be just the dialogue itself, or possibly a series of juxtaposed paratactic tellings of a shared circumstance, as in the Synoptic Gospels, or perhaps only a sequence of separate tellings in search of a common theme, or even a contrapuntal interweaving of tellings, or of a theme and variations (cf. Marcus and Cushman 1982; Clifford 1983a). Unlike the traditional teller of tales or his folklorist counterpart, the ethnographer would not focus on monophonic performance and narrativity, though neither would he necessarily exclude them if they were appropriate in context.

I do not wish to suggest that such a text would resemble an edited collection of authored papers, one of those authorless books produced by committee, or an accidental collage like an issue of the *American Anthropologist*. These three used together, though, do characterize a ubiquitous ethnographic form called the 'newspaper.' In fact, had there been a modernist movement in ethnography, it would have taken the newspaper as its literary model. The collection and the collage preserve differences of perspective, but differ on the dimension of accident vs. purpose, though we can all think of edited collections that are in fact collages, so little do their selections relate to common themes or topics that their presence in the same volume seems accidental, and we are all familiar with thematized collages like the newspaper, whose items are minimally linked by the common theme, 'here are today's relevances for nobody in particular as put together by nobody in particular.'

Polyphony is a means of perspectival relativity and not just an evasion of authorial responsibility of a guilty excess of democracy, though . . . it articulates best with that social form, and it does correspond with the realities of fieldwork in places sensitive to the issue of power as symbolized in the subject–object relationship between he who represents and she who is represented. And it is not that ethnographers have never before used the idea of authorless texts, for myths and folktales, even when related by someone, are pure examples of the form, though we must think in that case of a committee extended in time whose participants never convene to compose the work.

The point is that questions of form are not prior, the form itself should emerge out of the joint work of the ethnographer and his native partners. The emphasis is on the emergent character of textualization, textualization

being just the initial interpretive move that provides a negotiated text for the reader to interpret. The hermeneutic process is not restricted to the reader's relationship to the text, but includes as well the interpretive practices of the parties to the originating dialogue. In this respect, the model of post-modern ethnography is not the newspaper but that original ethnography – the Bible. . . .

Having perceived the limiting meaning of the second member of the compound term 'ethnography' ('-graphy' fr. *graphein* 'to write'), some ethnographers have tamed the [other] not with the pen, but with the tape recorder, reducing him to a 'straight man,' as in the script of some obscure comic routine, for even as they think to have returned to 'oral performance' or 'dialogue,' in order that the native have a place in the text, they exercise total control over her discourse and steal the only thing she has left – her voice. . . .

Because it is participatory and emergent, post-modern ethnography cannot have a predetermined form, for it could happen that participants might decide that textualization itself is inappropriate – as have many informants in the past, though their objections were seldom taken to be significant in themselves, being treated instead as impediments to the ethnographer's monophonic text. Whatever form the text takes – if any – it will stress sonorant relativity, not only between the text and the community of discourse of which it is a part – the usual sense of 'cultural relativity' – but within the text itself as a constitutive feature of the text. . . .

[Post-modern ethnography] refuses to become a fetishized object among objects – to be dismantled, compared, classified, and neutered in that parody of scientific scrutiny known as criticism. The ethnographic text is not only *an* object, it is not *the* object; it is instead a means, the meditative vehicle for a transcendence of time and place that is not just transcendental but a transcendental return to time and place.

Because its meaning is not in it but in an understanding, of which it is only a consumed fragment, it is no longer cursed with the task of representation. The key word in understanding this difference is 'evoke,' for if a discourse can be said to 'evoke,' then it need not represent what it evokes, though it may be a means to a representation. Since evocation is nonrepresentational, it is not to be understood as a sign function, for it is not a 'symbol of,' nor does it 'symbolize' what it evokes. . . . It is not a presence that calls into being something that was absent; it is a coming to be of what was neither there present nor absent, for we are not to understand 'evocation' as linking two differences in time and place, as something that evokes and something else evoked. . . .

The whole point of 'evoking' rather than 'representing' is that it frees ethnography from *mimesis* and the inappropriate mode of scientific rhetoric that entails 'objects,' 'facts,' 'descriptions,' 'inductions,' 'generalizations,' 'verification,' 'experiment,' 'truth,' and like concepts that, except as empty invocations, have no parallels either in the experience of ethnographic

fieldwork or in the writing of ethnographies. The urge to conform to the canons of scientific rhetoric has made the easy realism of natural history the dominant mode of ethnographic prose, but it has been an illusory realism, promoting, on the one hand, the absurdity of 'describing' nonentities such as 'culture' or 'society' as if they were fully observable, though somewhat ungainly, bugs, and, on the other, the equally ridiculous behaviorist pretense of 'describing' repetitive patterns of action in isolation from the discourse that actors use in constituting and situating their action, and all in simple-minded surety that the observers' grounding discourse is itself an objective form sufficient to the task of describing acts.

The problem with the realism of natural history is not, as is often claimed, the complexity of the so-called object of observation, nor failure to apply sufficiently rigorous and replicable methods, nor even less the seeming intractability of the language of description. It is instead a failure of the whole visualist ideology of referential discourse, with its rhetoric of 'describing,' 'comparing,' 'classifying,' and 'generalizing,' and its presumption of representational signification. In ethnography there are no 'things' there to be objects of a description, the original appearances that the language of description 'represents' as indexical objects for comparison, classification, and generalization; there is rather a discourse, and that too, no thing, despite the misguided claims of such translational models of ethnography as structuralism, ethno-science, and dialogue, which attempt to represent either native discourse or its unconscious patterns, and thus re-commit the crime of natural history in the mind.

Ethnographic discourse is itself neither an object to be represented nor a representation of an object. Consequently the visualist rhetoric of representation, descending from the concreteness of the written word – of *de-scribere* – subverts the ethical purport of ethnography and can only give us as replacement a sense of incompleteness and failure, since its goals and means are always out of reach.

Ethnographic discourse is not part of a project whose aim is the creation of universal knowledge. It disowns the Mephistophelian urge to power through knowledge, for that, too, is a consequence of representation. To represent means to have a kind of magical power over appearances, to be able to bring into presence what is absent, and that is why writing, the most powerful means of representation, was called '*grammarye*' a magical act. The true historical significance of writing is that it has increased our capacity to create totalistic illusions with which to have power over things or over others as if they were things.

The whole ideology of representational significance is an ideology of power. To break its spell we would have to attack writing, totalistic representational signification, and authorial authority, but all this has already been accomplished for us. Ong (1977) has made us aware of the effects of writing by reminding us of the world of oral expression that contrasts with it. Benjamin (1978) and Adorno (1977) have counterposed the ideology of the

'fragment' to that of the whole, and Derrida (1974) has made the author the creature of writing rather than its creator. Post-modern ethnography builds its program not so much from their principles as from the rubble of their deconstruction.

A post-modern ethnography is fragmentary because it cannot be otherwise. Life in the field is itself fragmentary, not at all organized around familiar ethnological categories such as kinship, economy, and religion . . . [N]or do particular experiences present themselves, even to the most hardened sociologist, as conveniently labeled synecdoches, microcosms, or allegories of wholes, cultural or theoretical. At best, we make do with a collection of indexical anecdotes or telling particulars with which to portend that larger unity beyond explicit textualization. It is not just that we cannot see the forest for the trees, but that we have come to feel that there are no forests where the trees are too far apart, just as patches make quilts only if the spaces between them are small enough.

We confirm in our ethnographies our consciousness of the fragmentary nature of the post-modern, for nothing so well defines our world as the absence of a synthesizing allegory, or perhaps it is only a paralysis of choice brought on by our knowledge of the inexhaustible supply of such allegories that makes us refuse the moment of aesthetic totalization, the story of stories, the hypostatized whole.

But there are other reasons, too. We know that these textual transcendentals, these invocations of holism, of functionally integrated systems are literary tropes, the vehicles that carry imagination from the part to the whole, the concrete to the abstract, and knowing them for what they are, whether mechanismic or organismic, makes us suspect the rational order they promise.

More important than these, though, is the idea that the transcendental transit, the holistic moment is neither textually determined nor the exclusive right of the author, being instead the functional interaction of text-author-reader. It is not some secret hidden in the text, or between texts; nor in the mind of the author and only poorly expressed/repressed by him; nor in the reader's interpretation, no matter what his critical persuasion – if any. . . . They derive from dialogue rather than the monophonic internal dialectic of the author with his text. Even though [Theodor] Adorno argues that the essay, by means of negative dialectics, aims at the liquidation of all viewpoints, it cannot achieve this goal so long as it is monophonic, projected from the viewpoint of a single author. It expresses only the cognitive utopia of the author (Kauffmann 1981: 343–53). Unlike negative dialectics, the oppositions of dialogue need not be held in unresolved suspension without the possibility of transcendence, but like negative dialectics, post-modern ethnography does not practice synthesis within the text. . . . The text has the paradoxical capacity to evoke transcendence without synthesis. . . . In common with Adorno's program, it avoids any supposition of a harmony between the . . . conceptual order of the text and the order of things. . . .

The ancient metaphor of thought as movement, a species of motion, bequeathed to us by Aristotle, is in question here, for it is the simultaneous juxtaposition of these contrary motions and their mutually neutralizing conflict that enables the whole I seek to evoke, that stillness at the center where there is neither higher nor lower, forward nor back, past nor future, when space and time cancel each other out in that familiar fantasy we all know as the everyday, commonplace world, that breach in time, that ever present, never present simultaneity of reality and fantasy that is the return to the commonsense world, floating, like the Lord Brahmā, motionless in the surfaceless void, all potentiality suspended within us in perfect realization, a return that is not a climax, terminus, stable image, or homeostatic equilibrium, but a reduction of tension as the moment of transcendence simultaneously approaches, draws near, and departs without having arrived. And that is why the post-modern ethnography is an occult document; it is an enigmatic, paradoxical, and esoteric conjunction of reality and fantasy that evokes the constructed simultaneity we know as naive realism. It conjoins reality and fantasy, for it speaks of the occult in the language of naive realism and of the everyday in occult language, and makes the reason of the one the reasonableness of the other. It is a fantasy reality of a reality fantasy whose aim is to evoke in reader and writer alike some intimation of a possible world already given to us in fantasy and commonsense, those foundations of our knowledge that cannot themselves be the objects of our knowledge 'for as by them we know all else, by nought else can they be known. We know them indeed, but only in the fact that with them and through them we know' (Hamilton 1863: 255).

Post-modern ethnography is a return to the idea of aesthetic integration as therapy once captured in the sense of Proto-Indo-European *ar-* ('way of being,' 'orderly and harmonious arrangement of the parts of a whole'), from which have come English 'art,' 'rite,' and 'ritual,' that family of concepts so closely connected with the idea of restorative harmony, of 'therapy' in its original sense of 'ritual substitute' (cf. Hittite *tarpan-alli*), and with the poet as *therápon*, 'attendant of the Muse.' Post-modern ethnography is an object of meditation that provokes a rupture with the commonsense world and evokes an aesthetic integration whose therapeutic effect is worked out in the restoration of the commonsense world. Unlike science, it is not an instrument of immortality, for it does not hold out the false hope of a permanent, utopian transcendence, which can only be achieved by devaluing and falsifying the commonsense world and thereby creating in us a sense of permanent alienation from everyday life as we live in constant expectation of the messianic deliverance from it that can never come, or comes only with death, and science thus encourages us to die too soon. Instead, it departs from the commonsense world only in order to reconfirm it and to return us to it renewed and mindful of our renewal.

Because the post-modern world is a post-scientific world without the illusion of a transcendental, neither transcendental science nor transcendental

religion can be at home in it, for that which is inhospitable to the transcendence by abstraction of the one must also be unfriendly to the similar character of the other. Neither the scientific illusion of reality nor the religious reality of illusion is congruent with the reality of fantasy in the fantasy reality of the post-modern world. Post-modern ethnography captures this mood of the post-modern world, for it, too, does not move toward abstraction, away from life, but back to experience. It aims not to foster the growth of knowledge but to restructure experience; not to understand objective reality, for that is already established by common sense, nor to explain how we understand, for that is impossible, but to reassimilate, to reintegrate the self in society and to restructure the conduct of everyday life.

Save in the commonsense world, discourse cannot autonomously determine its . . . effects. Neither its form nor its authorial intention determine how it will be understood, for it is impossible in text or speech to eliminate ambiguity and to structure totally for all time the auditor's purposes and interests. Her reading and listening are as much expressions of her intentions and will as is the author's writing and speaking. . . . Because the text can eliminate neither ambiguity nor the subjectivity of its authors and readers, it is bound to be misread, so much so that we might conclude, in a parody of Bloom, that the meaning of the text is the sum of its misreadings.

Such may indeed be the fate of the text, but the meaning of this inherent failure to control ambiguity and subjectivity is that is provides good reason for rejecting the model of scientific rhetoric, that Cartesian pretense that ideas are effable in clear, unambiguous, objective, and logical expression, for the inner form of a text is not logical, . . . but paradoxical and enigmatic, not so much ineffable, as over-effable, illimitably effable, possessing a surplus of effability. . . .

For post-modern ethnography the implication is, if not clear, at least apparent that its text will be projected neither in the form of this inner paradox nor in the form of a deceptive outer logic, but as the tension between them, neither denying ambiguity nor endorsing it, neither subverting subjectivity nor denying objectivity, expressing instead their interaction in the subjective creation of ambiguous objectivities that enable unambiguous subjectivity. The ethnographic text will thus achieve its purposes not by revealing them, but by making purposes possible. It will be a text of the physical, the spoken, and the performed, an evocation of quotidian experience, a palpable reality that uses everyday speech to suggest what is ineffable, not through abstraction, but by means of the concrete.

Historical subcultures

Introduction to part five

■ Ken Gelder

I T H A S A L R E A D Y been noted that the term 'subculture' is fairly recent, used descriptively for the first time around fifty years ago by American sociologists. But subordinate or marginal social groups had been accounted for in various ways long before this term gained currency. The culture of beggars and vagabonds, for example, was described as far back as the fifteenth century in 'beggar-books' which alerted readers to the kinds of tricks and deceptions these people might practise upon them. By the late sixteenth century, detailed accounts of the specialized languages of rogues, beggars and cony-catchers (swindlers) were being printed. The emphasis was on jargon or 'cant': the latter word especially connects the language of a subordinate social group with the ability to deceive or mislead. By the end of the seventeenth century, and later, an increasing number of specialist dictionaries were being compiled in order both to register and to explain (especially for those who may fall victim to it) the otherwise impenetrable argot of particular groups of 'low life' – as in Captain Francis Grose's *A Classical Dictionary of the Vulgar Tongue* (1785), later revised by Pierce Egan. We can think of these compilations as early kinds of sociology, often involving extensive contact between authors and informers. They embody a process of 'scientific' enlightenment

which sits alongside other more luridly revealing genres: certain types of popular fiction, such as the picaresque novel of the eighteenth century or the realist melodramas of Victor Hugo and Charles Dickens; criminal biographies, 'rogue literature' and police memoirs; insights into life 'behind the scenes' (e.g. Sue 1842–43) and descriptions of exhilarating 'descents' into subcultural realms, such as Egan's best-selling *Life in London* (1812).

The use of the category 'underworld' to signify subcultural life is probably also quite modern, associated in particular with a way of imagining organized criminal activity in the United States (see Goldin *et al.*, 1950; also Partridge 1949). It has been used retrospectively, however: there are numerous studies of Victorian, Elizabethan and even medieval subcultural life which align various social groups – vagabonds, idlers, prostitutes, homosexuals, thieves, criminals, certain kinds of labourers – together under this heading (e.g. Chesney 1970; McCall 1979; Salgado 1984). We tend to associate the 'underworld' most of all with the rise of the metropolis in the early and mid-nineteenth century, however. The relationship between non-respectable and respectable classes in cities was often a cause for concern. Segregation ran the risk of allowing underworlds to develop unhindered. But the closeness of non-respectable and respectable classes to each other was also worrying: proximity seemed to go hand in hand with promiscuity, for example. One result of this concern was that various kinds of 'low life' received attention from an increasingly disciplined set of institutions – some of which were coercive (the nineteenth century saw the development of an effective civil police force), others of which emphasized reform as a way of assimilating or 'recovering' the disenfranchised. They each worked to produce their own 'sociologies' of subcultural life, mapping the culture, language and movement of those social groups Karl Marx had designated as the *lumpenproletariat* – people in the 'lower orders' of society who were designated as non-revolutionary because they were not aligned to the working class. Their potential 'threat' to society, in other words, was not produced through class-based organization in the workplace; rather, it was tied more to what might happen while they were *not* at work.

In the mid-nineteenth century, the connection between an ideology of social reform and a form of sociological description is best

illustrated in the work of Henry Mayhew. Mayhew's interviews with the 'street folk' and criminal classes of London for the *Morning Chronicle* in the 1840s and 1850s – work which was gathered together in his massive *London Labour and the London Poor* (1851–61) – is the best early modern example of what Andrew Tolson, in his contribution to this Part, calls the 'sociological gaze'. Mayhew characterized these people as 'wandering tribes', appropriating a discrimination drawn in anthropology at this time between settled or 'civilized' people and nomadic or 'uncivilized' people which is still very much in use in popular designations of subcultures today (e.g. as 'urban primitives' or 'new age travellers'). Nomadism became the definitive feature of these social groups, rather than, say, their ability (imagined or otherwise) to deceive or swindle. Indeed, although Mayhew observed that they could sometimes be 'slippery' or prone to exaggeration, he praised the honesty of his many informants, as if they always willingly assisted in the production of a 'truth' about themselves – which journalism could then bring to light.

In this Part, we present four contemporary extracts which either assess much earlier kinds of subcultural analysis, or attempt themselves to reconstruct subcultural activity from the past. Andrew Tolson's chapter on Henry Mayhew looks at what was at stake in this Victorian ethnographer's encounters with the *lumpenproletariat*. Influenced by Michel Foucault, Tolson suggests that a process of 'subjectification' is put to work, whereby the interviewee (the 'watercress girl', for example) is both allowed a subjectivity and positioned in such a way that she is subject *to* the interviewer – who locates her in a larger narrative of enlightenment which remains more or less undisturbed by her even as it makes her 'visible'. Geoffrey Pearson's genealogy of the 'hooligan', by contrast, endows this figure with a far greater ability to disturb: it is surely significant in this respect that the exemplary figures Tolson takes from Mayhew are both female, while for Pearson all 'hooligans' are young men.

Pearson shows that 'moral panics' over unruly youth, of the kind traced by Stanley Cohen (1972), are not a recent phenomenon. He traces the 'hooligan' (the word may originally have derived from the name of an Irish immigrant family) back to the 1890s – also reminding us that the association of youth and fashion was by no means a post-war development. The 'hooligan' mobilized

an extensive and often hysterical media response which aligned itself with the law and 'public opinion'. Thus, as with many unruly subcultures, the impact of the 'hooligan' is more symbolic than real, generating a range of responses and representations in various arenas which then gather their own momentum. Also, class is recovered here as a definitive characteristic: the 'hooligan' is a slum-dweller, a working-class boy who – especially when out of work – is 'trouble'. The association of hooliganism and the working class is long-standing; for a rather different historical account of male gangs and street violence, involving upper-class 'rakes' in the eighteenth century, see Allen (1933) and Statt (1995).

Pearson's account of the 'hooligan' relies mainly on newspaper reports of events at the time, quoting from them extensively. Because of this method of 'media analysis', he tends to reproduce the hooligan as an 'object' which is always in the process of being *described* – and always in receipt of moral judgements. Jeffrey Weeks' examination of male homosexual prostitution at the turn of the century draws on a wider range of sources, however, including literary descriptions and autobiographies. In this account, subcultural identity becomes less generic, less able to be neatly categorized. The study looks in particular at participants' self-definition in relation to the subculture, something Pearson could not have done given his dependence upon 'objectifying' reportage. For Weeks, self-definition is a complicated issue since many men engaged in (sometimes quite elaborate) transactions for homosexual sex only casually and may not have thought of themselves as 'prostitutes', or even as 'homosexuals' at all. On the other hand, clients and contacts sometimes developed long-lasting relationships. For Pearson, the hooligan is positioned or fixed through journalistic description, police reports and moral outrage. For Weeks, however, the male prostitute is more mobile and 'ambivalent', much less circumscribed by class boundaries or location, for example. In this sense, his extract compares with Laud Humphreys' study of men's involvement in the 'tearoom trade' (see Chapter 25), as well as Albert J. Reiss's (1961) famous article, 'The social integration of queers and peers', which Weeks mentions.

Tolson, Weeks and Pearson look at how subcultures in the late nineteenth century are discursively constructed as 'other', in order

to be regulated or reformed. Peter Stallybrass and Allon White, on the other hand, stress the dominant order's dependency upon a construction of 'otherness' in order to create *itself*. That dependency is registered through an almost contradictory mixture of repulsion and fascination. To account for this, Stallybrass and White turn to the concept of *carnival*, as developed, influentially, by Mikhail Bakhtin (1968). Like spectacular subcultures, carnival involves the flamboyant elaboration of the body, transforming the world through inversion (where high culture becomes low culture, where the serious becomes the comic, etc.). This can obviously have disruptive effects. Indeed, by turning to Bakhtin, more so than, say, Foucault, Stallybrass and White produce a more enabling, creative account of 'symbolic' resistance – comparing very much to the 'semiotic guerilla warfare' described in Hebdige's earlier work (1979). In the process, however, they tend to reproduce the kind of conceptual problems we see with some Birmingham Centre's analysts, notably, the reduction of carnival to a single effect. Moreover, the authors are ambivalently located in relation to their account of dominant culture: although they are by no means repelled by what they describe, they continue through the very *act* of description to register the carnivalesque as a source of fascination. In this respect, their account is typical of subcultural analysis, which in fact requires an anthropological fascination with 'otherness' in order to proceed. The work of contemporary social historians, sociologists and semioticians thus remains very much bound up in the processes of enlightenment noted earlier in this introduction, rendering subcultures 'visible' through a form of analysis which – although it may wish otherwise – can never be entirely free from what Tolson calls 'subjectification'. Indeed, in Tolson's account Henry Mayhew emerges as a kind of contemporary in this respect, bringing together a number of disciplinary procedures to produce a 'modern technique' for representing subcultural life. But how *does* a modern researcher produce activated subjects out of discursive formations (legal, journalistic, moral, literary, 'sociological', and so on) to which subcultures have already been subjected? It is here, in the excavation of subcultures-in-history, that the issue of an appropriate discourse – an appropriately 'positioned' way of describing subcultures – becomes particularly apparent.

Jeffrey Weeks

INVERTS, PERVERTS, AND MARY-ANNES [1981]

The problem

IT IS SIGNIFICANT that writings on male prostitution began to emerge simultaneously with the notion of 'homosexuals' being an identifiable breed of persons with special needs, passions, and lusts. The early studies of male prostitution by F. Carlier, head of the morals police in Paris in the 1860s, were also the first major quantitative studies of homosexuality. Havelock Ellis, Iwan Bloch, Magnus Hirschfeld, and Sigmund Freud also commented on the prevalence of homosexual prostitution. 'Xavier Mayne,' who wrote on the homosexual subculture in the early part of this century, suggested that male was no less frequent than female prostitution in major European cities. In 1948, Alfred Kinsey noted that male prostitutes were not far inferior in number to females. In the 1960s, D. J. West suggested that homosexual males' 'inclination to such an outlet with prostitutes' was greater than that of heterosexual males, who usually were married and consequently had less pressing sexual urges as well as less time or opportunity to consort with prostitutes [West 1968: 127].

But, although the existence of male prostitution is mentioned frequently, it has been studied less often. . . . This neglect is unfortunate. The subject should not be regarded as marginal. A study of homosexual prostitution could illuminate the changing images of homosexuality and its legal and social regulation, as well as the variability of sexual identities in our social history and their relationship to wider social structures. . . .

Much recent work has stressed the vital importance of distinguishing among behavior, role, and identity in any sociological or historical approach

to the subject of homosexuality. Cross-cultural studies, as well as studies of schoolboy sex play, prison homosexuality, and sex in public places, show that homosexual behavior does not give rise automatically, or even necessarily, to a homosexual identity. Homosexual roles and identities are historically constructed. Even if the homosexual 'orientation' were given in a fixed minority of the population, as some . . . writers suggest, the social definitions and the subjective meaning given to the orientation can vary enormously. The mass of typologies and categorizations in the works of Krafft-Ebing, Albert Moll, Havelock Ellis, Magnus Hirschfeld, and others at the beginning of the century was an early attempt to grapple with this fact. Historians and social scientists alike have failed to fit everyone who behaves in a homosexual manner within a definition of 'the homosexual' as a unitary type. Even those categorized as 'homosexuals' often have had great difficulty in accepting the label.

If this is the case for the clients of male prostitutes (the 'steamers' or 'punters,' 'swells' or 'swanks'), how much more true is it for the prostitute himself who must confront two stigmatized identities – that of the homosexual and that of the prostitute? There is no legitimizing ideology for homosexual prostitution similar to that which condones heterosexual prostitution even when condemning the female prostitute. A number of studies have suggested that many males who prostitute themselves regard themselves as heterosexual and devise complex strategies to neutralize the significance of their behavior [e.g. Reiss 1961]. Our knowledge of this phenomenon is speculative, however, limited to particular classes of people, such as 'delinquents,' and we do not know how attitudes change historically or in a particular lifetime. More generally, there is the problem of what constitutes an act of prostitution. One of Oscar Wilde's pickups in the 1890s, Charlie Parker, who eventually gave evidence against him, commented: 'I don't suppose boys are different to girls in taking presents from them who are fond of them' [Hyde 1962: 172]. On a superficial level this is true, but the association with a stigmatized sexual activity has shaped profoundly the contours of male prostitution. These deserve serious examination.

This [chapter] does not pretend to be an exhaustive study of the patterns of male prostitution. The necessary detailed empirical research still has to be done. Rather, the intention is to examine some of the practical and theoretical problems attendant upon this research and to make specific reference to evidence from the late nineteenth and early twentieth centuries. There are three broad areas of concern. First, we must pay closer attention than hitherto to the specific social circumstances that shaped concepts of, and attitudes toward, homosexuality. Second, the close, indeed symbiotic, relationship between forms of prostitution and the homosexual subcultures has to be recognized and analyzed. Third, the nature of the prostitution itself, the self-concepts it led to, the 'way of life' it projected, and its differences from female prostitution must be articulated and theorized.

The social and legal context

Certain types of subcultural formations associated with homosexual activity have existed in Britain for centuries, at the courts of certain monarchs (where the royal 'favorite' can be seen as analogous to the 'courtesan'), in the theatrical profession from the sixteenth century, or in developing urban centers, such as London and Bristol, from the seventeenth century. Forms of prostitution undoubtedly existed within these subcultures and became more complex as the subculture expanded in the nineteenth century. Well into the present century the lineaments of the subcultures were much less well defined in Britain, even in London, than in such places as Paris and Berlin, and as a result the evidence of prostitution is less concrete. Different legal practices and moral traditions have had highly significant effects. In Britain, in contrast to France, homosexual behavior *per se* (not just prostitution) was regarded as a major social problem. Contemporary foreign observers had no doubt that male prostitution was as rife in England as elsewhere, but its visibility was minimal. Much of our evidence for British prostitution is consequently sporadic, often the result of zealous public morality drives or of spectacular scandals. . . .

It is striking that as late as 1871 concepts of both homosexuality and male prostitution were extremely undeveloped in the Metropolitan Police and in high medical and legal circles. Neither was there any comprehensive law relating to male homosexuality before 1885. Prior to that date, the only relevant law was that concerning buggery, dating from the 1530s, and notionally carrying the maximum of a death sentence until 1861. Other male homosexual acts generally were subsumed under the heading of conspiracy to commit the major offense. Proof was notoriously difficult to obtain, however, and it was ostensibly to make proof, and therefore conviction, easier that Henry Labouchère introduced his famous amendment to the Criminal Law Amendment Act of 1885. Labouchère claimed, though the substantiating evidence for this appears no longer to exist, that it was a communication from W. T. Stead about homosexual prostitution in London that prompted him to act. The amendment defined 'acts of gross indecency' between two men whether in *public* or *private* as 'misdemeanors,' punishable by up to two years of hard labor. This in effect made all male homosexual acts and all homosexual 'procuring' illegal.

The 1898 Vagrancy Act further affected homosexual activities by enacting that any male person who knowingly lived wholly or in part on the earnings of female prostitutes, or who solicited or importuned for immoral purposes, was to be deemed a rogue and a vagabond under the terms of the Vagrancy Acts. The latter clauses were applied almost invariably to homosexual offenses. By a further Criminal Law Amendment Act ('The White Slave Trade Act') in 1912, the sentence was set at six months' imprisonment, with flogging for a second offense, *on summary jurisdiction* (that is, without a jury trial), a clause which, as G. B. Shaw put it, 'is the final triumph of the vice

it pretends to repress' [cited in Gibson 1978: 164]. It is not entirely clear why the soliciting clauses were in practice confined exclusively to men meeting each other for homosexual purposes. The Royal Commission on the Duties of the Metropolitan Police noted in 1908 that there was nothing in the Act to prevent the clauses being applied to men soliciting women for immoral purposes, but in fact they never were, nor have the activities of men who solicit women for acts of prostitution ever been illegal. The 1928 Street Offences Committee recommended that no change take place in these provisions.

Although obviously less severe than a death sentence or life imprisonment for buggery, the new clauses were all-embracing and more effectively applied. They had specific effects on the relationship between male prostitution and homosexuality. *All* male homosexual activities were illegal between 1885 and 1967, and this fact largely shaped the nature of the homosexual underworld in the period 'between the Acts.' In particular it shaped the relationship between those who defined themselves as 'homosexual' and those who prostituted themselves; for instance, it increased the likelihood of blackmail and violence. It also affected the nature of the prostitution itself, certainly making it less public and less sharply defined. As observers noted at the time, the male prostitute had the professional disadvantage of being obliged to avoid the open publicity of solicitation available to female prostitutes. This had important consequences.

In terms of social obloquy, all homosexual males as a class were equated with female prostitutes. It is striking that all the major enactments concerning male homosexuality were drawn from Acts designed to control female prostitution (1885, 1898, 1912). The juncture of the two concerns was maintained as late as the 1950s, when a Department Committee (the 'Wolfenden Committee') was established to investigate both.

After the repeal of the Contagious Diseases Acts in the 1880s, female prostitution was subject to a peculiar 'compromise' that sought neither outright repression nor formal state regulation. Prostitution was frowned upon, and the female prostitute was an outcast increasingly defined as a member of a separate caste of women, but prostitution was 'tolerated' as fulfilling a necessary social need. Beyond this was the distinction, which social purity campaigns sought to emphasize, between the sphere of public decency and that of private behavior. There were periods, particularly in the early decade of the twentieth century, when the advocates of social purity did reach toward straightforward repression, but by and large the compromise held.

On a formal level, the compromise never applied to male homosexuality. Even the sodomy provisions were applied to private as well as public behavior, and after 1885 the situation was even more explicit. In practice, of course, enforcement varied between different police areas, depending on local police chiefs, the power of watch committees, and, over time, on the general social climate and the effectiveness of social purity campaigns. There were also difficulties in the legal situation. Juries often refused to

convict under the 1885 Act, and police often preferred not to prosecute if 'public decency' were reasonably maintained. Even after 1885, the government's legal officers preferred caution. In 1889, the Director of Public Prosecutions noted 'the expediency of not giving unnecessary publicity' to cases of gross indecency. At the same time, he felt that much could be said for allowing 'private persons – being full grown men – to indulge their unnatural tastes in private.'

When the law was applied, however, it was applied with rigor, particularly against males who importuned. Figures are difficult to come by, for until 1954 statistics for prosecution of male solicitation were always published with those for men living off immoral earnings, but one observer has suggested that the law was the cause of even greater misery than the 1885 Act [Schofield 1965]. It was enforced through summary jurisdiction, and, compared to the forty-shilling fine imposed on female prostitutes before 1959, the maximum sentence of six months' imprisonment and the associated stigmatization ground hard on homosexual males.

Given the social restrictions on forms of sexual contact, the demand for special services, and, in the case of homosexuality, the continuing difficulties of leading an openly homosexual life, there is undoubtedly at all times a market for prostitution. Given the legal situation since the end of the nineteenth century and the simultaneous refinement of hostile social norms, homosexual activity was potentially very dangerous for both partners and carried with it not only public disgrace but the possibility of a prison sentence. This also fed into the market for prostitution and dictated much of the furtiveness, guilt, and anxiety that was a characteristic of the homosexual way of life. . . .

The homosexual subculture

A sexual subculture can fulfill a number of complementary functions: alleviating isolation and guilt, schooling members in manners and mores, teaching and affirming identities. The most basic purpose of the homosexual subculture in the nineteenth and early twentieth centuries, however, was to provide ways to meet sexual partners. Until comparatively recently, very few people found it either possible or desirable to incorporate sexual mores, social activities, and public identity into a full-time homosexual 'way of life.' Perhaps the only people who lived wholly in the subculture were the relatively few 'professionals,' the chief links between the world of aristocratic homosexuality and the metropolitan subculture of Molly houses, pubs, fields, walks, squares, and lavatories.

As early as the 1720s, these meeting places had been known as 'markets,' corresponding to the contemporaneous heterosexual use of the term 'marriage market.' This does not differ much from Evelyn Hooker's description of the modern American gay bar scene as free markets in which the buyer's right to enter is determined solely by having the right attributes and

the ability to pay [Hooker 1967: 174]. By the 1870s, any sort of homosexual transaction, whether or not money was involved, was described as 'trade.' . . . In this world of sexual barter, particularly given the furtiveness, the need for caution, and the great disparities of wealth and social position among the participants, the cash nexus inevitably dominated.

Despite the wide social range of the subculture, from pauper to peer, it was the ideology of the upper classes that seems to have dominated, probably because there was a much more clearly defined homosexual identity amongst men of the middle and upper middle class and because these men had a greater opportunity, through money and mobility, to make frequent homosexual contacts. A related phenomenon was the widely recognized upper-middle-class fascination with crossing the class divide, fascination that shows a direct continuity between male heterosexual and male homosexual mores. J. A. Symonds might have disapproved of some of his friends' compulsive chasing after working-class contacts, but it was undoubtedly an important component of the subculture. The Post Office messenger boys of the Cleveland Street scandal and the stable lads, newspaper sellers, and bookmakers' clerks in the Wilde trial illustrate a few of the many sections of the working class involved. . . .

The desire for a relationship across class lines (the product, perhaps, of a feeling that sex could not be spontaneous or 'natural' within the framework of one's own class) interacted with a desire for a relationship with a 'man,' a real man, a heterosexual. E. M. Forster wanted 'to love a strong young man of the lower classes and be loved by him' and finally developed an ambiguous relationship with a policeman. Edward Carpenter proclaimed his love for the poor and uneducated in obviously erotic tones: 'The thick-thighed, hot, coarse-fleshed young bricklayer with the strip around his waist.' J. R. Ackerley sometimes felt that 'the Ideal friend . . . should have been an animal man . . . the perfect human male body always at one's service through the devotion of a faithful and uncritical beast' [Forster 1975: 16; d'Arch Smith 1970: 192; Ackerley 1966: 218].

There are very complex patterns recurring here. On the one hand was a form of sexual colonialism, a view of the lower classes as a source of 'trade.' On the other were an often sentimental rejection of one's own class values and a belief in reconciliation through sexual contact. As J. A. Symonds put it, 'The blending of Social Strata in masculine love seems to me one of its most pronounced and socially hopeful features' [Scheuller and Peters 1969: 3: 808]. With this went a common belief that the working class and the Guardsmen (notorious from the eighteenth century and throughout Europe for their easy prostitution) were indifferent to homosexual behavior. One regular customer of the Guardsmen observed: 'Young, they were normal, they were working class, they were drilled to obedience' [Ackerley 1966: 135]. They also were widely available: 'The skeptic has only to walk around London, around any English garrison centre, to stroll around Portsmouth, Aldershot, Southampton, Woolwich, large cities of North Britain or Ireland

to find the soldier prostitute in almost open self-marketing' [Mayne 1908: 220]. With the guards, the money transaction was explicit. In the rarefied atmosphere of the 'Uranian' poets, money would change hands but ideology minimized its significance. The Uranians worshipped youth, spoke of the transience of boyhood, and delighted in breaking class barriers.

These class and gender interactions ('working class' equals 'masculine' equals 'closeness to nature') were to play important roles in the rituals of prostitution, affecting, for instance, the stance adopted by the 'prostitute' and the behaviors he was expected to tolerate.

The nature of prostitution

The exchange of money could create a host of different symbolic meanings for both parties, while the uncertainty of both could make the transaction itself very ambiguous. It was not always easy, for instance, to distinguish among extortion, blackmail, and a begging letter. The giving of gifts could have the same complex inflection. Oscar Wilde's gift to his contacts of a dinner at Kettner's and a silver cigarette box (varying in cost from £1 to £5) could be interpreted either as payment for services about to be rendered or as tokens of friendship. A working-class man like George Merrill, Edward Carpenter's long-time companion, was able to recount quite unself-consciously his liaison in the 1880s with an Italian count who gave him presents, flowers, neckties, handkerchiefs, and money, which Merrill usually sent home to his mother. In this sort of situation, the significance attached to the transaction could be quite complex, with the money and gifts often playing a secondary role.

Even when the commercial element was quite unambiguous, complex mechanisms could be adopted to mask the exchange. A client easily could adopt a self-saving attitude: 'I seemed always to be pretending . . . that the quid that usually passed between us at once (the boys were always short of cash) was not a *quid pro quo* but a gift' [Ackerley 1966: 215]. Joe Ackerley has told of his nightly search for an ideal comrade and of his numberless pickups (Guardsmen and policemen). He writes, however: 'The taint of prostitution in these proceedings nevertheless displeased me and must, I thought, be disagreeable to the boys themselves . . . I therefore developed mutually self-saving techniques to avoid it, such as standing drinks and giving cash at once, without any suggestive conversation, leaving the boy free to return home with me if he wished, out of sexual desire or gratitude, for he was pretty sure to know what I was after' [ibid., 136]. . . .

In a historical survey it is often very difficult to determine which actions are purely instrumental and which are affective. It is easier to describe the motivations and fantasies of the clients than to delineate the experiences and beliefs of those who prostituted themselves. Late-nineteenth-century theorists of the etiology of homosexuality looked to masturbation, bad

parentage, congenital degeneracy, or corruption. A consensus developed among sexologists that, whatever one's moral views of homosexual behavior, there were essentially two types to distinguish: those who were inherently, perhaps congenitally, homosexual, 'the inverts'; and those who behaved in a homosexual way from lust, 'the perverts.' Thoinot noted that 'male prostitution finds as clients, on the one hand, *true uranists*, or the *passionates* as they are called in the language of the French police, and, on the other hand, libertines, old or young, disgusted with normal relations and impotent towards women' [Thoinot and Weysse 1911: 346]. This was an important distinction because it colored a great deal of public reaction. The Director of Public Prosecutions, reflecting on the affair of the Cleveland Street brothel in 1889, wrote that it was a duty 'to enforce the law and protect the children of respectable parents taken into the service of the public . . . from being made the victims of the unnatural lusts of full-grown men.' The notion of the upper class corrupting the working class into vice is repeated in Labouchère's description of the boys named in the Cleveland Street affair as being 'more sinned against than sinning.' The constable in charge of the boys came to the conclusion that 'they were ignorant of the crimes they committed with other persons' [Hyde 1976: 28]. The merging of homosexuality with the class question was recurrent in the press during the Cleveland Street scandal and continued through the 1950s.

Alongside this view, and to some extent contradicting it, was the theory that the prostitute exhibited a characteristic predisposition toward corruption and sexual degeneracy, a characteristic sign of which was effeminacy. It is true that throughout Europe, from the eighteenth century on, those who prostituted themselves often displayed stereotyped 'effeminate' characteristics and adopted female names, but it is wrong to assume that male prostitutes were drawn from any particular type of person predisposed toward prostitution. Effeminate behavior can be as much an adopted role as inherent, and, as we have seen, the homosexual subculture stressed the desire for 'manly' men. In fact, a variety of factors drew people into prostitution.

Writing of Berlin in the 1920s, Werner Picton mentions two prostitute populations: an 'outer' ring that fluctuated in numbers and composition and was caused by unemployment and want, and 'the inner and more stable nucleus of this variable and non-coherent body . . . less driven by want or unemployment than by other circumstances, such as psychopathy, hysteria, mental instability, sexual curiosity, love of adventure and longing for luxuries' [Picton 1931: 90]. Some of these categories ('psychopathy,' 'hysteria,' 'mental instability') conform to the view that prostitutes were 'degenerate' or had been pushed into prostitution by emotional inadequacy or sex-role confusion. The other categories, however, suggest what appears to have been commonly the case: that the men had experienced a general and characteristic 'drift into deviancy' (described as a 'sliding down') that had varying, and certainly not predetermined, effects on their self-concepts and identities.

'Drift' has been identified as characteristic for both female and male prostitution, with 'situational and cognitive' processes tending to be the dominant influences [Davis 1971: 297]. Whereas with female prostitution frequent sexual relations with men can lead to a woman's decision that her future transactions will be for money, the pattern is significantly different for male prostitutes. Here the dominant pattern seems to be one of chance contacts, accidental learning, or association with a subculture (such as that of the Guards) with a tradition of casual prostitution.

Youthful sex play frequently led to casual prostitution. . . . [Another] route . . . was through a world symbiotic with homosexuality, such as the Guards. . . . Sometimes a propensity for leading an explicitly homosexual life, a particular skill for learning the ways of the subculture, support from other prostitutes or homosexual men, or the willingness to recognize himself as a prostitute would turn a man to 'professionalization,' but 'professionals' were very much in minority among Guards men and nonmilitary youths alike.

The records of professional prostitutes are rare, which give a particular interest to *The Sins of the Cities of the Plain* (1881), the life story of Jack Saul (a historical character who later – in 1890 – gave evidence in the Euston libel case as part of the Cleveland Street brothel scandal). A choice piece of homosexual pornography, the book is purportedly Saul's autobiography and, despite its presumably fictionalized account, gives vivid insights into male prostitution. In the libel trial, Saul asserted proudly that he was still a 'professional Maryanne': 'I have lost my character and cannot get on otherwise. I occasionally do odd jobs for different gay people.' These odd jobs, as he made clear in his cross-examination, were house cleaning for women on the beat, suggesting a commitment to a career as a professional, the ghettoization that could result from this choice of career, and its vagaries as age diminished charm. The life was no by means completely harsh, however, as this dialogue shows:

> And were you hunted by the police?
>
> No, they have never interfered. They have always been kind to me.
>
> Do you mean they have deliberately shut their eyes to your infamous practices?
>
> They have had to shut their eyes to more than me.

The likes of Saul were few, however. His purported memoirs note that 'We do not know of many professional male sodomites in London' [Saul 1881: 2: 109].

The life

The professional organization that has been characteristic of female prostitution never arose within homosexual prostitution. Even in the larger European cities, such as Berlin and Paris, the 'boy-houses' were rare, though numerous places of rendezvous existed under the guise of literary clubs and athletic societies. In England, the Criminal Law Amendment Act of 1885 had been directed partly against brothels but was ambiguous in its application to homosexual haunts. The Director of Public Prosecutions complained to the Home Secretary in 1889 that he was 'quite aware that although it is a legal offence to keep a bawdy house – it is not a legal offence to keep or frequent a house kept for the accommodation of sodomites.' Labouchère claimed in 1889 to have in his possession 'a short list of houses, some in fashionable parts of the city, which are every inch as bad; if not worse,' but nothing seems to have followed from his threat to reveal them.

Such establishments had dozens of clients. Soldiers, MPs, peers, members of the National Liberal Club, a tailor, and a banker all frequented 19 Cleveland Street, for example. The boys were paid 'sometimes a sovereign, sometimes half a sovereign; 4/- was kept by themselves and the rest given to Hammond or kept by Newlove.' Jack Saul lived with Hammond for a while, and both earned their livelihood as 'sodomites:' 'I used to give him all the money I earned, oftentimes as much as £8 or £9 a week.'

Hammond lived a fully professional life as a 'madame,' married a French prostitute, Madame Carolino, and lived with her thereafter. He also had a 'spooney-boy,' one Frank Hewitt, who used to 'go with him' and procure boys for the establishment.

Even within this twilight world there were subtle distinctions. Saul complained to Hammond of his allowing boys 'in good position in the Post Office to be in the house while I had to walk the streets for what is in my face and what is shame.' Professional Mary-Annes with neatly printed calling cards like gentlemen's visiting cards were scarcely the norm. More common contact would be the likes of Mrs. Truman, who received orders for Guardsmen at her tobacconist shop near the Albany Street barracks in Regents Park. The Guards themselves also might take up an informal pimping role. One customer tells how he met one Guard several times: '. . . and then he said, well do you want anybody else . . . I can bring them along . . . So I said . . . have you got one with ginger hair . . . And then of course (he) procured me – oh – dozens. Dozens of them.'

There were also widespread informal coteries. Oscar Wilde made many of his contacts through his friend, Alfred Taylor, who lived in exotically furnished rooms in Little College Street near Westminster Abbey. The son of a wealthy cocoa manufacturer, Taylor became notorious for introducing young men to older men and as the center of a 'sort of secret society' [Hyde 1962: 60, 125, 162]. . . .

In London, however, most contacts would be made in the normal picking-up places and at 'watering holes' (public lavatories), the occasional 'mixed' pubs, the rave private clubs, the public walks, and parks. Some places, such as Piccadilly Circus, were notorious, and here the more 'obvious' or blatant young prostitutes might gather. Some of the more obviously effeminate prostitutes wore women's clothing and powder, but most young men were more discreet. Discretion was indeed the hallmark of homosexual prostitution.

Definitions of homosexuality

Picton's survey of 154 Berlin prostitutes revealed that approximately two-thirds spent between one and five years on the game, having started between the ages of seventeen and twenty-five. This admittedly very rough survey suggests that most men had quit the trade by their mid-twenties. The routes out were numerous, from becoming a 'kept boy' (either in a long-term relationship or in successive relationships), to integration into the homosexual world, or to a return to heterosexual family life. At least two of the boys involved in the Cleveland Street affair founded 'modest but upwardly mobile family dynasties' (Chester et al. 1977: 225) and lost all contact with the world of prostitution. The participants' self-concepts, as homosexual and as prostitute, were likely to determine how long a man remained a 'Mary-Anne.' Historically specific definitions are all-important here.

A human identity is not a given in any particular historical situation but is the product of different social interactions, of the play of power, and sometimes of random choices. The homosexual orientation may be strong, but its significance depends on a host of factors that change over time.

For example, in the 1890s Jack Saul regarded himself as a 'sodomite,' a term not necessarily coextensive with 'homosexual.' In his memoirs he reports that one of his clients was 'not an actual sodomite. He likes to play with you and then "spend" on your belly.' The distinction would be strange to the present century, but in 1890 the term 'sodomite' was related to an act; 'homosexual' implied a type of person, a member of a 'species.'

An individual who could identify as 'a homosexual' was more likely to be absorbed into the homosexual subcultures, to develop friendship networks and relationships (whether as 'kept boy' or as partner), and to use his homosexuality as a way to rise in the world. One respondent, who took pride in having been 'passed from hand to mouth' in the 1930s, moved from a poor working-class background in the North of England to the center of the metropolitan subculture as the companion of a gregarious member of the London intelligentsia: 'I was never kept in the background . . . he wore me like a badge.' The respondent was fully prepared to adapt himself to his new ambience, adopting a new accent and learning to 'entertain': 'You weren't just taken . . . out because you were pretty . . . you weren't taken out the second time because you were just a pretty face.' Such a person is more likely to

be able to cope with a wider range of sexual demands than one who is anxious to preserve a male and heterosexual self-image. . . . Reiss's [1961] classic study of delinquent youth has shown the sort of norms that may govern casual transactions. First, because the boy must make it clear to his partner and to himself that the relationship is solely a way to make money, the boy must not actively pursue his own sexual gratification. Secondly, the sexual transaction must be limited to specific sexual acts (for example, no buggery) or sexual roles ('active'). Thirdly, the participants must remain emotionally neutral for fear of endangering the basis for the contract. Violence can be avoided as long as these rules are maintained but could erupt if they were threatened.

A variety of self-definitions is possible: as homosexual, as homosexual prostitute, as a prostitute but not homosexual, or as neither homosexual nor prostitute. One respondent, who admitted to having been maintained by a friend, was highly indignant at having been described in a book as a 'well-known male prostitute.' Another interviewee, who as a Guardsman had had a large number of homosexual experiences, and had followed these by a life-long friendship with a homosexual man, was careful to explain that he was neither homosexual nor bisexual, but a 'real' man who did it for the money.

The general impression that emerges from the nineteenth and early twentieth century is that the more casual the prostitution, the less likely was the individual to identify himself as homosexual or as a prostitute in the absence of any firm public categorization. Conversely, the longer the person stayed in the homosexual subculture the more likely he was to accept its values and to identify himself as primarily homosexual. In each case the important factor was not inherent propensity but the degree to which the man's activities and self-concepts were supported by the subculture. Prostitution flourished among the Guardsmen and among the messenger boys of Cleveland Street precisely because the ideology operating in both networks acted to sustain the men's existing self-images as heterosexual 'trade.'

Conclusion

It is difficult to define homosexual prostitution, dependent as it is on changing definitions of homosexuality and shifts in the homosexual subculture. Clearly, there was a vast difference between the casual act of prostitution in a public lavatory for a small amount of money and the conscious adaptation of homosexuality as a 'way of life.' The experiences are related, however, not so much by the fact of the sexual acts as by the experience of homosexuality as a stigmatized category. This opprobrium demanded strategies of adaptation and techniques of avoidance. In this regard, male prostitution was strikingly different from the experience of female prostitution, for once the barrier to the initial act of prostitution has been crossed, the female prostitute could enter a world of values that served to support the choices she

made and to reinforce the identity she was adopting. There was no comparable subculture of homosexual prostitution. For a young man who prostituted himself, the choices were effectively between retaining a conventional self-concept (and hence adopting neutralizing techniques to explain his behavior to himself and to others) or accepting a homosexual identity with all its attendant dangers in a hostile society.

Once the choice had been made, however, full integration into the nonprofessional homosexual subculture could take place. In this there were advantages unavailable to the female prostitute. The asymmetry of relationship between the female prostitute and the client was permanent, and the stigma of prostitution was lasting. In the homosexual world the patterns and relationships were inevitably more ambiguous. The 'deviance' of prostitution was supplementary to the 'deviance' of homosexuality.

Geoffrey Pearson

VICTORIAN BOYS, WE ARE HERE! [1983]

T HE WORD 'HOOLIGAN' made an abrupt entrance into common English usage, as a term to describe gangs of rowdy youths, during the hot summer of 1898. 'Hooligans' and 'Hooliganism' were thrust into the head-lines in the wake of a turbulent August Bank Holiday celebration in London which had resulted in unusually large numbers of people being brought before the courts for disorderly behaviour, drunkenness, assaults on police, street robberies and fighting. One of the more alarming aspects of these Bank Holiday disturbances was that they highlighted fierce traditions of resistance to the police in working-class neighbourhoods, so that not uncommonly policemen attempting to make street arrests would be set upon by large crowds – sometimes numbering two or three hundred people – shouting 'Rescue! Rescue!' and 'Boot him!'

At first it was not entirely clear where the word 'Hooligan' had sprung from – and it remains unclear to this day – or exactly what it meant, other than some kind of novel reference to street violence and ruffianism. It seems most likely, however, that it was a word like 'Teddy Boy' or 'Mod' or 'Skinhead' which, coming out of the popular culture of working-class London, had been adopted by youths in some localities in order to describe them-selves and what they took for their common identity. A Music Hall song from the 1890s, introduced by the Irish comedians O'Connor and Brady, had probably first popularised the word:

Oh, the Hooligans! Oh, the Hooligans!
 Always on the riot,
 Cannot keep them quiet,

> Oh, the Hooligans! Oh, the Hooligans!
>> They are the boys
>> To make a noise
>> In our backyard.

How it came to be adopted by, and applied to, youthful street gangs is something of a mystery. But whatever its humble origins, when the new word was picked up by the newspapers in August 1898 it was quickly transformed into a term of more general notoriety, so that 'Hooligan' and 'Hooliganism' became the controlling words to describe troublesome youths who had previously been known more loosely as 'street arabs', 'ruffians' or 'roughs'. And once they were christened, as we might expect, the 'Hooligans' were understood as an entirely unprecedented and 'un-British' phenomenon: indeed, we must allow that it was most ingenious of late Victorian England to disown the British Hooligan by giving him an 'Irish' name.

In other ways, too, the phenomenon was located within a scale of alien values and temperaments, thus stamping it as foreign and 'un-English'. When *The Times* (17 August 1898) first turned its attention to the August disorders, describing them as 'something like organised terrorism in the streets', it struck the key-note in an editorial on 'The Weather and the Streets':

> It is curious that simultaneously with reports of excessive heat should come the record of an unusual number of crimes of lawless violence . . . Does the great heat fire the blood of the London rough or street arab, with an effect analogous to that of a southern climate upon the hot-blooded Italian or Provencal? . . . Or is the connexion between heat and lawlessness not so much one of cause and effect as coincident circumstances – heat generating thirst, and thirst a too frequent consumption of fiery liquor unsuitable for a tropical climate?

A couple of years later, asking 'What are we to do with the "Hooligan"? Who or what is responsible for his growth?' *The Times* (30 October 1900) would harp on the same theme, announcing that 'Every week some incident shows that certain parts of London are more perilous for the peaceable wayfarer than the remote districts of Calabria, Sicily, or Greece, once the classic haunts of brigands'. In the heat of the immediate events of 1898, however, while denouncing the excessive leniency of the law, *The Times* (17 August 1898) had boomed out an even more momentous possibility that 'un-English' violence might have to be curbed by un-English methods:

> In Continental cities, or in the free Republic of America, they have very little scruple about calling out troops and shooting down organised disturbances of the peace . . . But if we do not adopt continental methods of dealing with street lawlessness . . . if we do not wish our

police to be formidable as an armed force, we must not grudge an increase in their numbers.

Headline news

If the 'Hooligans' were regarded as an un-English phenomenon, they were also understood as an entirely unprecedented development and respectable England felt itself to have been suddenly engulfed in a new rush of crime. A pattern of trouble quickly came to be associated with the street gangs. The Hooligans fought pitched battles among themselves – Chelsea Boys against Fulham Boys, or Chapel Street against Margaret Street – and they were said to take great pride in their famous victories over rival neighbourhoods. The Hooligans were also said to hunt in cowardly packs, however, and news reports regularly featured them smashing up coffee-stalls and public houses, assaulting staff in pubs and cheap eating-houses, robbing and assaulting old ladies, attacking foreigners such as Italian ice-cream vendors or 'Froggy' cafe owners, and setting upon policemen in the streets with savage howls of 'Boot 'em!' Because, if the supposedly traditional habit of respect for the law was not much in evidence here, then frequent headlines such as ' "Boot 'em" at Waterloo', 'They Play Football with a Man' and 'Kick a Man like a Football' serve to remind us that the English 'fair play' tradition of fighting with the fists – and not with the feet – had also gone into eclipse. In South London, for example, it was said that the gangs wore 'boots toe-plated with iron, and calculated to kill easily'.

Not everyone was agreed, however, that the Hooligans represented a novel development, nor about the scale of the outrages. When a question was asked in Parliament in August 1898, the Home Secretary's department was 'not satisfied that there was any such insecurity as was alleged'. Mr Patrick McIntyre, a South London publican and former New Scotland Yard detective who wrote a regular crime column for the *South London Chronicle*, was another who cast doubt on the Hooligan panic, accusing newspapers of being in their 'silly season' and of taking the matter up merely 'as a suitable and sensational means of filling their columns at the present moment'. Thomas Holmes, the distinguished London Police Court Missioner, agreed and described the affair as 'press-manufactured Hooliganism'. Nor was there much evidence of concern in the correspondence columns of *The Times* – that bush-telegraph of respectable opinion – which were absorbed with more pressing matters such as the scarcity of swallows in England that summer. There were even back-biting accusations among some sections of the press that their competitors were indulging in 'silly season' sensationalism.

Further controversy was prompted by a manifesto issued from the self-styled South London Ratepayers' Association which called for a 'display of fearless strength' by local people, advising that 'a discriminating application of the "cat-o'-nine-tails" will soon sweep away this reign of terror'. There

were any number of flogging editorials in response to the Hooligan outrages
– in *The Daily Mail*, for example, the *News of the World* and even the medical
journal *The Lancet* – and the Ratepayers' Association manifesto was widely
reported in the press as evidence of public support for flogging. But *The Sun*
[3 August 1898] thought that 'the meeting was a bogus one, if it was held
at all', further alleging that this clandestine organisation (which said that it
had met in secrecy because it feared Hooligan reprisals) was a put-up job by
someone in the pay of *The Daily Telegraph*. Amidst such confusion as this,
however, the press was more commonly inclined to shout down the leniency
of magistrates, or 'this appalling apathy on the part of the police', because
if in some quarters the press were accused of bulling up the Hooligan affair,
elsewhere the police were said to be playing it down.

More radical sections of the press placed further doubts against the feeling
that there had been a sudden eruption of street violence. Describing London as
'a city of illusions, subject every now and then to a series of harsh awakenings',
The Echo (11 August 1898) believed that while some of the stories were
undoubtedly exaggerated they nevertheless served a purpose: 'We steadily shut
our eyes to the submerged lawlessness of less fortunate districts until a series of
Whitechapel outrages, or Hooligan exploits, make us not only aware of what is
going on, but actually afraid of our lives'. In a similar line of argument, *Reynold's
Newspaper* (14 August 1898) viewed the Hooligan panic as an indictment of the
hypocrisy of a civilisation that took 'so painful an interest about moral hand-
kerchiefs and hymn books for the barbarians of the wild Soudan' while turning
a blind eye towards 'the far wilder barbarians they may find within a few paces
from their own street-doors'. For the socialist press, in any event, the burning
issue in working-class London during the hot summer of 1898 was not the
Hooligans, but the water shortage which was reaching crisis proportions. With
a fine eye for a 'newsworthy item', the *News of the World* (28 August 1898)
blamed youths for wasting water by larking about with street taps, but the
socialist press saw a more permanent difficulty in the negligence of the private
water companies. Indeed, urging people not to pay their rates to the East End
Water Company, *Reynold's Newspaper* (28 August 1898) conjured with the
circumstances under which, in the struggle against what it called 'Horrible
London', even the horrible Hooligans might lend a hand:

> If they would only attack the present cabinet, we should feel inclined
> to be a little more lenient . . . if Chamberlain, or Chaplin, or Balfour,
> or Goschen were knocked down in the Old Kent Road by a Hooligan
> gang, we should soon hear of some scheme to improve London life.

The Clarion, with its devilish sense of fun, would no doubt have agreed.
Although it hardly seemed to notice the Hooligan affair, and its only imme-
diate response [20 August 1898] was a front-page poem 'Hot Weather and
Crime' which can only have been intended as a slap in the face for *The Times*
leader on 'The Weather and the Streets':

HOT WEATHER AND CRIME

> I scarcely can fink
> That 'ot weather and drink
> Is sole causes of murders and priggins,
> And I'll tell you my views
> (Which the same mayn't be news)
> Wot I frequent relates to Bill 'Iggins
>
> I'm one of the group
> Of pore cowves in the soup
> I knows wot the treadmill and clink is;
> I ain't quite t-t,
> For I'm boozed frequentlee
> So I knows wot the evils of drink is
>
> Us chaps drink a lot
> When the weather is 'ot –
> That statement I will not deny it;
> But it ought to be told
> That we drinks when it's cold
> And whene'er we can steal it or buy it
>
> We lives and we dies
> In foul dens and styes
> Without any fun or hexcitement
> Like sparrers in cages –
> 'Ard work and low wages –
> Till we figgers vithin a hindictment.

The message was clear enough: if it took crime and violence to attract the attention of the mighty to the lives of the poor, then so be it. It was not that ruffianism was thought to be funny, but the radical and socialist press wished to place a different emphasis on the criminal question which took full account of the social and material circumstances of working-class life. What they could find room to laugh at, however, was the way in which respectable England could ignore the realities of slum life for so many years, while showering the Empire with the benefits of Christianity and imperial wars, and then get itself into a respectable lather in such a short time about a few broken heads among rough lads.

A tour of the quiet streets

Before looking in more detail at who the 'Hooligans' were, and in order to place the controversies that surrounded them in perspective, it will be helpful to make an imaginative effort to reconstruct the kind of social world in which

the original 'Hooligans' moved. On so many occasions, the way in which 'Hooliganism' was greeted implied a sudden, alien interruption of a peaceful and well-ordered way of life. But what did this way of life look like at street level? And what were the habits of the Hooligans' gentle neighbours and families and friends? A brief tour of inspection of London's streets at the time that the Hooligans were publicly christened will help us to see something of what these quiet streets were made of.

In some localities trouble had undoubtedly been expected at the time of the Bank Holiday, and it was reported in Lambeth police court that plainclothes men had been specially stationed 'for the purpose of dealing with cases of street ruffianism'. The newspapers were particularly impressed by the appearance in Marylebone court of 88 people in a single day, 70 of whom were charged with disorderliness of some sort, although *The Times* (16 August 1898) observed that 'the majority of cases were of a very ordinary kind'. The troubled signs of this 'ordinary' street life were very much in evidence, however, and press reports were packed with accounts of assaults and robberies, 'dipping' gangs at race meetings, gang fights and stabbings, vandalism, punch-ups and 'free fights'. The 'free fight' must have been sometimes quite an occasion: a Bank Holiday bust-up in the Old Kent Road, for example, consumed the energies of 200 people.

In the foreground of the Bank Holiday outrages were the 'Hooligan' gangs themselves. In one disturbance that received wide publicity, a policeman had stumbled across a gang of about twenty youths, said to be known as the 'Chelsea Boys' who 'armed with sticks and stones were fighting a contingent of similar young ruffians from Battersea' at Cheyne Walk by the river. A 17-year-old paper-stainer, James Irons, was brought before the magistrate – described by the police as a ring-leader and by his mother as a 'good boy' – where it was said he had 'used disgusting language, and discharged a number of stones larger than walnuts from a powerful catapult'. Charged with disorderly conduct and with discharging stones from a catapult to the common danger, he was found to have four previous convictions against him for gambling, disorderly behaviour and stone-throwing. Regretting 'that he had no power to send him to prison without the option of a fine', the magistrate imposed a fine of 40 shillings (probably amounting to more than a month's wages) or twenty-one days' hard labour.

Another typical Bank Holiday incident of the kind that brought such infamy to the Hooligans involved four young men, described as 'larrikins' aged between 17 and 20 years, who were charged with damaging an ice-cream feeder belonging to an Italian ice-cream vendor, and assaults on police and a park-keeper. There had been an argument and the youths had overturned the ice-cream barrow, and after a chase there was a scuffle with the police. Identified by police witnesses as the 'Somers Town Boys', the two youths charged with assault received six weeks' hard labour and a month's hard labour. According to one witness, as they ran away across a park they were heard to shout, 'Look out for the Hooligan gang'.

After these incidents the look-outs were certainly posted in the press, and the word 'Hooligan' began to be used widely, if at first somewhat indiscriminately. More to the point, if 'Hooliganism' was an entirely novel outburst as was usually supposed, then a tropical growth of gang life must have sprouted overnight. From August onwards the newspapers were overflowing with the exploits of the various gangs in London: the 'Lion Boys' from the Lion and Lamb in Clerkenwell; the so-called 'Clerkenwell "Pistol Gang" '; the 'Girdle Gang' which took its name from Thomas, alias 'Tuxy', Girdle; the 'Somers Town Gang' who were said to be the pests of Euston Road and Gower Street; the 'Pinus Gang' who infested Leather Lane and Clerkenwell; the 'Drury Lane Boys'; the notorious 'Waterloo Road Gang'; the 'Pickett Gang'; 'McNab's'; the 'Rest Gang'; the 'Fulham Boys'; the 'Chelsea Boys'; the 'Velvet Cap Gang'; the 'Plaid-Cap Brigade' from Poplar; the gangs who romped around King Street and Great Church Lane in Hammersmith and who were said to be 'not "Hooligans" but worse'; and may others, including a band of youngsters who had adopted the dare-devil title of the 'Dick Turpin Gang'.

At first the press were inclined to brand anything as the newly named 'Hooliganism'. When the Girdle Gang appeared in court for an assault on a man whom, it was said, they had kicked 'like a football', *The Daily Graphic* described them as 'a gang of the Hooligan type'. Mr Girdle's solicitor, on the other hand, complained that 'the "Girdle Gang" did not really exist, except in the imagination of a "needy paragraphist" '. But although 'Tuxy' Girdle may not have been a youthful Hooligan, it did emerge that he had been running whores and he received a substantial sentence of penal servitude for the assault on the man whom the gang had suspected of being a police spy.

The new word quickly settled down, however, as a regular pattern began to emerge in the trouble associated with the London Hooligans. They cluttered up the streets in noisy gatherings, swearing at passers-by, spitting on them, and sometimes assaulting and robbing them. *The Daily Graphic* (15 August 1898) reported the antics of the 'Velvet Cap Gang' from Battersea: 'Some dozen boys, all armed with sticks and belts, wearing velvet caps, and known as the "Velvet Cap Gang", walking along. . . pushing people off the pavement, knocking at shop doors, and using filthy language'. And then, a few days later there was a similar story from another part of London: 'A gang of roughs, who were parading the roadway, shouting obscene language, playing mouth organs, and pushing respectable people down. The young ruffians were all armed with thick leather belts, on which there were heavy brass buckles' (*The Daily Graphic*, 25 August 1898).

There were innumerable accounts of a similar character, describing 'larking' in the streets. The frequent reports of people being hustled, or pushed off the pavement, probably derived from the practice among working-class youths known as 'holding the street'. This violent ritual of territorial supremacy, as described by Walter Besant in 1901, sounds remarkably like

the modern practice at football grounds of 'holding the End': 'The boys gather together and hold the street; if anyone ventures to pass through it they rush upon him, knock him down, and kick him savagely about the head; they rob him as well. . . the boys regard holding the street with pride' [Besant 1901: 177]. . . .

Dressed to kill: the fashionable hooligan

One thing that quickly became apparent in the aftermath of the Bank Holiday affair was that the Hooligans all looked alike. But it was not in the way that the poor had always looked alike – it was not, that is, because they were shabby, shoeless and grubby as moles – but because the gangs wished to look alike, and had adopted a uniform dress-style. 'Look at them well', said *The Daily Graphic* (16 November 1900) when the dust had settled a little and the danger could be looked in the face, 'They are the genuine article – real Hooligans':

> The boys affect a kind of uniform. No hat, collar, or tie is to be seen. All of them have a peculiar muffler twisted around the neck, a cap set rakishly forward, well over the eyes, and trousers very tight at the knee and very loose at the foot. The most characteristic part of their uniform is the substantial leather belt heavily mounted with metal. It is not ornamental, but then it is not intended for ornament.

There can be no doubt that the buckle-end of a belt could be a formidable weapon, but in fact the belts were often pricked out in fancy patterns or embellished with metal studs in much the same way that modern motor-bike boys adorn their jackets with stud designs. Newspaper cartoons depicting the London Hooligans added another small detail of fashion: the bell-bottom trousers were shown with a tasty buttoned vent in the side. Local gangs also improvised local variations in style – velvet caps in Battersea or plaid caps in Poplar, for example, as a badge of identity – and there were certainly trend-setters among the Hooligans. One way-out youngster appeared in court following the Bank Holiday disturbances with his hair dressed in what sounds remarkably like the 'Mohican cut' which had a brief moment of popularity among more outlandish Teds in the 1950s and which has reappeared with the Punks. 'The appearance of the witness caused some amusement in court', observed *The Daily Graphic* (6 August 1898). 'His hair had been clipped as closely as possible to the scalp, with the exception of a small patch on the crown of the head, which was pulled down over the forehead to form a fringe'. It was probably no more than a daring exaggeration of the 'donkey-fringe' style which was the standard Hooligan haircut. But here was a youth so far ahead of his time that if he had turned up on the streets of London sixty or seventy years later, he would still have been recognised as a sure sign of an alarmingly unrivalled degeneration among the young.

What is perhaps even more remarkable, given post-war wisdom about the unparalleled nature of post-war youth cultures, is that the youth style that came to be associated with the London Hooligans was a nationwide phenomenon. In Manchester, the gangs were known as 'Scuttlers' – a word which went back to the 1880s – and their gang fights and rowdyism as 'Scuttling' or 'Scuttles'. Local gangs such as the infamous 'Forty Row' from Ancoats, the 'Bengal Tiger' from Bengal Street, the 'Bungall Boys' from Fairfield Street, 'Alum Street' or 'Hope Street' from Salford would do battle for neighbourhood supremacy, sometimes retiring to parks or open crofts for these engagements. One fight reported from Newton Heath in 1890 involved a pitched battle in Holland Street of between 500 and 600 youths, and shopkeepers were obliged to barricade themselves behind shutters to prevent damage and looting when a 'Scuttle' was announced. The Scuttlers also jealously guarded the territorial seclusion of their local beer-house – known as the 'blood-house' or 'blood-tub' – and they were such a force in Lancashire that the public authorities made various petitions to the Home Secretary for sterner repressive measures to put them down. Charles Russell described the Scuttler's appearance:

> You knew him by his dress. A loose white scarf would adorn his throat; his hair was plastered down upon his forehead; he wore a peaked cap rather over one eye; his trousers were of fustian, and cut – like a sailor's – with 'bell bottoms.' This fashion of the trousers was the most distinctive feature of his attire and make-up.
>
> [Russell 1905: 51]

In 1890 Alex Devine, Police Court Missioner to Lads in Salford, had described how the 'professional scuttler' was attired in a 'puncher's cap', 'narrow-go-wides' trousers, and narrow-toed brass-tipped clogs. Devine was particularly taken by the ornamental designs on the Scuttlers' belts, produced with metal pins: 'These designs include figures of serpents, a heart pierced with an arrow (this appears to be a favourite design), Prince of Wales' feathers, clogs, animals, stars, etc., and often either the name of the wearer of the belt or that of some woman' [Devine 1890: 7].

Early in the new century the Manchester and Salford Scuttlers were succeeded by the new generation calling themselves 'Ikes' or 'Ikey Lads', a name which may have had something to do with distinctive dress-styles made by Jewish tailor shops. Robert Roberts recalls that the Scuttler's girl friend also had her own style of dress – 'clogs and shawl and a skirt with vertical stripes' [Roberts 1973: 155] – although I know of no other references to female attire, and as usual within these hooligan preoccupations attention was rootedly fixed on the boys.

In Birmingham, corner boys and street gangs were known as 'Peaky Blinders', or less commonly as 'Sloggers', and they too had adopted the standard uniform of bell-bottom trousers, neck scarf, heavy belt, peaked cap and

short cropped hair with a 'donkey fringe'. There was even a character in *Comic Cuts* in the 1890s, a youthful prowler named 'Area Sneaker' – and what a pseudonym that is to conjure with from the supposedly untroubled late Victorian era – who reflected the fashion. Young Area Sneaker was the faithful companion of 'Chokee Bill', himself a prototypical comic-strip crook with swag-bag and cosh, and in their weekly scrapes with the law – personified for *Comic Cuts* readers in the ineffectual shape of 'Fairyfoot the Fat Cop' – he was quite recognisably dressed in a budding Hooligan's attire: bell-bottoms, flowing neck-scarf, cap set at jaunty angle, and boots two sizes too big.

The Scuttlers, Peaky Blinders and Area Sneaker himself all pre-dated the christening of the Hooligans, and in other towns there were similar gangs – the 'Grey Mare Boys' from Bradford or the 'High Rip' gangs of Liverpool – and London also had an earlier tradition of gangs such as the 'Tiger Bay', the 'Monkey's Parade' gang at Bow, or the 'Bowry Boys' of Poplar who were already in evidence in the late 1880s. It is possible that some elements of the Hooligan dress-style were derived from the clothes favoured by coster-mongers in mid-nineteenth-century London. Henry Mayhew described how the costers preferred tasty cable-cord trousers, 'made to fit tightly at the knee and swell gradually until they reached the boot, which they nearly cover'. The bell-bottom trousers, together with the King's Man neck-scarf, a small cloth cap and well-kept boots were the main features of the coster style. The boots, Mayhew tells us, were an object of special price, often 'tastily ornamented . . . with a heart or thistle, surrounded by a wreath of roses, worked below the instep' [Mayhew 1968: 1: 51]. We should remember from Mayhew's account that the boots also came in handy for kicking policeman and other traditional foes of the costers. Arthur Morrison's subsequent descriptions in *A Child of the Jago* (1896) of the clothes in fashion among the cosh-carrying denizens of the slums again resembled Mayhew's costers. However, his version of the Jago people buying their 'kicksies', 'benjies', and 'daisies' – that is, their trousers, coats and boots ('daisy-roots') – from a local 'ikey' tailor may simply have been borrowed from Mayhew. In any case, Morrison's narrative of violent neighbourhood rivalries, robberies and attacks on policemen – 'for kicking practice' as he put it – did not need to be either borrowed or invented in late nineteenth-century London.

The 'Hooligan' fashion also bore a resemblance to that of their Australian cousins, the 'Larrikins', who wore a uniform of high-heeled boots, bell-bottom trousers, neck scarves, heavy belts and snazzy hats. Before the word 'Hooligan' had fully established itself in England, young ruffians were often described as youths of the 'Larrikin type' or as 'London Larrikins'. The Larrikins, who can be traced back to 1870 in Australia, were also organised into local gangs or 'pushes', and even allowing for exaggeration and over-involvement (we need not readily accept, for example, that they gorged themselves on raw meat or rigged elections by terrorising voters, as was sometimes alleged) their behaviour was unbeatably appalling. Assaults on

policemen, Chinese and defenceless women, window-smashing, gang fights, breaking up holiday resorts, and gobbing on the steps of churches and also the worshippers assembled there, were among their least terrible adventures. A verse from the *Sydney Bulletin* in 1882 summed up a familiar controversy about how to interpret a phenomenon such as Larrikinism:

> The larrikin is all a myth,
> An ideal scourge, forsooth;
> And all that we are troubled with,
> 'Exuberance of Youth!'

> Thus David, oracle sublime
> Propounds a wondrous truth;
> This is the hoodlum's simple crime,
> 'Exuberance of Youth!'

> That blacken'd eye, that broken beak,
> That swiftly loosened tooth,
> These little trifles but bespeak,
> 'Exuberance of Youth!'

> That language foul which shocks the ear
> Of some fair modest Ruth –
> What of it? Don't you know it's mere
> 'Exuberance of Youth!'

We must leave the question of the origins of the 'Hooligan' style where it rests, however, as simply one murky aspect of an otherwise murky affair. It is difficult enough, in any case, to unravel how contemporary youth styles such as 'Skinheads' or 'Teddy Boys' originated and were disseminated, and we can recognise the Hooligan uniform for what it was: a simple adaptation of the clothing available to young working-class people in order to create an easily reproducible style. The Scuttlers in their clogs and fustian would no doubt look somewhat dowdy alongside modern youth in their crease-proof, sta-prest trousers, their swinging blue jeans, or their body-hugging drip-dry shirts. But the rudimentary nature of the 'Hooligan' style was not in any essential way different from the later youth fashions in the 'affluent' post-war era where the kids would put together their 'unprecedented' styles out of various permutations of available scraps such as tight trousers, baggy trousers, long hair, short hair, no hair, jeans, braces, T-shirts, string ties, broad ties, no ties, heavy boots, narrow winkle-picker shoes, long jackets, short jackets, etc. With the Punks, of course, this jumble-sale of fashion would arrive at a self-consciously surreal conclusion in that the scraps were now held together, literally and very visibly, with safety-pins. As for the Hooligans, newspaper cartoonists' sketches of their dress permutation depicted a more sharply defined style than anything that can be discerned by modern eyes from surviving photographs of the period – although that should

not surprise us, because it is also a characteristic feature of the emphasis given to the cut of clothes within 'high' fashion sketches. The essential point, moreover, is that the 'Hooligan' style was recognisable to their contemporaries (and presumably to themselves) as a distinctive mode of attire, thus helping to form the feeling which was struggling to give itself expression in other areas, that too much freedom and affluence had been given to the working class at the turn of the century. The evening promenade, ridiculed as the 'monkey walk', when young people gathered together in their finery hoping to 'click' with a member of the opposite sex was another sure sign of the unchaperoned freedoms of the new street people who would inherit the new century. Not only could slum youth sometimes afford to pay their fines when they appeared in the police courts – a shocking enough fact to their respectable contemporaries that was often remarked upon – but they could even pick and choose what clothes they would wear when they came to court. Where would it all end?

Peter Stallybrass and Allon White

FROM CARNIVAL TO TRANSGRESSION [1986]

> The new historian, the genealogist, will know what to make of this
> masquerade. He will not be too serious to enjoy it; on the contrary,
> he will push the masquerade to its limits and prepare the great carnival
> of time where masks are constantly reappearing. Genealogy is history
> in the form of a concerted carnival.
>
> (Foucault 1977: 160–1)

> In the world of carnival the awareness of the people's immortality is
> combined with the realisation that established authority and truth are
> relative.
>
> (Bakhtin 1968: 10)

THERE IS NOW A LARGE and increasing body of writing which sees
carnival not simply as a ritual feature of European culture but as a *mode
of understanding*, a positivity, a cultural analytic. How is it that a festive ritual
now virtually eliminated from most of the popular culture of Europe has
gained such prominence as an epistemological category? Is there a connec-
tion between the fact of its elimination as a physical practice and its
self-conscious emergence in the artistic and academic discourses of our time?
For both Michel Foucault in the passage cited above and for Mikhail Bakhtin
in his seminal study *Rabelais and his World*, the Nietzschean study of history
leads to the ideal of carnival. Everywhere in literary and cultural studies
today we see carnival emerging as a model, as an ideal and as an analytic
category in a way that, at first sight, seems puzzling.

Undoubtedly it was the translation of Mikhail Bakhtin's monumental study of Rabelais and the carnivalesque which initially catalysed the interest of Western scholars (albeit slowly – the book was only translated into English in 1968) around the notion of carnival, marking it out as a site of special interest for the analysis of literature and symbolic practices. . . . *Rabelais and his World* is ostensibly a scholarly study of Rabelais's popular sources in carnivalesque folk-culture which shows how indebted Rabelais is to the popular, non-literary, 'low' folk humour of the French Renaissance. His intention in the study was self-consciously iconoclastic:

> No dogma, no authoritarianism, no narrow-minded seriousness can coexist with Rabelaisian images; these images are opposed to all that is finished and polished, to all pomposity, to every ready-made solution in the sphere of thought and world outlook.
>
> (Bakhtin 1968: 3)

Naturally this reading of Rabelais has not gone unchallenged by conventionally learned scholars. . . . But although Bakhtin is deeply concerned to elucidate the sources of Rabelais's work, the main importance of his study is its broad development of the 'carnivalesque' into a potent, populist, critical inversion of *all* official words and hierarchies in a way that has implications far beyond the specific realm of Rabelais studies. Carnival, for Bakhtin, is both a populist utopian vision of the world seen from below and a festive critique, through the inversion of hierarchy, of the 'high' culture:

> As opposed to the official feast, one might say that carnival celebrates temporary liberation from the prevailing truth of the established order; it marks the suspension of all hierarchical rank, privileges, norms and prohibitions. Carnival was the true feast of time, the feast of becoming, change and renewal. It was hostile to all that was immortalized and complete.
>
> (Bakhtin 1968: 109)

Carnival in its widest, most general sense embraced ritual spectacles such as fairs, popular feasts and wakes, processions and competitions, . . . comic shows, mummery and dancing, open-air amusement with costumes and masks, giants, dwarfs, monsters, trained animals and so forth; it included comic verbal compositions (oral and written) such as parodies, travesties and vulgar farce; and it included various genres of 'Billingsgate,' by which Bakhtin designated curses, oaths, slang, humour, popular tricks and jokes, scatological forms, in fact all the 'low' and 'dirty' sorts of folk humour. Carnival is presented by Bakhtin as a world of topsy-turvy, heteroglot exuberance, of ceaseless overrunning and excess where all is mixed, hybrid, ritually degraded and defiled.

If there is a principle to this hotch-potch it resides in the spirit of carnivalesque laughter itself, to which Bakhtin ascribes great importance:

Let us say a few initial words about the complex nature of carnival-esque laughter. It is, first of all, a festive laughter. Therefore it is not an individual reaction to some isolated 'comic' event. Carnival laughter is the laughter of all the people. Second, it is universal in scope; it is directed at all and everyone, including the carnival's participants. The entire world is seen in its droll aspect, in its gay relativity. Third, this laughter is ambivalent: it is gay, triumphant, and at the same time mocking, deriding. It asserts and denies, it buries and revives. Such is the laughter of the carnival.

(Bakhtin 1968: 11–12)

Carnival laughter, then, has a vulgar, 'earthy' quality to it. With its oaths and profanities, its abusive language and its mocking words it was profoundly ambivalent. Whilst it humiliated and mortified it also revived and renewed. For Bakhtin ritual defilements went along with reinvigoration such that 'it was precisely this ambivalent abuse which determined the genre of speech in carnival intercourse' (Bakhtin 1968: 16). The 'coarse' and familiar speech of the fair and the marketplace provided a complex vital repertoire of speech patterns excluded from official discourse which could be used for parody, subversive humour and inversion. 'Laughter degrades and materialises' (Bakhtin 1968: 20). Fundamental to the corporeal, collective nature of carnival laughter is what Bakhtin terms 'grotesque realism.' Grotesque realism uses the material body – flesh conceptualized as corpulent excess – to represent cosmic, social, topographical and linguistic elements of the world. Thus already in Bakhtin there is the germinal notion of *transcodings* and *displacements* effected between the high/low image of the physical body and other social domains. Grotesque realism images the human body as multiple, bulging, over- or under-sized, protuberant and incomplete. The openings and orifices of this carnival body are emphasized, not its closure and finish. It is an image of impure corporeal bulk with its orifices (mouth, flared nostrils, anus) yawning wide and its lower regions (belly, legs, feet, buttocks and genitals) given priority over its upper regions (head, 'spirit,' reason).

Bakhtin is self-consciously utopian and lyrical about carnival and grotesque realism. . . . Others, however, have been more critical. Whilst almost every reader of Bakhtin admires his comprehensive and engaged generosity, his combination of festive populism and deep learning, and whilst few would deny the immediate appeal and the vitality of the notion of carnival, various writers have been sceptical of Bakhtin's overall project.

Terry Eagleton thinks that the weakness of Bakhtin's positive embrace of carnival is transparent:

Indeed carnival is so vivaciously celebrated that the necessary political criticism is almost too obvious to make. Carnival, after all, is a *licensed* affair in every sense, a permissible rupture of hegemony, a contained

popular blow-off as disturbing and relatively ineffectual as a revolutionary work of art. As Shakespeare's Olivia remarks, there is no slander in an allowed fool.

(Eagleton 1981: 148)

Most politically thoughtful commentators wonder, like Eagleton, whether the 'licensed release' of carnival is not simply a form of social control of the low by the high and therefore serves the interests of that very official culture which it apparently opposes. The classic formulation of this is in Max Gluckman's now somewhat dated *Order and Rebellion in Tribal Africa* (1963) and *Custom and Conflict* (1956), in which he asserted that while these 'rites of reversal obviously include a protest against the established order . . . they are intended to preserve and strengthen the established order' (Gluckman 1956: 109). Roger Sales amplifies both on this process of containment and its ambivalence:

There were two reasons why the fizzy, dizzy carnival spirit did not necessarily undermine authority. First of all, it was licensed or sanctioned by the authorities themselves. They removed the stopper to stop the bottle being smashed altogether. The release of emotions and grievances made them easier to police in the long term. Second, although the world might appear to be turned upside down during the carnival season, the fact that Kings and Queens were chosen and crowned actually reaffirmed the *status quo*. Carnival was, however, Janus-faced. Falstaff is both the merry old mimic of Eastcheap and the old corruptible who tries to undermine the authority, or rule, of the Lord Chief Justice. The carnival spirit, in early-nineteenth century England as well as in sixteenth-century France, could therefore be a vehicle for social protest and the method for disciplining that protest.

(Sales 1983: 169)

. . . It actually makes little sense to fight out the issue of whether or not carnivals are *intrinsically* radical or conservative, for to do so automatically involves the false essentializing of carnivalesque transgression (White 1982: 60). The most that can be said in the abstract is that for long periods carnival may be a stable and cyclical ritual with no noticeable politically transformative effects but that, given the presence of sharpened political antagonism, it may often act as *catalyst* and *site of actual and symbolic struggle*.

It is in fact striking how frequently violent social clashes apparently 'coincided' with carnival. Le Roy Ladurie's *Carnival in Romans* (1981) has popularized one such incident when the 1580 festival at Romans in eastern France was turned into armed conflict and massacre. Other social historians have documented similar occurrences (Davis 1975; Burke 1978; Thompson 1972). However, to call it a 'coincidence' of social revolt and carnival is

deeply misleading for, as Peter Burke has pointed out, it was only in the late eighteenth and early nineteenth centuries – and then only in certain areas – that one can reasonably talk of popular politics *dissociated* from the carnivalesque at all. John Brewer has described English politics in the eighteenth century as 'essentially a calendrical market,' by which he designates a deliberate commingling of holiday and political events (in this case organized by the Hanoverians for conservative motives):

> Far too little attention had [sic] been paid to the emergence during the eighteenth century of a Hanoverian political calendar, designed to inculcate loyal values in the populace, and to emphasize and encourage the growth of a national political consensus. Nearly every English market town celebrated the dates which were considered the important political landmarks of the nation. They can be found in most almanacs of the period, barely distinguishable from the time-honoured dates of May Day, Plough Monday, Twelfth Night, Shrove Tuesday and the like . . . In the early eighteenth century, these dates, together with the occasion of the Pretender's birthday, were occasions of conflict. The year of the Jacobite Rebellion, 1715, was especially contentious, with Hanoverian Mug House clubs fighting it out in the streets with Jacobite apprentices and artisans. On October 30, frequenters of a Jacobite alehouse on Ludgate Hill were beaten up by members of the Loyal Society who were celebrating the birthday of the Prince of Wales, the future George II. A Jacobite attempt to burn William III in effigy on November 4 was thwarted by the same Whig clubmen who the next day tried to cremate effigies of the Pretender and his supporters. On 17 November further clashes ensued and two Jacobites were shot dead.
>
> (Brewer *et al.* 1983: 247)

Again this should act as a warning against the current tendency to essentialize carnival *and* politics. On the one hand carnival was a specific calendrical ritual: carnival proper, for instance, occurred around February each year, ineluctably followed by Lenten fasting and abstinence bound tightly to laws, structures and institutions which had briefly been denied during its reign. On the other hand carnival also refers to a mobile set of symbolic practices, images and discourses which were employed throughout social revolts and conflicts before the nineteenth century.

Recent work in the social history of carnival reveals its political dimensions to be more complex than either Bakhtin or his detractors might suspect. . . . Carnivals, fairs, popular games and festivals were very swiftly 'politicized' by the very attempts made on the part of local authorities to eliminate them. The dialectic of antagonism frequently *turned* rituals into resistance at the moment of intervention by the higher powers, even when no overt oppositional element had been present before. . . .

297

In his research on the carnivalesque Bakhtin had substantially anticipated by some thirty years main lines of development in symbolic anthropology. In his exploration of the *relational* nature of festivity, its structural inversion of, and ambivalent dependence upon, 'official culture,' Bakhtin set out a model of culture in which a high/low binarism had a fundamental place. Bakhtin's use of carnival centres the concept upon its 'doubleness . . . there is no unofficial expression without a prior official one or its possibility. Hence, in Bakhtin's analysis of carnival, the official and unofficial are locked together' (Wilson 1983: 320). Symbolic polarities of high and low, official and popular, grotesque and classical are mutually constructed and deformed in carnival. Two of the best general synopses of Bakhtin's work correctly perceive this to be the most significant aspect of *Rabelais and his World*. Ivanov (1976) links Bakhtin's discovery of the importance of binary oppositions with the work of Lévi-Strauss:

> the books by Bakhtin and Lévi-Strauss have much in common in their treatment of the functioning of oppositions in the ritual or the carnival which can be traced back historically to ritual performance. For Lévi-Strauss the chief purpose of the ritual and the myth is the discovery of an intermediate link between the members of a binary opposition: a process known as *mediation*. The structural analysis of the ambivalence inherent in the 'marketplace word' and its corresponding imagery led Bakhtin to the conclusion (made independently from and prior to structural mythology) that the 'carnival image strives to embrace and unite in itself both terminal points of the process of becoming or both members of the antitheses: birth–death, youth– age, top–bottom, face–lower bodily stratum, praise–abuse' [Bakhtin 1968: 238]. From this standpoint, Bakhtin scrutinized various forms of inverted relations between top and bottom 'a reversal of the hier- archy of top and bottom' [Bakhtin 1968: 81] which takes place during carnival.
>
> (Ivanov 1976: 35)

The convergence of Bakhtin's thinking and that of current symbolic anthropology is highly significant. . . . We may note, for instance, the simi- larity of Bakhtin's concept of carnivalesque high/low inversion to the concepts developed in *The Reversible World*, a collection of essays on anthropology and literature edited by Barbara Babcock. Although apparently unaware of Bakhtin's study she assembles a range of writing on 'symbolic inversion and cultural negation' which puts carnival into a much wider perspective. She writes:

> 'Symbolic inversion' may be broadly defined as any act of expressive behaviour which inverts, contradicts, abrogates, or in some fashion presents an alternative to commonly held cultural codes, values and

norms be they linguistic, literary or artistic, religious, social and political.

<div align="right">(Babcock 1978: 14)</div>

This is what we refer to . . . as 'transgression' (though there is another, more complex use of the term which arises in connection with extremist practices of modern art and philosophy; these designate not just the infraction of binary structures, but movement into an absolutely negative space *beyond the structure of significance itself*). For the moment it is enough to suggest that, in our view, the current widespread adoption of the idea of carnival as an *analytic* category can only be fruitful if it is displaced into the broader concept of symbolic inversion and transgression.

This is not to deny the usefulness of the carnivalesque as a sort of 'modelling,' at once utopian and counter-hegemonic, whereby it is viewed, in Roberto da Matta's words, as a *privileged locus* of inversion. In his attempt to go beyond Bakhtin's nostalgic and over-optimistic view of carnival, Matta acknowledges the degree to which festivity is licensed release, but he also praises its deep modelling of a different, pleasurable and communal ideal 'of the people,' even if that ideal cannot immediately be acted upon. . . . In this perspective the carnivalesque becomes a resource of action, images and roles which may be invoked both to model and legitimate desire and to 'degrade all that is spiritual and abstract.' 'The cheerful vulgarity of the powerless is used as a weapon against the pretence and hypocrisy of the powerful' (Stamm 1982: 47). In a most engaging description of this utopian/critical role of carnival Stamm continues:

> On the positive side, carnival suggests the joyful affirmation of becoming. It is ecstatic collectivity, the superseding of the individuating principle in what Nietzsche called 'the glowing life of Dionysian revellers' . . . On the negative, critical side, the carnivalesque suggests a demystificatory instrument for everything in the social formation which renders such collectivity difficult of access: class hierarchy, political manipulation, sexual repression, dogmatism and paranoia. Carnival in this sense implies an attitude of creative disrespect, a radical opposition to the illegitimately powerful, to the morose and monological.
>
> <div align="right">(Stamm 1982: 55)</div>

Refreshingly iconoclastic, this nevertheless resolves none of the problems raised so far concerning the politics of carnival: its nostalgia; its uncritical populism (carnival often violently abuses and demonizes *weaker*, not stronger, social groups – women, ethnic and religious minorities, those who 'don't belong' – in a process of *displaced objection*); its failure to do away with the official dominant culture, its licensed complicity.

<div align="right">299</div>

In fact those writers and critics who remain purely within the celebratory terms of Bakhtin's formulation are unable to resolve these key dilemmas. It is only by completely shifting the grounds of the debate, by transforming the 'problematic' of carnival, that these issues can be solved. . . . We have chosen therefore to consider carnival as one instance of a generalized economy of transgression and of the recoding of high/low relations across the whole social structure. The symbolic categories of grotesque realism which Bakhtin located can be rediscovered as a governing dynamic of the body, the household, the city, the nation–state – indeed a vast range of interconnected domains.

Marcel Détienne puts a similar notion most persuasively in *Dionysos Slain*:

> A system of thought . . . is founded on a series of acts of partition whose ambiguity, here as elsewhere, is to open up the terrain of their possible transgression at the very moment when they mark off a limit. To discover the complete horizon of a society's symbolic values, it is also necessary to map out its transgressions, its deviants.
>
> (Détienne 1979: ix)

By tracking the 'grotesque body' and the 'low-Other' through different symbolic domains of bourgeois society since the Renaissance we can attain an unusual perspective upon its inner dynamics, the inner complicity of disgust and desire which fuels its crises of value. For the classificatory body of a culture is always double, always structured in relation to its negation, its inverse. 'All symbolic inversions define a culture's lineaments at the same time as they question the usefulness and the absoluteness of its ordering' (Babcock 1978: 29). Indeed by attending to the low and the marginal we vindicate, on the terrain of European literary and cultural history, the more general anthropological assertion that the process of symbolic inversion,

> far from being a residual category of experience, is its very opposite. What is socially peripheral is often symbolically central, and if we ignore or minimize inversion and other forms of cultural negation, we often fail to understand the dynamics of symbolic processes generally.
>
> (Babcock 1978: 32)

This is a scrupulously accurate and indispensable formulation. The carnival, the circus, the gypsy, the lumpenproletariat, play a symbolic role in bourgeois culture out of all proportion to their actual social importance. The dominant features of the psycho-symbolic domain cannot be mapped one-to-one onto the social formation. Thus 'work,' for example, which occupied such a central place in individual and collective life, is notoriously 'underrepresented' in artistic forms . . . but this should not be ascribed to some wilful act of ideological avoidance. Although work is 'actually central' in the production and reproduction of the whole social ensemble there is no reason,

beyond an irrationally vulgar Marxist one, to suppose that capitalism should be totally different from other societies in locating its most powerful *symbolic* repertoires at borders, margins and edges, rather than at the accepted centres, of the social body. Thus a writer such as Arnold Bennett, committed to a realist and sympathetically accurate account of commercial working life in the industrial Midlands, reaches out to the circus, the Burslem Wakes, a hot-air balloon ascent and a public execution for significant climaxes in the dramatic narrative of *The Old Wives' Tale*. The complex of utilitarianism, industry and calculating parsimony which were fundamental to the English bourgeoisie by the nineteenth century drew its imaginative sustenance from precisely those groups, practices and activities which it was earnestly and relentlessly working to marginalize and destroy. . . .

It is perhaps worth recapitulating the points we have made so far. By focusing upon the 'taboo-laden' overlap between high and low discourse which produces the grotesque, we have tried to effect a transposition of the Bakhtinian conception of the carnivalesque into a framework which makes it analytically powerful in the study of ideological repertoires and cultural practices. If we treat the carnivalesque as an instance of a wider phenomenon of transgression we move beyond Bakhtin's troublesome *folkloric* approach to a political anthropology of *binary extremism* in class society. This transposition not only moves us beyond the rather unproductive debate over whether carnivals are politically progressive or conservative, it reveals that the underlying structural features of carnival operate far beyond the strict confines of popular festivity and are intrinsic to the dialectics of social classification as such. The 'carnivalesque' mediates between a classical/classificatory body and its negations, its Others, what it excludes to create its identity as such. In this process discourses about the body have a privileged role, for transcodings between different levels and sectors of social and psychic reality are effected through the intensifying grid of the body. It is no accident, then, that transgressions and the attempt to control them obsessively return to somatic symbols, for these are ultimate elements of social classification itself.

Andrew Tolson

SOCIAL SURVEILLANCE AND SUBJECTIFICATION

The emergence of 'subculture' in the work of Henry Mayhew[1] [1990]

1. In a short, but very interesting section of his essay on 'youth surveillance and display' [see Chapter 43], Dick Hebdige draws attention to the fact that a history of concern for problems of juvenile delinquency can be traced back at least as far as the mid-nineteenth century (Hebdige 1988: 19–22). Hebdige specifically mentions the work of Henry Mayhew as a 'celebrated' instance of this concern. A man of many parts and several careers, Mayhew was primarily a journalist who began to publish his own survey of urban poverty and conditions of labour in the London *Morning Chronicle* during 1849–50. Subsequently, in his book *London Labour and the London Poor* (1851), Mayhew extended his poverty survey to include details of domestic life, moral attitudes and what today might be defined as aspects of the 'lived culture' of sections of the metropolitan working class. Another commentator on Mayhew, Eileen Yeo, has suggested that this later work, especially its study of costermongers, amounts to a 'full blown cultural study, treating them at length as a group with distinctive social habits.' She argues that Mayhew was groping 'towards the concept of sub-culture which he could not, in the end, successfully formulate' (Thompson and Yeo 1973: 97–98).

It is significant that Yeo and Hebdige have located the discovery of subcultures in this mid-nineteenth-century context. For in one respect, this is radically to question the assumption, in several cultural studies accounts, that the emergence of spectacular urban subcultures is a distinctively post-war phenomenon. It suggests that subcultures are not an effect of the new consumer society, nor are they a symbolic response to the post-war restructuring of working-class communities. However, I also want to suggest that it is possible to develop Hebdige's argument, and to trace the public visibility

of subcultures to the formation of a particular kind of social perspective, a 'sociological gaze,' which begins to emerge in the 1830s and 1840s. In the post-war period, youth subcultures may have *re-emgerged* in their distinctive modern forms; but the conditions and criteria for their recognition seem to have a much more extended history.

For, as Hebdige observes, the conditions within which subcultures first appear as spectacular are themselves related to a variety of strategies for social intervention, in nineteenth-century practices of philanthropy, education and moral reform. The important point here is that an early form of cultural research is developed within what Foucault has defined as the modern approach to 'governmentality' (Foucault 1979b). Mayhew himself was at the liberal, reformist end of the spectrum, but he was nonetheless operating within the 'domain of the social,' which Paul Hirst has characterised as a distinctively new discursive formation, opening up a range of approaches to the classification, supervision and policing of urban populations (Hirst 1981). In this light, subcultures can be regarded as one way in which such populations become socially visible and in terms of which they can be categorised. And hence, this early form of (sub)cultural studies, in its concern for the identification and classification of different urban 'ways of life,' is bound up with the exercise of new forms of social power. . . .

Having mentioned Mayhew's pioneering study of the costermongers, Hebdige goes on to discuss the most novel nineteenth-century technique for 'surveillance and display,' namely, the use of photography. But Mayhew, of course, was not a photographer; rather, his principal method for making his subjects socially visible was the interview, more or less faithfully recorded. On the pages of *London Labour*, and since then in innumerable similar studies, what appears for public examination and scrutiny is the *speech* of working-class people, spoken in very particular and somewhat peculiar circumstances. Looking at some examples from Mayhew's work, I want to make some critical observations about the emergence of the interview as a research technique. In particular, my attention will be focused on the criteria through which working-class people have become visible in interviews, to the extent that particular kinds of social and (sub) cultural *identity* have been attributed to them.

2. . . . According to one historical account of the origins of interviewing, it was in the mid-nineteenth century that the term 'interview' was first defined as a 'special journalistic genre' (Nilsson 1971). Previously it had been used to describe records of meetings or conversations, but now it became a professional technique for journalistic inquiry. . . . However, it is important also to note that in this period techniques of interviewing were not only pioneered by journalists. Simultaneously, in Britain at least, prototypical forms of interviewing were being developed in two emerging fields of social research: (i) in the reports of various parliamentary select committees, factory inspectors etc. into the moral condition of the working class; and (ii) in the

development of new kinds of 'criminological' interest in the reform of 'delinquents.' It was these areas of social research which Mayhew merged and popularised in the 1850s and within which new forms of cultural visibility were constructed.

Mayhew's debt to the first area of social research is well established, [since] it is the focus for Yeo's discussion of his importance as a social investigator. Here, the interview was used as a technique to elicit public testimony, in the course of a formal, quasi-legal practice of cross-examination. However, in the second, 'criminological' context, the interview was developed not so much as a public ritual, but more as an intensive, individualised and private practice of *confession*. Here the institutional prototype was not the formal cross-examination, but rather the ongoing interpersonal relationship between an individual and his/her parish priest. Indeed, in this context, as James Bennett (1981) has shown, it was the clergyman, and specifically, the prison chaplain, who became the first 'oral historian'. . . .

The point here is that Mayhew's methodology seems to develop from several simultaneous sources, through a variety of routes, which are independent of each other, but which overlap to some extent. To adopt another Foucaultian concept, it seems appropriate to recognise that Mayhew was working within a mid-nineteenth-century *discursive formation*, – that is a 'systematic dispersion of statements' (see Cousins and Hussain 1984), which can be located in newspapers, in literary discourse, in official reports and essays. It is the configuration of these various elements in Mayhew's work that makes possible a certain kind of 'subcultural' interest, within the developing context of the 'domain of the social.'

In the end, any search for the 'origins' of the sociological interview is probably fruitless. It is not possible to privilege any one of these various sources (legal interrogation; journalistic 'human interest'; social investigation; 'cell confession') over the others. What we have in Foucaultian terms are various 'surfaces of emergence' for the interview. Of course, it does not diminish the significance of Mayhew's achievement to recognise that it was accomplished on the basis of these prior institutional conditions. There have been, in histories of journalism, protracted debates about which particular journalist can be regarded as the 'inventor' and even as the 'father' of the newspaper interview (see Turnbull 1936). The suggestion that Mayhew was a pioneer of the sociological interview need not take us that far. He was simply in the right place at the right time; but the scope of his achievement is certainly worthy of close examination.

3. For it is under these general conditions that new forms of public statement begin to appear in the mid-nineteenth century. In order to appear in this new context, public statements must follow certain conventions: they must be professionally mediated (by journalists, inspectors, social investigators etc.); but they must also appear in particular, socially recognisable forms. In Mayhew's work, however, such recognisable forms of statement

neither follow a single, standardised protocol, nor are their discursive functions identical. To some extent, as James Bennett has show, Mayhew achieved a certain public recognition for a 'naturalistic' approach to social inquiry, and what came to be known as the 'life history' interview. Similarly, from a more literary standpoint, Anne Humphreys has located Mayhew's achievement 'in the magnification of facts in the life histories he reported,' such that 'each individual grew in stature until he became a full-size human being for the reader' (Humphreys 1977: 61–62). But it is also necessary to observe that in Mayhew's work the interview can serve very different purposes, sometimes on adjacent pages of text; and that for each purpose, a different kind of public speech is relevant. We are, I think, at a stage in the development of social inquiry where the different sociological paradigms have yet to demarcate their methodologies.

For instance, Mayhew begins his investigations in the *Morning Chronicle* series as a political economist conducting a poverty survey. Here, as Eileen Yeo has argued, Mayhew inherited an established discourse of social investigation (Royal Commissions and Select Committees) into the condition of the working class. To be sure, Mayhew not only inherited this discourse but also extended it, conducting 'the first empirical survey into poverty as such' (Thompson and Yeo 1973: 60); developing an original theory of the causes of low wages; and most important, improving the methods of investigation of the survey tradition. But these points do not take Mayhew out of political economy altogether; he does not immediately transcend its discursive protocols, at least as far as the function of the interview is concerned. For political economy is essentially dedicated to statistical calculation: the first purpose of the interview is fact-finding. Mayhew did, from the outset, involve workers themselves in the investigation, but as Yeo has pointed out, it is the *representative* individual who is interviewed:

> Before entering upon my investigations, I consulted several of the most experienced and intelligent workmen, as to the best means of arriving at the correct opinion, respecting the state of the trade. It was agreed among us that first, with regard to an estimate of the amount of wages, I should see a hand employed at each of the different branches of the trade. After this I was taken to a person who was the captain or leading man of the shop; then to one who, in the technicality of the trade, had a 'good chance' of work; and, finally, to one who was only casually employed. It was considered that these classes, taken in connection with the others, would give the public a correct view of the condition, earnings and opinions of the trade.
>
> (Thompson and Yeo 1973: 220)

To this extent then, Mayhew took up the position of an 'official' nineteenth-century social investigator, and he seems to have gone about his business with particular scientific care. It is significant, as Richard Johnson observes,

that it was the evidence of middle-class professionals, and not the working classes themselves, that was routinely sought in the public tribunals and reports of the mid-nineteenth century: it was not until 1887 that three 'representatives of the working classes' appeared in a series of Commissions relating to education (Johnson undated: 4). It would seem then that there were social and political conventions which predetermined who could be counted as a 'representative' individual for official purposes. Perhaps the initial popularity of Mayhew's survey with the workers who participated was related to the fact that it challenged such conventions.

Nevertheless, what the *Morning Chronicle* survey had in common with previous social investigations was that it sought to bring certain facts into the public domain. In this context, as we have suggested, the survey acted as a kind of public tribunal: individuals were recruited as representative witnesses – literally, they made public 'representations' whether it be to a Parliamentary Commission, or in this case, to a newspaper journalist. What the representative witness produces when he or she speaks in these circumstances is counted as 'testimony'; and as such it must exhibit the appropriate epistemological guarantees – either through the social credibility of the witness, or through the consistency of evidence in the face of cross-examination. Social identities are not really *constructed* in this type of interview; rather, they are pre-supposed. They are defined in terms of the individual already possessing a certain role or . . . status which provides a prior qualification from which to speak.

4. However, consider the following [letter from Mayhew, dated 11 December 1849]. It indicates a subtle shift in the focus for Mayhew's inquiries, and another kind of function for the interview:

> to prevent the chance of error . . . I begged to be favoured with such accounts of earnings as would be procured from the operatives. This I thought would place men in a fair condition to judge of the incomings and physical condition of the class, but still I was anxious to arrive at something like a criterion of the intellectual, political, and moral character of the people, and I asked to be allowed an interview with such persons as the parties whom I consulted might consider would fairly represent these peculiar features of their class to the world. The results of my inquiry I shall now proceed to lay before the public.
> (Thompson and Yeo 1973: 221)

It seems to me that there is an ambiguity here in the meaning of the word 'represent,' which is indicative of another kind of 'social inquiry' which is beginning to emerge in Mayhew's work. For when it comes to representing 'the moral character of the people,' an individual does not so much speak by virtue of social status or prior qualification about something of which he or she has knowledge; rather, in this formulation, the individual *is* a

representation – embodying and exhibiting 'the particular features of their class to the world.' It is at this point that the social individual begins to appear in terms which come to be defined as 'cultural,' or perhaps 'subcultural'; and Eileen Yeo argues that this develops more fully in *London Labour*, in Mayhew's second study of the costermongers. But I would suggest that the seeds are sown very early in the *Morning Chronicle* series, alongside his poverty survey.

Crucially, what seems to occupy a pivotal place in the shift from the social survey to the 'cultural' study is the concept of *character*. As used by Mayhew, this is a complex concept with several nineteenth-century connotations – 'intellectual, political and moral,' as the above quotation puts it. In all these contexts, however, the key point is that *character* is the quality which is embodied and exhibited rather than spoken about in interviews; and it is detected in certain *ways* of speaking rather than facts to be reported and verified. The social investigator now looks for *signs* of character in the speech of the interviewee, and the methodological requirement is that people are now interviewed in such a way that they might 'represent' such 'features' in their attitude, demeanour, or manner of speaking.

I have two examples, from *London Labour*, of the way Mayhew's discourse begins to incorporate this new form of cultural interest. The first is his encounter with a representative poor Irishwoman:

> I have before had occasion to remark the aptitude of the poor Irish in the streets of London not so much to lie, which may be too harsh a word when motives and idiosyncrasy are considered, but to exaggerate, and misrepresent, and colour in such a way that the truth becomes a mere incident in the narrative, instead of being the animating principle throughout. I speak here not as regards any direct question or answer on one specific point, but as regards a connected statement. Presuming that a poor Irishwoman, for instance, had saved up a few shillings, very likely for some laudable purpose, and had hidden them about her person, and was asked if she had a farthing in the world, she would reply with a look of most stolid innocence, 'Sorra a fardin, Sir.' This of course is an unmitigated lie. Then ask her *why* she is so poor and what are her hopes for the future, and a very slender substratum of truth will suffice for the putting together of a very ingenious history, if she think the occasion requires it.
>
> (Mayhew 1985: 31)

There are two points which clearly mark the difference between this kind of encounter and the research which Mayhew conducted for his poverty survey. The first point is that there is a level of disingenuity in the way Mayhew conducts this discussion. For he is no longer principally concerned with the real facts about the Irishwoman's poverty: in this context whether she actually has several shillings or a farthing is immaterial. Nor is this a

moment for a true confession and a show of repentance such as the criminological discourse might require. From the perspective which is now in dominance, that is, the interest in social 'character,' Mayhew is much more fascinated with the *way* the Irishwoman speaks, and with the kinds of stories she tells, which now become signs of 'Irishness.'

Possibly, we might say, the interest has shifted from the 'content' to the 'form' of the discourse; but also, in methodological terms, a key shift in the nature of the evidence has occurred. For there is no guarantee that this particular poor Irishwoman is representative of the Irish in general – indeed this seems unlikely. We are simply (as often in *London Labour*) being invited to take Mayhew's word for it. In short, the second methodological point is that the relationship between the cultural generalisation and the evidence cited has become *rhetorical*.

What is constructed in this process is a new kind of social identity which is quite different from the representative witness, and indeed from the penitent individual. I will define this as the 'typical individual': the *type*. That is to say, the emerging sociology of culture in Mayhew's work is no longer simply concerned to deduce, or calculate, or reform – it is concerned to *typify*. Typification does not need to look for representative facts; what it requires are signs, which can be read to support cultural generalisations. In this way a certain kind of interest in language becomes possible – in so far as linguistic differences signify cultural variation (cf. Mayhew's interest in coster-slang, etc.). Other signs of 'culture' which fall within the purview ('gaze') of this discourse are dress, domestic environment, leisure activities (cf. the 'penny gaff') and that nineteenth century favourite, physiognomy.

Again, however, it is important to emphasise that in this transition to the cultural, the criminological focus does not simply disappear. Indeed, it is firmly in place in Mayhew's attitude to the poor Irishwoman, where some sense of 'normal'/'civilised' behaviour is implicated in the discussion from the start. I want to suggest therefore that although, in the shift from individual penitence to cultural typification, the interview becomes a different kind of technique (i.e. it is no longer a confession); nevertheless it borrows something from criminology – a certain stance, a position, perhaps a 'gaze,' which continues to see the interviewee as more or less 'other.' This is the condition in which it is possible to represent 'character,' as defined by its signs or characteristics. But whereas the criminological gaze individualises, and confronts the delinquent with his life history, the cultural gaze collectivises and typifies the individual within a class. In this respect Mayhew's cultural sociology seems to have effected a particular kind of synthesis between the discourses of criminology and political economy which he inherited.

5. The most interesting thing, however, is that individuals do not simply disappear from this culturalist discourse; they are manifestly present in Mayhew's work, but within a further set of discursive conventions:

The little watercress girl who gave me the following statement, although only eight years of age, had entirely lost all her childish ways, and was, indeed, in thoughts and manner, a woman. There was something cruelly pathetic in hearing this infant, so young that her features had scarcely formed themselves, talking of the bitterest struggles of life, with the calm earnestness of one who had endured them all. I did not know how to talk with her. At first I treated her as a child, speaking on childish subjects; so that I might, by being familiar with her, remove all shyness, and get her to narrate her life freely. I asked her about her toys and her games with her companions; but the look of amazement that answered me soon put an end to any attempt at fun on my part.

(Mayhew 1985: 64–65)

Mayhew's vocation as a writer and journalist needs to be taken into account, not simply as a biographical milieu, but also because it constitutes yet another purpose for the interview. For in so far as various criminological and socio-cultural concerns are popularised in Mayhew's journalism, a very interesting but also very tricky effect is produced. Fundamentally, this hinges around a further ambiguity in the word 'character,' which on the one hand is located firmly within an evaluative moral framework (an individual is of good or bad character, etc.), but on the other slips into something like its more usual contemporary meaning, as a feature of narrative discourse. In this sense, *London Labour* contains a wealth of 'characters,' like the Watercress Girl.

It is not a novel – for one thing, Mayhew's characters are anonymous; and Eileen Yeo has argued forcefully that Mayhew's work cannot be reduced to the 'genre of literary rambles' which includes 'characters and scenes of London' (Thompson and Yeo 1973: 74). Nevertheless, as Humphreys shows, Mayhew's journalistic style (its descriptive passages, its representation of direct speech) has much in common with the novelistic (e.g. Dickens). None of Mayhew's commentators, however, have considered the exceedingly complex effects this produces for his representations of character. For in place, simultaneously, there is the possibility of an individual character analysis (criminology), an iden-tification of cultural traits or 'characteristics' (cultural sociology), and the representation of characters to the reader of a literary/journalistic narrative.

Today, we can identify in Mayhew certain discursive strategies which have become institutionalised, not only in literary journalism, but also in documentary broadcasting:

The 'they' that is always implied and often stated in direct address forms becomes an other, a grouping outside the consensus that confirms the consensus. Certain characteristic attitudes are taken towards these outsiders: patronisation, hate, wilful ignorance, pity, generalised con-cern, indifference. These are encouraged by the complicity that broadcast TV sets up between itself and its viewers.

(Ellis 1982: 139–40)

But we can observe that this mode of documentary address is already established in Mayhew, and it is this which permits the attitude of patronisation and pity towards the Watercress Girl. The journalistic discourse is predicated on a community of address: the direct address form ('I' am speaking to 'you') is in place, and the journalist surveys the streets on 'our' behalf. Moreover, in so far as his survey is represented in a narrative form – for instance, as Mayhew visits the street market, the penny gaff, the homes of the Irish etc. – the journalist also becomes a narrator. He is no longer simply the objective reporter – rather, a persona, a *personality*, is constructed for him.

It is at this moment, it seems to me, as Mayhew's survey and/or cultural study is narrativised, that the conditions are established for the appearance of another form of social identity. For in her representation as a character, the Watercress Girl is no longer simply a social type – like the poor Irishwoman. The cultural type essentially confirms our expectations; all Irishwomen are like this. But the narrative discourse, in its representation of a specific encounter, permits the narrator to register his *surprise*. He is confronted with circumstances which he (and we, his readers) did not at first anticipate. It is at this point that the contained reference to, and quotation of, culturally typical ways of speaking, passes on into a form of *dialogue*:

> I then talked to her about the parks, and whether she ever went to them. 'The parks!' she replied in wonder, 'where are they?' I explained to her, telling her that they were large open places with green grass and tall trees, where beautiful carriages drove about, and people walked for pleasure, and children played. Her eyes brightened up a little as I spoke; and she asked, half doubtingly, 'Would they let such as me go there – just to look?' All her knowledge seemed to begin and end with watercresses, and what they fetched.
>
> (Mayhew 1985: 65)

Mayhew did not transcribe his interviews precisely, but as Anne Humphreys suggests, it is frequently possible to infer a dialogic form to the interview, if only from the representation of replies. It is at this moment that the social character is no longer merely an object – Mayhew's other is also a subject; or rather (and this is the really tricky effect of characterisation), the social character becomes a subject *on the grounds that she is already objectified*. The Watercress Girl clearly is already cast as other – this is a precondition; but at certain moments this otherness is not simply and easily containable. It breaks through to produce a new kind of social recognition.

What kind of recognition is given to the social characters encountered in interviews? It seems to me that this element of surprise, the unexpected, never really amounts to a serious disturbance of the cultural consensus. It is capable of being read in a way which, although on one level shocking, on another level seems to reaffirm the validity of the norms which it disturbs.

In the case of the Watercress Girl these are clearly certain middle-class norms about childhood innocence. So paradoxically a dominant cultural framework is confirmed, even though the individual encountered in the interview does not, at first sight, conform to it. But perhaps she does deep down, because 'her eyes brightened up a little' at the mention of play.

6. . . . Some general critical questions are raised about the practices of interviewing in some forms of sociology and cultural studies. Specifically, interviewing must be regarded as taking an active part in the *construction* of social identities. That is to say, interviews do not simply discover and transparently reflect pre-given social experiences; rather, in their various forms of articulation, these experiences are defined and recognised according to different social criteria. Arguably these criteria, in common circulation, will begin to have material effects: having been interviewed by Mayhew, the Watercress Girl now enters the public sphere, the domain of the social, where it is quite easy to imagine that her plight might be the focus for philanthropic concern. But equally, it should not be possible to overlook the ambiguities in these constructions, to the extent that the social identity of the Watercress Girl is predicated on her objectification, and the philanthropic intervention itself assumes a pre-existing social distance from her (subcultural) world.

From this point of view, the sociological interview is not so much a methodology as a discursive *technology*, which produces, through the recognition it gives to certain forms of speech, specific forms of social identity. The perspective I am adopting here is of course derived from Foucault's work, and so I think it is appropriate to close with a quotation which will identify the terrain of questions I have discussed. This comes from Foucault's remarks on the question of 'subjectification':

> This form of power applies itself to immediate everyday life which categorises the individual, marks him by his own individuality, attaches to him his own identity, imposes a law of truth on him which he must recognise and which others have to recognise in him. It is a form of power which makes individuals subjects.
>
> (Foucault 1982: 210)

In these terms I would suggest that interviewing in general can be defined as a pervasive, modern technique for 'subjectification,' with the sociological interview (in its 'culturalist' mode) as one specific variant.

Note

1 This chapter has been edited and revised by the author for this publication.

Place, identity, territory

Introduction to part six

■ Ken Gelder

SUBCULTURAL STUDIES HAVE often emphasised a subcul-
ture's creative engagement with a particular place. It can be
reclaimed or transformed or made over, often unconventionally and
sometimes illicitly – as we have seen in Laud Humphreys' account
of the tearoom trade in Chapter 25, for example. The emphasis
on transformation allows us to compare subcultural relations to
place with subcultural relations to style (as contributions to Part
Seven will show), insofar as both provide significant forums through
which subcultural identity is evoked. Of course, there is a romantic
view of subcultures, in the tradition of Henry Mayhew, which would
see them as *dis*-placed – as 'homeless' or nomadic. Most of the
contributions collected here correct this view by giving a strong
sense of subcultures as being *in* place, firmly connected to a particu-
lar location. Subcultural identity can cohere in this way; by
identifying with a place (a club or a football terrace, for instance),
participants can lay claim to a sense of belonging, even exclusivity.
But subcultures are by no means always defined through their
local-ness. They can produce alliances with people in *other*
places: other cities, other nations. And in the process they are
themselves transformed or made over. Indeed, it is often difficult
for a subculture *not* to be dis-placed, and a participant's sense of

belonging may be compromised or nourished by this fact, depending on the case.

This Part brings together a number of important studies, from the 1940s to the present day, which each take up the relationship between a subculture and a place. It begins with a short extract from William Foote Whyte's classic 1943 ethnography of Italian youth in a place he called 'Cornerville' – actually, Boston's North End. Whyte's aim was to produce an image of the slum-dweller as a 'human being', countering middle-class perceptions of these people as an undifferentiated 'mass' as well as media representations which turn to the slum-dweller only when he becomes 'spectacular' (e.g. through crime). Whyte also saw the street-corner – where Italian youth would congregate – not so much as indicative of the extent of their alienation but, rather, as one aspect of a more wide-ranging pattern of everyday life. He divided the boys he met into two groups: the corner boy gang, led by Doc, and the college boys, lead by Chick Morelli. This structuring anticipates Willis (see Chapter 14) through its distinction between those who are underprivileged – and thus remain 'in place' at Cornerville – and the more upwardly mobile, ambitious boys who manage to get *out* of that place. The former gain status, however, by claiming the street corner as their own, and in this respect they are more integrated even though at other levels they are disenfranchised. Whyte also shows how the apparently disorganised way of life at and around the street corner is in fact very organised indeed. Moreover, he looks beyond Cornerville to other groups – racketeers, politicians – which are enmeshed with the fortunes of the corner gang and the college boys. Whyte certainly documents a social hierarchy in this respect, placing the corner boys at the bottom of the ladder. But his analysis of 'reciprocal obligations' enables street corner society to radiate out beyond itself, having real effects on larger formations even as it is dominated by them.

Whyte's study is comparable both to Peter Marsh, Elizabeth Rosser and Rom Harré's analysis of football supporters at the Ends, and Wendy Fonarow's study of participants at 'indie' music gigs. In each case, the emphasis is on internal modes of organisation or stratification in an activity which might appear rather chaotic to an outsider. Marsh *et al.* look at the use Oxford United football

fans make of the 'terraces', mapping out a territorial arrangement based on internal distinctions ('novices', 'rowdies', 'town boys') and aspirations. The arrangement is hierarchical, leading them to categorize a fan's movement from the bottom to the top and from one zone in the terraces to another as a 'career'. They also emphasize the exclusivity of the terraces, which must be made distinctive in order for 'discrepant behaviour' to flourish. Fonarow's article similarly isolates her site of activity – an emblematic music venue – and divides it into zones. She is particularly interested in the way participants in each zone align themselves to the band. The way that alignment is accounted for and acted out produces a 'statement', a self-evaluation not just in relation to the band but also to others at the gig.

Marsh *et al.* acknowledge a debt to Erving Goffman in their account of territorial identity at the terraces. Goffman is best known for his analyses of aspects of social behaviour and forms of communication (gestures, body language, and so on) in various everyday situations, but the contribution included here, from *Asylums* (1961), is quite firmly tied to a specific kind of institution. Goffman preserves the confidentiality of his asylum through its anonymous-sounding title 'Central Hospital' – much like Whyte's use of 'Cornerville' – and in the process renders the site generic or typical. As with Whyte again (and recalling Albert Cohen), the focus here is on 'adjustments', or lack of them, to what is registered as normal behaviour. Certain 'adjustments' function as what Goffman calls 'make-do's' – a term which anticipates Hebdige's use of *bricolage* – involving distinctive or deviant uses of hospital space and materials. Goffman sees this as a personal rather than collective activity, however. He also sees it not so much as a refusal of what is authorized or legitimate, but as a means of elaborating or extending it (which means acquiring an intimate knowledge of the hospital system). Certainly asylums are built around insider/outsider distinctions. But there are zones of distinction *inside* the asylum, too – personal, carved-out territories in the midst of socially sanctioned space. The contribution included here involves the geographical division of the hospital into zones which are scaled in this way, from the institutionally determined to the more self-determining.

The chapters by Paul Gilroy and George Lipsitz turn to musical forms and ethnicity, examining the relations between subcultural claims on place and the more dis-placing or diffusive features of capitalism. Gilroy focuses on the club scene in 'black Britain', which draws together a fairly precise sense of ethnic location, the Caribbean in this case, and a level of participation which operates through the 'international networks' of record distribution. The emphasis here is not on the original place of production, but on where the music is *consumed*, which may be another place alto-gether. The club scene in 'black Britain' is thus presented as diasporic, privileging an otherwise marginally influential place like the Caribbean as a 'sub-cultural resource', but at the same time distributing that resource into new, highly transformative market-places. Like Hebdige (1979), Gilroy portrays a sequence of events built around black innovation (tied more to place and its tradi-tions) and white 'borrowing', turning towards the end of this essay to the somewhat fragile, utopian event of mixed-race 'two tone' music during the early 1980s. He celebrates the diasporic identity of 'black Britain', offering it as a means of thinking about the way place is mobilised and transformed – but by no means done away with – through the distribution of commercial musical forms.

George Lipsitz's chapter looks at Mexican-American music emerging from the *barrios* of East Los Angeles, seeing it as medi-ating between localized subcultures and the distributive processes of capitalism which send it into the wider community. Lipsitz suggests that Mexican-Americans here are neither assimilated into, nor separate from, mainstream US culture; they are distinctive, but not discrete. Certainly they remain dominated, even reviled; but Lipsitz also characterizes Mexican-American subcultures as highly creative, capable of producing effects which flow out into the culture at large. (His remarks on zoot-suiters may be compared with Turner and Surace's analysis in Chapter 41) The chapter from which this contribution is taken also presents the kind of musical genealogies found in Gilroy, but it is more celebratory of what Gilroy had called the 'sub-cultural resource' – the place of produc-tion – focusing less on the ways in which that 'resource' might be transformed by consumers elsewhere. Interestingly, Lipsitz turns

back to Antonio Gramsci in his account, using him in a slightly different way to analysts at Birmingham – describing the subculturalist as an 'organic intellectual', for example, and drawing on Gramsci's notion of an 'historical bloc' of oppositional activity.

The contributors to this Part formulate subcultural relations to place in a number of different ways: through hierarchically arranged internal distinctions or stratifications, through contestation or territorialization, through alignments or interactions with wider formations, and through hybridizations which send traces of place-based subcultural forms into quite different kinds of location. We can also see the authors of these chapters – to draw on a phrase in Fonarow's account of indie gig audiences – as 'taking a stand' in relation to the subcultures they describe. In some cases, authors produce an ethical alignment to place, with particular consequences: Whyte's call to recognize (rather than disenfranchise) local forms of leadership in Cornerville, for example, or Lipsitz's championing of the creativity of the *barrios*. In all cases, place is put to use, both enabling subcultural identities to cohere and reaching out beyond itself as a 'resource' for others.

William Foote Whyte

THE PROBLEM OF CORNERVILLE [1943]

THE TROUBLE WITH the slum district, some say, is that it is a disorganized community. In the case of Cornerville such a diagnosis is extremely misleading. Of course, there are conflicts within Cornerville. Corner boys and college boys have different standards of behavior and do not understand each other. There is a clash between generations, and, as one generation succeeds another, the society is in a state of flux — but even that flux is organized.

Cornerville's problem is not lack of organization but failure of its own social organization to mesh with the structure of the society around it. This accounts for the development of the local political and racket organizations and also for the loyalty people bear toward their race and toward Italy. This becomes apparent when one examines the channels through which the Cornerville man may gain advancement and recognition in his own district or in the society at large.

Our society places a high value upon social mobility. According to tradition, the workingman starts in at the bottom and by means of intelligence and hard work climbs the ladder of success. It is difficult for the Cornerville man to get onto the ladder, even on the bottom rung. His district has become popularly known as a disordered and lawless community. He is an Italian, and the Italians are looked upon by upper-class people as among the least desirable of the immigrant peoples. This attitude has been accentuated by the war. Even if the man can get a grip on the bottom rung, he finds the same factors prejudicing his advancement. Consequently, one does not find Italian names among the leading officers of the old established business of Eastern City. The Italians have had to build up their own business hier-

archies, and, when the prosperity of the 1920s came to an end, it became increasingly difficult for the newcomer to advance in this way.

To get ahead, the Cornerville man must move either in the world of business and Republican politics or in the world of Democratic politics and the rackets. He cannot move in both worlds at once; they are so far apart that there is hardly any connection between them. If he advances in the first world, he is recognized by society at large as a successful man, but he is recognized in Cornerville only as an alien to the district. If he advances in the second world, he achieves recognition in Cornerville but becomes a social outcast to respectable people elsewhere. The entire course of the corner boy's training in the social life of his district prepares him for a career in the rackets or in Democratic politics. If he moves in the other direction, he must take pains to break away from most of the ties that hold him to Cornerville. In effect, the society at large puts a premium on disloyalty to Cornerville and penalizes those who are best adjusted to the life of the district. At the same time the society holds out attractive rewards in terms of money and material possessions to the 'successful' man. For most Cornerville people these rewards are available only through advancement in the world of rackets and politics.

Similarly, society rewards those who can slough off all characteristics that are regarded as distinctively Italian and penalizes those who are not fully Americanized. Some ask, 'Why can't those people stop being Italians and become Americans like the rest of us?' The answer is that they are blocked in two ways: by their own organized society and by the outside world. Cornerville people want to be good American citizens. I have never heard such moving expressions of love for this country as I have heard in Cornerville. Nevertheless, an organized way of life cannot be changed overnight. As the study of the corner gang shows, people become dependent upon certain routines of action. If they broke away abruptly from these routines, they would feel themselves disloyal and would be left helpless, without support. And, if a man wants to forget that he is an Italian, the society around him does not let him forget it. He is marked as an inferior person – like all other Italians. To bolster his own self-respect he must tell himself and tell others that the Italians are a great people, that their culture is second to none, and that their great men are unsurpassed. It is in this connection that Mussolini became important to Cornerville people. Chick Morelli expressed a very common sentiment when he addressed these words to his Italian Community Club:

> Whatever you fellows may think of Mussolini, you've got to admit one thing. He has done more to get respect for the Italian people than anybody else. The Italians get a lot more respect now than when I started going to school. And you can thank Mussolini for that.

It is a question whether Mussolini actually did cause native Americans to have more respect for Italians (before the war). However, in so far as

Cornerville people felt that Mussolini had won them more respect, their own self-respect was increased. This was an important support to the morale of the people.

If the racket–political structure and the symbolic attachment to Italy are aspects of a fundamental lack of adjustment between Cornerville and the larger American society, then it is evident that they cannot be changed by preaching. The adjustment must be made in terms of actions. Cornerville people will fit in better with the society around them when they gain more opportunities to participate in that society. This involves providing them greater economic opportunity and also giving them greater responsibility to guide their own destinies. The general economic situation of the Cornerville population is a subject so large that brief comments would be worse than useless.

One example, the Cornerville House recreation-center project, will suggest the possibilities in encouraging local responsibility. The center project constituted one of the rare attempts made by social workers to deal with Cornerville society in its own terms. It was aimed to reach the corner gangs as they were then constituted. The lesson which came out of the project was that it is possible to deal with the corner boys by recognizing their leaders and giving them responsibility for action.

The social workers frequently talk about leaders and leadership, but those words have a special meaning for them. 'Leader' is simply a synonym for group worker. One of the main purposes of the group worker is to develop leadership among the people with whom he deals. As a matter of fact, every group, formal or informal, which has been associated together for any period of time, has developed its own leadership, but this is seldom recognized by the social workers. They do not see it because they are not looking for it. They do not think of what leadership is; instead they think of what it should be. To outsiders, the leading men of the community are the respectable business and professional men – people who have attained middle-class standing. These men, who have been moving up and out of Cornerville, actually have little local influence. The community cannot be moved through such 'leaders'. Not until outsiders are prepared to recognize some of the same men that Cornerville people recognize as leaders will they be able to deal with the actual social structure and bring about significant changes in Cornerville life.

So far this discussion sounds much like the anthropologist's prescription to the colonial administrator: respect the native culture and deal with the society through its leaders. That is certainly a minimum requirement for dealing effectively with Cornerville, but is it a sufficient requirement? Can any program be effective if all the top positions of formal authority are held by people who are aliens to Cornerville? What is the effect upon the individual when he has to subordinate himself to people that he recognizes are different from his own?

Doc once said to me:

You don't know how it feels to grow up in a district like this. You go to the first grade – Miss O'Rourke. Second grade – Miss Casey. Third grade – Miss Chalmers. Fourth grade – Miss Mooney. And so on. At the fire station it is the same. None of them are Italians. The police lieutenant is an Italian, and there are a couple of Italian sergeants, but they have never made an Italian captain in Cornerville. In the settlement houses, none of the people with authority are Italians.

Now you must know that the old-timers here have a great respect for schoolteachers and anybody like that. When the Italian boy sees that none of his own people have the good jobs, why should he think he is as good as the Irish or the Yankees? It makes him feel inferior.

If I had my way, I would have half the schoolteachers Italians and three-quarters of the people in the settlement. Let the other quarter be there just to show that we're in America.

Bill, those settlement houses were necessary at first. When our parents landed here, they didn't know where to go or what to do. They needed the social workers for intermediaries. They did a fine job then, but now the second generation is growing up, and we're beginning to sprout wings. They should take that net off and let us fly.

Erving Goffman

HOSPITAL UNDERLIFE
Places [1961]

I N CENTRAL HOSPITAL, as in many total institutions, each inmate tended to find his world divided into three parts, the partitioning drawn similarly for those of the same privilege status.

First, there was space that was off-limits or out of bounds. Here mere presence was the form of conduct that was actively prohibited – unless, for example, the inmate was specifically 'with' an authorized agent or active in a relevant service role. For example, according to the rules posted in one of the male services, the grounds behind one of the female services were out of bounds, presumably as a chastity measure. For all patients but the few with town parole, anything beyond the institution walls was out of bounds. So, too, everything outside a locked ward was off-limits for its resident patients, and the ward itself was off-limits for patients not resident there. Many of the administrative buildings and administrative sections of buildings, doctors' offices, and, with some variations, ward nursing stations were out of bounds for patients. Similar arrangements have of course been reported in other studies of mental hospitals:

> When the charge [attendant] is in his office, the office itself and a zone of about 6 square feet outside the office is off limits to all except the top group of ward helpers among the privileged patients. The other patients neither stand nor sit in this zone. Even the privileged patients may be sent way with abrupt authority if the charge or his attendants desire it. Obedience when this order occurs – usually in a parental form, such as 'run along now' – is instantaneous. The privileged patient

is privileged precisely because he understands the meaning of this social space and other aspects of the attendant's position.

(Belknap 1956: 179–90)

Second, there was *surveillance space*, the area a patient needed no special excuse for being in, but where he would be subject to the usual authority and restrictions of the establishment. This area included most of the hospital for those patients with parole. Finally, there was space ruled by less than usual staff authority; it is the varieties of this third kind of space that I want to consider now.

The visible activity of a particular secondary adjustment may be actively forbidden in a mental hospital, as in other establishments. If the practice is to occur, it must be shielded from the eyes and ears of staff. This may involve merely turning away from a staff person's line of vision. The inmate may smile derisively by half-turning away, chew on food without signs of jaw motion when eating is forbidden, cup a lighted cigarette in the hand when smoking is not permitted, and use a hand to conceal cigarette chips during a ward poker game when the supervising nurse passes through the ward. These were concealment devices employed in Central Hospital. A further example is cited from another mental institution:

> My total rejection of psychiatry, which had, after coma, become a fanat-ical adulation, now passed into a third phase — one of constructive criticism. I became aware of the peripheral obtuseness and the admini-strative dogmatism of the hospital bureaucracy. My first impulse was to condemn; later, I perfected means of maneuvering freely within the clumsy structure of ward politics. To illustrate, my reading matter had been kept under surveillance for quite some time, and I had at last perfected a means of keeping *au courant* without unnecessarily alarming the nurses and attendants. I had smuggled several issues of *Hound and Horn* into my ward on the pretext that it was a field-and-stream maga-zine. I had read Hoch and Kaslinowski's *Shock Therapy* (a top secret manual of arms at the hospital) quite openly, after I had put it into the dust jacket of Anna Balakian's *Literary Origins of Surrealism*.
>
> (Solomon 1959: 177–78)

In addition, however, to these temporary means of avoiding hospital surveil-lance, inmates and staff tacitly cooperated to allow the emergence of bounded physical spaces in which ordinary levels of surveillance and restriction were markedly reduced, spaces where the inmate could openly engage in a range of tabooed activities with some degree of security. These places often also provided a marked reduction in usual patient population density, contributing to the peace and quiet characteristic of them. The staff did not know of the existence of these places, or knew but either stayed away or tacitly relin-quished their authority when entering them. Licence, in short, had a

geography. I shall call these regions *free places*. We may especially expect to find them when authority in an organization is lodged in a whole echelon of staff instead of in a set of pyramids of command. Free places are backstage to the usual performance of staff–inmate relationships.

Free places in Central Hospital were often employed as the scene for specifically tabooed activities: the patch of woods behind the hospital was occasionally used as a cover for drinking; the area behind the recreation building and the shade of a large tree near the centre of the hospital grounds were used as locations for poker games.

Sometimes, however, free places seemed to be employed for no purpose other than to obtain time away from the long arm of the staff and from the crowded, noisy wards. Thus, underneath some of the buildings there was an old line of cart tracks once used for moving food from central kitchens; on the banks of this underground trench patients had collected benches and chairs, and some patients sat out the day there, knowing that no attendant was likely to address them. The underground trench itself was used as a means of passing from one part of the grounds to another without having to meet staff on ordinary patient–staff terms. All of these places seemed pervaded by a feeling of relaxation and self-determination, in marked contrast to the sense of uneasiness prevailing on some wards. Here one could be one's own man.

Peter Marsh, Elizabeth Rosser and Rom Harré

LIFE ON THE TERRACES [1978]

Territory

YOUNG SUPPORTERS AT every football league ground (and at many non-league grounds) have defined sections of the terracing as their own territory – an area from which they always watch the football game. Although, to the casual observer, the terraces may seem unremarkable slabs of tiered concrete, certain areas within them are sacrosanct to the fans who habitually occupy them. The chosen section is usually in the open areas behind the goals – areas of the ground which have traditionally been occupied by working-class men since the grounds were built. Such areas also tend to be the cheapest to get into. These territories are known by the generic term *Ends* and each ground has a distinctive name for its End. The 'Kop' of Liverpool and the 'Shed' of Chelsea are two well-known examples. In addition, many Ends are known by the name of the road which runs past the turnstile entrance to them – e.g. the 'Stretford End' at Manchester United and the 'London Road End' at Oxford.

Ends such as these are reserved by the home fans solely for their own use – visiting fans being relegated to other areas of the ground. These 'away' areas are often behind the opposite goal to the home End and are recognized by the visiting supporters as their 'spots'.

The distinctive nature of Ends is further reinforced by the subsequent actions of club officials and police. Once territories have been established by young fans, occupants are physically confined within them for the entire duration of the match. Barriers have been erected at all Football League grounds in the light of recommendations made in the Lang Report (1969) – their

purpose being 'the segregation of young people from other spectators'. In most cases this has meant that steel fences and wire grilles have been built around the Ends and the areas most frequently occupied by young visiting supporters. At some grounds (notably Manchester United's) security fencing and iron grilles of the type that zoo cages are made of have been installed. . . .

The net effect of the fortifications around Ends, and of the strategies to keep people in them, is, of course, the highlighting of their distinctive nature. The police and officials have succeeded in delineating fans' territories in a way that the fans themselves could never have done. Another by-product of official strategy is one which involves the fans and the police acting in a concerted and co-operative manner. The maintenance of territorial integrity has become a joint enterprise. Invading fans are not only repulsed by the occupants in defence of their home 'turf', but also by the police in their pursuit of law and order and the *status quo*. It thus comes as little surprise to find that police and fans share similar commonsense conceptions of territoriality, and that their accounts of what goes on during 'raids' on Ends have much in common.

The notion of territoriality here is quite critical to an understanding of social action on the terraces and to the social structures that exist. Territories here are seen as action-facilitating in the sense that many of the patterns of action we have observed rely for their appropriateness on the fully defined context in which they take place. Using the notion provided by Erving Goffman (1971a), and further elaborated by Lyman and Scott (1970) football Ends are viewed as 'free' territories. As Lyman and Scott explain:

> Free territory is carved out of space and affords the opportunities for idiosyncrasy and identity. Central to the manifestation of these opportunities are boundary creation and enclosure. This is because activities that run counter to expected norms need seclusion or invisibility to permit unsanctioned performance, and because the peculiar identities are sometimes impossible to realise in the absence of the appropriate setting. Thus the opportunities for freedom and action – with respect to normatively discrepant behaviour and maintenance of specific identities – are intimately connected with the ability to attach boundaries to space and to command access to or exclusion from territories.

The free territories of the Ends become 'converted', through regular use, into 'home' territories. A special kind of relationship comes to exist between users of such a territory and the physical space itself such that new conceptual and linguistic markers are attached to the space. Unlike most forms of home territory, however, Ends are not colonized in opposition to authority. In reality, the guardians of authority collude in the maintenance of the territory once it has been colonized, and as a result enter into the social framework on the terraces. Police at football matches are not seen as the immediate

enemy in the way that they might be, say, in dealing with trespassers or others laying false claim to an essentially public area. They may be seen as obstructive when restraining rival groups of fans, but the venom and anger characteristic of, for instance, thwarted political demonstrators, is noticeably absent at most football matches.

During the 1974 and 1975 seasons young supporters of Oxford United were concentrated in an area of terracing known as the 'London Road End'. During the close season in 1974 a dry moat had been constructed and new barriers installed. The setting in some ways was a little unusual in that rival fans occupied the other half of the same block of terracing. In 1974 the two rival groups were separated by a corridor of barriers patrolled by police. In 1975, a steel fence was added on the visiting supporters' side of the corridor to further restrict access between the two halves. . . .

Most football grounds now divide their rival fans by placing them at opposite ends of the ground and by preventing access between the ends. At Leeds, for example, not only are fans separated in this way, but a wedge-shaped piece of terracing at the corner of the visiting fans' terrace is designated a 'no-man's-land', surrounded by high fencing, and kept empty. Any fan trying to get from one end to the other would have to pass through this area and would be immediately arrested. Strategies at other grounds are often even more elaborate. With the Oxford system, however, a distinct interface existed between the two sets of rival fans, and although kept apart by police and fences, it was still possible to 'get at' the opposition with determined effort. The system also resulted in chants and songs being directed sideways to the rival fans, rather than across the pitch to the other end.

The fact that visiting supporters were allowed in to the same terracing, even though distinctly segregated, was a constant source of irritation to many Oxford fans, and it was often pointed to as an explanation for the occurrence of 'bovver'. The label 'London Road End' was carefully used to refer only to the half of the terrace occupied by Oxford fans.

Social groupings at Oxford United

Initial research work at Oxford United's ground consisted mainly of making a large number of video-recordings of fans in the London Road End. These were made discreetly with the aid of a telephoto lens and with the full co-operation of the club. Early analysis of these tapes revealed a grouping pattern in the London Road End which remained quite static over a considerable period of time. Later reports from the fans themselves revealed that they were very aware of such groupings and were able to attribute a number of salient behavioural and social characteristics to them. . . .

Group A comprised boys mainly between the ages of 12 and 17. The mean age of a sample of thirty-four boys in this group who were to contribute

greatly to the later stages of the research was 15.1 years. The most distinctive aspect of this group was the pattern of dress. . . . The presence of flags, banners and emblems of allegiance was also very marked. When the newspapers and television hold forth about football hooligans it is usually to members of groups like this that they are referring. Not only are they the most identifiable group in terms of their appearance, but also in terms of the high level of activity among the group which is apparent even to the casual observer. They make the most noise – singing, chanting and shouting imprecations against the opposition fans – they run the most and they can represent a rather awesome spectacle to their rivals. For this reason we refer to this group as the 'Rowdies', rather than the media appellation of hooligans, for as we shall see, the label 'hooligan' carries special meaning within the soccer micro-culture.

Group C, in contrast to the Rowdies group, consisted of rather older boys and young men up to the age of about 25. The mean age of a sample of fourteen was 18.7. The style of dress within this group was unremarkable and differed little from that worn by people of this age group in most social contexts. Nor were any banners or flags visible. In fact, members of this group would not be identifiable as football fans at all outside of the ground. Younger fans referred to this group as the 'Town Boys' and were clearly deferential to them.

Group B, lying between the Rowdies and the Town Boys on the right-hand side of the London Road Terrace, was a much less distinct group which varied in composition from game to game. One consistent characteristic, however, was the presence of a disproportionately high number of boys with a record of arrests, probation and care orders. Out of a total of seventeen boys from this group interviewed over a period of one year, no fewer than ten had been in trouble with the police for offences not connected with activities at football matches. This compares with an overall average of about 8 per cent for the London Road End as a whole.

Apart from this characteristic, the group seemed to have features of both the Rowdies and the Town Boys groups. The average age was about 16.5 and some of the more distinctive dress elements were present. The activity level, however, was much lower than that of the Rowdies and some of the fans in this group were only infrequent attenders at football matches.

Groups D and E were much less homogeneous than any of the others and effectively marked the edges of the active arena in the London Road End with which we are concerned. In the main, they both consisted of boys and young men who were rather more reluctant to join in the ritual chanting and singing and were even less keen to get mixed up in the aggro. The only difference between the groups was that those in E were generally a little older and a few females were also to be found there. Both groups contained a number of fans who were scathingly referred to as 'part-time' supporters by those in the Rowdies and Town Boys groups. Among such part-timers were a few public-school boys playing at being football fans but failing really

to understand what it was all about. The left-hand boundaries of these groups were totally undefined.

In Group F were to be found young children (average age about 10) who sat, when they were not moved off by police, on the wall in the front of the terrace, overlooking the dry moat. Their major occupation consisted of watching the antics of those at the back in the Rowdies group. Because of the age and inexperience of these boys, we refer to this group as the 'Novices'. Other fans simply call them little kids, but they are to be distinguished from other 'little kids' in other areas of the ground.

The pattern of grouping described here is probably unique to Oxford United's ground, but analogues of such groups appear to be present at all league club grounds – with the possible exception of some of the very small Fourth Division grounds. What is most striking about such groupings is that they provide for *careers* on the football terraces. The Novices, Rowdies and Town Boys provide a fairly linear hierarchy. Fans may aspire to progress through this hierarchy, and within each group certain role positions are open. The role positions enable demonstrations of character and worth, leading to the attainment of status, to take place within an ordered and rule-governed framework. 'Becoming somebody' on the terraces is a highly structured affair, and an understanding of this structure is the first step in rendering the apparently anomic behaviour at football matches intelligible.

Careers

In using the by no means original sociological concept of 'careers' we do not wish to imply that action on the part of the soccer fans is somehow *determined* by a restricting set of institutional restraints. We would certainly want to use the term 'careers' in a rather different way from some criminologists who speak of 'delinquent careers' in which young deviants are inescapably forced along the path of community school, borstal and prison. Rather we see careers in a much less mechanistic way – as available structures in a youth culture for the establishment of self. At this point we are seeking only to explain the social frameworks which render certain actions intelligible, and we do not wish to imply causal links between social frames and social action. The extent to which fans will carve out careers for themselves on the terraces will, to a large extent, reflect their commitment to the soccer culture and to their immediate peer group. The greater the commitment, the more a fan has at stake. But, as we shall see, the richness of the soccer social world provides for commitments to be expressed in many different ways.

We have suggested that the Novices–Rowdies–Town Boys groups provide a distinct hierarchical framework for careers. Such a framework has more than a passing similarity with the career structure observed by Howard Parker in his study of young delinquents in Liverpool [1974]. Although his groups, 'Tiddlers', 'Ritz', and 'Boys', reflected increasing involvement in

delinquent activities, they served the same function of enabling young people to achieve the sort of reputations and images denied them in mainstream society. On the football terrace, however, the other groups mentioned serve as side channels to the main career framework. They provide for the less committed who still wish to enjoy some of the fruits of the soccer culture. Groups D and E can certainly be seen to have this function. A fan who was totally uncommitted to the culture, who simply wanted to watch the match, would probably choose not to go into the London Road End at all but rather to one of the quieter side terraces. Group B, on the other hand, seems a little anomalous. To some extent we see members of this group as 'failures' in the career development process. They occupy fringe positions to both the Rowdies and Town Boys but have status in neither. Their high delinquency level also puts them at a further distance. . . .

In charting the progress of fans' careers, two types of data have been used. The first, and the easiest to collect, consisted of biographical material obtained from samples of fans in each of the groups, with special attention given to the Rowdies and Town Boys. The second type of data was obtained from close observation of the changes in the compositions of the groups and in the holders of clearly defined role positions within the groups. Both types of data, however, are problematic in that the whole structure within which careers are established changes over time. . . .

Other changes in structure developed more slowly, but although the pattern *looked* different over a period of a few years, analogues of the basic groups seem to have been present ever since the phenomenon of the contemporary football fan arose in the middle to late 1960s. There has always been the equivalent of the Novices group, for example, allowing entrance to the soccer microculture for any boy willing to learn the rules of being a fan. Similarly, the Rowdies have always made their present felt – as any 'old-timer' will eagerly tell you. At one time the Rowdies were mainly skinheads for whom the terraces were but one of a number of arenas for collective action. Those most dedicated to soccer culture became known as 'Terrace Terrors', but their successors are currently moving away from the baggy trouser and braces image that they fostered. Rowdies today often have quite elaborately coiffeured hairstyles – contrasting markedly with the heavy Dr Marten footwear which they still retain. Finally, Rowdies have always had the more manly and mature equivalent of the Town Boys to join once they had proved their worth and their masculinity.

In interpreting data, then, the gradual changes in the social framework at Oxford United have been taken into account. Note has also been taken of where particular groups have positioned themselves at various times in their evolution, and of their differences in style which have characterized such groups over time.

Two distinct aspects of the career process are to be distinguished. The first of these, the between-group *graduation* process, is concerned with movement from one group to another and with the fact that membership of a

particular group affords a certain status in relation to members of other groups. The second, the within-group *development* process, is concerned with the establishment of certain well-defined status positions within each group and with the acquisition of the appropriate social knowledge to equip a member to 'carry off' the performances required by such roles.

Social roles

Social roles within each of the groups have been isolated primarily from the accounts given by fans and from prolonged observation in the London Road End. In many cases fans were able to attach labels to certain positions, but in some cases the role was defined only by the range of behaviours required of it. The Rowdies group provided by far the widest range of available roles, and it is with a discussion of these that we start.

Chant leader

During the 1974 season about six individuals occupied such a position within the group. The role of such a person was simply to initiate songs and chants and to act as 'caller'. The job of a caller is rather like that of a priest who intones, line by line, the words of a prayer and to whom the congregation responds, at each stage, using the appropriate replies. A simple example of this calling takes the following form:

> Give us an 'O'
> [O]
> Give us an 'X'
> [X]
> Give us an 'F'
> [F]
>
> etc.
>
> What have we got?
> [OXFORD]

At other times the chant leader is required to initiate chants in reply to a chant from the opposition fans. A common example of this occurs in the interposing of an imprecation in between a chant of allegiance by the rival group. Thus, a chant of '*Chelsea! – Chelsea!*' is transformed into '*Chelsea! (Shit) Chelsea! (Shit)*'. The job of the chant leader is simply to make sure that '*Shit!*' comes in at exactly the right time. . . .

One other major aspect of the chant leader's role is related to the creation of new chants and songs. The vast majority of chants are common to virtually all football grounds, with slight variations. Liverpool supporters would

have us believe that they all originate from the Kop, but this is doubtful. One reason for the ubiquity of chants lies in the fact that a large number of fans move around the country to support their team at away games. A rapid and widescale communication network is thus provided, and good chants can be taken over from one set of fans and used against a different set the following week. From time to time, however, songs and chants of a completely novel kind are heard. The origins are often to be found by watching and listening to what goes on in the Soccer Specials – the trains and coaches which fans hire to transport themselves to away games. To fill in the travelling time chant leaders are actively engaged in trying out new versions of old chants or making them up from scratch. Those that meet with approval are then usually tried out on the terraces, and if found to have some power, make their way into the repertoire. . . .

Aggro leader

An aggro leader is not to be confused with a 'good fighter' for, because of the peculiar nature of aggro, he might never have to do any fighting at all. At Oxford United a person occupying such a role would have been one of six or seven boys who were always at the front when conflicts arose with the rival fans. In 'running battles' they would always be the last to retreat. For these purposes they would also tend to wear the most heavily reinforced boots and might occasionally carry weapons of some kind.

Within the Rowdies group, there was some confusion as to who was and who was not an aggro leader and also with regard to the characteristic behaviours expected of such a person. Three fans were placed in this category on the basis of lengthy observation and in accord with what were taken to be the appropriate criteria for judging such people. These boys, however, turned out not to be aggro leaders at all. This was because a very important dimension had been ignored – one which, in keeping with everyday social talk, we refer to as 'Bullshit'. In order to prove himself as an aggro leader, a fan has not only to prove his ability to lead charges but also the fact that he really means what he is doing. The manner in which he must do this, however, is not always clear. He may do it by actually 'clobbering' somebody, but this would imply a rather drastic escalation of the conflict situation and happens too rarely for everyone in the aggro-leader role to prove themselves. Instead, there simply has to be some consensus among the Rowdies that if things got really bad he would still maintain his stance and be man enough to deal with it. Evidence for such qualities might come from other areas of youth culture. Thus a boy with a reputation for challenging the authority of his teacher in school, or with a record of resisting the restraints of the police, might find it easier to be accepted in the aggro-leader role. Without a reinforcing reputation he might simply be classed as a 'Bullshitter' – the boy who thinks he's hard but isn't – and rejected accordingly. . . .

In general, an aggro leader has to show a distinct sense of fearlessness – he has to be a 'hard case'. But his lack of fear must not be too great, for total fearlessness, the issuing of challenges against impossible odds, is the prerogative of the nutter. And fans are in no doubt as to where bravery ends and sheer lunacy begins.

Nutter

There are usually about five or six nutters in the London Road End at any one time. These are individuals whose behaviour is considered to be so outrageous as to fall completely outside the range of actions based on reasons and causes. Typical of their behaviour would be 'going mad', 'going wild' or 'going crazy'. Attempting to beat someone to a pulp would be described in these terms. It is the existence of this kind of role, and the presence of notions of 'unreasoned' action, which is taken as strong corollary evidence for assuming the existence of a tacit awareness among fans of the rules governing social behaviour on the terraces.

To call someone a nutter, however, is not to use what they would see as a term of abuse. It is simply to make a comment about their style of doing things. Blackpool fans even have a chant which runs: '*We are the Nutters – we come from the sea*'. The implication would seem to be that the opposition fans had better watch out because Blackpool fans might not be restricted by normal conventions. The chant '*There's gonna be a Nasty Accident*' probably expresses a similar sentiment.

We talked to nutters frequently over a period of two years and some were 'interviewed' in a more structured manner. All of them were aware of their role and didn't seem to mind too much that their peers thought them to be crazy. . . . The function of their role we see as being, like that of the deviant in relation to society, the visible demonstration of the limits to 'legitimate' action. The nutter is acceptable in that he demonstrates to other fans what they should not do, and provides living proof of their own propriety. It is at this point that we can begin to see how deviant groups – even evil Folk Devils – construct an order which in many ways is based closely on the order of the society which makes them outcasts.

Although the behaviour of nutters is clearly different from that of other fans in the Rowdies group, there is still a sense of order in what they do. Even 'going crazy' involves the following of certain conventions and restrictions. . . . In many ways, their crazy actions are analogous to the hysteria of young girl pop fans, who on first sight seem to be totally out of control, but can clearly be shown to be engaging in an intentional, conscious and structured activity. . . .

Hooligan

The term 'hooligan' derives from the name 'Houlihan', a noticeably anti-social Irish family in nineteenth-century east London. Since 1970, the media

335

in this country have become very attached to the label, judging by the extent to which they increasingly use it. Before this time, fans were referred to mainly as 'ruffians' or 'tearaways' and the use of 'hooligan' marks a distinct stage in the media's contribution to deviancy amplification. But as Laurie Taylor and others have shown (Taylor 1976), terms which originally begin life as terms of abuse or disapproval often become used by the victims of the term to mean something quite different. Thus football fans have incorporated the term 'hooligan' into their own social talk and use it as a term for referring to boys who commit acts generally thought worthy of some praise. Such acts often involve minor damage to property or disruption of certain routine social events. The main characteristic, however, is not the act itself, but rather the manner in which it is carried out – in particular it has to be funny. Picking up a bubble-gum machine from outside of a shop and running off with it, for example, would be generally thought rather dull. Picking it up and pretending to do a rather elaborate waltz along the road with it, on the other hand, would be thought of as a much more creditable act of hooliganism. The object is not to create damage and disorder *per se*, but to carry out an act which is guaranteed to enrage the victim without doing what he thinks you are doing, i.e. stealing his machine. In all probability the machine would be replaced once the 'laugh' was over, and failure to do so might well lead to censure from others in the Rowdies group. Those most skilled in carrying out such activities and getting away with them come to be recognized within the group as hooligans. . . .

Becoming a hooligan within the Rowdies group is not a simple matter. Powers of witty innovation have to be developed which enable a fan to change the whole nature of a social situation. In a sense he must be a jester – a player of practical jokes and a bit of a 'devil'. But he must never be simply a 'clown'. Clowns in the social world of soccer fans, are the pathetic figures who will never make it. They are the ones who aspire to being hooligans but lack the 'bottle' to succeed in such a role.

Organizer

The London Road End always seems to have at least one organizer, and usually two. Their function is simply that of dealing with the business aspects of terrace life and of negotiating with the outside world. Chiefly they are responsible for hiring coaches to away matches and for getting occasional petitions signed. . . .

Like the other roles we have sketched, being an organizer required a particular set of skills and a particular commitment to the group. It demanded a lot of work and the carrying of a great deal of responsibility. But it provided the occupant of this role with a very central and secure position within the group via a means that required no conflict with the rest of society. . . .

The major purpose in outlining the roles within the Rowdies group has been to demonstrate that football fans of this type are not simply to be viewed

as a disordered bunch of maniacs. But a demonstration or orderliness must also involve appeal to an existing social structure which serves to 'institutionalize' action – that is, to impose a set of constraints on behaviour and, at the same time, to endow action with meaning. For this purpose, we need to show that the roles serve as a focus for patterns of social relationships and for a framework enabling social development. With this in mind, one must be concerned with how fans gain admission to the Rowdies group, how they are able to progress socially within the group, and with how they are able to graduate out of the group.

Admission to the Rowdies group can be obtained in one of two ways. The first method involves graduation from the Novices group. Having spent some time as a 'little kid' at the front of the terrace, and having learned through close observation the most rudimentary rules of conduct appropriate to being a Rowdy, the young fan simply shifts his location to the back of the End and to the fringes of the Rowdies group. Here he will have to serve a form of apprenticeship before he is accepted or even noticed. An exception to this might arise if a young fan has, as a Novice, shown special merit which has come to the attention of others. He might, for example, have shown himself to be a little 'hard-nut'. A small boy of 8 called Louis had done just this. His diminutive figure was always to be seen during battles with the opposition, and for this reason he gained exceptionally early admission to the Rowdies as a kind of unofficial mascot. Apart from Louis, however, most Novices moved quietly up when they felt ready for it. Within their own group there was little to strive for since there were no clearly identifiable roles available. Nor was there much in the way of a social structure. Novices 'hung around' together but there were few strong ties between them.

The other method of entry to the Rowdies was by joining one's mates from school or local housing estate. In this way many fans were able to miss out the first graduation step and serve a short probation at the back of the terrace. It should be remembered that there are no formal rules for admission to the Rowdies. Anyone who is prepared to wear the right 'gear' and to join in the singing and chanting will be accepted. Identification with the team and engaging in the correct patterns of support for it are sufficient. (So long as one isn't a 'creep' of course.) Having gained admission, the way is then open to choose the direction of one's career and to become known by name to others within the group. . . .

The Rowdies group represents the most salient stage in the fan's career. It is within this group that he comes to establish both personal social bonds within his particular sub-group, but also comes to feel part of a wider social collective, as witnessed by the 'we're all in it together' type of accounts given by members. It is also within this group that a fan has the most obvious opportunities for becoming somebody special. By the time he has reached the age of 17 of 18, however, a new decision has to be made. By this time a fan will be working and will be getting too mature to maintain the style of dress and behaviour that membership of the Rowdies group requires. Two

choices present themselves. He can either 'retire' to less active parts of the ground (assuming he wishes to continue watching football) or he can seek acceptance with the Town Boys.

The Town Boys in a way are an enigma, and how one joins them is by no means easy to discover. They speak disparagingly of the Rowdies, yet many of them were once Rowdies themselves. They have a reputation for being tough but rarely give any evidence of being so. In fact, at most matches, they do very little at all except set up a few chants when things are a bit quiet. Despite this, however, it was possible to isolate two major roles within the group and to gain some insight concerning the requirements of anyone wishing to graduate into this group.

Fighter

About six members of the Town Boys were consistently referred to as people with reputations for fighting. Stories were told about how they had actually done considerable damage to some visiting fans when situations had got out of hand. There was no indication that they, unlike the aggro leaders, were actively engaged in inciting other fans to join in the scraps or that they led concerted attacks against the opposition. Rather, when trouble had boiled over, which was pretty rare, they were the ones who stood and slugged it out. Two such fighters were persuaded, over several pints of beer, to talk about themselves and the reputations they had acquired. (One doesn't simply *interview* a fighter.) One fighter had been a Skinhead and had worn the appropriate 'gear' of his time but had now grown out of this kind of thing. (He was 22.) The other fighter came from Nottingham four years ago and had seen much worse than one ever saw at Oxford. . . . They totally dissociated themselves from the Rowdies, who they thought of as kids, who, by mouthing off all the time, started trouble which was left to them to finish off. One of the fighters later became a club steward and, dressed in a white coat with a red armband, was officially hired to sort out the Rowdies.

Heavy drinker

A number of other young men in the Town Boys group were well known for their ability to drink impossible-sounding quantities of beer. Estimates of the volume varied, but a figure of fifteen pints in one evening was common. Many appeared to be visibly drunk at matches and were often thrown out by the police for this reason. They did, however, provide a good deal of entertainment for the rest of the group and would be missed if they did not turn up for a game.

The common feature of all members of the Town Boys group was that they had all held dominant roles within the Rowdies group or its equivalent at some stage in their careers. . . .

Membership of the Town Boys represents the last promotion in the career of the football fan at Oxford and only the most committed are eligible.

Having got this far they can rest on their laurels for as long as they wish. No more will they be called upon to prove themselves by engaging in certain prescribed activities and no longer need they safeguard their hard-won reputations. Eventually they will retire to other parts of the ground to watch the match with their wives and girlfriends. . . .

We have been suggesting that career structures can serve well in the explanation of social behaviour which might otherwise appear to have little rationality. The activities of a fan become intelligible if we can interpret them as being instrumental in establishing him in a particular role, or if such activities can be shown to be acceptable demonstrations of character and worth among his peers. This is not in any way to imply any moral or ethical stance on our part. The task is not one of excusing behaviour or of attributing condemnation to it – only one of rendering it explicable in terms of a revealed social order. We may not like what fans do and we may view aggro leaders and their like as unhappy reminders of a violent society in which we live. Similarly we may see the nutter as a pathetic figure who has to resort to self-humiliation in order to establish an identity for himself. But at the same time, we must pay careful attention to what such young people are actually *doing* rather than to the easy caricatures of them which some seem to prefer. Whilst we may feel that it is unfortunate that such career structures exist at all we might do well to examine our own mechanisms for getting ahead. In doing so, we might, to our discomfort, recognize that football fans are playing a very similar game to the rest of us in society.

Chapter 37

Paul Gilroy

DIASPORA, UTOPIA AND THE CRITIQUE OF CAPITALISM [1987]

BLACK EXPRESSIVE CULTURES affirm while they protest. The assimilation of blacks is not a process of acculturation but of cultural syncretism (Bastide 1978). Accordingly, their self definitions and cultural expressions draw on a plurality of black histories and politics. In the context of modern Britain this has produced a diaspora dimension to black life. Here, non-European traditional elements, mediated by the histories of Afro-America and the Caribbean, have contributed to the formation of new and distinct black cultures amidst the decadent peculiarities of the Welsh, Irish, Scots and English. These non-European elements must be noted and their distinctive resonance must be accounted for. Some derive from the immediate history of Empire and colonization of Africa, the Caribbean and the Indian sub-continent from where post-war settlers brought both the methods and the memories of their battles for citizenship, justice and independence. Others create material for the processes of cultural syncretism from extended and still-evolving relationships between the black populations of the over-developed world and their siblings in racial subordination elsewhere.

The effects of these ties and the penetration of black forms into the dominant culture mean that it is impossible to theorize black culture in Britain without developing a new perspective on British culture *as a whole*. This must be able to see behind contemporary manifestations into the cultural struggles which characterized the imperial and colonial period. An intricate web of cultural and political connections binds blacks here to blacks elsewhere. At the same time, they are linked into the social relations of this country. Both dimensions have to be examined and the contradictions and continuities which exist between them must be brought out. Analysis must for

example be able to suggest why Afrika Bambaataa and Jah Shaka, leading representatives of hip-hop and reggae culture respectively, find it appropriate to take the names of African chiefs distinguished in anti-colonial struggle, or why young black people in places as different as Hayes and Harlem choose to style themselves the Zulu Nation. Similarly we must comprehend the cultural and political relationships which have led to Joseph Charles and Rufus Radebe being sentenced to six years imprisonment in South Africa for singing banned songs written by the Birmingham reggae band Steel Pulse – the same band which performed to London's RAR carnival in 1978.

The social movements which have sprung up in different parts of the world as evidence of African dispersal, imperialism and colonialism have done more than appeal to blacks everywhere in a language which could invite their universal identification (Sheppard *et al.* 1875). They have communicated directly to blacks and their supporters all over the world asking for concrete help and solidarity in the creation of organizational forms adequate to the pursuit of emancipation, justice and citizenship, internationally as well as within national frameworks. The nineteenth-century English abolitionists who purchased the freedom of Frederick Douglass, the distinguished black activist and writer, were responding to an appeal of this type. The eighteenth-century settlement of Sierra Leone by blacks from England and their white associates and the formation of free black communities in Liberia (Geiss 1974) remain an important testimony to the potency of such requests. The back-to-Africa movements in America, the Caribbean and now Europe, Negritude and the birth of the New Negro in the Harlem Renaissance (Perry 1976; Berghahn 1977) during the 1920s all provide further illustrations of a multi-faceted desire to overcome the sclerotic confines of the nation state as a precondition of the liberation of blacks everywhere (Padmore 1956).

Technological developments in the field of communication have, in recent years, encouraged this desire and made it more powerful by fostering a global perspective from the memories of slavery and indenture which are the property of the African diaspora. The soul singers of Afro-America have been able to send 'a letter to their friends' in Africa and elsewhere. The international export of new world black cultures first to whites and then to 'third world' markets in South America and Africa itself (Wallis and Malm 1984), has had effects unforeseen by those for whom selling it is nothing other than a means to greater profit. Those cultures, in the form of cultural commodities – books and records – have carried inside them oppositional ideas, ideologies, theologies and philosophies. As black artists have addressed an international audience and blues, gospel, soul and reggae have been consumed in circumstances far removed from those in which they were originally created, new definitions of 'race' have been born. A new structure of cultural exchange has been built up across the imperial networks which once played host to the triangular trade of sugar, slaves and capital. Instead of three nodal points there are now four – the Caribbean, the US, Europe and Africa. The cultural and political expressions of new world blacks have been transferred

not just to Europe and Africa but between various parts of the new world itself. By these means Rastafari culture has been carried to locations as diverse as Poland and Polynesia, and hip-hop from Stockholm to Southall.

Analysis of the political dimensions to the expressive culture of black communities in Britain must reckon with their position within international networks. It should begin where fragmented diaspora histories of racial subjectivity combine in unforeseen ways with the edifice of British society and create a complex relationship which has evolved through various stages linked in different ways to the pattern of capitalist development itself. . . .

Daddy Peckings, the proprietor of Pecking's Studio One record shop in West London, was the first person to sell reggae and its antecedents – blue beat, ska and rocksteady – in this country. He has described the gradual transformation of American musical forms, particularly jazz and jump blues, and their junction with traditional Jamaican musics. This cross-fertilization would eventually lead to modern reggae, the evolution of which can be traced through the development of 'sound systems' (Bradshaw 1981) – large mobile discos – and their surrounding culture in Jamaica and Britain. According to Peckings, the sound systems playing in the dance-halls of Kingston in the late 1940s and early 1950s – Waldron, Tom 'The Great' Sebastian and Nick – offered a mixture of bebop and swing. The big-band sounds of Duke Ellington and Count Basie were reworked by local musicians: Milton McPherson, Redva Cooke, Steve Dick and Jack Brown. Travelling to England in May 1960, Peckings set up a UK outlet for the product of legendary Jamaican producer and entrepreneur Coxsone Dodd, boss of the legendary Studio One label and the man credited not only with the discovery of modern Jamaica's greatest musical talents – The Heptones, Freddie McGregor, Jackie Mittoo, The Wailers – but with the creation of reggae itself. The fledgling sound system culture of urban Jamaica was transplanted into Britain during the 1950s and on his arrival, Peckings began to supply records to Duke Vin of Ladbroke Grove, the first sound system in this country.

The basic description of a sound system as a large mobile hi-fi or disco does little justice to the specificities of the form. They are, of course, many thousands of times more powerful than a domestic record player but are significantly different from the amplified discos through which other styles of music have been circulated and consumed. The sound that they generate has its own characteristics, particularly an emphasis on the reproduction of bass frequencies, its own aesthetics and a unique mode of consumption. The form of sound systems and the patterns of consumption with which they have become associated will be discussed in detail below. The mark of African elements can be identified on different aspects of sound system culture.

Regardless of their forms and characteristic content, it is necessary to comprehend the importance of the sound systems for both the Jamaican reggae music industry which grew directly out of their activities and for the expressive culture of black Britain in which they remain a core institution. Perhaps the most important effect of the sound systems on the contempo-

rary musical culture of black Britain is revealed in the way that it is centred not on live performances by musicians and singers, though these are certainly appreciated, but on records. Public performance of recorded music is primary in both reggae and soul variants of the culture. In both, records become raw material for spontaneous performances of cultural creation in which the DJ and the MC or toaster who introduces each disc or sequence of discs, emerge as the principal agents in dialogic rituals of active and celebratory consumption. It is above all in these performances that black Britain has expressed the improvization, spontaneity and intimacy which are key characteristics of all new world black musics, providing a living bridge between them and African traditions of music-making which dissolve the distinctions between art and life, artefact and expression which typify the contrasting traditions of Europe (Hoare 1975; Keil 1973; Sithole 1972). As Keil points out, 'outside the west, musical traditions are almost exclusively performance traditions' (1972: 85). Sound system culture redefines the meaning of the term performance by separating the input of the artists who originally made the recording from the equally important work of those who adapt and rework it so that it directly expresses the moment in which it is being consumed, however remote this may be from the original context of production. The key to this process is the orality of the artistic forms involved.

The shifting, specialized vocabularies of sound system culture have changed and developed within contradictions generated by wider political and cultural processes – changing patterns of 'race' and class formation in the Caribbean, the US and Britain. The reliance on recorded music takes on even greater significance when it is appreciated that for much of the postwar period, Britain, unlike the US and the Caribbean, lacked both a domestic capacity to produce black musics and any independent means for their distribution. At this stage, the BBC was not interested in including African and Caribbean music in their programmes. When 'pop' charts began to be compiled, black shops and products were structurally excluded from the operations which generated them. This situation contrasts sharply with the position in the US where a well-developed market for 'race records' had grown up (Gillett 1972), with its own distributors, charts and above all radio stations as a crucial means to spread and reproduce the culture.

Black Britain prized records as the primary resource for its emergent culture and the discs were overwhelmingly imported or licensed from abroad. The dependency of the British music scene on musics produced elsewhere has progressed through several phases. But even as self-consciously British black forms have been constructed, the basic fact of dependency has remained constant. The cultural syncretism that has taken place across the national boundaries that divide the African diaspora has involved relations of unequal exchange in which Britain, for demographic and historical reasons, has until recently had a strictly subordinate place. The importing of music, often in small quantities, encouraged the underground aspects of a scene in which outlets into the dominant culture were already rare. Competition between

sound system operators had been an early feature of the Jamaican dance-halls, and was entrenched over here as sound systems jostled for the most up-to-date and exclusive tunes imported from the US as well as the Caribbean. In a major survey of London's black music scene of the early 1970s, Carl Gayle explored the appeal of imported 'pre-release' records on the dance-hall circuit:

> The youngsters today spend more than they can afford on records, but they want the best and the rarest. . . . 'We import our records three times a week from Jamaica' said a young guy called Michael. . . . 'Pre-release music to me and many people like Sound System men and their follow-ers, is like underground music. As soon as it's released it's commercial music. So you find the youth of today, the ghetto youth like myself, pre-release music is like medicine. They'll go anywhere to hear it'.
>
> [Gayle 1974]

The identification of imported music as free from the commercialization which characterized the British music industry is an important expression of the politics which infused the roots music scene. The supposedly non-commercial status of imported records added directly to their appeal and demonstrated the difference between black culture and the pop-world against which it was defined.

The rivalry between 'sounds' over records was paralleled on the dance-floors by the intense competition between their followers. The ritual expressions of both were dance competitions and the occasional fight. In the early 1970s reggae and soul scenes, the formal competitions centred on 'shuf-fling' and the rivalry between different sound systems was particularly intense where operators from north and south of the river clashed, each operator and toaster striving to match the other tune for tune, rhythm for rhythm, until the system with the best tunes and the weightiest sound emerged as the victor. Carl Gayle identified the level of violence in these encounters as one factor in the decomposition of the scene into sharply differentiated soul and reggae sub-scenes during the 1970s:

> The rivalry which developed between North and South . . . was the foundation for much of the violence of the Ram Jam and other clubs and was perpetrated by the supporters of the Sound Systems – Coxon and Duke Reid in the South and Count Shelly in the North especially. This rivalry, which often erupted into violence was responsible for the division of the black music scene as a whole. . . . The clubs lost their respectability. Consequently many black youngsters dropped out of the once peaceful reggae-oriented sub-culture, opting for the more tran-quil soul scene. Soul had always been popular with West Indians anyway and a lot of people just got scared of the hooliganism.
>
> [Gayle 1974]

Gayle tentatively suggests that this violence was something which made reggae attractive to white youth and that it was a significant element in the forging of links between reggae and the skinheads around common conceptions of masculinity and machismo.

At its height, the late 1960s and early 1970s club scene involved alcohol-free daytime sessions completely dominated by dance at some of the best venues. For example, the Sunday afternoon 2–6 p.m. sessions at the Ram Jam in Brixton provided an antecedent for the equally drinkless Saturday lunch time events organized by DJ Tim Westwood, which were instrumental in the spread of hip-hop in London during the 1980s. Like the hip-hop mixers of the later era the sound system DJs often removed the labels from the records which they used. This gesture combined the obvious desire to keep the information contained on the labels secret, with a comment on the distance which these sub-cultures had travelled from the commercialized, overground equivalents. The removal of labels subverted the emphasis on acquisition and individual ownership which the makers of black music cultures identified as an unacceptable feature of pop culture. This simple act suggested alternative collective modes of consumption in which the information essential to purchase was separated from the pleasure which the music created. The record could be enjoyed without knowing who it was by or where it was in a chart. Its origins were rendered secondary to the use made of it in the creative rituals of the dance-hall.

Deprived of access to the official charts, the black record sellers began to produce their own alternative indices of roots popularity in specialist publications devoted to black music and in the community's own news and political weeklies. The specialist monthly *Black Music* was launched in December 1973, at exactly the same time as minority programming of black musics was beginning to be introduced into the newly expanded local radio network. The size and distribution of Britain's black populations imposed severe limits on the amount of money which could be made from catering to their leisure needs. The communities remained diverse, small and scattered. These characteristics were important factors in the expansion of black leisure institutions and their partial adaptation to the demands of white Britons. The involvement of whites, particularly young people, in the consumption of black cultures was noted by commentators in the early 1960s. It has been discussed by other authors and by myself elsewhere (Patterson 1966; Hebdige 1979; Gilroy and Lawrence 1982). The centrality of distinctively black forms to white youth cultures was observed by Hamblett and Deverson in 1964:

> The Blue Beat is here to stay. . . . Around the dancehalls and discotheques the Blue Beat has been added to the youngsters' already overstepping dance crazes. . . . Many mods that I have spoken to say that the Mersey Sound is out and this new sound is the big thing at the moment. As one youngster put it to me 'The Beatles have been well and truly squashed and we don't dig their sound anymore'.

This mod's use of black American slang, 'dig', and the Beatles' early reliance on cover versions of material from rhythm and blues artists like Barrett Strong and Larry Williams are probably as significant as the blue beat itself in the history of how popular culture has formed spaces in which the politics of 'race' could be lived out and transcended in the name of youth.

The development of Jamaican popular music in the encounter between folk forms and American R and B picked up from radio stations transmitting in the southern states is well known (Clarke 1980; Kimberley 1982). At each stage of its progress through blue beat, ska, rocksteady and reggae it is possible to indicate shifting patterns in the involvement of young whites. For example, a white reggae band 'Inner Mind' was formed in London during 1967 and was considered good enough to back such vintage Jamaican performers as Laurel Aitken, Alton Ellis and Owen Grey. The band played at all the leading black venues of the period – Mr B's, the Q and Colombo's in London, the Santa Rosa in Birmingham and Wolverhampton's Club '67. . . . The mass marketing of Caribbean music as a pop form can be traced from Millie Small's 'My Boy Lollipop' through the reggae festival at Wembley Stadium in 1969 and into the selling of Bob Marley as a 'rebel superstar'. Simon Jones (1986) has pointed out that there were seventeen top twenty hits based on Jamaican music during the period 1969–72. The attempts of white companies to sell the music to whites also relied on the growth of minority programming within the newly established local radio network. The local stations which proliferated between 1970 and 1972 were concentrated in urban areas and each of them featured two or three hours of black music per week. This development was more significant in the history of Caribbean forms, because the pirate radio stations and the American Forces station in Europe already carried a certain amount of soul music to British fans. Radio Luxembourg, a leading pirate, broadcast Dave Christian's 'Soul Bag' early (1.30 a.m.) on Monday mornings. The new local stations made black music available to anyone who was interested enough to tune in to the unpopular slots – usually Sunday lunchtime – in which the minority shows were programmed. In the south-east, Steve Barnard's 'Reggae Time' on Radio London became particularly influential. Having experimented with several presenters for their reggae programme, Capital Radio launched David Rodigan's 'Roots Rockers' in October 1979. This show become the most important in reggae broadcasting, extending its running time from one and a half to three hours. The power of the show and the extent to which the reggae industry depended on it were revealed in 1985 when Rodigan announced that he had been threatened and intimidated by a small minority of record producers who sought to use the show to push their own product and ensure its commercial success regardless of artistic considerations. Rodigan did not name the producers responsible for his harassment, but told his listeners over the air:

> I've reached the point of no return with these hustlers. I'm tired of the threats and I'm standing up to them from now on. I'm going

to entertain the public, not the reggae producers. I'm not going to bow down any more. All they can do is kill me now – that's all they can do.

[Rodigan 1985]

The gradual involvement of large corporations with a broad base in the leisure industries in the selling of reggae stimulated important changes reflecting a conscious attempt to separate the product from its producers and from its roots in black life. Whatever the effect of the reggae film *The Harder They Come* in the Caribbean (Brathwaite 1984), in Britain, it marked the beginning of a new strategy for white consumption. The film was presented as little more than visual support for the sound-track recording made available by Island Records, an Anglo-Jamaican company. Cinemas showing the film became artificially insulated spaces in which images of black life, in this case as backward, violent, sexist and fratricidal, could be consumed without having to face the difficulties associated with sharing leisure space with real live black people. Island Records, the company who pioneered this ploy, elaborated it further in subsequent films of reggae artists in live performance and in the 'adventure fantasy', *Countryman* in 1982. This last film, a tale of Obeah and adventure, was based on a simple inversion of the Robinson Crusoe myth. 'Friday', recast in the form of a Rasta hermit–fisherman endowed with magical powers that originated in his total harmony with the natural world, saves and protects two young white Americans who fall into his Eden as the result of a plane crash. They are unwittingly involved in the drug business but with his help are reunited with their families and sent back to the US once the villains, the military wing of Michel Manley's socialist government, have been put in their place. This plot is less significant than the fact that the film was billed as 'A tribute to Bob Marley'. This time, the soundtrack recording featured his songs.

Island Records was also at the forefront of moves to sign black performers and, having adjusted their music and image to the expectations of white rock audiences, sell them as pop stars. The example of Bob Marley, an Island artist from 1972 until his death in 1981, provides the most acute illustration of a marketing process which was repeated by the company on a smaller, less successful scale with other lesser known (in rock terms) artists like the Heptones and Burning Spear. It was a strategy which was less productive for other rival British companies which lacked Island's roots in the Caribbean. Foremost among these was Virgin, who signed many leading Jamaican performers – the Gladiators, U Roy and the Mighty Diamonds – in the early 1970s. Marley's rise was also significant in that it facilitated the popularization of Rastafari ideology in Britain and throughout the world. The years between 1972 and 1981 saw him rise to outernational prominence and take reggae music forever into the lexicon of pop. There are good reasons to support the view that his foray into pop stardom was a calculated development in which he was intimately involved, having realized that the

solidification of communicative networks across the African diaspora was a worthwhile prize. The minor adjustments in presentation and form that rendered his reggae assimilable across the cultural borders of the overdeveloped countries were thus a small price to pay. His incorporation of bluesy guitar playing and 'disco' rhythms can be interpreted not as obvious concessions to the demands of a white rock audience (Wallis and Malm 1984), but as attempts to utilize the very elements most likely to appeal to the black audiences of North America.

Marley died at the very moment when he had steered reggae to the brink of an organic and overdue encounter with rhythm and blues. His work found considerable support in the new pop markets of Latin America and Africa, where he had performed at the independence ceremonies for Zimbabwe, symbolizing the recovery of Africa for the black peoples of the new world and the recovery of the new world diaspora for Africa. Whatever the ambiguities in Marley's music and mode of presentation, he provided a heroic personality around which the international mass-marketing of reggae could pivot. His 'Exodus' album remained on the British pop chart for fifty-six consecutive weeks in the period 1977–8. Marley acknowledged his newfound white listeners with the release of 'Punky Reggae Party' also in 1977. It signified not so much the confluence of two oppositional impulses – Rasta and punk – as the durability of pop and its capacity to absorb diverse and contradictory elements. The Caribbean was becoming an increasingly important sub-cultural resource once white British youth began to break free of their own dependency on American images and meanings (Hebdige 1983). By consolidating reggae's position on the charts outside novelty categories and becoming a star, Marley created a new space in pop. In the period leading up to his death, it was a space filled primarily by the 'two-tone' cult. In this movement, earlier Caribbean forms, particularly ska, which had been exposed by the serious reggae fans' search for musical authenticity behind Marley's obvious compromises, were captured and rearticulated into distinctively British styles and concerns. This fusion took several contrasting paths. The assertively 'white' reggae of London bands like Madness and Bad Manners attracted the support of young racists, whose patriotic nativism had been reborn in the revival of the skinhead style. It contrasted sharply with the work of racially mixed groups from the Midlands. Where Madness simply hijacked ska and declared it white, the Beat, the Specials and other similar outfits sought to display the contradictory politics of 'race' openly in their work. Their best efforts acknowledged the destructive power of racism and simultaneously invited their audience to share in its overcoming, a possibility that was made concrete in the co-operation of blacks and whites in producing the music.

If Marley's excursions into pop had seeded the ground for this two-tone harvest, this era suggests that the lasting significance of his rise to prominence lies not at the flamboyant extremities of youth subculture where punks had reworked the themes and preoccupations of Rastafari around their dissent

from and critique of Britishness, but in the youth–cultural mainstream. Here, the posters of Bob, locks flying, which had been inserted into his crossover product by Island, became icons in the bedroom shrines of thousands of young whites. In his egalitarianism, Ethiopianism and anti-imperialism, his critique of law and of the types of work which were on offer, these young people found meanings with which to make sense of their lives in post-imperial Britain. The two-tone bands appreciated this and isolated the elements in Marley's appeal that were most appropriate to the experiences of young, urban Britons on the threshold of the 1980s. They pushed the inner logic of his project to its conclusion by fusing pop forms rooted in the Caribbean with a populist politics. Marley's populism had been focused by the imperatives of black liberation and overdetermined by the language of Rastafarian eschatology. Theirs was centred instead on pointing to the possibility that black and white young people might discover common or parallel meanings in their blighted, post-industrial predicament. The experience of living side by side in a 'ghost town' had begun to raise this question. The Specials' song, which topped the chart as the rioting of 1981 was at its peak, asked, 'Why must the youth fight against themselves?' and cleverly entangled its pleas against both racism and youth-cultural sectarianism. The two-tone operation depended on being seen to transcend the various prescriptive definitions of 'race' which faced each other across the hinterland of youth culture. With Marley's death equilibrium was lost. One pole of the cultural field in which two-tone had formed ceased functioning. Marley's position was usurped eagerly not by the next generation of Jamaican and British artists who had been groomed by their record companies to succeed him, but by a new wave of post-punk white reggae musicians. The best known of these inverted the preconceptions of Rasta by calling themselves The Police and armed with 'Aryan' good looks and dedication to 'Reggatta de Blanc' served, within pop culture at least, to detach reggae from its historic association with the Africans of the Caribbean and their British descendants.

George Lipsitz

CRUISING AROUND THE HISTORICAL BLOC

Postmodernism and popular music in East Los Angeles [1990]

DURING HIS FIRST VISIT to Los Angeles, Octavio Paz searched in vain for visible evidence of Mexican influence on that city's life and culture. The great Mexican writer found streets with Spanish names and subdivisions filled with Spanish Revival architecture, but to his surprise and dismay he perceived only a superficial Hispanic gloss on an essentially Anglo-American metropolis. Mexican culture seemed to have evaporated into little more than local color, even in a city that had belonged to Spain and Mexico long before it became part of the United States, a city where one-third of the population traced its lineage to Olmec, Maya, Toltec, Aztec, Spanish, and Mexican ancestors, and a city which had more Mexican residents than all but two of Mexico's own cities. Paz detected a 'vague atmosphere' of Mexicanism in Los Angeles, manifesting itself through 'delight in decorations, carelessness and pomp, negligence, passion and reserve'. But he felt that this 'ragged but beautiful' ghost of Mexican identity only rarely interacted with 'the North American world based on precision and efficiency.' Instead, this Mexicanism floated above the city, 'never quite existing, never quite vanishing' [Paz 1961: 13].

As both the oldest and the newest immigrants to Los Angeles, Mexican-Americans have faced unique problems of cultural identity and assimilation. But the anguish of invisibility that Paz identified among them is all too familiar to minority ethnic communities around the globe. Everywhere, cultural domination by metropolitan elites eviscerates and obliterates traditional cultures rooted in centuries of shared experience. For ethnic minorities, failure to assimilate into dominant cultures can bring exclusion from vital economic and political resources, but successful assimilation can annihilate prized tradi-

tions and customs essential to individual and collective identity. Cultural institutions and the mass media alike depict dominant cultures as 'natural' and 'normal,' while never representing the world from the vantage point of ethnic communities. Active discrimination and economic exploitation reinforce a sense of marginality among aggrieved peoples, but mass-media images rarely grant legitimacy to marginal perspectives. Traditional forms of cultural expression within ethnic communities lose their power to order and interpret experience, yet they persist as important icons of alienated identity. Surrounded by images that exclude them, included in images that seem to have no real social power, ethnic communities come to feel that they never quite exist and never quite vanish.

But the transformation of real historical traditions and cultures into superficial icons and images touches more than ethnic communities. A sharp division between life and culture provides an essential characteristic of life in all modern industrialized societies, affecting dominant as well as subordinated groups. As Walter Benjamin points out [1968: 255], the production and distribution of art under conditions of mechanical reproduction and commodity form lead to an alienated world in which cultural objects are received outside of the communities and traditions that initially gave them shape and meaning. Created artifacts from diverse cultures blend together into a seeming contextless homogenized mass, encountered independently from the communities that gave birth to them. Mass communications and culture rely on an ever-expanding supply of free-floating symbols only loosely connected to social life. Experience and traditions seem to have no binding claims on the present. Ours is a world in which 'all that is solid melts into air' as Marshall Berman [1982] asserts in a phrase appropriated from the *Communist Manifesto*.

Members of dominant social groups might not feel quite the same anguish of invisibility that oppresses cultural minorities, but cultural identity for them has become no less an exercise in alienation. The seeming collapse of tradition and the tensions between cultural commodities and social life make mass cultural discourse a locus of confusion and conflict. A proliferation of composite cultural creations and marginal subcultures claim the same 'authority' wielded by traditions rooted in centuries of common experience. The revered 'master narratives' of the past – religion, liberal humanism, Marxism, psychoanalysis – survive in truncated form, influencing but not dominating social discourse. Instead, a multivocal and contradictory culture that delights in difference and disunity seems to be at the core of contemporary cultural consciousness. This 'postmodern' culture allows the residues of many historical cultures to float above us, 'ragged but beautiful,' 'never quite existing and never quite vanishing' [Paz 1961: 13].

Postmodern culture places ethnic minorities in an important role. Their exclusion from political power and cultural recognition has allowed aggrieved populations to cultivate sophisticated capacities for ambiguity, juxtaposition, and irony – all key qualities in the postmodern aesthetic. The imperatives of

351

adapting to dominant cultures while not being allowed full entry into them leads to complex and creative cultural negotiations that foreground marginal and alienated states of consciousness. Unable to experience either simple assimilation or complete separation from dominant groups, ethnic cultures accustom themselves to a bifocality reflective of both the ways that they view themselves and the ways that they are viewed by others. In a world that constantly undermines the importance and influence of traditions, ethnic cultures remain tied to their pasts in order to explain and arbitrate the problems of the present. Because their marginality involves the pains of exclusion and exploitation, racial and ethnic cultures speak eloquently about the fissures and frictions of society. Because their experience demands bifocality, minority-group culture reflects the decentered and fragmented nature of contemporary human experience. Because their history identifies the sources of marginality, racial and ethnic cultures have an ongoing legitimate connection to the past that distinguishes them from more assimilated groups. Masters of irony in an ironic world, they often understand that their marginalized status makes them more appropriate spokespersons for society than mainstream groups unable to fathom or address the causes of their alienations.

Discussions about postmodern sensibilities in contemporary culture often revolve around trends and tendencies in painting, architecture, and literature, but they have even greater relevance to analyses of commercialized leisure. It is on the level of commodified mass culture that the most popular, and often the most profound, acts of cultural *bricolage* take place. The destruction of established canons and the juxtaposition of seemingly inappropriate items characteristic of the self-conscious postmodernism in 'high culture', have long been staples of commodified popular culture. With their facility for cultural fusion and their resistance to univocal master narratives, expressions of popular culture contain important lessons about the problems and promises of culture in a world in which 'all that is solid melts into air.'

The Mexican-American community of Los Angeles that so disappointed Octavio Paz provides an instructive example of how ethnic minority groups can fashion forms of cultural expression appropriate to postmodern realities. Paz's static and one-dimensional view of Mexican identity prevented him from seeing the rich culture of opposition embedded within the Los Angeles Chicano community. What seemed to him an ephemeral cloud 'hovering and floating' above the city in actuality represented a complicated cultural strategy designed to preserve the resources of the past by adapting them to the needs of the present. In many areas of cultural production, but especially in popular music, organic intellectuals within Mexican-American Los Angeles pursued a strategy of self-presentation that brought their unique and distinctive cultural traditions into the mainstream of mass popular culture. Neither assimilationist nor separationist, they drew upon 'families of resemblance' – similarities to the experiences and cultures of other groups – to fashion a 'unity of disunity' [Berman 1982: 15]. In that way, they sought to make alliances with other groups by cultivating the ways in which their particular

experiences spoke with special authority about the ideas and alienations felt by others. They used the techniques and sensibilities of postmodernism to build a 'historical bloc' of oppositional groups united in ideas and intentions, if not experience.

Popular music in Mexican–American Los Angeles

During the 1940s, defense spending and war mobilization changed the face of Los Angeles, stimulating a massive in-migration of whites, blacks, and Chicanos. Traditional residential segregation confined Afro-Americans to the south-central area, while limiting Chicanos largely to housing in downtown East Side neighborhoods. Private bankers and government planners encouraged housing segregation by class and race, viewing ethnic heterogeneity in Los Angeles (as in other cities) as a defect of urban life rather than as one of its advantages. In this way vicious prejudice became written into federal loan policies and private commercial practices. For example, the Home Owners Loan Corporation City Survey File on Los Angeles for 1939 contained a confidential memorandum that argued against the feasibility of loans to Mexican-Americans because

> While many of the Mexican race are of high caliber and descended from the Spanish grandees who formerly owned all of the territory in Southern California, the large majority of Mexican peoples are a definite problem locally and their importation in the years gone by to work the agricultural crops has now been recognized as a mistake.

Translated into public policy, that perception of Mexican-Americans meant that Chicano neighborhoods would not be eligible for housing loans, thereby ensuring residential segregation in the region. Federal appraisers rated the eligibility of each Los Angeles neighborhood for home loans, giving the highest rating to areas reserved for the exclusive use of white Christians, while assigning the lowest rating to black, Chicano, and mixed neighborhoods. The Federal Housing Authority gave its lowest possible rating to Boyle Heights in East Los Angeles because [of] its mixture of Chicano, Jewish, and Eastern European residents. . . .

Yet the opening of new shipyards and aircraft assembly plants combined with Los Angeles's severe housing shortage produced unprecedented interethnic mixing in the city. Official segregation gave way bit by bit as Chicanos and European ethnics lived and worked together in Boyle Heights and Lincoln Park, while blacks and Chicanos lived in close proximity to each other in Watts and in the San Fernando Valley suburb of Pacoima. On the factory floor, on public transportation, and on the streets of thriving commercial districts, diverse groups mixed with each other as never before. Wherever one traveled in the city's *barrios*, ghettos, and mixed neighborhoods, one

could easily find the potential for inter-group conflicts and rivalries; some-times they took the form of actual racial and ethnic violence. But there also existed a vibrant street life built upon communication and cooperation in community organizations and in neighborhood life.

In this milieu, small entrepreneurs catering to the local market sensed a demand for cultural commodities that reflected the social life of the new urban environment. Before RCA's purchase of Elvis Presley's contract from Sun Records in 1955, the major studios ignored the music emanating from working-class neighborhoods, leaving the field to the more than four hundred independent labels that came into existence after the war. Existing outside corporate channels, the smaller firms in working-class areas produced records geared to local audiences, especially in minority communities. The invention of magnetic recording tape made it possible to enter the record business with relatively little capital, while concentrations of transplanted war workers provided a ready market for music based on country music and blues.

Recruiting performers from the communities they knew best, small-scale local record producers responded to trends in the streets. In addition, the proliferation of local radio stations in the post-war years offered exposure to new audiences. Juke box operators, furniture-store owners, and musicians responded to the consumer demand for a popular music that reflected the folk roots and multiracial ethos of the new urban streets. For example, a 1948 hit record by Los Angeles's Don Tosti Band title 'Pachuco Boogie' went on to sell more than two million copies, an extraordinary total for any Spanish-language record in the U.S., but especially for one that glorified one of the *barrio*'s more reviled subcultures – the Pachucos.

In many ways, Pachucos embodied the defiance of conventional authority that came to symbolize the appeal of rock and roll. Pachucos were teenaged gang members sporting zoot suits, ducktail haircuts, and distinctive tattoos; they had attracted public attention during the war years when newspaper stories blamed them for much of the youth crime in Los Angeles. Tensions peaked in June 1943 when hundreds of sailors invaded the East Los Angeles community to beat up Mexican-American youths who wore zoot suits. The police, prosecutors, and city council joined forces to praise this criminal attack, lauding the sailors for the efforts to 'clean up' the city. But the racism manifest in the attacks caused many Mexican-Americans to start looking at the Pachucos as defenders of the community against outside encroachments and as symbols of Chicano victimization and marginality.

The Don Tosti Band's 'Pachuco Boogie' captured the spirit of that new-found admiration for street rebels. The song's lyrics employed *calo*, the street slang associated with Pachucos but considered vulgar by 'respectable' Mexican-Americans. 'Pachuco Boogie' blended Mexican speech and rhythms with Afro-American scat-singing and blues harmonies to form a provocative musical synthesis. Some Spanish-language radio stations refused to play the song, but Anglo disc jockeys programming black rhythm-and-blues shows aimed at white teenagers put it on their playlists, to the delight of their

listeners. Band member Raul Diaz remembers what it was like before that record became a hit, how Mexican-American musicians like himself often had to wear sombreros and tropical outfits to get work playing music during intermissions at motion-picture theaters. 'We wanted to play Chicano music, not come on like some clowns,' Diaz recalled in the *Los Angeles Times* (12 October 1980)] 'but at that time the scene was dominated by people like Desi Arnaz and Xavier Cugat and the music was really bland.' The Don Tosti Band changed that when 'Pachuco Boogie' sold more than two million copies. Itself a blend of Chicano, Anglo, and Afro-American musical forms, 'Pachuco Boogie' garnered commercial success by uniting a diverse audience into a new synthesis – a 'unity of disunity.'

'Pachuco Boogie' signaled the start of creative new links among previously divided groups. Anglo youths especially imitated the distinctive dress of Mexican-American 'cholos' with their khaki pants and long-sleeved Pendleton shirts over sleeveless white undershirts, and 'cholo' became a hip slang word with larger meanings. The word 'cholo' probably derives from an Aztec word meaning servant, and it connotes someone with low status, usually a recent immigrant from a rural area. Cholos spoke a bilingual slang, displayed elaborate tattoos, and staked their claims to urban neighborhoods by covering walls with stylized graffiti. The studied disinterest and cultivated detachment affected by cholos echoed the oppositional postures of other postwar subcultures including bop musicians and beat poets. But in Los Angeles the cholo relationship to rock and roll made that subculture the most accessible model of 'otherness' for middle-class white youths. When Anglo, black, or even Chicano youths embraced the cholo image, they flaunted their alienation by openly identifying with one of society's most despised groups. . . .

Popular music and postmodernism

The rock-and-roll music created by Mexican-American musicians in Los Angeles since World War II bears particular relevance to the issues of ethnicity, identity, and culture raised in Octavio Paz's lament. From the Don Tosti Band of the 1940s through Los Lobos in the 1980s, Los Angeles's Chicano musicians have made commercially successful records by blending the folk music of Mexico with the cultural fusions of the modern day *barrio*. Their proclivities for mixing eclectic styles, for making references to their community and its history, and for acknowledging the diverse influences on their art display a conscious or intuitive postmodernism – delighting in difference, undermining univocal master narratives, and celebrating the decentered and polyglot nature of popular culture. In its most successful commercial forms, Chicano rock-and-roll music from Los Angeles transformed a specific ethnic culture rooted in common experiences into more than just a novelty to be appropriated by uncomprehending outsiders. Confronted with media monopolies and public sentiments blind to the unique circumstances of

Mexican-Americans, Chicano musicians drew upon both residual and emergent elements in their community to win some measure of participation in the creation and dissemination of mass popular culture. Musical forms and social attitudes emanating from the isolation and marginality of *barrio* life took on new meaning when appropriated as 'youth' music by consumers with little knowledge or concern about the ethnicity of the musicians.

In his superb work in ethnic autobiographies, anthropologist Michael M. J. Fischer [1986] identifies the core components of the postmodern sensibility as bifocality or reciprocity of perspectives, juxtaposition of multiple realities, intertextuality, inter-referentiality, and comparisons through families of resemblance. Fischer's categories encompass the central practices of Los Angeles Mexican-American rock-and-roll musicians since World War II. Caught between the realities of life in their community and the hegemony of Anglo-capitalist culture, Chicano artists fashioned a bifocal music accessible from both inside and outside their community. They juxtaposed multiple realities, blending Mexican folk music with Afro-American rhythm and blues, playing English-language songs in a Mexican style for audiences filled with Spanish speakers, and answering requests for both Mexican and rock music with the same song – 'La Bamba.' They practiced particularly intricate forms of intertextuality by connecting their music to community subcultures and institutions oriented around speech, dress, car customizing, art, theater, and politics. References to shared historical and cultural experiences permeated Mexican-American rock-and-roll songs, but these references extended beyond the immediate Chicano community as songs featured rockabilly and soul influences borrowed from white and black working-class music. That inter-referentiality complemented an equally adept facility for making comparisons through families of resemblance. Chicano musicians and artists could incorporate white rockabilly or black rhythm-and-blues music into their songs because they recognized similarities in form and content that transcended surface differences. Yet even while drawing upon families of resemblance, Mexican-American musicians in Los Angeles never lost sight of the singular historical realities shaping them and their community.

The emergence of Los Lobos as a significant commercial rock-and-roll band in the 1980s provides an illustration of the persistent bifocality, juxtaposition of multiple realities, intertextuality, inter-referentiality, and comparisons through families of resemblance in Los Angeles Chicano music. Mixing Mexican *Norteno* accordions and *guitarrons* with Afro-American and Anglo rockabilly drums and electric guitars, Los Lobos stand between Chicano culture and mass culture, playing to audiences in both camps. The five members of the group first learned to play their instruments in response to the popularity of the Beatles, but they secured their first employment as musicians playing Mexican folk music for neighborhood gatherings. In response to critics who charge that the band's forays into rock and roll betray their roots in folk music, drummer Louis Perez replied in the *Los Angeles*

Times (28 December 1982) 'We always aspired to play to everybody, but there was no place to expose it. We haven't gone back on the basic philosophy of this band, which was to play cultural music. It's a music that's as much Mexican culture as it is American, and that's what we are.' . . .

The fusions that characterize Chicano rock-and-roll music reflect more than the confusions and ambiguities of postmodern society. Their definitive contours come from the conscious choices made by organic intellectuals attempting to address the anguish of invisibility by bringing their own cultural traditions into the mainstream of mass culture. Mexican-American musicians could stay with traditional Chicano musical forms like *ranchera* or *cumbia* musics and find recognition and reward within their own community. Or they could master Anglo styles and assimilate into the mainstream without anyone being aware of their Chicano identity. But Los Angeles Chicano rock-and-roll artists have generally selected another path. They have tried to straddle the line between the two cultures, creating a fusion music that resonates with the chaos and costs of cultural collision. Their choices arbitrate particularly complex tensions emanating from ethnicity and oppression for Chicanos, while holding open to other groups a vision of cultural fusion based on families of resemblance and similarities of emotion and experience.

As members of an aggrieved community, and as artists involved in the generation and circulation of ideas reflecting the needs of that community, Mexican-American rock musicians from Los Angeles have functioned as what Antonio Gramsci referred to as 'organic intellectuals' [1971: 9–10]. Gramsci felt that dominant social groups wield power as much through ideological hegemony as through physical force, and he charged that traditional intellectuals reinforce social hierarchies by serving as 'experts in legitimation.' But Gramsci pointed out that subordinated groups have their own intellectuals who attempt to pose a 'counter-hegemony' by presenting images subversive of existing power relations. The elite try to 'manage consent' by making domination appear natural, voluntary, and inevitable. Organic intellectuals, on the other hand, attempt to build a 'historical bloc' – a coalition of oppositional groups united around counter-hegemonic ideas. The efforts by Chicano rock musicians in Los Angeles to enter the mainstream by linking up with other oppositional cultures reflect their struggle to assemble a 'historical bloc' capable of challenging the ideological hegemony of Anglo cultural domination. In the struggle, they found that their primary weapons included bifocality, juxtaposition of multiple realities, intertextuality, inter-referentiality, and comparison through families of resemblance.

Juxtaposition of multiple realities in Chicano life allowed for juxtaposition of multiple realities in Mexican-American music. In a culture that drew sharp lines among black, white, and brown music and audiences, Chicano rock-and-roll artists worked to break down barriers. To a commercial marketing structure that imposed rigid categories on rock, popular, folk, and ethnic music, they offered songs that fit no simple description. The dominant culture and its popular culture industry often treated ethnicity as a discrete and

finite entity, but Chicano musicians treated it as plastic and open-ended. For them, ethnicity seemed as much a strategic response to the present as an immutable series of practices and beliefs derived from the past. Consequently, they brought a sense of play and whimsy to the arts of *bricolage*. Just as Ritchie Valens experimented with a Bo Diddley-style rhythm-and-blues bass line beneath the Latin guitar standard 'La Malaguena,' Los Lobos brought the accordion and *guitarron* into use as rock-and-roll instruments.

The same forces that encourage Los Angeles's Chicano rock-and-roll musicians to roll back the boundaries of ethnic identity also compel them to incorporate ideas from nonmusical sources into their work. As organic intellectuals chronicling the cultural life of their community, they draw upon street slang, car customizing, clothing styles, and wall murals for inspiration and ideas, as well as upon more traditional cultural creations such as literature, plays, and poems. Their work is intertextual, constantly in dialogue with other forms of cultural expression, and most fully appreciated when located in context.

The commercially successful Chicano band Tierra got its start in the early 1970s as a favorite band of the low-rider [car customizing] subculture in Los Angeles. . . . Low riders are themselves masters of postmodern cultural manipulation. They juxtapose seemingly inappropriate realities – fast cars designed to go slowly, 'improvements' that flaunt their impracticality, like chandeliers instead of inside overhead lights. They encourage a bifocal perspective – they are made to be watched but only after adjustments have been made to provide ironic and playful commentary on prevailing standards of automobile design. They are intertextual – cars are named after songs or incidents in Mexican history, zoot-suited *pachucos* appear in car paintings. Low-rider 'happenings' incorporate elements of popular fashion, dance, and music in a community ritual celebrating the utility and beauty of automobiles that the dominant culture would deem impractical, tasteless, and garish. Tierra incorporated low-rider intertextuality in its music, using fragments of *barrio* memories in song lyrics that celebrate zoot suits and rhythms that approximate the jitterbug dancing of the 1940s and 1950s. In a similar fashion Thee Midnighters wrote and recorded 'Whittier Boulevard' in 1965 to celebrate the culture of car customizers and cruisers along East Los Angeles's main thoroughfare in the 1960s. In 1982 Ruben Guevara's 'c/s' explored Chicano history through the 'writing on the walls' – the distinctive graffiti of the *barrio*.

Chicano musicians had to assume a bifocal perspective as a matter of self-respect. The dominant culture imposed an identity on them. Regardless of their characteristics as individuals, Anglo stereotypes about Mexicans and their culture influenced the ways in which Chicanos were perceived outside the *barrio*, and they had to be aware of the limits imposed on them by that cultural domination. But to accept the stereotypes would mean denying one's own vision. Prevented from defining themselves because of pervasive discrimination and prejudice, but unwilling to leave the work of definition to others,

they adopted a bifocal perspective that acknowledged but did not accept the majority culture's image of Chicanos. . . .

Almost forty years after Octavio Paz's visit to Los Angeles, Mexican-Americans in that city still suffer from the anguish of invisibility. Their numbers have increased, but discrimination and exploitation leave them under-represented and under-rewarded. The expanded reach and scope of the mass media over the past four decades has exacerbated the cultural crisis facing Mexican-Americans; rarely do they see their world presented sympathetically or even accurately in the communications media that reinforce and legitimate Anglo cultural hegemony. But the 'vague atmosphere' of Mexicanism perceived by Paz persists in the present. In community sub-cultures and styles, in the prefigurative counter-hegemony of organic intellectuals, it continues to inform the struggles of the present with perceptions and values of the past. Conscious of the fragmentation of the modern world, this constantly changing 'Mexicanism' cultivates its own marginality even as it reaches out to other groups. It is not a buried master narrative, but, rather, a conscious cultural politics that survives by 'floating and hovering', never quite existing and never quite vanishing. Invisibility has its psychic and political costs, but for Chicano musicians in Los Angeles, it provides the ultimate camouflage for the difficult work of building a historical bloc.

Wendy Fonarow

THE SPATIAL ORGANIZATION OF THE INDIE MUSIC GIG [1995]

WITHIN THE SCOPE of the gig, a live musical performance, a terri-
tory of meaning is constructed in the activity of a musical performance.
At indie gigs, social relationships are enacted through spatial distribution and
different modes of participation within a specific participant framework.
A participant framework provides a frame for the interpretation of activities,
a sense for which actions and utterances are to be taken (Goffman 1974).
Participant frameworks provide guidelines for expected behaviors in an event
including different activities for those with different roles. For indie gigs,
a variable participant framework correlated with different spatial domains
designates a topography of spectorial positionings.

The indie (i.e. independent) music community in Great Britain is defined
by its association with a particular genre of guitar music. For the most part,
indie music is played by young white males in their late teens to early thir-
ties. However, the indie community is fairly welcoming to female performers.
While indie music has been characterized in England as primarily a middle-
class student phenomenon, the community is composed of a cross section of
classes, with a particular ethic that favors showy poverty for performers. The
indie community is predominantly white and straight with a proclivity for
imagery that is sexually muted or androgenous.

For the audience at a gig, there are different modes of participation:
modes dependent upon where the individual members place themselves in
the venue. Activities appropriate in one area are entirely inappropriate in
another. Indie gigs take place in social spaces that differ from traditional
concerts which have assigned seating. Gigs occur in venues where partici-
pants distribute themselves in space. These venues present the opportunity

for interaction, which is often characterized by a high degree of activity and bodily contact. In contrast, concerts that occur in seated halls place participants in equidistant positions and generally discourage or limit physical contact. In open halls, participants place *themselves*; they choose where to stand and what to do with their bodies within the parameters of expected behaviors. This different participatory structure significantly impacts on how the event is experienced.

Indie gigs occur in a number of different settings from small pubs without stages, where the line between audience and performer may be as thin as a piece of tape stuck to the floor, to huge events such as the Reading festival with large stages, security personnel and a gap of some twenty feet between the performer and spectator. Structurally, gigs are predicated on a rudimentary distinction, between the space of the performers and the space of the audience.

The space occupied by the audience can be classified into three zones of activity due to the distinct types of activity that are exhibited in these areas (Figure 39.1). The description of zones is based on the spatial organization of a well-attended gig, ones with at least a few hundred participants. Gigs themselves range in number from performances where only the employees are in attendance to audiences of approximately 2,000. The number of individuals engaging in this participant framework, however, can be much greater. The distribution of audience members at an indie festival like Reading, for example, is analogous to a large gig.

For well-attended shows, these three zones regularly appear. The pit, the area closest to the stage, is the most physically complicated. The second zone on the main floor begins a quarter of the way back into the venue and reaches to the back of the floor area. It is the most static. The third is the area in the back of the venue – including the bars. It has the most disparate activities and far-reaching effects on the transnational culture of music production and consumption.

Zone one: stage side and the pit

Zone one is composed of the front rows of people, the 'pit', and the people immediately behind the pit (Figure 39.2). Near the front, audience density is very high and activities such as diving from the stage on to other audience members or being hoisted by friends and rolling on top of the crowd are quite common. Often horizontal pressure is such that an individual's feet are lifted off the ground. There is a high degree of bodily activity including pogoing, slamming, moshing, and the shaking of heads.

Zone one is the domain of greatest and most frenetic activity, the youngest audience and strongest statement of fanship. The front is comprised of the very youngest members of the audience, from about the age of 14 to the age of 21. Within this zone, there are acute gender distinctions in terms

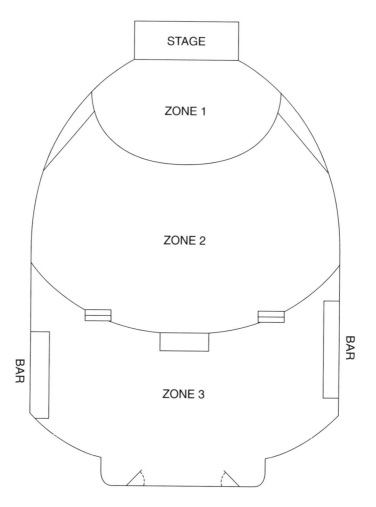

Figure 39.1 The Forum, London

of bodily distribution. At indie gigs, females consistently constitute only 35 per cent of the audience. In zone one, females generally stand in the front three rows or slightly further back in the peripheral side areas. The mosh area is primarily male.

The space and the participant framework at the front of these gigs present rather uncommon bodily conditions for social interaction. Here, one has intimate physical contact with strangers. The front is a social space that allows 'crowd surfing', an activity where one is supported on top of other audience members and rolls horizontally across the crowd. Crowd surfing is extremely collaborative. Not only does an individual need at least one other person to enable him/her to climb on top of the crowd, but the spectators that compose the base also need to be supportive. While some people in the front rows

Figure 39.2 Detail of zone one

are often not happy about spending a large portion of the show having people roll over them, the majority of individuals in this region comment that this is an integral part of the gig experience. However, if individuals do not roll appropriately or if they dive off the stage improperly, they will not be supported. Several of the violations are not keeping one's feet up, kicking people, diving in such a way that you concentrate your body weight in a single location rather than distributing it horizontally, and staying in one location rather than moving.

Rather than being uncooperative, it is far more likely that fellow participants in the front are enthusiastically supportive. In general, participants are very careful to make sure that no-one gets seriously hurt. To get down from the top of the crowd, rollers either move towards the front row where they will be pulled off by concert security or move to the side where they slip down feet first. There are times when, despite the efforts of others, a person who is rolling will fall down in the middle of the crowd or slip down from the top of the crowd head first. This is a very dangerous moment: there is the potential for being smothered or trampled. If a person falls through a pocket in the crowd in any way other than feet first, those around him/her will grab hold of anything they can to preclude the roller from hitting the ground. If a person falls down, the people in the area will surround him/her and help him/her to get up. At festivals, where a great number of people can fall simultaneously, this process of falling and helping everyone up can

take up the major portion of a band's performance. Initially, looking at the frenetic activity of the front region, the audience may appear wild and uncontrolled. The microlevel of interaction, however, reveals the activities of the front to be regulated by participants with mechanisms present by which the crowd monitors itself.

Behind this initial area is 'the pit', an area where people dance into one another forcefully. The pit is the area of the audience floor where people dance vigorously and jump or push into one another. This type of dancing is called *moshing* and traces its roots back to the punk era. Standing around the pit area, one is sure to spend a good portion of the performance having people run, bump, jump into or on top of oneself.

Maintaining oneself in the front is often a very arduous experience. Often people leave the venue with clothes in tatters, bruises, black eyes, and on rare occasions, broken bones. The signs of suffering incurred in the front are often referred to as battle scars and there is pride in the recounting of how one incurred these injuries. Falling in this setting is very frightening; it seems a reasonable outcome that the participant could be seriously hurt. The moment when a stranger or someone from your cohort aids you by catching you or picking you up is reported to be an exhilarating and bonding experience:

> Once at the Senseless Things, I went down and I couldn't get up because the mosh was so tight. Eventually some blokes came round and helped to pick me up. It was pretty scary though, I couldn't breathe and there are people almost trampling you. I didn't think I could get back up. But then that bloke came and helped me and I was so happy . . . I really remember the way my head was spinning and the excitement. It was just one of those experiences that you never forget. I'd seen other people do it, they had all been caught. None of them had fallen down; there was always someone there to catch you.
>
> (Ian, aged 17)

The activity in the first zone of a gig produces an emotional feeling of community and connectedness with others in this area. The participants describe the feeling of being at the front as euphoric and energizing. For the people who habituate this zone, the other areas in the venue seem boring and lack atmosphere. As one informant told me: 'If you aren't going to come up to the front and get into it, you might as well just listen to the record at home with earphones' (James, aged 15).

Locating oneself in the front is a public assertion of alignment to the band, a public statement of positive assessment on the part of the audience member. This is clear when comparing a well-attended show to one that is not well attended. At the latter, distribution density is often inverted. In these cases, the back is the most densely occupied part of the venue. The majority of audience members stand beyond 12 to 15 feet back, usually just

outside the light from the stage. On occasion, a few individuals, usually friends of the band, stand in the visible range. Standing in the front is not merely the result of an *a priori* assumption that the front is the best place to be. Rather, selection of that location is a visible signifier of an assessment to other participants, including the band. To move up front is to positively align oneself with the band. Placement in the back is seen as non-committal. For popular bands, audience members will wait in line for hours to have the opportunity to be in the front. For unknown bands without 'fans', the gig becomes in part a place to try to entice people to move closer and inhabit the space fans would usually occupy.

The people who inhabit zone one privilege this area as being the best in the venue. They say it is the most exciting and that in this area you are 'closest' to the band, using proximity to invoke the notion of affective intimacy.

Zone two: the floor/middleground

Zone two extends behind the front area towards the back of the venue. It is more difficult to delimit the boundaries of this zone. Whereas the distinction between zone one and two is exceptionally sharp, zone two moves gradually into zone three. This area is characterized by the least amount of movement of any area. Here, people are located in close proximity without actual physical contact between bodies. In this area, there are some proxemic distinctions between strangers and those who know each other; known individuals stand in clusters and correspondingly there are greater distances between strangers, in contrast to zone one. In zone two, participants are visibly and physically oriented towards the band and stand facing the stage. There is a modest amount of physical response in some participants – rocking back and forth, gently moving the head, and tapping one's feet in rhythm to the music. However, within this area the physical demonstrativeness of audience members is rather muted.

The audience members in zone two tend to range from early to late twenties. This area includes people who have habitually been attending shows for years, but also those who come only on occasion as companions of those who habitually attend. The majority of those who comprise this section were once members of zone one, but have moved back as they have aged.

Age is a critical issue for the indie music community. The social organization of the space at the gig is age-graded. Participants distribute themselves in space by age with the youngest participants in the front where there is the most physical activity, gradually ageing towards the older individuals in the back. It is not infrequent for there to be younger people in the back of the venue at times, getting drinks or waiting for a different band to perform. However, it is infrequent to see the inverse; it is very rare for older individuals to be in the front. In discourse, there is a sensitivity around age. Ageing is seen to marginalize one's ability to participate.

Zone two is the area to watch the performance with the least amount of distraction – visibly, physically, and aurally. If participants want to be more physically active, they will move up front. Additionally, if a person in this area indulges in the activities associated with the front, such as bumping into other people, he/she can be thrown out. Zone two is also the area for drinking and smoking. The audience density in the front makes it prohibitively difficult to drink in that area. Often individuals who want to have a cigarette or have a drink will stand in zone two prior to re-entering zone one. However, it is far more likely for individuals who are drinking and smoking in zone two to remain there. Many of the individuals in zone one will drink to excess prior to admission, both to save money and to preclude having to get drinks during the performance.

The difference in participation between the front and middle zones generates distinct experiences. For zone one, the experience of the gig is tactile, visual and aural, whereas for zone two, the experience is primarily of the auditory and the visual. The tactile dimension of zone one involves physical activity and contact with other participants, but also includes a somatic experience of music with high bass and decibel levels. For both of these zones, sight and sound are essential components that comprise the gig experience.

Many members of zone two privilege their spectator positioning in their claims that the people who comprise the front are more interested in crowd surfing than in the band. They refer to this behavior as distracting. Many participants from zone two claim that this is the location for the optimum sound, asserting it is the best place to *hear* the band's music. The majority of participants of this domain privilege their spectatorship in terms of aural connoisseurship and the undivided attention given to the performers.

Zone three: the bar and beyond

Zone three reaches into the back of the venue, where numerous activities that do not directly pertain to the performance take place. Here, we find the bar and the most active socializing in the conventional sense of the word. It is also where much of the logistical work for those putting on the event occurs. Zone three is the mediational zone between the inside and outside, an area a majority of audience members will pass through in selecting where to place themselves at a particular gig. Zone three's activities and attentional foci are relatively diverse and there is not the same degree of specificity and regularity of activities.

Zone three is the area of disalignment, where participants go if they wish to distance themselves from the performance. Participants move to the back if they do not like the band. There is a marked contrast in the activities in zone three from the other two. Visual orientation towards the stage is much more lax. In general eye gaze is not focused on the band, but body orientation is still to a large degree towards the stage. One of the chief activities

of those in the back is to watch other audience members. Within this area, there is a great deal of conversation. Just as the individual who wants to be more active moves towards the stage, so people in the front wishing to talk move back into this area to do it. This is also where individuals come to purchase drinks. By placing the bar in the back, the structural design of venues encourages the location of the back of the venue for activities that are not in coordination with the performance on stage.

Zone three is also the domain of the professionals, composed of music industry personnel including: booking agents, promoters, press agents, managers, crew, record personnel, product managers, journalists, and musicians from other bands not performing. This area includes the oldest fans (late twenties to thirties), individuals who are engaged in different activities other than watching the band, those individuals who dislike the particular performance, anthropologists, and the professional gig-goers. By this latter category I mean those individuals who have learned the norms of conduct of gigs to the degree that they mimic professionals in their demeanor and activities in shows.

For the record industry, a gig for a band that has attained a critical consensus functions as a conference presenting the opportunity for various industry personnel to meet face-to-face and extend their network of colleagues. To be at a gig that has an exclusive guest list marks a professional as having an extensive network of allies within the industry. For industry personnel, the gig has a detailed and complex system of markers of their hierarchy. In Britain, there is an elaborate system of guest passes/lists at most shows. For many gigs, there are five levels of guest passes – guest, after party, photo, all access, and laminate – with different levels of access and different levels of prestige associated with each pass. Where one places a pass is also a marker of status; overt pass display is considered a sign of a novice. Professionals generally discreetly place passes on the inside of a jacket or in a back pocket.

The professionals in the back also privilege their own spectatorship. Professionals often joke that the back is where the bar is and that it is far more important to be near alcohol than it is to be near the band. Within this community, a great deal is made of drinking to excess so that an alignment to alcohol is a humorous way of validating one's participation in the back of the venue. Professionals also privilege their spectatorship over that of the 'punters', the paying customers, through their access to the band. Professionals have stage passes that give them entrance to the after party or to the back stage. They interact with performers regularly in other professional settings. The professionals use their personal access to locate themselves as being the closest to the performers. Significantly, while each of the zones is privileged by the audience members who inhabit it, each zone is evaluated by employing the same idiom of closeness to the performers. Audience members' relationships to each other are organized by their exhibited relationships to the performers on stage. The professionals are so 'close' to the band that they do not need to be proximate or demonstrative.

Spatial distribution and social difference

A fundamental distinction in the cultural organization of space at indie gigs is the communication of alignments. At the indie gig, where one places oneself is a physical enactment of a *statement* of assessment and allegiance. Physical proximity, physical activities such as movement that correspond to the music's rhythm, and visual concentration on performers are socially constructed markers of alignment. Physical distance and attention to other activities are acts of disalignment, non-commitment, and/or status differentials. Thus, an activity such as crowd surfing where audience members stop between songs is taken as a token of alignment with the band. An activity such as talking that does not attend to the performance on stage is taken as a lack of positive association. So while there may be a preponderance of reasons to stand in a particular location within the venue, the act of standing within a particular space and comporting oneself in a particular way is read as *taking a stand*.

In each activity zone, individuals give reasons why their own location in space is the best and denigrate participation in other zones. Each zone uses the same idiom of closeness to the band to privilege its position in the participant framework. The band acts not only as the visual focus of the performance, but also the focus of veneration for the community. In this setting, the performers function as valorized ritual objects where audience members mark their distinctions between each other in relationship to their access and association to these ritual objects. So while there are distinct spectorial positionings at a gig, there is a common ideological system that unites participants which is grounded in the mapping of one's relationship to others in terms of his/her relationship to a band.

Making allegiances and distinctions are fundamental acts in the building of constituencies. The members of the indie community are intensely concerned with the distinctions between members and who has access to the object of value, the band. It is important to recognize that making distinctions and affinities are two sides of the same process. A disalignment on the value of a band is not merely a disalignment on a topic; it is a disalignment in a relationship. For the people who make an intense association with music, finding others who like the same music and bands is a compelling force in their lives.

The audience at a specialized event such as the gig is not homogeneous, but a body of organized and contesting spectatorships. This variable participation framework, correlated with different spatial domains, designates a typography of fanship. Placement and bodily comportment are public statements of types of fanships. To be in the front embodies a particular way of being in the world – passionate and physically expressive, leaving an event drenched with sweat and physically exhausted. Moving through space, one finds the embodiment of a different world view. The undemonstrativeness of the pass placement of the professional is part of a way of being that values

being composed – cool rather than hot in demeanor and body temperature. Each of the zones invoke different forms of spectatorship with the most actively passionate in the front, moving across space to the more reserved and remote in the back.

Indie music is imagined as a youth phenomenon and gig going marks one as being 'young'. This movement from hot spectatorship to cool spectatorship, from active and demonstrative to inactive and undemonstrative, is a marker of ageing. In this social organization, one can see the gig with its accompanying participation framework as an event that marks one's course through adolescence. As individuals age, they move back through space until they are aged out of the venue all together. When older people stop going to gigs, they do not stop attending musical performances. They attend concerts – concerts that are performed in venues with seats, a move that compels even more reserved bodily composure. The gig is an event that communicates the expected behaviors associated with ageing: youth as the time of physical and emotional expressiveness, and adulthood as a time of reserved, composed demeanor and sedentary lifestyle. The young fan in the front is ardently expressive. Moving further from the stage, age and distance increase to the perhaps equally ardent but less expressive older fan in the back. Gigs are an age-set activity not separable from the general culture, but nevertheless a fundamental ritual event in the constitution of youth as a social category.

Sounds, styles and embodied politics

Introduction to part seven

■ Ken Gelder

ANALYSES OF SUBCULTURAL STYLE have flourished over the last two decades, especially following Dick Hebdige's (1979) influential book, to which many subsequent studies have been indebted. Style, as it is manifested through dress, look, sound, performance, and so on, is a powerful means of giving a group validation and coherence. It functions perhaps rather like the 'totem' according to Emile Durkheim (1915), as something which gives visible expression to an individual's sense of belonging to a group – of belonging to something which compensates for the lack which characterizes 'individuality'. It allows a group to recognize itself and to be recognized (although not necessarily 'understood') by others; it makes a 'statement' which can be sent across the group as well as directed beyond it. Indeed, subcultural style is always relational in this sense, measuring itself not only against internal distinctions but also against much wider contexts.

A critical sense of the 'politics of style' has developed which responds to this, crediting the look or the sound of a subculture with the production of certain real effects upon the culture at large. 'Display' is not a politically neutral activity; indeed, it may draw together a range of issues (to do with sexuality, gender, ethnicity, class, and so on) which are then focused, and given expression,

through such an activity. Style thus has an enabling function. But we need not necessarily go on to equate subcultural style with 'resistance' or opposition. The contributions collected here tend to celebrate subcultural involvements with style and display, but they also often note the 'ambiguous' effects of that involvement. Style is the most self-absorbing feature of a subculture, for example – having something in common with the fetish in the Freudian sexual economy. It is also highly vulnerable to commodification, easily sliding into the more diffused realm of 'fashion'.

In many cases, style may be a subculture's most readable feature. It says something *about* that subculture – although what it says exactly may or may not be clear. Most of the contributions collected here view subcultural style as a 'symbol' or a 'sign' of something else; consequently, they adopt a semiotic, rather than a sociological, approach to their subject. Indeed, in some cases the subculture is treated as a kind of text to be deciphered or interpreted 'objectively' in a manner akin to literary criticism. But subcultural style is never isolated from its socio-political contexts in these analyses. It is seen as producing reactions, but it is also itself a reaction; it is acted upon, and it re-acts in turn. The best work on subcultural style addresses these interactive processes.

The first chapter in this Part is in fact a close analysis of reaction, examining a subcultural effect on the wider community. Turner and Surace's important study of newspaper responses to the Mexican-American 'zoot-suiters' in the late 1930s and 1940s anticipates the later turn to semiotics in work by Hebdige and others by treating the zooters as political 'symbols' which embody certain connotations and which – because of this embodiment – elicit particular responses. For Surace and Turner, some symbols – meaning in this case designations for particular groups of people – are ambiguous: the 'Mexican' is an example, since the designation evokes prejudice but also romantic or nostalgic identifications. But some symbols are *un*ambiguous, and they trace out the way the 'zoot-suiter' displaced the 'Mexican' in newspaper reportage, as a symbol which only evoked hostility. Such a symbol may come to embody connotations well beyond its actuality: the 'zoot-suiter' in this respect compares to the 'hooligan' in Geoffrey Pearson's account in Chapter 30.

T.R. Fyvel's account of the Teds in London at the end of the 1950s – part of a larger study of changes in British society at the time – also anticipates much of the work to come from Birmingham later on. He saw the working-class Teddy Boys as a reflection of wider social changes, 'only more so': the subculture, in other words, embodies what is happening across society, but in an excessive manner. For Fyvel, the Teds lived out prevailing social trends (which is why he viewed them ambivalently), in particular, the rise in affluence and increase in upward mobility, which meant less rigidly class-based identities. But this movement produced 'quirks' in the subculture, one aspect of which is subcultural style. In the chapter here, he draws an inspired connection between style and 'social revolt' which suggests that the look and the postures of the working-class Teds – far from excluding them – enabled their integration into a social system which might otherwise have left them behind.

Dick Hebdige's contribution reflects a change in the direction of his work from that included in Part Two, turning here to Michel Foucault and the 'micropolitics' of the body. This chapter also comes after the phenomenon of punk – his earlier work had celebrated it while it was still unfolding – and is less up-beat as a consequence, responding especially to the commodification of punk's 'bizarre poses'. Hebdige returns to Henry Mayhew to chart a history of the way youth has been associated with the 'exotic' and the spectacular, in the service of various agendas on behalf of dominant culture; but he also argues that youth finds pleasure in this association, actively participating in a representation of themselves as 'objects'. Accordingly, Hebdige now stresses the ambiguity of style: that it is neither resistance nor conformity; that it is a form of empowerment which expresses 'the fact of powerlessness', and so on. Style is the means by which an otherwise disenfranchised group can be seen; but to be seen is to be located, observed and 'incorporated'. Nevertheless, Hebdige's use of the more enabling side of Foucault – emphasizing the transformative function of 'history from below' – leads him finally to celebrate style and posture as a kind of 'insubordination'.

The contributions from Kobena Mercer, Marcos Becquer and José Gatti, and Marjorie Garber each elaborate this emphasis on

the ambiguity of the subcultural sign in its wider context. Mercer takes hair as a 'key ethnic signifier' – so that a hairstyle, for black Americans in this case, functions both semiotically and politically. This chapter shares concerns with Gilroy and Lipsitz from Part Six, connecting style to diasporic conditions or 'interculturation', and trying to disentangle innovations 'from below' from commodificatory appropriations 'from above'. Becquer and Gatti's essay on vogueing invokes the concept of 'articulation', whereby two otherwise quite distinct elements (e.g. poverty and stardom; Africanism and modern urban gayness) are combined together under certain conditions to produce a subcultural style. They carefully distinguish between 'hybridity' – which suggests a synthesis of different features – and syncretism, which refuses synthesis and implies contingency, permeability and change. The latter term, which they prefer, enables an 'interruption' of otherwise discrete categories of identification to occur. The contribution from Garber's *Vested Interests* sees transvestism and the butch-femme relationship in a similar way, as a means of disrupting conventional gender distinctions. She briefly charts a history of responses to butch-femme lesbians – from oppression to (increasing) integration – and she notes the current emphasis on the changeability of styles and the way in which one's 'look' need not correspond to one's 'identity', contributing to the 'ambiguity' of the pose. For Garber, transvestism is much like vogueing: it enacts a slippage between (rather than a merging of) the 'real' and the pose, where the masculine and the feminine resemble and yet are distinguished from each other at the same time.

The contribution from Douglas Crimp looks at a different and more directed kind of gay 'interruption', namely, the AIDS activist graphics produced by the group ACT UP (The AIDS Coalition to Unleash Power). This group draws together politics, sexuality and design to produce what Crimp calls 'appropriation art' – art which borrows images from elsewhere and transforms them to produce a certain 'shock' effect. However, the group would seem to live out the kind of ambiguity associated with display that Hebdige describes, both asserting its distinctiveness and yet requiring the attention and affirmation of others (onlookers, the media, the art world itself). Crimp notes this ambivalence in his remarks on the

sub-group Gran Fury, who have 'remained wary of their own success'. But the importance of this piece is that it celebrates the bonding of signification and politics through an example of what used to be called 'direct action'; and it sees this as empowering enough to produce prolonged social effects.

This Part also includes two chapters which discuss musical style for its aural rather than visual features. Robert Walser looks at another subcultural 'articulation', heavy metal's borrowing from the repertoire of classical music. This is a borrowing 'from below' which similarly confounds otherwise distinct categories – in this case, 'high' and 'low' culture. The former is reworked into 'noisy articulations', while the latter gains a certain virtuosity and pedigree. Again, the struggle (and it is, in part, a *class* struggle here) is over, and within, the frame of the sign. For Walser, the musical academy tries to stabilize 'classical music', rendering it 'uni-accentual' by locking signifier (music) and signified (institution) together. Reclaimed and reanimated by heavy metal, however, 'classical music' becomes a *multi-accentual* sign. Walser makes special claims for this relationship, seeing metal as in some senses making the most faithful or authentic use of the classical canon. He thus departs from the kind of emphasis found in the chapters by Becquer and Gatti and Garber – which try to preserve the sense of disjunction which the word 'articulation' implies.

The contribution by Dave Laing focuses on an aspect of punk music that is often either treated dismissively (punk musicians 'can't play', etc.) or celebrated for its subversive incoherence (as 'noise'). In fact Laing treats the punk song as a highly constructed text which can be read not just for its lyrics but for the sonic particularities of its voice, instrumentation, arrangements, and so on. Laing is not interested in syncretism or appropriation. His contribution instead stresses the singularity of the punk style; and indeed, the pleasure of identification with punk lies precisely in the fact that it *is* 'uniaccentual'. But punk, like any other subcultural form, is also relational or 'intertextual', and this can certainly produce ambiguity. Whether or not punk style has 'subversive' effects upon other constituencies depends especially upon the institutional context in which those effects are felt. Laing's contribution has much to say about the 'shock effect' of subcultural style, locating it first in

terms of the processes of reception brought into play within various institutions, and second in terms of a modern tradition of the *avant garde*. Both of these cases stress the way the context of a performance determines its meaning and politics – intensifying the shock or managing it or reducing it, depending on the situation. Laing's interest is thus in the particularity of one's relationship to a punk song, rather than, say, the ideological nature of punk in general – and accordingly his account of punk is relatively restrained and careful.

Laing's analysis of punk through the context of *avant gardism* says something about academic accounts of subcultures in general. The influence of Continental theorists – Roland Barthes, Julia Kristeva, Michel Foucault, Walter Benjamin, etc. – on the humanities and social sciences in universities over the last twenty years is only too well known and is reflected in many of the contributions collected in this Part. An academic alignment is produced with a mode of theory which itself privileges the *avant garde*, valuing formally disruptive works of art, for example. This no doubt helps to create the framework for an affinity with certain subcultures, the more spectacular ones especially: voguers, transvestites, punks. That is, academics are drawn to subcultural activity because it seems to live out what is valued in much of the Continental theory to which they are committed – being formally disruptive, dislocating the signifier from the signified, and so on. These features are projected on to subcultures, providing definitive criteria through which they are formulated. This has certainly produced a sophisticated focus on the complexities of meaning at work in subcultures. But the semiotic approach to subcultures has its limits, too, as Laing in particular recognizes. To see subcultural style as disrupting conventional modes of identification may make it difficult then to determine how one identifies *with* a subculture and how that identification is maintained. The effects of a style, in other words, can often be emphasized at the expense of the nature and behaviour of the participants who put it to use, the analysis of which would return us again to an approach which is more sociological and ethnographic.

Ralph H. Turner and
Samuel J. Surace

ZOOT-SUITERS AND MEXICANS
Symbols in crowd behavior [1956]

T HE PURPOSE OF THIS CHAPTER is to test a hypothesis concerning the symbols with which a hostile crowd designates the object of its action. The hypothesis is that hostile crowd behavior requires an unambiguously unfavorable symbol, which serves to divert crowd attention from any of the usual favorable or mitigating connotations surrounding the object. The hypothesis has been tested by a content analysis of references to the symbol 'Mexican' during the ten-and-one-half-year period leading up to the 1943 'zoot-suit riots' in Los Angeles and vicinity.

Theory and hypothesis

The hypothesis under examination is related to two important characteristics of crowd behavior. First, crowd behavior is *uniform* behavior in a broad sense, in contrast to behavior which exposes the infinitely varied attitudes of diverse individuals. Many attitudes and gradations of feeling can be expressed in a group's actions toward any particular object. However, the crowd is a group expressing *one* attitude, with individual variations largely concealed.

In non-crowd situations uniform behavior may be achieved by majority decision, acceptance of authority, or compromise of some sort. But crowd behavior is not mediated by such slow and deliberate procedures. Within the crowd there is a readiness to act *uniformly* in response to varied suggestions, and, until such readiness to act has spread throughout the crowd's recruitment population, fully developed and widespread-acting crowd behavior is not possible.

379

The response in the community to shared symbols is crucial to this uniformity of action. Ordinarily, any particular symbol has varied connotations for different individuals and groups in the community. These varied connotations prevent uniform community-wide action or at least delay it until extended processes of group decision-making have been carried out. But, when a given symbol has a relatively uniform connotation in all parts of the community, uniform group action can be taken readily when the occasion arises. To the degree, then, to which any symbol evokes only one consistent set of connotations throughout the community, only one general course of action toward the object will be indicated, and formation of an acting crowd will be facilitated.

Second, the crowd follows a course of action which is at least partially sanctioned in the culture but, at the same time, is normally inhibited by other aspects of that culture. Mob action is frequently nothing more than culturally sanctioned punishment carried out by unauthorized persons without 'due process.' Support of it in everyday life is attested to in many ways. Organizations such as the Ku Klux Klan and other vigilante groups act as self-appointed 'custodians of patriotism' and are fairly widely accepted as such. The lynching of two 'confessed' kidnappers in California in 1933 was given public sanction by the then governor of the state on the grounds of its therapeutic effect on other would-be criminals. The legal system in America implicitly recognizes these supports by including statutes designed to suppress them.

Hostile acting crowd behavior can take place only when these inhibiting aspects of the culture cease to operate. Conflict between the norms sanctioning the crowd's action and the norms inhibiting it must be resolved by the neutralization of the inhibiting norms.

There is normally some ambiguity in the connotations of any symbol, so that both favorable and unfavorable sentiments are aroused. For example, even the most prejudiced person is likely to respond to the symbol 'Negro' with images of both the feared invader of white prerogatives and the lovable, loyal Negro lackey and 'mammy.' The symbol 'bank robber' is likely to evoke a picture of admirable daring along with its generally unfavorable image. These ambiguous connotations play an important part in inhibiting extreme hostile behavior against the object represented by the symbol.

The diverse connotations of any symbol normally inhibit extreme behavior in two interrelated ways. First, the symbol evokes feelings which resist any extreme course of action. A parent, for example, is normally inhibited from punishing his child to excess, because affection for him limits the development of anger. Pity and admiration for courage or resolute action, or sympathy for a course of action which many of us might like to engage in ourselves, or charity toward human weakness usually moderate hostility toward violators of the mores. So long as feelings are mixed, actions are likely to be moderate.

Second, the mixed connotations of the symbol place the object *within the normative order*, so that the mores of fair play, due process, giving a fair

hearing, etc., apply. Any indication that the individual under attack respects any of the social norms or has any of the characteristics of the in-group evokes these mores which block extreme action.

On the other hand, unambiguous symbols permit immoderate behavior, since there is no internal conflict to restrict action. Furthermore, a symbol which represents a person as outside the normative order will not evoke the in-group norms of fair play and due process. The dictum that 'you must fight fire with fire' and the conviction that a person devoid of human decency is not entitled to be treated with decency and respect rule out these inhibiting norms.

We conclude that a necessary condition for both the uniform group action and the unrestricted hostile behavior of the crowd is a symbol which arouses uniformly and exclusively unfavorable feelings toward the object under attack. However, the connotations of a symbol to the mass or crowd do not necessarily correspond exactly with the connotations to individuals. The symbol as presented in the group context mediates the overt expression of attitudes in terms of sanction and the focus of attention. The individual in whom a particular symbol evokes exclusively unfavorable feelings may nevertheless be inhibited from acting according to his feelings by the awareness that other connotations are sanctioned in the group. Or the individual in whom ambivalent feelings are evoked may conceal his favorable sentiments because he sees that only the unfavorable sentiments are sanctioned. He thereby facilitates crowd use of the symbol. Furthermore, of all the possible connotations attached to a symbol, the individual at any given moment acts principally on the basis of those on which his attention is focused. By shielding individuals from attending to possibly conflicting connotations, the unambiguous public symbol prevents the evocation of attitudes which are normally present. Thus, without necessarily undergoing change, favorable individual attitudes toward the object of crowd attack simply remain latent. This process is one of the aspects of the so-called restriction of attention which characterizes the crowd.

While unambiguous symbols are a necessary condition to full-fledged crowd behavior, they may also be a product of the earlier stages of crowd development. In some cases sudden development of a crowd is facilitated by the pre-existing linkage of an already unambiguous symbol to the object upon which events focus collective attention. But more commonly we suspect that the emergence of such a symbol or the stripping-away of alternative connotations takes place cumulatively through interaction centered on that object. In time, community-wide interaction about an object takes on increasingly crowd-like characteristics in gradual preparation for the ultimate crowd action. It is the hypothesis of this [chapter] that *overt hostile crowd behavior is usually preceded by a period in which the key symbol is stripped of its favorable connotations until it comes to evoke unambiguously unfavorable feelings.*

The 'zoot-suit' riots

Beginning on June 3, 1943, Los Angeles, California, was the scene of sporadic acts of violence involving principally United States naval personnel, with the support of a sympathetic Anglo community, in opposition to members of the Mexican community which have come to be known as the 'zoot-suit riots.' 'Zooter' referred mainly to two characteristics. First, zoot suits consisted of long suit coats and trousers extremely pegged at the cuff, draped full around the knees, and terminating in deep pleats at the waist. Second, the zooters wore their hair long, full, and well greased.

During the riots many attacks and injuries were sustained by both sides. Groups of sailors were frequently reported to be assisted or accompanied by civilian mobs who 'egged' them on as they roamed through downtown streets in search of victims. Zooters discovered on city streets were assaulted and forced to disrobe amid the jibes and molestations of the crowd. Street-cars and buses were stopped and searched, and zooters found therein were carried off into the streets and beaten. Cavalcades of hired taxicabs filled with sailors ranged the East Side districts of Los Angeles seeking, finding, and attacking zooters. Civilian gangs of East Side adolescents organized similar attacks against unwary naval personnel.

It is, of course, impossible to isolate a single incident or event and hold it responsible for the riots. Local, state, and federal authorities and numerous civic and national groups eventually tried to assess blame and prevent further violence. The most prominent charge from each side was that the other had molested its girls. It was reported that sailors became enraged by the rumor that zoot-suiters were guilty of 'assaults on female relatives of servicemen.' Similarly, the claim against sailors was that they persisted in molesting and insulting Mexican girls. While many other charges were reported in the newspapers, including unsubstantiated suggestions of sabotage of the war effort, the sex charges dominated the precipitating context.

Method

In the absence of any direct sampling of community sentiment in the period preceding the riots, it is assumed that the use of the symbol 'Mexican' by the media of mass communication indicates the prevalent connotations. Any decision as to whether the mass media passively reflect community sentiment, whether they actively mold it, or whether, as we supposed, some combination of the two processes occurs is immaterial to the present method. Ideally we should have sampled a number of mass media to correct for biases in each. However, with the limited resources at our disposal we chose the *Los Angeles Times*, largest of the four major newspapers in the Los Angeles area. It is conservative in emphasis and tends away from the sensational treatment of minority issues. In the past a foremost romanticizer of Old Mexico

[Harry Carr] had been a prominent member of the *Times* editorial staff and board of directors.

In order to uncover trends in the connotation of the symbol under study, one newspaper per month was read for the ten and one-half years from January, 1933, until June 30, 1943. These monthly newspapers were selected by assigning consecutive days of the week to each month. For example, for January, 1933, the paper printed on the first Monday was read; for February, the paper printed on the first Tuesday was read. After the seven-day cycle was completed, the following months were assigned, respectively, the *second* Monday, the *second* Tuesday, etc. To avoid loading the sample with days that fell early in the first half of the month, the procedure was reversed for the last half of the period. Then, to secure an intensive picture of the critical period, consecutive daily editions were read for one month starting with May 20, 1943, through June 20, 1943. This covered approximately ten days before and after the period of violence. Any editorial, story, report or letter which had reference to the Mexican community or population was summarized, recorded, and classified. The articles were placed in five basic categories: favorable themes, unfavorable themes, neutral mention, negative-favorable mention, and zooter theme.

1. *Favorable:* (a) Old California Theme. This is devoted to extolling the traditions and history of the old rancheros as the earliest California settlers. (b) Mexican Temperament Theme. This describes the Mexican character in terms of dashing romance, bravery, gaiety, etc. (c) Religious Theme. This refers to the devout religious values of the Mexican community. (d) Mexican Culture Theme. This pays homage to Mexican art, dance, crafts, music, fifth of May festivities, etc.

2. *Unfavorable:* (a) Delinquency and Crime Theme. This theme includes the specific mention of a law violator as 'Mexican,' associating him with marihuana, sex crimes, knife-wielding, gang violence, etc. (b) Public Burden Theme. This attempts to show that Mexicans constitute a drain on relief funds and on the budgets of correctional institutions.

3. *Neutral:* This is a category of miscellaneous items, including reports of crimes committed by individuals possessing obvious Mexican names but without designation of ethnic affiliation.

4. *Negative-Favorable*: This category consists of appeals which *counter* or *deny* the validity of accusations against Mexicans as a group. For example: 'Not all zoot-suiters are delinquents; their adoption by many was a bid for social recognition'; 'At the outset zoot-suiters were limited to no specific race . . . The fact that later on their numbers seemed to be predominantly Latin was in itself no indication of that race' (*Los Angeles Times*, 11 July, 1943).

5. *Zooter Theme*: This theme identifies the zooter costume as 'a badge of delinquency.' Typical references were: 'reat pleat boys,' 'long coated gentry,' coupled with mention of 'unprovoked attacks by zoot-suited

youths,' 'zoot-suit orgy,' etc. Crime, sex violence, and gang attacks were the dominant elements in this theme. Almost invariably, the zooter was identified as a Mexican by such clues as 'East Side hoodlum,' a Mexican name, or specific ethnic designation.

If the hypothesis of this [chapter] is to be supported, we should expect a decline in the favorable contexts of the symbol 'Mexican.' The change should serve to produce the type of symbol suggested by the hypothesis, a symbol dominated by unambiguously unfavorable elements.

Findings

The favorable and unfavorable themes are reported alone in Table 41.1 for the ten and one-half years. The table by itself appears to negate our hypothesis, since there is no appreciable decline in the percentage of favorable themes during the period. Indeed, even during the last period the mentions appear predominantly favorable, featuring the romanticized Mexican. However, there is a striking decline in the total number of articles mentioning the Mexican between the second and third periods. Treating the articles listed as a fraction of all articles in the newspapers sampled and using a sub-minimal estimate of the total number of all articles, the t test reveals that such a drop in the total number of articles mentioning Mexicans could have occurred by chance less than twice in one hundred times. We conclude, then, that the decline in total favorable and unfavorable mentions of 'Mexican' is statistically significant.

While the hypothesis in its simplest form is unsubstantiated, the drop in both favorable and unfavorable themes suggests a shift away from *all* the traditional references to Mexicans during the period prior to the riots. If it can be shown that an actual substitution of symbols was taking place, our hypothesis may still be substantiated, but in a somewhat different manner than anticipated.

Table 41.1 Favorable and unfavorable mention of 'Mexican' during three periods

Period	Favorable themes	Unfavorable themes	Percentage favorable
January, 1933–June, 1936	27	3	90
July, 1936–December, 1939	23	5	82
January, 1940–June, 1943	10	2	83
Total	60	10	86

Table 41.2 Distribution of all themes by three periods

Period	Percentage favorable	Percentage unfavorable	Percentage neutral	Percentage negative-favorable	Percentage zooter	Total percentage	Total number
January, 1933–June, 1936	80	9	11	0	0	100	34
July, 1936–December, 1939	61	13	23	3	0	100	38
January, 1940–June, 1943	25	5	32	8	30	100	40

From the distribution of all five themes reported in Table 41.2 it is immediately evident that there has been no decline of interest in the Mexican but rather a clear-cut shift of attention away from traditional references. The straightforward favorable and unfavorable themes account for 89, 74, and 30 per cent of all references, respectively, during the three periods. This drop and the drop from 61 to 25 per cent favorable mentions are significant below the 1 per cent level. To determine whether this evidence confirms our hypothesis, we must make careful examination of the three emerging themes.

The *neutral* theme shows a steady increase throughout the three periods. While we have cautiously designated this 'neutral,' it actually consists chiefly of unfavorable presentations of the object 'Mexican' without overt use of the symbol 'Mexican.' Thus it incorporates the unfavorable representation of Mexican, which we assume was quite generally recognized throughout the community, without explicit use of the symbol.

The *negative-favorable* theme, though small in total numbers, also increased. At first we were inclined to treat these as favorable themes. However, in contrast to the other favorable themes, this one documents the extent of negative connotation which is accumulating about the symbol 'Mexican.' By arguing openly against the negative connotations, these articles acknowledge their widespread community sanction. When the implicitly favorable themes of romantic Mexico and California's historic past give way to defensive assertions that all Mexicans are not bad, such a shift can only reasonably be interpreted as a rise in unfavorable connotations.

The most interesting shift, however, is the rise of the *zoot-suit* theme, which did not appear at all until the third period, when it accounts for 30 per cent of the references. Here we have the emergence of a new symbol which has no past favorable connotations to lose. Unlike the symbol 'Mexican,' the 'zoot-suiter' symbol evokes no ambivalent sentiments but appears in exclusively unfavorable contexts. While, in fact, Mexicans were attacked *indiscriminately* in spite of apparel (of two hundred youths rounded up by the

police on one occasion, very few were wearing zoot suits), the symbol 'zoot-suiter' could become a basis for unambivalent community sentiment supporting hostile crowd behavior more easily than could 'Mexican.'

It is interesting to note that, when we consider only the fifteen mentions which appear in the first six months of 1943, ten are to zooters, three are negative-favorable, two are neutral, and none is the traditional favorable or unfavorable theme.

In Table 41.3 we report the results of the day-by-day analysis of the period immediately prior, during, and after the riots. It shows the culmination of a trend faintly suggested as long as seven years before the riots and clearly indicated two or three years in advance. The traditional favorable and unfavorable themes have vanished completely, and three-quarters of the references center about the zooter theme.

Table 41.3 Distribution of all themes from May 20 to June 20, 1943

Theme	Percentage of all mentions*
Favorable	0
Unfavorable	0
Neutral	3
Negative-favorable	23
Zooter	74
Total	100

*Total number = 61.

From the foregoing evidence we conclude that our basic hypothesis and theory receive confirmation, but not exactly as anticipated. The simple expectation that there would be a shift in the relative preponderance of favorable and unfavorable contexts for the symbol 'Mexican' was not borne out. But the basic hypothesis that an unambiguously unfavorable symbol is required as the rallying point for hostile crowd behavior is supported through evidence that the symbol 'Mexican' tended to be displaced by the symbol 'zoot-suiter' as the time of the riots drew near.

The conception of the romantic Mexican and the Mexican heritage is deeply ingrained in southern California tradition. The Plaza and Olvera Street in downtown Los Angeles, the Ramona tradition, the popularity of Mexican food, and many other features serve to perpetuate it. It seems quite probable that its force was too strong to be eradicated entirely, even though it ceased to be an acceptable matter of public presentation. In spite, then, of a progressive decline in public presentation of the symbol in its traditional favorable contexts, a certain ambivalence remained which prevented a simple replacement with predominantly unfavorable connotations.

Rather, two techniques emerged for circumventing the ambivalence. One was the presenting of the object in an obvious manner without explicit use of the symbol. Thus a Mexican name, a picture, or reference to 'East Side hoodlums' was presented in an unfavorable context. But a far more effective device was a new symbol whose connotations at the time were exclusively unfavorable. It provided the public sanction and restriction of attention essential to the development of overt crowd hostility. The symbol 'zoot-suiter' evoked none of the imagery of the romantic past. It evoked only the picture of a breed of persons outside the normative order, devoid of morals themselves, and consequently not entitled to fair play and due process. Indeed, the zoot-suiter came to be regarded as such an exclusively fearful threat to the community that at the height of rioting the Los Angeles City Council seriously debated an ordinance making the wearing of zoot suits a prison offense.

The 'zooter' symbol had a crisis character which mere unfavorable versions of the familiar 'Mexican' symbol never approximated. And the 'zooter' symbol was an omnibus, drawing together the most reprehensible elements in the old unfavorable themes, namely, sex crimes, delinquency, gang attacks, draft-dodgers, and the like and was, in consequence, widely applicable.

The 'zooter' symbol also supplied a tag identifying the object of attack. It could be used, when the old attitudes toward Mexicans were evoked, to differentiate Mexicans along both moral and physical lines. While the active minority were attacking Mexicans indiscriminately, and frequently including Negroes, the great sanctioning majority heard only of attacks on zoot-suiters.

Once established, the zooter theme assured its own magnification. What previously would have been reported as an adolescent gang attack would now be presented as a zoot-suit attack. Weapons found on apprehended youths were now interpreted as the building-up of arms collections in preparation for zoot-suit violence. In short, the 'zooter' symbol was a recasting of many of the elements formerly present and sometimes associated with Mexicans in a new and instantly recognizable guise. This new association of ideas relieved the community of ambivalence and moral obligations and gave sanction to making the Mexicans the victims of widespread hostile crowd behavior.

T. R. Fyvel

FASHION AND REVOLT [1963]

IF THE TEDDY-BOY MOVEMENT is looked on . . . as a symptom of proletarian rebellion, a piece of defiant flag-flying, then it is interesting to note that the actual post-war Edwardian fashion was from the start a symbol of revolt, but on two extremely separate social levels.

The full Edwardian fashion actually started in Mayfair. It was said to have been launched from Savile Row soon after the war as an answer to American styles. For the young exquisites-about-town, who first and briefly took it up, its extravagance was also like a gesture against the war that was past, against mass culture, the Labour Government, the notion of England's decline. In its exaggerated form (curled bowlers worn over long hair, long Edwardian coats, ultra-tight trousers) the style was also short-lived, vanishing from Mayfair as it reached suburbia.

Meanwhile, however, the fashion had utterly unexpectedly been transported across the Thames, to the tough and swarming working-class riverside areas around the Elephant, Southwark, and Vauxhall, and this was quite an event – a symbol of social revolt on another level, though at first not recognized as such.

To the public eye, the new thorough-going proletarian Teddy boys, standing about at the Elephant in their full regalia, looked at first like music-hall caricatures – and at the same time somewhat ominous. From all accounts, these first pioneers were certainly 'a pretty rough lot'. In terms of age-groups, they still had their links with the older cloth-capped gangs which in earlier periods had dominated areas like the Elephant, keeping the police on the run and razors in their pockets. A social worker from the Elephant area told me, 'As I recall it, the local Teddy-boy fashion in its first bloom had

few law-abiding members. It was definitely the submerged tenth who popularized the new clothes. They were the groups who were not respectable, not socially acceptable'. A young man who was briefly in one of the earliest gangs described its members as almost entirely un-skilled workers or just drifters. 'They were market porters, roadworkers, a lot of van boys, all in jobs that didn't offer much – labourers could cover the lot'. Some of them were out of work but had their own methods of keeping up.

> They just went in for thieving. Many of the Teds thought nothing of it: they call it having a bit of business. I remember how they'd always try to bring in words they didn't know the meaning of, like calling somebody they didn't like 'bombastic'.

Not very promising material from which to start a new 'Movement', yet this is precisely what the first few hundred Teddy boys from south of the Thames achieved. Through similar gangs which soon spread elsewhere in London, they created a subculture whose mark was certainly its utter unexpectedness. There was the dressing-up which among the first Teds seemed simply weird. For one thing, they were still proletarians: their faces did not go with the dandified clothes; they had not yet the smooth look of the later generation of English working-class boys accustomed to money. For another thing, as determined innovators, the first Teddy boys carried the eccentricity of their garb to an extreme which had an effect of masquerade.

Was it, as it seemed, un-English? The influences were mixed. In hairstyles they derived plainly from America and the films. The most common consisted of aggressive sideboards, with masses of hair at the back and a fuzzy shock of it above the brow. Other styles favoured were the jutting Tony Curtis, the Boston, the fiercely shaved Mohican. These fancy hair-styles, involving appointments with special barbers and expensive to come by and maintain, were to their wearers clearly symbols of masculinity. Among the clothes the jacket of the suit, long and fully draped with flaps and velvet collar, came nearest to true 'Edwardian'. With it went knitted ties, plain or flowery waistcoats, tight-fitting trousers or 'strides', and – incongruously at first – blunt shoes with enormous crêpe soles. The whole theatrical outfit might cost upwards of £20; considerably less than such smart clothes cost a few years later, but in this first phase, when cash and credit were not so easy to come by, an unprecedented sum for a low-paid young manual worker to spend on himself.

Given the ingrown conservatism of English working-class life and its hostility towards any dandyism or hint of effeminacy it must have taken special determination for the first Teddy boys of south London to swagger along their drab streets in their exaggerated costume. What lay behind their impulse? The rest of the charade gave the clue to this act of self-assertion. For with the clothes went a special Teddy-boy manner – dead-pan facial expressions which delighted caricaturists, and an apparent lassitude of bearing

which seemed a cover for the tensions among the gang. It was a point of honour for Teddy boys to be more interested in themselves than in girls. In dance-halls – this was before the arrival of rock-'n'-roll – they did not deign to dance, or only in a condescending manner. This lassitude was, of course, only a surface affectation. If girls were scorned as real companions, they were very much in the Teddy boys' minds as objects and as prey. In fact, one could say that this whole dressing up in groups by young unskilled wage-earners was only a means of furthering the usual aim of such young men – the nightly prowl for girls. And, just as the sartorial fashion was like a roman-tically stylized assertion of being important, 'being somebody', so the primitive romanticism which inspired the clothes was applied to the night-life, too. The result was the organization of Teddy boys in gangs, some quite large, to defend territories defined as 'theirs'; or, when the mood came, to raid those of other gangs for girls. In this way the police and public around 1953 and 1954 first became aware of a new type of Teddy-boy disorder in the late night hours. This disorder was also formalized, rather like a ragged fantasy of warfare. A bus conductor told me that in a certain public house at the end of his run, which was something of a frontier post, he could on Saturday nights see huddled groups from different gangs watching each other like cats, or in the words of the old song 'Tread on the tail of my coat'.

In fact, before long the Teddy boys seemed to have created a little world of their own: a subculture with its own laws of dress, behaviour, and terri-tory, in which they strutted about, looked challengingly at outsiders, chased girls, occasionally fought each other, and planned the occasional larceny. There were perhaps a few thousand of them in inner London, and in its peculiarly organized form the cult went on for a few years. On the whole, it was a primitive performance. The early Teddy boys were working-class youths with an itch to assert themselves against society – this was the new element – but since their little 'anti-society' did not help them to get on, it remained in this respect unreal. There might be some satisfaction in the obsessive banding together, in wreaking violent vengeance against anyone who disparaged the uniform, in the occasional large-scale fights, in baiting the police and being in on the knowledge of local crime: but since all this did not help the individual Teddy boys to get anywhere as adolescence passed, most of them, in fact, led a dreary life. Driven on by boredom, by the need for spending money or just by anger against society, a good many of them landed up in the dock and went on to Borstal or prison. Others vanished vaguely into adult life, and that was the end.

Winds of change

It was easy enough to scoff at the whole performance, as most people did, yet in view of what has subsequently happened in English society it is now possible to see it was more than a joke – that the early Teds were on to

something, early figures in a process of far-reaching social change. The way in which these working-class youths maintained their stylized dress and gang-life for several years, regardless of what society thought or the jeers they encountered, showed that the winds of change were blowing not only through Africa but through the English slums. The very fact that the early Teds came from the 'submerged tenth' was significant: it showed that in the new post-war English generation even unskilled young workers were no longer ready to be excluded from society and what were deemed its pleasures.

For the chief point about the Teddy-boy cult was that it went on: the dandyism it had brought into working-class life remained there. True, the sartorial fashion itself changed. Step by step, through various deviations, the clothes and haircuts grew less eccentric and extreme, until at the end of the 1950s they had become unified in the rather attractive 'Italian style', which had become normal walking-out wear for the working-class boy; and by 1960 this had blended with 'conservative cool', or just very ordinary but well-cut clothes.

By this time, it is true, the strange pioneers, the original Teddy boys, had long been superseded. Their gangs had broken up, the very term 'Ted' had become one of derision, denoting ill-mannered behaviour. Yet it was also possible to see what the movement they started off had finally achieved. Towards the end of the 1950s one could say that for the first time English working-class youths had in their great majority become meticulous about their persons and highly fashion-conscious. This dandyism, moreover, was not one in which they imitated their middle-class betters. Quite the contrary, it was rather more in line with what was worn by young people on the Continent. Other barriers, too, were being lowered. English working-class youths had also broken away from the old shirtsleeves or Sunday best into the weekend informality of jeans and sports clothes. Altogether, this added up to quite a revolution, illustrating the new affluence of working-class life, and it is interesting to see how far this social revolution went down the rigid English class-scale. My young informant from east London, who as a teenager had been among the early Teddy boys, found when he came out of the Navy at the end of the 1950s that his area was still a tough working-class 'manor', yet the whole atmosphere had subtly changed.

> The gangs were definitely smaller. For one thing the pin-table Arcades where the fellows used to hang out had mostly disappeared. And a good thing, too. They had been depressing places, dirty and moribund.
>
> The fellows in the gangs were different, too. Where early on it had only been about two out of ten, now five out of ten of all boys were dress-conscious. I noticed flick knives had come in much more, but I still think most of the fellows carried them only out of bravado. Mostly they happened to know someone who knew how to use a knife genuinely, who'd got a name for it, so all the others would back him up.

The big change was, the average fellow had more money – you had to have more money now to be in the swim. Things cost more but there was a lot more cash about. For one thing, all the chief gangs now had fellows with cars and motor-bikes. The special motor-bike mob who wore black leather jackets thought of themselves as the top lot; they met by themselves in their own pub. In general, the fellows now met not only in cafés but in dance-halls and saloon bars, and the older ones had started drinking again. You could go to all kinds of clubs – that was new, too – and there were lots of parties. Some of the fellows had record players and you'd have a party going on all Sunday, with fellows and girls and drink and dozens of records.

That is, even in the dead-end districts of London, there had been radical social change. Boys and youths working in unskilled jobs were no longer loutish but searching to take part in ordinary mid-twentieth-century city life. This was the positive side of the social revolt whose flag had been raised by the Teddy boys half a dozen years earlier.

Dick Hebdige

POSING ... THREATS, STRIKING ... POSES

Youth, surveillance, and display [1983]

F OUCAULT'S DEFINITION [OF POWER] entails a shift in focus away from the familiar monolith of the State as the sole 'source or point of confluence of power'[Foucault 1980a: 188], away from the State as the overbearing Master of (all oppressive) Ceremonies. Instead it directs attention down towards particular issues, particular instances, to the *micro*-relations of domination and resistance. Foucault writes:

> Between every point of a social body, between a man and a woman, between the members of a family, between a master and his pupil, between every one who knows and every one who does not, there exist relations of power which are not purely and simply a projection of the sovereign's great power over the individual; they are rather the concrete, changing soil in which the sovereign's power is grounded, the conditions which make it possible for it to function.
>
> [ibid., 187]

This recognition that power always takes place, always functions in particular ways in particular locales, draws on local resources, is produced through strategies which are not co-ordinated from some pre-existent center by an individual or collective 'will,' requires us to rethink how and where power functions and is generated because, to use Foucault's own words again, 'where there is power there is resistance, not in the sense of an external, contrary force, but by the very fact of [the] existence [of power]. Power relations

depend on a multiplicity of points of resistance, which serve at once as adversary, target, support, foothold' [ibid., 190].

As Foucault puts it, power comes from everywhere, 'there is a capillarity from below to above' [ibid., 201], as well as vice versa, a channel in which a countervailing force is generated. And this is a crucial point: it qualifies Foucault's celebrated 'pessimism.' For, despite the apparent closure of Foucault's universe with its vast technologies of power that interpellate whole epochs, that both engender and contain the relations of forces which characterize those epochs and the apparent 'truths' produced within them, nonetheless in Foucault's writing there is this other potential, an immanence altogether more positive, for at the same moment that Foucault charts the ineluctable progression of power from one point on the surface of the social body to the next, he also allows for the possibility that change can be effected from beneath. He documents the spread of the carceral system, the rise, from the eighteenth century onwards, of those institutions which mark the official boundaries of the public domain – the factory, the school, the prison, the asylum, the clinic, the regulated environment. But at the same time, he reinstates the forbidden discourses of the lunatic, the criminal, the patient and the pervert within the general economy of power and knowledge which produced them in the first place and which, paradoxically, serves to guarantee their 'logic' and their 'truth.' He brings another history into speech, one which, as he put it at an earlier stage in his writing [Foucault 1978], takes place below the level of power on the other side of legality – the history, through their statements and expressions, their testimonies and confessions, of those groups and individuals who have again and again been consigned to the margins, incarcerated, disciplined and punished, their exile insured through the one law which unites all discourse and which endows all 'official' discourse with its peculiar punitive effects: the rule that speech is both enabling and proscriptive, that it creates new objects, new relations to existing objects and yet does so, first and foremost, by operating as a system of exclusion, that is, according to the basic rule of language, that which is not nominated remains unsaid.

In this [chapter] I explore some of the implications of the adjustment in priorities and procedures laid down by Foucault's micro-physics of power in relation to sexuality and the public realm. The vectors of power I want to trace cut across a number of heterogeneous sites – discursive categories, institutions, and the spaces between institutions. Those sites are youth, sexuality, fashion, subculture, display, and its corollary, surveillance. Clearly, although many of these sites are themselves quite literally superficial, to propose to glide across them in even the most cursory way in the space available is absurd. A conventional presentation of history in which selected themes are carefully pursued along a single line leading from a finished past to a yet-to-be completed present will have to be abandoned. Instead I want to posit each site as a terminus in a circuit within which a different kind of knowledge, a different kind of truth can be generated, a knowledge and a

truth which cannot be encapsulated within the confines of a discrete histori-
cal period, one which skirts around the logic of defensible positions, one
which sets out instead with the best of intentions – to pull the Father's beard.

I shall start at the most obvious point of departure for any discussion of
public space which proposes, as this one does, to address problems of *genealogy*
– the Industrial Revolution. The scenario is a familiar one and includes the
following. In Western Europe during the eighteenth and nineteenth centuries,
the enormous expansion of productive forces opened up by technological
innovation and change in the mode of production served to accelerate the
process of urbanization, concentrating human and capital resources into larger
and larger units and introducing a degree of social and geographical mobility
that was unprecedented in any other epoch. A new phenomenon emerges –
the giant industrial conurbation, Spengler's daunting megalopolis, an archi-
tectural cacophony inhabited by the new and alien species we call the urban
mass. As depicted in contemporary novels, in crusading magazine and news-
paper articles about proletarian housing conditions, and in all manner of
concerned cultural criticism, the modern city appears monstrous, ill propor-
tioned, and grotesque. It is a threatening place.

The threat is variously represented but one of the perceptions around
which this threat revolves is that the rules which formerly governed social
interaction in public places have been disrupted, that a harmonious demar-
cation between the public and private domains is no longer possible.
One image recurs: the silent crowd, anonymous, unknowable, a stream of
atomized individuals intent on minding their own business. Wrote Engels
in 1844:

> The restless and noisy activity of the crowded streets is highly distasteful,
> and it is surely abhorrent to human nature itself. Hundreds of thou-
> sands of men and women drawn from all classes and ranks of society
> pack the streets of London. . . . they rush past each other as if they
> had nothing in common. They are tacitly agreed on one thing only –
> that everyone should keep to the right of the pavement so as not to
> collide with the stream of people moving in the opposite direction.
> . . . this narrow-minded egotism – is everywhere the fundamental prin-
> ciple of modern society. But nowhere is this selfish egotism so blatantly
> evident as in the frantic bustle of the great city.
>
> (Engels 1958: 30–31)

That passage, that image, is no doubt familiar enough. The crowd functions
here as a metaphor for the law of private interest which Engels regards as
the fundamental principle of capitalism. The crowd is seen as a symptom.
It is the literal embodiment of Engels' thesis that the workers' alienation
from the means of production is replicated elsewhere, everywhere; that it
reverberates across every other category of social life producing other and
parallel alienations.

When attention is directed to the trajectory inscribed within this passage from the particular to the general, from particular observations via metaphor to general causes, to the unraveling of what Engels thinks his observation means, then the analysis begins to tilt away from the question of *what* Engels said to *why* he felt compelled to say it in the first place. For one of the major threats which the silent urban crowd seems to have posed to literate bourgeois observers of all political persuasions lay in its other silences – the possibility that the urban crowd might be *illegible* as well as *ungovernable*. Indeed, the two threats were inextricably linked, the link guaranteed by the complicity between power and knowledge. The urban crowd's opacity and its potential for disorder were imbrocated one upon the other.

The link between the impetus to penetrate and supervise, to control the urban mass and to render it intelligible becomes clearer if we close in on one section of the crowd – youth – and begin to examine the historical construction of 'modern youth' as a category within the social sciences and more generally as a privileged focus for philanthropic and juridical concern. It should be possible through such an examination to assess the effects of this dual inheritance – the philanthropic and the juridical, the benevolent and the punitive – on contemporary documentation of youth. Finally this process may lead to a questioning of some of the distinctions which now operate across the field of youth studies and which serve to articulate youth as a meaningful category.

The definition of the potentially delinquent juvenile crowd as a particular urban problem can be traced back, in Britain at least, to the 1780s and the beginnings of the Sunday School movement, an attempt on the part of the Church to extend its moderating influence downwards in terms both of social class and biological age. A more concentrated group of sightings occur during the mid-nineteenth century when intrepid social explorers began to venture into the 'unknown continents,' the 'jungles,' and the 'Africas' – this was the phraseology used at the time – of Manchester and the slums of East London.

We could cite as an example Henry Mayhew's observations of the quasi-criminal London costermongers. The costers were street traders who made a precarious living selling perishable goods from barrows. The young coster boys were distinguished by their elaborate style of dress – beaver skin hats, long jackets with moleskin collars, vivid patterned waistcoats, flared trousers, boots decorated with hand-stitched heart and flower motifs, a red 'kingsman' kerchief knotted at the throat. This style was known in the coster idiom as looking 'flash' or 'stunning flash.' The costers were also marked off from other equivalent groups by a developed argot – backwards slang and rhyming slang. In coster speech, beer was 'reeb,' the word 'police' was carved up, turned back to front and truncated into 'escop,' later 'copper,' finally 'cop.' This symbolic assault on the newly formed police force (introduced by Sir Robert Peel in 1840) was frequently complemented by gang attacks on solitary policemen. The police were resented because their supervision of public

space in working-class ghettoes was already jeopardizing the survival not only of coster culture but of their very livelihoods. Charged with the mission of imposing uniform standards of order throughout the metropolis irrespective of local circumstances, the police actively disrupted the casual street economy upon which the costers depended. The mass of detailed observations of urban street life assembled and collated by social explorers like Mayhew eventually formed the documentary basis for legislative action, for the formation of charitable bodies and the mobilization of public opinion through newspaper articles on the plight of what were called the 'wandering tribes' of London. In these ways the social explorers served to articulate and direct a growing moral impetus towards the education, reform, and civilization of the working-class masses, an impetus which was itself underwritten by a generalized concern with the problems involved in disciplining and monitoring the shifting urban population. The initiatives taken to improve the impoverished classes on the one hand and to control them on the other were indistinguishable.

Foucault, working with archive material emanating from northern French towns, dates the beginning of a concerted campaign of intervention in the working-class milieu, particularly through education, from the period 1825–30, and refers specifically to the legislative measures introduced by Guizot. In Britain, Mary Carpenter performed a similar role lobbying for the establishment of government-funded programs devoted to the education and reform of juvenile offenders. Mary Carpenter's war on 'ignorance, want and parental incompetence' centered on the compartmentalization of working-class youths into three categories – those destined for the Ragged Schools, the industrial schools, and the reformatories. Further, in 1852 her submission to a Parliamentary committee on the treatment of juvenile offenders was designed to institutionalize a set of distinctions which recur again and again in official documents produced on crime and punishment during the mid-nineteenth century; the distinctions were between the 'respectable' and 'criminal' classes, the 'deserving' and 'undeserving' poor, the 'delinquent' and 'perishing' juveniles. Eventually these distinctions were to be replicated in the educational and punitive provisions made for working-class youths during the period. The Ragged Schools were open to all street urchins irrespective of their criminal inclinations. The industrial schools were designed to wrest potentially redeemable children from the clutches of corrupting parents, to inculcate the virtues of factory time-discipline and orderly behavior, and to give young people an opportunity of learning a useful trade. The reformatories were reserved for the recalcitrants – the hardened young criminals who would previously have been committed to adult prisons. By 1859, only four years after the Youthful Offenders Act authorized their establishment, there were over fifty reformatory schools in England. The progression is clear: from reportage to action, from description to intervention, from the construction of a concerned polemic to the erection of a penal institution. The traces left by a 'gathering of the facts,' motivated by

compassion as far as the fact gatherers themselves were concerned, are real enough.

Here is a candidate for the Ragged School [see Plate 43.1]. The fact that a photographic record has survived is important. It indicates a new departure – the systematic monitoring by means of photographic plates and daguerrotypes of potentially delinquent nomadic juveniles. The 'scientific' administration of the urban setting required a mass of evidence, statistics, and documentation of details about the most intimate aspects of individual lives. It required a supportive, efficient bureaucracy. As John Tagg has ably demonstrated (Tagg 1981), the camera played its part in this process, supplanting earlier systems of classification employed by the police to identify known criminals and record the distinctive features of new ones. It replaced systems like Alphonse Bertillon's unwieldy 'anthropometric' method which required an intricate web of interlocking statistical and verbal portraits. By drawing representation closer to reality, photography seemed to make the dream of complete surveillance possible. Inscribed into photography and photographic practice from its very inception were these official documentary uses, this potential for surveillance, by no means natural, representing, rather, a particular point of view, particular interests, embodying a desire and a will to know the alien-in-our-midst, the Other, the victim, and the culprit.

The technology was adaptable. It translated to new contexts of control. For example, it served the needs of a charitable institution like Doctor Barnado's Home for Working and Destitute Lads (founded in the late nineteenth century) as efficiently, as competently as it served the police. Barnado amassed some 55,000 photographic portraits of the inmates of his homes. This documentation served two main purposes. First, it was used to publicize the good works of the Barnado organization and hence to elicit funds from a sympathetic public and secondly, to monitor and classify potential delinquents and runaways (the police were given routine access to Barnado files).

These relations, this set of positions – Us and Them, us as concerned and voyeuristic subjects, them as brutalized and wayward objects – have persisted in documentary photographs of contemporary victims, contemporary culprits, the new criminal class, the new undeserving poor. After the Other Victorians have come the Other Elizabethans, the roundheads, the skinheads, and the punks, the rockabillies, the mods, the rastas, and the rest – the black and white trash of Britain's declining inner cities. An enormous 'explanatory' literature has developed round the fringes of the 'youth problem' and this literature has its visual corollary in the tasteful anthologies of photographs of every British subculture, anthologies which abound in British bookshops. Unlike the powerful who opt for anonymity, these people make a pretty picture, make a 'spectacle' of themselves, respond to surveillance as if they were expecting it, as if it were perfectly natural. They make interesting 'character studies.' These portraits, as carefully cropped as

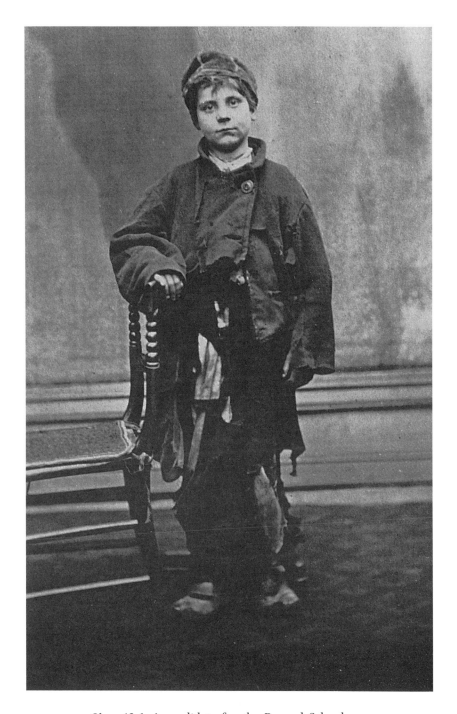

Plate 43.1 A candidate for the Ragged School

Source: Metropolitan Borough of Stockport Library

the heads of the skins themselves, fix crime on a pin for us. We can gawp, indulge our curiosity from the safety of our positions out here. The skinhead, for example, as object of our pity, our contempt, our fear. The skinhead fixed in our compassionate and punitive gaze. The skinhead as victim, the skinhead as culprit. The skinhead 'at home,' placed in a context which immediately fits – the urban ghetto, the underpass, the day out at the beach, the life inside the factory, the tiled public bathroom. Places we wouldn't dare to venture in. These are our 'unknown continents,' our 'Africas,' our 'jungles.' These are people we wouldn't dare to stare at in the street. These are the signs of our times.

If we turn from documentary photography to the construction of youth within sociology, a similar pattern, a similar set of relations, is disclosed. The category 'youth' emerges in sociology in its present form most clearly around the late 1920s and the responsibility for that construction is generally attributed to the American tradition of ethnographic research, particularly to the work produced by the Chicago school of deviancy. Robert Park and his colleagues at the University of Chicago were concerned with developing a broadly based theory on the social ecology of city life [see Chapter 3]. The high incidence of juvenile crime in inner city areas and the significance of peer group bonding in distinctive juvenile gangs were explained by these writers through organic metaphors – the metaphors of social pathology, urban disequilibrium, the breakdown of the organic balance of city life. This tradition is largely responsible for establishing the equation, by now a familiar one in the sociology of youth, between adolescence as a social and psychological problem of particular intensity on the one hand and the juvenile offender as the victim of material, cultural, psychological or moral deprivation on the other. These two enduring images – the more general one of youth as a painful transitional period, the more particular one of violent youth, of the delinquent as the product of a deprived urban environment – are fixed within sociology largely through the work of the Chicago school and of those American researchers who, throughout the 1950s and 1960s, continued to publish 'appreciative' studies of marginal groups based on the Chicago model.

It is this tradition which produces or secures the frames of reference which then are applied to the study of youth in general and which define what is going to be deemed significant and worth studying in the area: the links between deprivation and juvenile crime, and the distinctive forms of juvenile bonding (youth culture, the gang, the deviant subculture, the masculinist emphasis) are carried over intact into social scientific discourse. Youth becomes the boys, the wild boys, the male working-class adolescent out for blood and giggles – youth-as-trouble, youth-in-trouble.

By the 1950s, relative affluence brings the other face of British youth into focus – youth at its leisure; exotic, strange, youth-as-fun. The term 'teenager,' invented in the United States, is imported into Britain and applied by popular weekly journals like the *Picture Post* to those cultures of the

'submerged tenth' of working-class youth whose consumption rituals, musical tastes, and commodity preferences are most clearly conditioned by American influences. The word 'teenager' establishes a permanent wedge between childhood and adult-hood. The wedge means money. The invention of the teenager is intimately bound up with the creation of the youth market. Eventually a new range of commodities and commercial leisure facilities is provided to absorb the surplus cash which working-class youth is calculated to have, for the first time, at its disposal to spend on itself and to provide a space within which youth can play with itself, a space in which youth can construct its own identities untouched by the soiled and compromised imaginaries of the parent culture. Eventually: boutiques, record shops, dance halls, discotheques, television programs, magazines, the 'Hit Parade.'

The new images are superimposed on the old images – youth-as-trouble, youth-as-fun. During the 1950s, the distinction between 'respectable' and 'criminal' classes was transmuted into the distinction between 'conformist' and 'nonconformist' youth, the workers and the workshy, 'decent lads' and 'inverts,' 'patriots' and 'narcissists.' The new youth cultures of consumption were regarded by the arbiters of taste and the defenders of the 'British way of life,' by taste-making institutions like the BBC and the British design establishment, as pernicious, hybrid, unwholesome, 'Americanized.' When the first rock 'n roll film, *Blackboard Jungle*, was shown at a cinema in South London in 1956, Britain witnessed its first rock riot. The predictions were fulfilled. Teenage sexuality dissolved into blood lust. Seats were slashed. Teddy boys and girls jived in the aisles. Those expelled from the cinema vented their rage on a tea-stall situated on the pavement outside. Cups and saucers were thrown about. It was a very English riot. It represented a new convergence – trouble-as-fun, fun-as-trouble.

The two image clusters – the bleak portraits of juvenile offenders, the exuberant cameos of teenage life – reverberate, alternate, sometimes get crossed. By the mid-1960s, at the height of the mod craze, youth culture had become largely a matter of commodity selection, of publicly stated taste preferences: this rather than that type of music or style or dress or brand of cigarette, 'mod' not 'beat,' 'mod' not 'rocker,' 'mod' not 'ted.' For youths in search of an expressive medium, goods could function symbolically as 'weapons of exclusion' [Douglas and Isherwood 1979: 85], as boundary markers, as a means of articulating identity and difference. Converting themselves into objects, those youths immersed in style and the culture of consumption seek to impose systematic control over the narrow domain which is 'theirs' and within which they see their 'real' selves invested, the domain of leisure and appearance, of dress and posture. The posture is auto-erotic: the self becomes the fetish. There is even a distinctive mod way of standing. According to one original mod, 'feet had to be right. If you put your hands in your pocket, you never pulled the jacket up so it was wrinkled. You'd have the top button done up and the jacket would be pulled back behind the arm so that you didn't ruin the line. You'd only ever put

one hand in your pocket if you were wearing a jacket' [Barnes 1980: 10]. The circle has now been fully described: fractions of youth now aspire to the flatness and the stillness of a photograph. They are completed only through the admiring glances of a stranger. This is the other side of affluence – a rapacious specularity, the coming of the greedy I. Henri Lefebvre calls it the Display Myth, describing its circularity thus: 'consuming of displays, displays of consuming, consuming of displays of consuming, consuming of signs, signs of consuming. . . .' [Lefebvre 1971: 114] . . .

I end with three propositions on youth, sexuality, subculture: propositions which, like much else in this [chapter], remain lodged at the level of assertion, speculative assertion.

Proposition one: that in societies such as ours, youth is present only when its presence is a problem, or rather when its presence is *regarded* as a problem. The category 'youth' only gets activated, is only mobilized in official documentary discourse in the form of editorials, magazine articles, in the supposedly disinterested tracts on 'deviance,' 'cognitive dissonance,' and 'maladjustment' emanating from the social sciences, when young people make their presence felt by going out of bounds, by dressing strangely, by resisting through rituals, by breaking bottles, windows, heads, by confounding surveillance, by confronting the police, by issuing challenges, by striking . . . bizarre poses.

When they adopt these strategies, they get talked about, taken seriously, their grievances are acted upon. They get arrested, harrassed, arraigned before the courts. They get interrogated, interviewed, photographed, admonished, disciplined, incarcerated, applauded, punished, vilified, emulated, listened to. When they riot, they get defended by social workers and other concerned philanthropists, they get explained by sociologists, social psychologists, by pundits of every political complexion, they get visited by senior police officials, by Mrs. Margaret Thatcher. They get noticed. Their portraits appear in the right-wing press and the left-wing little magazines. They become visible. In other words, the reactive machinery is set in motion. When adolescents, most particularly when disaffected inner city and unemployed adolescents resort to violence – symbolic and actual violence – they are playing with the only power at their disposal – the power to discomfit, the power, that is, to pose . . . to pose a threat. Far from abandoning good sense, they are acting in accordance with a logic which is manifest: that as a condition of their entry into the adult domain, the field of public debate, the place where real things really happen, they must break the laws which order that domain, which order the distribution of significance within that field, that place. They must exceed consensual definitions of the proper and the permissible. They must challenge the symbolic order which guarantees their subordination by nominating them 'children,' 'youngsters,' 'young folk.' And there is pleasure in transgression.

Proposition two: that the kind of micropolitics, the politics of pleasure in which youth subcultures habitually engage, cannot be collapsed into existing

forms of organized political activity. Quite clearly there are new forces at work here. We are witnessing the formation of new collectivities, new forms of social and sexual being, new configurations of power and resistance. We see the continuing trend toward the concentration of power and resources, the fragmentation of the industrial workforce, the tendency towards privatization in leisure, specialization in the labor process, de-skilling, the expansion of new technologies, the systematic de-manning of industry, the increasingly important role played by the mass media in forming opinion, organizing consent, providing a common national, even international focus; the accelerated move in both Britain and the United States into militarism; the move away from indirect to overtly authoritarian forms of social control, crowd management, and monitoring; the extension of police powers, the formation of specialist guerrilla squads (in Britain, the Special Patrol Group and the Special Air Service). All these shifts in power mean that older cultural traditions which provided the basis for collective forms of identity and action are being disrupted and eroded and that new ones are beginning to emerge. As power is deployed in new ways, so new forms of powerlessness are produced and new types of resistance become possible.

The riots we witnessed in England in the summer of 1981 occupy just one end of a spectrum of possible strategies – civil disobedience, dissidence, sexual politics, role refusal, alternative life styles, the dispersal of personal identity, deviance, symbolic transgression, the exhumation of dead or buried traditions, the mobilization of taboos, in short, the return of the repressed. Viewed from this perspective, even the spectacular subcultures of the young (whose resistance is most clearly and easily contained because it is expressed primarily through consumption, posture, through *symbolic* disaffection) take on some subversive value. They can be seen as attempts to win some kind of breathing space outside the existing cultural parameters, outside the zone of the given. They can be seen as collective responses on the part of certain youth fractions and factions to dominate value systems, as forms through which certain sections of youth oppose or negotiate, play with and transform the dominant definitions of what it means to be powerless, on the receiving end.

Proposition three: that the politics of youth culture is a politics of gesture, symbol, and metaphor, that it deals in the currency of signs and that the subcultural response is, thus, always essentially ambiguous. I have tried to suggest that its very nature and form, the very conditions which produce it, dictate that it should always slip beneath any authoritative interpretation. For the subcultural milieu has been constructed underneath the authorized discourses, in the face of the disciplines of the family, the school, and the workplace. Subculture forms at the interface between surveillance and the evasion of surveillance. It translates the fact of being under scrutiny into the pleasures of being watched, and the elaboration of surfaces which takes place within it reveals a darker will towards opacity, a drive against classification and control, a desire to exceed.

Subculture is, then, neither simply an affirmation or a refusal, neither simply resistance against symbolic order nor straightforward conformity with the parent culture. It is both a declaration of independence, of Otherness, of alien intent, a refusal of anonymity, of subordinate status. It is an *insub-ordination*. And at the same time, it is also a confirmation of the fact of powerlessness, a celebration of impotence. Subcultures are both a play for attention and a refusal, once attention has been granted, to be read according to the Book.

It is appropriate that Foucault should provide us with a metaphor on which we can close, but not close off. For something of the ambiguity and paradox of the subcultural response can be seen in Foucault's description of the chain gangs which, until the 1830s, provided the French peasantry a dramatic entertainment, a celebration of criminality, an image of a world turned upside down:

> In every town it passed through, the chain-gang brought its festival with it; it was a saturnalia of punishment, a penalty turned into a privilege. And, by a very curious tradition which seems to have escaped the ordinary rites of the public execution, it aroused in the convict not so much the compulsory marks of repentance as the explosion of a mad joy that denied the punishment. To the ornaments of the collar and the chain, the convicts themselves added ribbons, braided straw, flowers or precious stuffs. The chain was the round and the dance; it was also a coupling, a forced marriage in forbidden love [Quoted from a contemporary account] 'They ran in front of the chains, bunches of flowers in their hands, ribbons or straw tassels decorated their caps and the most skilful made crested helmets. . . . And throughout the evening that followed the riveting, the chain-gang formed a great merry-go-round. . . . [One commentator remarked:] Woe betide the warders if the chain-gang recognized them; they were enveloped and drowned in its rings; the prisoners remained masters of the field of battle until nightfall . . . [when the warders reestablished their control].
>
> [Foucault 1979a: 261]

I think that is a suitable image on which to end, an image of contained revolt, of spectacular transgressions circumscribed, of crime as carnival, of resistance and chains. A nice point on which to end: to end on an image which rounds things off, framed, as it is, by the consecrating words of Michel Foucault who is also said to have said the following: 'I heard someone talking about power the other day – it's in fashion' [Foucault 1980a: 207]. In *fashion* precisely. For power is inscribed even in the most 'superficial' *sartorial* flourishes. Power is inscribed in the look of things, in our looking at things. In this [chapter], I have attempted to outline how the inconsequential, how that which is regarded as without consequence has, on the contrary, its effects, how those places where we feel least inclined to say what it is we see and

from what angle we see it, stand in the way of our really saying it, consti-tute blind spots, a space to look dumb in. And more than this: a larger project. For we are engaged in the production of a discourse which is cut against the grain of science, a discourse which is informed by a peculiar sense of urgency, a sense of the emergent, one tilted to deliver a particular knowl-edge, a knowledge of the particular, a knowledge which threatens within the academic sphere to present a simulacrum of those other kinds of knowledge generated underneath, outside, within (for instance) the subcultural milieu, a knowledge which cannot be systematized, generalized, a knowledge that doesn't travel at all well.

Engaged in deconstructions, reflexive deconstructions, discursively promiscuous, we aim to fabricate a logic which is diverse and discontinuous, a science, if you like, a science of the concrete, which is to say an unscience, a science of things happening, a discourse which breaks a silence in order to produce dis . . . quiet, this quiet.

Dave Laing

LISTENING TO PUNK [1985]

Voices

RECORDINGS CAN BE THOUGHT of as spaces in which the various sounds are placed in relation to each other. Conventionally, a recording will foreground one particular element, the others arranged behind or around it as supports. Typically in popular music recordings what is foregrounded is the voice. This point can perhaps be supported negatively in that the listener notices (often with a sense of frustration) when the voice 'disappears' into what significantly is called the 'backing'. The frustration comes from a problem of comprehension (not being able to decipher the words) but also from the withdrawal of the opportunity of identification with 'the voice which typically, if not in every case, provides the level of the song which engages our desire most directly' [Cubitt 1984: 211].

The amplified voice can be seen to provide a comparable object for identification to that of the screen image of the film hero or heroine. In addition, the *musicality* of the process is crucial to this sense of perfection and coherence: singing can make a voice extraordinary in a way that everyday speech cannot (though heightened, dramatic speech can – an important point for punk).

Punk voices, to start with, seem to want to refuse the perfection of the 'amplified voice'. In many instances the homogeneity of the singing voice is replaced by a mixture of speech, recitative, chanting or wordless cries and mutterings Philip Tagg has pointed out that recitatives (used here as a generic term for vocalizations that are between ordinary speech and singing)

are among those forms 'where the verbal narrative seems often to be more important than the musical discourse' [Tagg 1981: 14]. This would certainly seem to be the case with many punk records which employ recitative with serious intent. . . . Virtually all the Sex Pistols tracks (with Rotten on lead vocal) and those of Mark Perry's Alternative TV are examples. The implicit logic would seem to involve the conviction that by excluding the musicality of singing, the possible contamination of the lyric message by the aesthetic pleasures offered by melody, harmony, pitch and so on, is avoided. Also avoided is any association with the prettiness of the mainstream song, in its forms as well as its contents: . . . punk has few love songs.

Yet any hope for the pure message, vocals as reflector of meaning, is doomed. Deprived of the conventional beauties of singing as a place for identification, for distraction, the listener may shift to some other aspect of the voice. What is at stake here is that element which Roland Barthes variously called the 'third meaning' or the 'geno-song'. The latter is contrasted with the 'pheno-song' which 'describes everything in the performance which is in the service of communication, representation, expression . . .'. The geno-song, by contrast is

> The volume of the singing and speaking voice, the space where significations germinate from within language and in its very materiality. . . . It is that apex (or depth) of production where the melody really works at the language – not at what it says, but the voluptuousness of its sound-signifiers, of its letters.
>
> [Barthes 1977: 182]

This is not a distinction between form and content or signifier and signified, with special emphasis being given to form. Barthes is concerned only with the role of singing-forms – are they subordinated to the message or content, there to underline it (as is the case in most of the Stranglers' work), or are there places where elements of form 'exceed' the message, providing a different focus for the listener? Johnny Rotten's vocal style offers some examples. In 'God Save The Queen', the word 'moron' comes out as 'mo-rrrr-on-er', with an exaggerated rolled 'r' in the middle and the addition of the extra 'er' syllable at the end. As pheno-song, two readings are possible. This presentation of the word both gives added emphasis within the narrative to the description of the Queen as a 'moron', and also connotes a relish on the part of the singer in making the comparison. So the sound 'in the service of representation' informs the listener of the most important part of the lyric message and provides information about the 'character' of the singer (and in doing so links up with the extra-musical discourse on the Sex Pistols).

But . . . by refocusing, the listener can hear Rotten's 'moron' as geno-song, as pleasure in the 'voluptuousness of . . . sound-signifiers'. For there is a sense in which the emphasis on the word is gratuitous within the lyric

of 'God Save The Queen'. In the next line, for instance, the word 'H-Bomb', which semantically carries greater impact in general discourse, receives no such special emphasis. . . .

It is thus possible (if difficult) to find pleasure in this celebrated punk rock song without the necessity of agreeing with its message. This is something which is conventionally the case with mainstream popular song – the listener can take pleasure from a vocal representation of suffering without sharing the emotion. But it is clearly an outcome that 'protest' type songs would try to exclude. If someone who rejects the message can still like the song, a gap has opened which was unintended.

There are especial difficulties here for the songs of subcultures. While the subculture (or more precisely its interpreters) may pride itself on its ability to subvert dominant or established meanings, a listener to a manifestly punk song may be able to miss the point, and avoid reacting either as a punk initiate or as a shocked adherent of dominant social values. The latter should, in principle, recoil from 'Dead Cities' by The Exploited, a 'formalist punk' record. Yet, such is the frenetic pace of the piece, that the enunciation of the title can easily be heard as a kind of 'scat' singing, as 'Deh See', and enjoyed as a form of abstract (wordless) vocalizing. The point of this example is that the potential play of the signifiers will always challenge the idea of a 'pure' oppositional or subcultural music. To minimize this challenge, a subculture intent on preserving itself and its meaning must organize the context of reception (through audience dress and response) to ensure that the subcultural meaning predominates. The only place for this is the live concert; once the music is on radio or record, other meanings, inflected by other ways of listening (usually structured by the priorities of the musical mainstream) may come to the fore.

A further aspect of the recorded voice is what can be called the *vocal stance*. In his study of Abba's 'Fernando', Philip Tagg describes how the singer's mouth is 'placed nearer the listener's ear by means of mike positioning and volume level in relation to accompaniment at the final mixdown. This reflects the actual/imagined distance between two persons (transmitter and receiver) in an intimate/confidential dialogue' [Tagg 1981: 13]. This private and confidential stance is in contrast to a public and declamatory one, which reflects a greater distance between the voice singing and the ears listening. As Tagg indicates, both imply a communicative function for the voice and belong very much to the pheno-song aspect of music.

Indeed, the confidential and declamatory emphases tend to be aligned with specific genres of music, different lyric subject-matter and contrasting 'modes of address' in the lyric. . . . [T]he genres most closely associated in popular song with the confidential vocal stance are the lyric ballad deriving from the 'standard' song-writing of Irving Berlin through to Lennon and McCartney and some blues styles. The declamatory mode, by contrast, is generally rooted in mainstream soul music, the 'shouting' style of R&B singing which in turn influenced early rock 'n roll through Bill Haley, Little Richard

and Jerry Lee Lewis and a white narrative ballad style deriving via Bob Dylan from Woody Guthrie and the Carter Family.

While the descriptions 'confidential' and 'declamatory' are meant to indicate tendencies in singing, rather than hard and fast categories, it is useful to note that of the Top 50 best-selling singles of 1976 . . . nearly half were clearly confidential in tendency. . . . In general, there is a connection between the preponderance of love songs and the confidential vocal stance. . . .

Within punk rock, however, the confidential stance was very rare. The Buzzcocks' Peter Shelley was one of the few who presented lyrics in a manner approaching that of the mainstream balladeers. Within the declamatory mode as employed by punk, elements of the soul style were equally scarce: Poly Styrene of X-Ray Spex uses falsetto whoops on 'Oh Bondage Up Yours!', while among the few bands to adopt American vocal accents were the Vibrators, The Damned (on the first album) and the Boomtown Rats, where the debt to Mick Jagger's rock-American intonation was very noticeable.

Simon Frith expresses the general view of the innovation in punk accents by describing how Johnny Rotten 'developed an explicitly working-class voice by using proletarian accents, drawing on football supporter chants . . .' [Frith 1981a: 161]. But the argument that punk imported extra-musical elements into the popular music discourse tends to underplay the previous applications of similar accents in rock music[: for example, the] modified 'stage cockney' of Anthony Newley and a young David Bowie in the 1960s – an accent alluded to in The Clash's 'Safe European Home' which includes the line, 'Wouldn't it be luverly' – a quotation from the hit musical *My Fair Lady*.

That accent influenced punk rock through some of the Vibrators' singing, but several punk bands offered a flatter London accent shorn of the aesthetic 'quaintness' which stage cockney had acquired. Prime examples were the querulous and whinging tone of Mark P. (notably on 'My Love Lies Limp' and 'How Much Longer') and the ultra-morose Malcolm Owen of The Ruts in whose singing the word 'feel' came out as 'feeyuwuh'. But if the intention in using such voices . . . on record was to signify the 'ordinary', the language of the streets, the result was paradoxical. For, in the context of popular music, the mundane and everyday was actually the mainstream American or 'non-accented' (sometimes called 'mid-Atlantic') accent associated in 1976 with singers like Abba or Queen's Freddie Mercury. What was ordinary in the streets became extraordinary on record and on radio.

Here is one point, then, where the 'realism' claimed by [the fanzine] *Sniffin' Glue* for punk rock is connected with the exotic and unnatural element in the music emphasized by other commentators. Voices which could be strongly identified with 'real' accents acquired a colourful resonance. The more neutral connotations which were perhaps most suited to naturalistic lyrics – the transparent voice – belonged to vocals such as Joe Strummer's, where the standard mainstream rock voice was not so much replaced as

shifted. 'White Riot' had the same phrasing as the breathless singing of The Ramones, but without the pronunciation of key sounds which fully identify The Ramones as American. In the syllable 'White', for example, the American tendency to stretch the vowel towards an 'ah' sound (which is also characteristic of rock singing in general) was resisted by The Clash, who retain the short 'i' sound. And the final 't' was clipped off by the British voice, while most American rock pronunciation would keep it, in whole or in part.

Strummer's vocals share with virtually all punk rock singing a lack of variety. There are no moves within songs from high to low, soft to loud, or from one accent to another. One thing which gives the Johnny Rotten voice a special place within punk rock is its unusual practice of changing direction within a song, a verse or even a line. By 'direction', I refer to a vocal strategy, a general approach to the choice of vocal effects. In punk rock, the basic distinction at this level is between 'straight' and 'embellished' singing. Early Clash records exemplify the straight style, where the project is to subordinate the vocal method to the lyric message – a mode appropriate to Barthes' pheno-song. Now, 'Anarchy In The UK' by the Sex Pistols sets off in this mode, a staccato delivery of words with one syllable assigned strictly to one beat. But something happens to deflect that single-mindedness at the end of the second line: 'I am the Anti-Christ/I am an Anarchist. . . .' The final syllable comes out not as 'kissed' but to rhyme with 'Christ'. The embellishment shifts the attention away from the message to the rhyme-scheme and could momentarily set up an ambivalent signal about the 'sincerity' of the whole enterprise. Can anyone who changes the pronunciation of such a key political word be wholly intent on conveying the message of the lyric? This relish for the signifier emerges in other ways that have already been mentioned (the rolled 'r' etc.), and works in tension with the punk ideal of 'straight' singing in the work of Johnny Rotten. As I have already suggested, such a tension can never be fully eliminated from any vocal performance, but it seems more central to the Sex Pistols' music than to most other punk bands of 1976–8. . . .

Words: intertextuality

. . . The titles of the Top 50 songs of 1976 reveal the predictable cluster of words around 'Love', which itself appears seven times, including thrice in one song title. This cluster includes 'heart', 'kisses', 'breaking', 'angel', 'cry'. Another, perhaps less expected, linguistic area which is well represented is that of music and dancing themselves. 'Dance' occurs four times and 'music' three; with 'rock', 'songs', 'rhapsody' and 'funky', this group of words turns up in the titles of ten out of the Top 50 and in the body of the lyrics of at least two others (Abba's 'Fernando' and 'Under the Moon Of Love' by Showaddywaddy).

410

Among the first five punk rock albums, the song titles of The Vibrators yield three appearances of 'heart' and two of 'baby'. None of the other bands have lyric titles including words in this 'love' area, while the only ones remotely near the music and dance field are 'Garageland' by The Clash ('garage band' being a term for 1960s punk groups) and 'Fan Club' by The Damned. Remaining at the level of the vocabulary of titles, the most outstanding clusters of words in the punk rock songs are those around violence ('kill', 'stab', 'burning', 'whips', 'hate and war', 'riot', 'wrecked') and in references to actual places and people. 'London' appears three times, along with 'Toulouse', 'USA', 'New York', 'Janie Jones', 'The Queen' and 'EMI'. Compared to this the Top 50 titles have just 'Mississippi' and 'Zaire'.

Attention to individual words as an indicator of difference in song lyrics can, however, be misleading, since the centre of meaning of the word is dependent on its context. That context is both that of the immediate statement of which it is a part, and the larger discourses (of a song and a genre) of which the statement in its turn forms a part. For example, 'killing' can be found in the mainstream romantic discourse, most notably in 'Killing Me Softly With His Song', where the word clearly has a metaphorical sense. 'Burning' is another word which is similarly used to convey an excess of feeling ('Burning Love'). The Damned's title 'Born To Kill', however, reinstates the literal meaning of the word, while Clash's 'London's Burning' ('with boredom') involves a metaphorical connection based not on overheated passion but on the effects of urban rioting.

Even this distinction between literal and metaphorical word use is less important when we recognize the 'intertextual' nature of all language statements. For instance, while 'Born To Kill' is part of a paradigm of statements using 'Kill' in a dramatic way (e.g. sensational newspaper accounts of murder trials, film titles like *Dressed To Kill*), it also connects with a group of 'Born to . . .' statements, which emphasize ideas of heredity ('born to be king') or of predestination or fate: song titles in this mode include 'Born To Be Wild', 'Born To Run', 'Born To Be With You' and 'Born To Boogie'. And each of those instances involves using the predestination form of statement to emphasize the singer's total commitment to one or other of the staple roles of rock lyrics: the wild one, the outsider, the lover, the abandoned dancer. The weight of this aspect of The Damned's song title . . . ties it to more 'standard' areas of musical and cultural meaning than one might expect from punk rock. . . .

The kind of analysis which traces networks of connotations for a phrase like 'Born To Kill', networks deriving from similar usages in other places in the culture, and most particularly in the texts of popular culture, is based on the principle of 'intertextuality'. This term is mainly used in literary criticism, and in that field Terry Eagleton has offered one of the most cogent definitions of the process of intertextuality. If 'music' or 'lyric' is substituted for 'literary' here, the applicability of the description to popular song can be grasped:

> All literary texts are woven out of other literary texts, not in the
> conventional sense that they bear the traces of 'influence', but in the
> more radical sense that every word, phrase or segment is a reworking
> of other writings which precede or surround the original work. There
> is no such thing as literary 'originality', no such thing as the 'first'
> literary work: all literature is 'intertextual'. A specific piece of writing
> thus has no clearly defined boundaries: it spills over constantly into the
> works clustered around it, generating a hundred different perspectives
> which dwindle to vanishing point.
>
> [Eagleton 1983: 138]

Eagleton rightly points out that any text (in our case, any punk rock lyric)
has 'no clearly defined boundaries'. But there are several levels at which
boundaries are imposed on that text, places where, for various motives, the
'reworking' of other texts is limited. The first is a legal and commercial one:
a song has to be a clearly separate entity both to take the form of a commodity
to be marketed and sold, and to become a piece of intellectual property, to
have an 'author' who owns a copyright in that song. . . .

Then, a text will always be presented in a context, within a discursive
formation, which will attempt to impose a way of reading or listening on
the consumer. For Eagleton's literary texts, the distinction between reading
inside the educational formation or inside a leisure context will produce
different effects. Within popular music, the dominant discursive formation
is that associated with the major record companies, the charts and music
radio. It emphasizes the values of what Simon Frith has called 'orderly
consumption' [1981a: 270] and what elsewhere I have called the 'leisure
apparatus' [Laing 1978: 126]. Here, entertainment is emphasized and enlight-
enment excluded, leisure defined as a passive relaxation and recuperation
and feeling are extolled at the expense of thought.

Further, the drive for the largest possible audience causes the narrowing
down of positions to be occupied by the listener. This involves both the
'unique and vaguely defined' addressee of the [song's lyric] and a certain
homogenization of music which occurs within the Top 50 system. Here
very different forms of music are presented in a context of comparison a
nd competition which can delimit the audience's awareness of their poten-
tially radical differences. When the Sex Pistols finally appeared on the BBC
TV chart show 'Top Of The Pops', how far was it a victory for 'punk' –
its chance to present itself to a mass audience – or for the dominant discur-
sive formation, which had now presented 'punk' as just another musical
trend?

The shift by the BBC from the exclusion of 'God Save The Queen' to
the inclusion of 'Pretty Vacant' (the first Pistols' record to be shown on 'Top
Of The Pops') typified a dilemma for the leisure apparatus. One crucial way
in which the institutions of popular music try to maintain their dominance
is through ignoring musics which contain elements of alien discourses (e.g.

politics, obscenity, explicit sexuality), for if those elements are brought into popular music they may have a disruptive effect. When they are brought in (and here, the popular music institution is caught in an ambivalent posture, since it also feels the need for a renewing of its own discursive practice in order to replenish its products), there are procedures for incorporating those external elements (be they rhythms, hair-styles or lyric statements) to minimize their disruption of orderly consumption.

At the level of song themes, punk rock was responsible for the importation of elements not from 'real life' so much as from other discourses into popular music. Its rhetoric of social and political comment echoed much of the news discourse of the period, sometimes inflected with that of left-wing ideology. To an extent, popular music had earlier, with protest song, had to handle such themes; though here, the emphasis on violent denunciation made punk rock more of a destabilizing factor.

Even more destabilizing was that area of punk language which drew on discourses which not only had been previously absent from popular song, but which had been excluded from the mainstream media discourse of society as a whole: the area of 'pornography' and 'obscenity'. The first rock recording to include the word 'fuck' had appeared in 1969, when *Love Chronicles* by the singer-song-writer Al Stewart had included the lines: 'It grew a little less like fucking, and more like making love'. Although dutifully banned by the BBC, this usage was clearly a conservative one, and no doubt justifiable as 'artistically appropriate'. John Lennon achieved greater publicity when he transferred the swearing usage into song with his reference to 'fucking peasants' on 'Working Class Hero'. A number of other 'progressive rock' performers committed the word to wax during the early 1970s, including Joni Mitchell, Dory Previn, Buffy Sainte-Marie and Nilsson.

It was left to punk rock to introduce 'fuck' and the rest wholesale to popular music. Both the 'explicit' sexual and the expletive swearing versions were available. The Clash and the Sex Pistols went in for the latter, for example in 'All The Young Punks', an answer to subcultural critics of The Clash for 'selling out', where Joe Strummer refers contemptuously to them as 'All the young cunts'. The explicitly sexual usage was left mainly to the literal-minded Stranglers on tracks including 'Bring On The Nubiles' and 'School Marm'. The latter, and the Buzzcocks' 'Orgasm Addict' provided a 'bonus' of wordless pantings, punk rock's answer to the soft-porn sounds of the 1969 hit 'Je T'Aime, Moi Non Plus' by Jane Birkin and Serge Gainsbourg.

The Stranglers' songs mentioned have scenarios of pornographic fantasies, with strongly sadistic overtones, and elsewhere that group and the early Adam And The Ants produced litanies of detailed violent acts: 'I'll sew up your mouth', 'You kicked my cheekbones in', 'Smack your face, treat you rough, beat you till you drop'. In so far as these songs disrupted the discourse of mainstream popular music, it was through their ability to 'shock' the listener.

413

But which kind of listener (a 'mainstream' one? a 'punk' one?) and what kind of shock?

Shock effects

The idea that music, or any other artistic form, should aim to shock is an established part of avant-garde aesthetics. Writing in the 1930s, the German critic Walter Benjamin described the effect of the Dadaists in terms of shock: 'Their poems are "word salad" containing obscenities and every imaginable waste product of language. . . . One requirement was foremost: to outrage the public' [Benjamin 1968: 239]. This attitude of *épater le bourgeois* is a time-honoured one, and a motive that is consciously present in punk rock. In interviews, a number of musicians spoke of 'shock' as an intention. But what precisely was entailed in the shock; was it simply to traumatize the recipients, or in some way to enlighten them? In Benjamin's writings, there are several approaches to this issue. His essay on the nineteenth-century poet Charles Baudelaire considers two kinds of response to shock. The context is Benjamin's discussion of the new conditions of everyday life in the metropoli of industrial capitalism where the sudden jolt or shock is a frequent occurrence. Using Freud, Benjamin distinguishes between 'shock defence' which neutralizes the power of shock and a different response which integrates the content of shock into experience by the recipient's exposing him or herself more directly to the shock effect. For this to occur, the shock must be 'cushioned, parried by consciousness'. In effect, Benjamin argues that the 'shock defence', the inability to 'digest' shock content, produces trauma [1973: 115–18]. For the audience of an artistic event, the trauma involves what Barthes calls 'a suspension of language, a blocking of meaning' [1977: 30]. The resistance of the audience to the music or other art-work makes it impossible for any meaning to be registered. The viewer or listener turns off when confronted with the film of torture or the 'tuneless' piece of avant-garde music.

Theodor Adorno, a contemporary of Benjamin and astringent critic of his ideas, discussed this kind of response to what he called the 'radical music' of Schoenberg. There the listener was faced with 'the dissonances which frighten' and 'speak to the very condition of his existence: that is the only reason why they are unbearable' [Adorno 1973: 9]. Adorno, then, imparts a direct epistemological significance to the 'shock defence' identified by Benjamin. The rejection of avant-garde music by the mass of the population means that they have refused to face up to the truth about their lives. The theme of truth-telling at all costs is a familiar one in punk rock too: 'The Clash tell the truth', said Mark P. in *Sniffin' Glue*. For Barthes, in contrast, the cause of 'shock defence' and its accompanying trauma has a semiotic explanation: the shock-photo is the one for which the reader can find no connotation, no symbolism. Once a picture of a wartime atrocity can connote

'horrors of war' or 'imperialism' it can be integrated into the reader's consciousness. If it remains a pure denotation of sadism, the 'blocking of meaning' occurs.

The distinction between the two responses to the shock-effect – the negative shock-defence and the positive response which integrates the shock-effect – recurs in Walter Benjamin's essay 'The Work Of Art In The Age Of Mechanical Reproduction'. But here, as the title indicates, the argument is placed in the context of the history of different media, rather than the general history of industrializing capitalist societies. Briefly, his thesis is that the avant-garde movements of one artistic form are the heralds of a future cultural medium, whose technologies and techniques will be quite different:

> Traditional art forms in certain phases of their development strenu-ously work towards effects which later are effortlessly attained by the new ones. Before the rise of the movie, the Dadaists' performances tried to create an audience reaction which Chaplin later evoked in a more natural way.
>
> [Benjamin 1968: 251–2]

Benjamin then contrasts the shock-effects of Dada and the cinema. The Dadaist work 'hit the spectator like a bullet, it happened to him, thus acquiring a tactile quality'. But it also kept the 'physical shock effect' wrapped in a 'moral shock effect' (*épater le bourgeois?*); 'By means of its technical structure', film has dispensed with the moral wrapping and presents a shock-effect which 'like all shocks, should be cushioned by heightened presence of mind' [ibid., 240].

The suggestion is that Dada and other avant-garde art-forms were consciously motivated by a desire to make a negative impact, perhaps to arouse a 'shock defence' or trauma in a section of its audience through the 'moral shock effect'. Indeed, part of its success depended on achieving that negative response. But the 'technical structure' of film allowed it to make a new impact without recourse to such deliberate traumatizing. Film's shock-effects were positive, transforming the outlook of the viewer.

If Benjamin's ideas are applied to the 1970s, where does punk rock stand in the contrast between Dada and film, and in that between the two responses to the shock-effect? It seems to have contained characteristics of both a frenzied critique of established art-forms (e.g. Dada) and of the effortless achieving by new technical means of effects or results striven hard for by earlier avant-gardes. Like Dada's 'word salad', much punk use of language involved both the shock of the new (importation of obscenity, politics, etc. in to popular lyrics) and the shock of the real (justification of this impor-tation by the assertion that this is what happens on the street). Additionally certain organizational effects of punk rock may turn out to be harbingers of a future, more widespread medium. In particular, the very small-scale 'do it yourself' world of small labels but especially of home-made taped

music represented the virtual dissolution of the barrier between performer and audience that was part of the ethos of much punk activity. . . .

On the other hand, there is a perspective within which punk rock seems more like Benjamin's description of the cinema, which can evoke 'in a more natural way' things strained for by previous avant-gardes. The punk opening up of self-production and distribution represented a relatively painless achieving of something avant-garde rock bands of a few years earlier had to go through debilitating tussles with record companies to get. Punk found ways of access to audiences for new music in a manner which had totally evaded the earlier bands.

The production of shock-effects involves confronting an audience with unexpected or unfamiliar material which invades and disturbs the discourse to which that audience is attuned. The nature of the material will therefore depend entirely on the specific context. . . .

Clearly, the shock-effect actually occurs only at the point of impact on the listener. Until that moment the production of shock by the specific formal organization of musical material remains potential rather than actual. But it is possible to distinguish amongst the formal organizations between those which are more likely to achieve the full shock-effect and those which are less likely to do so. The other active element in all this will of course be the position of the listener her or himself: there will be varying degrees of receptivity, depending on that individual's ideolect and on the context in which they hear the music.

In discussing the potential of different types of organization of musical material to produce shock-effects, it is necessary to return to Benjamin's notion of the two types of impact, the 'traumatizing' and the 'integrated'. I want to suggest that while the first type can be produced by any punk text, only some are capable of going further to achieve the second type of response, which implies the listener's increase in awareness in some form or other.

To explain this further means introducing a distinction between *local* and *structural* shock-effects. A local shock-effect occurs when just one aspect of a musical piece is composed of shock-material, leaving the overall structure intact. When the Stranglers introduce obscene or sadistic lyrics, but retain vocal stylings and musical forms acceptable to the mainstream, a 'traumatic' response to obscenity is quite possible. But for a listener who is able to 'absorb' that shock and integrate it into their consciousness, there is little likelihood of a further 'pay-off' in heightened awareness. In fact, the most likely response is that hearing the music as a whole will mean hearing it as conventionally pleasurable. The local shock-effect is neutralized by the compatibility of the structure of the whole piece with the discourse of dominant popular music.

A structural shock-effect should have a greater chance of reaching the second level of impact, since it can potentially change the whole 'shape' of a recording or performance. 'Love Like Anthrax' by the Gang Of Four includes sequences in which two vocalists simultaneously deliver different

sets of lyrics, joining together at certain chorus lines. Although it is still possible to hear this as a 'normal' record – by making one vocalist the centre of attention and ignoring the other – the most probable effect is that it will force the listener into a different way of listening, a way which involves considering the relation of the two lyrics to each other, and so on. . . . How far those shock-effects work on the listener is, to repeat, in part a function of how that listener hears the music, and in particular whether and how the process of *identification* operates in the listening experience.

Systematic discussion of modes of identification in listening is very sparse, so it seems appropriate to adapt the ideas developed about looking in film theory, especially as the Freudian discourse (to which those ideas belong) indicates that the 'invocatory' (listening) drive is a basic component of the human psyche alongside the 'scopic' (looking) drive [Metz 1975: 59–61]. A primary form of identification is with that which occupies the central point of a representation, the place of the *hero*, where that term applies not just to a character but to a function which moves the 'narrative' (story or song) along and in doing so establishes itself as something . . . more perfect than the listener him or herself.

In the song, this position is most frequently occupied by the lead vocal, which as has already been remarked is conventionally mixed 'to the front' of a recording. Sean Cubitt points out that the identificatory power of this positioning is apparent from the way dancers at a disco sing along with the lead vocal line: 'We can . . . through vocal identification become the singer and produce the song as our own' [Cubitt 1984: 212].

Laura Mulvey 1981 has shown that the comparable form of identification in watching a film can *potentially* affect any listener, regardless of gender, social class or ideological position. But she adds that it is frequently problematic or in some tension with differences between a listener and the 'hero-figure' (actor or singer). This latter case can be seen in the instance of Mick Jagger's voice and the ambivalent position of certain women listeners, drawn both to identification with Jagger as the source of musical power and control and repelled by Jagger as source of a sexist, sadistic ideology expressed in the lyric.

The importance attached to the issue of identification in radical culture criticism can be traced back to Bertolt Brecht. His dramatic characterization was deliberately designed to foil any empathy between spectator and character because, he argued, such identification precluded the spectator achieving any critical awareness of the character's situation. Hence the Brechtian notion of 'alienation' or 'distanciation' whereby the actor . . . *presents* the character to the audience rather than *becoming* it for them. In this way the art-work could make the audience think rather than simply feel.

Within punk rock, this Brechtian mode of non-identification can possibly be found in three ways. The first, and most questionable, derives from Roland Barthes' distinction [noted above] between geno-song and pheno-song. Barthes' exposition of this distinction contains distinct echoes of the

Brechtian theme when he describes the pheno-song as being involved in 'the ideological alibis of a period', including the 'personality of the artist' [1977: 182]. It is the presentation of the singing voice as primarily this 'personality' . . . which is equivalent to the Brechtian identification and empathy. For Barthes it produces only *plaisir*, a form of enjoyment which merely confirms the listener in his or her status quo, without changing it.

In Barthes' account, change comes through *jouissance*, the more radical form of pleasure which 'shatters – dissipates, loses – [the] cultural identity, [the] ego' [1977: 9]. *Jouissance* proves the truth of psychoanalytic theory, that the self is not a unified whole, but a shifting bundle of elements, constructed by the drives of the unconscious and by social forces. And it is the geno-song of the voice that produces *jouissance* in the listener. By hearing those elements of a singing voice which are surplus to the communication of a message, such as Rotten's embellishments . . ., the listener escapes identification with the voice as ideal ego.

Such, at least, is Barthes' argument. But the implication of Sean Cubitt's account of identification with the singing voice is that such a distinction as that between pheno- and geno-song is irrelevant. The voice needs only consistency to become a place for identification.

Punk rock's second way of frustrating the primary identification with the singing voice occurs when a reading is structured so that there is no clearly presented centre of power and control. This can take two forms. First there are various 'avant-gardist' strategies which involve mixing a record so that the lead voice is displaced from the aural focus: the Gang Of Four disc considered above is one example of a text with no single centre for identification. Cubitt mentions also the 'post-punk' all-woman group, The Raincoats, 'who mix their voices down to the same level as the instruments'.

Secondly, there is the case of the voice which repels the listener's hope for identification by its 'unpleasing' character. Historically, this is always one effect of innovation in popular music – the introduction of material from a discourse outside the mainstream is recognized by many as 'unlistenable'. But some punk rock seems to re-double this effect by presenting itself as a *challenge* to listeners, as an act, not of a new version of the popular vocal tradition, but of defiance of that tradition's broadly ingratiating stance towards its audience. There is then a distinction between, say, early Elvis Presley, where the 'traumatizing' shock-effect was an unintended by-product of the novelty of the vocal style, and the Sex Pistols, where the provocation of the 'boring old farts' among listeners was often built-in to the structure of the record and frequently signalled in the lyrics, as the second-person addressees, as well as in the tone of singing voice.

If, then, this interdiction of identification with the singing voice as such, affected, 'shocked,' every listener, it was also the point at which a 'punk' and a 'non-punk' listener began to be constituted. While the latter suffered Benjamin's shock-defence and switched off from any attempt at comprehension, the 'punk' listener made a second-level identification –

not with the sound of the voice but with the singer or band making that sound. . . .

The 'punk listener', however, is involved with another aspect. For his or her alignment with the musician's strategy of provocation must include a pleasure in the awareness of how the other, 'traumatized' listener will be discomforted. That is, the identity of punk as something different depends in part on its achieving a disquieting impact on listeners whose expectations are framed by mainstream popular music and its values. Punk is not alone here. Much 'youth' music or music of outrage depends on its fans not so much being outraged or scandalized themselves, but on their awareness of the results of unpleasant listening in other people. And, finally, we may note that it is quite feasible for the same individual to both feel the effects of shock and to observe and enjoy the disturbance thus caused. That person could well be an example of Benjamin's ideal audience, possessed of 'heightened presence of mind'.

Kobena Mercer

BLACK HAIR/STYLE POLITICS [1987]

Tangled roots and split ends: hair as symbolic material

AS ORGANIC MATTER produced by physiological processes, human hair seems to be a natural aspect of the body. Yet hair is never a straight-forward biological fact, because it is almost always groomed, prepared, cut, concealed and generally worked upon by human hands. Such practices socialize hair, making it the medium of significant statements about self and society and the codes of value that bind them, or do not. In this way hair is merely a raw material, constantly processed by cultural practices which thus invest it with meanings and value.

The symbolic value of hair is perhaps clearest in religious practices – shaving the head as a mark of worldly renunciation in Christianity or Buddhism, for example, or growing hair as a sign of inner spiritual strength for Sikhs. Beliefs about gender are also evident in practices such as the Muslim concealment of the woman's face and hair as a token of modesty. Where 'race' structures social relations of power, hair – as visible as skin color, but also the most tangible sign of racial difference – takes on another forcefully symbolic dimension. If racism is conceived as an ideological code in which biological attributes are invested with societal values and meanings, then it is because our hair is perceived within this framework that it is burdened with a range of negative connotations. Classical ideologies of race established a classificatory symbolic system of color, with white and black as signifiers of a fundamental polarization of human worth – 'superiority/ inferiority.' Distinctions of aesthetic value, 'beautiful/ugly,' have always been central to the way racism divides the world into binary oppositions in its adjudication of human worth.

Although dominant ideologies of race (and the way they dominate) have changed, the legacy of this biologizing and totalizing racism is traced as a presence in everyday comments made about our hair. 'Good' hair, when used to describe hair on a black person's head, means hair that looks European, straight, not too curly, not that kinky. And, more importantly, the given attributes of our hair are often referred to by descriptions such as 'woolly,' 'tough' or, more to the point, just plain old 'nigger hair.' These terms crop up not only at the hairdresser's but more acutely when a baby is born and everyone is eager to inspect the baby's hair and predict how it will 'turn out.' The pejorative precision of the salient expression, *nigger hair*, neatly spells out how, within racism's bipolar codification of human worth, black people's hair has been historically *devalued* as the most visible stigmata of blackness, second only to skin. . . .

Stuart Hall . . . emphasizes the composite nature of white-bias, which he refers to as the 'ethnic scale,' as both physiological and cultural elements are intermixed in the symbolization of one's social status. Opportunities for social mobility are therefore determined by one's ranking on the ethnic scale, and involve the negotiation not only of socioeconomic factors such as wealth, income, education and marriage, but also of less easily changable elements of status symbolism such as the shape of one's nose or the shade of one's blackness (Hall, 1977: 150–82). In the complexity of this social code, hair functions as a key *ethnic signifier* because, compared with bodily shape or facial features, it can be changed more easily by cultural practices such as straightening. Caught on the cusp between self and society, nature and culture, the malleability of hair makes it a sensitive area of expression. . . .

With its organizing principles of biological determinism, racism first politicized our hair by burdening it with a range of negative social and psychological meanings. Devalorized as a 'problem,' each of the many stylizing practices brought to bear on this element of ethnic differentiation articulate ever so many 'solutions.' Through aesthetic stylization each black hairstyle seeks to *revalorize* the ethnic signifier, and the political significance of each rearticulation of value and meaning depends on the historical conditions under which each style emerges. The historical importance of Afro and Dreadlocks hairstyles cannot be underestimated as marking a liberating rupture, or 'epistemological break,' with the dominance of white-bias. But were they really that 'radical' as solutions to the ideological problematization of black people's hair? Yes: in their historical contexts, they *counter*politicized the signifier of ethnic and racial devalorization, redefining blackness as a desirable attribute. But, on the other hand, perhaps not: because within a relatively short period both styles became rapidly *de*politicized and, with varying degrees of resistance, both were incorporated into mainstream fashions within the dominant culture. What is at stake, I believe, is the difference between two logics of black stylization – one emphasizing *natural* looks, the other involving straightening to emphasize *artifice*.

Nature/culture: some vagaries of imitation and domination

Our hair, like our skin, is a highly sensitive surface on which competing defi-
nitions of 'the beautiful' are played out in struggle. The racial
overdeterminations of this nature/culture ambivalence are writ large in this
description of hair-straightening by a Jamaican hairdresser:

> Next, apply hot oil, massaging the hair well which prepares it for a
> shampoo. You dry the hair, leaving a little moisture in it, and then
> apply grease. When the hair is completely dry you start *cultivating* it
> with a hot comb. . . . Now the hair is all straight. You can use the
> curling iron on it. Most people like it curled and waved, not just
> straight, not just dead straight.
>
> (quoted in Henriques, 1953: 55)

Her metaphor of 'cultivation' is telling because it makes sense in two contra-
dictory ways. On the one hand, it recuperates the brutal logic of white-bias:
to cultivate is to transform something found 'in the wild' into something of
social use and value, like domesticating a forest into a field. It thus implies
that in its natural given state, black people's hair has no inherent aesthetic
value: it must be worked upon before it can be beautiful. But on the other
hand, all human hair is 'cultivated' in this way insofar as it merely provides
the raw material for practices, procedures and ritual techniques of cultural
writing and social inscription. Moreover, in bringing out other aspects of the
styling process which highlight its specificity as a cultural practice – the skills
of the hairdresser, the choices of the client – the ambiguous metaphor alerts
us to the fact that nobody's hair is ever just natural, but is always shaped
and reshaped by social convention and symbolic intervention.

An appreciation of this delicate 'nature/culture' relation is crucial if
we are to account both for the emergence of Dreadlocks and Afro styles as
politicized statements of pride *and* their eventual disappearance into the main-
stream. To reconstruct the semiotic and political economy of these black
hairstyles we need to examine their relation to other items of dress and the
broader historical context in which such ensembles of style emerged. An
important clue with regard to the Afro in particular can be found in its
names, as the Afro was also referred to, in the United States, as the 'natural.'

The interchangability of its two names is important because both signi-
fied the embrace of a 'natural' aesthetic as an alternative ideological code of
symbolic value. The 'naturalness' of the Afro consisted in its rejection both
of straightened styles and of short haircuts: its distinguishing feature was the
length of the hair. With the help of a pick or Afro-comb the hair was encour-
aged to grow upwards and outwards into its characteristic rounded shape.
The three-dimensionality of its shape formed the signifying link with its status
as a sign of Black Pride. Its morphology suggested a certain dignified body

posture, for to wear an Afro you have to hold your head up in pride, you cannot bow down in shame and still show off your 'natural' at the same time. . . .

In its 'naturalistic' logic the Afro sought a solution that went to the roots of the problem. By emphasizing the length of hair when allowed to grow 'natural and free,' the style countervalorized attributes of curliness and kinkiness to convert stigmata of shame into emblematics of pride. Its names suggested a link between 'Africa' and 'nature' and this implied an oppositional stance *vis-à-vis* artificial techniques of any kind, as if any element of artificiality was imitative of Eurocentric, white-identified, aesthetic ideals. The oppositional economy of the Afro also depended on its connections with dress styles adopted by various political movements of the time.

In contrast to the Civil Rights demand for equality within the given framework of society, the more radical and far-reaching objective of total liberation and freedom from white supremacy gained its leverage through identification and solidarity with anticolonial and anti-imperialist struggles of emergent Third World nations. At one level, this alternative political orientation of Black Power announced its public presence in the language of clothes.

The Black Panthers' 'urban guerrilla' attire – turtlenecks, leather jackets, dark glasses and berets – encoded a uniform of protest and militancy by way of the connotations of the common denominator, the color black. The Panthers' berets invoked solidarity with the violent means of anti-imperialist armed struggle, while the dark glasses, by concealing identity from the 'enemy,' lent a certain political mystique and a romantic aura of dangerousness.

The Afro also featured in a range of ex-centric dress styles associated with cultural nationalism, often influenced by the dress codes of Black Muslim organizations of the late 1950s. Here, elements of 'traditional' African dress – tunics and dashikis, head-wraps and skull caps, elaborate beads and embroidery – all suggested that black people were contracting out of Westernness and identifying with all things African as a positive alternative. It may seem superficial to reread these transformative political movements in terms of style and dress: but we might also remember that as they filtered through mass media, such as magazines, music, or television, these styles contributed to the increasing visibility of black struggles in the 1960s. As elements of everyday life, these black styles in hair and dress helped to underline massive shifts in popular aspirations among black people and participated in a populist logic of rupture.

As its name suggests, the Afro symbolized a reconstitutive link with Africa as part of a counter-hegemonic process helping to redefine a diaspora people not as Negro but as Afro-American. A similar upheaval was at work in the emergence of Dreadlocks. As the Afro's creole cousin, Dreadlocks spoke of pride and empowerment through their association with the radical discourse of Rastafari which, like Black Power in the United States,

inaugurated a redirection of black consciousness in the Caribbean. Walter Rodney drew out the underlying connections and 'family resemblances' between Black Power and Rastafari (Rodney, 1968: 32–3). Within the strictures of Rastafari as spiritual doctrine, Dreadlocks embody an interpretation of a religious, biblical injunction that forbids the cutting of hair (along the lines of its rationale among Sikhs). However, once 'locks were popularized on a mass social scale – via the increasing militancy of reggae, especially – their dread logic inscribed a beautification of blackness remarkably similar to the 'naturalistic' logic of the Afro.

Dreadlocks also embrace 'the natural' in the way they valorize the very materiality of black hair texture, for black people's is the only type of hair that can be 'matted' into such characteristic configurations. While the Afro's semiotics of pride depended on its rounded shape, 'locks countervalorized nappy-headed blackness by way of this process of matting, which is an option not readily available to white people because their hair does not 'naturally' grow into such organic-looking shapes and strands. And where the Afro suggested an articulating link with Africa through its name and its association with radical political discourses, Dreadlocks similarly implied a symbolic link between their naturalistic appearance and Africa by way of a reinterpretation of biblical narrative which identified Ethiopia as 'Zion' or Promised Land. With varying degrees of emphasis, both invoked 'nature' to inscribe Africa as the symbol of personal and political opposition to the hegemony of the West over 'the rest.' Both championed an aesthetic of nature that opposed itself to any artifice as a sign of corrupting Eurocentric influence. But nature had nothing to do with it! Both these hairstyles were never just natural, waiting to be found: they were stylistically *cultivated* and politically *constructed* in a particular historical moment as part of a strategic contestation of white dominance and the cultural power of whiteness.

These styles sought to liberate the materiality of black hair from the burdens bequeathed by racist ideology. But their respective logics of signification, positing links between the natural, Africa and the goal of freedom, depended on what was only a *tactical inversion* of the symbolic chain of equivalences that structured the Eurocentric system of white-bias. . . . The biological determinism of classical racist ideology first politicized our hair by burdening it with 'racial' meanings: its logic of devalorization of blackness radically devalued our hair, debarring it from access to dominant regimes of the 'truth of beauty.' This aesthetic denegation logically depended on prior relations of equivalence which posited the categories of *Africa* and *Nature* as equally other to Europe's deluded self-image which sought to monopolize claims to human beauty.

The equation between these two categories in Eurocentric thought rested on the fixed assumption that Africans had no culture or civilization worthy of the name. Philosophers like Hume and Hegel validated such assumptions, legitimating the view that Africa was outside history in a savage and rude 'state of nature.' Yet, while certain Enlightenment reflections on aesthetics

saw in the Negro only the annulment of their ideas of beauty, Rousseau and later, in the eighteenth and nineteenth centuries, romanticism and realism in the arts, saw Nature on the other hand as the source of all that was good, true and beautiful. The Negro was none of these. But by inverting the symbolic order of racial polarity, the aesthetic of 'nature' underpinning the Afro and Dreadlocks could negate the negation, turn white-bias on its head and thus revalorize all that had been so brutally devalorized as the very annulment of aesthetics. In this way, the black subject could accede – and only in the twentieth century, mind you – to that level of self-valorization or aesthetic idealization that had hitherto been categorically denied as unthinkable. The radicality of the 1960s' slogan, Black is Beautiful, lay in the function of the logical copula *is*, as it marked the ontological affirmation of our nappy nigger hair, breaching the bar of negation signified in that utterance from the Song of Songs which Europe had rewritten (in the King James version of the Bible) as, 'I am black *but* beautiful.'

However radical this countermove was, its tactical inversion of categories was limited. One reason why may be that the 'nature' invoked in black counterdiscourse was not a neutral term but an ideologically loaded *idea* created by binary and dualistic logics within European culture itself. The 'nature' brought into play to signify a desire for liberation and freedom so effectively was also a Western inheritance, sedimented with symbolic meaning and value by traditions of science, philosophy and art. Moreover, this ideological category had been fundamental to the dominance of the West over 'the rest'; the nineteenth-century bourgeoisie sought to legitimate the imperial division of the world by way of mythologies that aimed to universalize, eternalize and hence 'naturalize' its power. The counterhegemonic tactic of inversion appropriated a particularly romanticist version of nature as a means of empowering the black subject; but by remaining within a dualistic logic of binary oppositionality (to Europe and artifice) the moment of rupture was delimited by the fact that it was only ever an imaginary 'Africa' that was put into play.

Clearly, this analysis is not to write off the openings and effective liberations gained and made possible by inverting the order of aesthetic oppression; only to point out that the counterhegemonic project inscribed in these hairstyles is not completed or closed, and that this story of struggles over the same symbols continues. Nevertheless, the limitations underline the diasporic specificity of the Afro and Dreadlocks, and ask us to examine, first, their conditions of commodification and, second, the question of their *imaginary* relationship to Africa and African cultures as such.

Once commercialized in the marketplace the Afro lost its specific signification as a 'black' cultural–political statement. Cut off from its original political contexts, it became just another fashion: with an Afro wig anyone could wear the style. Now the fact that it could be neutralized and incorporated so readily suggests that the aesthetic interventions of the Afro operated on terrain already mapped out by the symbolic codes of the dominant

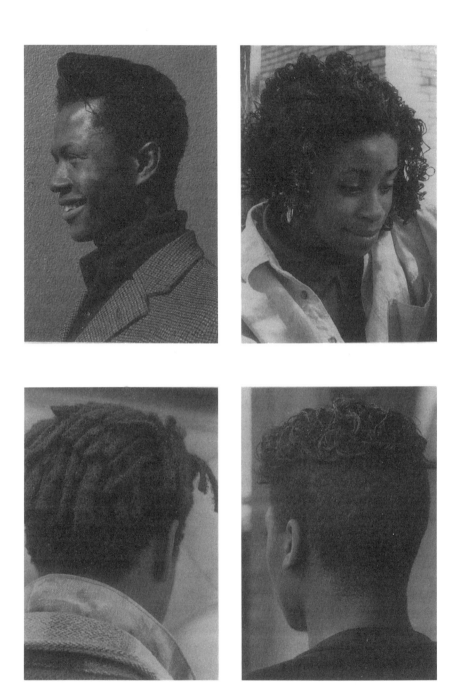

Plate 45.1a Cut 'n mix: contemporary styles, London 1989

Source: Christine Parry

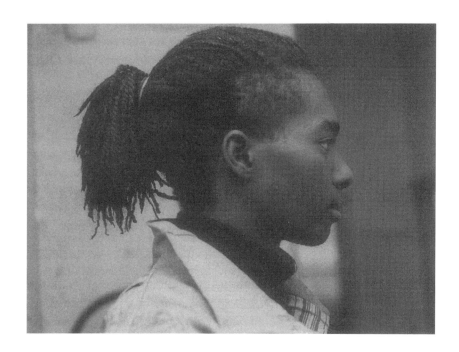

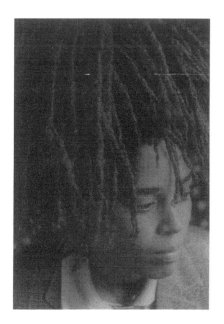

Plate 45.1b

white culture. The Afro not only echoed aspects of romanticism, but shared this in common with the 'countercultural' logic of long hair among white youth in the 1960s. From the Beatles' mop-tops to the hairy hippies of Woodstock, white subcultures of the sixties expressed the idea that the longer you wore your hair, somehow the more 'radical' and 'right-on' your lifestyle or politics. This *far-out* logic of long hair among the hippies may have sought to symbolize disaffection from Western norms, but it was rapidly assimilated and dissimulated by commodity fetishism. The incorporation of long hair as the epitome of protest, via the fashion industry, advertising and other economies of capitalist mediation, culminated at one point in a Broadway musical that ran for years – *Hair*.

Like the Afghan coats and Kashmiri caftans worn by the hippy, the dashiki was reframed by dominant definitions of ethnic otherness as 'exotica:' its connotations of cultural nationalism were clawed back as just another item of freakish exoticism for mass consumption. Consider also the inherent semiotic instability of militant chic. The black leather jackets and dark glasses of the Panthers were already inscribed as stylized synonyms for rebellious-ness in white male subcultures from the 1950s. There, via Marlon Brando and the metonymic association with macho and motor bikes, these elements encoded a youthful desire for freedom, in the image of the American highway and the open road, implying opposition to the domestic norms of their parent culture. Moreover, the color black was not saturated by exclusively 'racial' connotations. Dark, somber colors (as well as the occasional French beret) featured in the downbeat dress statements of the 1950s boho-beatniks to suggest mystery, 'cool,' outsider status, anything to alienate the normative values of 'square society.'

The fact that these white subcultures themselves appropriated elements from black American culture (rock 'n' roll and bebop respectively) is as important as the fact that a portion of the semiotic effectiveness of the Panther's look derived from associations already embedded by previous articulations of the same or similar elements of style. The movement back and forth indicates an underlying dynamic of struggle as different discourses compete for the same signs. It shows that, for style to be socially intelligible as an expression of conflicting values, each cultural nucleus or articulation of signs must share access to a common stock or resource of signifying elements. To make the point from another point of view would amount to saying that the Afro engaged in a critical dialogue between black and white Americans, not one between black Americans and Africans. Even more so than Dreadlocks, there was nothing particularly African about the Afro at all. Neither style had a given reference point in existing African cultures, in which hair is rarely left to grow 'naturally.' Often it is plaited or braided, using weaving techniques to produce a rich variety of sometimes highly elab-orate styles that are reminiscent of the patternings of African textiles and the decorative designs of African ceramics, architecture and embroidery. Underlying these practices is an African approach to the aesthetic. In contrast

to the separation of the aesthetic sphere in post-Kantian European thought, this is an aesthetic sensibility which incorporates practices of beautification in everyday life. Thus artifice – the agency of human hands – is valued in its own right as a mark of both invention and tradition, and aesthetic skills are deployed within a complex economy of symbolic codes in which communal subjects recreate themselves collectively.

Neither the Afro nor Dreadlocks operate within this context as such. In contemporary African societies, such styles would not signify Africanness ('locks in particular would be regarded as something 'alien,' precisely the tactical objective of the Mau Mau in Kenya when they adopted such dread appearances in the 1950s); on the contrary, they would imply an identification with First World-ness. They are specifically diasporean. However strongly these styles expressed a desire to 'return to the roots' among black peoples in the diaspora, in Africa *as it is* they would speak of a modern orientation, a modelling of oneself according to metropolitan images of blackness [see Plates 45.1a and 45.1b].

If there was nothing especially 'African' about these styles, this only goes to show that neither was as natural as it claimed to be. Both presupposed quite artificial techniques to attain their characteristic shapes and hence political significance: the use of special combs in the case of the Afro, and the process of matting in the case of 'locks, often given a head start by initially plaiting long strands of hair. In their rejection of artifice both styles embraced a 'naturalism' that owed much more to Europe than it did to Africa. . . .

Style and fashion: semiotic struggles in the forest of signs

Having alighted on a range of paradoxes of 'race' and aesthetics via this brief excursion into the archeology of the Afro, I want now to reevaluate the symbolic economy of straightening in the light of these contradictory relations between black and white cultures in diaspora societies. Having found no preexisting referent for either hairstyle in 'actually existing' African cultures, I would argue that it should be clear that what we are dealing with are New World creations of black people's culture which, in First World societies, bear markedly different relations with the dominant Euro-American culture from those that obtain in the Third World.

By ignoring these differences, arguments that hold straightened styles to be slavish imitations of Western norms are in fact complicit with an outmoded anthropological view that once tried to explain diasporean black cultures as bastard products of unilateral 'acculturation.' By reversing the axes of traditional analysis we can see that throughout the era of cultural modernity it is white people who have been doing a great deal of the imitating while black people have done much of the innovating. . . .

Diaspora practices of black stylization are intelligible at one 'functional' level as dialogic responses to the racism of the dominant culture, but at another level involve acts of appropriation from that same 'master' culture through which 'syncretic' forms of cultural expression have evolved. Syncretic strategies of black stylization, 'creolizing' found or given elements, are writ large in the black codes of modern music like jazz, where elements such as scales, harmonies or even instruments like the piano or saxophone from Western cultural traditions are radically transformed by this neo-African, improvisational approach to aesthetic and cultural production. In addition there is another 'turn of the screw' in these modern relations of intercul-turation when these creolized cultural forms are made use of by other social groups and then, in turn, are all incorporated into mainstream 'mass' culture as commodities for consumption. Any analysis of black style, in hair or any other medium, must take this field of relationships into account.

Hairstyles such as the conk of the 1940s or the curly-perm of the 1980s are syncretic products of New World stylization. Refracting elements from both black and white cultures through this framework of exchange and appro-priation, imitation and incorporation, such styles are characterized by the *ambivalence* of their meaning. It is implausible to attempt a reading of this ambivalence in advance of an appreciation of the historical contexts in which they emerged alongside other stylized surfaces of syncretic inscription in speech, music, dance and dress.

As a way into this arena of ambiguity, listen to this voice, as Malcolm X describes his own experience of hair-straightening. After recounting the physical pain of the hot-lye and steel-comb technology, he tells of pride and pleasure in the new, self-stylized image he has made for himself:

> My first view in the mirror blotted out the hurting. I'd seen some pretty conks, but when it's the first time, on your *own* head, the trans-formation, after a lifetime of kinks, is staggering. The mirror reflected Shorty behind me. We were both grinnin' and sweating. On top of my head was this thick, smooth sheen of red hair – real red – as straight as any white man's.
>
> (Malcolm X, 1966: 134–9)

In his autobiographical narrative the voice then shifts immediately from past to present, wherein Malcolm sees the conk as 'my first really big step towards self-degradation.' No attempt is made to address this mixture of feel-ing: pleasure and pride in the past, shame and self-denigration in the present. The narrative seems to 'forget' or exclude from consciousness the whole life-style of which the conk was a part. By invoking the idea of 'imitation' Malcolm evades the ambiguity, and his discourse cancels from the equation what his 'style' meant to him at that moment in front of the mirror.

In this context the conk was but one aspect of a modern style of black American life, forged in the subaltern social bloc of the northern ghettos by

people who, like Malcolm Little, had migrated from southern systems of segregation only to find themselves locked into another more modern, and equally violent, order of oppression. Shut out from access to illusions of 'making it,' this marginalized urban formation of modern diaspora culture sponsored a sense of style which answered back against these conditions of existence.

Between the years of economic depression and World War II, big bands like Duke Ellington's, Count Basie's and Lionel Hampton's (who played at the Boston dancehall where Malcolm worked as a shoeshine boy) accelerated on rhythm, seeking through 'speed' to preempt the possibility of white appropriations of jazz, as happened in the 1920s. In the underground music scene incubated around Kansas City in the 1940s, the accent on improvisation, which later flourished as bebop, articulated an 'escape' – simultaneously metaphysical and subterranean – from that system of socioeconomic bondage, itself in the ruins of war. In the high-energy dance styles that might accompany the beat, the lindy hop and jitterbug traced another line of flight: through the catharsis of the dance a momentary release might be obtained from all the pressures on mind and body accumulated under the ritual discriminations of racism. In speech and language, games like signifyin', playing the dozens and what became known as jive-talk, verbal style effected a discursive equivalent of jazz improvisation. The performative skills and sheer wit demanded by these speech-acts in black talk defied the idea that Black English was a degraded 'version' of the master language. These games refuted America's archetype of Sambo, all tongue-tied and dumb, muttering 'Yessa massa' in its miserable abjection. In the semantic play of verbal stylization, hepcats of the cool world greeted each other as Man, systematically subverting the paternalistic interpellation – boy! – of the white master code, the voice of authority in the social text of the urban plantation.

In this historical moment style was not a substitute for politics. But, in the absence of an organized direction of black political discourse and in a situation where blacks were excluded from official channels of 'democratic' representation, the logic of style manifested across cultural surfaces in everyday life reinforced the terms of shared experience – blackness – and thus a sense of collectivity among a subaltern social bloc. Perhaps we can trace a fragile common thread running through these styles of the 1940s: they encoded a refusal of passivity by way of a creolizing accentuation and subtle inflection of given elements, codes, and conventions.

The conk involved a violent technology of straightening, but this was only the initial stage in a process of creolizing stylization. The various waves, curls and lengths introduced by practical styling served to differentiate the conk from the conventional white hairstyles which supposedly constituted the 'originals' from which this black style was derived as imitation or 'copy.' No, the conk did not copy anything, and certainly not any of the prevailing white male hairstyles of the day. Rather, the element of straightening suggested resemblance to white people's hair, but the nuances, inflections

431

and accentuations introduced by artificial means of stylization emphasized *difference*. In this way the political economy of the conk rested on its ambiguity, the way it played with the given outline shapes of convention only to disturb the norm and hence invite a 'double take,' demanding that you look twice.

Consider also the use of dye, red dye: why red? To assume that black men conked up *en masse* because they secretly wanted to become 'red-heads' would be way off the mark. In the chromatic scale of white-bias, red hair is seen as a mild deviation from gendered norms which hold blonde hair as the color of 'beauty' among women and brunet hair among men. Far from an attempted simulation of whiteness, I think the dye was used as a stylized means of defying the 'natural' color codes of conventionality in order to highlight artifice, and hence exaggerate a sense of difference. Like the purple and green wigs worn by black women, which Malcolm mentions in disgust, the use of red dye seems trivial: but by flouting convention with varying degrees of artifice such techniques of black stylization participated in a defiant 'dandyism,' fronting out oppression by the artful manipulation of appearances. Such dandyism is a feature of the economy of style statements in many subaltern class cultures, where 'flashy' clothes are used in the art of impression management to defy the assumption that to be poor one necessarily has to 'show' it. The strategic use of artifice in much stylized modes of self-presentation was also written into the reat pleats of the zoot suit which, together with the conk, constituted the *de rigueur* hepcat look in the black male 'hustler' lifestyles of the 1940s ghettos. With its wide shoulders, tight waist and baggy pants – topped off with a wide-brimmed hat, and worn with slim Italian shoes and lots of gold jewels – the zoot suit projected stature, dignity and presence: it signified that the black man was 'important' in his own terrain and on his own terms.

The zoot suit is said to have originated within the *pachuco* subcultures of Chicano males in California – whatever its source, it caused a 'race riot' in Los Angeles in 1943 as the amount of cloth implicated in its cut exceeded wartime rations, provoking ethnic resentment among white males [see Chapter 41]. But perhaps the real historical importance of the zoot suit lies in the irony of its appropriation. By 1948 the American fashion industry had ripped it off and toned it down as the new, post-war, 'bold look' marketed to the mainstream male. By being commodified within such a short period, the zoot suit demonstrated a reversal in the flow of fashion diffusion, as now the style of the times emerged from social groups *below*, whereas previously regimes of taste had been set by the *haute couture* of the wealthy and then translated back down, via mass manufacturing, to the popular classes. This is important because, as an aspect of interculturation, this story of black innovation/white imitation has been played out again and again in post-war popular culture, most markedly in music and, in so far as music has formed their nucleus, a whole procession of youth subcultures from teddy boys to B-boys.

Once we recontextualize the conk in this way, we confront a series of 'style wars,' skirmishes of appropriation and commodification played out around the semiotic economy of the ethnic signifier. The complexity of this force field of interculturation ambushes any attempt to track down fixed meanings or finalized readings and opens out instead onto inherently ambiguous relations of economic and aesthetic systems of valorization. On the one hand, the conk was conceived in a subaltern culture, dominated and hedged in by a capitalist master culture, yet operating in an 'underground' manner to subvert given elements by creolizing stylization. Style encoded political messages to those in the know which were otherwise unintelligible to white society by virtue of their ambiguous accentuation and intonation. But, on the other hand, that dominant commodity culture appropriated bits and pieces from the otherness of ethnic differentiation in order to reproduce the 'new' as the emblem of modernity and so, in turn, to strengthen its dominance and revalorize its own symbolic capital. Assessed in the light of these paradoxical relationships, the conk suggests a covert logic of cultural struggle operating *in and against* hegemonic cultural codes, a logic quite different from the overt oppositionality of the naturalistic Afro or Dreadlocks. At one level this only underlines the different historical conditions, but at another the emphasis on artifice and ambivalence rather than the inversion of equivalence strikes me as a particularly modernist way in which cultural utterances may take on the force of 'political' statements. Syncretic practices of black stylization, such as the conk, zoot suit or jive-talk, recognize themselves self-consciously as products of a New World culture, that is, they incorporate an awareness of the contradictory conditions of interculturation. It is this self-consciousness that underscores their ambivalence, and in turn marks them off as stylized signs of blackness. In jive-talk the very meanings of words are made uncertain and undecidable by self-conscious stylization which sends signifiers slipping and sliding over signifieds: bad means good, superbad means better. Because of the way blackness is recognized in such strategems of creolizing intonation, inflection and accentuation, these practices of stylization can be said to exemplify 'modernist' interventions whose economy of political calculation might best be illustrated by the 'look' of someone like Malcolm X in the 1960s.

Malcolm always eschewed the ostentatious, overly symbolic dress code of the Muslims and wore 'respectable' suits and ties, but unlike the besuited Civil Rights leaders his appearance was always inflected by a certain *sharpness*, an accentuation of the hegemonic dress code of the corporate business suit. This intonation in his attire spelt out that he would talk to the polity on his terms, not theirs. This nuance in his public image echoed the 'intellectual' look adopted by jazz musicians in the 1950s, but then again, from another frame, Malcolm looked like a mod! And in the case of this particular 1960s subculture, white English youth had taken many of the 'found objects' of their stylistic bricolage precisely from the diasporic cultural expression of black America and the Caribbean. Taking these relations

433

of appropriation and counterappropriation into account, it would be impossible to argue for any one 'authoritative' interpretation of either the conk in the past or the curly-perm today. Rather, the complexity of these violent relations of interculturation, which loom so large over the popular experience of modernity, demands that we ask instead: are there any laws that govern this semiotic guerilla warfare in the concrete jungle of the modern metropolis?

If, in the British context, 'we can watch, played out on the loaded surfaces of . . . working class youth cultures, a phantom history of race relations since the war' (Hebdige, 1979: 45), then any analysis of black hairstyle in this territory of the diaspora must reckon with the contradictory terms of this accelerated interculturation around the ethnic signifier. Somewhere around 1967 or 1968 something very strange happened in the ethnic imaginary of Englishness, as former mods assembled a new image out of their parents' work clothes, creating a working-class youth culture that gained its name from their cropped hairstyles. Yet the skinhead hairstyle was an imitation of the mid-1960s soulboy look, where closely shaven haircuts provided one of the most 'classic' solutions to the problem of kinks and curls. Every black person (at least) recognizes the 'skinhead' as a political statement in its own right – but then how are we to understand the social and psychological bases for this postimperial mode of mimicry, this ghost dance of white ethnicity? Like a photographic negative, the skinhead crop symbolized 'white power' and 'white pride' sure enough, but then *how* (like their love of ska and bluebeat) did this relate to their appropriation of Afro-Caribbean culture?

Similarly, we have to confront the paradox whereby white appropriations seem to act both as a spur to further experimentation and as modified models to which black people themselves may conform. Once the Afro had been ingested, black Americans brought traditional braiding and plaiting styles out from under their wraps, introducing novel elements such as beads and feathers into corn-row patterns. No sooner said than done, by the mid-1970s the beaded corn-row style was appropriated by one-hit wonder Bo Derek. It also seemed that her success validated the style and encouraged more black people to corn-row their hair.

Moreover, if contemporary culture functions on the threshold of what has been called 'postmodernism,' an analysis of this force field of interculturation must surely figure in the forefront of any reconstructive rejoinder to debates which have so far marginalized popular culture and aesthetic practices in everyday life. If, as Fredric Jameson argues, postmodernity merely refers to the dominant cultural logic of late capitalism, which 'now assigns an increasingly essential structural function to aesthetic innovation and experimentation' (Jameson, 1984: 56) as a condition of higher rates of turnover in consumer culture, then any attempt to account for the gradual dissolution of boundaries between 'high' and 'low' culture, between taste and style, must reckon with the dialogic interventions of diasporic, creolizing

cultures. . . . So who, in this postmodern melee of semiotic appropriation and countervalorization, is imitating whom?

Any attempt to make sense of these circuits of hyperinvestment and over-expenditure around the symbolic economy of the ethnic signifier encounters issues that raise questions about race, power and modernity which go far beyond those allowed by a static moral psychology of 'self-image.' I began with a polemic against one kind of argument and have ended up in another: namely one that demands a critical analysis of the multifaceted economy of black hair as a condition for appropriate aesthetic judgments. 'Only a fool does not judge by appearances,' said Oscar Wilde, and by the same token it would be foolish to assume that because somebody wears 'locks they are necessarily dealing in peace, love and unity; Dennis Brown also reminded us to take the 'wolf in sheep's clothing' syndrome into account. There are no just black hairstyles, just black hairstyles. This [chapter] has prioritized the semiotic dimension in its readings so as to clear some ground for further analyses of this polyvocal economy, but there are other facets to be examined: such as the exploitative priorities of the black hairdressing industry as it affects workers and consumers alike under precarious market conditions, or the important question of gendered differentiations (and similarities) in strategies of self-fashioning.

On the political horizon of postmodern popular culture I think the *diversity* of contemporary black hairstyles is something to be proud of, because this variousness testifies to an inventive, improvisational aesthetic that should be valued as an aspect of Africa's 'gift' to modernity, and because, if there is the possibility of a 'unity-in-diversity' somewhere in this field of relations, then it challenges us to cherish plurality politically.

Douglas Crimp, with Adam Rolston

AIDS ACTIVIST GRAPHICS
A demonstration [1990]

THE AIDS ACTIVIST GRAPHICS illustrated here were all produced by and for ACT UP, the AIDS Coalition to Unleash Power, 'a diverse, nonpartisan group united in anger and committed to direct action to end the AIDS crisis.' ACT UP New York was founded in March 1987. Subsequently, autonomous branches have sprung up in other cities, large and small, here and abroad – Chicago, Los Angeles, and San Francisco; Atlanta, Boston, and Denver; Portland and Seattle, Kansas City and New Orleans; Berlin, London, and Paris. Graphics are part of the action everywhere, but we confine ourselves to those associated with ACT UP New York as a matter of expediency. We live in New York – the city with the highest number of reported cases of AIDS in the world. We are members of ACT UP New York. We attend its meetings, join the debate, march in demonstrations, and get arrested for acts of civil disobedience here. And we're familiar with New York ACT UP's graphics, the people who make them, the issues they address. The limitation is part of the nature of our demonstration. We don't claim invention of the style or the techniques. We have no patent on the politics or the designs. There are AIDS activist graphics wherever there are AIDS activists. But ours are the ones we know and can show to others, presented in a context we understand. We want others to keep using our graphics and making their own. Part of our point is that nobody owns these images. They belong to a movement that is constantly growing – in numbers, in militancy, in political awareness.

Although our struggles are most often waged at the local level, the AIDS epidemic and the activist movement dedicated to ending it is national – and international – in scope, and the U.S. government is a major culprit in the

problems we face and a central target of our anger. ACT NOW, the AIDS Coalition to Network, Organize, and Win – a national coalition of AIDS activist groups – has coordinated actions of national reach, most notably against the Food and Drug Administration (FDA) in October 1988. Health care is a national scandal in the United States; the FDA, the Centers for Disease Control (CDC), and the National Institutes of Health (NIH) are all critical to our surviving the epidemic, and we have monitored, lobbied, and fought them all. We have also taken our demands beyond U.S. borders. The Fifth International AIDS Conference in Montreal in June 1989 was *our* conference, the first of these annual, previously largely scientific and policy-making AIDS roundups to have its business-as-usual disrupted by the combative presence of an international coalition of AIDS activists. We took the stage – literally – during the opening ceremonies, and we never relinquished it. One measure of our success was that by the end of the conference perhaps one-third of the more than 12,000 people attending were wearing SILENCE=DEATH buttons.

That simple graphic emblem – SILENCE=DEATH printed in white Gill sanserif type underneath a pink triangle on a black ground [Plate 46.1] – has come to signify AIDS activism to an entire community of people confronting the epidemic. This in itself tells us something about the styles and strategies of the movement's graphics. For SILENCE=DEATH does its work with a metaphorical subtlety that is unique, among political symbols and slogans, to AIDS activism. Our emblem's significance depends on foreknowledge of the use of the pink triangle as the marker of gay men in Nazi concentration camps, its appropriation by the gay movement to remember a suppressed history of our oppression, and, now, an inversion of its positioning (men in the death camps wore triangles that pointed down; SILENCE=DEATH's points up). SILENCE=DEATH declares that silence about the oppression and annihilation of gay people, *then and now*, must be broken as a matter of our survival. As historically problematic as an analogy of AIDS and the death camps is, it is also deeply resonant for gay men and lesbians, especially insofar as the analogy is already mediated by the gay movement's adoption of the pink triangle. But it is not merely what SILENCE=DEATH says, but also how it looks, that gives it its particular force. The power of this equation under a triangle is the compression of its connotation into a logo, a logo so striking that you ultimately *have* to ask, if you don't already know, 'What does that mean?' And it is the answers we are constantly called upon to give to others – small, everyday direct actions – that make SILENCE=DEATH signify beyond a community of lesbian and gay cognoscenti.

Although identified with ACT UP, SILENCE=DEATH precedes the formation of the activist group by several months. The emblem was created by six gay men calling themselves the Silence=Death Project, who printed the emblem on posters and had them 'sniped' [pasted onto hoardings] at their own expense. The members of the Silence=Death Project were present at the formation of ACT UP, and they lent the organization their graphic design

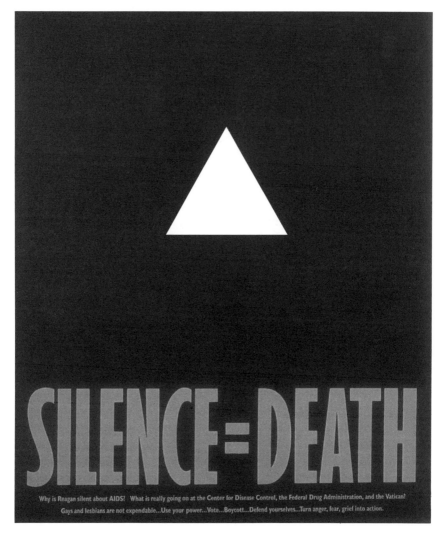

Plate 46.1 Science = Death poster

for placards used in its second demonstration – at New York City's main post office on April 15, 1987. Soon thereafter SILENCE=DEATH T-shirts, buttons, and stickers were produced, the sale of which was one of ACT UP's first means of fundraising.

Nearly a year after SILENCE=DEATH posters first appeared on the streets of lower Manhattan, the logo showed up there again, this time in a neon version as part of a window installation in the New Museum of Contemporary Art on lower Broadway. New Museum curator Bill Olander, a person with AIDS and a member of ACT UP, had offered the organization the window space for a work about AIDS. An ad hoc committee was

formed by artists, designers, and others with various skills, and within a few short months *Let the Record Show*, a powerful installation work, was produced. Expanding SILENCE=DEATH's analogy of AIDS and Nazi crimes through a photomural of the Nuremburg trials, *Let the Record Show* indicted a number of individuals for their persecutory, violent, homophobic statements about AIDS – statements cast in concrete for the installation – and, in the case of then president Ronald Reagan, for his six-year-long failure to make any statement at all about the nation's number-one health emergency. The installation also included a light-emitting diode (LED) sign programmed with ten minutes of running text about the government's abysmal failure to confront the crisis. *Let the Record Show* demonstrated not only the ACT UP committee's wide knowledge of facts and figures detailing government inaction and mendacity, but also its sophistication about artistic techniques for distilling and presenting the information. If an art world audience might have detected the working methods of such artists as Hans Haacke and Jenny Holzer in ACT UP's installation, so much the better to get them to pay attention to it. And after taking in its messages, who would have worried that the work might be too aesthetically derivative, not original enough? The aesthetic values of the traditional art world are of little consequence to AIDS activists. What counts in activist art is its propaganda effect; stealing the procedures of other artists is part of the plan – if it works, we use it.

ACT UP's ad hoc New Museum art project committee regrouped after finishing *Let the Record Show* and resolved to continue as an autonomous collective – 'a band of individuals united in anger and dedicated to exploiting the power of art to end the AIDS crisis.' Calling themselves Gran Fury, after the Plymouth model used by the New York City police as undercover cars, they became, for a time, ACT UP's unofficial propaganda ministry and guerrilla graphic designers. Counterfeit money for ACT UP's first-anniversary demonstration, WALL STREET II; a series of broadsides for New York ACT UP's participation in ACT NOW's spring 1988 offensive, NINE DAYS OF PROTEST; placards to carry and T-shirts to wear to SEIZE CONTROL OF THE FDA; a militant *New York Crimes* to wrap around the *New York Times* for the TARGET CITY HALL – these are some of the ways Gran Fury contributed to the distinctive style of ACT UP. Their brilliant use of word and image has also won Gran Fury a degree of acceptance in the art world, where they are now given funding for public artworks and invited to participate in museum exhibitions and to contribute 'artist's pages' to *Artforum*.

But, like the government's response to the AIDS activist agenda, the art world's embrace of AIDS activist art was long delayed. Early in 1988, members of the three ACT UP groups Gran Fury, Little Elvis, and Wave Three protested at the Museum of Modern Art (MOMA) for its exclusion of AIDS activist graphics. The occasion was an exhibition organized by curator Deborah Wye called 'Committed to Print: Social and Political Themes in Recent American Printed Art.' Work in the show was divided into broad

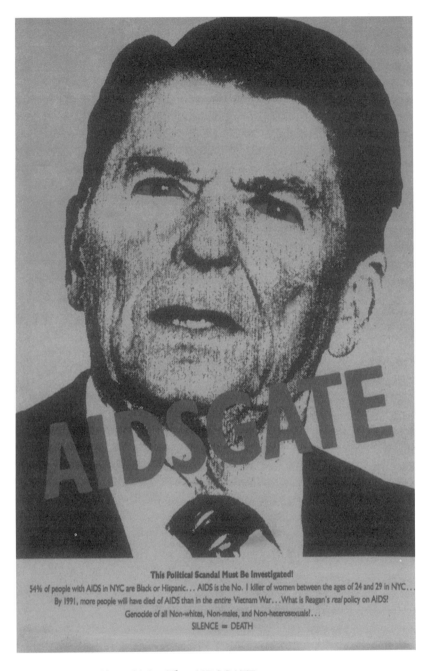

Plate 46.2 The AIDSGATE poster

categories: gender, governments/leaders, race/culture, nuclear power/ ecology, war/revolution, economics/class struggle/the American dream. The singleness of 'gender' on this list, the failure to couple it with, say, 'sexuality,' already reveals the bias. Although spanning the period from the 1960s to the present, 'Committed to Print' included no work about either gay liberation or the AIDS crisis. When asked by a critic at the *Village Voice* why there was nothing about AIDS, the curator blithely replied that she knew of no graphic work of artistic merit dealing with the epidemic. AIDS activists responded with a handout for museum visitors explaining the reasons for demonstrating:

- We are here to protest the blatant omission from 'Committed to Print' of any mention of the lesbian and gay rights movement and of the AIDS crisis.
- By ignoring the epidemic, MOMA panders to the ignorance and indifference that prolong the suffering needlessly.
- By marginalizing 20 years of lesbian and gay rights struggles, MOMA makes invisible the most numerous victims of today's epidemic.
- Cultural blindness is the accomplice of societal indifference. We challenge the cultural workers at MOMA and the viewers of 'Committed to Print' to take political activism off the museum walls and into the realm of everyday life.

The distance between downtown and uptown New York – and between its constituent art institutions – was rarely so sharply delineated as it was with MOMA's blindness to SILENCE=DEATH, for it was only a few months earlier that Bill Olander had decided to ask ACT UP to design *Let the Record Show*, after having seen the ubiquitous SILENCE=DEATH poster the previous year: 'To me,' he wrote, 'it was among the most significant works of art that had yet been inspired and produced within the arms of the crisis' [Olander 1987: 1]. For more traditional museum officials, however, a current crisis is perhaps less easy to recognize, since they 'see' only what has become distant enough to take on the aura of universality. The concluding lines of MOMA curator Wye's catalogue essay betray this prejudice: 'In the final analysis it is not the specific issue or events that stand out. What we come away with is a shared sense of the human condition: rather than feeling set apart, we feel connected' [Wye 1988: 10]. The inability of others to 'feel connected' to the tragedy of AIDS is, of course, the very reason we in the AIDS activist movement have had to fight – to fight even to be thought of as sharing in what those who ignore us nevertheless presume to universalize as 'the human condition'.

But there is perhaps a simpler explanation for MOMA's inability to see SILENCE=DEATH. The political graphics in 'Committed to Print' were, it is true, addressed to the pressing issues of their time, but they were made by 'bona fide' artists – Robert Rauschenberg and Frank Stella, Leon Golob

and Nancy Spero, Hans Haacke and Barbara Kruger. A few collectives were included – Group Material and Collaborative Projects – and even a few ad hoc groups – Black Emergency Cultural Coalition and Artists and Writers Protest Against the War in Vietnam. But these were either well-established artists' organizations or groups that had been burnished by the passage of time, making the museum hospitable to them. The Silence=Death Project (whose AIDSGATE poster had been printed in the summer of 1987 [Plate 46.2]) and Gran Fury (who by the time of the MOMA show had completed their first poster, AIDS: 1 in 61) were undoubtedly too rooted in movement politics for MOMA's curator to see their work within her constricted aesthetic perspective; they had, as yet, no artistic credentials that she knew of.

The distance between downtown and uptown is thus figured in more ways than one. For throughout the past decade postmodernist art has deliberately complicated the notion of 'the artist' so tenaciously clung to by MOMA's curator. Questions of identity, authorship, and audience – and the ways in which all three are constructed through representation – have been central to postmodernist art, theory, and criticism. The significance of so-called appropriation art, in which the artist forgoes the claim to original creation by appropriating already-existing images and objects, has been to show that the 'unique individual' is a kind of fiction, that our very selves are socially and historically determined through preexisting images, discourses, and events.

Young artists finding their place within the AIDS activist movement rather than the conventional artworld have had reason to take these issues very seriously. Identity is understood by them to be, among other things, coercively imposed by perceived sexual orientation or HIV status; it is, at the same time, willfully taken on, in defiant declaration of affinity with the 'others' of AIDS: queers, women, Blacks, Latinos, drug users, sex workers. Moreover, authorship is collectively and discursively named: the Silence=Death Project, Gran Fury, Little Elvis, Testing the Limits (an AIDS activist video production group), DIVA TV (Damned Interfering Video Activist Television, a coalition of ACT UP video-makers), and LAPIT (Lesbian Activists Producing Interesting Television, a lesbian task group within DIVA). Authorship also constantly shifts: collectives' memberships and individual members' contributions vary from project to project.

Techniques of postmodernist appropriation are employed by these groups with a sly nod to art world precursors. In a number of early posters, for example, Gran Fury adopted Barbara Kruger's seductive graphic style, which was subsequently, and perhaps less knowingly, taken up by other ACT UP graphic producers. In the meantime, Gran Fury turned to other sources. Their best-known appropriation is undoubtedly the public service announcement on San Francisco (and later New York) city buses produced for 'Art Against AIDS on the Road,' under the auspices of the American Foundation for AIDS Research. Imitating the look of the United Colors of Benetton advertising campaign, Gran Fury photographed three stylish young interracial couples

kissing and topped their images with the caption KISSING DOESN'T KILL: GREED AND INDIFFERENCE DO. The punch of the message, its implicit reference to the risk of HIV transmission, and its difference from a Benetton ad derive from a simple fact: of the three kissing couples, only one pairs boy with girl. If their sophisticated postmodern style has gained art world attention and much-needed funding for Gran Fury, the collective has accepted it only hesitantly, often biting the hand that feeds. Their first poster commission from an art institution was discharged with a message about art world complacency: WITH 42,000 DEAD, ART IS NOT ENOUGH. Familiar with the fate of most critical art practices – that is, with the art world's capacity to co-opt and neutralize them – Gran Fury has remained wary of their own success. Such success can ensure visibility, but visibility *to whom*?

For AIDS activist artists, rethinking the identity and role of the artist also entails new considerations of audience. Postmodernist art advanced a political critique of art institutions – and art itself as an institution – for the ways they constructed social relations through specific modes of address, representations of history, and obfuscations of power. The limits of this aesthetic critique, however, have been apparent in its own institutionalization: critical postmodernism has become a sanctioned, if still highly contested, art world product, the subject of standard exhibitions, catalogues, and reviews. The implicit promise of breaking out of the museum and marketplace to take on new issues and find new audiences has gone largely unfulfilled. AIDS activist art is one exception, and the difference is fairly easy to locate.

The constituency of much politically engaged art is the art world itself. Generally, artists ponder society from within the confines of their studios; there they apply their putatively unique visions to aesthetic analyses of social conditions. Mainstream artistic responses to the AIDS crisis often suffer from just such isolation, with the result that the art speaks only of the artist's private sense of rage, or loss, or helplessness. Such expressions are often genuine and moving, but their very hermeticism ensures that the audience that will find them so will be the traditional art audience.

AIDS activist artists work from a very different base. The point of departure of the graphics . . . and of the work in video . . . is neither the studio nor the artist's private vision, but AIDS activism. Social conditions are viewed from the perspective of the movement working to change them. AIDS activist art is grounded in the accumulated knowledge and political analysis of the AIDS crisis produced collectively by the entire movement. The graphics not only reflect that knowledge, but actively contribute to its articulation as well. They codify concrete, specific issues of importance to the movement as a whole or to particular interests within it. They function as an organizing tool, by conveying, in compressed form, information and political positions to others affected by the epidemic, to onlookers at demonstrations, and to the dominant media. But their primary audience is the movement itself. AIDS activist graphics enunciate AIDS politics to and for all of us in the movement. They suggest slogans (SILENCE=DEATH becomes 'We'll

never be silent again'), target opponents (the *New York Times*, President Reagan, Cardinal O'Connor), define positions ('All people with AIDS are innocent'), propose actions ('Boycott Burroughs Wellcome'). Graphic designs are often devised in ACT UP committees and presented to the floor at the group's regular Monday night meetings for discussion and approval. Contested positions are debated, and sometimes proposed graphic ideas are altered or vetoed by the membership. In the end, when the final product is wheatpasted around the city, carried on protest placards, and worn on T-shirts, our politics, and our cohesion around those politics, become visible to us, and to those who will potentially join us. Sometimes our graphics signify *only* internally, as when an ACT UP affinity group went to TARGET CITY HALL wearing T-shirts silk-screened with a photograph of the actress Cher. The group adopted the movie star's name as a camp gesture, and each time someone asked what it meant, CHER became an acronym for whatever could be concocted on the spot: anything from 'Commie Homos Engaged in Revolution' to 'Cathy Has Extra Rollers.'

ACT UP's humor is no joke. It has given us the courage to maintain our exuberant sense of life while every day coping with disease and death, and it has defended us against the pessimism endemic to other Left movements, from which we have otherwise taken so much. The adoption of the name CHER for an affinity group makes this point. A tradition of Left organizing, affinity groups are small associations of people within activist movements whose mutual trust and shared interests allow them to function autonomously and secretly, arrive at quick decisions by consensus, protect one another at demonstrations, and participate as units in coordinated acts of civil disobedience. ACT UP's affinity groups function in all of these ways, but our affinities, like our identities, are complexly constituted. Because being queer is an identity most of us share, one of our happiest affinities is camp. ACT UP graphics reflect that part of our politics too.

Marcos Becquer and José Gatti

ELEMENTS OF VOGUE [1991]

VOGUEING – THE DANCE FAD, the (sub)cultural practice – is not the *object* of this [chapter]; rather, it designates a knowledge practice contiguous to our own. As such, our concern is not to define vogueing, but to elaborate upon the relations among some of the discourses implicated in it as a performance. The various representations of vogueing in recent film and video, particularly Jennie Livingston's *Paris Is Burning* [1990], but also Madonna's *Vogue* [1990] and Marlon Riggs' *Tongues Untied* [1989], among others, enable our elaboration not so much because they unproblematically reflect vogueing, but because they initiate their own discourses (theorisations) of it. Thus, they provide the occasion for a critique which marks vogueing as a site of intersection for the categories of race, class, gender, and sexuality.

Vogueing can be briefly described as a dance which is practised both casually, at gathering places like the pier in Greenwich Village (shown in *Tongues Untied*), night-clubs and even subway cars; and more formally, at events called balls (shown in *Paris Is Burning*) where it serves as a means of challenge between deferent 'houses' (or 'gangs') of poor, young black and hispanic gays. At balls, voguers compete for 'realness' in such categories as, e.g., 'banjee-realness', 'executive-realness', 'high fashion Parisian', 'luscious body-realness', and even 'butch queen first time in drag at a ball'. As deciphered by Willie Ninja, a voguer featured in some of the above-mentioned films and videos, vogueing brings together poses from the magazine of the same name, breakdancing moves, and gestures represented in Egyptian hieroglyphics. Vogueing, then, *articulates*, in a particular form, discursive practices usually associated with diverse social, historical and ethnic contexts.

By 'articulation', here, we mean a practice which both speaks and links a set of elements whose historically shifting identities are modified in the process of being articulated [see Laclau and Mouffe 1985: 105].

Recent works dealing with identity politics have deployed the concept of hybridity in an effort to foreground the non-essentiality of composite articulations like vogueing. These works are involved in a critical project which would contest, through the celebration and radicalization of the hybrid, essentialist notions of ethnic and cultural identity. Few if any of these works, however, have directly addressed or critiqued the ideological baggage with which hybridity comes equipped.

Etymologically linked to animal husbandry and agriculture, for instance, hybridity may, and often does, still presuppose the 'pure' origin of elements – that is, their fixed, essential identities – prior to their hybridization. As one of the definitions found in *Webster's Dictionary* clarifies, a hybrid is 'an offspring of two animals or plants of different races, breeds, varieties, species, or genera.' Hence hybridity may not imply the erasure of essentialism in the hybridized 'offspring' as much as it might merely temporarily defer such essentialism onto parents which have been discreetly classified into 'static, homogeneous' categories.

Moreover, this more or less straightforward reference to parents and offspring threatens to reinforce the ultimate essentialism of sexual(ity) differ-ence, even as it might highlight the heterogeneity of ethnic and cultural identity. In this sense, hybridity harbors the danger of contributing to the hegemony of the heterosexist metaphor which also informs numerous, oft-cited theories of the natural and of material relations. The specific logic implicit here, that two contrasting entities 'come' together to produce a third, masquerades as both universal and transhistorical. It is akin to what Foucault has called 'the meagre logic of contradiction', an Aristotelian notion that has enjoyed special prominence since the nineteenth century, and of which he finds evidence in 'the sterilising constraints of the dialectic' [Foucault 1980a: 143–144]. Indeed, such logic can be seen to naturalize not only domi-nant, teleological conceptions of progress and evolution (which are also germane to eugenicist notions of ethnic and cultural purity), but also total-izing and reductive accounts of the mechanisms of struggle which privilege conflicts as *the* means of change. The prevalence of theories of historical development and social transformation informed by such logic no doubt plays a role in the maintenance of the current hierarchical forms of subjectivity.

Thus, while we do not reject conflict as a form of struggle, we ques-tion its privileged epistemological status in the presently dominant regime of truth. It is our contention that the power relations implicit in vogueing exceed autotelic logics of contradiction and synthesis, and challenge the hegemony such hetero-logics enjoy. Indeed, considering the subject posi-tion(alitie)s occupied by vogueing's (sub)cultural practitioners, and the ones they embrace (and critique, but don't simply contradict) as they traverse sexualities, genders, races and classes in performance, we feel the demand

for more nuanced understandings of resistance processes and strategies. Here lies the importance of vogueing (and similar articulations) to the project of thinking struggle.

As a politico-aesthetic characterisation of articulatory discourses such as vogueing, the concept of *syncretism* may prove more suggestive than hybridity. Though the two terms have often been used interchangeably, we would like to stress some important differences between them. The etymology of syncretism points to the tactical articulation of different elements, exemplified in Plutarch by the communities of ancient Crete which, despite their differences, joined to face a common enemy. Thus, syncretism foregrounds the political – rather than the (un)natural – paradigm of articulation and identity, a paradigm under which the factional inhabitants of Crete, rather than forming a homogeneous whole, compose a heterogeneous front of distinct communities in altered relations to each other. As such, the discursive alignment implicit in syncretism remains contingent to relations of power and subject to change according to historical specificity; the elements united in it are denied any a priori 'necessary belongingness', and are precluded any sense of an originary fixity both to their identities and to their relations. In this manner, syncretism designates articulation as a politicized and discontinuous mode of becoming. It entails the 'formal' coexistence of components whose precarious (i.e., partial as opposed to impartial) identities are mutually modified in their encounter, yet whose distinguishing differences, as such, are not dissolved or elided in these modifications, but strategically reconstituted in an ongoing war of position.

In so far as syncretism thus testifies to its elements' permeable boundaries, the political and methodological efficacy of strict relations of contradiction/complementarity between identities presumed fixed (as in, say, dominant models of heterosexuality and/or objectivist dialectics – often functioning as undergirding structures for subordinations in the social) can be radically questioned. It is this implicit relational challenge that most dramatically distinguishes syncretism from hybridity. . . .

It has been significantly due to an ethnography nostalgic for ever-fleeting cultural and ethnic 'purity' that syncretism has gained a derogatory weight, distancing it from its etymology. The ideological effects of this operation, by which the technologies of (post)colonialism have emptied the concept of its political content in a rhetorical manoeuvre casting alignment and resistance as contradiction, are made evident in the present dictionary definitions of syncretism: 'flagrant compromise in religion or philosophy; eclecticism that is illogical or leads to inconsistency; uncritical acceptance'.

In the African diaspora, [for example,] the responses to such colonialist distortions are varied. On the one hand, there have been some attempts to propose alternatives to syncretism as an analytical tool. To mention but a recent one, Brazilian scholar Muniz Sodré offers the concept of 'plasticity' as one of the distinctive features of West African religious and cultural systems, which has kept them open to dialogic interaction. This plasticity,

Sodré suggests, has been 'used as a resource by an Africanist continuum in exile' for both survival and adaptation [Sodré 1989: 99; our translation]. On the other hand, a vast diasporic literature (as well as filmography) has also appropriated syncretism by simply casting aside the standards of authenticity and charges of (illogical, primitive) contradiction that mark its use by colonialist ethnography. While we maintain the designation of cultural and/or religious practices, like the ones previously mentioned, as 'syncretic', we argue here for a repoliticization of the concept – which may be accomplished not only by retracing the word's etymology, but also by problematizing its historical deployment.

Hence, we propose a reinscription of the contact between, for example, European and African symbolic systems in syncretic articulations, not as contradictory but as *antagonistic*, i.e., in relations which are animated by the partial presence of the other within the self, such that the differential identity of each term is at once enabled and prevented from full constitution. These relations, which, depending on the configurations of power in contingent historical conditions, may or may not crystallize into oppositionalities, exist both horizontally (in equivalential alignments among diverse groups united in struggle, as in the Cretan example) as well as vertically (in dominant/subaltern confrontations, as in colonialism). Antagonistic relations, then, indicate the limits of absolutist conceptions of culture based upon a closed system of unalloyed, hetero-topic differences, and thereby expand the logics of struggle.

Syncretic relations are, in this sense, traversed by a double movement of both alliance and critique. Syncretism involves neither 'flagrant compromise' (ultimately a transposition of the logic of contradiction to a quantitative transaction), nor 'uncritical acceptance' (i.e., pluralist inclusion), but rather a process which articulates elements in a manner that modifies their intelligibility and transforms their combinatory spaces. The Egyptian hieroglyphics, for example, identified by Willie Ninja as one element of vogue, can be seen as an assertion of the heritage claimed by Africanism in the diaspora. Indeed, the paraphernalia that surrounds the voguers interviewed in *Paris Is Burning* often includes gilded Egyptian heads – reminders of a proud African past, as well as indices of non-white standards of beauty. At the same time, however, this aesthetic appropriation also connects vogueing with the (white) gay tradition of self-display through the 'exotic', i.e., through what is literally out of visibility. Michael Moon, for instance, suggests that Orientalist narratives, in which Western/male supremacy represses the (over)sensual Orientals, have had a special resonance for gay audiences subjected to homophobic oppression; the flamboyant re-enactment of these narratives has enabled gays, in turn, to stage performances of political resistance. Jack Smith's films, particularly *Flaming Creatures*, are examples for Moon of this type of re-appropriation which, he writes, 'fueled innumerable small- and large-scale eruptions of queer rebellion . . .' [Moon 1989: 54]. Thus, two discourses apparently separate (and often considered 'opposed') are syncretized in vogueing: those of

Africanist and of gay struggles. These elements engage, to use Clyde Taylor's expression, in an 'epistemological underground' [Taylor 1989: 102], where oppositional knowledges, dispersed in a field in which the effect of domination both disjoins and subordinates them in historically specific yet continuous ways, nonetheless find structuring connections and challenge hegemony.

Through breakdancing, vogueing establishes another such connection: that of black and hispanic gays with the hip hop culture, that emerged in the South Bronx in the 1970s. Writing about the hip hop movement 'Zulu Nation', Dick Hebdige sees it as 'rapped in a tradition which valorizes verbal and physical dexterity', and that is 'overtly pledged to the sublimation of fight into dance, of conflict into contest, of desperation into style and a sense of self respect' [Hebdige 1988: 216]. This description, which uncannily recalls the spirit of the balls, aligns hip hop and vogueing with an African diasporic tradition that includes limbo dance contests in the West Indies and the martial art of *capoeira* in Brazil. Vogueing, however, multiplies the fronts of struggle in alignment by repositioning breakdancing within an emergent history of black and hispanic *gay* pride, thereby critiquing certain (hetero)sexist currents within hip hop. Thus, the syncretic articulation is shown to entail not simply the destruc(tura)tion nor the unqualified acceptance of preceding discourses, but their (re)structuration.

Similar antagonistic tensions and affinities also obtain between voguers and the attitudes of fashion. In *Paris Is Burning*, pre-op transsexual Venus Extravaganza can be seen to underscore tensions with fashion magazines' essentialist representations of woman, by foregrounding the constructed character of her own womanness in performance. At the same time, however, Venus' plans of stardom (as a fashion model) and/or 'normalcy' (as a suburban housewife) also reinforce her affinities with 'the multiplication of persons in a single being which', according to Roland Barthes, 'is always considered by Fashion as an index of [woman's] power' [Barthes 1983: 256–57]. In this double movement, then, Venus 'deforms' dominant representations of woman-as-essence, as she re-moulds the concept of woman into what may be called woman-as-positionality. Venus is thus articulated to 'woman' in a manner which modifies both the elements articulated – concept of woman, Venus's own subjectivity – and the discourses in which they are now (and were previously) positioned.

Thus, the syncretization of, e.g., Egyptian hieroglyphics, breakdancing moves and fashion magazine poses demonstrates how sexuality, gender, class and race are (re)posited in vogueing. A space is thereby opened where different discursive formations can strategically figure unsuspected alignments of significations which, nonetheless, remain distinct.

In this sense, we may revise popular accounts of vogueing's relations with the media. Both *Paris Is Burning* and Madonna's *Vogue*, rather narcissistically (in as far as the media, here, assumes the importance of its own impact), accentuate the 'influence' of the media on voguers. The Hollywood icon medley in Madonna's video, typified by the line 'Rita Hayworth gave

good face', hails vogueing as the next step in a continuing line of utopian glamour (epitomized by Madonna herself?), but glosses its positions in the traditions of resistance, outside of Hollywood and camp, to which we have referred. *Paris Is Burning*, on the other hand, presents voguers as subjects who, though duped by media ideology, more or less unwittingly subvert it in the momentary euphoria of carnivalesque inversion. . . .

If the media interpellates them as consumers, voguers antagonize such identificatory hailing by means of performances that defy the limits and the strictures of that address. It is, for instance, not necessarily their identities as consumers (nor, for that matter, as representatives of the 'real lives' of the other) but as *stars* (and the mobility between such discursive constructions) that are both enabled and prevented in voguers' relations with the media in its present organization. Their posed articulation thus demands the radical, structural change of both the media and voguers' interpellated, marginalized subjectivities. The engagement of vogueing in the politics of representation in this sense exceeds the cut-and-dry terms of a reductive dialectic, where opposing poles (and the quantity of their influence) would be clearly fixed and identified. Voguers' confrontations with the media are instead marked by the *shifting* limits of their own *agency* in a process *overdetermined* by historical circumstances. Less informed by the fatalism of cooptation than the discourse of influence would insinuate, voguers' simultaneous critique and embrace of the media is played out in a struggle over appropriation.

The stress on influence in *Paris Is Burning*, then (despite its sympathetic portrayals), might well be read as symptomatic of, as Kobena Mercer writes in another context, 'an underlying anxiety to pin down and categorize a practice that upsets and disrupts fixed expectations and normative assumptions' [Mercer 1988: 51]; in other words, as an integral part of the film's very ambition to normatively 'explain' vogueing. In order to accomplish its explanatory mission, *Paris Is Burning* institutes a pedagogical relationship with its audience, a relationship indexed in the film by a univocal system of questions and answers that attempts to translate voguers' rich and creative vocabulary. The word 'reading', to take just one example, is flashed in white letters upon a black screen as voguers are summoned to provide an accurate definition. Here, the ideological tenets grounding the film's pedagogical operation (starkly inscribed in the very black-and-whiteness of the graphic images) can be seen not only to presuppose an audience uninformed about vogueing, but also to circumscribe the critical dissemination of the terms' significations. . . . By (re)encoding a system of self-same differences as its interpretive grid, *Paris Is Burning* in effect delimits the ideological terrain upon which vogueing may operate. As a competent ethnographic primer, the film establishes a structural gap between 'the (fixed) world of voguers' and 'the (fixed) audience', a gap supposedly bridged by a civilising filmmaking, always in search of exotic, authentic phenomena.

It is in this sense that 'influence' and its companion other, 'cooptation', acquire an additional function: that of distinguishing an authentic vogueing from one corrupted by commercialization. This logic turns one voguer's statement, that the balls are no longer what they used to be, into a piece of evidence used to reassure us that *Paris Is Burning* has itself 'captured' the real vogueing at its height – a strategy of validation retroactively further underscored at the film's very beginning, when a character's voice-over announces that the film is about 'the ball circuit and the gay people that are involved in it'. Yet, the idea of authenticity, as we have suggested, is problematized by vogueing itself as a syncretic practice. We might consider, in this sense, Madonna's *Vogue* video less a cooptation (or corruption) than a rearticulation of vogueing, a rearticulation that is not necessarily juxtaposed to the 'authenticity' of vogueing as a subcultural practice, but that is prompted by vogueing as a knowledge practice which produces identity as mobile and unfixed.

Still, the rhetoric of authenticity in *Paris Is Burning* serves to replace any sustained effort towards authorial self-reflexivity, and instead enthrones the *authority* of experience. Indeed, it is precisely upon the basis of the experiential – an epistemological category which dissimulates its own appeals to arbitrarily structured forms of (re)cognition by naturalizing them as immediate presence – that *Paris Is Burning* is, as Livingstone herself declares, 'giving you definitions . . . It's taking forms that you are used to and doing something else to them' [Livingstone 1991]. Hence, the film ultimately interprets the knowledge voguers practice, that 'something else', by relegating – and thus containing – it to certain subject position(alitie)s, i.e., to a certain race, gender, sexual orientation and class, and 'their experience'. Not surprisingly, then, voguers are depicted as grotesque embodiments of contradiction (and not antagonism) as they 'playfully reverse' existing power/identity hierarchies. At the expense of its syncretic reconfigurations of the real, vogueing remains fixed in a semiotic realm of differential relations so acquiescent to the dictates of a facile multiculturalism. It becomes just another instance (or moment) in a chain of rationalization which operates in terms of clearly identifiable and stable oppositions (say, black/white, poor/rich, gay/straight, female/male, etc), and which signifies, multiplies and hierarchizes difference by 'explaining' it in terms of closed, arrested categories. An entire heterogeneous community (voguers walk not only as, say, 'Virginia Slims Girls', but also as homeboys, soldiers, executives, students, etc.) is in this sense grouped into a unified, homogeneous Other, housed under the rubric of 'their experience' and fixed in an unproblematized sequence of absolute differences.

In *Tongues Untied*, on the other hand, rather than the experiential being deployed to 'explain' vogueing, it is vogueing that is recruited to redefine the experiential. Marlon Riggs' appearance in the (auto)biographical narrative of *Tongues Untied* reflexively foregrounds the experiential as a construct which, rather than homogenizing an 'authentic(ated)' black gay identity,

451

diversifies black gay discourses. Thus his statement that '[*Tongues Untied*] crosses many boundaries of genre' indexically illustrates what, for him, is an important part of the video's message, 'that the way to break loose of the schizophrenia in trying to define identity is to realize that you are many things within one person' [Simmons 1991: 191, 193]. Indeed, the vogueing sequence (along with many others in the video's constitutive 'digressions') works to render identity heterogeneous. By re-introducing the collective into the filmic discourse, vogueing here challenges the univocality which often accompanies common understandings of the experiential. However, as a syncretic artic-ulation, vogueing can be seen to radicalize even the search for a definite – albeit heterogeneous – black gay identity. By emphasizing the inconclusive-ness of the self in antagonism, vogueing *interrupts* the very coherence of the experiential which informs the collective 'I' constructed in *Tongues Untied*.

By 'interruption' here, we mean a practice which critically separates and (re)opens the closed structures into which existing discursive configurations have ossified. As it syncretizes elements in performance, vogueing effectively literalizes interruption in the form of the pose. In Craig Owens' psychoan-alytic account of it, the pose stands in an aggressive relation to (the desire of) power [Owens 1985]. It inscribes the phallic compulsion to halt the 'dance of signs' and (re)produce significations; it also dramatizes, through its very artificiality, the untenability of this desire for stasis in the movement of history. It is in this sense that interruption can be understood as a point of dislocation between the subject and the structure that supposedly contains it. Thus the pose becomes a form of resistance to the evil eye (Lacan's *fascinum*) of the subject–structures that would immobilize it in the chain of significations.

In Madonna's video this resistant pose – encapsulated in the otherizing ethnography of *Paris Is Burning* and emergent in the stroboscopic lyricism of *Tongues Untied* – is given a new, (de)politicized character. It becomes a (star) vehicle of escape to the polymorphous perversity of an idealized, universally available dance floor where, as the lyrics go, 'it makes no difference if you're black or white, if you're a boy or a girl'. Madonna thus defines the very *topos* of multiculturalism as a place where antagonisms would be erased and struggles rendered superfluous. It is in this indifferent space, under-written by what Ernesto Laclau calls the violence of the universal [Laclau 1990: xi], that objective differential identities expand indefinitely. Here we discover a crucial link between *Paris Is Burning* and Madonna's *Vogue*, between realism and escapism; both are synecdochic of the prevailing constructions of the multicultural. They fetishize an objectified other and/or subsume her under a myth of equality. Both partake in the production of newness, a process which purports to keep us up-to-date as it continually adds on novelties to a relational system that absorbs them; both contain vogueing beneath the pluralist umbrella of hipness. Conceiving of knowledge in quantitative terms, this safely heterogeneous yet hegemonic multicultur-alism excludes nothing.

What is ignored in this process, however, is the status of desire which, in our own interruptive (rather than interpretive) reading of vogueing, continually reassesses differences in qualitative terms. In this sense, voguers can be seen to pose desire itself as a form of counter-hegemonic knowledge. Understood as a syncretic articulation, vogueing explores the possible within the existing. By embracing, critiquing and restructuring, e.g., ethnicity, gayness, gender, class, etc., it intervenes in sovereign discursive structures – like the experiential and the authentic – which would reduce its elements to immanent moments of a naturalized system of differences and which vogueing 'reads' as inadequate to its reconfigurations of the real. Interrupting the closure of identities and of their relations, vogueing's syncretisms propose new possibilities of struggle.

Marjorie Garber

SIGN, CO-SIGN, TANGENT
Cross-dressing and cultural anxiety [1992]

IF TRANSVESTISM OFFERS a critique of binary sex and gender distinctions, it is not because it simply makes such distinctions reversible but because it denaturalizes, destabilizes, and defamiliarizes sex and gender *signs*. When a homosexual relation seems to trope off a heterosexual relation, what is revealed is that the signs by which heterosexuality had encoded and recognized itself have been detached from a referent with which those signs are thereby revealed to have had a conventional rather than natural connection. Thus Joan Nestle strongly defends butch-femme relationships against the claim by lesbian-feminists that butch-femme merely reproduces heterosexual models. 'Butch-femme relationships, as I experienced them,' she writes, 'were complex erotic statements, not phony heterosexual replicas. . . . None of the butch women I was with, and this included a passing woman, ever presented themselves to me as men' [Nestle 1987: 100].

In a brief and powerful essay that she says took her forty years to write (she was about forty when she wrote it), Nestle deconstructs the term *Lesbian-feminist* as itself a butch-femme relationship, 'butch-femme,' that is, 'as it has been judged, not as it was.' *Lesbian*, she says, bears 'the emotional weight that butch does in modern judgment,' and *feminist* becomes 'the emotional equivalent of the stereotyped femme, the image that can stand the light of day' [ibid., 106–07]. Many feminists of the 1970s were chary of calling themselves lesbians without the hyphenated adjunct. Nestle critiques the term *role-playing* as it is used to describe butch-femme relationships, since for her the names came after, not before, the roles; 'as a femme,' she insists, 'I did what was natural for me . . . I did not learn a part.'

Sue-Ellen Case argues in 'Toward a Butch-Femme Aesthetic' for the importance of the lesbian roles of butch and femme as strong models for the theorization of a feminist subject 'endowed with the agency for political change, located among women, outside the ideology of sexual difference, and thus the social institution of heterosexuality' [Case 1989: 283]. Case protests against the aestheticization and appropriation of camp, 'the style, the discourse, the *mise en scène* of butch-femme roles' [ibid., 286] by avant-garde critics like Susan Sontag, and also against 'the critical maneuvers of heterosexual feminist critics who metaphorize butch-femme roles, transvestites and campy dressers into a "subject who masquerades"' or cross-dresses [ibid., 289].

What I want to stress here, from Case's essay, is both the way in which she insists on the suppression of the butch in favor of the femme in film theories of spectatorship like that of Mary Ann Doane, and the close connection Case makes between classism and the feminist critique of butch-femme. (Joan Nestle also makes this last point forcefully in *A Restricted Country*: upperclass butch-femme figures, like Natalie Barney, Renée Vivien, Vita Sackville-West, and Radclyffe Hall are regarded as style setters and role models; but the butch-femme style of the working-class lesbian, especially the passing female-to-male transvestite, the bull dyke, the bulldagger, makes heterosexual feminists uncomfortable.)

'What would you say butch/femme is about?' lesbian columnist Lee Lynch asked a lesbian friend. 'Butch', replied the friend, 'is knowing how to stand on a streetcorner and catch a femme's eye'. 'And femme?' 'Is spotting the butch and knowing how to get her clothes off.' Laughingly, Lynch asked what had happened to the rhetoric of equality. 'Are you saying the femme is the active partner?' And her friend laughed back. 'Don't you *know* that by now?' [Lynch 1988: 12].

Here it is *difference* that is erotic; difference within sameness, a difference discerned, descried, achieved rather than given. But the mechanism of dislocation, of the detachable part, . . .the anxiety of artifice, becomes the sartorial signature of gay and lesbian dress – and undress. A leather jacket with a plenitude of zippers; a close-cropped haircut; makeup on a man; the absence of makeup on a woman. Taken separately – taken apart – these are signals, like the earring on the proper ear, the pinky ring, the bunch of keys. But the conundrum remains. If one piece, or a couple, of these sartorial signs are present we call it fashion; mainstreamed, it may not even any longer signify erotic style or sexual preference. . . .

Nor is it always easy to 'read' butch-femme on the street. 'Since at times femmes dressed similarly to their butch lovers,' Nestle notes, 'the aping of heterosexual roles was not always visually apparent, yet the sight of us was enraging' (102). Onlookers shouted at them, as they walked hand in hand, 'Which one of you is the man?' A butch woman was stoned in Washington Square Park for wearing men's clothes. A group of straight people in the 1950s, encountering Nestle as she walked through Central Park, inquired cheerfully of one another, as if she weren't there, 'What shall we feed it?'

'*It*' is the word that stings, the third category, dehumanized and dehumanizing. Radclyffe Hall describes a similar scenario in *The Well of Loneliness* [1928] when Stephen Gordon visits a Bond Street jewelers in search of a ring for the woman she loves:

> People stared at the masculine-looking girl who seemed so intent upon feminine adornments. And someone, a man, laughed and nudged his companion: 'Look at that! What is it?'
> 'My God! What indeed?'
>
> [Hall 1981: 165]

Times change, styles change, eroticisms reconfigure and resignify. The 1987 edition of a San Francisco guidebook advises tourists visiting the Castro (the city's gay scene) to 'Cast aside stereotypes for your trip to San Francisco. Fathers now worry if a son's hair is too short, if his dress is too macho, or his muscles too well-developed, since these are the trademarks of the new breed of San Francisco gay man' (Wurman 1987: 132). One stereotype or 'trademark' is here being substituted for another. Likewise, 'Eighties butch-femme', declares an article in the gay-lesbian journal *Out/Look*,

> – if it accurately can be termed as such – is a self-conscious aesthetic that plays with style and power, rather than an embrace of one's 'true' nature against the constraints of straight society . . . There is no longer a clear one-to-one correspondence between fashion and identity. For many, clothes are transient, interchangeable; you can dress as a femme one day and a butch the next. You can wear a crew-cut along with a skirt. Wearing high heels during the day does not mean you're a femme at night, passive in bed, or closeted on the job.
>
> [Stein 1989: 38]

Nor – is it needless to say? – can this assumption be made about a *man* in a dress, about men in drag. The politics of drag are complicated by persistent divisions within gay male culture about the relationship of 'dressing up' to gay male identity. Is the drag queen a misogynistic put-down of women, a self-hating parody, or a complex cultural sign that defies any simple translation into 'meaning'?

As Oscar Montero has argued, although 'drag may become so incorporated into the fabric of a culture . . . [although it] may answer so precisely that culture's own desire that it ceases to provoke and becomes entertainment,' as in the case of female impersonators Danny La Rue or Charles Pierce, drag can also be an important destabilizing element that, in performance, 'questions the limits of representation:'

> The imperfection of her imitation is what makes her appealing, what makes her eminently readable. Foolproof imitations of women by men,

or men by women, are curious, but not interesting. There has to be some telltale, not the gross five o'clock shadow or the limp wrist of the amateur, but something readable, a foot that is too big, a subtle gesture or the peculiar grain of the voice.

[Montero 1988: 41]

Thus 'illusionist' Jim Bailey, in his one-man show as Judy Garland, was 'unmistakably a man in a dress,' according to one critic ('he's no Garland, but he's prettier' [LaSalle 1989: E3], while another noted that 'everyone had time to become acquainted with all the ways Bailey does not resemble Garland. Then he moved – a few of her familiar, jerky, offhand motions, her tender ways of embracing herself' so that ultimately 'he reversed the impressionists's illusion: the longer he was on stage the more he resembled her' [Alarik 1989: 84].

Colette testifies to the same technique of double-reading in her account of cross-dressing in the lesbian Paris of the 1920s:

How timid I was, at that period when I was trying to look like a boy, and how feminine I was beneath my disguise of cropped hair. 'Who would take us to be women? Why, women.' They alone were not fooled. With such distinguishing marks as pleated shirt front, hard collar, sometimes a waistcoat, and always a silk pocket handkerchief, I frequented a society perishing on the margin of all societies.

(Colette [1967]: 67)

This emphasis on *reading* and *being read*, and on the deconstructive nature of the transvestite performance, always undoing itself as part of its process of self-enactment, is what makes transvestism theoretically as well as politically and erotically interesting – at least to me. No critic has made this point more forcefully than the Cuban writer Severo Sarduy, formerly a writer with the journal *Tel Quel*, and author of a series of postmodern novels in which the figure of the transvestite serves as the hinge of a postmodern culture in the process of political and social rupture.

In an essay called 'Writing/Transvestism' Sarduy makes explicit the fascination of transvestism as inversion carried to its limits. Citing Lacan (the unconscious is structured like a language subject to its own codes and transgressions; signifiers produce an *effect* that is their sense) and Barthes (metaphor is a sign without content; the symbolic process is one that designates a distance from meaning), Sarduy locates the crux of this new or renewed understanding about the signifier and its displacements in transvestism:

Transvestism . . . is probably the best metaphor for what writing really is: . . . not a woman *under whose outward appearance* a man must be hiding, a cosmetic mask which, when it falls, will reveal a beard, a rough hard face, but rather *the very fact of transvestism itself*. . . . the coexistence, in a

457

single body, of masculine and feminine signifiers: the tension, the repulsion, the antagonism which is created between them. . . .

Painted eyebrows and beard; that mask would enmask its being a mask.

[Sarduy 1973: 33]

Not something beneath the mask, but *the very fact of transvestism* itself. This is the directive to look *at* rather than through the transvestite once again; and it is worth noting that Sarduy does not need to disarticulate his fictive transvestites from their homosexuality in order to do so. He does not read or write transvestism as a figure for something else; for Sarduy, transvestism, like those other, supposedly 'exterior' elements – the page, the blank spaces, the horizontality of writing, the writing itself – are the alternative signifiers waiting to be read. 'These are the things that a persistent prejudice has considered the exterior face, the obverse of something which must be what that face *expresses*' [ibid., 32]. But, for Sarduy, what that face expresses, and what transvestism expresses, it *itself* – figure rather than ground, figure as ground, and as the calling into question of the possibility of ground. 'Those planes of intersexuality are analogous to the planes of intertextuality . . . planes which communicate on the same exterior.' And 'that interaction of linguistic textures, of discourses, that dance, that parody, is writing' [ibid., 33].

Robert Walser

ERUPTIONS
Heavy metal appropriations of
classical virtuosity [1993]

IN THE LINER NOTES for his 1988 album *Odyssey*, heavy metal guitarist
Yngwie J. Malmsteen claimed a musical genealogy that confounds the
stability of conventional categorizations of music into classical and popular
spheres. In his list of acknowledgments, along with the usual cast of agents
and producers, suppliers of musical equipment, and relatives and friends,
Malmsteen expressed gratitude to J.S. Bach, Nicolò Paganini, Antonio
Vivaldi, Ludwig van Beethoven, Jimi Hendrix, and Ritchie Blackmore. From
the very beginnings of heavy metal in the late 1960s, guitar players had
experimented with the musical materials of eighteenth- and nineteenth-
century European composers. But the trend came to full fruition around the
time of Malmsteen's debut in the early 1980s; a writer for the leading profes-
sional guitar magazine said flatly that the single most important development
in rock guitar in the 1980s was 'the turn to classical music for inspiration
and form' (Stix 1986: 59).

Heavy metal, like all forms of rock and soul, owes its biggest debt to
African-American blues. The harmonic progressions, vocal lines, and guitar
improvisations of metal all rely heavily on the pentatonic scales derived from
blues music. The moans and screams of metal guitar playing, now performed
with whammy bars and overdriven amplifiers, derive from the bottleneck
playing of the Delta blues musicians and ultimately from earlier African-
American vocal styles. Angus Young, guitarist with AC/DC, recalls, 'I started
out listening to a lot of early blues people, like B. B. King, Buddy Guy, and
Muddy Waters' [Szatmary 1987: 154]. Such statements are not uncommon,
and heavy metal guitarists who did not study the blues directly learned second-
hand, from the British cover versions of Eric Clapton and Jimmy Page or

from the most conspicuous link between heavy metal and blues and r&b, Jimi Hendrix.

But from the very beginning of heavy metal there has been another important influence: that assemblage of disparate musical styles known in the twentieth century as 'classical music.' Throughout metal's twenty-year history, its most influential musicians have been guitar players who have also studied classical music. Their appropriation and adaptation of classical models sparked the development of a new kind of guitar virtuosity, changes in the harmonic and melodic language of heavy metal, and new modes of musical pedagogy and analysis.

Classical prestige and popular meanings

The classical influence on heavy metal marks a merger of what are generally regarded as the most and least prestigious musical discourses of our time. This influence thus seems an unlikely one, and we must wonder why metal musicians and fans have found such a discursive fusion useful and compelling. Musicologists have frequently charaterized adaptive encounters among musical practices as natural expansions of musical resources, as musicians find in foreign music new means with which to assert their innovative creativity. Yet such explanations merely reiterate, covertly, a characteristically Western interest in progress, expansion, and colonization. They do little to account for the appearance of specific fusions at particular historical moments or to probe the power relations implicit in all such encounters. We will need more cogent explanations than those with which musicology has traditionally explained classical exoticism, fusions of national styles, and elite dabblings in jazz.

I should emphasize that my discussion of the relationship of heavy metal and classical music is not simply a bid to elevate the former's cultural prestige. Attempts to legitimate popular culture by applying the standards of 'high' culture are not uncommon, and they are rightly condemned as wrongheaded and counterproductive by those who see such friends of 'low' culture as too willing to cede the high ground. That is, the assumptions that underpin cultural value judgments are left untouched, and the dice remain loaded against popular culture. An attempt to legitimate heavy metal in terms of the criteria of classical music, like prior treatments of the Beatles' and other rock music, could easily miss the point, for heavy metal is in many ways antithetical to today's classical music. Such a project would disperse the differences between metal and other musics, accomplishing a kind of musicological colonization that musicians, fans, and cultural historians alike would find alienating and pointless.

But in the case of heavy metal, the relationship to classical modes of thought and music making is not merely in the eye of the beholder. To compare it with culturally more prestigious music is entirely appropriate, for

the musicians who compose, perform, and teach this music have tapped the modern classical canon for musical techniques and procedures that they have then fused with their blues-based rock sensibility. Their instrumental virtuosity, theoretical self-consciousness, and studious devotion to the works of the classical canon mean that their work could be valorized in the more 'legitimate' terms of classical excellence. But more important, metal guitarists' appropriations of classical music provide a vital opportunity for examining musical signification in contexts of popular creativity and cultural contestation.

The history of American popular music is replete with examples of appropriation 'from below' – popular adaptations of classical music. . . . The sorts of value popular appropriators find in classical music might be grouped around these topics: semiotics, virtuosity, theory, and prestige. I will explore each of these aspects in turn. . . . But before examining the classical influence upon metal, I must clarify my understanding of the term 'classical music,' particularly my attribution to it of prestige and semiotic significance.

The prestige of classical music encompasses both its constructed aura of transcendent profundity and its affiliation with powerful social groups. Although the potency of its aura and the usefulness of its class status depend upon the widespread assumption that classical music is somehow timeless and universal, we know that 'classical music' is a relatively recent cultural construct. The canon of the music now known as 'the great works of the classical tradition' began to form early in the nineteenth century, with revivals of 'ancient' music (Bach and Mozart) and series publications of composers' collected works. Lawrence W. Levine [1988] has carefully detailed the process of elevation and 'sacralization,' begun midway through the nineteenth century, whereby European concert music was wrenched away from a variety of popular contexts and made to serve the social agenda of a powerful minority of Americans. Along with the popular plays of Shakespeare, German music was elevated, as an elite attempted to impose a monolithic 'moral order,' repudiating the plurality of cultural life. By the twentieth century, institutional and interpretive structures came to shape musical reception so completely that what we know today as 'classical music' is less a useful label for a historical tradition than a genre of twentieth-century music.

Perhaps the most forceful critique of the institution of modern concert music is that of Christopher Small [1980, 1987], who argues that this process of sacralization has almost completely effaced original social and political meanings. Musical works that were created for courts, churches, public concerts, and salons of connoisseurs, and that had modeled and enacted the social relationships important to those specific audiences, have become a set of interchangeable great pieces. All of the vast range of meanings produced by these disparate musics are reduced to singularity in the present. That single meaning, Small maintains, is one of defense – specifically, defense of the social relationships and ideologies that underpin the status quo. Cultural hierarchy is used to legitimate social hierarchy and to marginalize the voices

461

of all musicians who stand outside the canon, representing those who stand at the margins of social power. Small's critique is important because it is essential to realize that classical music is not just 'great' music; it is a constructed category that reflects the priorities of a historical moment and that serves certain social interests at the expense of others. Classical music is the sort of thing Eric Hobsbawm calls an 'invented tradition,' whereby present interests construct a cohesive past to establish or legitimate present-day institutions or social relations [Hobsbawm and Ranger 1983]. The hodgepodge of the classical canon – aristocratic and bourgeois music; academic, sacred, and secular; music for public concerts, private soirees, and dancing – has one thing in common: its function as the most prestigious culture of the twentieth century.

Once established, though, classical music can be negotiated; it has been both a bulwark of class privilege and a means whereby other social barriers could be overcome. African-American performers and composers have long worked to defeat racist essentialism by proving their ability to write and perform European concert music. The chamber jazz of the Modern Jazz Quartet, with its cool fusions of swing and classical forms, was also a statement of black pride, however conservative it seemed amid the turmoil of the 1960s. Duke Ellington was a crucial figure in the struggle to achieve widespread respect for African-American music, in large measure because his skills as composer, orchestrator, and leader made him, of all jazz musicians, most closely match the prestigious model of the classical composer.

Rock fusions with classical styles are most often associated with the 'progressive rock' or 'art rock' of the late 1960s. With *Sgt. Pepper's Lonely Hearts Club Band*, the Beatles kicked off an era of self-conscious experimentation with the instrumentation and stylistic features of classical music. Producer George Martin's training as a classical oboist exposed him to many of the peculiarities that appeared on the Beatles' recordings: piccolo trumpet (a modern instrument now associated with Baroque music), classical string quartets, odd metric patterns perhaps inspired by Stravinsky or Bartók (or more directly by the non-Western music that had inspired *them*). . . . [G]roups as different as The Who, Yes, The Kinks, and Emerson, Lake, and Palmer composed classically influenced rock songs, rock concertos, and rock operas. Deep Purple, eventually recognized as one of the founding bands of heavy metal, began to develop in that direction only after guitarist Ritchie Blackmore grew dissatisfied with fusions such as keyboardist Jon Lord's ambitious *Concerto for Group and Orchestra* (1969) and reoriented the band:

> I felt that the whole orchestra thing was a bit tame. I mean, you're playing in the Royal Albert Hall, and the audience sits there with folded arms, and you're standing there playing next to a violinist who holds his ears everytime you take a solo. It doesn't make you feel particularly inspired.
>
> [Kleidermacher 1991: 62]

Blackmore realized that the institutions and audience expectations that frame classical music would always control the reception of any music performed within that context; while he was attracted to classical musical resources, he found that he would have to work with them on his own turf.

Discussions of art rock rarely move beyond sketching influences to address the question of *why* classical music was used by these groups. Certainly one of the most important reasons is prestige. Rock critics' own preoccupation with art rock reflects their acceptance of the premises of the classical model. Performers who haven't composed their own material – 'girl groups,' Motown, soul singers – have rarely won critical respect comparable to that granted artists who better fit the model of the auteur, the solitary composing genius. Sometimes performers stake their claims to classical prestige explicitly. Emerson, Lake, and Palmer's neoclassical extravaganzas, such as their rendering of Mussorgsky's *Pictures at an Exhibition* (1972), were intended as elevations of public taste and expressions of advanced musicianship. Keith Emerson's attraction to classical resources was unabashedly elitist; he considered ordinary popular music degraded and took on the mission of raising the artistic level of rock. In such art rock, classical references and quotations were intended to be recognized as such; their function was, in large measure, to invoke classical music and to confer some of its prestigious status and seriousness.

Other popular musicians have been attracted to classical resources for reasons of signification beyond prestige. At least since the late 1920s, when classical string sections began to appear on recordings of Tin Pan Alley music, classical means have been used to expand the rhetorical palette – and social meanings – of popular music. In Bing Crosby's Depression-era hit, 'Brother, Can You Spare a Dime?' (1932), the strings function to underscore the sincerity of Crosby's voice and magnify the poignancy of his character's plight. The recorders on Led Zeppelin's 'Stairway to Heaven' (1971) similarly contribute to the song's musical semiotics. They sound archaic and bittersweet; their tranquil contrapuntal motion is at once soothing and mysterious.

Of all the stylistic or historical subdivisions of classical music, rock music has borrowed most from the Baroque. Richard Middleton has tried to account for this by arguing that there is a 'relatively high syntactic correlation' between Baroque and rock musical codes. Like rock music, Baroque music

> generally uses conventional harmonic progressions, melodic patterns and structural frameworks, and operates through imaginative combinations, elaborations and variations of these, rather than developing extended, through-composed forms. It also tends to have a regular, strongly marked beat; indeed, its continuo section could be regarded as analogous to the rhythm section of jazz and rock.
>
> [Middleton 1990: 30]

Middleton suggests, for example, that Procul Harum's 'A Whiter Shade of Pale' (1967), by fusing harmonic and melodic material taken from a Bach

463

cantata with the soul ballad vocal style of Ray Charles and Sam Cooke, presented the counterculture with an image of itself as 'sensuously spiritual' and 'immanently oppositional' [ibid., 131].

Here the usefulness of Baroque materials depends on both their aura as 'classical' and their present semiotic value, to the extent that these meanings are separable. For although this music was composed long ago, it is still circulating, producing meanings in contemporary culture. Metal musicians generally acquire their knowledge of classical music through intense study, but they owe their initial exposure to the music and their audiences' ability to decode it not to the pickled rituals of the concert hall, but to the pervasive recycling of all available musical discourses by the composers of television and movie music. Classical musics are alive and omnipresent in mass culture, despite the best efforts of proponents of cultural apartheid and in part due to their missionary efforts. Mass mediation ensures that there can be no absolute separation of 'high' and 'low' culture in the modern world; classically trained composers write film scores that draw upon their conservatory studies but succeed or fail on their intelligibility and meaningfulness for mass audiences. Classical music surely no longer signifies as it did originally, but neither are its meanings ahistorical or arbitrary. It is available to culturally competitive groups who claim and use its history, its prestige, and its signifying powers in different ways.

Heavy metal appropriations of classical music are, in fact, very specific and consistent: Bach, not Mozart; Paganini rather than Liszt; Vivaldi and Albinoni instead of Telemann or Monteverdi. This selectivity is remarkable at a time when the historical and semiotic specificity of classical music, on its own turf, has all but vanished, when the classical canon is defined and marketed as a reliable set of equally great and ineffable collectibles. By finding new uses for old music, recycling the rhetoric of Bach and Vivaldi for their own purposes, metal musicians have reopened issues of signification in classical music. Their appropriation suggests that despite the homogenization of that music in the literatures of 'music appreciation' and commercial promotion, many listeners perceive and respond to differences, to the musical specificity that reflects historical and social specificity. Thus, the reasons behind heavy metal's classical turn can reveal a great deal, not only about heavy metal but also about classical music. We must ask: if we don't understand his influence on the music of Ozzy Osbourne or Bon Jovi, do we really understand *Bach* as well as we thought we did? . . .

[The original version of this chapter included extensive discussion of four guitar players, with a dozen musical transcriptions illustrating their involvements with classical music and their influence on heavy metal. Ritchie Blackmore's classical studies prepared him, as he has explained, to adapt virtuosic figuration from Vivaldi and Bach for his solos. Eddie Van Halen drew upon classical training, blues models, and new technological developments to create a fast, fluid, tremendously influential style of playing. Van Halen's perfection of unusual techniques, such as tapping the frets with the

right hand, enabled him to perform quick series of arpeggios, making the energetic harmonic progressions of Vivaldi and others, and the heroic effects they articulated, even more easily transferable to the electric guitar. Randy Rhoads, the son of two music teachers and a life-long student of classical guitar, made even more explicit the classical influence on his harmonic progressions, cadenzas, and solos. Even more than Van Halen, Rhoads inspired among rock guitarists a new sort of disciplined practice and pedagogy based on classical training; new guitar schools and magazines, featuring transcriptions and modal analyses, spring up to meet the demand. Swedish virtuoso Yngwie Malmsteen managed to reconcile the influences of his two heroes, Jimi Hendrix and Nicolò Paganini, upping the stakes of guitar virtuosity through new scales (such as the harmonic minor), imaginative rhetoric, precise technique, and sheer speed. Malmsteen's impact on guitarists was much greater than his popularity with audiences; he took the classical influence about as far as it would go: into fruitful dialogue with many aspects of the classical tradition, but also into the isolated, impoverishing regimes of practice and analysis that now dominate that tradition. R. W.]

Popular music as cultural dialogue

There are different ways to view the encounter of classical music and heavy metal, in part because there are . . . two different 'classical musics': the twentieth-century genre of classical music, which comprises 'great' pieces that are marketed and promoted (in part via 'music appreciation') as largely interchangeable; and the collection of disparate historical practices – occupying vastly different social positions, employing incompatible musical discourses to varied cultural ends – that now are called by that name. On the one hand, heavy metal and classical music exist in the same social context: they are subject to similar structures of marketing and mediation, and they 'belong to' and serve the needs of competing social groups whose power is linked to the prestige of their culture. The immense social and cultural distance that is normally assumed to separate classical music and heavy metal is in fact not a gap of musicality. Since heavy metal and classical music are markers of social difference and enactments of social experience, their intersection affects the complex relations among those who depend on these musics to legitimate their values. Their discursive fusion may well provoke insights about the social interests that are powerfully served by invisible patterns of sound.

On the other hand, there is a sense in which this sort of fusion marks an encounter among different cultures and affords an opportunity for cross-cultural critique. In their influential book, *Anthropology as Cultural Critique* [1986], George E. Marcus and Michael M. J. Fischer called for new critical projects that would simultaneously explore multiple cultural moments. Besides the usual 'objective' studies of individual cultural practices, ethno-

465

graphic work, they argued, can become cultural criticism by reciprocally probing different 'ways of knowing,' by encouraging defamiliarization and the location of alternatives, and by breaking through patterns of thought that attempt to keep meanings singular and stable in the face of multiplicity and flux. . . . But scholars are not the only ones who undertake such critical juxtapositions; heavy metal musicians, by engaging directly with seventeenth-, eighteenth-, and nineteenth-century composers and performers, by claiming them as heroes and forebears despite contemporary boundaries that would keep them separate, have already done something similar.

Historians and critics of popular music have so far failed to take seriously the musical accomplishments of heavy metal musicians. The prevailing stereotype portrays metal guitarists as primitive and noisy; virtuosity, if it is noticed at all, is usually dismissed as 'pyrotechnics.' One of the standard histories of rock grudgingly admitted that Edward Van Halen was an impressive guitarist but maintained doggedly that 'the most popular 1980s heavy metal acts broke little new ground musically' [Ward et al. 1986: 608]. In the academy, heavy metal (along with rap) remains the dark 'Other' of classical preserves of sweetness and light.

Nor are metal's musical accomplishments acknowledged in the reports of the general press, where the performances of heavy metal musicians are invariably reduced to spectacle, their musical aspects represented as technically crude and devoid of musical interest. Life's sensationalist dismissal of Judas Priest is typical: 'The two lead guitarists do not so much play as attack their instruments' [Fadiman 1984: 106]. Given the intensity and aggressiveness of Judas Priest's music, the characterization is not unfair; indeed, such a sentence, if printed in Hit Parader or Metal Mania, would be understood as a complimentary metaphor, praising the musicians' vigor. But in Life the image of attack takes the place of understanding; the magazine plays to class and generational prejudices by mocking the musical skills and imagination of the group.

In fact, heavy metal guitarists, like all other innovative musicians, create new sounds by drawing on the power of the old and by fusing together their semiotic resources into compelling new combinations. Heavy metal musicians recognize affinities between their work and the tonal sequences of Vivaldi, the melodic imagination of Bach, the virtuosity of Liszt and Paganini. Metal musicians have revitalized eighteenth- and nineteenth-century music for their mass audience in a striking demonstration of the ingenuity of popular culture. Although their audience's ability to decode such musical referents owes much to the effects of the ongoing appropriations of classical music by TV and movie composers, heavy metal musicians have accomplished their own adaptation of what has become the somber music of America's aristocracy, reworking it to speak for a different group's claims to power and artistry.

In one of his most incisive essays, Theodor Adorno criticized twentieth-century 'devotees' of classical music for flattening out the specific signification

of that music, making composers such as Bach into 'neutralized cultural monuments' [Adorno 1981: 136]. In Adorno's view, the prestigious position of Bach in contemporary culture seems to demand that his music be tamed, that it be made to seem to affirm the inevitability of present social power relationships, at the top of which are the sources of the subsidies that sustain classical music. Metal musicians have appropriated the more prestigious discourses of classical music and reworked them into noisy articulations of pride, fear, longing, alienation, aggression, and community. Their adaptations of classical music, though they might be seen as travesties by modern devotees of that music, are close in spirit to the eclectic fusions of J. S. Bach and other idols of that tradition. While a few musicologists have tried to delineate strategies for performing and interpreting Bach's music that reclaim its cultural politics, it may be that only heavy metal musicians have achieved this to a significant degree. To alter slightly the closing of Adorno's essay on Bach, 'Perhaps the traditional Bach can indeed no longer be interpreted. If this is true, his heritage has passed on to [heavy metal] composition, which is loyal to him in being disloyal; it calls his music by name in producing it anew' [ibid., 146].

For we should have learned long ago from Adorno that social relations and struggles are enacted within music itself. This is especially visible when musical discourses that belong to one group, whose history has been told according to that group's interests, are made to serve other social interests. Metal appropriations are rarely parody or pastiche; they are usually a reanimation, a reclamation of signs that can be turned to new uses. Unlike art rock, the point is typically not to refer to a prestigious discourse and thus to bask in reflected glory. Rather, metal musicians adapt classical signs for their own purposes, to signify to their audience, to have real meanings in the present. This is the sort of process to which V. N. Vološinov referred when he wrote that the sign can become an arena of class struggle. Vološinov and the rest of the Bakhtin circle were interested in how signs not only reflect the interests of the social groups that use them but are also 'refracted' when the same signs are used by different groups to different ends. Thus, heavy metal musicians and 'legitimate' musicians use Bach in drastically different ways. As Vološinov wrote:

> Class does not coincide with the sign community, i.e., with the community which is the totality of users of the same set of signs for ideological communication. Thus various different classes will use one and the same language. As a result, differently oriented accents intersect in every ideological sign. Sign becomes an arena of the class struggle.
>
> This social *multiaccentuality* of the ideological sign is a very crucial aspect. By and large, it is thanks to this intersecting of accents that a sign maintains its vitality and dynamism and the capacity for further development. A sign that has been withdrawn from the pressures of the social struggle – which, so to speak, crosses beyond the pale of the

class struggle – inevitably loses force, degenerating into allegory and becoming the object not of live social intelligibility but of philological comprehension. The historical memory of mankind is full of such worn out ideological signs incapable of serving as arenas for the clash of live social accents. However, inasmuch as they are remembered by the philologist and the historian, they may be said to retain the last glimmers of life.

[1986: 23]

The discourse of signs that make up 'Baroque music' certainly survives in the present; since its revival in the middle of the nineteenth century, Bach's music has occupied an important place in the concert and Protestant liturgical repertoires. Moreover, as with all classical music, Baroque signs appear in the music of television and film, where visual cues depend upon and reinvest the music with affective power. While the music of the precanonic Dufay or Philippe de Vitry may have become largely the concern of musicological 'philologists,' mass mediation has made the musical discourses of all times and places available to contemporary composers, and the semiotic vocabulary and rhetoric of the European classical canon still forms the backbone of Hollywood's prodigious musical output.

Heavy metal musicians, too, draw upon the resources of the past that have been made available to them through mass mediation and their own historical study. But it is precisely such predations that the musical academy is supposed to prevent. Bach's contemporary meanings are produced in tandem by musicologists and the marketing departments of record companies and symphony orchestras, and the interpretation of Bach they construct has little to do with the dramatic, noisy meanings found by metal musicians and fans and everything to do with aesthetics, order, and cultural hegemony. The classical music world polices contemporary readings of the 'masterworks'; the adaptations of Randy Rhoads [of Quiet Riot and Ozzy Osbourne fame] and Bon Jovi are ignored while the acceptability of Stokowski's orchestral transcriptions is debated. Malmsteen's performances fall outside the permissible ideological boundaries that manage to contain Maurice André and Glenn Gould. The drive to enforce preferred ideological meanings is, as Vološinov put it, 'nondialogic.' It is oppressive, authoritative, and absolute.

The very same thing that makes the ideological sign vital and mutable is also, however, that which makes it a refracting and distorting medium. The ruling class strives to impart a supraclass, eternal character to the ideological sign, to extinguish or drive inward the struggle between social value judgements which occurs in it, to make the sign uniaccentual.

[ibid., 1986: 23]

But since the world of language (or music) preexists its inhabitants, and since cultural hegemony is never absolute, such appropriations constantly

appear on the field of social contestation we call 'popular culture.' Such disruptions are rarely even acknowledged by academics. In the histories they write and the syllabi they teach, most musicologists continue to define 'music' implicitly in terms of the European concert tradition, ignoring non-Western and popular musics and treating contemporary academic composers such as Milton Babbitt as the heirs to the canon of great classical 'masters.' But Babbitt's claim to inherit the mantle of Bach is perhaps more tenuous than that of Randy Rhoads, and not only because the latter two utilize, to some extent, a common musical vocabulary. The institutional environment within which Babbitt works (and which he has vigorously championed) rewards abstract complexity and often regards listeners and their reactions with indifference or hostility, whereas both Bach and Rhoads composed and performed for particular audiences, gauging their success by their rhetorical effectiveness. Babbitt's music demonstrates his braininess; Bach's and Rhoads's offer powerful, nuanced experiences of transcendence and communality.

Many heavy metal musicians are acutely aware of their complicated relationship to the prestigious music of the classical past. Theorists like Wolf Marshall necessarily refer to that canon in their efforts to account for the musical choices displayed in particular pieces, and other musicians recurringly articulate the similarities they perceive in the values and practices of these two musics, which are usually assumed to be worlds apart. Vocalist Rob Halford earnestly emphasises the discipline and skill needed to succeed in either style:

> This might sound like a bizarre statement, but I don't think playing heavy metal is that far removed from classical music. To do either, you have to spend many years developing your style and your art; whether you're a violinist or a guitarist, it still takes the same belief in your form of music to achieve and create. It is very much a matter of dedication. . . . You get narrow-minded critics reviewing the shows, and all they think about heavy metal is that it is just total ear-splitting, blood-curdling noise without any definition or point. This is a very, *very* professional style of music. It means a great deal to many millions of people. We treat heavy metal with respect.
>
> [Considine 1984: 46, 48]

Metal musicians' appropriations have already profoundly changed not only their music but their modes of theorization, pedagogy, and conceptualization. Their fusions may even come to affect the reception and performance of classical music as well. We should welcome such revitalization: contrast today's pious, sterile reiterations of the 'Pachelbel Canon' with Vinnie Moore's furious soloing over that piece in concert. Compare classical musicians' timid ornamentation of Italian sonatas with Yngwie Malmsteen's free and virtuosic improvisations over the chord progressions of Albinoni, more faithful to the practices of the early eighteenth century despite his nonclassical instrument.

Heavy metal musicians erupted across the Great Divide between 'serious' and 'popular' music, between 'art' and 'entertainment,' and found that the gap was not as wide as we have been led to believe. As Christopher Small put it,

> The barrier between classical and vernacular music is opaque only when viewed from the point of view of the dominant group; when viewed from the other side it is often transparent, and to the vernacular musician there are not two musics but only one. . . . Bach and Beethoven and other 'great composers' are not dead heroes but colleagues, ancestor figures even, who are alive in the present.
>
> [Small 1987: 126]

It should come as no surprise that such an eruption, propelled by the social desires and tensions of patriarchy and capitalism, reinscribes familiar constructions of masculinity and individuality, even as the new meritocracy of guitar technique opens doors to female and African-American musicians. And we should not be dismayed to find that classically influenced heavy metal can reinterpret the past even as it is itself co-opted into the world of advertising and soundtracks. For that is how popular culture works: through ingenuity and contradiction toward revisions of meaning and prestige. Heavy metal musicians' appropriations from classical music have already changed popular music; they may yet change classical music and perhaps even our understanding of how the cultural labor of popular musicians can blur the distance between the two, defying the division that has been such a crucial determinant of musical life in the twentieth century.

Mediated and virtual subcultures

Introduction to part eight

■ Sarah Thornton

T HE SUBCULTURAL TRADITION has tended to privilege
non-verbal communication and face-to-face dialogue within the
same geographical space. However, mediated communication has
long been integral to the definition and operation of subcultures.
In his exceptional book, *Folk Devils and Moral Panics*, Stanley
Cohen examines the determinations of media coverage to the forma-
tion of the identities and activities of Mods and Rockers in 1960s
Britain. Generally, however, media have been seen as outside and
after the fact of subculture. Scholars have tended to position media
as incorporating or co-opting rather than aiding in the formation
of subcultures. Until the adoption and development of subcultural
theories for the investigation of media audiences, the mediated
nature of relations *within* social groups had often been effaced.

The five chapters in this Part think through key issues in the
subcultural tradition in relation to what is arguably the fastest
growing area of subcultural activity - that of media 'audiences',
'fans' or 'users'. The adoption of subcultural studies by mass
communication and media studies was part of a reaction against
the quantitative research of audiences which tended to deal in
ratings, perhaps even 'appreciation indexes', but had little to say
about how media fit into and make sense within people's everyday

lives. It was part of a project to portray audiences as active partici-
pants in culture rather than abstract demographic segments or
empty attention spans.

One direct connection between the concerns of subcultural
studies and those of these audience studies pivots around the
perceived deviance of the fan. Derived from the word 'fanatic',
'fan' suggests immoderate, arcane tastes or obsessive, abnormal
likings. As Henry Jenkins writes in his chapter,

> whether viewed as a religious fanatic, a neurotic fantasist or
> a lust crazed groupie, the fan remains a 'fanatic' or false
> worshipper, whose interests are fundamentally alien to the
> realm of 'normal' cultural experience and whose mentality is
> dangerously out of touch with reality.

This positioning of fans as aberrant outsiders is a recurrent trope
of post-war descriptions of media audiences. Barbara Ehrenreich,
Elizabeth Hess and Gloria Jacobs argue that the 'hysteria' of young
girls over the Beatles in the 1960s was *defiant*, if not quite *deviant*.
They dispute claims that the behaviour of female Beatles fans was
the result of mindless acquiescence to a well-managed media
campaign. Instead, they argue that the phenomenon was a loud (in
fact, screaming) protest against the feminine norms of chastity,
the 'calculated pragmatic, sexual repression of teenage life'.
Commercial marketing which addressed young people as indepen-
dent 'teens' contained within it the 'seeds of an oppositional
identity'. Emboldened by their new status as 'teenagers', many girls
used the records, representations and appearances of the Beatles
to explore and express their sexual desire independent of the
demands of domesticity, marriage and children.

One of the key questions for media subcultures is: what happens
to their structure and sense of communal self when their partici-
pants do not actually occupy the same social spaces? Jenkins's
Star Trek fans have a strong sense of affinity partly because they
gather at conventions, but mostly because they are linked by an
'intertextual network composed of many programs, films, books,
comics, and other popular materials'. Moreover, Caroline Bassett's
analysis of an Internet subculture suggests that bodily presence is

unnecessary for extensive and intensive symbolic interaction. The members of the multi-user domain called LamdaMOO participate in a social world even though they never meet 'in real life'. They know each other only through written descriptions and textual repartee; through these means, they make friends, flirt and dance, explore 'perverse' alter-egos, and live out on-line identities.

This sense of meaningful association without collective congregation has been theorized most effectively and influentially by Lawrence Grossberg. Grossberg develops the concept of 'affective alliance' in order to explain the social reality and emotional power of popular culture in general and popular music in particular. An affective alliance is the 'organisation of concrete material practices and events, cultural forms and social experience which both opens up and structures the space of our affective investments in the world'. It describes the 'network of empowerment' which motivates our use of popular cultural forms; media function effectively for their audiences not in the way they represent the world, but in the way they evoke structures of feeling. In other words, they are important to the ways in which we imaginatively identify and ally ourselves with others.

Will Straw extends Grossberg's notion of affective alliance to explore the manner in which people can have a strong sense of unity over vast geographical and social distances. Straw offers an abstract conception of 'scenes' in place of the term 'subculture' to describe the cosmopolitan, interactive and mutating terrains of North American musical constituencies like alternative rock and dance club cultures. The discourses of these scenes assert distinct and often paradoxical relations to place, space and locale in the way they chronicle their origins, histories, apogees and values.

One danger of Grossberg's and Straw's work is that we lose a sense of the social groups from which the participants in these popular cultures come. These 'subcultures' become attenuated and unanchored, effectively untied from social structures and stratifications. But have sociologists have put too much credence in concrete and immutable difference? Perhaps, we should take our lead from Bassett who, using Judith Butler's notion of 'performativity', suggests that there is always something virtual about difference, subcultural or otherwise?

As more people spend more time reading, listening, watching and using communications media, it is likely that more sub-societies and subcultural alliances will develop around and through their enthusiasms. The glue that binds these new forms of subculture is no longer just word-of-mouth or even telephones, but fanzines and magazines, records and television, computers and the Internet. Undoubtedly, the tradition of subcultural studies will continue to work through the issues of taste, mediation, imaginative allegiance, virtual assembly, and globalism brought to the fore by old and new communications technologies.

Lawrence Grossberg

ANOTHER BORING DAY
IN PARADISE
Rock and roll and the empowerment
of everyday life [1984]

T HE ASSUMPTION that musical texts, even with lyrics, function by
representing something – meanings, ideas or cultural experience – is
problematic. When applied to rock and roll, the assumption does not seem
false, merely incomplete: particular instances of rock and roll may represent
different things for different audiences and in different contexts. Much of
the recent writings on rock and roll is similarly incomplete. For example,
Frith (1981a) argues that rock and roll is a form of leisure activity which
represents various fantasies about the possibilities of a life constituted entirely
as leisure. The matrix of these fantasies is the dialectic of working-
class–urban–street culture and middle-class–suburban–creative culture.
Hebdige (1979), coming out of the tradition of British subcultural studies,
locates rock and roll within the larger category of subcultural styles which
represents and provides an imaginary solution to the experienced contradic-
tions of British working-class life. Both Frith and Hebdige treat rock and roll
as a 'representation' located within a context of class relationships. But while
they each capture important aspects of the place and effects of rock and roll
in contemporary culture, neither one is able to account for the reality and
the generality of the affective power of the music. . . .

Each of these writers proposes, adjacent to his interpretation of rock and
roll, an alternative strategy. Frith proposes that we study the ways in which
the audiences use the music, while Hebdige suggests that the effects of rock
and roll depend upon its existence as a range of signifying practices. Still,
. . . neither approach is able to respond to two significant questions that I
wish to raise: How does one describe the specific effects (and popularity) of
particular forms of rock and roll? How does one describe the consistency

which constitutes rock and roll as a determinate cultural form? Nevertheless, my own approach takes something from each of these writers. Like Frith, I propose to examine rock and roll functionally. But rather than assuming its audience in advance and asking how individuals, either consciously or unconsciously, use the music, I will focus on the ways in which rock and roll produces the material context within which its fans find themselves, a context defined by affective investments rather than by semantic representations. Thus, the rock and roll fan is a part of the effects of the functioning of rock and roll itself. My concern is with the possibilities opened up between, by and for, the music and its audiences, within the everyday life of post-war America.

Like Hebdige, I propose to treat rock and roll as a set of practices, but practices of strategic empowerment rather than of signification. Rock and roll structures the space within which desire is invested and pleasures produced. It is thus immediately implicated in relations of power and a politics of pleasure. I am concerned with the ways in which rock and roll provides strategies of survival and pleasure for its fans, with the ways in which rock and roll is empowered by and empowers particular audiences in particular contexts. Rock and roll becomes visible only when it is placed within the context of the production of a network of empowerment. Such a network may be described as an 'affective alliance': an organisation of concrete material practices and events, cultural forms and social experience which both opens up and structures the space of our affective investments in the world. My aim then is to describe the parameters of rock and roll's empowering effects in terms of the production of affective alliances. . . .

I will propose five general hypotheses to describe rock and roll, framed within the problematic of power as the organisation of desire. The first suggests that the dominant affective context of rock and roll is a temporal rather than a sociological one. While class, race, gender, nationality, subculture and even age may be partly determinate of specific effects, the emergence of rock and roll is enabled within the context of growing up (in the United States for my purposes) after the Second World War. This context defines the practice of rock and roll's continued self-production. The second hypothesis argues that the power of rock and roll cannot be sufficiently described in ideological terms: either as the constitution of an identity or the production of a critical utopia. Rather, rock and roll inscribes and cathects a boundary within social reality marked only by its otherness, its existence outside of the affective possibilities of the ruling culture (the hegemony). In more traditional terms, rock and roll inscribes the particular mark of post-war alienation upon the surface of other social structures of difference. The third hypothesis describes the strategic functioning of rock and roll: it brings together disparate fragments of the material context of the everyday life of its audiences within different rock and roll apparatuses. It is the rock and roll apparatus which maps out particular lines of affective investment and organisation. It therefore both locates and produces the sites at which pleasure

is possible and important for its audiences; it provides the strategies through which the audience is empowered by and empowers the musical apparatus. The fourth hypothesis describes the diverse possibilities of rock and roll by using the concepts of 'encapsulation' and 'affective alliances' presented in the previous two sections. The final hypothesis discusses the notion of 'cooptation' as a significant strategy by which rock and roll produces its own history and reproduces its affective power. . . .

Hypothesis 1. Rock and roll in the post-war context

. . . Consider . . . the obvious fact that rock and roll emerged in a particular temporal context, variously characterised as late capitalism, post-modernity, etc. The dominant moments of this post-war context have been widely described: the effects of the war and the holocaust on the generations of parents; economic prosperity and optimism; the threat of instant and total annihilation (the atomic bomb); the cold war and McCarthyism with the resulting political apathy and repression; the rise of suburbia with its inherent valorisation of repetition; the development of late capitalism (consumption society) with its increasingly sophisticated technology for the rationalisation and control of everyday life; the proliferation of mass media and advertising techniques and the emergence of an aesthetic of images; the attempt and ultimate inability to deal with the fact of the baby boom; the continuation of an ideology of individuality, progress and communication (the American Dream); and, to echo Sontag, an increasingly receding threshold of the shocking. The result was a generation of children that was not only bored (the American Dream turned out to be boring) and afraid, but lonely and isolated from each other and the adult world as well. The more the adult world emphasised their children's uniqueness and promised them paradise, the angrier, more frustrated and more insecure they grew.

These cultural effects were themselves located within an even broader apparatus whose significance is only now being recognised: they operated in a world characterised by a steadily rising rate of change. What is unique, however (since this process had been going on for some time), is that change increasingly appears to be all that there is; it does not allow any appeal to a stable and predictable teleology. There is in fact no sense of progress which can provide meaning or depth and a sense of inheritance. Both the future and the past appear increasingly irrelevant; history has collapsed into the present. The ramifications of this fact are only now becoming visible as we confront a generation that no longer believes that their lives will be better than that of their parents, even though the 'rhetoric of progress' is still present. . . .

Rock and roll emerges from and functions within the lives of those generations that have grown up in this post-war, post-modern context. It does not simply represent and respond to the experiences of teenagers,

nor to those of a particular class. It is not merely music of the generation gap. It draws a line through that context by marking one particular historical appearance of the generation gap as a permanent one. Similarly, class divisions are reinscribed and realigned as they are traversed by the boundary of post-modernity, of the desires of those generations who have known no other historical moment. Post-modernity is, I shall suggest, not merely an experience nor a representation of experience; it is above all a form of practice by which affective alliances are produced, by which other practices and events are invested with affect.

While many commentators have described rock and roll as watered down rhythm and blues (or more accurately, a synthesis of blues and white hillbilly music), I would argue that the fact of its production and reception by white youth involved a real transformation of its musical roots. It located them within a different, emergent historical formation, whose contours I have described in terms clearly meant to echo the aesthetic of post-modern practice: a denial of totality and a subsequent emphasis on discontinuity, fragmentation and rupture; a denial of depth and a subsequent emphasis on the materiality of surfaces; a denial of any teleology and a subsequent emphasis on change and chance so that history becomes both irrelevant and the very substance of our existence; a denial of freedom and innocent self-consciousness and a subsequent emphasis on context, determination and the intertextuality of discursive codes.

The question is whether the post-modernist rejection of meaning in favour of the production of fragments is merely the logical conclusion of the capitalist commodity fetish. In what sense is the post-modernist fragment, even when it accepts the inevitability of its existence as a commodity, something other than a commodity? The commodity in late capitalism exists at the site of the contradiction between modernist and post-modernist cultural practices. The commodity as such is still determined by a representation of totality; it signifies a fragmentation only in the context of a totalising impulse which gives meaning, not only to the particular object (e.g., as status, fashion or exchange value) but also to the general process of commodification. Post-modern practice denies any such totalising impulse. We might say that the object in late capitalism functions in the context of an ideological aesthetic on the one hand and that of a structural aesthetic on the other. The former describes the way the object is represented; post-modern fragments are appropriated into the context of the commodity by defining them in purely economic or aesthetic (avant-garde) terms. This is made easier by post-modernism's propensity to use capitalist commodities within its discourse. A structural aesthetic describes post-modern practice as a demystification of the commodity, its aesthetic reduction to a fragment *sans* context or significance, a signifier without a signified. Post-modernism is the aesthetic practice of deconstruction.

The object within late capitalism then exists in the space of the contradiction between these two practices: an ideological mystification which turns it into a commodity and a structural demystification which returns it to the

material context. By their very nature, post-modern objects cannot be merely consumed unless they have been recuperated by being re-presented as commodities. Thus, the post-modern aesthetic of rock and roll does not determine the music's existence as a commodity but rather as a constant struggle between commodification and fragmentation.

I can now try to specify the particular form of post-modern practice that characterises rock and roll as an appropriation of hegemonic practices into its own discourses. If the response of the hegemony to resistance is through practices of incorporation (see Williams 1981), then the power of rock and roll lies in its practice of 'excorporation', operating at and reproducing the boundary between youth culture and the dominant culture. Rock and roll reverses the hegemonic practices of incorporation – by which practices claiming a certain externality are relocated within the context of hegemonic relations. Rock and roll removes signs, objects, sounds, styles, etc. from their apparently meaningful existence within the dominant culture and relocates them within an affective alliance of differentiation and resistance. The resultant shock – of both recognition and of an undermining of meaning – produces a temporarily impassable boundary within the dominant culture, an encapsulation of the affective possibilities of the rock and roll culture. Rock and roll is a particular form of *bricolage*, a uniquely capitalist and post-modern practice. It functions in a constant play of incorporation and excorporation (both always occurring simultaneously), a contradictory cultural practice. . . . Rock and roll practice is a form of resistance for generations with no faith in revolution. Rock and roll's resistance – its politics – is neither a direct rejection of the dominant culture nor a utopian negation (fantasy) of the structures of power. It plays with the very practice that the dominant culture uses to resist its resistance: incorporation and excorporation in a continuous dialectic that reproduces the very boundary of existence. Because its resistance remains, however, within the political and economic space of the dominant culture, its revolution is only a 'simulacrum'. Its politics emerge only at that moment when political consciousness is no longer possible. Its practice is surrealism without the dream/nightmare, dada without the representation of a political option.

Unable to reject, control or even conceptualise this post-modern reality, it becomes both the source of oppression and the object/context of celebration and fun. Repelled and angered by the boredom (repetitiveness), meaningless-ness and dehumanisation of the contemporary world, youth celebrates these very conditions in its leisure (technology, noise, commodity fetish, repetition, fragmentation and superficiality). Despondency and pleasure become mutually constitutive. Rock and roll seeks its place within and against the very post-modernity that is its condition of possibility.

Hypothesis 2. The power of rock and roll: affective difference

We might begin to understand how rock and roll works by affirming that it is, above all, fun – the production of pleasure (e.g., in the sheer energy of the music, the danceable beat, the sexual echoes, etc.). In fact, the most devastating rejection of a particular rock and roll text is to say that it is 'boring'. Thus, rock and roll can never take itself too seriously. To be effective, it must constantly deny its own significance; it must focus the attention of its audiences on its surface. Its power lies not in what it says or means but in what it does in the textures and contexts of its uses. For in fact, different audiences interpret the same texts differently, and there seems to be little correlation between semantic readings and uses/pleasures. I do not mean to suggest a disjunction to each other) but rather that rock and roll cannot be approached by some textual analysis of its message. Rock and roll, whether live or recorded, is a performance whose 'significance' cannot be read off the 'text'. It is not that rock and roll does not produce and manipulate meaning but rather that meaning itself functions in rock and roll affectively, that is, to produce and organise desires and pleasures. . . .

But of course, on the other hand, rock and roll does take itself seriously. Not only is it extremely self-conscious, but it continuously reconstitutes and re-encapsulates itself (e.g., in its intertextuality, its self-references, its recreation of its history through the incorporation of 'covers', etc.). In fact, it is an essential sign of the popularity of rock and roll that it constantly marks its difference from other musical cultures, whether popular or not. Rock and roll is, from its own side, not merely a subset of 'pop', and there must always be music which is not rock and roll. Such 'other' music is 'coopted', 'sold out', 'bubblegum', 'family entertainment', etc.

If the power of rock and roll, then, depends not upon meaning but upon affective investments, it is related not so much to what one feels as to the boundary drawn by the very existence of different organisations of desire and pleasure. Its oppositional power is not the result of its offering a particular desire that the dominant culture cannot accept, nor of the particular structure of pleasure, nor of its calling for the unlimited realisation of desire. Rock and roll need not always offer an ideological critique of the dominant culture, although at some moments it certainly has, aimed at particular repressions as well as the very presence of repression itself. However, rock and roll does not project an antinomy of freedom and constraint, since rock and roll always produces its own constraints on itself and its fans. Its history is rather the deconstruction of that antinomy; it plays with the relation of desire and its regimentation by always circumscribing its own possibilities for the production of pleasure. Rock and roll's relation to desire and pleasure serves to mark a difference, to inscribe on the surface of social reality a boundary between 'them' and 'us'; it constantly rearticulates and recathects a permanent rupture at the point of the intersection of post-modernity, youth and pleasure. It makes a particular historical moment –

and the generations emerging within it – into an apparently permanent rupture. This rupture is accomplished through the production of 'affective alliances' which disrupt the hegemonic control of desire and pleasure; in the ideological register, these effects are most visible within the so-called 'emotional life' of its fans.

This mark of difference is not, however, a simple boundary between inside and outside, hegemony and revolution. Rock and roll locates its fans as different even while they exist within the hegemony. The boundary is inscribed within the dominant culture. Rock and roll is an insider's art which functions to position its fans as outsiders. This 'encapsulation' may sometimes be produced through ideological representations which either explicitly attack the hegemony or define an alternative identity for those living within its affective alliances. But these local considerations too often cloud the general stratification of social space that rock and roll produces: it defines an exteriority for itself inside the dominant culture through particular practices that constitute affective alliances. . . .

The politics of rock and roll arises from its articulation of affective alliances as modes of survival within the post-modern world. It does not bemoan the death of older structures but seeks to find organisations of desire that do not contradict the reality in which it finds itself. Rock and roll, at its best, transforms old dreams into new realities. It rejects that which is outside of its self-encapsulation not on political grounds but because their organisations of affect are no longer appropriate in the post-modern world. It celebrates the life of the refugee, the immigrant with no roots except those they can construct for themselves at the moment, constructions which will inevitably collapse around them. Rock and roll celebrates play – even despairing play – as the only possibility for survival (e.g., Elvis' pink cadillac, the Beatles' antics, punk's shock tactics and post-punk's dissonance). It does not oppose its own ideological representations to those of the dominant culture: it locates itself within the gaps and cracks of the hegemony, the points at which meaning itself collapses into desire and affect.

Hypothesis 3. The work of rock and roll: affective alliances

. . . I want to suggest that a particular music exists as 'rock and roll' for an audience only when it is located in a larger assemblage which I will call 'the rock and roll apparatus'. Within such a context, the music is inflected in ways that empower its specific functioning. The rock and roll apparatus includes not only musical texts and practices but also economic determinations, technological possibilities, images (of performers and fans), social relations, aesthetic conventions, styles of language, movement, appearance and dance, media practices, ideological commitments and media representations of the apparatus itself. The apparatus describes 'cartographies of taste'

which are both synchronic and diachronic and which encompass both musical and non-musical registers of everyday life. For example, not only do particular apparatuses define differing boundaries of 'acceptable music', they place different forms of rock and roll in different affective positions; they empower them in different ways. At any moment, rock and roll is constituted by a number of different forms and while certain forms of conventions may remain common, their effects change in terms of their synchronic and diachronic relations as defined within the apparatus. Furthermore, these positions are always changing as new forms appear and disrupt the musical economy.

To treat rock and roll as a set of musical texts whose effects can be read off their surface or be located within the isolated relation between music and fan is already to assume an interpretation of its place within a particular rock and roll apparatus. Instead, the music's effects and identity can only be described within the apparatus which connects particular fragments of the heterogeneous domains of social, cultural and material practices. It is, then, the rock and roll apparatus that encapsulates itself, that inscribes the difference between 'them' and 'us'. And it is the apparatus which exists as a *bricolage* through the 'excorporation' of hegemonic signs and events. By treating them as fragments, it reinvests them within a different 'topography of desire'.

It would be mistaken however to see the apparatus as a passive collection of discrete material events; it is the apparatus itself which is constantly producing ever-changing structures of desire, and thus reproducing itself. The rock and roll apparatus organises the seemingly random collection of cathected events and codes that interpenetrate the rock and roll culture. It is an array of strategies with which youth organises its affective existence. Such 'topographies of desire' might then be described as 'affective formations' in order to affirm both their relation and irreducibility to ideological, political and economic formations.

The power of the rock and roll apparatus, therefore, lies not mainly in its 'theft' of partial objects from the various domains of social life, nor even in the mere fact that it draws lines connecting them. Rather its power lies in its foregrounding and production of particular organisations within and between these fragments. The apparatus is a machine which, in constantly reproducing itself, reshapes our affective life by mapping the vectors of its own economy of desire upon our material life. My claim is that the continuity of rock and roll is constituted by the continued inscription of a three-dimensional topography which describes its 'affective formation'. By operating at this level of abstraction, I am ignoring questions about the specific fragments upon which the apparatus works at a particular moment, as well as the particular inflections which these axes of the apparatus may be given at such moments. Rather than looking at particular apparatuses and formations, I want to begin by describing the boundaries of the rock and roll apparatus: the moment of its emergence, the possibility of its cessation, the range of its variability, etc.

The rock and roll apparatus affectively organises everyday life according to three intersecting axes: (1) youth as difference: the social difference of generations is inscribed upon the phenomenological field of social relations; (2) pleasure of the body: the celebration of pleasure is inscribed upon the site of the body; and (3) post-modernity: the structure of uncertainty (the fragment) is inscribed upon the circuit of history and meaning. I will comment briefly on each of these.

Most obviously, the rock and roll apparatus is constructed around the category of youth; and while it is certainly true that 'youth' has a number of different ideological inflections, youth is also a material body that can be located socially and historically —a body which is traversed and inscribed both affectively and ideologically. In fact, the rock and roll apparatus has produced a 'generational politics' which can be described structurally as a politics of difference and exclusion, and substantively as a politics of boredom. As I have argued, rather than defining any necessary identity for its fans, the rock and roll apparatus functions as a boundary which encapsulates its fans and excludes the others. It is this difference which affectively invests the category of youth within the apparatus itself anddefines the site of youth culture. The 'other' which is excluded from the apparatus is not, however, defined chronologically but rather by a phenomenology of boredom. The rock and roll apparatus institutionalises a politics defined only by its opposition to boredom as the experience of hegemonic reality. The politics of youth celebrates change: the work of the apparatus transforms the very structures of boredom into pleasure.

The second affective axis of the rock and roll apparatus involves its celebration of the body as the site of pleasure – in its transformation of identity into style, in the centrality of rhythm and dance, and in its courting of sexuality and sexual practices. The musical practice itself is inserted into the apparatus at the site of the body: it is a music of bodily desire. There is an immediate material relation to the music and its movements. This relation, while true of music in general, is foregrounded in rock and roll. At its simplest level, the body vibrates with the sounds and rhythms, and that vibration can be articulated with other practices and events to produce complex effects. The materiality of music gives it its affective power to translate individuals (an ideological construct) into bodies. This material relation is there, within the apparatus, available to its fans. The body becomes the site at which pleasure is restructured and desire potentially redirected. One might examine, for example, the complex and often contradictory relations between rock and roll and black music in the United States (the fact that it is both so compatible and so distanced at various moments) in terms of the changing investments of this axis. Furthermore, it is here that one might try to articulate the possibilities of an oppositional sexual politics within the rock and roll apparatus. . . .

The third axis of the rock and roll apparatus foregrounds the post-modern context within which it emerged. Whether it be understood as the absence

of a future by which we can organise our lives ('The future is a hoax created by high school counsellors and insurance salemen'; 'Life is hard and then you die') or of meaning ('Even if there were a meaning to life, I probably wouldn't agree with it', as one of my students said), the rock and roll apparatus is materially structured by this absence of structure. The rock and roll apparatus functions to provide strategies for escaping, denying, celebrating, finding pleasure in – in other words, for surviving within – a post-modern world.

This third axis reflexively positions the rock and roll apparatus within its post-modern context and constitutes rock and roll's ambiguity towards its own importance and power. Unlike other forms of popular culture, the 'post-modern politics' of rock and roll undermines its claim to produce a stable affective formation. Rather, it participates in the production of temporary 'affective alliances' which celebrate their own instability and superficiality. While such alliances may apparently make claims to totality within their own moment of empowerment, they are decisively marked by their fluidity and self-deprecation . . . and by the ease with which the rock and roll apparatus slides from one alliance into another. In other words, the rock and roll apparatus incorporates and even celebrates the 'disposibility' of any affective alliance without thereby sacrificing its own claim to existence. . . .

Hypothesis 4. The diversity of rock and roll . . .

The inscription of difference

. . . I propose to construct a two dimensional schema: the horizontal axis specifies the various structures by which rock and roll differentiates its culture from the other; the vertical axis describes the different affective statuses that rock and roll has assigned to or invested in its own existence. . . .
Rock and roll has produced three forms of boundaries: oppositional, alternative and independent. An oppositional boundary inscribes the fact of difference explicitly; both us and them are affectively charged. Its effectiveness depends upon the presence of the other as an enemy. Thus oppositional rock and roll presents itself as a direct challenge or threat to the dominant culture, perhaps even confronting the power of the dominant culture with its own power. It might be expressed in the phrase 'we want the world and we want it now'. An alternative boundary is inscribed when the other is only implicitly present. The enemy is negatively charged only as that against which the rock and roll culture differentiates itself. Alternative rock and roll mounts an implicit attack on the dominant culture; the fact of its existence implies a potential substitution for the hegemonic organisation of desire: 'we want the world but on our terms'. An independent boundary is inscribed when the other is effective only by its absence. Independent rock and roll does not

present itself as a challenge, either explicitly or implicitly, to the dominant culture although it may function as such. It apparently exists outside of its relation to the dominant culture; it does not want the world. It seeks to escape, to define a space which neither impinges upon nor is impinged upon by the hegemony: 'we want our world'. . . . Without recognising these different structures of difference, whatever affirmations rock and roll may produce are likely to be described independently of the particular historical context. While it is possible that some music may consistently produce the same positive affects across different contexts, the effects of the affirmations are bound to change as their particular relation to the dominant culture are differentially cathected.

What then is the nature of the affirmative affect of rock and roll? I have argued against seeing it as the representation of identities, the subject-positions articulated by rock and roll are often multiple and contradictory. Rather, it defines particular affective statuses for its own culture. By describing itself as a particular structuration of affect, rock and roll locates *social* subjects in a *nonrepresentational* space. One can identify three such self-cathexes: visionary, experiential and critical. These are, essentially, self-attributions; they describe different forms of affective alliances, modes of affectively relating to and surviving within the world. Again, it is not the content of the particular affirmation that is effective (although ideological representation may play an important role) but the status that it assigns to the existence of its own desires.

Visionary rock and roll projects itself as a utopian practice. Its power derives from its claim to be a stable structure of desire. The particular rock and roll culture lives out – in its music – the possibility of a moment of stability in the face of change and regimentation. Whether the real audience succeeds in actualising its utopian possibility and the particular content of the vision are only secondary. The affective and political power of the music depends upon its constituting itself as something more than just a mode of survival, as a vision of a potentially permanent affective alliance. Experiential rock and roll is more modest; it projects itself not as a necessary mode of survival but only as a viable possibility in the present context. It valorises its own affirmation of change and movement. The alliances which it organises are at best temporary respites. It celebrates the behaviours and images of its own youth cultures (e.g., driving, dancing, sexuality, rhythm) which deny both regimentation and the possibility of stability. Its affirmation is only in the very pleasure of the music, in engulfing oneself within the musical context, in participating within the practices of youth culture. Such an affirmation tends to be neither as optimistic and pretentious as the visionary, nor as pessimistic and self-destructive as the critical. A critical affirmation refuses even the claim that it can produce temporary spaces within which the audience might control and make sense of its life. By rejecting any possibility of stability and value – including that implied by the valorisation of change itself – it undermines its own status as a viable mode of survival. It affirms and

valorises only its own negativity. Its status as pleasurable depends upon its status as the only response to the reality of post-modernity. All that can be affirmed is the practice of critique, the deconstruction of all affective alliances, including that produced by its own inscription of the difference between them and us. The affirmation of critical rock and roll is a self-reflexive affirmation of difference, a decathexis of any affirmation. . . .

The matrix of 'stances' that these two dimensions generate describes the possibilities of an affective politics offered by rock and roll. It is not a description of musical styles nor of a group's intentions. Further, no group or style can be stably located within a category; groups can play with a number of stances simultaneously. The affective stance of particular music is, as I have emphasized, locally produced. . . .

The structures of affective alliances

There are at least two problems with this schema. First, it leaves unaddressed the differences which may exist between musics located within the same position. For example, while the Sex Pistols and the Gang of Four may both be located as 'critical–alternative', this says nothing about the differences between the rock and roll apparatuses within which they are effective. Second, rock and roll fans, as well as many critics, act as if the same music has the same function for its entire audience. We forget that there is no stable and homogeneous rock and roll audience except as it is constructed through the marketing practices of the dominant economic institutions. Our analysis must allow that the same music can be located within different apparatuses, and that different apparatuses may coexist within the same position of difference. . . . The particular 'politics of pleasure' and structures of empowerment effected by particular music will, therefore, depend upon the range of apparatuses within which the music exists.

Consequently, the music itself cannot be assigned a social power apart from the different affective alliances within which it is implicated. But such apparatuses/alliances are only partly described by their structural position vis à vis the hegemony. We have already alluded to the terms with which particular apparatuses can be identified, but I want to propose a strategy which will allow us to schematise the positive differences between major forms. If the rock and roll apparatus is defined by the particular arrangement and inflections of the three axes (youth; the body; post-modernity), different apparatuses can be described as foregrounding particular ones. That is, I propose to locate a significant positive difference among affective alliances according to the relative investment which is made in each of the three axes. It is tempting, and perhaps historically accurate, to identify the three axes with the three affirmative affective positions (youth, the body and post-modernity with the utopian, the experiential and the critical respectively). However, the equation is not a necessary one and would have the effect of occluding new possibilities (e.g. a post-modern utopianism). It seems best, therefore,

to treat the two schemas as conceptually independent and concretely inter-active.

. . . The apparatuses constructed around punk and post-punk musics apparently foreground the axis of post-modernity. I would like to develop this particular example, beginning with punk. Hebdige has argued (1979: 62–70) that punk emerged from the working-class experiences of historically changing racial relations and of economic pessimism (no work, no future, no meaning) in England. Frith has rejected this view of its origins: 'The pioneering punk-rockers themselves were a self-conscious, artful lot with a good understanding of both rock tradition and populist cliché; their music no more reflected directly back on conditions in the dole queue than it emerged spontaneously from them' (Frith 1981a: 158). He could also have pointed to the emergence of American punk bands in the mid-1970s (Television, Patti Smith, Ramones, Residents, etc.) as further evidence for his view of the origins. Frith proposes to read punk instead in the context of its representation of a 'new sort of street culture . . . punk's cultural significance was derived not from its articulation of unemployment but from its exploration of the aesthetics of proletarian play' (1981a: 267). However, Frith goes beyond this to locate punk within the history of rock and roll conventions:

> The original punk texts had a shock effect. They challenged pop and rock conventions of romance, beauty, and ease. Punks focused their lyrics on social and political subjects, mocked conventional rock 'n' roll declarations of young virility and power, disrupted their own flow of words with their images and sounds. It soon became apparent though, as the shock wore off, that punk was constricted by its realist claims, by its use of melodic structures and a rhythmic base that were taken to tell-it-like-it-was just *because* they followed rock 'n' roll rules – the 4:4 beat, shouted vocals, rough guitar/bass/drums lineup.
>
> (Frith 1981a: 160)

Greil Marcus has similarly argued that the Sex Pistols 'used rock and roll as a weapon against itself' (Marcus 1980: 452; see also Marcus 1980b; 1981a). Punk recathected the boundary between rock and roll and the outside world precisely by rejecting, not merely what rock and roll had become econom-ically and aesthetically,, but affectively as well. It rejected the affective possibilities which had defined and constrained rock and roll, structures which I have described as 'utopian' and 'experiential'. It affirmed only its own nega-tivity, constituting a set of 'critical' apparatuses, while leaving open the possibilities of its structural relation to the hegemony. It did this in part, in much the same way as disco operated, by an explosion of its own practice of 'excorporation'; anything could be incorporated into punk (or disco) culture. But, unlike disco, punk made the excorporative practice of rock and roll the only possible response to the context of everyday life. As Hebdige

has argued, punk 'deconstructed' all signs, all value and significance. Punk acted out its negative deconstruction of the world and of rock and roll itself. By foregrounding the artificiality of all taste, the risk of all affective investments, it attempted to decathect anything below its own surfaces, including rock and roll itself. There is a sense in which, after punk, one can no longer reasonably believe in the 'magic that can set you free'.

Regardless of its origin (in the reality of working-class experience or the image of proletarian play), the punk apparatus was constituted by its foregrounding of the axis of post-modernity: it made rock and roll into its own post-modern practice. Further, punk (unlike disco) often decathected the axis of the body as the site of pleasure, rejecting not only love but sexuality – the musical crescendo (orgasm?) is replaced by pulse, drones and continuous noise. On the other hand, the punk apparatus often continued to invest its power in the axis of youth and made the body itself into the site for the inscription of difference (through clothing, style, etc). But the cathexis of difference forced it back into the context of an implicit faith in youth and consequently, in rock and roll itself. As Marcus has observed, 'Perhaps the only true irony in the whole story was that, in the end, it all came down to rock and roll – nothing less but nothing more' (Marcus 1980a: 455).

Hypothesis 5. The history of rock and roll: cooptation

Discussions of 'cooptation' usually focus on the techniques by which rock and roll, youth culture and the more general context of post-war experience have been exploited and transformed by the economic system and the various 'ideological state apparatuses', especially the mass media. By the end of the 1950s, the youth market was recognised as an enormous source of consumer expenditure, one considered easily manipulable. Further, the sheer numbers of the baby boom generation made them a potential economic and political threat which had to be incorporated into the dominant culture. Clearly, this exploitation and incorporation have often been quite successful through a wide variety of strategies that have remained largely unexamined. According to most histories of rock and roll, this process has been going on since the late 1950s, and at each stage, rock and roll loses its power and becomes a commodity which can be produced, marketed and consumed. But it is also apparently true that each time it has happened, rock and roll breaks out of that coopted stance and reaffirms its affective power, creating new sounds and new political stances. The result is that the history of rock and roll is read as a cycle of cooptation and renaissance in which rock and roll constantly protests against its own cooptation.

This reading is reinforced by the view that the cooptation of new sounds, styles and stances seems to take place at an increasingly rapid rate. We seem today to be caught in a situation in which the vast majority of the rock and

roll audience is incapable of making the distinction between coopted and non-coopted any more:

> Sitting around with friends one night, I remember saying that instead of being the triumph of our lives, rock and roll might be the great tragedy. It had given us a sense of possibility so rich and radical that nothing could ever feel as intense – and then the world went back to business as usual, leaving us stranded . . . As mass-media folk culture, rock and roll was always an anomaly. Since the direction of mass culture is toward more control and less spontaneity, the record industry has worked ceaselessly to suborn rock back into the status quo of enter-tainment, and succeeded. Nearly every band that still thinks rock and roll was meant to change your life now labors under the contradiction of creating popular culture that isn't popular anymore. Yet they can't give up the dream of making as big a difference as Elvis or the Beatles, because their music doesn't make sense any other way. If such grand ambitions are now meaningless to the mass audience, the attempt is tragic for them; in so far as we give credence to their ambitions, it's tragic for us.
>
> (Carson 1981: 49)

Even worse, one must face the argument that this process is inevitable since cooptation is simultaneous with commercial success.

This rather pessimistic reading of the history of rock and roll assumes that it is a form of mass art. Others argue that rock and roll is either folk art or the product of individual creativity, but these do not escape the cycle of cooptation and the ultimately pessimistic reading of rock and roll's history. In order to challenge such views, we need to recognise that there are two meanings of rock and roll as product (or commodity): music and records. Although good rock and roll is often produced locally, even out of a local community with a set of shared experiences, and is as well often the product of individual talent, its audience is always more inclusive: some subset of youth who have grown up in an increasingly urbanised, electronic-techno-logical society – and the music uses the sounds, rhythms and textures of that common environment. (For a critique of both the 'folk culture' and 'art' views of rock and roll, see Frith 1981b.) The notion of community (and hence of 'folk art') is problematic when applied to youth culture, for the so-called community of rock and roll cannot be defined geographically. But the notion of community is a spatial one: everyday face-to-face interaction has been assumed to be the dominant determinant of shared experience and the criterion for community. But if temporality has replaced spatiality in defining the rock and roll audience, then the music requires widespread dissemination to be shared among the members of its appropriate audience. The musical product must be reproduced as an object (e.g. a record) precisely if it is to be available to those whom it addresses, to those existing within

491

its boundaries. The music must voluntarily enter into various systems of economic practices, and hence accept its existence as apparently mass art.

This suggests a very different understanding of cooptation and a different reading of the history of rock and roll. The problem with both the 'folk' and the 'mass' art view of cooptation (and this is true of Frith's approach as well) is that they define it in purely economic terms, as if it were simply the result of strategies imposed on rock and roll from without. They assume that rock and roll is coopted when the demands of the economic systems of production and distribution are allowed to define the production of the music as well as of the object. Thus, the attempt is to make rock and roll into a commodity, to make it saleable to an audience without any acknowledgement of differences within the youth culture. While such views are partially correct, they ignore a number of characteristics of 'cooptation' in rock and roll. First, they ignore the tension within rock and roll – for mass distribution is a real part of its functioning. The appropriate audience for any particular music cannot always be defined ahead of time (consider the new listening alliance made up of 'high school kids, housewives and assorted adult-contemporary types': Considine 1981: 51). Second, they ignore the fact that the question of cooptation is raised and answered at specific moments within the rock and roll culture.

In fact, the notion of cooptation allows us to see clearly the existence of rock and roll at the intersection of youth culture and the hegemony. Rather than assuming a homogeneity of either external strategies or of internal formations, a study of cooptation would have to begin with an analysis of the concrete forms it has taken at various points in the history of rock and roll.

Thus cooptation no longer appears only as an external action perpetrated upon rock and roll – a hegemonic stratgegy which is at best reflected in the judgements of rock and roll fans. To see it in these terms is to set rock and roll against the capitalist mode of production, distribution and consumption. But in fact, as Frith argues, rock and roll is always a form of capitalist commodity. To describe certain rock and roll as coopted is to acknowledge and contribute to its normalisation. Cooptation is a decathexis of the boundary, a de-encapsulation of the music and its culture and an incorporation of its affective alliance into the hegemonic organisations of desire. Cooptation indicates an affective re-alliance of the music rather than an alteration of the aesthetic or ideological constitution of the text. Cooptation is the result of a recontextualization of affect, a restructuring of the affective alliances penetrating and surrounding the music. What may serve in one context as a powerful cathexis of difference may, under a variety of circumstances, lose or be deprived of that affective function.

Cooptation is one form of rock and roll's production of its own history. Rock and roll constantly marks differences within itself just as it marks the difference of its audience. Coopted rock and roll is music which no longer potently inscribes its difference and the difference of its fans. And this is measured from within the culture of rock and roll. Cooptation is the mode

by which rock and roll produces itself anew, rejecting moments of its past and present in order to all the more potently inscribe its own boundary. 'Cooptation' is a particular affective charge made from one stance within rock and roll upon others; it produces new affective alliances within the corpus and cultures of rock and roll. This entails a very different reading of the history of rock and roll. This entails a very different reading of the history of rock and roll. Rather than a cycle of authentic and coopted music, rock and roll exists as a fractured unity within which differences of authenticity and cooptation are defined in the construction of affective alliances and networks of affiliation. These alliances are always multiple and contradictory. Thus, the 'cooptedness' of a particular form of rock and roll is an historically unstable judgement; it may change in response to developments within the changing musical and political possibilities of rock and roll. It certainly changes as one moves between particular fractions of the rock and roll audience.

Will Straw

COMMUNITIES AND SCENES IN
POPULAR MUSIC [1991]

IN A SUGGESTIVE PAPER, Barry Shanks has pointed to the usefulness of a notion of 'scene' in accounting for the relationship between different musical practices unfolding within a given geographical space (Shanks 1988). As a point of departure, one may posit a musical scene as distinct, in significant ways, from older notions of a musical community. The latter presumes a population group whose composition is relatively stable — according to a wide range of sociological variables — and whose involvement in music takes the form of an ongoing exploration of one or more musical idioms said to be rooted within a geographically specific historical heritage. A musical scene, in contrast, is that cultural space in which a range of musical practices coexist, interacting with each other within a variety of processes of differentiation, and according to widely varying trajectories of change and cross-fertilization. The sense of purpose articulated within a musical community normally depends on an affective link between two terms: contemporary musical practices, on the one hand, and the musical heritage which is seen to render this contemporary activity appropriate to a given context, on the other. Within a musical scene, that same sense of purpose is articulated within those forms of communication through which the building of musical alliances and the drawing of musical boundaries take place. The manner in which musical practices within a scene tie themselves to processes of historical change occurring within a larger international music culture will also be a significant basis of the way in which such forms are positioned within that scene at the local level.

At one level, this distinction simply concretizes two countervailing pressures within spaces of musical activity: one towards the stabilization of local

historical continuities, and another which works to disrupt such continuities, to cosmopolitanize and relativize them. Clearly, the point is not that of designating particular cultural spaces as one or the other, but of examining the ways in which particular musical practices 'work' to produce a sense of community within the conditions of metropolitan music scenes. This move – recasting powerful unities as ideological effects – is obviously a familiar and rather conventional one within cultural theory, and my intention is not that of exposing the relative status of notions of musical community. . . . Nevertheless, as subsequent sections of this chapter will argue, the cosmopolitan character of certain kinds of musical activity – their attentiveness to change occurring elsewhere – may endow them with a unity of purpose and sense of participating in 'affective alliances' (Grossberg 1984) just as powerful as those normally observed within practices which appear to be more organically grounded in local circumstances.

The ongoing debate within popular music studies over the relative primacy of production and consumption has often precluded the analysis of what might be called the 'logics' of particular musical terrains. I hope, in the sections which follow, to leave entangled three relevant prior uses of the term 'logic'. The first, drawn from Pierre Bourdieu's (1984) notion of the 'field' of cultural practices, is meant to suggest those procedures through which principles of validation and means of accommodating change operate within particular cultural spaces so as to perpetuate their boundaries. It may be argued that the complex and contradictory quality of cultural texts – to which cultural studies research has been so attentive – has prevented neither their circulation within societies nor their alignment with particular population groups and cultural spaces from following regularized and relatively stable patterns. If this predictability is the result of semantic or ideological contradictions within these texts usually being resolved in favour of one set of meanings over others, then an analysis of these more general patterns, rather than of the conflicts which unfailingly produce them, may have a provisional usefulness at least.

The specificity of these 'fields', nevertheless, is shaped in part by the 'regions' they occupy, as markets and contexts of production, relative to a given set of cultural institutions. Bernard Miège's (1986: 94) elaboration of a 'social logic' of cultural commodities, while concerned principally with processes of production, may be extended to an examination of the ways in which cultural commodities circulate within their appropriate markets and cultural terrains. If there is a specificity to cultural commodities, it has much to do with the ways in which their circulation through the social world is organized as a lifecycle, in the course of which both the degree and basis of their appeal is likely to change. Different cultural spaces are marked by the sorts of temporalities to be found within them – by the prominence of activities of canonization, or by the values accruing to novelty and currency, longevity and 'timelessness'. In this respect, the 'logic' of a particular musical culture is a function of the way in which value is constructed within them

relative to the passing of time. Similarly, cultural commodities may themselves pass through a number of distinct markets and populations in the course of their lifecycles. Throughout this passage, the markers of their distinctiveness and the bases of their value may undergo significant shifts.

Finally, and in what is admittedly an act of trivialization and infidelity, I would take from the writings of Michel de Certeau (1990) the sense of a logic of circumstantial moves. The preoccupation of music sociologists with the expressive substance of musical forms has often obscured the extent to which particular instances of change might best be explained in terms of an as-yet elusive microsociology of backlashes or of failed and successful attempts at redirection within a given cultural terrain. This is particularly true in the case of contemporary dance-music culture, where, one might argue, there is little rationality to certain 'moves' (such as the 'Gregorian House' moment of early 1991) beyond the retrospective sense of appropriateness produced by their success. The risk of an analysis pursued along these lines is that it will result in little more than a formalism of cyclical change. One may nevertheless see the logic of these moves as grounded in the variable interaction between two social processes: (a) the struggles for prestige and status engaged in by professionals and others (such as disc jockeys) serving as 'intellectuals' within a given musical terrain; and (b) the ongoing transformation of social and cultural relations – and of alliances between particular musical communities – occurring within the context of the contemporary Western city. An attentiveness to the interaction between these two processes is necessary if one is to avoid either of two traps: on the one hand, privileging the processes within popular musical culture which most resemble those of an 'art world' and overstating the directive or transformative force of particular agents within them; on the other, reading each instance of musical change or synthesis as unproblematic evidence of a reordering of social relations.

Localizing the cosmopolitan: the culture of alternative rock

By the early or mid-1980s, a terrain of musical activity commonly described as 'alternative' was a feature of virtually all US and Canadian urban centres. In one version of its history, the space of alternative rock is seen to have resulted from the perpetuation of punk music within US and Canadian youth culture, a phenomena most evident in the relatively durable hardcore and skinhead cultures of Los Angeles and elsewhere. As local punk scenes stabilized, they developed the infrastructures (record labels, performance venues, lines of communication, etc.) within which a variety of other musical activities unfolded. These practices, most often involving the eclectic revival and transformation of older musical forms, collectively fell under the sign of the term 'alternative'. As the centrality of punk within local musical cultures declined, the unity of alternative rock no longer resided in the stylistic qualities of the music embraced within it. Rather, as I shall argue, that unity

has come to be grounded more fundamentally in the way in which such spaces of musical activity have come to establish a distinctive relationship to historical time and geographical location.

Arguably, the most notable feature of alternative rock culture over the last decade or so has been the absence within it of mechanisms through which particular musical practices come to be designated as obsolete. By the middle of the 1980s, the pluralism of alternative rock culture was such that the emergence of new stylistic forms within it would rarely be accompanied by the claim that such forms represented a trajectory of movement for that culture as a whole. On the contrary, those processes by which musical forms become central poles of attraction and are subsequently rendered obsolete had largely disappeared. . . .

Within this terrain, different musical practices came to map out a range of increasingly specific stylistic combinations within an ongoing process of differentiation and complexification. Change within the culture of alternative rock, to the extent that it was observable at all, more and more took the form of new relationships between generic styles constitutive of the canon which had sedimented within alternative rock culture since the late 1970s. It was no longer the case, as it had been in the period immediately following punk, that change would involve the regular displacement of styles as the historical resonance of each emerged and faded. The stabilization of this distinct temporality has had its most profound effects on the relationship between alternative culture and African-American musical forms, with the latter standing implicitly for a relationship to technological innovation and stylistic change against which the former has come to define itself.

To understand this condition, we may examine the role still played within the terrain of alternative rock by musical cross-fertilization and hybridization. Here, the exercise of combining styles or genres will rarely produce the sense of a synthesis whose constituent elements are displaced, or through which musical communities are brought into new alliances, as has been the case at particular transitional points within rock history. Rather, one sees the emergence of a wide variety of stylistic or generic exercises, in which no style begins as privileged or as more organically expressive of a cultural point of departure. One effect of this has been to install the individual career, rather than the culture of alternative rock as a whole, as the principal context within which change is meaningful. Moves within this culture – from punk to country, psychedelia to boogie blues, and so on – represent idiosyncratic passages across the space of alternative rock rather than attempts at collective redirection.

This characteristic of the terrain of alternative rock has both shaped and responded to the commodity forms which circulate within it. In its reliance on the institutional infrastructures of campus radio stations, independent record stores, and live performance tours, alternative rock has been allied with institutions engaged in the valorization of their exhaustivity and

diversity, and in maintaining the accessibility of a wide range of musical prac-
tices. The slowness of turnover which this produces is linked to the growth
in importance of performer careers, in as much as the value of a particular
recording is not dependent upon its capacity to register collective change
within the larger cultural space in which it circulates. In this respect, the
much-discussed 'co-optation' of punk and post-punk musics by major
recording firms represents, in part, a paradoxical convergence of operational
logics. Of the various forms of appropriation of these musics attempted by
major firms, the most successful has been the ongoing monitoring of alter-
native rock culture (often through the setting-up or affiliation of specialty
labels) so as to discover careers susceptible to further development.

One effect of these processes has been an intermittently observed sense
of crisis within the culture of alternative rock music. As suggested, the
capacity of this culture to cater to the most specific of taste formations is
accompanied by the sense that no particular stylistic exercise may be held
up as emblematic of a collective, forward movement on the part of this
terrain as a whole. . . . The organization of alternative rock culture in these
terms has had two significant – and generally overlooked – consequences
which any political diagnosis of that culture must confront. These extend
beyond the more general (and not necessarily negative) waning of collective
purpose and criteria of judgement common within cultural spaces marked
by high levels of pluralism and eclecticism.

The first of these is the enshrining of specific forms of connoisseurship
as central to an involvement in alternative musical culture. Here, an alter-
native reading of the stabilization of post-punk culture within the US and
Canada suggests itself. Despite the difficulty of reconstructing this historical
context, I would point to the important interaction, in the mid and late
1970s, between the terrain of punk and 'New Wave' and pre-existing
connoisseurist tendencies within the culture of rock music. To a consider-
able extent, the institutions of New Wave within the United States and
Canada came to overlap with those constitutive of a network of enterprises
catering for an interest in the history of rock-based forms of recorded music
– an infrastructure which had existed at least since the early 1970s. These
institutions were active in the historical documentation and revival of a variety
of older rock-based musical movements (such as 'surf' music or the 'garage-
band' movement of the mid-1960s). From the mid-1970s through to the
present, a variety of small enterprises have involved themselves simultane-
ously in projects of historical revival (reissuing recordings from the 1960s
and publishing fan magazines devoted to older musical forms) and in the
production, distribution and sale of recordings associated with punk and those
tendencies which succeeded it.

This overlapping of alternative rock culture and the cultural space of
record collectors and historical archivism should scarcely be surprising, given
the predictable settling of both within the sociological limits of a largely white
bohemia. Part of the implicit work of alternative rock culture over the past

decade has been the construction of a relatively stable canon of earlier musical forms – 1960s trash psychedelia, early 1970s metal, the dissident rock tradition of the Velvet Underground and others – which serves as a collective reference point. The substance of this canon is less significant, at this point in my account, than is the fact that the cultivation of connoisseurship in rock culture – tracking down old albums, learning genealogical links between bands, and so on – has traditionally been one rite of passage through which the masculinism of rock music culture has been perpetuated. . . .

A second consequence of the logic of development of alternative-music culture within Canada and the US is the paradoxical status of localism within it. In their reliance on small-scale infrastructures of production and dissemination, these spaces are rooted deeply within local circumstances, a feature commonly invoked in claims as to their political significance. Nevertheless, the degree to which localism remains an important component of musical meaning within the culture of alternative rock requires close examination. The aesthetic values which dominate local alternative terrains are for the most part those of a musical cosmopolitanism wherein the points of musical reference are likely to remain stable from one community to another. The development of alternative rock culture may be said to follow a logic in which a particular pluralism of musical languages repeats itself from one community to another. Each local space has evolved, to varying degrees, the range of musical vernaculars emergent within others, and the global culture of alternative rock music is one which localism has been reproduced, in relatively uniform ways, on a continental and international level.

One consequence of this condition is that the relationship of different local or regional scenes to each other is no longer one in which specific communities emerge to enact a forward movement to which others are drawn. What has declined is the sense, important at different moments within rock music's history, that a regional or local style offers the direction for change deemed appropriate to a given historical moment and provides a particular trajectory of progress which others will follow. Rather, the relationship of different local spaces of activity to each other takes the form of circuits, overlaid upon each other, through which particular styles of alternative music circulate in the form of recordings or live performances. The ability of groups and records to circulate from one local scene to another, in a manner that requires little in the way of adaptation to local circumstances, is an index of the way in which a particularly stable set of musical languages and relationships between them has been reproduced within a variety of local circumstances.

Drawing lines, making centres: the culture of dance music

. . . Dance clubs are positioned relative to others, not only along the predictable lines of musical style, age, sexual orientation and ethnicity, but

in terms of a variety of less frequently acknowledged criteria: the explicit-ness of sexual interaction within them, the manner in which their DJ handles the tension between playing requests and retaining prestige within his peer community, the level of tolerance of deviations from expected behavioural norms and so on. Among a club's clientèle, further distinctions take shape around the degree to which people dance within disciplined parameters (as opposed to cutting loose), or such minor clues as whether or not one remains on or leaves the dance floor when a new and as-yet unpopular song is played. Most importantly, the composition of audiences at dance clubs is likely to reflect and actualize a particular state of relations between various populations and social groups, as these coalesce around specific coalitions of musical style.

The significance invested in these differences obviously works against one familiar reading of the experience of dance: as a transcendent experience of the body in motion. The difficulty of writing about dance music is very much rooted in what Jane K. Cowan, speaking of a very different context, has called 'the paradoxically double sense of engrossment and reflexivity that characterize the experience of the dancer' (Cowan 1990: xi). Discussions of dance are often able to privilege its engrossing qualities through an implicit sliding from the subjective and corporal sense of release to a notion of collec-tive transcendence, such that the personal and the social are united under [such signs as 'youth' or 'women' or 'gay men']. Clearly, however, few cultural practices are marked so strongly by the intervention of differences which fracture that unity and render unavoidable the reflexivity of which Cowan writes. Bringing together the activities of dance and musical consump-tion, the dance club articulates the sense of social identity as embodied to the conspicuous and differential display of taste. As such, it serves to render explicit the distribution of knowledges and forms of cultural capital across the vectors of gender, race and class.

It is at this point that we may begin to outline certain divergences between the cultures of alternative rock and dance music. The most significant of these, arguably, has to do with the manner in which each has responded to the hierarchies and tensions produced by the aforementioned differences. The ongoing development of dance music culture is shaped by the relationship between certain relatively stable social spaces (whether these be geograph-ical regions or racial and ethnic communities) and the temporal processes produced and observable within that culture's infrastructures (record labels, dance music magazines, disc-jockey playlists, and so on). This relation-ship is not one of direct mirroring. The lines of fracture which run through the audiences of dance music are normally turned into the bases of that music's own ongoing development, but in this process they are often trans-formed. Typically, they are restated in the language of aesthetic choice and invoked as the pretexts for moves of redirection. In the culture of alterna-tive rock, by contrast, the most consistent development has been the drawing of lines around that culture as a whole, such that certain forms (classically

soulful voices, for example) are permanently banished, or, like some uses of electronics, tolerated as part of a circumscribed pluralism. (In neither instance do they serve as the basis of a tension inviting a collective response.)

These differences may be expressed in more schematic terms. The terrain of alternative rock is one in which a variety of different temporalities have come to coexist within a bounded cultural space. There is often a distinctive density of historical time within the performance styles of alternative groups: most noticeably, an inflection of older, residual styles with a contemporary irony which itself evokes a bohemian heritage in which that combination has its antecedents. Similarly, as moves within alternative rock produce more and more detailed syntheses of style and form, they fill in the range of options between canonical styles, the latter serving . . . as . . . markers of privileged antecedents from which eclectic stylistic exercises develop outwards. This process as a whole might be described as one in which temporal movement is transformed into cartographic density.

The culture of dance music, in contrast, is one in which spatial diversity is perpetually reworked as temporal sequence. At one level, dance music culture is highly polycentric, in that it is characterized by the simultaneous existence of large numbers of local or regional styles – Detroit 'techno' music, Miami 'bass' styles, Los Angeles 'swingbeat', etc. Other regional centres – like New York or London – will be significant, less as places [for the] emergence of styles one could call indigenous, than because they occupy positions of centrality as sites for the reworking and transformation of styles originating elsewhere. Dance music culture is characterized by two sorts of directionality: one which draws local musical activity into the production styles of one or more dominant, indigenous producers or sounds; and another which articulates these styles elsewhere, into centres and processes of change monitored closely by the international dance music community as a whole. One effect of these sorts of movement is that coexisting regional and local styles within dance music are almost always at different stages within their cycles of rising and declining influence. A comfortable, stable international diversity may rarely be observed.

Further evidence of these differences may be found in the sorts of publications which circulate within each terrain. *Maximum Rock and Roll* or *Rock Around The World: The Alternative Live Music Guide* manifest the preoccupation of alternative culture with cataloguing diversity, offering dozens of 'scene' reports or touring schedules in each issue. Those publications which serve the dance music community, in contrast, are striking for their concern with registering movement, ranking records and judging styles in terms of their place within ascendant or downward trajectories of popularity. This distinction is hardly surprising – given, on the one hand, the self-definition of alternative rock as the locus of a rock classicism, and, on the other, the observable overlap of dance-music culture with both the turbulent space of Top 40 radio and a more subcultural terrain resembling (and interacting with) the world of vestimentary fashion. More interesting, for my purposes, are

the ways in which both cultures have responded to the musical diversity found in each, endowing that diversity with distinctive values and relationships to change.

The intermittent sense of crisis within the culture of North American alternative rock . . . is arguably rooted in the loss of a teleology of historical purpose of the sort which has often organized accounts of rock music's history. In its place, we find enshrined a pluralism evoked as a sign of health and vitality. Within the culture of dance music, [by] contrast, a condition of pluralism is commonly cited as the sign of imminent troubles or divisions, rather than of that culture's richness or stability. One finds, within the dance community, an investment in historical movement based almost exclusively on the ability of that movement to suggest collective purpose. Processes of historical change within dance music, as suggested, respond to shifting relationships between different (primarily urban) communities, but there is little sense that the convergences or alliances produced are permanent or constitutive steps in a movement towards a final dissolution of boundaries. Well-known moments held to be emblematic of a new unity of black and white youth cultures, like the punk–reggae moment of the late 1970s, either produce their own backlashes or appear in retrospect as temporary acts of rejuvenation undertaken by one of the communities involved.

The discursive labour of dance music's infrastructures operates implicitly to prevent the fractures and lines of difference which run through the culture of metropolitan dance music from either fragmenting that culture into autonomous, parallel traditions, or producing a final unity which will permanently paper over those lines. Like the worlds of fashion and painting, the dance music community accomplishes this by restating ongoing disagreements over cultural purpose and value as calculations about the imminent decay or emergent appropriateness of specific generic styles. One revealing example, within the recent history of dance music, is the ongoing controversy over the comparative appeal of synthesized sounds and 'real' human voices. The highly electronic acid house of 1987 and 1988 gave way, in influential corners of dance music culture, to the 'garage' house of 1988–9, a form which valorized classic, soulful and identifiable voices. In 1990, and in the context of an increased rapidity of cyclical change, synthesized and sample-dominated Italian house emerged as central, accompanied by defences which underscored its knowing cleverness. Italian house was then displaced by the slowed-down, more obviously 'classical' Soul II Soul sound, which briefly, but spectacularly, attained international success. Predictably, a backlash followed, and Italian house was newly valorized at the beginning of 1991 – the 'tackiness' with which it had been marked during its brief banishment now regarded as a creative eclecticism. These shifts, while obviously trivial and localized, nevertheless revolve at a fundamental level around the appropriate centrality to be accorded the traditions of African-American vocal music relative to those of a primarily white, European studio

wizardry. Most often, however, they are given the form of oppositions of taste susceptible to regular revision: high- versus low-end sonic ranges, 'live' versus creatively manufactured sounds, the purist versus the novel, and so on. . . .

The condition of dance music described here – in particular, its rates and logics of change – has been intensified in recent years by the rise to prominence of house music. House music emerged (from Chicago) as a set of distinct styles in the mid-1980s, but its larger importance comes from its recentring of the historical movement of dance music culture as a whole. As was the case prior to the rise of house, dance music within the Western world has continued to be marked by opposed tendencies towards unity/coherence and diversity/differentiation, but the logics through which these processes unfold have become much more integrated. On the one hand, house music has drawn most dance-based musical forms into various sorts of accommodation to it. Currents within rap were compelled to adapt, most notably through an increased tempo, giving rise to forms known as hip-house and swingbeat. The Hi-NRG music associated during the previous decade with gay discos was revitalized as high-house, 'high' signalling a greater number of beats-per-minute than was the average within house music (Ferguson 1991). Older or more eclectic forms, like industrial dance music and versions of jazz, have often been drawn into a sequence of transformations within house music, as influences defining those transformations. Those dance forms which did not lend themselves to this integration, for a variety of reasons – Go-Go music from Washington, or the Minneapolis sound associated with Prince and his collaborators – have been marked with relative obsolescence, at least as far as international success is concerned.

At the same time, however, the durability and expansiveness of appeal of house music are such that these variations have come to be positioned laterally within a division of tastes running across dance music culture. The techno-pop and Hi-NRG associated with producers like Stock-Aitken-Waterman would, by the late 1980s, come to be positioned at one point within a continuum running through all forms of house music and overlapping with the terrain of international Top 40 pop. Much of Latin-based, English-language pop within the United States is now part of a complex of forms known as 'freestyle', in which one finds articulated elements of rap, house, and mainstream pop. More telling examples are those involving forms of dance music perpetuated within the space of a rock-based avant-garde. So-called New Beat music, associated principally with record labels based in Belgium, pulled elements of industrial dance rock into the overall culture of dance music, but simultaneously compelled industrial dance music to define itself in part through the vigilant maintenance of narrow boundaries between its own perceived transgressiveness and the lure of accessible, popular forms of house. One can see here the dilemma confronting tendencies within a post-punk avant-garde whose terrain has long bordered that of dance music.

On the one hand, their project has derived much of its credibility from the consistent and avowedly purist exploration of a limited set of stylistic and formal figures overlapping those found within currents of alternative rock (stark instrumentation, the use of 'found' voices from television, etc.). On the other hand, the culture of British dance music has so successfully re-defined the terms of credibility as accruing from participation in an unfolding sequence of musical styles that their resistance to this history risks casting them as irrelevant.

My emphasis . . . on the logics of change typical of different musical terrains is not intended to suggest that the value of such terrains is a func-tion of their collective historical purpose. What these logics invite, however, is a reading of the politics of popular music that locates the crucial site of these politics neither in the transgressive or oppositional quality of musical practices and their consumption, nor uniformly within the modes of operation of the international music industries. The important processes, I would argue, are those through which particular social differ-ences (most notably those of gender and race) are articulated within the building of audiences around particular coalitions of musical form. These processes are not inevitably positive or disruptive of existing social divisions, nor are they shaped to any significant extent by solitary, wilful acts of realignment. . . . Typically, the character of particular audiences is determined by the interlocking operation of the various institutions and sites within which musics are disseminated: the schoolyard, the urban dance club, the radio format. These sites, themselves shaped by their place within the contemporary metropolis and aligned with populations along the lines of class and taste, provide the conditions of possibility of alliances between musical styles and affective links between dispersed geographical places.

There are any number of examples of this in the recent history of Canadian, US and Western European popular music: the coalescing of the original audience for disco around Hispanic, black and gay communities in the mid-1970s, or the unexpected alignment of country music and its tradi-tional audiences with urban-based, adult-oriented radio stations in the early 1980s. The particular condition of alternative rock music culture, which I have described at length, has been shaped in part by the way in which coali-tions of black teenagers, young girls listening to Top 40 radio, and urban club-goers have coalesced around a dance music mainstream and its margins and thus heightened the insularity of white, bohemian musical culture. What interests me, as someone who studies musical institutions, is the way in which these alliances are produced, in part, through the overlapping logics of devel-opment of different forms. One reason why coalitions of musical taste which run from British dance culture through black communities in Toronto and significant portions of the young female market are possible is that these constituencies are all ones which value the redirective and the novel over the stable and canonical, or international circuits of influence over the mining

of a locally stable heritage. The substance of these values is less important than are the alliances produced by their circulation within musical culture. One need neither embrace the creation of such alliances as a force for social harmony or condemn them as politically distracting to recognize their primacy in the ongoing politics of popular musical culture.

Henry Jenkins

TELEVISION FANS, POACHERS, NOMADS [1992]

Fans and fanatics

I AM NOT A TREKKIE. I am not a Trekker. I am, however, a television fan who has enjoyed an active, participatory relationship to *Star Trek* and a variety of other programs for more than twenty years. I am part of a community of cultural nomads and poachers which has defined itself through its dynamic, productive relationship to television. When I write as an ethnographer about fan culture, I am also writing about my own experiences.

Contrary to popular mythology, there is no such thing as a Trekkie. The Trekkie is a stereotype, visible everywhere from *Saturday Night Live* to *Newsweek*, which constructs fans as brainless consumers, trivia buffs, social misfits, desexualized and infantilized geeks and nerds, and people confused about the line between fantasy and reality. Many of these stereotypes seem to have been attached to the term 'fan' from its very inception. 'Fan' is an abbreviated form of the word 'fanatic,' which has its roots in the Latin word, 'fanaticus.' In its most literal sense, 'fanaticus' simply meant 'of or belonging to the temple, a temple servant, a devotee' but it quickly assumed more negative connotations, 'of persons inspired by orgiastic rites and enthusiastic frenzy' (*Oxford Latin Dictionary*). As it evolved, the term 'fanatic' moved from a reference to certain excessive forms of religious belief and worship to any 'excessive and mistaken enthusiasm,' often evoked in criticism to opposing political beliefs, and then, more generally, to madness 'such as might result from possession by a deity or demon' (*Oxford English Dictionary*). Its abbreviated form, 'fan,' first appeared in the late [nineteenth] century in journalistic accounts describing followers of professional sports teams (especially in base-

ball) at a time when the sport moved from a predominantly participant activity to a spectator event, but soon was expanded to incorporate any faithful 'devotee' of sports or commercial entertainment. One of its earliest uses was in reference to women theater-goers, 'Matinee Girls,' who male critics claimed had come to admire the actors rather than the plays (Auster 1989). If the term 'fan' was originally evoked in a somewhat playful fashion and was often used sympathetically by sports writers, it never fully escaped its earlier connotations of religious and political zealotry, false beliefs, orgiastic excess, possession, and madness, connotations that seem to be at the heart of many of the representations of fans in contemporary discourse. . . .

[Building on the word's traditional links to madness and demonic posses-sion, news reports frequently characterize fans as psychopaths whose frustrated fantasies of intimate relationships with stars or unsatisfied desires to achieve their own stardom take violent and antisocial forms. The fan community rejects this stereotypical understanding of the 'Trekkie' as reli-gious fanatic, psychopathic killer, neurotic fantasist, or lust-crazed groupie, insisting on the value of their own lives and culture. Instead, many of them adopt the name, 'Trekker,' which points to their active participation in *Star Trek* culture.

That these fans can speak back, can defend their own taste and recon-ceptualize their own identities, distinguishes them from the anonymous letter writers who Ien Ang (1985) describes as incapable of defending their taste for *Dallas* amid circulating attacks on mass culture.] The *Dallas* viewers wrote in isolation, watching the program in their own homes with little or no acknowledgement that others shared their enthusiasm for the series. What led them to write to Ang in response to an advertisement soliciting such letters might have been an attempt to overcome these feelings of cultural isolation, to gain a larger identity as fans apart from the alienation imposed on them by dominant discourse about mass culture. Ang's respondents were *Dallas* fans only in the narrow sense that they watched the program regu-larly but they lacked social connections to a larger network of fans and did not participate in the complex fan culture described here. The Trekkers, however, see themselves as already participating in a larger social and cultural community, as speaking not only for themselves but for *Star Trek* fans more generally. These fans often draw strength and courage from their ability to identify themselves as members of a group of other fans who shared common interests and confronted common problems. To speak as a fan is to accept what has been labelled a subordinated position within the cultural hierarchy, to accept an identity constantly belittled or criticized by institutional author-ities. Yet it is also to speak from a position of collective identity, to forge an alliance with a community of others in defense of tastes which, as a result, cannot be read as totally aberrant or idiosyncratic. Indeed, one of the most often heard comments from new fans is their surprise in discovering how many people share their fascination with a particular series, their pleasure in discovering that they are not 'alone.'

[Rejecting media-fostered stereotypes of fans as cultural dupes, social misfits, and mindless consumers, this chapter perceives fans as active producers and manipulators of meaning. In doing so, it moves beyond the narrow construction of fans around a specific program to see fans as part of a more expansive and inclusive cultural community. This chapter] proposes an alternative conception of fans as readers who appropriate popular texts and reread them in a fashion that serves different interests, as spectators who transform the experience of watching television into a rich and complex participatory culture. Viewed in this fashion, fans become a model of the type of textual 'poaching' [Michel] de Certeau associates with popular reading. Their activities post important questions about the ability of media producers to constrain the creation and circulation of meanings. Fans construct their cultural and social identity through borrowing and inflecting mass culture images, articulating concerns which often go unvoiced within the dominant media.

The fans' response typically involves not simply fascination or adoration but also frustration and antagonism, and it is the combination of the two responses which motivates their active engagement with the media. Because popular narratives often fail to satisfy, fans must struggle with them, to try to articulate to themselves and others unrealized possibilities within the original works. Because the texts continue to fascinate, fans cannot dismiss them from their attention but rather must try to find ways to salvage them for their interests. Far from syncopathic, fans actively assert their mastery over the mass-produced texts which provide the raw materials for their own cultural productions and the basis for their social interactions. In the process, fans cease to be simply an audience for popular texts; instead, they become active participants in the construction and circulation of textual meanings. . . .

Textual poachers

Michel de Certeau (1984) has characterized such active reading as 'poaching,' an impertinent raid on the literary preserve that takes away only those things that are useful or pleasurable to the reader: 'Far from being writers . . . readers are travellers; they move across lands belonging to someone else, like nomads poaching their way across fields they did not write, despoiling the wealth of Egypt to enjoy it themselves' (de Certeau: 174). De Certeau's 'poaching' analogy characterizes the relationship between readers and writers as an ongoing struggle for possession of the text and for control over its meanings. De Certeau speaks of a 'scriptural economy' dominated by textual producers and institutionally sanctioned interpreters and working to restrain the multiple voices' of popular orality, to regulate the production and circu-lation of meanings. The 'mastery of language' becomes, for de Certeau, emblematic of the cultural authority and social power exercised by the

dominant classes within the social formation. School children are taught to read for authorial meaning, to consume the narrative without leaving their own marks upon it: 'This fiction condemns consumers to subjection because they are always going to be guilty of infidelity or ignorance. . . . The text becomes a cultural weapon, a private hunting reserve' ([de Certeau]: 171).

Under this familiar model, the reader is supposed to serve as the more-or-less passive recipient of authorial meaning while any deviation from meanings clearly marked forth within the text is viewed negatively, as a failure to successfully understand what the author was trying to say. The teacher's red pen rewards those who 'correctly' decipher the text and penalizes those who 'get it wrong,' while the student's personal feelings and associations are rated 'irrelevant' to the task of literary analysis (according to the 'affective fallacy'). Such judgments, in turn, require proper respect for the expertise of specially trained and sanctioned interpreters over the street knowledge of the everyday reader; the teacher's authority becomes vitally linked to the authority which readers grant to textual producers. As popular texts have been adopted into the academy, similar claims about their 'authorship' have been constructed to allow them to be studied and taught in essentially similar terms to traditional literary works; the price of being taken seriously as an academic subject has been the acceptance of certain assumptions common to other forms of scholarship, assumptions that link the interests of the academy with the interests of producers rather than with the interests of consumers. Both social and legal practice preserves the privilege of 'socially authorized professionals and intellectuals' over the interests of popular readers and textual consumers. . . . The expertise of the academy allows its members to determine which interpretive claims are consistent with authorial meaning (whether implicit or explicit), which fall beyond its scope. Since many segments of the population lack access to the means of cultural production and distribution, to the multiplexes, the broadcast airwaves or the chain bookstore shelves, this respect for the 'integrity' of the produced message often has the effect of silencing or marginalizing oppositional voices. The exclusion of those voices at the moment of reception simply mirrors their exclusion at the moment of production; their cultural interests are delegitimized in favor of the commercial interests of authorized authors. . . .

Like the poachers of old, fans operate from a position of cultural marginality and social weakness. Like other popular readers, fans lack direct access to the means of commercial cultural production and have only the most limited resources with which to influence the entertainment industry's decisions. Fans must beg with the networks to keep their favorite shows on the air, must lobby producers to provide desired plot developments or to protect the integrity of favorite characters. Within the cultural economy, fans are peasants, not proprietors, a recognition which must contextualize our celebration of strategies of popular resistance. . . .

The history of media fandom is at least in part the history of a series of organized efforts to influence programming decisions – some successful, most

ending in failure. Many have traced the emergence of an organized media fan culture to late 1960s efforts to pressure NBC into returning *Star Trek* to the air, a movement which has provided a model for more recent attempts to reverse network decisions, such as the highly publicized efforts to save *Beauty and the Beast* or *Cagney and Lacey* (D'Acci 1988). Local *Blake's 7* clubs emerged in many American cities throughout the 1980s, with their early focus on convincing local PBS stations to buy the rights to this British science fiction program. American *Doctor Who* supporters volunteer their time at PBS stations across the country, trying to translate their passion for the program into pledge drive contributions that will ensure its continued airing. *War of the Worlds* devotees directed pressure against its producers trying to convince the studio not to kill some of their favorite characters, playfully suggesting that the only rationale for such a decision could be that 'aliens have infiltrated Paramount studios!!!!!' (flier distributed at MediaWest, 1989). COOP, a national *Twin Peaks* fan organization, employed local rallies and computer networking to try to keep that doomed series on the air ('All we are saying is give *Peaks* a chance!'). . . .

The television networks often help to publicize such audience campaigns, especially when they later decide to return programs from hiatus, as evidence of their responsiveness to their viewership. *Cagney and Lacey* producer Barney Rosenzweig actively solicited viewer support in his effort to convince CBS to give the series a second chance to attract higher ratings and publicizing the degree to which he had incorporated audience reactions directly into 'the actual production process' (D'Acci 1988). . . .

Many program producers are sympathetic to such campaigns and have shrewdly employed them as a base of support in their own power struggles with the network executives. Others, however, have responded to such fan initiatives with contempt, suggesting that fan efforts to protect favorite aspects of fictional texts infringe upon the producer's creative freedom and restrict their ability to negotiate for a larger audience. Confronted with a letter campaign by *Batman* comic book fans angry about the casting of Michael Keaton as the Dark Knight, *Batman* director Tim Burton responded: 'There might be something that's sacrilege in the movie. . . . But I can't care about it. . . . This is too big a budget movie to worry about what a fan of a comic would say' (Uricchio and Pearson 1991: 184). William Shatner adopts a similar position in his characterization of *Star Trek* fans: 'People read into it [the series] things that were not intended. In *Star Trek*'s case, in many instances, things were done just for entertainment purposes' (*Starlog*, May 1987: 40). Here, Shatner takes on himself the right to judge what meanings can be legitimately linked to the program and which are arbitrary and false.

In extreme cases, producers try to bring fan activities under their supervision. Lucasfilm initially sought to control *Star Wars* fan publications, seeing them as rivals to their officially sponsored and corporately run fan organization. Lucas later threatened to prosecute editors who published works that violated the 'family values' associated with the original films. A letter

circulated by the director of the official *Star Wars* fan club, summarized the corporation's position:

> Lucasfilm Ltd. does own all rights to the Star Wars characters and we are going to insist upon no pornography. This may mean no fanzines if that measure is what is necessary to stop the few from darkening the reputation our company is so proud of. . . . Since all of the *Star Wars* Saga is PG rated, any story those publishers print should also be PG. Lucasfilm does not produce any X-rated *Star Wars* episodes, so why should we be placed in a light where people think we do?. . . .You don't own these characters and can't *publish* anything about them without permission.

This scheme met considerable resistance from the fan-writing community, which generally regarded Lucas's actions as unwarranted interference in their own creative activity. Several fanzine editors continued to distribute adult-oriented *Star Wars* stories through an underground network of 'special friends', even though such works were no longer publicly advertised or sold. A heated editorial in *Slaysu*, a fanzine that routinely published feminist-inflected erotica set in various media universes, reflects these writers opinions:

> Lucasfilm is saying, 'you must enjoy the characters of the *Star Wars* universe for male reasons. Your sexuality must be correct and proper by my (male) definition.' I am not male. I do not want to be. I refuse to be a poor imitation, or worse, of someone's idiotic ideal of femininity. Lucasfilm has said, in essence, 'This is what we see in the *Star Wars* films and we are telling you that this is what you will see.'
> (*Slaysu* 1982: 144)

[*Slaysu*'s] editorial asserts the rights of fan writers to revise the character of the original films, to draw on elements from dominant culture in order to produce underground art that explicitly challenges patriarchal assumptions. C. A. Siebert and other editors deny the traditional property rights of producers in favor of a readers' right of free play with the program materials. As another *Star Wars* fan explained in response to this passage:

> I still don't agree with the concept that property rights over fiction, such as *Star Wars*, include any rights of the author/producer to determine *how* readers or viewers understand the offering. In this sense, I don't believe fans can take from the producers anything which the producer owns. . . . Any producer or author who wants to ensure as a legal right that audiences experience the same feelings and thoughts s/he put into the work, has misread both the copyright law and probably the Declaration of Independence. . . . Fans' mental play is no business

of producers and neither are their private communications, however lengthy.

<div style="text-align: right">(Barbara Tennison, Personal Correspondence, 1991)</div>

This conflict is one which has had to be actively fought or at least negotiated between fans and producers in almost every media fandom; it is one which threatens at any moment to disrupt the pleasure that fans find in creating and circulating their own texts based on someone else's fictional 'universe' – though an underground culture like fandom has many ways to elude such authorities and to avoid legal restraint on their cultural practices.

The relationship between fan and producer, then, is not always a happy or comfortable one and is often charged with mutual suspicion, if not open conflict. . . . De Certeau's term, 'poaching,' forcefully reminds us of the potentially conflicting interests of producers and consumers, writers and readers. It recognizes the power differential between the 'landowners' and the 'poachers'; yet it also acknowledges ways fans may resist legal constraints on their pleasure and challenge attempts to regulate the production and circulation of popular meanings. And, what is often missed, de Certeau's concept of 'poaching' promises no easy victory for either party. Fans must actively struggle with and against the meanings imposed upon them by their borrowed materials; fans must confront media representations on an unequal terrain.

A few clarifications need to be introduced at this time. First, de Certeau's notion of 'poaching' is a theory of appropriation, not of 'misreading.' The term 'misreading' is necessarily evaluative and preserves the traditional hierarchy bestowing privileged status to authorial meanings over reader's meanings. A conception of 'misreading' also implies that there are proper strategies of reading (i.e., those taught by the academy) which if followed produce legitimate meanings and that there are improper strategies (i.e., those of popular interpretation) which, even in the most charitable version of this formulation, produce less worthy results. Finally, a notion of 'misreading' implies that the scholar, not the popular reader, is in the position to adjudicate claims about textual meanings and suggests that academic interpretation is somehow more 'objective,' made outside of a historical and social context that shapes our own sense of what a text means. . . . Secondly, de Certeau's notion of 'poaching' differs in important ways from Stuart Hall's more widely known 'Encoding and Decoding' formulation (1980b). First, as it has been applied, Hall's model of dominant, negotiated, and oppositional readings tends to imply that each reader has a stable position from which to make sense of a text rather than having access to multiple sets of discursive competencies by virtue of [a] more complex and contradictory place within the social formation. Hall's model, at least as it has been applied, suggests that popular meanings are fixed and classifiable, while de Certeau's 'poaching' model emphasizes the process of making meaning and the fluidity of popular interpretation. To say that fans promote their own meanings over those of

producers is not to suggest that the meanings fans produce are always oppositional ones or that those meanings are made in isolation from other social factors. Fans have chosen these media products from the total range of available texts precisely because they seem to hold special potential as vehicles for expressing the fans' pre-existing social commitments and cultural interests; there is already some degree of compatibility between the ideological construction of the text and the ideological commitments of the fans and therefore, some degree of affinity will exist between the meanings fans produce and those which might be located through a critical analysis of the original story. What one fan says about *Beauty and the Beast* holds for the relationship many fans seek with favorite programs: 'It was as if someone had scanned our minds, searched our hearts, and presented us with the images that were found there.' (Elaine Landman, 'The Beauty and the Beast Experience,' undated fan flier)

Such a situation should warn us against absolute statements of the type that appear all too frequently within the polemical rhetoric of cultural studies. Readers are not *always* resistant; *all* resistant readings are not necessarily progressive readings; the 'people' do not I always recognize their conditions of alienation and subordination. As Stuart Hall (1981) has noted, popular culture is 'neither wholly corrupt [n]or wholly authentic' but rather 'deeply contradictory', characterized by 'the double movement of containment and resistance, which is always inevitably inside it' (228). Similarly, Hall suggests, popular reception is also 'full of very contradictory elements – progressive elements and stone-age elements.' Such claims argue against a world of dominant, negotiating, and oppositional readers in favor of one where each reader is continuously re-evaluating his or her relationship to the fiction and reconstructing its meanings according to more immediate interests. . . .

Nomadic readers

De Certeau offers us another key insight into fan culture: readers are not simply poachers; they are also 'nomads,' always in movement, 'not here or there,' not constrained by permanent property ownership but rather constantly advancing upon another text, appropriating new materials, making new meanings (174). Drawing on de Certeau, Janice Radway has criticized the tendency of academies to regard audiences as constituted by a particular text or genre rather than as 'free-floating' agents who 'fashion narratives, stories, objects and practices from myriad bits and pieces of prior cultural productions' (Radway 1988: 363). While acknowledging the methodological advantages and institutional pressures that promote localized research, Radway wants to resist the urge to 'cordon' viewers for study, to isolate one particular set of reader–text relationships from its larger cultural context. Instead, she calls for investigations of 'the multitude of concrete connections

513

which ever-changing, fluid subjects forge between ideological fragments, discourses, and practices' (1988: 365).

Both academic and popular discourse adopt labels for fans – 'Trekkies', 'Beastie Girls,' 'Deadheads' – that identify them through their association with particular programs or stars. Such identifications, while not totally inaccurate, are often highly misleading. Media fan culture, like other forms of popular reading, may be understood not in terms of an exclusive interest in any one series or genre; rather, media fans take pleasure in making intertextual connections across a broad range of media texts. The female *Star Trek* fans discussed earlier understood the show not simply within its own terms but in relationship to a variety of other texts circulated at the time (*Lost in Space*, say, or NASA footage on television) and since (the feminist science fiction novels of Ursula LeGuin, Joanna Russ, Marion Zimmer Bradley, and others). Moreover, their participation within fandom often extends beyond an interest in any single text to encompass many others within the same genre – other science fiction texts, other stories of male bonding, other narratives which explore the relationship of the outsider to the community. . . . Fans, like other consumers of popular culture, read intertextually as well as textually and their pleasure comes through the particular juxtapositions that they create between specific program content and other cultural materials.

On the wall of my office hangs a print by fan artist Jean Kluge [see Plate 53.1] – a pastiche of a pre-Raphaelite painting depicting characters from *Star Trek: The Next Generation*: Jean-Luc Picard, adopting a contemplative pose atop a throne, evokes the traditional image of King Arthur; Beverly Crusher, her red hair hanging long and flowing, substitutes for Queen Guinevere; while in the center panel, Data and Yar, clad as knights in armor, gallop off on a quest. Visitors to my literature department office often do a double-take in response to this picture, which offers a somewhat jarring mixture of elements from a contemporary science fiction series with those drawn from chivalric romance. Yet, this print suggests something about the ways in which *Star Trek* and other fan texts get embedded within a broader range of cultural interests, indicating a number of different interpretive strategies. The print could be read in relation to the primary series, recalling equally idiosyncratic juxtapositions during the holodeck sequences, as when Picard plays at being a tough-guy detective, when Data performs *Henry V* or studies borscht-belt comedy, or when the characters dash about as Musketeers in the midst of a crew member's elaborate fantasy. Indeed, Kluge's 'The Quest' was part of a series of 'holodeck fantasies' which pictured various *Star Trek* characters at play. The combinations of characters foreground two sets of couples –Picard and Crusher, Yar and Data – which were suggested by program subplots and have formed the focus for a great deal of fan speculation. Such an interpretation of the print would be grounded in the text and yet, at the same time, make selective use of the program materials to foreground aspects of particular interest to the fan community. Ironically, spokesmen for *Star Trek* have recently appeared at fan conventions seeking to deny that Data has emotions

Plate 53.1
Source: Jean Klug

and that Picard and Crusher have a romantic history together, positions fans have rejected as inconsistent with the series events and incompatible with their own perceptions of the characters.

The image could also invite us to think of *Star Trek* transgenerically, reading the characters and situations in relation to tradition of quest stories and in relation to generic expectations formed through fannish readings of popular retellings of the Arthurian saga, such as Marion Zimmer Bradley's *Mists of Avalon* (1983), Mary Stewart's *The Crystal Cave* (1970), T. H. White's

The Once and Future King (1939), or John Boorman's *Excalibur*. Such an inter- pretation evokes strong connections between the conventional formula of 'space opera' and older quest myths and hero sagas.

The print can also be read extratextually, reminding us of actor Patrick Stewart's career as a Shakespearean actor and his previous screen roles in sword and sorcery adventures like *Excalibur*, *Beast Master*, and *Dune*. Fans often track favored performer's careers, adding to their video collections not simply series episodes but also other works featuring its stars, works which may draw into the primary text's orbit a wide range of generic traditions, including those of high culture.

A fan reader might also interpret the Kluge print subculturally, looking at it in relation to traditions within fan writing which situate series charac- ters in alternate universes, including those set in the historical past or in the realm of fantasy, or which cross media universes to have characters from different television series interacting in the same narrative.

Finally, a fan reader might read this print in relation to Kluge's own œuvre as an artist; Kluge's works often juxtapose media materials and histori- cal fantasies, and encompass not only her own fannish interests in *Star Trek* but a variety of other series popular with fans (*Blake's 7*, *Beauty and the Beast*, *Alien Nation*, among others).

Contemplating this one print, then, opens a range of intertextual networks within which its imagery might be understood. All available to *Trek* fans and active components of their cultural experience, these networks link the original series both to other commercially produced works and to the cultural traditions of the fan community. Not every fan would make each of these sets of associations in reading the print, yet most fans would have access to more than one interpretive framework for positioning these specific images. Thinking of the print simply as an artifact of a *Star Trek*-fixated fan culture would blind us to these other potential interpretations that are central to the fans' pleasure in Kluge's art.

Approaching fans as cultural nomads would potentially draw scholars back toward some of the earliest work to emerge from the British cultural studies tradition. As Stuart Hall and Tony Jefferson's *Resistance through Rituals* (1976) or Dick Hebdidge's *Subculture: The Meaning of Style* (1979) document, British youth groups formed an alternative culture not simply through their relationship to specific musical texts but also through a broader range of goods appropriated from the dominant culture and assigned new meanings within this oppositional context. The essays assembled by Hall and Jefferson recorded ways symbolic objects – dress, appearance, language, ritual occa- sions, styles of interaction, music – formed a unified signifying system in which borrowed materials were made to reflect, express, and resonate aspects of group life. Examining the stylistic bricolage of punk culture, Hebdige concluded that the meaning of appropriated symbols, such as the swastika or the safety pin, lay not in their inherent meanings but rather in the logic of their use, in the ways they expressed opposition to the dominant culture.

Feminist writers . . . criticized these initial studies for their silence about the misogynistic quality of such youth cultures and their exclusive focus on the masculine public sphere rather than on the domestic sphere which was a primary locus for femine cultural experience. Yet their own work continued to focus on subcultural appropriation and cultural use. Their research emphasized ways women define their identities through their association with a range of media texts. McRobbie's 'Dance and Social Fantasy' (1984), for example, offers a far-reaching analysis of the roles dance plays in the life of young women, discussing cultural materials ranging from a children's book about Anna Pavlova to films like *Fame* and *Flashdance* and fashion magazines. Like Hebdige, McRobbie is less interested in individual texts than in the contexts in which they are inserted; McRobbie shows how those texts fit into the total social experience of their consumers, how they are discussed at work or consumed in the home, and how they provide models for social behavior and personal identity. . . .

Following in this . . . tradition, I . . . focus on media fandom as a discursive logic that knits together interests across textual and generic boundaries. While some fans remain exclusively committed to a single show or star, many others use individual series as points of entry into a broader fan community, linking to an intertextual network composed of many programs, films, books, comics, and other popular materials. Fans often find it difficult to discuss single programs except through references and comparisons to this broader network; fans may also drift from one series commitment to another through an extended period of involvement within 'fandom.' As longtime fan editor Susan M. Garrett explains: 'A majority of fans don't simply burn out of one fandom and disappear. . . . In fact, I've found that after the initial break into fandom through a single series, fans tend to follow other people into various fandoms, rather than stumble upon programs themselves' (Personal correspondence, July 1991). Garrett describes how fans incorporate more and more programs into their interests in order to facilitate greater communication with friends who share common interests or possess compatible tastes: 'Well, if she likes what I like and she tends to like good shows, then I'll like this new show too' (Personal correspondence, July 1991). Garrett describes how fans incorporate more and more programs into their interests in order to facilitate greater communication with friends who share common interests or possess compatible tastes. 'Well, if she likes what I like and she tends to like good shows, then I'll like this new show too' (Personal correspondence, July 1991). To focus on any one media product – be it *Star Trek* or 'Material Girl' – is to miss the larger cultural context within which that material gets embedded as it is integrated back into the life of the individual fan.

Fans often form uneasy alliances with others who have related but superficially distinctive commitments, finding their overlapping interests in the media a basis for discussion and fellowship. Panels at MediaWest, an important media fan convention held each year in Lansing, Michigan, combine

speakers from different tandems to address topics of common interest, such as 'series romances,' 'disguised romantic heroes,' 'heroes outside the law,' or 'Harrison Ford and his roles.' Letterzines like *Comlink*, which publish letters from fans, and computer net interest groups such as Rec.Arts.TV, which offer electronic mail 'conversation' between contributors, facilitate fan discussion and debate concerning a broad range of popular texts. Genzines (amateur publications aiming at a general fan interest rather than focused on a specific program or star) such as *The Sonic Screwdriver*, *Rerun*, *Everything But . . . The Kitchen Sink*, *Primetime*, or *What you Fancy* offer unusual configurations of fannish tastes that typically reflect the coalition of fandoms represented by their editors; these publications focus not on individual series but on a number of different and loosely connected texts. *Fireside Tales* 'encompasses the genre of cops, spies and private eyes,' running stories based on such series as *Hunter*, *I Spy*, *Adderly*, *Riptide*, and *Dempsey and Makepeace* while *Undercover* treats the same material with a homoerotic inflection. *Walkabout* centers around the film roles of Mel Gibson including stories based on his characters in *Lethal Weapon*, *Year of Living Dangerously*, *Tim*, *Tequila Sunrise*, and *The Road Warrior*. *Faded Roses* focuses on the unlikely combination of *Beauty and the Beast*, *Phantom of the Opera*, and *Amadeus*, 'three of the most romantic universes of all time.' *Animazine* centers on children's cartoons, *The Temporal Times* on time-travel series, *The Cannell Files* on the series of a particular producer, *Tuesday Night* on two shows (*Remington Steele* and *Riptide*) which were once part of NBC's Tuesday night line-up, and *Nightbeat* on stories in which the primary narrative action occurs at night, 'anything from vampires to detectives.'

This logic of cultural inclusion and incorporation is aptly expressed within the flier for one fan organization:

DO YOU:

> Have the urge to wear a 17-foot scarf?
> Desire to be known as 'Madame President?'
> Find it 'Elementary, my dear Watson?'
> Are you continually looking toward the sky for
> 'Unwelcome' visitors?

OR

> Do you just want to visit 'Fawlty Towers?' Or
> Join CI-5 to become a true 'Professional?'
> Then you need search no further!
> Set your time/space/relative dimensions coordinates

FOR:
ANGLOFANS UNLIMITED
(A British media/Doctor Who/Blake's 7, etc. club).

Members of this club share not simply or even primarily a strong attachment to any given series but a broader configuration of cultural interests and a

particularly intimate relationship to media content. The 'etc.' in the club's description foregrounds the group's constant and 'unlimited' ability to accommodate new texts.

What do poachers keep?

If I find de Certeau's notions of textual poaching and nomadic reading particularly useful concepts for thinking about media consumption and fan culture, I want to identify at least one important way in which my position differs from his. . . . De Certeau draws a sharp separation between writers and readers:

> Writing accumulates, stocks up, resists time by the establishment of a place and multiplies its production through the expansionism of reproduction. Reading takes no measures against the erosion of time (one forgets oneself *and* also forgets), it does not keep what it acquires, or it does so poorly.
>
> (de Certeau 1984: 174)

Writing, for de Certeau, has a materiality and permanence which the poached culture of the reader is unable to match; the reader's meaning-production remains temporary and transient, made on the run, as the reader moves nomadically from place to place; the reader's meanings originate in response to immediate concerns and are discarded when they are no longer useful. . . .

While this claim may be broadly applicable to the transient meaning-production which generally characterizes popular reading, it seems false to the specific phenomenon of media fandom for two reasons. First, de Certeau describes readers who are essentially isolated from each other; the meanings they 'poach' from the primary text serve only their own interests and are the object of only limited intellectual investment. They are meanings made for the moment and discarded as soon as they are no longer desirable or useful. Fan reading, however, is a social process through which individual interpretations are shaped and reinforced through ongoing discussions with other readers. Such discussions expand the experience of the text beyond its initial consumption. The produced meanings are thus more fully integrated into the readers' lives and are of a fundamentally different character from meanings generated through a casual and fleeting encounter with an otherwise unremarkable (and unremarked upon) text. For the fan, these previously 'poached' meanings provide a foundation for future encounters with the fiction, shaping how it will be perceived, defining how it will be used.

Second, fandom does not preserve a radical separation between readers and writers. Fans do not simply consume preproduced stories; they manufacture their own fanzine stories and novels, art prints, songs, videos,

519

performances, etc. In fan writer Jean Lorrah's words, 'Trekfandom . . . is friends and letters and crafts and fanzines and trivia and costumes and artwork and folksongs and buttons and film clips and conventions – something for everybody who has in common the inspiration of a television show which grew far beyond its TV and film incarnations to become a living part of world culture' (Lorrah 1984). Lorrah's description blurs the boundaries between producers and consumers, spectators and participants, the commercial and the homecrafted, to construct an image of fandom as a cultural and social network that spans the globe. Fandom here becomes a participatory culture which transforms the experience of media consumption into the production of new texts, indeed of a new culture and a new community.

Howard Becker has adopted the term 'ArtWorld' to describe 'an established network of cooperative links' ([Becker 1992]: 34) between institutions of artistic production, distribution, consumption, interpretation, and evaluation: 'Art Worlds produce works and also give them aesthetic values' (ibid.: 39). An expansive term, 'Art World' refers to systems of aesthetic norms and generic conventions, systems of professional training and reputation building, systems for the circulation, exhibition, sale, and critical evaluation of artworks. In one sense, fandom constitutes one component of the mass media Art World, something like the 'serious audience' which Becker locates around the symphony, the ballet, or the art gallery. Not only do 'serious audience members' provide a stable base of support for artistic creation, Becker suggests, they also function as arbiters of potential change and development. Their knowledge of and commitment to the art insures that they 'can collaborate more fully with artists in the joint effort which produces the work' (1982: 48). Historically, science fiction fandom may be traced back to the letter columns of Hugo Gernsbeck's *Amazing Stories*, which provided a public forum by which fans could communicate with each other and with the writers their reactions to published stories; critics suggest that it was the rich interplay of writers, editors, and fans which allowed science fiction to emerge as a distinctive literary genre in the 1930s and 1940s [Moskowitz 1954; Ross 1991b]. Since Gernsbeck and other editors also included addresses for all correspondents, the pulps provided a means by which fans could contact each other, enabling a small but dedicated community of loyal science fiction readers to emerge. Fans, under the approving eye of Gernsbeck and the other pulp editors, organized local clubs and later, regional science fiction conventions to provide an area where they could exchange their ideas about their favorite genre. By 1939, fandom had grown to such a scale that it could ambitiously host a world science fiction convention, a tradition which has continued to the present day.

So, from its initiation, science fiction fandom has maintained close ties to the professional science fiction writing community and has provided intelligent user criticism of published narratives. Fan conventions play a central role in the distribution of knowledge about new releases and in the promotion of comic books, science fiction novel, and new media productions. They

offer a space where writers and producers may speak directly with readers and develop a firmer sense of audience expectations. Fan awards, such as the Hugo, presented each year at the World Science Fiction Convention, play a key role in building the reputations of emerging writers and in recognizing outstanding accomplishment by established figures. Fan publishing has represented an important training ground for professional writers and editors, a nurturing space in which to develop skills, styles, themes, and perhaps most importantly, self-confidence before entering the commercial marketplace. Marion Zimmer Bradley (1985) has noted the especial importance of fandom in the development of female science fiction writers at a time when professional science fiction was still male-dominated and male-oriented; fanzines, she suggests, were a supportive environment within which women writers could establish and polish their skills.

Yet media fandom constitutes as well its own distinctive Art World, operating beyond direct control by media producers, founded less upon the consumption of pre-existing texts than on the production of fan texts. Much as science fiction conventions provide a market for commercially produced goods associated with media stories and as a showcase for professional writers, illustrators, and performers, the conventions are also a marketplace for fan-produced artworks and a showcase for fan artists. Fan paintings are auctioned, zines are sold, performances staged, videos screened, and awards are given in recognition of outstanding accomplishments. Semiprofessional companies are emerging to assist in the production and distribution of fan goods – song tapes, zines, etc. – and publications are appearing whose primary function is to provide technical information and commentary on fan art (*Apa-Filk* for fan music, *Art Forum* for fan artists, *Treklink* and *On the Double* for fan writers, etc.) or to publicize and market fan writing (*Datazine*). Convention panels discuss zine publishing, art materials, or costume design, focusing entirely on information needed by fan artists rather than by fan consumers. MediaWest, in particular, has prided itself on being fan-run and fan-centered with no celebrity guests and programming; its activities range from fan video screenings and fanzine reading rooms to workshops with noted fan artists, focused around providing support for the emergence of fan culture. These institutions are the infrastructure for a self-sufficient fan culture.

From its initiation in the 1960s in the wake of excitement about *Star Trek*, media fandom has developed a more distant relationship to textual producers than that traditionally enjoyed within literary science fiction fandom. If literary fans constituted, especially in the early years, a sizeable segment of the potential market for science fiction books, active media fans represent a small and insignificant segment of the audience required to sustain a network television series or to support a blockbuster movie. Media producers and stars have, thus, looked upon organized fandom less as a source of feedback than as, at best, an ancillary market for specialized spin-off goods. The long autograph lines that surround media stars often prohibit the closer interaction that fans maintain with science fiction writers and editors.

Indeed, the largely female composition of media fandom reflects a historical split within the science fiction fan community between the traditionally male-dominated literary fans and the newer, more feminine style of media fandom. Women, drawn to the genre in the 1960s, discovered that the close ties between male fans and male writers created barriers to female fans and this fandom's traditions resisted inflection or redefinition. The emergence of media fandom can be seen, at least in part, as an effort to create a fan culture more open to women, within which female fans could make a contribution without encountering the entrenched power of long-time male fans; these fans bought freedom at the expense of proximity to writers and editors. Where this closeness has developed, as in the early years of American *Blake's 7* fandom, it has proven short-lived, since too many institutional pressures separate media professionals and fans. . . .

Media fandom gives every sign of becoming a permanent culture, one which has survived and evolved for more than twenty-five years and has produced material artifacts of enduring interest to that community. Unlike the readers de Certeau describes, fans get to keep what they produce from the materials they 'poach' from mass culture, and these materials sometimes become a limited source of economic profit for them as well. Few fans earn enough through the sale of their artworks to see fandom as a primary source of personal income, yet, many earn enough to pay for their expenses and to finance their fan activities. This materiality makes fan culture a fruitful site for studying the tactics of popular appropriation and textual poaching. Yet, it must be acknowledged that the material goods produced by fans are not simply the tangible traces of transient meanings produced by other reading practices. To read them in such a fashion is to offer an impoverished account of fan cultural production. Fan texts, be they fan writing, art, song, or video, are shaped through the social norms, aesthetic conventions, interpretive protocols, technological resources, and technical competence of the larger fan community. Fans possess not simply borrowed remnants snatched from mass culture, but their own culture built from the . . . raw materials the media provides.

Barbara Ehrenreich, Elizabeth Hess and Gloria Jacobs

BEATLEMANIA

A sexually defiant consumer subculture?[1] [1992]

T HE NEWS FOOTAGE SHOWS police lines straining against crowds of hundreds of young women. The police look grim; the girls' faces are twisted with desperation or, in some cases, shining with what seems to be an inner light. The air is dusty from a thousand running and scuffling feet. There are shouted orders to disperse, answered by a rising volume of chants and wild shrieks. The young women surge forth; the police line breaks . . .

Looking at the photos or watching the news clips today, anyone would guess that this was the 1960s – a demonstration – or maybe the early 1970s – the beginning of the women's liberation movement. Until you look closer and see that the girls are not wearing 1960s-issue jeans and T-shirts but bermuda shorts, high-necked, preppie blouses, and disheveled but unmis-takably bouffant hairdos. This is not 1968 but 1964, and the girls are chanting, as they surge against the police line, 'I love Ringo.'

Yet, if it was not the 'movement,' or a clear-cut protest of any kind, Beatlemania was the first mass outburst of the 1960s to feature women – in this case girls, who would not reach full adulthood until the 1960s and the emergence of a genuinely political movement for women's liberation. The screaming ten- to fourteen-year-old fans of 1964 did not riot *for* anything, except the chance to remain in the proximity of their idols and hence to remain screaming. But they did have plenty to riot against, or at least to overcome through the act of rioting. In a highly sexualized society (one sociologist found that the number of explicitly sexual references in the mass media had doubled between 1950 and 1960), teen and preteen girls were expected to be not only 'good' and 'pure' but to be the enforcers of purity

within their teen society – drawing the line for overeager boys and ostracizing girls who failed in this responsibility. To abandon control – to scream, faint, dash about in mobs – was, in form if not in conscious intent, to protest the sexual repressiveness, the rigid double standard of female teen culture. It was the first and most dramatic uprising of *women's* sexual revolution.

Beatlemania, in most accounts, stands isolated in history as a mere craze – quirky and hard to explain. There had been hysteria over male stars before, but nothing on this scale. In its peak years – 1964 and 1965 – Beatlemania struck with the force, if not the conviction, of a social movement. It began in England with a report that fans had mobbed the popular but not yet immortal group after a concert at the London Palladium on 13 October, 1963. Whether there was in fact a mob or merely a scuffle involving no more than eight girls is not clear, but the report acted as a call to mayhem. Eleven days later a huge and excited crowd of girls greeted the Beatles (returning from a Swedish tour) at Heathrow Airport. In early November, 400 Carlisle girls fought the police for four hours while trying to get tickets for a Beatles concert; nine people were hospitalized after the crowd surged forward and broke through shop windows. In London and Birmingham the police could not guarantee the Beatles safe escort through the hordes of fans. In Dublin the police chief judged that the Beatles' first visit was 'all right until the mania degenerated into barbarism' [*New York Times Magazine* 1 December 1963]. And on the eve of the group's first US tour, *Life* reported, 'A Beatle who ventures out unguarded into the streets runs the very real peril of being dismembered or crushed to death by his fans' (*Life* 31 January 1964).

When the Beatles arrived in the United States, which was still ostensibly sobered by the assassination of President Kennedy two months before, the fans knew what to do. Television had spread the word from England; the approach of the Beatles is a license to riot. At least 4,000 girls (some estimates run as high as 10,000) greeted them at Kennedy Airport, and hundreds more laid siege to the Plaza Hotel, keeping the stars virtual prisoners. A record 73 million Americans watched the Beatles on 'The Ed Sullivan Show' on 9 February, 1964, the night 'when there wasn't a hubcap stolen anywhere in America.' American Beatlemania soon reached the proportions of religious idolatry. During the Beatles' twenty-three-city tour that August, local promoters were required to provide a minimum of 100 security guards to hold back the crowds. Some cities tried to ban Beatle-bearing craft from their runways; otherwise it took heavy deployments of local police to protect the Beatles from their fans and the fans from the crush. In one city, someone got hold of the hotel pillowcases that had purportedly been used by the Beatles, cut them into 160,000 tiny squares, mounted them on certificates, and sold them for $1 apiece. The group packed Carnegie Hall, Washington's Coliseum and, a year later, New York's 55,600-seat Shea Stadium, and in no setting, at any time, was their music audible above the frenzied screams of the audience. In 1966, just under three years after the start of Beatlemania,

the Beatles gave their last concert – the first musical celebrities to be driven from the stage by their own fans.

In its intensity, as well as its scale, Beatlemania surpassed all previous outbreaks of star-centered hysteria. Young women had swooned over Frank Sinatra in the 1940s and screamed for Elvis Presley in the immediate pre-Beatle years, but the Fab Four inspired an extremity of feeling usually reserved for football games or natural disasters. These baby boomers far outnumbered the generation that, thanks to the censors, had only been able to see Presley's upper torso on 'The Ed Sullivan Show.' Seeing (whole) Beatles on Sullivan was exciting, but not enough. Watching the band on television was a thrill – particularly the close-ups – but the real goal was to leave home and meet the Beatles. The appropriate reaction to contact with them – such as occupying the same auditorium or city block – was to sob uncontrollably while screaming, 'I'm gonna die, I'm gonna die,' or, more optimistically, the name of a favorite Beatle, until the onset of either unconsciousness or laryngitis. Girls peed in their pants, fainted, or simply collapsed from the emotional strain. When not in the vicinity of the Beatles – and only a small proportion of fans ever got within shrieking distance of their idols – girls exchanged Beatle magazines or cards, and gathered to speculate obsessively on the details and nuances of Beatle life. One woman, who now administers a Washington, DC-based public interest group, recalls long discussions with other thirteen-year-olds in Orlando, Maine:

> I especially liked talking about the Beatles with other girls. Someone would say, 'What do you think Paul had for breakfast?' 'Do you think he sleeps with a different girl every night?' Or, 'Is John really the leader?' 'Is George really more sensitive?' And like that for hours.

This fan reached the zenith of junior high school popularity after becoming the only girl in town to travel to a Beatles' concert in Boston: 'My mother had made a new dress for me to wear [to the concert] and when I got back, the other girls wanted to cut it up and auction off the pieces.'

To adults, Beatlemania was an affliction, an 'epidemic,' and the Beatles themselves were only the carriers, or even 'foreign germs.' At risk were all ten- to fourteen-year-old girls, or at least all white girls; blacks were disdainful of the Beatles' initially derivative and unpolished sound. There appeared to be no cure except for age, and the media pundits were fond of reassuring adults that the girls who had screamed for Frank Sinatra had grown up to be responsible, settled housewives. If there was a shortcut to recovery, it certainly wasn't easy. A group of Los Angeles girls organized a detox effort called 'Beatlesaniacs, Ltd.,' offering 'group therapy for those living near active chapters, and withdrawal literature for those going it alone at far-flung outposts.' Among the rules for recovery were: 'Do not mention the word Beatles (or beetles),' 'Do not mention the word England,' 'Do not speak with an English accent,' and 'Do not speak English' [*Life* 28 August 1964].

In other words, Beatlemania was as inevitable as acne and gum-chewing, and adults would just have to weather it out.

But why was it happening? And why in particular to an America that prided itself on its post-McCarthy maturity, its prosperity, and its clear position as the number one world power? True, there were social problems that not even *Reader's Digest* could afford to be smug about – racial segregation, for example, and the newly discovered poverty of 'the other America.' But these were things that an energetic President could easily handle – or so most people believed at the time – and if 'the Negro problem,' as it was called, generated overt unrest, it was seen as having a corrective function and limited duration. Notwithstanding an attempted revival by presidential candidate Barry Goldwater, 'extremism' was out of style in any area of expression. In colleges, 'coolness' implied a detached and rational appreciation of the *status quo*, and it was *de rigueur* among all but the avant-garde who joined the Freedom Rides or signed up for the Peace Corps. No one, not even Marxist philosopher Herbert Marcuse, could imagine a reason for widespread discontent among the middle class or for strivings that could not be satisfied with a department store charge account – much less for 'mania.'

In the media, adult experts fairly stumbled over each other to offer the most reassuring explanations. The *New York Times Magazine* offered a 'psychological, anthropological,' half tongue-in-cheek account, titled 'Why the Girls Scream, Weep, Flip.' Drawing on the work of the German sociologist Theodor Adorno, *Times* writer David Dempsey argued that the girls weren't really out of line at all; they were merely 'conforming.' Adorno had diagnosed the 1940s jitterbug fans as 'rhythmic obedients,' who were 'expressing their desire to obey.' They needed to subsume themselves into the mass, 'to become transformed into an insect.' Hence, 'jitter*bug,*' and as Dempsey triumphantly added: 'Beatles, too, are a type of bug . . . and to "beatle," as to jitter, is to lose one's identity in an automatized, insectlike activity, in other words, to obey.' If Beatlemania was more frenzied than the outbursts of obedience inspired by Sinatra or Fabian, it was simply because the music was 'more frantic,' and in some animal way, more compelling. It is generally admitted 'that jungle rhythms influence the "beat" of much contemporary dance activity,' he wrote, blithely endorsing the stock racist response to rock 'n' roll. Atavistic, 'aboriginal' instincts impelled the girls to scream, weep, and flip, whether they liked it or not: 'It is probably no coincidence that the Beatles, who provoke the most violent response among teenagers, resemble in manner the witch doctors who put their spells on hundreds of shuffling and stamping natives' [*New York Times Magazine* 23 February 1964].

Not everyone saw the resemblance between Beatlemanic girls and 'natives' in a reassuring light however. *Variety* speculated that Beatlemania might be 'a phenomenon closely linked to the current wave of racial rioting' [quoted in Schaffner 1977: 16]. It was hard to miss the element of defiance in Beatlemania. If Beatlemania was conformity, it was conformity to an imperative that overruled adult mores and even adult laws. In the mass experience

of Beatlemania, as for example at a concert or an airport, a girl who might never have contemplated shoplifting could assault a policeman with her fists, squirm under police barricades, and otherwise invite a disorderly conduct charge. Shy, subdued girls could go berserk. 'Perky,' ponytailed girls of the type favored by early [1960s] sitcoms could dissolve in histrionics. In quieter contemplation of their idols, girls could see defiance in the Beatles or project it onto them. *Newsweek* quoted Pat Hagan, 'a pretty, 14-year-old Girl Scout, nurse's aide, and daughter of a Chicago lawyer . . . who previously dug "West Side Story," Emily Dickinson, Robert Frost, and Elizabeth Barrett Browning: "They're tough," she said of the Beatles. "Tough is like when you don't conform . . . You're tumultuous when you're young, and each generation has to have its idols"' [*Newsweek* 24 February 1964]. America's favorite sociologist, David Riesman, concurred, describing Beatlemania as 'a form of protest against the adult world' [*US News and World Report* 24 February 1964].

There was another element of Beatlemania that was hard to miss but not always easy for adults to acknowledge. As any casual student of Freud would have noted, at least part of the fans' energy was sexual. Freud's initial breakthrough had been the insight that the epidemic female 'hysteria' of the late nineteenth century – which took the form of fits, convulsions, tics, and what we would now call neuroses – was the product of sexual repression. In 1964, though, confronted with massed thousands of 'hysterics,' psychologists approached this diagnosis warily. After all, despite everything Freud had had to say about childhood sexuality, most Americans did not like to believe that 12-year-old girls had any sexual feelings to repress. And no normal girl – or full-grown woman, for that matter – was supposed to have the libidinal voltage required for three hours of screaming, sobbing, incontinent, acute-phase Beatlemania. In an article in *Science News Letter* titled 'Beatles Reaction Puzzles Even Psychologists,' one unidentified psychologist offered a carefully phrased, hygienic explanation: Adolescents are 'going through a strenuous period of emotional and physical growth,' which leads to a 'need for expressiveness, especially in girls.' Boys have sports as an outlet; girls have only the screaming and swooning afforded by Beatlemania, which could be seen as 'a release of sexual energy' [*Science Newsletter* 29 February 1964].

For the girls who participated in Beatlemania, sex was an obvious part of the excitement. One of the most common responses to reporters' queries on the sources of Beatlemania was, 'Because they're sexy.' And this explanation was in itself a small act of defiance. It was rebellious (especially for the very young fans) to lay claim to sexual feelings. It was even more rebellious to lay claim to the *active*, desiring side of a sexual attraction: the Beatles were the objects; the girls were their pursuers. The Beatles were sexy; the girls were the ones who perceived them as sexy and acknowledged the force of an ungovernable, if somewhat disembodied, lust. To assert an active, powerful sexuality by the tens of thousands and to do so in a way calculated to attract maximum attention was more than rebellious. It was, in its own unformulated, dizzy way, revolutionary.

Sex and the teenage girl

In the years and months immediately preceding US Beatlemania, the girls who were to initiate a sexual revolution looked, from a critical adult vantage point, like sleepwalkers on a perpetual shopping trip. Betty Friedan noted in her 1963 classic, *The Feminine Mystique*, 'a new vacant sleepwalking, playing-a-part quality of youngsters who do what they are supposed to do, what the other kids do, but do not seem to feel alive or real in doing it' [Friedan 1963: 282]. But for girls, conformity meant more than surrendering, comatose, to the banal drift of junior high or high school life. To be popular with boys and girls – to be universally attractive and still have an unblemished 'reputation' – a girl had to be crafty, cool, and careful. The payoff for all this effort was to end up exactly like Mom – as a housewife.

In October 1963, the month Beatlemania first broke out in England and three months before it arrived in America, *Life* presented a troubling picture of teenage girl culture. The focus was Jill Dinwiddie, 17, popular, 'healthy, athletic, getting A grades,' to all appearances wealthy, and at the same time, strangely vacant. . . . Jill . . ., the 'queen bee of the high school,' is strikingly sexless: short hair in a tightly controlled style (the kind achieved with flat metal clips), button-down shirts done up to the neck, shapeless skirts with matching cardigans, and a stance that evokes the intense posture-consciousness of prefeminist girls' phys. ed. Her philosophy is no less engaging: 'We have to be like everybody else to be accepted. Aren't most adults that way? We learn in high school to stay in the middle' [*Life* 11 October 1963].

'The middle,' for girls coming of age in the early 1960s, was a narrow and carefully defined terrain. The omnipresent David Riesman, whom *Life* called in to comment on Jill and her crowd, observed, 'Given a standard definition of what is feminine and successful, they must conform to it. The range is narrow, the models they may follow few.' The goal, which Riesman didn't need to spell out, was marriage and motherhood, and the route to it led along a straight and narrow path between the twin dangers of being 'cheap' or being too puritanical, and hence unpopular. A girl had to learn to offer enough, sexually, to get dates, and at the same time to withhold enough to maintain a boy's interest through the long preliminaries from dating and going steady to engagement and finally marriage. None of this was easy, and for girls like Jill the pedagogical burden of high school was a four-year lesson in how to use sex instrumentally: doling out just enough to be popular with boys and never enough to lose the esteem of the 'right kind of kids.' Commenting on *Life*'s story on Jill, a University of California sociologist observed:

> It seems that half the time of our adolescent girls is spent trying to meet their new responsibilities to be sexy, glamorous and attractive, while the other half is spent meeting their old responsibility to be virtuous by holding off the advances which testify to their success.

Advice books to teenagers fussed anxiously over the question of 'where to draw the line,' as did most teenage girls themselves. Officially everyone – girls and advice-givers – agreed that the line fell short of intercourse, though by the 1960s even this venerable prohibition required some sort of justification, and the advice-givers strained to impress upon their young readers the calamitous results of premarital sex. First there was the obvious danger of pregnancy, an apparently inescapable danger since no book addressed to teens dared offer birth control information. Even worse, some writers suggested, were the psychological effects of intercourse: It would destroy a budding relationship and possibly poison any future marriage. According to a contemporary text-book titled, *Adolescent Development and Adjustment*, intercourse often caused a man to lose interest ('He may come to believe she is totally promiscuous'), while it was likely to reduce a woman to slavish dependence ('Sometimes a woman focuses her life around the man with whom she first has intercourse') [Crow and Crow 1965: 248–9]. The girl who survived premarital intercourse and went on to marry someone else would find marriage clouded with awkwardness and distrust. Dr Arthur Cain warned in *Young People and Sex* that the husband of a sexually experienced woman might be consumed with worry about whether his performance matched that of her previous partners. 'To make matters worse,' he wrote, 'it may be that one's sex partner is not as exciting and satisfying as one's previous illicit lover' [Cain 1967: 71]. In short, the price of premarital experience was likely to be postnuptial disappointment. And, since marriage was a girl's peak achievement, an anticlimatic wedding night would be a lasting source of grief.

Intercourse was obviously out of the question, so young girls faced the still familiar problem of where to draw the line on a scale of lesser sexual acts, including (in descending order of niceness): kissing, necking, and petting, this last being divided into 'light' (through clothes and/or above the waist) and 'heavy' (with clothes undone and/or below the waist). Here the experts were no longer unanimous. Pat Boone, already a spokesman for the Christian right, drew the line at kissing in his popular 1958 book, *'Twixt Twelve and Twenty*. No prude, he announced that 'kissing is here to stay and I'm glad of it!' But, he warned, 'Kissing is not a game, Believe me! . . . Kissing for fun is like play-ing with a beautiful candle in a roomful of dynamite!' [Boone 1967: 60]. (The explosive consequences might have been guessed from the centerpiece photos showing Pat dining out with his teen bride, Shirley; then, as if moments later, in a maternity ward with her; and, in the next picture, surrounded by 'the four little Boones.') Another pop-singer-turned-adviser, Connie Francis, saw nothing wrong with kissing (unless it begins to 'dominate your life'), nor with its extended form, necking, but drew the line at petting:

> Necking and petting – let's get this straight – are two different things. Petting, according to most definitions, is specifically intended to arouse sexual desires and as far as I'm concerned, petting is out for teenagers.
> [Francis 1962: 138]

529

In practice, most teenagers expected to escalate through the scale of sexual possibilities as a relationship progressed, with the big question being: How much, how soon? In their 1963 critique of American teen culture, *Teen-Age Tyranny*, Grace and Fred Hechinger bewailed the cold instrumentality that shaped the conventional answers. A girl's 'favors,' they wrote, had become 'currency to bargain for desirable dates which, in turn, are legal tender in the exchange of popularity.' For example, in answer to the frequently asked question, 'Should I let him kiss me good night on the first date?' they reported that:

> A standard caution in teen-age advice literature is that, if the boy 'gets' his kiss on the first date, he may assume that many other boys have been just as easily compensated. In other words, the rule book advises mainly that the [girl's] popularity assets should be protected against deflation.
>
> [Hechinger and Hechinger 1963: 54]

It went without saying that it was the girl's responsibility to apply the brakes as a relationship approached the slippery slope leading from kissing toward intercourse. This was not because girls were expected to be immune from temptation. Connie Francis acknowledged that 'It's not easy to be moral, especially where your feelings for a boy are involved. It never is, because you have to fight to keep your normal physical impulses in line.' But it was the girl who had the most to lose, not least of all the respect of the boy she might too generously have indulged. 'When she gives in completely to a boy's advances,' Francis warned, 'the element of respect goes right out the window.' Good girls never 'gave in,' never abandoned themselves to impulse or emotion, and never, of course, initiated a new escalation on the scale of physical intimacy. In the financial metaphor that dominated teen sex etiquette, good girls 'saved themselves' for marriage; bad girls were 'cheap.'

According to a 1962 Gallup Poll commissioned by *Ladies' Home Journal*, most young women (at least in the *Journal*'s relatively affluent sample) enthusiastically accepted the traditional feminine role and the sexual double standard that went with it:

> Almost all our young women between 16 and 21 expect to be married by 22. Most want 4 children, many want . . . to work until children come; afterward, a resounding no! They feel a special responsibility for sex *because* they are women. An 18-year-old student in California said, 'The standard for men – sowing wild oats – results in sown oats. And where does this leave the woman?' . . . Another student: 'A man will go as far as a woman will let him. The girl has to set the standard.'
>
> [*Ladies Home Journal* January 1962: 390]

Implicit in this was a matrimonial strategy, based on months of sexual teasing (setting the standard), until the frustrated young man broke down and

proposed. Girls had to 'hold out' because, as one *Journal* respondent put it, 'Virginity is one of the greatest things a woman can give to her husband.' As for what *he* would give to her, in addition to four or five children, the young women were vividly descriptive:

> . . . I want a split-level brick with four bedrooms with French Provincial cherrywood furniture.
> . . . I'd like a built-in oven and range, counters only 34 inches high with Formica on them.
> . . . I would like a lot of finished wood for warmth and beauty.
> . . . My living room would be long with a high ceiling of exposed beams. I would have a large fireplace on one wall, with a lot of copper and brass around. . . . My kitchen would be very like old Virginian ones – fireplace and oven.

So single-mindedly did young women appear to be bent on domesticity that when Beatlemania did arrive, some experts thought the screaming girls must be auditioning for the maternity ward: 'The girls are subconsciously preparing for motherhood. Their frenzied screams are a rehearsal for that moment. Even the jelly babies [the candies favored by the early Beatles and hurled at them by fans] are symbolic' (quoted in Norman 1981: 200). Women were asexual, or at least capable of mentally bypassing sex and heading straight from courtship to reveries of Formica counters and cherrywood furniture, from the soda shop to the hardware store.

But the vision of a suburban split-level, which had guided a generation of girls chastely through high school, was beginning to lose its luster. Betty Friedan had surveyed the 'successful' women of her age – educated, upper-middle-class housewives – and found them reduced to infantile neuroticism by the isolation and futility of their lives. If feminism was still a few years off, at least the 'feminine mystique' had entered the vocabulary, and even Jill Dinwiddie must have read the quotation from journalist Shana Alexander that appeared in the same issue of *Life* that featured Jill. 'It's a marvellous life, this life in a man's world,' Alexander said. 'I'd climb the walls if I had to live the feminine mystique.' The media that had once romanticized togetherness turned their attention to 'the crack in the picture window' – wife swapping, alcoholism, divorce, and teenage anomie. A certain cynicism was creeping into the American view of marriage. In the novels of John Updike and Philip Roth, the hero didn't get the girl, he got away. When a Long Island prostitution ring, in which housewives hustled with their husbands' consent, was exposed in the winter of 1963, a Fifth Avenue saleswoman commented: 'I see all this beautiful stuff I'll never have, and I wonder if it's worth it to be good. What's the difference, one man every night or a different man?' (*Look* 15 December 1964).

So when sociologist Bennett Berger commented in *Life* that 'there is nobody better equipped than Jill to live in a society of all-electric kitchens,

wall-to-wall carpeting, dishwashers, garbage disposals [and] color TV,' this could no longer be taken as unalloyed praise. Jill herself seemed to sense that all the tension and teasing anticipation of the teen years was not worth the payoff. After she was elected, by an overwhelming majority, to the cheer-leading team, 'an uneasy, faraway look clouded her face. "I guess there's nothing left to do in high school," she said, "I've made songleader both years, and that was all I really wanted." ' For girls, high school was all there was to public life, the only place you could ever hope to run for office or experience the quasi fame of popularity. After that came marriage – most likely to one of the crew-cut boys you'd made out with – then isolation and invisibility.

Part of the appeal of the male star – whether it was James Dean or Elvis Presley or Paul McCartney – was that you would *never* marry him; the romance would never end in the tedium of marriage. Many girls expressed their adulation in conventional, monogamous terms, for example, picking their favorite Beatle and writing him a serious letter of proposal, or carrying placards saying, 'John, Divorce Cynthia.' But it was inconceivable that any fan would actually marry a Beatle or sleep with him (sexually active 'groupies' were still a few years off) or even hold his hand. Adulation of the male star was a way to express sexual yearnings that would normally be pressed into the service of popularity or simply repressed. The star could be loved noninstrumentally, for his own sake, and with complete abandon. Publicly to advertise this hopeless love was to protest the calculated, pragmatic sexual repression of teenage life.

The economics of mass hysteria

Sexual repression had been a feature of middle-class teen life for centuries. If there was a significant factor that made mass protest possible in the late 1950s (Elvis) and the early 1960s (the Beatles), it was the growth and maturation of a teen market: for distinctly teen clothes, magazines, entertainment, and accessories. Consciousness of the teen years as a life-cycle phase set off between late childhood on the one hand and young adulthood on the other only goes back to the early twentieth century, when the influential psychologist G. Stanley Hall published his mammoth work *Adolescence*. (The word 'teenager' did not enter mass usage until the 1940s.) Postwar affluence sharpened the demarcations around the teen years: fewer teens than ever worked or left school to help support their families, making teenhood more distinct from adulthood as a time of unemployment and leisure. And more teens than ever had money to spend, so that from a marketing view point, teens were potentially much more interesting than children, who could only influence family spending but did little spending themselves. Grace and Fred Hechinger reported that in 1959 the average teen spent $555 on 'goods and services not including the necessities normally

supplied by their parents,' and noted, for perspective, that in the same year school-teachers in Mississippi were earning just over $3,000. 'No matter what other segments of American society – parents, teachers, sociologists, psychologists, or policemen – may deplore the power of teenagers,' they observed, 'the American business community has no cause for complaint' [Hechinger and Hechinger 1963: 151].

If advertisers and marketing men manipulated teens as consumers, they also, inadvertently, solidified teen culture against the adult world. Marketing strategies that recognized the importance of teens as precocious consumers also recognized the importance of heightening their self-awareness of themselves *as teens*. Girls especially became aware of themselves as occupying a world of fashion of their own – not just bigger children's clothes or slimmer women's clothes. You were not a big girl nor a junior woman, but a 'teen,' and in that notion lay the germs of an oppositional identity. Defined by its own products and advertising, slogans, teenhood became more than a prelude to adulthood; it was a status to be proud of – emotionally and sexually complete unto itself.

Rock 'n' roll was the most potent commodity to enter the teen consumer subculture. Rock was originally a black musical form with no particular age identification, and it took white performers like Buddy Holly and Elvis Presley to make rock 'n' roll accessible to young white kids with generous allowances to spend. On the white side of the deeply segregated music market, rock became a distinctly teenage product. Its 'jungle beat' was disconcerting or hateful to white adults; its lyrics celebrated the special teen world of fashion ('Blue Suede Shoes'), feeling ('Teenager in Love'), and passive opposition ('Don't know nothin' 'bout his-to-ry'). By the late 1950s, rock 'n' roll was the organizing principle and premier theme of teen consumer culture: you watched the Dick Clark show not only to hear the hits but to see what the kids were wearing; you collected not only the top singles but the novelty items that advertised the stars; you cultivated the looks and personality thatwould make you a 'teen angel.' And if you were still too young for all this, in the late 1950s you yearned to grow up to be – not a woman and a housewife, but a teenager.

Rock 'n' roll made mass hysteria almost inevitable: It announced and ratified teen sexuality and then amplified teen sexual frustration almost beyond endurance. . . . Hysteria was critical to the marketing of the Beatles. First there were the reports of near riots in England. Then came a calculated publicity tease . . . five million posters and stickers announcing 'The Beatles Are Coming' were distributed nation-wide. Disc jockeys were blitzed with promo material and Beatle interview tapes (with blank spaces for the DJ to fill in the questions, as if it were a real interview) and enlisted in a mass 'countdown' to the day of the Beatles' arrival in the United States. As Beatle chronicler Nicholas Schaffner reports:

> Come break of 'Beatle Day', the quartet had taken over even the disc-jockey patter that punctuated their hit songs. From WMCA and WINS

through W-A-Beatle-C, it was 'thirty Beatle degrees', eight-thirty Beatle time'. . .[and] 'four hours and fifty minutes to go.'

[Schaffner 1977: 9]

By the time the Beatles materialized, on 'The Ed Sullivan Show' in February 1964, the anticipation was unbearable. A woman who was a [14]-year-old in Duluth at the time told us, 'Looking back, it seems so commercial to me, and so degrading that millions of us would just scream on cue for those four guys the media dangled out in front of us. But at the time it was something intensely personal for me and, I guess, a million other girls. The Beatles seemed to be speaking directly to us and, in a funny way, *for us.*'

By the time the Beatles hit America, teens and preteens had already learned to look to their unique consumer subculture for meaning and validation. If this was manipulation – and no culture so strenuously and shamelessly exploits its children as consumers – it was also subversion. *Bad* kids became juvenile delinquents, smoked reefers, or got pregnant. Good kids embraced the paraphernalia, the lore, and the disciplined fandom of rock 'n' roll. (Of course, bad kids did their thing to a rock beat too: the first movie to use a rock 'n' roll soundtrack was *Blackboard Jungle*, in 1955, cementing the suspected link between 'jungle rhythms' and teen rebellion.) For girls, fandom offered a way not only to sublimate romantic and sexual yearnings but to carve out subversive versions of heterosexuality. Not just anyone could be hyped as a suitable object for hysteria: It *mattered* that Elvis was a grown-up greaser, and that the Beatles let their hair grow over their ears. . . .

[W]hen the Beatles arrived at crew-cut, precounterculture America, their long hair attracted more commentary than their music. Boy fans rushed to buy Beatle wigs and cartoons showing well-known male figures decked with Beatle hair were a source of great merriment. *Playboy*, in an interview, grilled the Beatles on the subject of homosexuality, which it was only natural for gender-locked adults to suspect. As Paul McCartney later observed:

There they were in America, all getting house-trained for adulthood with their indisputable principle of life: short hair equals men; long hair equals women. Well, we got rid of that small convention for them. And a few others, too.

[quoted in Schaffner 1977: 17]

What did it mean that American girls would go for these sexually suspect young men, and in numbers far greater than an unambiguous stud like Elvis could command? Dr Joyce Brothers thought the Beatles' appeal rested on the girls' innocence:

The Beatles display a few mannerisms which almost seem a shade on the feminine side, such as the tossing of their long manes of hair. . . .

These are exactly the mannerisms which very young female fans (in the
10-to-14 age group) appear to go wildest over.

[quoted in Schaffner 1977: 16]

The reason? 'Very young "women" are still a little frightened of the idea of
sex. Therefore they feel safer worshipping idols who don's seem too mascu-
line, or too much the "he man." '

What Brothers and most adult commentators couldn't imagine was that
the Beatles' androgyny was itself sexy. 'The idea of sex' as intercourse, with
the possibility of pregnancy or a ruined reputation, was indeed frightening.
But the Beatles construed sex more generously and playfully, lifting it out
of the rigid scenario of mid-century American gender roles, and it was this
that made them wildly sexy. Or to put it the other way around, the appeal
lay in the vision of sexuality that the Beatles held out to a generation of
American girls: They seemed to offer sexuality that was guileless, ebullient,
and fun – like the Beatles themselves and everything they did (or were shown
doing in their films *Help* and *A Hard Day's Night*). Theirs was a vision of
sexuality freed from the shadow of gender inequality because the group
mocked the gender distinctions that bifurcated the American landscape into
'his' and 'hers.' To Americans who believed fervently that sexuality hinged
on *la différence*, the Beatlemaniacs said, No, blur the lines and expand the
possibilities.

At the same time, the attraction of the Beatles bypassed sex and went
straight to the issue of power. Our informant from Orlando, Maine, said of
her Beatlemanic phase:

> I didn't feel sexual, as I would now define that. It felt more about
> wanting freedom. I didn't want to grow up and be a wife and it seemed
> to me that the Beatles had the kind of freedom I wanted: No rules,
> they could spend two days lying in bed; they ran around on motor-
> bikes, ate from room service. . . I didn't want to sleep with Paul
> McCartney, I was too young. But I wanted to be like them, something
> larger than life.

Another woman, who was thirteen when the Beatles arrived in her home
city of Los Angeles and was working for the telephone company in Denver
when we interviewed her, said:

> Now that I've thought about it, I think I identified with them, rather
> than as an object of them. I mean I liked their independence and sexu-
> ality and wanted those things for myself. . . . Girls didn't get to be
> that way when I was a teenager – we got to be the limp, passive object
> of some guy's fleeting sexual interest. We were so stifled, and they
> made us meek, giggly creatures think, oh, if only *I* could act that way,
> and be strong, sexy, and doing what you want.

535

If girls could not be, or ever hope to be, superstars and madcap adventurers themselves, they could at least idolize the men who were.

There was the more immediate satisfaction of knowing, subconsciously, that the Beatles were who they were because girls like oneself had made them that. As with Elvis, fans knew of the Beatles' lowly origins and knew they had risen from working-class obscurity to world fame on the acoustical power of thousands of shrieking fans. Adulation created stars, and stardom, in turn, justified adulation. Questioned about their hysteria, some girls answered simply, 'Because they're the Beatles.' That is, because they're who I happen to like. And the louder you screamed, the less likely anyone would forget the power of the fans. When the screams drowned out the music, as they invariably did, then it was the fans, and not the band, who were the show. . . .

Among male rock stars, the faintly androgynous affect of the Beatles was quickly eclipsed by the frank bisexuality of performers like Alice Cooper and David Bowie, and then the more outrageous antimasculinity of 1980s stars Boy George and Michael Jackson. The latter provoked screams again and mobs, this time of interracial crowds of girls, going down in age to eight and nine, but never on the convulsive scale of Beatlemania. By the 1980s, female singers like Grace Jones and Annie Lennox were denying gender too, and the loyalty and masochism once requisite for female lyrics gave way to new songs of cynicism, aggression, exultation. But between the vicarious pleasure of Beatlemania and Cyndi Lauper's forthright assertion in 1984 that 'girls just want to have fun,' there would be an enormous change in the sexual possibilities open to women and girls – a change large enough to qualify as a 'revolution.'

Note

1 Originally subtitled 'Girls Just Want to Have Fun'.

Caroline Bassett[1]

VIRTUALLY GENDERED
Life in an on-line world[1] [1995]

> A world of pleasures in which grins hang about without the cat.
>
> (Foucault 1980, p. x)

> From a self-consciously de-naturalized position we can see how the appearance of naturalness is constituted.
>
> (Judith Butler 1993, p. 110)

LambdaMOO is a live virtual world, a Multi User Domain or MUD, sited on servers at Xerox's Palo Alto Research Center (PARC) and publicly accessible through the Internet. Described by its founder as a 'text-based virtual reality' (Curtis and Nichols 1993), Lambda has a population of around 5,000 named inhabitants and a stream of more casual guests. It declares itself an international city:

> *Welcome to LambdaMOO!*
>
> LambdaMOO is a new kind of society, where thousands of people voluntarily come together from all over the world. What these people say and do may not always be to your liking: as when visiting any international city, it is wise to be careful who you associate with and what you say . . .
>
> . . . The lag is approximately 5 seconds; there are 220 connected.
> ***Connected***[2]

Cyberspace links individuals across space and time, as older technologies like the telephone do. But cyberspace is also an immersive place to 'be'. Beyond the mediating screen of the personal computer, life goes on in a new mode: that of the virtual. Those who meet in LambdaMOO interact within a labyrinthine structure of private and public 'rooms' which are continually and haphazardly expanded by their inhabitants. Wandering these subcultural spaces Lambdans 'talk', 'argue', 'flirt', and despite the limitations of a text-based world, they may 'dance the forbidden dance', 'eat' pizzas, 'drink' from a number of bars, or engage in various forms of cybersex. Here, on the far side of the screen, stripped of the bodily characteristics which establish their everyday identity 'In Real Life' (or IRL as those on-line refer to the world this side of the screen), players choose a name and a gender, and create a virtual 'appearance' or description for themselves.

Lambdans can freely edit these three basic attributes, adapting gender and appearance or discarding an old identity entirely. They may play with multiple subjectivities by 'morphing' (transforming) between different identities – sometimes adopting several in the course of a single interaction. Or they may build a relatively stable alternate identity within Lambda, an aspect of themselves with a specific gender, a sexuality, and a virtual home. Many Lambdans adopt a gender and description entirely at odds with their IRL selves.

In Lambda, outward 'appearances' are *assumed* to be 'deceptive' – unfaithful iterations of players' Real Life identity, and unstable even in terms of the MUD subculture itself. The acknowledged and accepted possibility of gender treachery threads through all interactions on Lambda. In this sense gendered identity is always performed on unstable grounds. But Lambda is also a highly conventional place. The 'manly men and womanly women' Howard Rheingold found in cyberspace (1994) are clearly in evidence on Lambda; often conforming to rigid stereotypes of 'their' chosen gender. The same tension between experiment and reaction prevails in the realm of sexuality. Homophobia surfaces from time to time in LambdaMOO. One Lambdan, for example, recently attempted to force Lambda inhabitants to vote to ban homosexuals. His proposal was defeated by a counter ballot 'BurnBanHomo' and a later proposal to 'KillMrConservative'.

The dynamic that emerges – a tension between gender play on the one hand, and a fairly rigid adherence to gender norms on the other – suggests that cyber-subjects, standing in a new relation to the body, which we may regard as potentially liberating, may also be understood to emerge through the power structures and gender asymmetries operating in Real Life.

This chapter is the result of observations as a named player and a guest on Lambda. It considers how gender identity is negotiated in this space beyond the flesh, if not entirely beyond the body.

Performing in cyberspace

Judith Butler's theories of gender performativity, outlined in *Gender Trouble* [1990a] and developed in *Bodies that Matter* [1993], have clear resonances with the virtual realities of cyberspace. Butler's contention is that gender and sexed bodies, neither constructed in culture, nor the products of an essential psychical or biological 'core', are materialized through a series of re-iterated acts in language.

Gender, she argues, is 'performative'. This term is defined by J. L. Austin in *How To Do Things With Words* as a speech act where 'the issuing of the utterance is the performing of the action.' (Austin 1975: 6). If gender is performative, that is, if the discourse of gender produces the effects it names, then pre-existing gender identity – what Butler calls the mythical gender core – is revealed as a ruse:

> If gender attributes and acts, the various ways in which a body shows or produces its cultural signification, are performative, there is no pre-existing identity by which an act or attribute might be measured; *there would be no true or false, real or distorted acts of gender*, and the postulation of a true gender identity would be revealed as a regulatory fiction.
>
> (Butler 1990: 40; my emphasis)

This is also to understand the subject her/himself as contingent, formed and reformed in the act of performance: 'An identity tenuously constituted in time, instituted . . . through a stylized repetition of acts' (Butler 1990: 140). Gender on Lambda, which clearly cannot be explained as a frozen attribute of sexed bodies, may be understood to be produced and reproduced through its insubstantial, reiterated performance. It is this cycle of living on-line that I investigate below.

Spatial practices: everyday life in LambdaMOO

> The thin film of writing becomes a movement of strata, a play of spaces . . .
>
> (de Certeau 1984: xxi)

At the heart of Lambda are a series of live textual exchanges – rolling conversations amongst those gathered in any of its 8,000 rooms, all of whom can also be 'seen' by others in the same room. Players take more or less active parts in the conversations scrolling up their screens – sometimes too fast for most people to type accurately. Fragmented interchanges, often involving different sub-groups of people, weave these inchoate texts together – there are, for instance, at least seven different subject threads in the conversation

cited below, which has no beginning and – as the room is continuously occupied – no real end. This exchange took place in the Living Room:

> Abraxas [to Husserl]: the act of reification becomes subjective, inasmuch as perception consists of the apprehension of itself . . . or am I way off?
> Green Guest says, 'Wellsie, my mistress sends her love, but not her body'
> Green Guest says to Wellsie, 'Stop trying to boss me around.'
> Husserl says, 'however his proof of the existence of god is at best spurious'
> lingerie [to M.K.]: sorry, I have to go now . . .
> Triton waves.
> Wellsie giggles at Green-Guest.
> M.K. bows gracefully to lingerie.
> Wellsie . o O (I always wondered how those puppets worked.)
> M.K. hugs lingerie warmly.
> susan smith says, 'I think it is silly to try to prove god.'
> lingerie hugs M.K. waves to everybody
> BRIAN* WAVES GOODBYE TO YOU AS HE LEAVES.
> Lucian says, 'anyone know the way to the gift shop?'
> Matte Guest comes out of the closet (so to speak . . .).
> Wellsie grabs a trashcan lid and crowns the Green Guest with it.
> *WHAM*
> *WHAM*
> *WHAM*
> *WHAM*
> Green Guest eventually loses consciousness.
> M.K. [to lingerie]: I will be seeing you around?
> susan smith says, 'or the existence thereof.'
> Wellsie causes Abraxas to fall down laughing.
> ELBEE SMILES

There is constant movement between rooms as Lambdans wander in search of new conversations and new players. Walking is *passé* here, most Lambdans 'teleport' directly from (populated) place to place. The exchange (above) is characteristic in that it involves a series of arrivals and departures – these comings and going are never invisible in Lambda, and are often elaborately acknowledged. Players cruise different rooms 'watching' conversations, looking up individuals, engaging them in talk, viewing or monitoring the conversations rolling down their screens. Lambda is a place to see and be seen in.

Being 'seen' works on another level too. Any player can 'look up' another by calling up their description. The extract below is typical. A look up is acknowledged ('gawking unabashed' is interpolated into the text) and

re-acknowledged (with the comment 'gaining new insights?'). A third person joins in (Tassie . . .) thus opening up the conversation. The original player then morphs – striking a new pose and inviting re-investigation of his appearance but also eluding the original look. And finally a new arrival provides the prospect of a new round of cyber-gazing:

> Blue Guest is gawking unabashed at Miraculux
> Tassie says; yeah ask him
> Miraculux [to Blue Guest] gaining new insights?
> Miraculux grins at you
> Blue Guest grins back, unbashfully
> Tassie smiles bashfully
> Miraculux's body shifts and changes as he turns into Leporello
> Leporello [to Tassie] did I miss your answer? what did you major in?
> Magadan teleports in.

Lambdans are thus at once the subject and the object of a virtual gaze. Voyeurism is part of the structure of life on-line.

Around the bare bones of this activity – of moving, speaking, looking – Lambdans flesh out more elaborate identities. Entrances and exits, for instance, can be rewritten to reflect a player. Entrances range from the hyperbolic: 'With a flash of light, and the sound of a woman's screaming orgasm, G-Spot makes his entrance.' To the hyper-feminine: 'With a soft swirl of colour, Bluesy paints herself into the living room'. To the belligerent: 'Pretty Hate Machine is here now. Get Used To It.'

Everyday life in Lambda is also about colonizing space: Digging (constructing) a room in lambda is to command a frame in which to stand. These private textual spaces express identity. [The following] room says more about Bara – and his/her gender – than his/her description:

> Neuterworld
> A bland, white room. Clean air is sucked into your nostrils and unclean exhalation is sucked out of the room through the huge roof mounted extractor fan. A sense of peace pervades the entire room. Bara is here.
> Bara
> A tall, dark individual of slight build. This person is curious in that it is impossible for you to tell whether it is male or female!
> It is sleeping.

Patrolling the internal borders of these virtual worlds Lambdans may defend 'their' spaces, refusing admission to those who become unwelcome. Ejections can be re-worked with attitude:

> Shockadelica's Monasteryo draws back and spits you out of the room.

541

You begin to move into the room but encounter some resistance. With a snap you're catapulted back where you came from. Either Quimby doesn't want to go, or Surreal Estate didn't accept her.

Talking a world

Conversation is also many layered. Talking or 'saying' may be general or directed in various ways: for instance to 'stage-talk', as the name suggests, is a kind of public exhibition of directed conversation – which may be intercepted by a third party. 'Emoting' takes display further. This form of virtual gesture allows players to express their relation to each other in 'physical' terms. Dancing, which is popular in Lambda, is an example of this form of interaction. The 'forbidden dance' is, naturally, the lambada:

> . . . Beta requests an orchestra with violins, double bass, and drums.
> Mr Spunky hands Buffy a rose which he places between his teeth. Then Buffy leads Mr Spunky through a rhythmic tango, stepping across the floor and ending with Mr Spunky holding Buffy in a low dip.
> Beta begins to dance
> Aphra begins to dance
> Buffy grabs Beta, as a heavy Latin beat begins. Buffy and Beta do the forbidden dance.
> Buffy dopes the Monster Mash. You catch on a flash and join in this graveyard smash.
> Mr Spunky and Buffy bang their heads together.
> Beta spins wildly.

Emoting is often 'physically' intimate. Emotes may be consensual or not. They may involve sex or sexual harassment which is banned on Lambda as its on-line Help file explains: 'Sexual harassment (particularly involving unsolicited acts which simulate rape against unwilling participants . . . is not tolerated by the Lambda community. A single incidence . . . may result . . . in permanent expulsion from LambdaMOO.' Lambdans will 'hug' and 'lick', 'bite', tickle' or 'poke' each other on slight acquaintance. Actions performed on virtual bodies may be casually (and playfully) violent: variously, 'Coolkat kills a guest', 'Catholic schoolgirl is prodded with an electric cattleprod', 'Remy-lebeau eats halo'.

On Lambda conversations are punctuated by – and sometimes largely consist of – an emoted cycle of display, greeting and acknowledgement. Players, in other words, repeatedly perform themselves to each other. Within these tactile dialogues, threads of more direct conversation are often dislocated. Direct speech on Lambda often becomes parodic and may be regarded as another form of exhibition. The priority in this cyberspace is the continual on-going, reiterated performance of 'being someone', of being a cyber-

subject. Many of the actions of its inhabitants can be understood in terms of 'making one's presence felt'.

Comprised of a 'thin film of writing' (see de Certeau, above), it is clear Lambda is nonetheless a spatial practice. Identity is played out in terms of the visibility and motility, of virtual bodies placed 'in relation to' one another.

Ritual: stamp three times

Lambdans assert individual identity in the context of a set of collective practices, embellishments, rituals, and codes. Many common activities here are flagged via a series of recurring statements, which are embedded into the conversation patterns of different rooms. For instance, if I type @home what will appear on the screen is '[Caroline] stamps her feet three times . . .'. Lambda invokes these strings, and while they can be edited by players, there is always a stream of 'newbies' and guests who haven't got round elaborating themselves. They will always be seen to 'stamp their feet three times' to leave. Similarly morphing is always 'sudden' and states of being [are] always 'asleep', 'distracted', or 'awake and looks alert'. And users 'pass out' if they disconnect suddenly. These phrases, and others like them, form part of the general texture of life here.

Other rituals based on objects or actions apply in specific rooms. For example, everyone always lands in the Hot Tub with a Splash!, the house-keeper always arrives to clean up disconnected bodies in the Living Room, and the cockatoo which lives there can be gagged (silenced) but always escapes eventually. Everyday activities on Lambda conform to expected patterns and tend to repeat.

Identity is thus performed collectively and individually in Lambda, and may be understood to be shaped by this production. But cyber-identity is also something consciously assumed – and re-assumed – through the processes of naming, gendering and description which I examine below.

Naming

The Coat Closet is a dark, cramped space. It appears to be very crowded in here; you keep bumping into what feels like coats, boots, and other people (apparently sleeping) . . .

In a peculiar inversion whereby Real Life becomes the dream, named players never leave Lambda; their 'sleeping' shadows are stored in the crowded Coat Closet or in their own rooms between sessions on-line. To acquire a name on Lambda is therefore to invest in a continuous identity – albeit one that may be recycled.

Guests, by contrast, have no permanent identity and are 'by definition nondescript' as the Lambda help code explains. Allocated a temporary name (like Red Guest or Blue Guest) as they log-on, guests tend to be regarded with suspicion. They are outsiders to the subculture and not always warmly welcomed, particularly if they demand attention. [For example] this exchange is typical:

> Olive Guest says: We could go to the abattoir and have a quiet conversation.
> Tetani [to Olive Guest] Do I know you?

Guests can take advantage of their shadowy status to disrupt threads with 'spamming' (inserting and re-inserting large amounts of text or line endings into conversations and thereby disrupting them), or to attack other guests or players. They are not properly a part of the Lambdan social contract; their exclusion underlines the fact that Lambda is a consensual reality, a negotiated subculture.

Finally, names are not only signs of membership, they suggest something about the way identity plays out here. In the absence of any form of visual representation, a name constitutes a first 'appearance'. The poverty of the medium – and high 'noise' levels within continually fragmenting conversations – tends to demand hyperbole. It is not unusual in Lambda to stumble across Hannibal Lecturer in conversation with Ethelred the Unready, or susan smith in communion with the ShotGun Messiah.

Doing gender

> What should I do first? Give yourself a description and a gender –
> (README for NewMooers):

To change gender on Lambda is the work of a single phrase: @gender me <female/male/other>. Player's descriptions sit behind names. They build on the basic name/gender skeleton, and are fundamental to 'doing gender' on Lambda. They are invoked and re-invoked as players come across each other in various parts of the MOO. Typing 'Look BloodLust' produces this:

> BloodLust
> A pair of deep blue eyes stare out at you coldly from an angular face framed by long wavy auburn hair and you shiver and sense that you are being probed. Her skin is amazingly pale and is flawless. She senses your eyes on her and she turns to gaze at you. She flashes a smile, and you notice two wicked looking fangs where normal incisors would be. She runs her tongue over her lips as she closes her mouth, and you notice her eyeing you lustily.

> She is wearing a long garnet evening dress that shimmers in the light. It is strapless and shows a modest amount of cleavage, enough to leave something to the imagination. The skirt seems to fade from clear to opaque, showing off her well formed legs. She is awake and looks alert.

BloodLust is a vampire, one of a score who appear regularly on Lambda. It transpires that in Real Life this lesbian vamp(ire) may be a man. She disputes it. Clearly, Lambda enables certain gender-crossings.

There are nine genders in Lambda including neuter, male, female, either, Spivak (described as 'an indeterminate gender'), splat, plural, egotistical, royal or 2nd – offered in that (non-alphabetical) order by Lambda Help. Exploiting these possibilities some Lambdans adopt genders which fall outside of the male/female binary. Peri, for instance, is Spivak, a gender which has as its pronouns e, eir, and eis.

> Look Peri
> The legendary tweaky spiv. oddly smirky
> E looks content, and eir eyes beam at you with a kind of amusement . . . the black suede mini hugs Peri's hips and barely covers eir crotch, black suede glistening in the light or lack there of. Carrying bodysuit, nipple clamps . . .
> E carries a #note on Eir gender in Real Life . . .

With the exception of neutrality, widely adopted by guests, and often regarded as a decision to conceal gender, these 'other' genders are relatively rare. Some dispute virtual gender, or even, as here, refuse to recognize those with 'virtual-only' genders as 'real people':

> Teal Guest to Biogeek:
> Biogeek wonders if you are a boy or a girl
> You say, 'I'm neutral'
> Biogeek says, 'wrong answer'
> . . .
> Biogeek says, 'you can't be neutral'
> You say, 'what was the right answer?'
> Biogeek says, 'weell, on the moo you can be anything you want . . . but *I* don't talk to people who are only characters'
> Biogeek says: 'I only talk to real people˙ . . .'

Most Lambdans have a more tolerant view of others' gender choices, but the majority of this population place themselves firmly under the aegis of one of the two 'Real Life' genders – which are, of course, not necessarily 'their' Real Life gender. Gender-switching is part of the subcultural furniture in Lambda and other MUDs, with a long history which may be traced in the Net-based MUD archives and on MUD newsgroups.

Gender-switching is itself clearly a gendered practice. As these explorations on Lambda suggest, and as other studies confirm, substantial numbers of men switch to female positions (see Bruckman 1993). This appears to be partly to attract attention – as G-Spot, who might be described as a switch without the courage of his convictions suggests in his description:

> G-Spot
> I know . . . you wanted to see why the heck I would name myself after a controversial female sexual area. Well, it was to get your attention . . . and it has worked.
> Okay, enough of that crap. I stand 6'4 . . . pretty tall eh? . . .

Females, on the other hand, often gravitate to neutral positions, precisely to *avoid* unwanted attentions.

Female-presenting males are easy enough to spot on Lambda, hyper-femininity raises doubts for those who wish to entertain them. The following 'female' is almost certainly a gender-switch:

> Beige Guest
> One luscious babe, with a flowing mane of brilliant red hair, with crystal emerald eyes, and the most enchanting smile on earth.

Gender-switching does not always involve a deception. Some morphers cross gender-lines openly, but an important element of gender-switching is 'passing' – getting by without being un-masked. Gender checking is a recurrent theme in Lambda. For example, the 'outing' of an on-line female as male in RealLife is debated and disputed here:

> Kaneda [to BloodLust]: you aren't a girl . . . I hate to be the bearer of bad news but hey . . . gotta get my kicks somehow
> Aly Girl gasps in astonishment!
> mOnkEyWrEnCH falls over
> Allyse . . . drops her false teeth . . .
>
> Kassia holds up a BIG sign: BloodLust Are you a GIRL?
>
> Allyse [to Kassia]: yuppers. . .bloodlust is!!
> BloodLust heads homeward to the safety of her lair
> . . .
> Kaneda [To Allyse]:did I say something aloud? I can't remember. . . .

Gender-switching reveals a paradoxical attitude to gender on Lambda. Clearly gender is the nub of a cyber-identity both in terms of its adoption and performance, in so far as these may be separated. Yet it is simultaneously always understood as a possible fiction. The presence of gender-switching produces

a generalized uncertainty. This is true particularly where the on-line/off-line worlds – and virtual and real bodies converge – most obviously in the context of cybersex. This type of exchange is not uncommon:

> Pheromone [to Dahlia]: so are you bi or just straight IRL and playing on here?

Lambda may be regarded as a low-risk place to play out fantasies with an identity which may be discarded. On the other hand, all virtual sex here also carries with it a certain anxiety. It is an event with a stranger of uncertain anatomy, whose Real Life appearance is unknown. Sexual experience – virtual or not – affects the participant beyond the act itself. Despite the conformity of its denizens, Lambda thus potentially disorganizes desire.

@Describe me as: electronic females

The female gender on Lambda is an exaggerated phenomenon. Hyper-femininity takes various forms. These 'women' display themselves in the third person, with a battery of physical features. They tend to present themselves as the object of a sexual gaze. For example:

> Wild Strawberry
> You see before you, a caring young female of about 18. She is extremely playful and loves to have fun. She has long blonde hair hanging about her face and light hazel eyes. She stands about 5' 8 and is wearing a purple satin nightie, which barely covers her soft white skin. She may seem a bit wild at first, but then again she is Wild Strawberry.

Mystery emerges as a trait in many females and may be regarded as a (somewhat uniform) search for distinction. Xaviera is an explicit example:

> Xaviera
> A mysterious looking woman with black hair which falls in curls down her back. Her eyes flash, and the color seems to change every time. One minute they are bright green, the next dark brown. She has full, red lips and her smile implies a secret only she knows. She is dressed in a deep purple shift made of silk and black, furry heels.

Female descriptions tend to foreground gender, many focus on desire, and the vast majority focus on the body, on body fragments (like long hair, eyes, lips), or on bodily 'accessories' (like clothes or shoes).

There are exceptions. crayon's description, for instance, amounts to a call to exploit the malleability of cyberspace to reconfigure sexual divisions – and body parts. Contra Lacan (1977), she demands to be a woman *and* have the phallus:

crayon
Try this in Real Space . . . Crayons are found in their natural state in
a short phallic cylinder, but because of their malleable waxy substance
are often transformed into various images . . . A crayon is an omnipo-
tent tool when used correctly and wisely.

Electronic males

Not put off by their lack of a physical body, many Lambdan men are tall.
Whether biker, angel, 'beefcake', or 'just a man from Pennsylvania' – they
tend to be just over six foot, with striking eyes. They are, quite literally,
larger than life. For instance:

Uriel
Uriel has yellow flaming blonde hair, and eyes of glowing blue. He
stands just over six feet tall . . .

the Wicked
This man is verry wicked. He is 6' 5 and wearing a verry long black
trench coat . . .

Males' descriptions divide more evenly between theatrical display and evasion.
Some deflect the gaze back to the looker – when they can read like Lonely
Hearts 'Wanted' columns, as here:

Snow Crash
He is a man of silence, a dreamer, one who has been dealt all bad
cards, hoping to find the wild card in the deck . . .
 That wild card would be a certain someone, could be a certain
you. He is a romantic, yet he is subdued, shy. Is it a shell to be broken?
It's going to take two to break it. He is sensitive, but tells you some-
thing: it brings more pain than happiness. He dreams of love, of power
in the written word, and of digital mastery. You listen for his word .
. .you hear his over-bearing trademark: silence. If one needs a helping
hand, or has feelings that need to be shared, he is there, the Listener.
Let us go forth, for I am one tired of shrinking back. . . .

A substantial group of males on Lambda avoid a physical description
entirely. These males often hide behind fantasy or cyberpunk 'roles'
(Snowcrash, Ford Prefect, Neuromancer, for example) or they may step
'around' themselves by referring to interests, competencies, or even laziness:

weird
Bodysurf all day, cybersurf all nite
weird's size is medium right now.

Hookleg
British, mid 20s too lazy to write a longer description.

Other males elude a virtual anatomy by becoming animals or inanimate objects. These evasions don't rule out hyper-masculinity. On the contrary:

> Cyberferret is a ferret . . . with several cybernetic implants. One leg is bionic, and his entire skeletal system is made of titanium. He is looking for something to KILL!

Virtual bodies?

Gender on Lambda is clearly theatrical. Lambda is an overheated place. Identity here, viewed through Lambdans accounts of themselves, is a highly stylized and ritualized affair, saturated with gender. Overall, these descriptions are striking for their extreme conformity. Lambdans create and re-create themselves as gendered archetypes: troops of long-haired women are counterposed by gangs of tall men with piercing eyes; virgins and whores face poets and athletes; vampires face dreamers; and slavers, their slaves.

It is noticeable that Lambda's virtual population re-creates itself as overwhelmingly white. And in the absence of the evidence of bodies, Lambdans with few exceptions, also present themselves as uniformly young. In this sense, Butler's insistence that performativity is the power of *discourse*, rather than the authority of the volitional 'subject', to produce and reproduce the gender it names, is germane. Butler argues gender performance occurs in the context of gender performativity: 'The understanding of performativity not as the act by which a subject brings into being what she/he names, but, rather, as that reiterative power of discourse to produce the phenomena that it regulates and constrains' (1993: 2). It is in this sense that gender norms may clearly be seen to have mobilized these subjects. To say '@gender me female' is to be interpellated into a gender – to perform beneath its mark. Even in cyberspace gender is, in this sense, compelled.

In these gender performances, Lambda therefore suggests that gender is a category, is an imitation, a regulatory ideal that is impossible to achieve fully *precisely because it is an ideal*. Here, at the limits of approximation, gender itself tends paradoxically, to both heighten and fragment. Detached from bodies, transmogrified into cyberspace, a process repeatedly enacted by the stream of individuals connecting to Lambda, gender emerges as an artificial construct. The mythical 'gender core' becomes a collection of virtual body parts, objects, attributes, limbs, clothes, hair, eyes, cloth. The twist in this tale is that, in so far as virtual bodies materialize into cyberspace, they may be understood to be mobilized by gender norms, rather than gendered essences.

To conclude, cyberspace demands a reconsideration of the workings of gender and identity. As Butler points out in relation to drag: 'From a

self-consciously de-naturalized position we can see how the appearance of naturalness is constituted' (Butler 1993: 110).

The virtual grounds of Lambda provide a peculiarly 'de-natural' zone. Via a technologically mediated rupture, Lambda works a disturbance in the smooth operation of sex/gender norms. Undermining those common-sense assumptions or 'regulatory fictions' – that sex, gender and the trajectory of desire follow automatically the one from the other, in a circuit initiated by biology, the small world of Lambda provides spaces for disruption, for the possibility of gender-play, and for the emergence of new forms of multiple subjectivity. Amongst the invincible, virtual bodies of LambdaMOO gendered relations play out differently.

Notes

1 I'd like to thank Sarah Thornton for reading, commenting on, and editing this article and Mandy Merck for supervising the original project. The mistakes, of course, are mine.

2 All quotations from Lambda were logged during twenty on-line sessions in May, June and July 1995. Each session lasted between one to four hours. I connected as a guest and as a player.

Bibliography

Abrams, M. (1959) *The Teenage Consumer*, London: London Press Exchange Ltd.

Ackerley, J.R. (1966) *My Father and Myself*, London: Bodley Head.

Ackroyd, Peter (1979) *Dressing Up: Transvestism and Drag*, New York: Simon and Schuster.

Adorno, Theodor (1968/1988) *Introduction to the Sociology of Music*, New York: Continuum.

Adorno, Theodor (1973) *Philosophy of Modern Music*, London: Seaburg.

Adorno, Theodor (1977) *Aesthetics and Politics*, London: New York Leht Books.

Adorno, Theodor (1981) 'Bach Defended Against His Devotees', *Prisms*, Cambridge, Mass.: MIT Press.

Adorno, Theodor (1991) *The Culture Industry*, London: Routledge.

Alarik, Scott (1989) 'Jim Bailey's Triumphant Turn as Judy Garland', *Boston Globe*, 8 June.

Allen, Robert J. (1933) *The Clubs of Augustan England*, Cambridge, Mass.: Harvard Studies in English.

Althusser, Louis (1969) *For Marx*, New York: Allen Lane.

Althusser, Louis (1971) 'Ideology and the State', *Lenin and Philosophy and Other Essays*, London: New Left Books.

Amit-Talai, Vered and Wulff, Helena (1995) *Youth Cultures: A Cross-Cultural Perspective*, London: Routledge.

Anderson, Nels (1923) *The Hobo*, Chicago: University of Chicago Press.

Ang, Ien (1985) *Watching Dallas*, London: Routledge.

Anscombe, Isabelle (1978) *Punk*, New York: Urizen.

Arnold, David O. (ed.) (1970) *Subcultures*, Berkeley: The Glendessary Press.

Ashley, Leonard R.N. (1980) '"Lovely, Blooming, Fresh and Gay": The Onamastics of Camp', *Maledicta: the international journal of verbal aggression* 4 (2).

551

Auster, Albert (1989) *Actresses and Suffragists: Women in American Theatre, 1890–1920*, New York: Praeger.

Austin, J.L. (1975) *How To Do Things With Words*, Oxford: Clarendon Press.

Babcock, B. (1978) *The Reversible World: Symbolic Inversion in Art and Society*, Oxford: Clarendon Press.

Bacrach, P. and Baratz, M. (1962) 'The Two Faces of Power', *American Political Science Review* 56.

Bailey, P. (1978) *Leisure and Class in Victorian England*, London: Routledge and Kegan Paul.

Baker, Houston A., Jr. (1991) 'Hybridity, the Rap Race and Pedagogy for the 1990s', in Andrew Ross and Constance Penley (eds) *Technoculture*, Minneapolis: University of Minnesota Press.

Baker, Houston A., Jr. (1993) *Black Studies, Rap, and the Academy*, Chicago: University of Chicago Press.

Bakhtin, M.M. (1968) *Rabelais and His World*, trans. H. Iswolsky, Cambridge, Mass.: MIT Press.

Barnes, Richard (1980) *Mods!*, London: Eel Pie Publishing.

Barrett, L.E. (1977) *The Rastafarians*, London: Heinemann.

Barthes, Roland (1971) 'Rhetoric of the Image', *Working Papers in Cultural Studies* 1 (University of Birmingham: Centre for Contemporary Cultural Studies).

Barthes, Roland (1972) *Mythologies*, New York: Paladin.

Barthes, Roland (1977) *Image–Music–Text*, ed. Stephen Heath, London: Collins.

Barthes, Roland (1983) *The Fashion System*, New York: Farrar Strauss & Giroux.

Bastide, R. (1978) *The African Religions of Brazil*, Baltimore and London: The Johns Hopkins University Press.

Becker, Howard S. (1963; rev. ed 1973) *Outsiders: Studies in the Sociology of Deviance*, New York: The Free Press.

Becker, Howard S. (ed.) (1964) *The Other Side: Perspectives on Deviance*, New York: The Free Press.

Becker, Howard (1967) 'Whose Side Are We On?', *Social Problems* xiv (3).

Becker, Howard (1982) *Art Worlds*, Berkeley: University of California Press.

Becker, Howard, Geer, Blanche, Hughes, Everett C. and Strauss, Anselm L. (1961) *Boys in White: Student Culture in Medical School*, Chicago: University of Chicago Press.

Becquer, Marcos and Gatti, José (1991) 'Elements of Vogue', *Third Text* 16/17: 65–81.

Belknap, Ivan (1956) *Human Problems of a State Mental Hospital*, New York: McGraw-Hill.

Bell, David, Binnie, John, Cream, Julia and Valentine, Gill (1994) 'All Hyped Up and No Place to Go', *Gender, Place and Culture* 1 (1).

Benjamin, Walter (1968) *Illuminations*, New York: Harcourt, Brace and World.

Benjamin, Walter (1973) *Charles Baudelaire: A Lyric Poet in the Era of High Capitalism*, London: New Left Books.

Benjamin, Walter (1978) *Reflections*, New York: Harcourt Press.

Bennahum, David (1994) 'Fly Me To The MOO: Adventures in Textual Reality', *Lingua Franca: The Review of Academic Life* 4 (4) (June).

Bennett, James (1981) *Oral History and Delinquency*, Chicago: University of Chicago Press.

Bennett, Tony, *et al.* (eds) (1981) *Culture, Ideology and Social Process: A Reader*, London: Open University Press.

Berger, Bennett (1963) 'The Sociology of Leisure', in E.O Smigel (ed.) *Work and Leisure*, New Haven: College and University Press.

Berger, Bennett (1991) 'Structure and Choice in the Sociology of Culture', *Theory and Society* 20.

Berger, P. and Luckman, T. (1964) 'Social Mobility and Personal Identity', *European Journal of Sociology*, 5.

Berghahn, M. (1977) *Images of Africa in Black American Literature*, London: Macmillan.

Berman, Marshall (1982) *All That is Solid Melts into Air*, New York: Simon and Schuster.

Besant, Walter (1912) *East London*, London: Chatto and Windus.

Bloch, E. *et al.* (1977) *Aesthetics and Politics*, London: New Left Books.

Bloch, Herbert and Niederhoffer, Arthur (1958) *The Gang: A Study in Adolescent Behavior*, New York: Philosophical Library.

Blum, L.H. (1966) 'The Discotheque and the Phenomenon of Alone-Togetherness', *Adolescence* 1.

Bogdanor, V. and Skidelsky, R. (eds) (1970) *The Age of Affluence 1951–1964*, London: Macmillan.

Boone, Pat (1967) *'Twixt Twelve and Twenty: Pat Boone Talks to Teenagers*, Englewood Cliffs, NJ: Prentice-Hall.

Booth, Charles (1903) *Life and Labour of the People of London: Notes on Social Influences*, London: Macmillan.

Booth, Mark (1983) *Camp*, New York: Quartet.

Bourdieu, Pierre (1984) *Distinction: A Social Critique of the Judgement of Taste*, Cambridge, Mass.: Harvard University Press.

Bourdieu, Pierre (1985), 'The Genesis of the Concepts of "Habitus" and "Field"', *Sociocriticism* 2 (2): 11–24.

Bourdieu, Pierre (1986) 'The Forms of Capital', in J. Richardson (ed.) *Handbook of Theory and Research for the Sociology of Education*, London: Greenwood Press.

Bourdieu, Pierre (1990) *In Other Words: Essays Towards a Reflexive Sociology*, Cambridge: Polity.

Bourdieu, Pierre (1991) 'Did You Say "Popular"?', *Language and Symbolic Power*, Cambridge: Polity.

Bourdieu, Pierre (1993) *Sociology in Question*, London: Sage.

Bourdieu, Pierre and Wacquant, Loic (1992) *An Invitation to Reflexive Sociology*, Cambridge: Polity.

Bradley, Marion Zimmer (1985) 'Fandom: Its Value to the Professional', in Sharon Jarvis (ed.), *Inside Outer Space: Science Fiction Professionals Look at their Craft*, New York: Frederick Ungar.

Bradshaw, P. (1981) 'A Big Sound System Splashdown', *New Musical Express*, 21 February.

Brake, Mike (1980) *The Sociology of Youth Culture and Youth Subcultures*, London: Routledge and Kegan Paul.

Brathwaite, E.K. (1984) *History and the Voice: The Development of Nation Language in Anglophone Caribbean Poetry*, London: New Beacon Press.

Brewer, John *et al.* (1983) *The Birth of a Consumer Society: The Commercialisation of Eighteenth-Century England*, London: Hutchinson.

Bruckman, Amy (1993) *Gender Swapping on the Internet*, presented to the Internet Society, San Francisco, ftp media.mitedu in pub/asb/papers/identity-workshop.

Bruckman, Amy and Resnick, M. (1993) *Virtual Professional Community: Results from MediaMoo*, ftp media. mit. edu in pub/MediaMoo/Papers/MediaMoo-3cyberconf.

Bruyn, Severyn T. (1966) *The Human Perspective in Sociology*, Englewood Cliffs, NJ: Prentice Hall.

Buff, Stephen (1970) 'Greasers, Dupers and Hippies: Three Responses to the Adult World', in L.K. Howe (ed.) *The White Majority: Between Poverty and Affluence*, New York: Random House.

Bulmer, Martin (1983) 'The Methodology of the Taxi-Dance Hall: An Early Account of Chicago Ethnography from the 1920s', *Urban Life* xii (1).

Burke, P. (1978) *Popular Culture in Early Modern Europe*, London: Temple Smith.

Burke, P. (1980) *Sociology and History*, London: George Allen and Unwin.

Bushnell, John (1990) *Moscow Graffiti: Language and Subculture*, Winchester, Mass.: Unwin Hyman.

Butler, Judith (1990a) *Gender Trouble*, London: Routledge.

Butler, Judith (1990b) 'Gender Trouble, Feminist Theory, and Psychoanalytic Discourse', in Linda J. Nicholson (ed.) *Feminism/Postmodernism*, London: Routledge.

Butler, Judith (1991) 'Imitation and Gender Insubordination', in Diane Fuss (ed.) *Inside Out*, London: Routledge.

Butler, Judith (1993) *Bodies That Matter*, London: Routledge.

Cain, Arthur (1967) *Young People and Sex*, New York: The John Day Co.

Cameron, William B. (1954) 'Sociological Notes on the Jam Session', *Social Forces*, 33 (December): 177–82.

Campbell, Anne (1981) *Girl Delinquents*, Oxford: Basil Blackwell.

Campbell, Anne (1984) *The Girls in the Gang*, New York: Basil Blackwell.

Carr, Ian, Case, Brian and Dellar, Fred (1986) *The Hip: Hipsters, Jazz and the Beat Generation*, London: Faber & Faber.

Carson, T. (1981) 'The David Johansen Story', *Village Voice* 8–15 July.

Carter, Erica (1979) 'Alice in Consumer Wonderland', in Angela McRobbie and Mica Nava (eds) *Gender and Generation*, London: Macmillan.

Case, Sue-Ellen (1989) 'Toward a Butch-Femme Aesthetic', in Lynda Hart (ed.) *Making a Spectacle*, Ann Arbor: University of Michigan Press.

Castleman, Craig (1982) *Getting Up: Subway Graffiti in New York*, Cambridge, Mass.: MIT Press.

Chambers, Iain (1986) *Popular Culture: The Metropolitan Experience*, London: Methuen.

Chesney, Kellow (1970) *The Victorian Underworld*, London: Temple Smith.

Chester, L., Leitch, D. and Simpson, C. (1977) *The Cleveland Street Affair*, London: Weidenfield and Nicholson.

Chibnall, Steve (1985) 'Whistle and Zoot: The Changing Meaning of a Suit of Clothes', *History Workshop Journal* 20: 56–81.

Clarke, Gary (1981) 'Defending Ski-Jumpers: A Critique of Theories of Youth Subcultures', in Simon Frith and Andrew Goodwin (eds) (1990) *On Record*, London: Routledge.

Clarke, John (1975) 'Style', in Stuart Hall and Tony Jefferson (eds) (1993) *Resistance Through Rituals*, London: Routledge.

Clarke, John (1978) 'Football and Working Class Fans: Tradition and Change', in R. Ingham *et al.* (eds) *Football Hooliganism: The Wider Context*, London: Interaction Imprint.

Clarke, John and Jefferson, Tony (1976) 'Working Class Youth Cultures', in G. Mungham and G. Pearson (eds) *Working Class Youth Culture*, London: Routledge and Kegan Paul.

Clarke, John *et al.* (1975) 'Subcultures, Cultures and Class', in Stuart Hall and Tony Jefferson (eds) (1993) *Resistance Through Rituals*, London: Routledge.

Clarke, S. (1980) *Jah Music*, London: Heinemann.

Clay, Mike (1988) *Cafe Racers: Rockers, Rock 'N' Roll and the Coffee Bar Cult*, London: Osprey.

Clifford, James (1983) 'On Ethnographic Authority', *Representations* 1(2): 118–46.

Clifford, James and Marcus, George (eds) (1986) *Writing Culture: The Poetics and Politics of Ethnography*, London: University of California Press.

Cloward, R. and Ohlin, L. (1960) *Delinquency and Opportunity: A Theory of Delinquent Gangs*, New York: The Free Press of Glencoe.

Coffield, Frank (1991) *Vandalism and Graffiti: The State of the Art*, London: Calouste Gulbenkian Foundation.

Cohen, Albert K. (1955) *Delinquent Boys: The Culture of the Gang*, New York: The Free Press.

Cohen, A.P. (1985) *The Symbolic Construction of Community*, London: Routledge.

Cohen, Phil (1972) 'Subcultural Conflict and Working Class Community', *Working Papers in Cultural Studies* 2 (University of Birmingham: Centre for Contemporary Cultural Studies).

Cohen, Phil (1979) 'Policing the Working Class City', in B. Fine *et al.*, *Capitalism and the Rule of the Law*, London: Hutchinson.

Cohen, Phil and Robins, Dave (1978) *Knuckle Sandwich: Growing Up in the Working Class City*, Harmondsworth: Penguin Books.

Cohen, Sarah (1991) *Rock Culture in Liverpool*, Oxford: Clarendon Press.

Cohen, Sarah (1993) 'Ethnography and Popular Music Studies', *Popular Music* xii (2).

Cohen, Stanley (ed.) (1971) *Images of Deviance*, Harmondsworth: Penguin Books.

Cohen, Stanley (1972; rev. edn 1980) *Folk Devils and Moral Panics: The Creation of the Mods and the Rockers*, Oxford: Martin Robertson.

Cohen, Stanley and Young, Jock (eds) (1973) *The Manufacture of News: Deviance, Social Problems and the Mass Media*, London: Constable.

Colette (1967) *The Pure and the Impure*, trans. Herma Briffault, New York: Farrar, Strauss & Giroux.

Collins, Jim (1990) *Uncommon Cultures*, London: Routledge.

Connor, Steve (1987) 'The Flag on the Road: Bruce Springsteen and the Live', *New Formations* 3.

Considine, J.D. (1981) 'REO + MOR = heavy metal pop', *Village Voice* 8–15 July.

Considine, J.D. (1984) 'Purity and Power', *Musician*, September.

Corrigan, Paul (1979) *Schooling the Smash Street Kids*, London: Macmillan.

Cosgrove, Stuart (1984) 'The Zoot Suit and Style Warfare', in Angela McRobbie (ed.) (1989) *Zoot Suits and Second-Hand Dresses*, London: Macmillan.

Cousins, M. and Hussain, A. (1984) *Michel Foucault*, London: Macmillan.

Cowan, Jane K. (1990) *Dance and the Body Politic in Northern Greece*, Princeton: Princeton University Press.

Cowie, C. and Lees, Sue (1981) 'Slags or Drags', *Feminist Review* 9.

Crane, Jonathan (1986) 'Mainstream Music and the Masses', *Journal of Communication Inquiry* X (3).

Cressey, Donald R. (1962) 'Role Theory, Differential Association and Compulsive Crimes', in A.M. Rose (ed.) *Human Behavior and Social Process*, Boston: Houghton Mifflin Co.

Cressey, Paul G. (1932) *The Taxi-Dance Hall*, New York: Greenwood Press.

Cressey, Paul G. (1983) 'A Comparison of the Roles of the "Sociological Stranger" and the "Anonymous Stranger"' in Field Research', *Urban Life*, 12 (1).

Crimp, Douglas with Rolston, Adam (1990) *AIDS DemoGraphics*, Seattle: Bay Press.

Crow, Lester D. and Crow, Alice (1965) *Adolescent Development and Adjustment*, New York: McGraw-Hill.

Cubitt, Sean (1984) 'Maybellene: Meaning and the Listening Subject', in R. Middleton and D. Horn (eds) *Popular Music: A Yearbook: Performers and Audiences*, London: Cambridge University Press.

Cummings, Scott and Monti, Daniel J. (eds) (1992) *Gangs: The Origins and Impact of Contemporary Youth Gangs in the United States*, New York: State University of New York Press.

Curtis, Pavel (1992) *Mudding: Social Phenomena in Text-Based Virtual Realities*, parcftp.xerox.com in pub/Moo/papers/MUDS Grow UP.

Curtis, Pavel (n.d.) *New Directions*, parcftp.xerox.com in pub/Moo/papers/MUDS Grow UP.

Curtis, Pavel and Nichols, D. (1993) *MUDS Grow Up: Social Virtual Reality in the Real World*, parcftp.xerox.com in pub/Moo papers/MUDS Grow UP.

D'Acci, Julie (1988) *Women, 'Woman' and Television: The Case of Cagney and Lacey*, Ph.D. dissertation University of Wisconsin, Madison.

D'Arch Smith, Timothy (1970) *Love in Earnest*, London: Routledge and Kegan Paul.

D'Emilio, John (1983) *Sexual Politics, Sexual Communities: The Making of a Homosexual Minority in the United States 1940–1970*, Chicago: University of Chicago Press.

Daniel, S. and McGuire, P. (eds) (1972) *The Paint House: Words from an East End Gang,* Harmondsworth: Penguin Books.

Davis, N.Z. (1975) *Society and Culture in Early Modern France*, Stanford: Stanford University Press.

Davis, Nanette J. (1971) 'The Prostitute: Developing a Deviant Identity', in James M. Henslin (ed.) *Studies in the Sociology of Sex*, New York: Appleton-Century-Crofts.

Davison, Graeme, Dunstan, David and McConville, Chris (eds) (1985) *The Outcasts of Melbourne: Essays in Social History*, Sydney: Allen & Unwin.

De Certeau, Michel (1984) *The Practice of Everyday Life*, trans. S. Rendell, Berkeley: University of California Press.

De Certeau, Michel (1985) 'Practice of Space', in M. Blonsky (ed.) *On Signs*, Baltimore: Johns Hopkins University Press.

De Certeau, Michel (1990) *L'invention du quotidien. 1. arts de faire*, Paris: Gallimard (Folio).

Decker, Jeffrey Louis (1994) 'The State of Rap: Time and Place in Hip Hop Nationalism', in Andrew Ross and Tricia Rose (eds) *Microphone Fiends*, New York and London: Routledge.

De Laurentis, Teresa (1987) *Technologies of Gender*, Bloomingdale: Indiana University Press.

Derrida, Jacques (1974) *Of Grammatology*, Baltimore: Johns Hopkins University Press.

Détienne, M. (1979) *Dionysos Slain*, trans. M. Mueller and L. Mueller, Baltimore: Johns Hopkins University Press.

Devine, A. (1890) *Scuttlers and Scuttling*, Manchester: Guardian Printing Works.

DiMaggio, Paul (1979) review essay on Pierre Bourdieu, *American Journal of Sociology*, lxxxiv (6).

Docherty, David *et al.* (1988) *The Last Picture Show: Britain's Changing Film Audiences*, London: BFI Publishing.

Docherty, Thomas (1988) *Teenagers and Teenpics: The Juvenilization of American Movies in the 1950s*, London: Unwin Hyman.

Doty, Alexander (1993) *Making Things Perfectly Queer: Interpreting Mass Culture*, Minneapolis: University of Minnesota Press.

Douglas, Mary (1967) *Purity and Danger: An Analysis of the Concepts of Pollution and Taboo*, Harmondsworth: Penguin Books.

Douglas, Mary (1991) 'The Idea of a Home: A Kind of Space', *Social Research* 58 (1).

Douglas, Mary and Isherwood, Baron (1979) *The World of Goods: Towards an Anthropology of Consumption*, London: Allen Lane.

Downes, D.M. (1966) *The Delinquent Solution*, London: Routledge and Kegan Paul.

Downes, D. and Rock, P. (1982) *Understanding Deviance*, Oxford: Oxford University Press.

Dubin, R. (1962) 'Industrial Workers' Worlds', in A. Rose (ed.) *Human Behaviour and Social Processes*, London: Routledge and Kegan Paul.

Dubin, Steven (1983) 'The Moral Continuum of Deviancy Research: Chicago Sociologists and the Dance Hall', *Urban Life*, 12 (1).

Dunning, E., Murphy, P. and Williams, J. (1988) *The Roots of Football Hooliganism*, London: Routledge.

Durant, Alan (1984) *The Conditions of Music*, London: Macmillan.

During, Simon (ed.) (1993) *The Cultural Studies Reader*, London: Routledge.

Durkheim, Emile (1915) *The Elementary Forms of the Religious Life*, trans. J.W. Swain, New York: The Free Press.

Dyer, Richard (1979) 'In Defense of Disco', in Simon Frith and Andrew Goodwin (eds) (1990) *On Record*, London: Routledge.

Dyer, Richard (1987) 'Judy Garland and Gay Men', *Heavenly Bodies*, London: Macmillan.

Dyer, Richard (1991) *Now You See It*, London: Routledge.

Dyer, Richard (1992) *Only Entertainment*, London: Routledge.

Eagleton, Terry (1981) *Walter Benjamin: Towards a Revolutionary Criticism*, London: Verso.

Eagleton, Terry (1983) *Literary Theory*, Oxford: Blackwell.

Eco, Umberto (1972) 'Towards a Semiotic Enquiry into the Television Message', *Working Papers in Cultural Studies* 3 (University of Birmingham: Centre for Contemporary Cultural Studies).

Eco, Umberto (1973) 'Social Life as a Sign System', in D. Robey (ed.) *Structuralism: The Wolfson College Lectures 1972*, London: Cape.

Egan, Pierce (1812) *Life in London*, London: Jones & Co.

Ellis, John (1982) *Visible Fictions*, London: Routledge.

Engels, Friedrich (1958) *The Condition of the Working Class in England*, ed. and trans. W.O. Henderson and W.H. Chaloner, Stanford: Stanford University Press.

Ehrenreich, Barbara (1990) *Fear of Falling: The Inner Life of the Middle Class,* New York: Harper Perennial.

Ehrenreich, Barbara, Hess, Elizabeth and Jacobs, Gloria (1992) 'Beatlemania: Girls Just Want to Have Fun', in Lisa A. Lewis (ed.) *The Adoring Audience*, London: Routledge.

Eisenstadt, S.N. (1956) *From Generation to Generation*, London: The Free Press.

Ernst, Max (1948) *Beyond Painting and Other Writing by the Artist and His Friends*, (ed.) B. Karpel, New York: Sculz.

Euromonitor (1989) *The Music and Video Buyers Survey: Tabular Report and Appendixes* (November).

Euromonitor (1990) 'Leisure Spending Among the Young', *Market Research Great Britain*, 31 (June).

Everhart, R.B. (1983) 'Classroom Management, Student Opposition and the Labor Process' in M. Apple and L. Weiss (eds) *Ideology and Practice in Schooling*, Philadelphia: Temple University Press.

Faderman, Lillian (1991) *Odd Girls and Twilight Lovers: A History of Lesbian Life in Twentieth Century America*, New York: University of Columbia Press.

Fadiman, Anne (1984) 'Heavy Metal Mania', *Life*, December.

Fairchild, Henry Pratt (ed.) (1944) *Dictionary of Sociology*, New York: Philosophical Library.

Farren, Mick (1985) *The Black Leather Jacket*, New York: Abbeville.

Feinbloom, D.H. (1976) *Transvestites and Transsexuals*, New York: Delta Books.

Ferguson, Dean (1991) 'HiNRG/Eurobeat', *Dance Music Report* 24: 38.

Finnegan, Ruth (1989) *The Hidden Musicians: Making Music in an English Town*, Cambridge: Cambridge University Press.

Fischer, Michael M. J. (1986) 'Ethnicity and the Post-Modern Arts of Memory', in James Clifford and George Marcus (eds) *Writing Culture*, Berkeley: University of California Press.

Fletcher, C.L. (1966) 'Beats and Gangs on Merseyside', in T. Raison (ed.) *Youth in New Society*, London: Hart-Davis.

Flores, Juan (1994) 'Puerto Rican and Proud, Boyee!: Rap Roots and Amnesia', in Andrew Ross and Tricia Rose (eds) *Microphone Fiends*, New York and London: Routledge.

Folb, Edith A. (1980) *Runnin' Down Some Lines: The Language and Culture of Black Teenagers*, London: Harvard University Press.

Fornas, Johan, Lindberg, Ulf and Sernhede, Ove (1995) *In Garageland: Rock, Youth and Modernity*, London: Routledge.

Forster, E.M. (1975) *The Life to Come and Other Stories*, Harmondsworth: Penguin Books.

Foucault, Michel (1965) *Madness and Civilisation: A History of Insanity in the Age of Reason*, trans. Richard Howard, New York: Random House.

Foucault, Michel (1977) *Language/Counter-Memory/Practice*, ed. D.F. Bouchard, trans. D.F. Bouchard and S. Simon, Ithaca: Cornell University Press.

Foucault, Michel (1978a) *The History of Sexuality: An Introduction*, trans. Robert Hurley, Harmondsworth: Penguin Books.

Foucault, Michel (ed.) (1978b) *I, Pierre Riviere . . .*, Harmondsworth: Penguin Books.

Foucault, Michel (1979a) *Discipline and Punish: The Birth of the Prison*, trans. Alan Sheridan, New York: Vintage.

Foucault, Michel (1979b) 'On Governmentality', *Ideology and Consciousness* 6.

Foucault, Michel (1980a) *Power/Knowledge: Selected Interviews and Other Writings 1972–1977*, New York: Pantheon.

Foucault, Michel (1980b) *Herculine Barbin, Being the Recently Discovered Memoirs of a Nineteenth-Century Hermaphrodite*, New York: Colophon.

Foucault, Michel (1982) 'The Subject and Power', in H. Dreyfus and P. Rabinow (eds) *Michel Foucault*, Brighton: Harvester.

Francis, Connie (1962) *For Every Young Heart*, Englewood Cliffs, NJ: Prentice Hall.

Friedan, Betty (1963) *The Feminine Mystique*, New York: W.W. Norton.

Frith, Simon (1980) 'Music for Pleasure', *Screen Education* 34: 51–61.

Frith, Simon (1981a) *Sound Effects: Youth, Leisure and the Politics of Rock 'n' Roll*, New York: Pantheon.

Frith, Simon (1981b) '"The Magic That Can Set You Free": The Ideology of Folk and the Myth of the Rock Community', *Popular Music* 1.

Frith, Simon (1986) 'Art Versus Technology: The Strange Case of Popular Music', *Media, Culture and Society* 8 (3).

Frith, Simon (1988a) *Music for Pleasure*, London: Polity.

Frith, Simon (ed.) (1988b) *Facing the Music*, New York: Pantheon.

Frith, Simon (1991) 'Anglo-America and its Discontents', *Cultural Studies* 5 (3).

Frith, Simon (1992) 'The Cultural Study of Music', in L. Grossberg *et al.* (eds) *Cultural Studies*, London: Routledge.

Frith, Simon and Goodwin, Andrew (eds) (1990) *On Record: Rock, Pop, and the Written Word*, London: Routledge.

Frith, Simon and Horne, Howard (1987) *Art into Pop*, London: Methuen.

Frow, John (1987) 'Accounting for Tastes: Some Problems in Bourdieu's Sociology of Culture', *Cultural Studies* 1 (1).

Fuss, Diana (ed.) (1991) *Inside/Out: Lesbian Theories, Gay Theories*, London: Routledge.

Fyvel, T.R. (1961) *The Insecure Offenders: Rebellious Youth in the Welfare State*, London: Chatto and Windus.

Gaines, Donna (1991) *Teenage Wasteland: Suburbia's Dead End Kids*, New York: Pantheon.

Galbraith, J.K. (1962) *The Affluent Society*, London: Penguin Books.

Gans, Herbert J. (1974) *Popular Culture and High Culture*, New York: Basic Books.

Garber, Marjorie (1992) *Vested Interests: Cross-Dressing and Cultural Anxiety*, London and New York: Routledge.

Garnham, Nicholas (1993) 'Bourdieu, the Cultural Arbitrary and Television', in C. Calhoun *et al.* (eds) *Bourdieu: Critical Perspectives*, Oxford: Polity.

Garnham, Nicholas and Williams, Raymond (1986) 'Pierre Bourdieu and the Sociology of Culture', in R. Collins *et al.* (eds) *Media, Culture and Society: A Critical Reader*, London: Sage.

Gayle, Carl (1974) Survey, *Black Music*, 1 (8).

Geertz, Clifford (1964) 'Ideology as a Cultural System', in D.E. Apter (ed.) *Ideology and Discontent*, New York: The Free Press.

Geiss, I. (1974) *The Pan-African Movement*, London: Methuen.

George, Nelson *et al.* (eds) (1985) *Fresh: Hip Hop Don't Stop*, New York: Random House.

Gibson, Ian (1978) *The English Vice: Beating, Sex and Shame in Victorian England and After*, London: Duckworth.

Giddens, Anthony (1964) 'Notes on the Concepts of Play and Leisure', *Sociological Review*, 12 (1).

Gilbert, J. (1986) *A Cycle of Outrage: America's Reaction to the Juvenile Delinquent in the 1950s*, New York: Oxford University Press.

Gillett, C. (1972) 'The Black Market Roots of Rock', in R.S. Denisoff and R.A. Peterson (eds) *The Sounds of Social Change: Studies in Popular Culture*, Chicago: Rand McNally.

Gilroy, P. and Lawrence, E. (1982) 'Two-tone Britain: Black Youth, White Youth and the Politics of Anti-racism', in H.S. Bains and P. Cohen (eds) (1988) *Multi-Racist Britain*: London: Macmillan Education.

Gilroy, Paul (1987) *There Ain't No Black in the Union Jack: The Cultural Politics of Race and Nation*, London: Unwin Hyman.

Gilroy, Paul (1993a) 'Between Afro-centrism and Euro-centrism: Youth Culture and the Problem of Hybridity', *Young: Nordic Journal of Youth Research* 1 (2): 2–13.

Gilroy, Paul (1993b) *Small Acts: Thoughts on the Politics of Black Cultures*, London: Serpent's Tail.

Gilroy, Paul (1993c) *The Black Atlantic*, London: Verso.

Glaser, B.G. and Strauss, A.L. (1979) 'Discovery of Substantive Theory: A Basic Strategy Underlying Qualitative Research', in W.J. Filstead (ed.) *Qualitative Methodology*, Chicago: Markham Pub. Co.

Gluckman, Max (1956) *Custom and Conflict in Africa*, Oxford: Blackwell.

Goffman, Erving (1961) *Asylums: Essays on the Social Situation of Mental Patients and other Inmates*, New York: Anchor Books, Doubleday & Co.

Goffman, Erving (1963) *Behavior in Public Places*, New York: The Free Press.

Goffman, Erving (1971a) *Relations in Public*, London: Allen Lane.

Goffman, Erving (1971b) *The Presentation of Self in Everyday Life*, Harmondsworth: Penguin Books.

Goffman, Erving (1974) *Frame Analysis*, Cambridge, Mass.: Harvard University Press.

Goldin, Hyman E. *et al.* (1950) *Dictionary of American Underworld Lingo*, London: Constable.

Goode, Erich (1970) *The Marihuana Smokers*, New York: Basic Books.

Goodman, Paul (1960) *Growing Up Absurd: Problems of Youth in the Organised Society*, New York: Random House.

Goodwin, Andrew (1990) 'Sample and Hold: Pop Music in the Digital Age of Reproduction', in Simon Frith and Andrew Goodwin (eds), *On Record*, London: Routledge.

Gordon, Milton (1947) 'The Concept of the Sub-Culture and its Application', *Social Forces* (October).

Gordon, Milton (1964) *Assimilation in American Life*, New York: Oxford University Press.

Gotfrit, Leslie (1988) 'Women Dancing Back: Disruption and the Politics of Pleasure', *Journal of Education* 170 (3).

Gottlieb, Joanne and Wald, Gayle (1994), 'Smells Like Teen Spirit: Riot Grrrls, Revolution and Women in Independent Rock', in Andrew Ross and Tricia Rose (eds) *Microphone Fiends*, New York and London: Routledge.

Gramsci, Antonio (1971) *Selections from the Prison Notebooks*, New York: Lawrence and Wishart.

Graves, T. S. (1923) 'Some Pre-Mohock Clansmen', *Studies In Philology*, 20.

Green, Arnold W. (1946) 'Sociological Analysis of Horney and Fromm', *The American Journal of Sociology* 51 (May).

Gross, Larry (1993) *Contested Closets: The Politics and Ethics of Outing*, Minneapolis: University of Minnesota Press.

Grossberg, Lawrence (1982) 'Experience, Signification and Reality: The Boundaries of Cultural Semiotics', *Semiotica* 41: 73–106.

Grossberg, Lawrence (1983) 'The Politics of Youth Culture: Some Observations on Rock and Roll in American Culture', *Social Text* 8: 104–26.

Grossberg, Lawrence (1984) 'Another Boring Day in Paradise: Rock and Roll and the Empowerment of Everyday Life', *Popular Music* 4: 225–58.

Grossberg, Lawrence (1987) 'The Politics of Music: American Images and British Articulations', *Canadian Journal of Political and Social Theory* xi (1 and 2).

Grossberg, Lawrence (1992) *We Gotta Get Out of This Place*, London: Routledge.

Grossberg, Lawrence *et al.* (eds) (1992) *Cultural Studies*, London: Routledge.

Grumley, Michael (1977) *Hard Corps: Studies in Leather and Sadomasochism*, New York: Dutton.

Hafner, Katie and Markoff, John (1991) *Cyberpunk: Outlaws and Hackers on the Computer Frontier*, London: Fourth Estate.

Hager, Steve (1984) *Hip Hop: The Illustrated History of Broadcasting, Rap Music, and Graffiti*, New York: St Martin's Press.

Hall, Radclyffe (1981) *The Well of Loneliness*, New York: Avon Books.

Hall, Stuart (1977) 'Culture, the Media and the "Ideological Effect"', in J. Curran *et al.* (eds), *Mass Communication and Society*, London: Edward Arnold.

Hall, Stuart (1980a) 'Cultural Studies: Two Paradigms', *Media, Culture and Society* 2.

Hall, Stuart (1980b) 'Encoding/Decoding', in Stuart Hall *et al.* (eds), *Culture, Media, Language*, London: Hutchinson.

Hall, Stuart (1981) 'Notes on Deconstructing "the Popular"', in Raphael Samuel (ed.), *People's History and Socialist Theory*, London: Routledge and Kegan Paul.

Hall, Stuart and Jefferson, Tony (eds) (1993) *Resistance Through Rituals: Youth Subcultures in Post-War Britain* , London: Routledge. (First published in 1975 as *Working Papers in Cultural Studies* 7/8).

Hall, Stuart and Whannel, Paddy (1964) *The Popular Arts*, London: Pantheon.

Hall, Stuart *et al.* (1978) *Policing the Crisis: Mugging, the State and Law and Order*, London: Macmillan.

Hall, Stuart *et al.* (eds) (1980) *Culture, Media, Language*, London: Hutchinson.

Hamblett, Charles and Deverson, Jane (1964) *Generation X*, London: Tandem Books.

Hamilton, William (1863/1895) 'On the Philosophy of Commonsense', *The Philosophical Works of Thomas Reid* vol. 2, Edinburgh: James Thin.

Hammersley, Martin and Atkinson, Paul (1983) *Ethnography: Principles and Practice*, London: Tavistock Publications.

Hargreaves, D. (1967) *Social Relations in a Secondary School*, London: Routledge and Kegan Paul.

Harris, Tim (1986) 'The Bawdy-House Riots of 1668', *Historical Journal* 24.

Harrison, T. (ed.) (1943) *The Pub and the People: A Worktown Study*, London: Victor Gollancz Ltd.

Harvey, John (1995) *Men in Black*, London: Reaktion Books.

Harvey, Lee (1987) *Myths of the Chicago School*, Aldershot: Avebury.

Hawkes, Terence (1977) *Structuralism and Semiotics*, London: Methuen.

Hay, Douglas *et al.* (1975) *Albion's Fatal Tree: Crime and Society in Eighteenth-Century Britain*, London: Allen Lane.

Hazzard-Gordon, Katrina (1990) *Jookin': The Rise of Social Dance Formations in African-American Culture*, Philadelphia: Temple University Press.

Hebdige, Dick (1974) 'Aspects of Style in the Deviant Sub-Cultures of the 1960's', *CCCS Stencilled Papers* (University of Birmingham), 20, 21, 24 and 25.

Hebdige, Dick (1975) 'The Meaning of Mod', in Stuart Hall and Tony Jefferson (eds) (1993) *Resistance Through Rituals*, London: Routledge.

Hebdige, Dick (1979) *Subculture: The Meaning of Style*, London: Methuen.

Hebdige, Dick (1981) 'Skinheads and the Search for White Working Class Identity', *New Socialist* 1.

Hebdige, Dick (1983a) 'Posing . . . Threats, Striking . . . Poses: Youth, Surveillance and Display', *SubStance* 37: 68–88.

Hebdige, Dick (1983b) 'Ska Tissue: The Rise and Fall of Two-Tone', in P. Simon and S. Davis (eds) *Reggae International*, London: Thames and Hudson.

Hebdige, Dick (1987a) 'The Impossible Object: Towards a Sociology of the Sublime', *New Formations* 1: 47–76.

Hebdige, Dick (1987b) *Cut 'n' Mix: Culture, Identity and Caribbean Music*, London: Comedia and Methuen.

Hebdige, Dick (1988) *Hiding in the Light*, London: Routledge.

Hechinger, Grace and Hechinger, Fred M. (1963) *Teen-Age Tyranny*, New York: William Morrow.

Henriques, Fernanda (1953) *Family and Colour in Jamaica*, London: Secker & Warburg.

Henry, Tricia (1989) *Breaking all the Rules: Punk Rock and the Making of a Style*, London: U.M.I Research Press.

Hentoff, N. (1962) *The Jazz Life*, London: P. Davies.

Herdt, Gilbert (1982) *Rituals of Manhood*, Berkeley: University of California Press.

Hirst, P.Q (1981) 'The Genesis of the Social', in *Politics and Power*, London: Routledge.

Hoare, I. (1975) 'Mighty, Mighty Spade and Whitey: Soul Lyrics and Black–White Crosscurrents', in I. Hoare *et al.* (eds) *The Soul Book*, London: Methuen.

Hobsbawm, Eric and Ranger, Terence (eds) (1983) *The Invention of Tradition*, New York: Cambridge University Press.

Hoggart, Richard (1957) *The Uses of Literacy*, London: Chatto and Windus.

Hoggett, Paul and Bishop, Jeff (1986) 'Leisure Sub-Cultures', in *Organising Around Enthusiasms: Patterns of Mutual Aid in Leisure*, London: Comedia Publishing Group.

Hollingshead, August B. (1949) *Elmstown's Youth: The Impact of Social Classes on Adolescents*, New York: John Wiley & Sons.

Hooker, Evelyn (1967) 'The Homosexual Community', in J.H. Gagnon and W. Simon (eds) (1967) *Sexual Deviance*, London: Harper & Row.

Huff, C. Ronald (ed.) (1990) *Gangs in America*, Newbury Park: Sage Publications.

Hughes, David (1964) 'The Spivs', in M. Sissons and P. French (eds) *The Age of Austerity 1945–51*, London: Penguin.

Hughes, Everett C. (1945) 'Dilemmas and Contradictions of Status', *American Journal of Sociology* 50 (5).

Hughes, Everett C. (1961) *Students' Culture and Perspectives: Lectures on Medical and General Education*, Lawrence, Kansas: University of Kansas Law School.

Hughes, Walter (1994) 'In the Empire of the Beat: Discipline and Disco', in Andrew Ross and Tricia Rose (eds) (1994) *Microphone Fiends*, New York and London: Routledge.

Huizinga, J. (1969) *Homo Ludens: A Study of the Play Element in Culture*, London: Paladin.

Humphreys, Anne (1977) *Travels into the Poor Man's Country: The Work of Henry Mayhew*, Athens, Georgia: University of Georgia Press.

Humphreys, Laud (1970) *Tearoom Trade: Impersonal Sex in Public Places*, Chicago: Aldine.

Humphreys, Laud (1972) *Out of the Closets: The Sociology of Homosexual Liberation*, New Jersey: Prentice Hall, Inc.

Humphries, S. (1985) *Hooligans or Rebels*, Oxford: Basil Blackwell.

Huxley, Aldous (1959) *The Doors of Perception and Heaven and Hell*, Harmondsworth: Penguin Books.

Huyssen, Andreas (1986) *After the Great Divide: Modernism, Mass Culture, Postmodernism*, Bloomington: Indiana University Press.

Hyde, H. Montgomery (1962) *The Trials of Oscar Wilde*, Harmondsworth: Penguin Books.

Hyde, H. Montgomery (1976) *The Cleveland Street Scandal*, London: Weidenfeld & Nicolson.

Irwin, J. (1973) 'Surfing: the Natural History of an Urban Scene', *Urban Life and Culture* 2 (2): 133–46.

Ivanov, V.V. (1976) 'The Significance of Bakhtin's Ideas on Sign, Utterance and Dialogue for Modern Semiotics', *Papers on Poetics and Semiotics* 4.

Jacobs, Harold (ed.) (1970) *Weathermen*, San Francisco: Ramparts Press.

Jameson, Fredric (1984) 'Postmodernism, or the Cultural Logic of Late Capitalism', *New Left Review*, 146.

Jameson, Fredric (1988) 'Cognitive Mapping', in C. Nelson and L. Grossberg (eds) *Marxism and the Interpretation of Culture*, Urbana: University of Illinois.

Janowski, Martin S. (1991) *Islands in the Street: Gangs and American Urban Society*, Berkeley: University of California Press.

Jay, Karla and Glasgow, Joanne (eds) (1990) *Lesbian Texts and Contexts: Radical Revisions*, New York: New York University Press.

Jefferson, Tony (1975) 'Cultural Responses of the Teds', in Stuart Hall and Tony Jefferson (eds) (1993) *Resistance Through Rituals*, London: Routledge.

Jenks, Chris (1993) *Culture*, London: Routledge.

Jenkins, Henry (1992) *Textual Poachers*, London: Routledge.

Johnson, Richard (no date) 'The Blue Books and Education 1816–96: the critical reading of official sources', Centre for Contemporary Cultural Studies, University of Birmingham (undated stencilled paper).

Jones, LeRoi (1963) *Blues People*, New York: Quill.

Jones, Simon (1986) *White Youth and Jamaican Culture*, unpublished Ph.D. thesis, Centre for Contemporary Cultural Studies, University of Birmingham.

Jones, Simon (1988) *Black Culture, White Youth: the Reggae Tradition from JA to UK*, London: Macmillan.

Kauffman, Robert Lane (1981) 'The Theory of the Essay: Lukács, Adorno and Benjamin', Ph.D. diss., University of California: San Diego.

Keating, P. (ed.) (1976) *Into Unknown England 1866–1913*, Manchester: Manchester University Press.

Keil, C. (1972) 'Motion and Feeling Through Music', in T. Kochman (ed.) *Rappin' and Stylin' Out: Communication in Urban Black America*, Chicago: University of Illinois Press.

Keil, Charles (1966) *Urban Blues*, Chicago: University of Chicago Press.

Kennedy, Elizabeth Lapovsky and Davis, Madeleine D. (1993) *Boots of Leather, Slippers of Gold: The History of a Lesbian Community*, London: Routledge.

Kerouac, Jack (1958) *The Subterraneans*, New York: Grove Press.

Kessel, N. and Walton, H. (1965) *Alcoholism*, Harmondsworth: Penguin Books.

Kimberley , N. (1982) 'Ska: How Jamaica Found a Sound of Its Own', *The Encyclopaedia of Rock* 5 (49).

King, Dave (1993) *The Transvestite and the Transsexual*, Aldershot: Avebury.

Kleidermacher, Mordechai (1991) 'Where There's Smoke . . . There's Fire!', *Guitar World*, February.

Kloosterman, Robert and Quispel, Chris (1990) 'Not Just the Same Old Show on My Radio: An Analysis of the Role of Radio in the Diffusion of Black Music Among Whites in the United States of America', *Popular Music* ix (2).

Knight, Nick (1982) *Skinhead*, London: Omnibus.

Kohn, Marek (1981) 'The Best Uniforms', in Angela McRobbie (ed.) (1989) *Zoot Suits and Second-hand Dresses*, London: Macmillan.

Kohn, Marek (1992) *Dope Girls: The Birth of the British Drug Underground*, London: Lawrence and Wishart.

Kopytko, Tania (1986) 'Breakdance as an Identity Marker in New Zealand', *Yearbook for Traditional Music* 18.

Kotarba, Joseph and Wells, Laura (1987) 'Styles of Adolescent Participation in an All-Ages Rock 'n' Roll Nightclub', *Youth and Society* 18 (4).

Krieger, Susan (1983) *The Mirror-Dance: Identity in a Woman's Community*, Philadelphia: Temple University Press.

Kristeva, Julia (1974; trans 1984) *The Revolution in Poetic Language*, trans. Margaret Walker, New York: Columbia University Press.

Kroker, Arthur and Kroker, Marilouise (eds) (1993) *The Last Sex: Feminism and Outlaw Bodies*, New York: St. Martin's Press.

Kruse, Holly (1993) 'Subcultural Identity in Alternative Music Culture', *Popular Music* 21 (1).

Lacan, Jacques (1977) *Écrits*, London: Tavistock.

Laclau, Ernesto (1990) *New Reflections on the Revolution of Our Time*, London: Verso.

Laclau, Ernesto and Mouffe, Chantal (1985) *Hegemony and Social Strategy: Towards a Radical Democratic Politics*, London: Verso.

Laing, Dave (1969) *The Sound of Our Time*, London: Sheed and Ward.

Laing, Dave (1978) 'Interpreting Punk Rock', *Marxism Today*, April.

Laing, Dave (1985) *One Chord Wonders: Power and Meaning in Punk Rock*, Milton Keynes: Open University Press.

Laing, Dave and Taylor, Jenny (1979) 'Disco–Pleasure–Discourse: On "Rock and Sexuality"', *Screen Education* 31.

LaSalle, Mick (1989) 'Garland - More or Less', *San Francisco Chronicle*, 12 October.

Lastrucci, Carlo (1941) 'The Professional Dance Musician', *Journal of Musicology* 3 (Winter).

Leary, Timothy (1970) *The Politics of Ecstasy*, New York: Paladin.

Lee, Stephen (1988) 'The Strategy of Opposition: Defining a Music Scene', Paper given at the International Communication Association Conference, New Orleans, 2 June.

Lefebvre, Henri (1971) *Everyday Life in the Modern World,* trans. Sacha Rabinovitch, New York: Harper & Row.

Lemert, Edwin (1964) 'Social Structure, Social Control and Deviation', in M. Clinard (ed.), *Anomie and Deviant Behavior*, New York: The Free Press of Glencoe: 64–71.

Lemert, Edwin (1967) *Human Deviance: Social Problems and Social Control*, Englewood Cliffs, NJ: Prentice Hall.

Leonard, N. (1962) *Jazz and the White Americans*, Chicago: University of Chicago Press.

Lesko, Nancy (1988) 'The Curriculum of the Body: Lessons from a Catholic High School', in Leslie G. Roman and Linda K. Christian-Smith (eds) *Becoming Feminine: The Politics of Popular Culture*, London: The Falmer Press.

Levine, Lawrence (1988) *Highbrow/Lowbrow: The Emergence of Cultural Hierarchy in America*, London: Harvard University Press.

Levi-Strauss, Claude (1966) *The Savage Mind*, London: Weidenfeld & Nicolson.

Levi-Strauss, Claude (1969) *The Elementary Structures of Kinship*, London: Eyre & Spottiswood.

Levy, Steven (1994) *Hackers*, Harmondsworth: Penguin Books.

Leznoff, Maurice and Westley, William A. (1956) 'The Homosexual Community', *Social Problems* 4: 257–63.

Lippard, L. (ed.) (1970) *Surrealists on Art*, Hemel Hempstead: Prentice Hall.

Lipsitz, George (1990) *Time Passages: Collective Memory and American Popular Culture*, Minneapolis: University of Minnesota Press.

Livingstone, Jennie (1991) 'Paris is Burning', *Outweek* 94.

Lorrah, Jean (1984) *The Vulcan Academy Murders*, New York: Pocket.

Lowe, Richard and Shaw, William (1993) *Travellers*, London: Fourth Estate.

Lukes, S. (1974) *Power: A Radical View*, London: Macmillan.

Lull, James (ed.) (1992) *Popular Music and Communication*, London, Sage.

Lyman, S. and Scott, M.B. (1970) *A Sociology of the Absurd*, New York: Appleton-Century-Crofts.

Lynch, Lee (1980) *The Amazon Trail*, Tallahassee, Florida: Naiad Press.

Lynd, Robert and Lynd, Helen (1929) *Middletown: A Study of Modern American Culture*, New York: Harcourt, Brace and World.

Lyttle, Thomas and Montagne, Michael (1992) 'Drugs, Music and Ideology: A Social Pharmacological Interpretation of the Acid House Movement', *The International Journal of the Addictions* 27 (10): 1159–77.

McCall, Andrew (1979) *The Medieval Underworld*, London: Hamish Hamilton.

McClary, Susan (1991) *Feminine Endings: Music, Gender and Sexuality*, Minneapolis: Minnesota University Press.

McGuigan, Jim (1992) 'Youth Culture and Consumption', in *Cultural Populism*, London: Routledge.

McIntosh, Mary (1968) 'The Homosexual Role', *Social Problems* 16 (2).

McRobbie, Angela (1978) 'The Culture of Working Class Girls', in A. McRobbie (ed.) (1991) *Feminism and Youth Culture*, London: Macmillan.

McRobbie, Angela (1980) 'Settling Accounts with Subcultures: A Feminist Critique', *Screen Education* 39.

McRobbie, Angela (1984) 'Dance and Social Fantasy', in A. McRobbie and M. Nava (eds) *Gender and Generation*, London: Macmillan.

McRobbie, Angela (1989a) 'Second-Hand Dresses and the Role of the Ragmarket', in Angela McRobbie (ed.) (1989) *Zoot Suits and Second-Hand Dresses: An Anthology of Fashion and Music*, London: Macmillan.

McRobbie, Angela (ed.) (1989b) *Zoot Suits and Second-Hand Dresses: An Anthology of Fashion and Music*, London: Macmillan.

McRobbie, Angela (1991) *Feminism and Youth Culture: From Jackie to Just Seventeen*, London: Macmillan.

McRobbie, Angela (1994) *Postmodernism and Popular Culture*, London: Routledge.

McRobbie, Angela and Garber, Jenny (1976) 'Girls and Subcultures', in Stuart Hall and Tony Jefferson (eds) (1993) *Resistance Through Rituals*, London: Routledge.

Mains, Geoff (1984) *Urban Aboriginals: A Celebration of Leather-Sexuality*, San Francisco: Gay Sunshine Press.

Major, Clarence (ed.) (1971) *Black Slang: A Dictionary of Afro-American Talk*, London: Routledge and Kegan Paul.

Malinowski, Bronislaw (1926/1954) 'Myth in Primitive Psychology', *Magic, Science and Religion*, New York: Doubleday Anchor Books.

Marcus, George (1986) 'Contemporary Problems of Ethnography in the Modern World System', in J. Clifford and George Marcus (eds.) *Writing Culture*, Berkeley: University of California Press.

Marcus, George and Cushman, Dick (1982) 'Ethnographies as Text', *Annual Review of Anthropology* 11: 25–69.

Marcus, George and Fischer, Michael M.J. (1986) *Anthropology as Cultural Critique*, Chicago: University of Chicago Press.

Marcus, Greil (1989) *Lipstick Traces: A Secret History of the 20th Century*, Cambridge, Mass.: Harvard University Press.

Marcuse, Herbert (1956) *Eros and Civilisation*, London: Routledge and Kegan Paul.

Marcuse, Herbert (1964) *One Dimensional Man*, London: Routledge and Kegan Paul.

Marsh, Peter, Rosser, Elizabeth, and Harré, Rom (1978) 'Life on the Terraces', in *The Rules of Disorder*, London: Routledge and Kegan Paul.

Marx, Karl (1938) *The German Ideology*, London: Lawrence and Wishart.

Marx, Karl (1964) *The Economic and Philosophical Manuscripts of 1844*, London: Lawrence and Wishart.

Matza, David (1961) 'Subterranean Traditions of Youth', *The Annals of the American Academy of Political and Social Science*, 338 (November).

Matza, David (1969) *Becoming Deviant*, New York: Prentice Hall.

Matza, David and Sykes, G. (1961) 'Juvenile Delinquency and Subterranean Values', *American Sociological Review*, 26.

Mayhew, Henry (1968/1985), *London Labour and the London Poor*, 4 vols, New York: Dover and Harmondsworth: Penguin Books.

Mayne, Xavier (1908) *The Intersexes: A History of Similisexualism as a Problem in Social Life*, London: privately printed.

Mays, John B. (1965) *The Young Pretenders*, London: Michael Joseph.

Mazon, Mauricio (1984) *Zoot Suit Riots*, Austin: University of Texas Press.

Mead, Margaret (1944) 'Are Today's Youth Different?', in Margaret Mead (ed.) *The American Character*, Harmondsworth: Penguin Books.

Melly, George (1972) *Revolt into Style*, Harmondsworth: Penguin Books.

Mercer, Kobena (1987) 'Black Hair/Style Politics', *New Formations* 3: 33–54.

Mercer, Kobena (1988) 'Diaspora Culture and the Dialogic Imagination: the Aesthetics of Black Independent Film in Britain', in Mbye B. Cham and Claire Andrade-Watkins (eds) *Blackframes: Critical Perspectives on Black Independent Cinema*, Cambridge, Mass.: MIT Press.

Mercer, Mick (1988) *The Gothic Rock Black Book*, London: Omnibus Press.

Mercer, Mick (1991) *Gothic Rock*, Birmingham: Pegasus.

Merriam, Alan and Mack, Raymond (1960) 'The Jazz Community', *Social Forces* 38 (March): 211–22.

Merton, Robert K. (1938) 'Social Structure and Anomie', *American Sociological Review* 3 (October).

Messinger, Sheldon (1962) 'Life as Theater: Some Notes on the Dramaturgic Approach to Social Reality', *Sociometry* (March).

Metz, Christian (1975) 'The Imaginary Signifier', *Screen* 16 (2).

Middleton, R. and Horn, D. (1984) *Popular Music: A Yearbook*, London: Cambridge University Press.

Middleton, Richard (1990) *Studying Popular Music*, Milton Keynes: Open University Press.

Miège, Bernard (1986) 'Les logiques à l'œuvre dans les nouvelles industries culturelles', *Cahiers de recherche sociologique* 4 (2): 93–110.

Miller, Daniel (1987) *Material Culture and Mass Consumption*, Oxford: Basil Blackwell.

Mills, C. Wright (1959) *The Sociological Imagination*, New York: Grove Press.

Mills, Richard (1973) *Young Outsiders: A Study of Alternative Communities*, London: Routledge and Kegan Paul.

Minh-ha, Trinh T. and West, Cornel (eds) (1990) *Out There: Marginalisation and Contemporary Culture*, Cambridge, Mass.: MIT Press.

Mintel (1988) *Mintel Special Report: Youth Lifestyles*.

Montero, Oscar (1988) 'Lipstick Vogue: The Politics of Drag', *Radical America* 22 (1).

Moon, Michael (1989) 'Flaming Closets', *October* 51.

Morris, Meaghan (1988) 'Banality in Cultural Studies', *Discourse* 10 (2).

Morris, Ronald (1980) *Wait Until Dark: Jazz and the Underworld*, Bowling Green: Bowling Green University Press.

Mort, Frank (1988) 'Boys Own? Masculine Style and Popular Culture', in R. Chapman and J. Rutherford (eds) *Male Order: Unwrapping Masculinity*, London: Lawrence and Wishart.

Morton, Brian (1995) *Bebop: The Music and the Players*, Oxford: Oxford University Press.

Moscovitz, Sam (1954) *The Immortal Storm*, New York: ASFO Press.

Mukerji, Chandra and Schudson, Michael (eds) (1991) *Rethinking Popular Culture*, Los Angeles: University of California Press.

Mulvey, Laura (1975) 'Visual Pleasure and Narrative Cinema', *Screen* 16 (3).

Mulvey, Laura (1981) 'On *Duel in the Sun*: Afterthoughts on "Visual Pleasure and Narrative Cinema"', *Framework* 15–17.

Mungham, G. and Pearson, G. (eds) (1976) *Working Class Youth Culture*, London: Routledge and Kegan Paul.

Mungo, Paul and Clough, Brian (1992) *Approaching Zero: The Extraordinary Underworld of Hackers, Phreakers, Virus Writers and Keyboard Criminals*, New York: Random House.

Murdock, G. and McCron, R. (1975) 'Consciousness of Class and Consciousness of Generation', in Stuart Hall and Tony Jefferson (eds) (1993), *Resistance Through Rituals*, London: Routledge.

Musgrove, F. (1968) *Youth and the Social Order*, London: Routledge and Kegan Paul.

Musgrove, F. (1974) *Ecstasy and Holiness: Counter Culture and Open Society*, London: Methuen.

Nelson, Cary and Grossberg, Lawrence (eds) (1988) *Marxism and the Interpretation of Culture*, Urbana: University of Illinois Press.

Nelson, Elizabeth (1989) *The British Counter-Culture 1966–73: A Study of the Underground Press*, London: Macmillan.

Nestle, Joan (1987) *A Restricted Country*, Ithaca: Firebrand Books.

Nettleford, R. (1970) *Mirror, Mirror*, Kingston: William Collins & Sangster.

Nettleford, R., Angier, R. and Smith, M.G. (1960) *The Rastafarian Movement in Kingston, Jamaica*, Kingston: Institute for Social and Economic Research, U.C.W.I.

Neville, R. (1971) *Playpower*, New York: Paladin.

Newcombe, Russell (1992) 'A Researcher Reports from the Rave', *Druglink: The Journal on Drug Misuse in Britain* 7 (1): 14–16.

Newton, Esther (1972) *Mother Camp: Female Impersonators in America*, Chicago: University of Chicago Press.

Newton, Francis (1959) *The Jazz Scene*, London: MacGibbon and Kee.

Nightingale, Virginia (1993) 'What's "Ethnographic" About Ethnographic Audience Research?', John Frow and Meaghan Morris (eds) *Australian Cultural Studies: A Reader*, Sydney: Allen & Unwin.

Nilsson, N.G. (1971) 'The Origin of the Interview', *Journalism Quarterly* Winter: 707–13.

Norman, Philip (1981) *Shout! The Beatles in Their Generation*, New York: Simon and Schuster.

Nuttall, J. (1969) *Bomb Culture*, New York: Paladin.

Ohmann, Richard (1991) 'History and Literary History: The Case of Mass Culture', in James Naremore and Patrick Brantlinger (eds) *Modernity and Mass Culture*, Bloomington: Indiana University Press.

Olander, Bill (1987) 'The Window on Broadway by ACT UP', *On View*, New York: Museum of Modern Art.

Oliver, Paul (ed.) (1990) *Black Music in Britain: Essays on the Afro-Asian Contribution to Popular Music*, Milton Keynes: Open University Press.

Ong, Walter (1977) *Interfaces of the World*, Ithaca, NY: Cornell University Press.

Owens, Craig (1985) 'Posing', *Difference: On Representation and Sexuality*, New York: New Museum of Contemporary Art.

Owens, J. (1976) *Dread: The Rastafarians*, Kingston: Sangster.

Padmore, G. (1956) *Pan-Africanism or Communism*, London: Dennis Dobson.

Park, Robert E. *et al.* (eds) (1925) *The City*, London: University of Chicago Press.

Parker, Howard (1974) *View from the Boys*, Newton Abbot: David and Charles.

Parkin, F. (1971) *Class Inequality and Political Order*, London: McGibbon and Kee.

Parsons, Talcott (1964) *Essays in Sociological Theory*, New York: The Free Press.

Parsons, Talcott *et al.* (1951) *Introduction Toward a General Theory of Action*, New York: Harper & Row.

Parsons, Tony and Burchill, Julie (1978) *The Boy Looked at Johnny*, London: Pluto Press.

Partridge, Eric (1949) *A Dictionary of the Underworld*, London: Routledge and Kegan Paul.

Patrick, J. (1973) *A Glasgow Gang Observed*, London: Eyre-Methuen.

Patterson, O. (1966) 'The Dance Invasion', *New Society* 15 September.

Patton, Cindy (1993) 'Embodying Subaltern Memory: Kinesthesia and the Problematics of Gender and Race', in Cindy Scwichtenberg (ed.) *The Madonna Connection: Representational Politics, Subcultural Identities, and Cultural Theory*, St Leonards, NSW: Allen & Unwin.

Paz, Octavio (1961) *The Labyrinth of Solitude*, New York: Grove Press.

Pearson, Geoffrey (1975) *The Deviant Imagination*, London: Macmillan.

Pearson, Geoffrey (1976) '"Paki-Bashing" in a North East Lancashire Cotton Town: A Case Study and Its History', in G. Mungham and G. Pearson (eds) *Working Class Youth Culture*, London: Routledge and Kegan Paul.

Pearson, Geoffrey (1978) 'Goths and Vandals: Crime in History', *Contemporary Crises* 2 (2): 119–39.

Pearson, Geoffrey (1983) *Hooligan: A History of Respectable Fears*, London: Macmillan.

Pearson, Geoffrey and Twohig, John (1975) 'Ethnography Through the Looking-Glass', in Stuart Hall and Tony Jefferson (eds) (1993) *Resistance Through Rituals*, London: Routledge.

Pearson, J. (1973) *The Profession of Violence*, London: Panther.

Pearson, K. (1979) *Surfing Subcultures of Australia and New Zealand*, St Lucia, Brisbane: University of Queensland Press.

Perkins, Eric (ed.) (1994) *Droppin' Science: Critical Essays on Rap Music and Hip Hop Culture*, Philadelphia: Temple University Press.

Perry, M. (1976) *Silence to the Drums: A Survey of the Literature of the Harlem Renaissance*, London: Greenwood Press.

Perry, Paul (1990) *On the Bus: The Complete Guide to the Legendary Trip of Ken Kesey and the Merry Pranksters and the Birth of the Counterculture*, London: Plexus.

Piccone, Paul (1969) 'From Youth Culture to Political Praxis', *Radical America* 15 November.

Picton, Werner (1931) 'Male Prostitution in Berlin', *Howard Journal* 3 (2).

Pinchbeck, Ivy and Hewitt, Margaret (1981) 'Vagrancy and Delinquency in an Urban Setting', in Mike Fitzgerald *et al.* (eds) (1981) *Crime and Society: Readings in History and Theory*, London: Routledge and Kegan Paul.

Plant, Mark and Plant, Moira (1992) *The Risk-Taker: Alcohol, Drugs, Sex and Youth*, London: Routledge.

Plummer, Ken (ed.) (1981) *The Making of the Modern Homosexual*, London: Hutchinson.

Plummer, Ken (ed.) (1992) *Modern Homosexualities: Fragments of Lesbian and Gay Experience*, London: Routledge.

Polhemus, Ted (1988) *Bodystyles*, Luton: Lennard.

Polhemus, Ted (1994) *Street Style: From Sidewalk to Catwalk*, London: Thames and Hudson.

Polsky, Ned (1967) *Hustlers, Beats and Others*, Harmondsworth: Penguin Books.

Poulantzas, N. (1973) *Political Power and Social Classes*, London: New Left Books.

Pryce, K. (1979) *Endless Pressure: A Study of West Indian Lifestyles in Bristol*, Harmondsworth: Penguin Books.

Radway, Janice (1988) 'Reception Study: Ethnography and the Problems of Dispersed Audiences and Nomadic Subjects', *Cultural Studies*, 2 (3).

Rains, Pru (1975) 'Imputations of Deviance: A Retrospective Essay on the Labelling Perspective', *Social Problems* 30: 410–24.

Raymond, Eric (ed.) (1993) *The New Hacker's Dictionary*, Cambridge, Mass.: MIT Press.

Redfield, Robert (1941) *The Folk Culture of Yukatan*, Chicago: University of Chicago Press.

Reiss, Albert J., Jr. (1961) 'The Social Integration of Peers and Queers', *Social Problems* 9: 102–20.

Rheingold, Howard (1994) *The Virtual Community: Finding Connection in a Computerized World*, London: Secker and Warburg.

Riesman, David, Glazer, Nathan and Denny, Reuel (1961) *The Lonely Crowd*, New Haven: Yale University Press.

Roberts, R. (1973) *The Classic Slum*, Harmondsworth: Penguin Books.

Robins, Dave (1984) *We Hate Humans*, Harmondsworth: Penguin Books.

Rock, Paul (1979) *The Making of Symbolic Interactionism*, London: Macmillan.

Rodigan, David (1985) *Time Out* 16–22 May.

Rodney, Walter (1968) *The Groundings with my Brothers*, London: Bogle L'ouverture.

Rogers, P. (1972) *Grub Street: Studies in a Subculture*, London: Methuen.

Rojek, Chris (ed.) (1989) *Leisure for Leisure: Critical Essays*, London: Macmillan.

Roman, Leslie G. (1988) 'Intimacy, Labor and Class: Ideologies of Feminine Sexuality in the Punk Slam Dance', in Leslie G. Roman and Linda K. Christian-Smith (eds) *Becoming Feminine: The Politics of Popular Culture*, London: Falmer Press.

Rose, Cynthia (1991) *Design After Dark: The Story of Dancefloor Style*, London: Thames and Hudson.

Rose, Tricia (1994a) 'A Style Nobody Can Deal With: Politics, Style and the Postindustrial City in Hip Hop', in Andrew Ross and Tricia Rose (eds) *Microphone Fiends*, New York and London: Routledge.

Rose, Tricia (1994b) *Black Noise*, Hanover, NH: Wesleyan University Press.

Rosenberg, Bernard and White, David M. (eds) (1957) *Mass Culture: The Popular Arts in America*, Glencoe, Illinois: The Free Press.

Ross, Andrew (1989a) 'Hip, and the Long Front of Color', in *No Respect: Intellectuals and Popular Culture*, New York and London: Routledge.

Ross, Andrew (1989b) 'Uses of Camp', in *No Respect: Intellectuals and Popular Culture*, New York and London: Routledge.

Ross, Andrew (1991a) 'Hacking Away at the Counterculture', in *Strange Weather: Culture, Science and Technology in the Age of Limits*, London: Verso.

Ross, Andrew (1991b) 'Getting Out of the Gernsback Continuum', *Critical Inquiry* (Winter): 411–33.

Ross, Andrew and Penley, Constance (eds) (1991) *Technoculture*, Minneapolis: University of Minnesota Press.

Ross, Andrew and Rose, Tricia (eds) (1994) *Microphone Fiends: Youth Music and Youth Culture*, New York and London: Routledge.

Roszack, T. (1971) *The Making of the Counter Culture*, London: Faber.

Rousseau, G. S. and Porter, Roy (eds) (1987) *Sexual Underworlds of the Enlightenment*, Manchester: Manchester University Press.

Rowbotham, Sheila (1973) *Woman's Consciousness, Man's World*, Harmondsworth: Penguin Books.

Rubin, Gayle (1989) 'The Catacombs: The Temple of the Butthole', in Mark Thompson (ed.) *Leatherfolk*, Boston: Alyson Publications.

Russell, C.E.B. (1905) *Manchester Boys*, Manchester: Manchester University Press.

Said, Edward (1985) *Orientalism,* Harmondsworth: Penguin Books.

Sales, R. (1983) *English Literature in History 1780–1830: Pastoral and Politics*, London: Hutchinson.

Salgado, G. (1984) *The Elizabethan Underworld*, Gloucester: Alan Sutton.

Sarduy, Severo (1973) 'Writing/Transvestism', *Review* 9.

Saul, John (1881) *The Sins of the Cities of the Plains, or Recollections of a Mary-Anne*, 2 vols, London: no publisher listed.

Saussure, F. de (1974) *Course in General Linguistics*, New York: Collins.

Savage, Jon (1988) 'The Enemy Within: Sex, Rock and Identity', in S. Frith (ed.) *Facing the Music*, New York: Pantheon.

Savage, Jon (1991) *England's Dreaming: The Sex Pistols and Punk Rock*, London: Faber & Faber.

Scannell, Paddy (1989) 'Public Service Broadcasting and Modern Public Life', *Media, Culture and Society* XI (2).

Schaffner, Nicholas (1977) *The Beatles Forever*, New York: McGraw-Hill.

Scheuller, H.M. and Peters, R.L. (eds) (1969) *The Letters of John Aldington Symonds*, Detroit: Wayne State University Press.

Schiller, F. (1795; 1967) *On the Aesthetic Education of Man, in a series of letters*, Oxford: Clarendon Press.

Schofield, Michael (1965) *Sociological Aspects of Homosexuality*, London: Longman, Green & Co.

Sedgwick, Eve Kosofsky (1991) *Epistemology of the Closet*, London: Harvester.

Shanks, Barry (1988) 'Transgressing the boundaries of a rock 'n' roll community', paper delivered at 'First Joint Conference of IASPM-Canada and IASPM-USA', Yale University, 1 October 1988.

Shaw, Clifford (1930) *The Jack-Roller*, Chicago: University of Chicago Press.

Shaw, Clifford (1931) *The Natural History of the Delinquent Career*, Chicago: University of Chicago Press.

Shaw, Clifford, McKay, Henry and McDonall, James (1938) *Brothers in Crime*, Chicago: University of Chicago Press.

Sheppard, E. *et al.* (1875) *The Story of the Jubilee Singers with Their Songs*, London: Hodder and Stoughton.

Shibutani, Tamotsu (1955) 'Reference Groups as Perspectives', *American Journal of Sociology* lxi: 562–9.

Short, James F., Jr., and Strodtbeck, Fred L. (1965) *Group Process and Gang Delinquency*, Chicago: University of Chicago Press.

Showalter, Elaine (1991) *Sexual Anarchy: Gender and Culture at the fin de siècle*, London: Bloomsbury.

Sidron, Ben (1981) *Black Talk*, New York: De Capo Press.

Simmons, Ron (1991) '*Tongues Untied*: An Interview with Marlon Riggs', in Essex Hemphill (ed.) *Brother to Brother*, Boston: Alyson Publications.

Sindall, Rob (1990) *Street Violence in the Nineteenth Century: Media Panic or Real Danger?*, Leicester: Leicester University Press.

Sithole, E. (1972) 'Black Folk Music', in T. Kochman (ed.) *Rappin' and Stylin' Out*, Chicago: University of Illinois Press.

Slobin, Mark (1993) *Subcultural Sounds: Micromusic in the West*, Hanover, NH: University Press of New England.

Small, Christopher (1980) *Music–Society–Education*, London: John Calder.

Small, Christopher (1987) *Music of the Common Tongue: Survival and Celebration in Afro-American Music*, New York: Riverrun.

Smith, Andrew James (1992) 'The Third Generation', *New Statesman and Society* 11 September: 31–2.

Smith, Dennis (1988) *The Chicago School: A Liberal Critique of Capitalism*, London: Macmillan.

Smith, L.S. (1978) 'Sexist Assumptions and Female Delinquency', in C. Smart and B. Smart (eds) *Women, Sexuality and Control*, London: Routledge and Kegan Paul.

Sodré, Muniz (1989) *O Terreiro e a Cidade*, Petropolis: Vozes.

Solomon, Carl (1959) 'Report from the Asylum', in G. Feldman and M. Gartenberg (eds) *The Beat Generation and the Angry Young Men*, New York: Dell Publishing Co.

Sontag, Susan (1966) 'Notes on "Camp"', in *Against Interpretation*, New York: Farrar Straus Giroux.

Stallybrass, Peter and White, Allon (1986) *The Politics and Poetics of Transgression*, London: Methuen.

Stamm, R. (1982) 'On the Carnivalesque' *Wedge* 1: 47–55.

Statt, David (1995) 'The Case of the Mohocks: Rake Violence in Augustan London', *Social History* 20, 2: 179–99.

Stearns, Marshall and Stearns, Jean (1968) *Jazz Dance: The Story of American Vernacular Dance*, New York: Macmillan

Stedman Jones, G. (1971) *Outcast London*, Oxford: Clarendon Press.

Steele-Perkins, Chris (1979) *The Teds*, London: Travelling Light/Exit.

Stein, Arlene (1989) 'All Dressed Up, But No Place to Go? Style Wars and the New Lesbianism', *Out/Look* 1 (4).

Sterling, Bruce (1992) *The Hacker Crackdown: Law and Disorder on the Electronic Frontier*, New York: Viking.

Stix, John (1986) 'Yngwie Malmsteen and Billy Sheehan: Summit Meeting at Chops City', *Guitar for the Practicing Musician*, March.

Stratton, Jon (1982) 'Interview with Dick Hebdige' *Art and Text* 8 (Summer): 10–30.

Stratton, Jon (1985) 'Youth Subcultures and Their Cultural Contexts', *Australian and New Zealand Journal of Sociology* 21 (2): 194–218.

Stratton, Jon (1986) 'Why Doesn't Anybody Write About Glam Rock', *The Australian Journal of Cultural Studies* 4 (1): 15–38.

Stratton, Jon (1992) *The Young Ones: Working-Class Culture, Consumption and the Category of Youth*, Perth: Black Swan Press.

Straw, Will (1990) 'Characterising Rock Music Culture: The Case of Heavy Metal', in Simon Frith and Andrew Goodwin (eds) *On Record*, London: Routledge.

Straw, Will (1991) 'Systems of Articulation, Logics of Change: Communities and Scenes in Popular Music', *Cultural Studies* 5 (3).

Strecker, Edward A. (1940) *Beyond the Clinical Frontier*, New York: W.W. Norton Company.

Stuart, Johnny (1987) *Rockers!* London: Eel Pie Publishing.

Sue, Eugene (1842–43) *Les Mystères des Paris*, Paris: C. Cosselin.

Sutherland, Edwin (1937) *The Professional Thief*, Chicago: University of Chicago Press.

Sutherland, Edwin and Cressey, Donald (1960) *Principles of Criminology* (6th edition), Philadelphia: J.B. Lippincott.

Suttles, Gerald D. (1968) *The Social Order of the Slum: Ethnicity and Territory in the Inner City*, Chicago: University of Chicago Press.

Swedenburg, Ted (1992) 'Homies in the 'Hood: Rap's Commodification of Insubordination', *New Formations* 18: 53–66.

Szatmary, David P. (1987) *Rockin' in Time: A Social History of Rock and Roll*, Englewood Cliffs, NJ: Prentice Hall.

Tagg, John (1981) 'Power and Philosophy', in Tony Bennett *et al.* (eds) *Culture, Ideology and Social Process*, Stony Stratford: Open University Press.

Tagg, P. (1981) *Fernando the Flute*, Gothenberg: University of Gothenberg Press.

Tate, Greg (1992) *Flyboy in the Buttermilk*, New York: Simon and Schuster.

Taylor, Clyde (1989) 'Black Cinema in the Post-Aesthetic Era', in Jim Pines and Paul Willemen (eds) *Questions of Third Cinema*, London: BFI Publishing.

Taylor, I. (1971) '"Football Mad": A Speculative Sociology of Soccer Hooliganism', in E. Dunning (ed.) *The Sociology of Sport*, London: Cass.

Taylor, I. and Taylor, L. (eds) (1973) *Politics and Deviance*, Harmondsworth: Penguin Books.

Taylor, I. and Wall, D. (1976) 'Beyond the Skinheads: Comments on the Emergence and Significance of the Glam Rock Cult', in G. Mungham and G. Pearson (eds) *Working Class Youth Culture*, London: Routledge and Kegan Paul.

Taylor, I., Walton, P. and Young, J. (eds) (1975) *Critical Criminology*, London: Routledge and Kegan Paul.

Taylor, Laurie (1976) 'Strategies for Coping with a Deviant Sentence', in Rom Harré (ed.) *Life Sentences*, London and New York: Wiley.

Taylor, Laurie (1984) *In the Underworld*, London: Unwin.

Theberge, Paul (1991) 'Musicians' Magazines in the 1980s: The Creation of a Community and a Consumer Market', *Cultural Studies* 5 (3).

Thoinot, L. and Weysse, A.W. (1911) *Medico Legal Aspects of Moral Offences*, Philadelphia: F.A. Davis.

Thomas, Helen (ed.) (1993) *Dance, Gender and Culture*, London: Macmillan.

Thompson, E.P. (1963) *The Making of the English Working Class*, Harmondsworth: Penguin Books.

Thompson, E.P. and Yeo, E. (1973) *The Unknown Mayhew*, Harmondsworth: Penguin Books.

Thompson, Hunter S. (1966) *Hell's Angels: A Strange and Terrible Saga*, New York: Random House.

Thompson, John B. (1989) *Ideology and Modern Culture*, Cambridge: Polity.

Thompson, John B. (1991) *Language and Symbolic Power*, Cambridge: Polity.

Thompson, Mark (ed.) (1991) *Leatherfolk: Radical Sex, People, Politics and Practice*, Boston: Alyson Publications.

Thompson, P. (1972) *The Grotesque*, London: Methuen.

Thomson, Raymond (1989) 'Dance Halls and Dance Bands in Greenock 1945–55', *Popular Music* 8 (2).

Thorne, Tony (1993) *Fads, Fashions and Cults: From Acid House to Zoot Suit*, London: Bloomsbury.

Thornton, Sarah (1990a) 'Club Class', *New Statesman and Society*, 16 November.

Thornton, Sarah (1990b) 'Strategies for Reconstructing the Popular Past', *Popular Music* 9 (1).

Thornton, Sarah (1994) 'Moral Panic, The Media and Rave Culture', in Andrew Ross and Tricia Rose (eds) *Microphone Fiends*, London: Routledge.

Thornton, Sarah (1995) *Club Cultures: Music, Media and Subcultural Capital*, Cambridge: Polity.

Thrasher, Frederic M. (1927) *The Gang*, Chicago: University of Chicago Press.

Tolson, Andrew (1990) 'Social Surveillance and Subjectification: The Emergence of "Subculture" in the Work of Henry Mayhew', *Cultural Studies* 4 (2).

Toop, David (1984) *The Rap Attack: African Jive to New York Hip Hop*, Boston: South End.

Torp, Lisbet (1986) 'Hip Hop Dances: Their Adoption and Function among Boys in Denmark from 1983–84', *Yearbook for Traditional Music* 18.

Trostle, Lawrence C. (1992) *The Stoners: Drugs, Demons, and Deliquency*, New York: Garland Publishing, Inc.

Trumbach, Randolph (1977) 'London's Sodomites: Homosexual Behaviour and Western Culture in the Eighteenth Century', *Journal of Social History* 11: 1–33.

Tulloch, Carol (1992) 'Rebel Without a Pause: Black Streetstyle & Black Designers', in Julia Ash and Elizabeth Wilson (eds) *Chic Thrills*, London: Pandora.

Turnbull, G. (1936) 'Some Notes on the History of the Interview', *Journalism Quarterly* Fall: 272–79.

Turner, Ralph H. and Surace, Samuel J. (1956) 'Zoot-Suiters and Mexicans: Symbols in Crowd Behavior', *The American Journal of Sociology* lvii (1): 14–20.

Turner, Victor (1967) *The Forest of Symbols: Aspects of Ndembu Ritual*, London: Cornell University Press.

Turner, Victor (1977) *The Ritual Process*, Ithaca, New York: Cornell University Press.

Tyler, Stephen (1986) 'Postmodern Ethnography: From Document of the Occult to Occult Document', in J. Clifford and G.E. Marcus (eds) *Writing Culture*, Berkeley: University of California Press.

Uricchio, William and Pearson, Roberta (1991) 'I'm Not Fooled by that Cheap Disguise', in W. Uricchio and R. Pearson (eds) *The Many Faces of Batman*, New York: Routledge.

Vale, V. and Juno, Andrea (eds) (1989) *Modern Primitives*, San Francisco: Re/Search Publications.

Valli, L. (1986) *Becoming Clerical Workers*, London: Routledge and Kegan Paul.

Varenne, H. (1982) 'Jocks and Freaks', in G. Spindler (ed.) *Doing the Ethnography of Schooling*, New York: Holt, Rinehart and Winston.

Veblen, Thorstein (1899) *The Theory of the Leisure Class*, New York: Penguin Books.

Vigil, James D. (1988) *Barrio Gangs*, Austin, Texas: University of Texas Press.

Vološinov, V.N. (1986) *Marxism and the Philosophy of Language*, Cambridge, Mass.: MIT Press.

Walker, Ian (1980) 'Skinhead: The Cult of Trouble', *New Society* 25 June.

Wallis, R. and Malm, K. (1984) *Big Sounds from Small Peoples*, London: Constable.

Walser, Robert (1993) *Running with the Devil: Power, Gender and Madness in Heavy Metal Music*, Hanover, NH: Wesleyan University Press.

Walser, Robert (1994) 'Highbrow, Lowbrow, Voodoo Aesthetics', in Andrew Ross and Tricia Rose (eds) *Microphone Fiends*, London: Routledge.

Ward, Colin (ed.) (1973) *Vandalism*, London: Architectural Press.

Ward, Ed, Stokes, Geoffrey and Tucker, Ken (1986) *Rock of Ages: The Rolling Stone History of Rock & Roll*, New York: Rolling Stone Press.

Warner, Lloyd W. *et al.* (1949) *Social Class in America*, Chicago: Science Research Associates.

Warren, Carol (1974) *Identity and Community in a Gay World*, London: John Wiley and Sons.

Waters, Chris (1981) 'Badges of Half-Formed, Inarticulate Radicalism: A Critique of Recent Trends in the Study of Working Class Youth Culture', *International Labour and Working Class History* 19: 23–37.

Webb, Eugene *et al.* (1966) *Unobtrusive Measures: Non-Reactive Research in the Social Sciences*, Chicago: Rand McNally.

Weeks, Jeffrey (1977) *Coming Out: Homosexual Politics in Britain from the Nineteenth Century to the Present*, London: Quartet.

Weeks, Jeffrey (1980/81) 'Inverts, Perverts and Mary-Annes: Male Prostitution and the Regulation of Homosexuality in England in the Nineteenth and Early Twentieth Century', *Journal of Homosexuality* 6 (1/2).

Weeks, Jeffrey (1985) *Sexuality and Its Discontents: Meanings, Myths, and Modern Sexualities*, London: Routledge and Kegan Paul.

Weinstein, Deena (1991) *Heavy Metal: A Cultural Sociology*, Oxford: Maxwell-Macmillan.

Weiss, L. (1983) 'Schooling and Cultural Production: A Comparison of Black and White Lived Culture', in M. Apple and L. Weiss (eds) *Ideology and Practice in Schooling*, Philadelphia: Temple University Press.

Wepman, D. *et al.* (1976) *The Life, the Love and Folk Poetry of the Black Hustler*, Los Angeles: Holloway House.

West, D.J. (1968) *Homosexuality*, Harmondsworth: Penguin Books.

West, D.J. and Farrington, D.P. (1977) *The Delinquent Way of Life*, London: Heinemann.

Wexler, P. (1983) 'Movement, Class and Education', in L. Barton and S. Walker (eds) *Race, Class and Education*, London: Croom Helm.

White, Allon (1982) 'Pigs and Pierrots: Politics of Transgression in Modern Fiction', *Raritan* II (2): 51–70.

Whittaker, Nicholas (1995) *Platform Souls: The Trainspotter as 20th-Century Hero*, London: Gollancz.

Whyte, William Foote (1943) *Street Corner Society: The Social Structure of an Italian Slum*, Chicago: University of Chicago Press.

Widdicombe, Sue and Wooffitt, Robin (1995) *The Language of Youth Subcultures: Social Identity in Action*, London: Harvester.

Williams, Raymond (1961) *The Long Revolution*, Harmondsworth: Penguin Books.

Williams, Raymond (1976) *Keywords*, Harmondsworth: Penguin Books.

Williams, Raymond (1981) *Culture*, London: Collins.

Williams, Rosalind (1990) *Notes on the Underground*, Cambridge, Mass.: MIT Press.

Willis, Paul (1977) *Learning to Labour: How Working Class Kids Get Working Class Jobs*, Aldershot: Gower Publishing.

Willis, Paul (1978) *Profane Culture*, London: Routledge and Kegan Paul.

Willis, Paul (1980) 'Notes on Method', in Stuart Hall *et al.* (eds) *Culture, Media, Language*, London: Hutchinson.

Willis, Paul (1990) *Common Culture*, Milton Keynes: Open University Press.

Willis, Susan (1993) 'Hardcore: Subculture American Style', *Critical Inquiry* 19.

Willmott, Peter (1966) *Adolescent Boys of East London*, London: Routledge and Kegan Paul.

Wilson, Elizabeth (1988) 'Memoires of an Anti-Heroine', in B. Cant and S. Hemmings (eds) *Radical Records: Thirty Years of Lesbian and Gay History*, London: Routledge.

Wilson, Elizabeth (1990) 'Deviant Dress', *Feminist Review* 35: 67–73.

Wilson, R. (1983) 'Carnival and Play', MMB (Coll.), Kingston, Ontario: Queen's University: 318–21.

Wolfe, Tom (1965) *The Kandy-Kolored Tangerine-Flake Streamline Baby*, New York: Farrar, Straus & Giroux.

Wolfe, Tom (1968a) *The Electric Kool Aid Acid Test*, New York: Bantam.

Wolfe, Tom (1968b) *The Pump House Gang*, New York: Bantam.

Wolfe, Tom (1976) 'Funky Chic', *Mauve Gloves & Madmen, Clutter and Vine*, New York: Farrar, Strauss & Giroux.

Wollen, Peter (1987) 'Fashion/Orientalism/The Body', *New Formations* 1 (1).

Wotherspoon, Gary (1991) *City of the Plain: History of a Gay Subculture*, Sydney: Hale & Iremonger.

Wurman, Richard Saul (1987) *SF Access*, New York: Access Press.

Wye, Deborah (1988) *Committed to Print: Social and Political Themes in Recent American Art*, New York: Museum of Modern Art.

X, Malcolm (with Alex Haley) (1966) *Autobiography of Malcolm X*, Harmondsworth: Penguin Books.

Yablonsky, Lewis (1965) 'Experiences with the Criminal Community', in A. Gouldner and S.M. Miller (eds) *Applied Sociology*, New York: The Free Press.

York, Peter (1980) *Style Wars*, London: Sidgwick and Jackson.

Young, Jock (1971) *The Drugtakers: The Social Meaning of Drug Use*, London: Paladin.

Young, Jock (1973) 'The Hippie Solution: An Essay in the Politics of Leisure', in I. Taylor and L. Taylor (eds) *Politics and Deviance*, Harmondsworth: Penguin Books.

Young, Jock (1974) 'New Directions in Subcultural Theory', in J. Rex (ed.) *Approaches to Sociology*, London: Routledge.

Young, Kimball (1946) *Social Psychology*, New York: Crofts and Company.

Zillman, Dolf and Bhatia, Azra (1989) 'Effects of Associating with Musical Genres on Heterosexual Attraction', *Communication Research* 16 (2).

Notes on contributors

Please note: Authors have named a few key intellectual influences *on the work published in the Reader* rather than on their academic or written work as a whole.

Bassett, Caroline (1961–)
Currently doing doctoral research on narrative and on-line worlds at Sussex University. Influences include: Donna Haraway, Judith Butler and Raymond Williams.

Becker, Howard (1928–)
Awarded his BA and PhD degrees in Sociology at University of Chicago, was Professor of Sociology at Northwestern University from 1965 to 1991 and is presently at University of Washington (Seattle). Some of his major books are: *The Outsiders: Studies in the Sociology of Deviance* (1963), *Art Worlds* (1982), *Writing for Social Scientists* (1986). Influences include: Oswald Hall, Everett C. Hughes, Robert E. Park, Georg Simmel.

Becquer, Marcos (1965–)
Did his postgraduate work at New York University. Published articles in *Wide Angle* (1991) and *The Ethnic Eye: Latino Media Arts* (1996). Influences include: Ernesto Laclau, Chantal Mouffe, Kobena Mercer, Dick Hebdige.

Clarke, John (1950–)
Studied at the Centre for Contemporary Cultural Studies, University of Birmingham. Currently Senior Lecturer in Social Policy at the Open University.

Contributing author to *Policing the Crisis*, co-author of *Managing Social Policy* (1994) and *The Managerial State* (1996) and author of *New Times, Old Enemies* (1991). Influences include Stuart Hall, Antonio Gramsci.

Cohen, Albert (1918–)

Completed his PhD in Sociology at Harvard University in 1951. Taught at Indiana University until 1965, then at University of Connecticut until his retirement in 1988. Key publications include: *Deviance and Control* (1946), *Delinquent Boys* (1955), *The Elasticity of Evil* (1974). Influences include: Talcott Parsons, Robert K. Merton, Edwin H. Sutherland.

Cohen, Phil (1943–)

Currently Reader in Cultural Studies, University of East London. Publications include his influential essay 'Subcultural Conflict and Working Class Community' (originally published in *Working Papers in Cultural Studies*, 1972), *Education, Labour and Cultural Studies* and *Re-thinking the Youth Question* (1996). Influences include: Louis Althusser, Claude Levi-Strauss, Gregory Bateson.

Cohen, Stanley (1942–)

Received PhD in Sociology from the London School of Economics, has been Professor of Criminology at the Hebrew University in Jerusalem since 1981, and began to divide his time between this post and a Professorship in Sociology at the London School of Economics in 1996. Author of *Folk Devils and Moral Panics* (1972), *Escape Attempts: The Theory and Practice of Resistance to Everyday Life* (with Laurie Taylor, 1976), *Against Criminology* (1988) and co-editor of *Images of Deviance* (1971). Influences include: Howard Becker, Michel Foucault and David Matza.

Cressey, Paul Goalby (1901–55)

Received his MA in Sociology from the University of Chicago in 1929. His MA thesis was subsequently published as *The Taxi Dance Hall: A Sociological Study of Commercialized Recreation and City Life* in 1932. Cressey went on to do his PhD at New York University and held teaching posts at Ohio Wesleyan University, Evansville College and University of Newark.

Crimp, Douglas (1944–)

Did his postgraduate work in the History of Art at City University of New York Graduate Center and is currently Professor of Visual and Cultural Studies at University of Rochester. He was editor of *October* between 1977 and 1990. Author of *AIDS Demo-Graphics* (1990) and *On the Museum's Ruins* (1993) and editor of *AIDS: Cultural Analysis/Cultural Activism* (1988). Influences include: Gregg Bordowitz, Walter Benjamin, Michel Foucault.

Fonarow, Wendy (1965–)

Currently completing her doctoral research in Anthropology at U.C.L.A. Her study is an ethnography of Indie music culture in Britain between 1993 and 1995. Influences include: Erving Goffman, Charles and Marjorie Goodwin, Stanley Walens.

Frith, Simon (1946–)

Studied at University of Oxford, then University of California, Berkeley. Currently co-director of the John Logie Baird Centre for Research in Television, Film and Music at Strathclyde University and Director of the ESRC Media Economics, Media Culture Research Programme. Books include: *Sound Effects* (1981), *Music for Pleasure* (1988) and *Performing Rites* (1996). Influences include: Howard Becker, Dave Laing and Karl Marx.

Fyvel, Tosco R. (1907–85)

Fyvel was best known as a London-based writer, journalist and broadcaster. He and George Orwell were joint editors of a series called *Searchlight Books* for which Orwell eventually wrote *Animal Farm*. Fyvel succeeded Orwell as literary editor of *Tribune* (1946–50), then worked in the External Services of the BBC until 1965. He was later literary editor of the *Jewish Chronicle* (1973–83). Author of *The Insecure Offenders: Rebellious Youth in the Welfare State* (1961), *The Malady and the Vision, Intellectuals Today: Problems in a Changing Society* (1968), *George Orwell: A Personal Memoir* (1982), *And There My Trouble Began: Uncollected Writings 1945–1985* (1986).

Garber, Marjorie (1944–)

Did her postgraduate work at Yale University and is presently Professor of English at Harvard University and Director of the Center for Literary and Cultural Studies. Author of three books on Shakespeare: *Dream in Shakespeare* (1974), *Coming of Age in Shakespeare* (1981) and *Shakespeare's Ghost Writers* (1987) as well as others on gender theory and cultural studies, including *Vested Interests: Cross-Dressing and Cultural Anxiety* (1993) and *Vice Versa: Bisexuality and the Eroticism of Everyday Life* (1995). Influences include: Jacques Lacan and the poststructuralist critique of the binary.

Gatti, José (1951–)

Did postgraduate work at Universidade de Sao Paulo and New York University. Publications include: *Barravento: A Estréia de Glauber* (1988). Currently Chairperson of the Cultural Studies Graduate Program at Universidade Federal de Santa Catarina, Brazil. Influences include: Mikhail Bakhtin, Roland Barthes, Paulo Emélio Salles Gomes.

Gelder, Ken (1955–)

Did his PhD at Stirling University, Scotland and is currently Senior Lecturer in English and Cultural Studies at University of Melbourne, Australia. Author of *Reading the Vampire* (1994). Influences include: Michel Foucault and Michel Maffesoli.

Gilroy, Paul (1956–)

Did his PhD at the Centre for Contemporary Cultural Studies, University of Birmingham and is currently Reader in Sociology, Goldsmiths' College, University of London. Co-author of *The Empire Strikes Back* (1982). Author of *There Ain't No Black in the Union Jack* (1987), *Black Atlantic: Modernity and Dark Consciousness* (1993) and *Small Acts: Thoughts on the Politics of Black Cultures* (1993).

Goffman, Erving (1922–82)

Awarded his MA and PhD from University of Chicago. Between 1954 and 1957, Goffman was a visiting scientist in the laboratory of socio-environmental studies at the National Institute of Health, during which he spent a year as a participant observer in St Elizabeth's Hospital, Washington DC. In 1958, he joined the sociology department at University of California, Berkeley and in 1968, he transferred to the department of Anthropology and Sociology at University of Pennsylvania. Author of many influential books including: *The Presentation of the Self in Everyday Life* (1959), *Encounters* (1961), *Asylums* (1961), *Behaviour in Public Places* (1963), *Stigma: Notes on the Management of Spoiled Identity* (1963), *Interaction Ritual* (1967), *Relations in Public* (1971), *Frame Analysis* (1974) and *Gender Advertisements* (1979).

Gordon, Milton

Was affiliated to the University of Pennsylvania when he published 'The Concept of a Sub-Culture and its Application' in 1947.

Grossberg, Lawrence (1947–)

Studied at the Centre for Contemporary Cultural Studies, University of Birmingham and the Institute of Communications, University of Illinois. Currently Professor of Communication Studies at University of North Carolina at Chapel Hill. Key publications include: *We Gotta Get Out of This Place* (1994), *Dancing to Keep from Crying* (forthcoming) and *Dancing in Spite of Myself* (forthcoming). Influences include: Stuart Hall, Meaghan Morris.

Hall, Stuart (1932–)

Awarded Rhodes scholarship for postgraduate study at Oxford University, was Director of Centre for Contemporary Cultural Studies, University of Birmingham during the 1970s and is presently Professor of Sociology at the Open University.

Key texts include co-authorship of *Resistance through Rituals* (1976), *Policing the Crisis* (1978) and *Stuart Hall: Critical Dialogues in Cultural Studies* (1996). Author of *The Hard Road to Renewal: Thatcherism and the Crisis of the Left* (1988). Influences include: Howard Becker, Stan Cohen, Antonio Gramsci.

Harré, Rom (1927–)

Received postgraduate training and subsequently taught at Oxford University. Currently Professor of Psychology, Georgetown University, Washington DC. Publications include: *Social Being* (1992) and *Pronouns and People* (1993). Influences include: J.L. Austin, Erving Goffman, Harold Garfinkel.

Hebdige, Dick (1951–)

Studied at University of Birmingham between 1972 and 1974, taught in British Art Schools between 1974 and 1984, then lectured in Communications at Goldsmiths' College, University of London until 1991. Currently Dean of the School of Critical Studies, California Institute of the Arts, Valencia. Publications include: *Subculture: The Meaning of Style* (1987), *Cut'n'mix: Culture, Identity and Caribbean Music* (1987), *Hiding in the Light* (1988). Influences: Roland Barthes, William Burroughs, Jean Genet, Stuart Hall.

Humphreys, Laud (1930–88)

Awarded his Masters of Divinity at Seaburg Western Theological Seminary in Illinois (1955), his PhD in Sociology and Criminology at Washington University in Missouri (1968), then became a licensed psychotherapist in the State of California (1980). His publications include: *The Tearoom Trade* (1970) and *Out of the Closet* (1972). Influences (supplied by Richard Koffler) include: Howard Becker, Erving Goffman, Harold Garfinkel and Lee Rainwater.

Jefferson, Tony (1946–)

Studied at the Centre for Contemporary Cultural Studies, University of Birmingham and is currently Professor in Criminology at University of Sheffield. Co-editor of *Resistance Through Rituals* (1976), *Policing the Crisis* (1978), *Masculinities, Social Relations and Crime* (special issue of the *British Journal of Criminology*, 1996). Author of *The Case Against Paramilitary Policing* (1990). Influences include: Phil Cohen, Antonio Gramsci and Roland Barthes.

Jenkins, Henry (1958–)

Did postgraduate work at Universities of Iowa and Wisconsin. Currently Associate Professor of Literature at MIT. Publications include: *What Made Pistachio Nuts?: Early Sound Comedy and the Vaudeville Aesthetic* (1992), *Textual Poachers: Television Fans and Participatory Culture* (1992), *Classical Hollywood Comedy* (1995). Influences include: John Fiske, David Bordwell, involvement in media fandom.

Laing, Dave (1947–)

Currently a Research Fellow in The School of Design and Media, University of Westminster and an editor of the journal, *Popular Music*. Publications include: *The Sound of Our Time* (1969), *One Chord Wonders: Power and Meaning in Punk Rock* (1985). Influences include: Walter Benjamin, Roland Barthes, Julia Kristeva.

Lipsitz, George (1947–)

Did his PhD at University of Wisconsin and is currently Professor of Ethnic Studies at University of California, San Diego. Author of *Time Passages* (1990), *Rainbow at Midnight* (1994), *Dangerous Crossroads* (1994), *A Life in the Struggle* (1995). Influences include: Americo Paredes, Janice Radway, C.L.R. James.

McRobbie, Angela (1951–)

Studied at the Centre for Contemporary Cultural Studies, University of Birmingham. Currently Reader in sociology at Loughborough University. Key publications include: *Feminism and Youth Culture: From Jackie to Just Seventeen* (1991) and *Postmodernism and Popular Culture* (1994). Editor of *Zoot Suits and Second Hand Dresses* (1989). Influences include: Tom Wolfe, Angela Carter, Stuart Hall.

Marsh, Peter (1946–)

Studied at Oxford University, was Senior Lecturer in Psychology, Oxford Brookes University and is presently Director of MCM Research. Publications include: *Rules of Disorder, Tribes, Aggro: The Illusion of Violence*. Influences include: Erving Goffman, C. Wright Mills and George Kelly.

Park, Robert Ezra (1864–1944)

After a diverse career as a journalist and political worker, Park returned to university to do a MA in Psychology at Harvard, then a PhD at University of Berlin where he was inspired by the lectures of Georg Simmel. His doctoral dissertation, *Masse und Publikum*, was published as *The Crowd and the Public* in 1904. At age 50 in 1914, Park took his first academic job in the sociology department at University of Chicago. Although he started by teaching a single course called 'The Negro in America', he became an influential permanent member of the faculty until 1936, training a generation of sociologists, including Everett C. Hughes, Herbert Blumer and Louis Wirth. Publications include: *Introduction to the Science of Sociology* (with Ernest W. Burgess, 1921), *The Immigrant Press and its Control* (1922) and several volumes of collected papers, including *The City: Suggestions for Investigation of Human Behaviour in the Urban Environment* (1925–67).

Pearson, Geoffrey (1943–)

Studied at Sheffield University and the London School of Economics. Currently Professor of Social Work at Goldsmiths' College, University of London. Publications

include: *The Deviant Imagination* (1975), *Working Class Youth Culture* (1976), *Hooligan: A History of Respectable Fears* (1983), *The New Heroin Users* (1987). Influences include: Raymond Williams, Edward Thompson, Stanley Cohen.

Polsky, Ned (1928–)

Did postgraduate work at University of Chicago between 1948 and 1950 and was Associate Professor of Sociology at the State University of New York until his retirement in 1983. Author of *Hustlers, Beats and Others* (1969). Influences include: Hans Gerth, Louis Wirth and Everett C. Hughes.

Roberts, Brian (1950–)

Studied Criminology at Sheffield University and Sociology at Birmingham University. Currently Senior Lecturer in the School of Human and Health Sciences at University of Huddersfield. Contributing author to *Resistance through Rituals* (1976), *Policing the Crisis* (1978), the journal *Auto/Biography* and others. Influences include: Robert E. Park, David Matza, George Herbert Mead, Charles Darwin and Karl Marx.

Stallybrass, Peter (1949–)

Studied and later lectured at University of Sussex. Currently Professor of English and Comparative Literature at University of Pennsylvania and an Associate of the Annenberg School for Communications. Co-author of *The Politics and Poetics of Transgression* (1986) and co-editor of *Subjects and Objects in Renaissance Culture* (1996). Influences include: Mikhail Bakhtin, Louis Althusser, Sigmund Freud.

Stratton, Jon (1950–)

Has an MA and a PhD in Sociology from the University of Essex. Currently Senior Lecturer in Cultural Studies at Curtin University, Perth, Western Australia. Books include: *Writing Sites: A Genealogy of the Postmodern World* (1990), *The Young Ones: Working Class Culture, Consumption and the Category of Youth* (1992), *The Desirable Body: Cultural Fetishism and the Erotics of Consumption* (1996). Influences include: Stuart Hall and Tony Jefferson, Dick Hebdige, Geoff Mungham and Geoff Pearson, Stanley Cohen.

Straw, Will (1954–)

Was a postgraduate student and is currently Associate Professor in Communications at McGill University. Co-editor of *Theory Rules: Art as Theory, Theory and Art* (1996) and *The Cambridge Companion to Popular Music* (forthcoming). Influences include: Arjun Appadurai, Pierre Bourdieu, Bernard Miege.

Surace, Samuel (1991–)

Received postgraduate training at universities of California, Berkeley and Los Angeles. Taught in the department of sociology at U.C.L.A. from 1961 to his

retirement as Professor Emeritus in 1989. Key publications include: *Ideology, Economic Change and the Working Classes* (1966), *Towards a Sociology of Borders: The U.S.-Mexican Case* (1969). Influences include: Ralph Turner, Herbert Blumer.

Thornton, Sarah (1965–)

Received PhD from the John Logie Baird Centre, Strathclyde University. Currently Lecturer in Media Studies at Sussex University and an editor of the journal, *Popular Music*. Publications include: *Club Cultures: Music, Media and Subcultural Capital* (1995). Influences include: Howard Becker, Pierre Bourdieu, Simon Frith.

Tolston, Andrew (1949–)

Studied at the Centre for Contemporary Cultural Studies, University of Birmingham and is presently Senior Lecturer in Media and Cultural Studies, Queen Margaret College, Edinburgh. Publications include: *The Limits of Masculinity* (1977), *Mediations: Text and Discourse in Media Studies* (1996). Influences include: Michel Foucault, Ian Hunter, Ian Spring.

Turner, Ralph (1919–)

Awarded his PhD from the University of Chicago, then taught between 1948 and 1990 in the Sociology department at U.C.L.A. where he is now a retired Professor Emeritus. He is author of *Collective Behaviour* (with Lewis Killian, 1957), *The Social Context of Ambition* (1964), *Family Interaction* (1970) and *Waiting for Disaster: Earthquake Watch in California* (1986). Editor of *Robert E. Park: On Social Control and Collective Behaviour* (1967) and co-editor of *Social Psychology: Sociological Perspectives* (1981). Influences include: Everett C. Hughes, Herbert Blumer, Emory Bogardus.

Tyler, Stephen (1932–)

Did MA and PhD at Stanford University. Currently Professor of Anthropology and Linguistics at Rice University in Houston, Texas. Books include: *The Said and the Unsaid: Mind, Meaning and Culture* (1978), *The Unspeakable: Discourse, Dialog and Rhetoric in the Postmodern World* (1989). Influences include: Martin Heidegger, Jacques Derrida, Walter Ong.

Walser, Robert (1958–)

Studied at University of Minnesota and has been Assistant Professor of Musicology at U.C.L.A. since 1994. Publications include: *Running with the Devil: Power, Gender and Madness in Heavy Metal music* (1995). Influences include: Susan McClary, George Lipsitz, Christopher Small.

Weeks, Jeffrey (1945–)

Did postgraduate work at University College London and University of Kent. Currently Professor of Sociology, South Bank University. Publications include: *Coming Out: Homosexual Politics in Britain from the 19th Century to the Present* (1977),

Sex, Politics and Society (1981), *Sexuality and its Discontents* (1985), *Against Nature: Essays on History, Sexuality and Identity* (1991), *Invented Moralities* (1995). Influences include: Mary McIntosh, Michel Foucault, Stuart Hall.

White Allon (1950–1986)
Studied at Universities of Birmingham and Cambridge and taught at Universities of East Anglia and Sussex. Publications include: *The Uses of Obscurity, The Politics and Poetics of Transgression* (with Peter Stallybrass, 1986) and *Carnival, Hysteria and Writing*. Influences (as supplied by Peter Stallybrass) include: Mikhail Bakhtin, Raymond Williams, Norbert Elias.

Willis, Paul (1945–)
Did postgraduate work at the London School of Economics and the Centre for Contemporary Cultural Studies, University of Birmingham. Currently a Reader at Wolverhampton University. Publications include: *Learning to Labour* (1977), *Profane Culture* (1978), *The Youth Review* (1988), *Common Culture* (1990). Influences include: Raymond Williams, Karl Marx, Richard Hoggart (*The Uses of Literacy*'s autobiographical bits).

Whyte, William Foote (1914–)
Did his postgraduate work at Universities of Harvard and Chicago. He is presently Professor Emeritus and Research Director of Programs for Employment and Workplace Systems in the School of Industrial and Labour Relations, Cornell University, New York. Publications include: *Street Corner Society* (1943) and *Making Mondragon: The Growth and Dynamics of the Worker Co-operative Complex* (with Kathleen King Whyte). Influences include: Conrad M. Arensberg, W. Lloyd Warner, Everett C. Hughes.

Young, Jock (1942–)
Did PhD at the London School of Economics. Currently Head of the Centre for Criminology, Middlesex University, London. Books include: *The Drugtakers* (1971), *The New Criminology* (1973), *What is to be Done about Law and Order* (with John Lea, 1993) and *The New Criminology Revisited* (1996). Influences include: Albert Cohen, Richard Cloward, Lloyd Ohlin.

Index